DATE DUE

DE 1 8 09			

DEMCO 38-296

The Power of Display

A History of Exhibition Installations at

the Museum of Modern Art

The Power of Display

A History of Exhibition Installations at the Museum of Modern Art

Mary Anne **Staniszewski**

The **MIT Press**

Cambridge, **Massachusetts**

London, England

This book was set in Franklin Gothic by Graphic Composition, Inc. and was printed and bound in the United States of America.

Library of Congress Cataloging-in-Publication Data

Staniszewski, Mary Anne.
 The power of display : a history of exhibition installations at the Museum of Modern Art / Mary Anne Staniszewski.
 p. cm.
 Includes bibliographical references and index.
 ISBN 0-262-19402-3 (alk. paper)
 1. Museum exhibits—New York (State)—New York—History. 2. Museum of Modern Art (New York, N.Y.) I. Museum of Modern Art (New York, N.Y.) II. Title.
N620.M9S83 1998
709'.04'00747471—dc21 98-7880
 CIP

Contents

List of Illustrations ➜ viii

Acknowledgments ➜ xiv

Introduction Installation Design: The "Unconscious" of Art Exhibitions ➜ xix

1 Framing Installation Design: The International Avant-Gardes ➜ 1

2 Aestheticized Installations for Modernism, Ethnographic Art, and Objects of Everyday Life ➜ 59

3 Installations for Good Design and Good Taste ➜ 141

4 Installations for Political Persuasion ➜ 207

5 Installation Design and Installation Art ➜ 261

6 Conclusion: The Museum and the Power of Memory ➜ 289

Notes ➜ 310

Bibliography ➜ 344

Reproduction Credits ➜ 360

Index ➜ 362

List of Illustrations

I.1 Varnedoe with Neuner, painting and sculpture galleries, MoMA (1997) xx

I.2 Installation photograph of MoMA's first exhibition, *Cézanne, Gauguin, Seurat, van Gogh* (1929) xxiv

I.3 Photographing exhibitions without viewers xxv

I.4 A publicity photograph of an exhibition xxvi

I.5 The museum as commercial space xxvi

I.6 Children's exhibition xxvii

1.1 Homage to Marconi (1932) 2

1.2 Kiesler, *International Exhibitions of New Theater Technique* (1924) 5

1.3 Kiesler, "L Type" display 6

1.4 Kiesler, "T Type" display 6

1.5 *The Armory Show* (1913) 7

1.6 Kiesler, *Eighteen Functions of the One Chair* (1942) 9

1.7 Visitors looking at artworks in Kiesler's *Painting "Library" and Study Area* (1942) 10

1.8 Kiesler, *Surrealist Gallery* (1942) 11

1.9 Kiesler, *Abstract Gallery* (1942) 12

1.10 Kiesler, *Kinetic Gallery* (1942) 13

1.11 Kiesler, *City in Space* (1925) 13

1.12 Rodchenko, *Worker's Club,* in *Exposition Internationale des Arts Décoratifs et Industriels Modernes* (1925) 15

1.13 Lissitzky, *Abstract Cabinet* (1927, 1928) 17

1.14 "Gallery 44" of Hanover Landesmuseum, after Dorner's reorganization (ca. late 1920s) 18

1.15 "Gallery 43" of Landesmuseum, before Dorner's reorganization (ca. early 1920s) 18

1.16 "Dome Gallery" of Landesmuseum, first exhibition after Dorner's reorganization (1930) 19

1.17 "Dome Gallery," *Reformation Exhibition,* Landesmuseum (1917) 19

1.18 Renaissance Gallery of Landesmuseum, after Dorner's reorganization (after 1925) 20

1.19 Moholy-Nagy, drawing, *The Room of Our Time* (ca. 1930) 21

1.20 Kiesler, detail of wall hinges, *Surrealist Gallery* (1942) 22

1.21 *First International Dada Fair* (1920) 23

1.22 Duchamp, *First Papers of Surrealism* (1942) 24

1.23 Gropius, café bar and gymnasium, *Exposition de la Société des Artistes Décorateurs* (1930) 26

1.24 Bayer, *Diagram of Field of Vision* (1930) 28

1.25 Bayer, furniture and architecture gallery, *Exposition de la Société des Artistes Décorateurs* (1930) 29

1.26 Bayer and Gropius, utensils display, *Exposition de la Société des Artistes Décorateurs* (1930) 30

1.27 Gropius, gymnasium and pool, *Exposition de la Société des Artistes Décorateurs* (1930) 31

1.28 Rapin and Rapin, swimming pool, *Exposition de la Société des Artistes Décorateurs* (1930) 31

1.29 Bayer, Gropius, and Moholy-Nagy, *Building Workers' Unions Exhibition* (1935) 32

1.30 Bayer, *Diagram of 360 Degrees of Field of Vision* (1935) 33

1.31 Bayer, Gropius, and Moholy-Nagy, louvers exhibit, *Building Workers' Unions Exhibition* (1935) 34

1.32 Bayer, Gropius, and Moholy-Nagy, directional footsteps and arrows on floor, *Building Workers' Unions Exhibition* (1935) 35

1.33 Schawinsky and Niegeman, Junkers Works, *Gas and Water Exhibition* (1928) 36

1.34 McQuaid, *Lilly Reich: Designer and Architect*, MoMA (1996) 40

1.35 Mies and Reich, *The Velvet and Silk Café*, in *Women's Fashion Exhibition* (1927) 41

1.36 Mies and Reich, *Living Room: Plate-Glass Hall*, in *The Dwelling* (1927) 42

1.37 Mies and Reich, *"Material Show": Wood Exhibit*, in *The Dwelling in Our Time* (1931) 42

1.38 Gropius, *Nonferrous Metals Exhibition*, in *German People/German Work* (1934) 43

1.39 Mies and Reich, *Mining Exhibit*, in *German People/German Work* (1934) 43

1.40 Moholy-Nagy, *Room One*, in *Film und Foto* (1929) 46

1.41 Lissitzky, cinema section with film-viewing devices, *Film und Foto* (1929) 47

1.42 Lissitzky and Senkin, mural, *The Task of the Press Is the Education of the Masses*, in *Pressa* (1928) 48

1.43 Lissitzky, *The Constitution of the Soviets* and *The Newspaper Transmissions*, in *Pressa* (1928) 49

1.44 Libera and De Renzi, facade of *Exhibition of the Fascist Revolution* (1932) 51

1.45 Exhibit in honor of Marconi, in *Exhibition of the Fascist Revolution* (1932) 52

1.46 Libera, *Sacrario*, in *Exhibition of the Fascist Revolution* (1932) 53

1.47, 1.48 Terragni, *Sala O*, in *Exhibition of the Fascist Revolution* (1932) 54, 55

1.49 Persico and Nizzoli, *Gold Medals Room*, in *Italian Aeronautics Exhibition* (1934) 56

2.1 Barr, MoMA's first exhibition, *Cézanne, Gauguin, Seurat, van Gogh* (1929) 60

2.2 *0.10: The Last Futurist Exhibition of Paintings* (1915–1916) 63

2.3 *The Armory Show* (1913) 63

2.4 Barr, *Vincent van Gogh*, MoMA (1935–1936) 65

2.5 Folkwang Museum, Essen (ca. 1934) 65

2.6 Barr looking at Calder's *Gibraltar* 67

2.7 Lissitzky, *Abstract Cabinet* (1927, 1928) 68

2.8 Kiesler, *Surrealist Gallery* (1942) 69

2.9 Barr, *Toward the "New" Museum of Modern Art*, MoMA (1959) 71

2.10 Varnedoe with Neuner, painting and sculpture galleries, MoMA (1997) 72

2.11 Barr, flowchart for *Cubism and Abstract Art* (1936) 75

2.12 Barr, German section, *Cubism and Abstract Art*, MoMA (1936) 76

2.13 Barr, wall-mounted chairs, *Cubism and Abstract Art* (1936) 76

2.14 Bayer, furniture and architecture gallery, *Exposition de la Société des Artistes Décorateurs* (1930) 77

2.15 Kiesler and Janis, *Visual Analysis of the Paintings by Picasso*, MoMA (1940) 79

2.16, 2.17 D'Amico, *Children's Holiday Circus of Modern Art*, MoMA (1943–1944) 80

2.18 Barr, "Cubism, 1906–10," in *Cubism and Abstract Art*, MoMA (1936) 82

2.19 Barr, Italian Futurism section, *Cubism and Abstract Art* (1936) 82

2.20 Barr, *Fantastic Art, Dada, Surrealism*, MoMA (1936–1937) 83

2.21 D'Harnoncourt, *Timeless Aspects of Modern Art*, MoMA (1948–1949) 85

2.22 D'Harnoncourt, *Mexican Arts*, Metropolitan Museum of Art (1930) 86

2.23 Map of prehistoric North America at entrance to "Prehistoric" section, *Indian Art of the United States*, MoMA (1941) 88

2.24 D'Harnoncourt with Klumb, "Mimbres Pottery" section, *Indian Art of the United States* (1941) 89

2.25 Re-creation of 16th-century Hopi murals, *Indian Art of the United States* (1941) 90

2.26 Re-creation of pictographs at Barrier Canyon, Utah, *Indian Art of the United States* (1941) 91

2.27 D'Harnoncourt with Klumb, "Northwest Coast" section, *Indian Art of the United States* (1941) 92

2.28 D'Harnoncourt with Klumb, Navaho poncho and blanket installation, *Indian Art of the United States* (1941) 93

2.29 D'Harnoncourt with Klumb, "Indian Art for Modern Living" section, *Indian Art of the United States* (1941) 95

2.30 Navaho sand painters, *Indian Art of the United States* (1941) 96

2.31 *Ancient and "Primitive" Art from the Museum's Collection,* American Museum of Natural History (1939) 100

2.32 Detail of case containing Benin Bronzes, *Ancient and "Primitive" Art from the Museum's Collection* (1939) 101

2.33 Newhall, entrance exhibit by Matter, *Photography: 1839–1937,* MoMA (1937) 102

2.34 Newhall, daguerreotype gallery, *Photography: 1839–1937* (1937) 103

2.35 Newhall, calotype gallery, *Photography: 1839–1937* (1937) 103

2.36 Newhall, "Depth of Focus" exhibit, *Photography: 1839–1937* (1937) 104

2.37 Adams and Newhall, prints on grid suspended from ceiling, *Sixty Photographs: A Survey of Camera Esthetics* (1940–1941) 106

2.38 Adams and Newhall, prints on wall, *Sixty Photographs,* MoMA (1940–1941) 107

2.39 Szarkowski, *Harry Callahan,* MoMA (1976–1977) 108

2.40 Haven and Szarkowski, *The Photo Essay,* MoMA (1965) 109

2.41 Galassi with Neuner, photography galleries, MoMA (1997) 110

2.42 D'Harnoncourt, chart of affinities for *Arts of the South Seas* (1946) 112

2.43 D'Harnoncourt, diagram of vista, *Arts of the South Seas* (1946) 112

2.44 D'Harnoncourt, vista, *Arts of the South Seas,* MoMA (1946) 113

2.45 D'Harnoncourt, Sepik River area gallery, *Arts of the South Seas* (1946) 114

2.46 D'Harnoncourt, Marquesas Islands section, *Arts of the South Seas* (1946) 115

2.47 Goldwater and d'Harnoncourt, *Selected Works from the Collection,* Museum of Primitive Art (1957) 118

2.48 Jones and Silver with LaFontaine, Michael C. Rockefeller Wing, Metropolitan Museum of Art (1997) 119

2.49 Henshall and Drexler, pavilion for *Art of the Asmat: The Michael C. Rockefeller Collection,* Museum of Primitive Art, at MoMA (1962) 120

2.50 D'Harnoncourt, installation within interior of pavilion for *Art of the Asmat* (1962) 120

2.51 Newton, Gunn, and Silver with LaFontaine, Michael C. Rockefeller Wing, Metropolitan Museum of Art (1997) 121

2.52 Rubin, Varnedoe, and Froom with Neuner, entrance, *"Primitivism" in Twentieth Century Art: Affinity of the Tribal and the Modern,* MoMA (1984–1985) 122

2.53 Rubin, Varnedoe, and Froom with Neuner, massive display cases, *"Primitivism" in Twentieth Century Art* (1984–1985) 123

2.54 Hall of Mexico and Central America, American Museum of Natural History (ca. 1900) 126

2.55 Foyer of Hall of Mexico and Central America after rearrangement (1945) 127

2.56 Barr, flowchart for *Cubism and Abstract Art* (1936) 128

2.57 D'Harnoncourt, chart of affinities for *Arts of the South Seas* (1946) 128

2.58 D'Harnoncourt, first gallery, *The Sculpture of Picasso,* MoMA (1967–1968) 130

2.59 D'Harnoncourt, *The Sculpture of Picasso* (1967–1968) 131

2.60 D'Harnoncourt, entrance, *Modern Art in Your Life,* MoMA (1949) 132

2.61 D'Harnoncourt, exhibition plan for *Modern Art in Your Life* (1949) 133

2.62 D'Harnoncourt, chart for *Modern Art in Your Life* (1949) 134

2.63 D'Harnoncourt, Surrealism gallery, *Modern Art in Your Life* (1949) 135

2.64 D'Harnoncourt, entrance to Surrealism gallery, *Modern Art in Your Life* (1949) 135

2.65 D'Harnoncourt, Geometric Stylization section, *Modern Art in Your Life* (1949) 137

2.66 D'Harnoncourt, entrance to Geometric Stylization section, *Modern Art in Your Life* (1949) 137

2.67 Rubin, entrance to *Dada, Surrealism, and Their Heritage*, MoMA (1968) 138

2.68 Rubin with d'Harnoncourt, Salvador Dalí gallery, *Dada, Surrealism, and Their Heritage* (1968) 139

3.1 Bayer and Gropius, entrance, *Bauhaus 1919–1938,* MoMA (1938–1939) 142

3.2 Bayer, plan, *Bauhaus 1919–1938* (1938–1939) 145

3.3 Bayer, exhibit illustrating "The Bauhaus Synthesis," *Bauhaus 1919–1938* (1938–1939) 146

3.4 Bayer, corrugated-paper room divider, *Bauhaus 1919–1938* (1938–1939) 147

3.5 Bayer, labels and exhibits tilted at angles from the wall, *Bauhaus 1919–1938* (1938–1939) 147

3.6 Bayer, circulation paths on floor, *Bauhaus 1919–1938* (1938–1939) 148

3.7 Bayer, curved tabletop suspended by string, *Bauhaus 1919–1938* (1938–1939) 148

3.8 Bayer, stacked glass box vitrines, *Bauhaus 1919–1938* (1938–1939) 149

3.9 Bayer looking into a peephole, *Bauhaus 1919–1938* (1938–1939) 150

3.10, 3.11 Johnson, *Machine Art,* MoMA (1934) 154, 155

3.12 Johnson, domestic glassware on display tables, *Machine Art* (1934) 156

3.13 Johnson, laboratory glassware spotlit on black velvet, *Machine Art* (1934) 157

3.14 *Useful Household Objects under $5.00,* MoMA (1938) 161

3.15 Items of portable display table, *Useful Objects of American Design under $10.00,* MoMA (1939–1940) 163

3.16 Visitors handling and looking at objects in *Useful Objects of American Design under $10.00,* MoMA (1940) 164

3.17 Mies and Johnson at *Mies van der Rohe Retrospective,* MoMA (1947–1948) 166

3.18 Noyes, room settings, *Organic Design in Home Furnishings,* MoMA (1941) 168

3.19 Noyes, display of chairs, *Organic Design in Home Furnishings* (1941) 169

3.20 *Organic Design* display, Kaufmann's Department Store, Pittsburgh (1941) 170

3.21 Kauffer's image of a hand, the icon of the *Organic Design* show, in Bloomingdale's ad (1941) 172

3.22 Bayer's image of a hand at the introduction to *Bauhaus 1919–1938* (1938–1939) 173

3.23 Interior displays in Macy's, New York (1883) 175

3.24 S. S. Silver and Co., interior display in Woolf Brothers department store, Kansas City, Mo. (1949) 175

3.25 Diagram of 1930 Deutscher Werkbund exhibition at *Exposition de la Société des Artistes Décorateurs* (1930) 177

3.26 Diagram of a traditional exhibition, showing rigid symmetry 177

3.27 Matter, *Good Design* window display, Carson Pirie Scott, Chicago (1950) 178

3.28 Charles and Ray Eames, Dorothy Shaver, and Edgar Kaufmann pictured at *Good Design* exhibition, MoMA (1950) 179

3.29 Charles and Ray Eames, "Hall of Light," *Good Design*, Merchandise Mart, Chicago (1950) 180

3.30 Charles and Ray Eames, introductory grouping at entrance, *Good Design*, MoMA (1950–1951) 181

3.31 Charles and Ray Eames, *Good Design*, MoMA (1950–1951) 182

3.32 Charles and Ray Eames, Herman Miller showroom, Los Angeles (1950) 183

3.33 Juhl, transparent room dividers, *Good Design,* MoMA (1951–1952) 185

3.34 Juhl, *Good Design,* MoMA (1951–1952) 185

3.35 Rudolph, ground plan, *Good Design* (1952) 186

3.36 Rudolph, *Good Design,* Merchandise Mart, Chicago (1952) 186

3.37 Rudolph, *Good Design,* MoMA (1952) 187

3.38 Girard, *Good Design,* Merchandise Mart, Chicago (1953) 188

3.39 Drexler, *Design for Sport,* MoMA (1962) 191

3.40 Constantine and Johnson, photographs of signs, *Signs in the Street,* MoMA (1954) 192

3.41, 3.42 Constantine and Johnson, signs in sculpture garden, *Signs in the Street* (1954) 193

3.43 Johnson, *Modern Architecture: International Exhibition,* MoMA (1932) 195

3.44 Woodner-Silverman with Evans, Aronovici, Johnson, and Payne, introduction, *America Can't Have Housing,* MoMA (1934) 197

3.45 Woodner-Silverman with Evans, Aronovici, Johnson, and Payne, third section, *America Can't Have Housing* (1934) 198

3.46 Breuer, *House in the Garden,* MoMA (1949) 200

3.47 Yoshida, Rockefeller, and d'Harnoncourt standing in front of Japanese exhibition house, MoMA (1954) 202

3.48 Yoshimura and Sano, *Japanese House in the Garden,* MoMA (1954, 1955) 203

3.49 Riley, Philip L. Goodwin Galleries, MoMA (1996) 204

4.1 Bayer and Steichen, first gallery, *Road to Victory,* MoMA (1942) 211

4.2 Bayer, model for *Road to Victory* (1942) 212

4.3 Bayer and Steichen, American communities, *Road to Victory* (1942) 213

4.4 Bayer and Steichen, "America First" meeting, *Road to Victory* (1942) 213

4.5 Bayer and Steichen, Pearl Harbor, *Road to Victory* (1942) 214

4.6 Bayer and Steichen, slightly larger-than-life-size soldier, *Road to Victory* (1942) 216

4.7 Bayer and Steichen, sea and sky with ships and planes, *Road to Victory* (1942) 217

4.8 Bayer and Steichen, photomural of marching soldiers, *Road to Victory* (1942) 218

4.9 Smith and Steichen, first gallery, *Power in the Pacific,* MoMA (1945) 225

4.10 Smith and Steichen, war photos, *Power in the Pacific,* Corcoran Gallery of Art (1945) 226

4.11 Bayer and Wheeler, entrance, *Airways to Peace,* MoMA (1943) 228

4.12 Bayer, model for *Airways to Peace* (1943) 229

4.13 Bayer, *Airways to Peace* (1943) 229

4.14 Bayer, foreground: "Global Strategy" section, *Airways to Peace* (1943) 232

4.15 Bayer, "outside-in" globe, *Airways to Peace* (1943) 233

4.16 Bayer, photomural of children, *Airways to Peace* (1943) 234

4.17 Rudolph and Steichen with Miller and Norman, *The Family of Man,* MoMA (1955) 237

4.18 Rudolph and Steichen, entrance, *The Family of Man* (1955) 239

4.19 Preliminary wall arrangements for photographs included in *The Family of Man* 240

4.20 Rudolph, plan for *The Family of Man* 242

4.21 Rudolph and Steichen, centerpiece of family portraits, *The Family of Man* (1955) 243

4.22 Rudolph and Steichen, vista of several thematic sections, *The Family of Man* (1955) 245

4.23 Rudolph and Steichen, "faces" exhibit, *The Family of Man* (1955) 246

4.24 Photograph of family in front of H-bomb photograph in *The Family of Man* 247

4.25 Rudolph and Steichen, photomural of UN delegates, with portraits, *The Family of Man* (1955) 248

4.26 Rudolph and Steichen, "magic of childhood" section, *The Family of Man* (1955) 249

4.27 Rudolph and Steichen, quotation of Atomic Energy Commission in work section, *The Family of Man* (1955) 252

4.28 Rudolph and Steichen, photograph of lynched man in the "inhumanities section," *The Family of Man* (1955) 253

4.29 Cast of *Father Knows Best* 258

5.1, 5.2 The Guerrilla Art Action Group's "blood bath" action (1969) 266

5.3 GAAG statement and GAAG communiqué 267

5.4 Olivetti, "visual jukebox" at the entrance of *Information* (1970) 272

5.5 McShine with Froom, *Information,* MoMA (1970) 273

5.6 McShine with Froom, *Information* (1970) 274

5.7 Haacke, *MoMA Poll* (1970) 275

5.8, 5.9 Acconci, *Service Area* (1970) 277

5.10 Group Frontera installation, *Information* (1970) 279

5.11 Pulsa, materials and equipment next to scupture garden installation, *Untitled,* in *Spaces,* MoMA (1969–1970) 283

5.12 Walther, *Instruments for Process,* MoMA (1969–1970) 284

6.1 Bayer, *Bauhaus 1919–1938,* MoMA (1938–1939) 290

6.2 Barr looking at Calder's *Gibraltar* 294

6.3 Visitors handling and looking at objects in *Useful Objects of American Design under $10.00,* MoMA (1940) 295

6.4 Adams, *Road to Victory,* in *Road to Victory/Project 25: Dennis Adams,* MoMA (1990–1991) 296

6.5 Adams, *Cocoon,* in *Road to Victory/Project 25: Dennis Adams* (1990–1991) 297

6.6 Lawler, *Untitled,* in *Enough/Projects: Louise Lawler,* MoMA (1987) 299

6.7, 6.8, 6.9 Hubert, Zelnio, and Phillips, *Frederick Kiesler,* Whitney Museum of American Art (1989) 300, 301

6.10 Kruger, *Picturing Greatness,* MoMA (1987–1988) 303

6.11 Hammons, *Public Enemy* (1992), in *Dislocations,* MoMA (1991–1992) 305

6.12 Piper, *What It's Like, What It Is, no. 3* (1992), in *Dislocations* (1991–1992) 306

6.13 Painting and sculpture galleries, MoMA (1997) 308

Acknowledgments

I would like to thank the following individuals at the MIT Press. I am especially grateful to Roger Conover for his initial interest in my manuscript and the continued enthusiastic support, intelligence, and generosity he has shown throughout the publishing process. He played a particularly vital role in enabling me to publish this book. I would like to thank Matthew Abbate for his guidance in overseeing the project and for all of the care and patient advice he has given me in editorial matters. I greatly appreciate his willingness to accommodate my varied requests regarding the book. I feel quite lucky to have had Alice Falk as an editor, for she is meticulous, judicious, and gifted in her work. Regarding the design of the book, I had very exacting ideas about the way I wanted it to look, to the point where I had created a maquette of the images for the designer to follow. Ori Kometani respected these ideas, but she also augmented them with her own graphic vision and, in many ways, produced an even more beautiful book than I had imagined. I would also like to thank Julie Grimaldi and Daniele Levine for their help with day-to-day matters and Ann Rae Jonas for her work on the catalogue.

A great deal of my research took place at the Museum of Modern Art, and there are a number of individuals at the Museum who helped make this book possible. I would like to thank MoMA's deputy director for education and research support, Patterson Sims—and MoMA's publications committee—for granting my request that the Museum make an exception to its policy of allowing only 25 percent of a book's images to be from MoMA's archives. This decision was instrumental in enabling me to properly present the history of the Museum, and it can be seen as evidence of an interest in the history of installation design. Mikki Carpenter, another member of the publications committee, deserves very special thanks. Mikki oversees MoMA's photographic archives, and it was she who helped me when I first began research some twelve years ago. Her professionalism in all matters regarding the archives and photographic materials is greatly appreciated. For the past several years, Jeffrey Ryan assisted me in my many visits to the archives. His energy and intellectual curiosity made my research more fun, and I want to thank him for his willingness to seek out all sorts of facts and detailed information. Also, for a short period of time Noel Soper assisted me with my photo research. MoMA's archivists and librarians deserve special thanks for all the help they gave me during all these years: chief archivist Rona Roob; the archive assistants and technicians, Michelle Elligott, Michelle Harvey, Leslie Heitzman, Aimee Kaplan, Apphia Loo, Rachael Wild; MoMA's librarians Janis Ekdahl, Daniel Starr, Eumie Imm Stroukoff, John Trause, Daniel Fermon, Clive Phillpot, and Jenny Tobias; and the photography study center supervisor, Virginia Dodier. Individuals in the registrar's department that helped me with my research were Lisa Archimbeau, Aileen Chuk, and Blanche Perris Kahn. Thanks to Laura Rosenstock for her aid with research regarding the painting and sculpture department.

An important component of this book are the interviews I conducted for it. I would like to thank the following individuals for giving their time and invaluable information: Dennis Adams, Mildred Constantine, Charles Froom, Hans Haacke, Jon Hendricks, Philip Johnson, April Kingsley, Barbara Kruger, Louise Lawler, Lucy Lippard, Wayne Miller, Jerome Neuner, Irving Petlin,

and the late Paul Rudolph. In particular Wayne Miller and Paul Rudolph gave or lent me important documents. I would also like to thank the following individuals who provided answers to some specific questions in shorter interviews: Christian Hubert, Kynaston McShine, Terence Riley, Jennifer Russell, and Daniel Bradley Kershaw, who was also extremely helpful in providing documentation of the Metropolitan Museum of Art exhibition design history.

Quite a number of people helped me with the challenging task of finding and acquiring the images for this book, and many of them were very generous in lending me photographs and in regard to fees. Thanks to Dennis Adams, Bettina Behr, Woodfin Camp, Eames Demetrios, Lucia Eames, Hans Haacke, Jon Hendricks, Barbara Kruger, Lillian Kiesler, Louise Lawler, Wayne Miller, Shelly Mills, Paul Rudolph, Tom Baione of the American Museum of Natural History, Katia Steiglitz of the Artists Rights Society, Alyssa Olins of Bloomingdales, and Christine Cordazzo of Esto Photographs; and thanks to the Barbara Gladstone Gallery, Jack Tilton Gallery, Mary Boone Gallery, Metro Pictures, Walker, Ursitti, and McGuinnis, and the John Weber Gallery. Javan and Joella Bayer were particularly generous regarding the Herbert Bayer images that are reproduced inside the book and on the jacket.

Gwen Finkel Chanzit has given me advice a number of times throughout this project, particularly regarding Herbert Bayer's work. Virginia Lee-Webb of the Metropolitan Museum of Art was very helpful with my research regarding the Museum of Primitive Art and related matters. Thanks to Nancy Malloy and Valerie Komor of the Archives of American Art; Emily Norris of the Busch-Reisinger Museum; Bob Viol of the Herman Miller Showroom Archive; Richard Fusick and Maricia Battle of the Library of Congress; Kevin De Vorsey of the National Museum of the American Indian; and Drew Diamond of New York University's Elmer Holmes Bobst Library. David Coombs and Paula Baxter (formerly of the MoMA library) are just two of the many individuals of the New York Public Library staff who have helped me with my work. Thanks to Olivier Lugon regarding some research questions and to Henry Smith-Miller for his interest in and support of this project during its early stages and his invitation to present my ideas at Harvard's Graduate School of Design in 1987.

This book is a modified version of my Ph.D. dissertation, and I would like to thank my advisor, Linda Nochlin, for her support through the years and for seeing me through to the end of my degree after she had left the Graduate School and University Center of the City University of New York for positions at other institutions. Thanks to Rose-Carol Washton Long for her meticulous reading of the dissertation and for the support she gave me throughout my work on my degree. I appreciate the helpful suggestions of Carol Armstrong, and special thanks to Milton Brown for his graciousness and conscientiousness regarding my defense when he had his own health concerns. I would also like to acknowledge my appreciation of the Art History Program of the Graduate Center for granting me three University Fellowships and one Program Dissertation Fellowship, and of the Rhode Island School of Design for granting me a faculty development grant.

Some of my most important thanks come near the end of these acknowledgments. First I must thank my dear friend Christopher Phillips. It was Christopher's article "The Judgment Seat of Photography" that led me to investigate MoMA's photographic archives, which became the foundation of this text. Throughout this project he gave generously of his intelligence, editorial skills, and knowledge of modern visual culture, which often included surprising or obscure but important facts and information. Another of my dearest friends, Allan Schwartzman, has also gone through this entire text, and in seemingly infinite discussions has shown great intelligence and patience with all kinds of questions, from the fine points of grammar to the conceptual issues of this book. These two friends, more than any others, shared this very important aspect of my life with me. Ann Reynolds has provided

priceless professional and personal support in regard to the dissertation process and the book. I thank her for balanced judgment and wisdom and for giving me advice, in particular, regarding the second chapter. Julie Mars, Mimi Thompson, and Jill Sussman have not only given me great friendship during my work on this project, but Julie and Mimi have helped me with editorial questions and Jill with design decisions, for which I am extremely grateful. Special thanks to Cynthia Cannell, not only for her friendship but for the constancy and respect she has always given me as a writer. There are quite a number of people who made this book possible in diverse and more personal ways. Thanks to Jeannette (Lydia) Araujo, Zorina Bagel, Jeanette Busch, Phil Block, Ellen Driscoll, Heidi Fleiss, Tati Gonzalez, Julia Heyward, Allan Kamlett, Deborah Kass, Papo Kolo, Iris Libby, Andrew Leitch, Branda Miller, Muntadas, Sylvia Netzer, Therese Osborn, Ilda Obiso, the late Gus O'Biso, Kathy O'Dell, Steve Pierce, Adrian Piper, Scott Roper, Harriet Senie, Kathy Schremerhorn, Mildred Schneider, Jon Smit, Chrysanne Stathacos, Laura Sydell, the late Paul Taylor, Hillary Thing, Jonathan Wilson, and Arnold Young. I have special gratitude to Jeanette Ingberman, Wanda López, and Ellen Silverstein, each of whom helped me in their own unique ways, generously giving friendship, advice, and support on what was often a daily basis, and I greatly appreciate Ellen's ideas regarding the jacket.

My most deeply felt words are the last. I want to thank my parents, Anna and the late Herbert Staniszewski, for the wisdom, inspiration, patience, support, and love they have given me during the many, many years I was working on this text. Although my father did not live to see this book, he had the satisfaction of knowing it was going to be published and was pleased it had been acquired by the MIT Press. Finally, thanks to my sister, Claudia Staniszewski, my brother and sister-in-law, Herbert and Kathy Staniszewski, my niece Anna, and my Aunt Mary.

Introduction

Installation **Design:**

The **"Unconscious"**

of Art **Exhibitions**

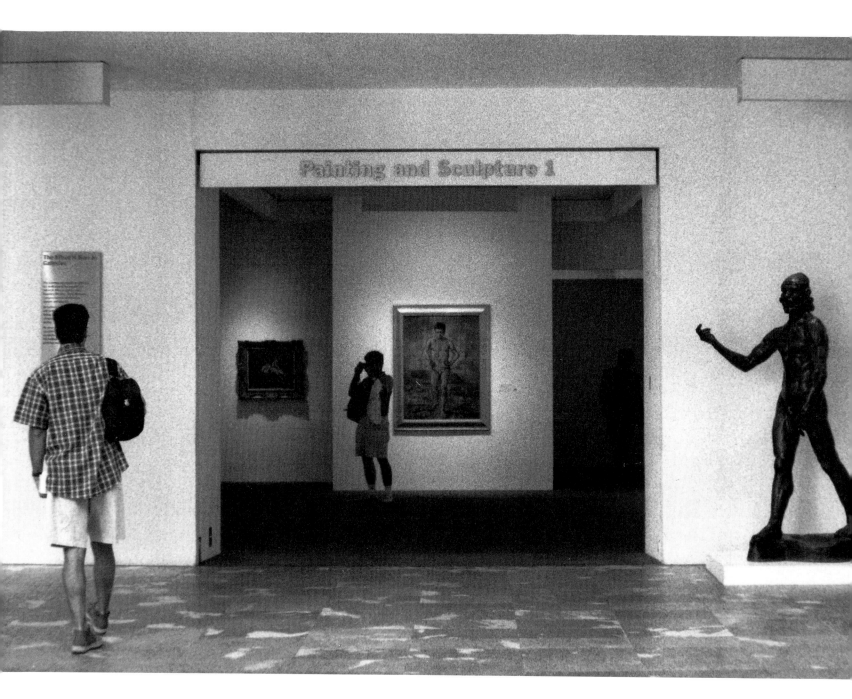

What historians omit from the past reveals as much about a culture as what is recorded as history and circulates as collective memory. In classic Freudian analysis, "the repressed" embodies resistance and opposition to consciously incorporating what are often the most powerful dimensions and desires of the individual. An analogy has often been made to memory at a collective level: the cultural mechanism that works to exclude or repress within the social landscape is ideology. Ellipses in our official histories and collective memories manifest historical limitations and demark the configurations of power and knowledge within a particular culture at a given moment.

In this book, I deal with an aspect of modern art history that has been, generally speaking, officially and collectively forgotten—installation design as an aesthetic medium and historical category. Although there has been an increased interest in installation design since the 1980s,[1] the way modern artworks are actually seen and displayed remains a relatively overlooked consideration.[2] The ephemeral nature of exhibitions, while certainly contributing to this amnesia, cannot adequately explain why art history consists predominantly of histories of individual artworks in which the installations are ignored. However much art historians may foreground the historical context of an image or object, the subject of analysis, in most instances, remains the discrete work of art; and there is an implicit acceptance of its autonomy. Art historians have analyzed the works included in an exhibition and a show's effect as it is received within aesthetic, social, and political discourses. But they have rarely addressed the fact that a work of art, when publicly displayed, almost never stands alone: it is always an element within a permanent or temporary exhibition created in accordance with historically determined and self-consciously staged installation conventions. Seeing the importance of exhibition design provides an approach to art history that acknowledges the vitality, historicity, and time-and-site-bound character of all aspects of culture.

I.1
Kurt Varnedoe, curator of the Department of Painting and Sculpture, with the assistance of Jerome Neuner, director of exhibition design and production, painting and sculpture galleries, Museum of Modern Art, New York, 1997.

Exhibitions, like the artworks themselves, represent what can be described as conscious and unconscious subjects, issues, and ideological agendas. Their unconscious, or less obviously visible, aspects can be understood as manifestations of historical limitations and social codes. One effective strategy for seeing these often overlooked yet extremely powerful dimensions of art exhibitions is to analyze their installation designs.

The Power of Display is an investigation of exhibition installations as representations. My subject is the history of exhibitions at the Museum of Modern Art, a paradigm of modern aesthetic institutions of cultural production, reception, and distribution—what might be called the contemporary art apparatus. The first chapter presents installation design as a historical category, a medium in its own right, and an important aspect of the twentieth-century international avant-gardes.[3] In so doing, it provides an aesthetic, historical, and theoretical framework within which to discuss the exhibition history of the Museum of Modern Art. This overview brings together previously documented paradigmatic exhibitions in order to open a discourse on twentieth-century installation design.

Chapters 2 through 5 feature paradigmatic installations from the Museum of Modern Art's inception in 1929 to today. The exhibitions included in these chapters provide a representative sampling of the diversity of exhibition design found at MoMA and establish what might be considered the spectrum of possibilities for MoMA's installations.[4] Chapter 2 deals with traditionally aesthetic exhibitions, such as those for painting and sculpture. The display of so-called primitive art and the installation practices of natural history museums are examined because of their role in the development of modern aesthetic installation techniques. The subjects of chapter 3, MoMA's architecture and design exhibitions, are analyzed in relation to the history and display techniques of the commercial sector and the department store.

Chapter 4 is a study of MoMA's exhibitions that were explicitly political propaganda, created in affiliation with U.S. government agencies. In chapter 5, the inception of installation art is examined in conjunction with the political and cultural activism of the 1960s and 1970s.

The discussion in chapter 5 also deals with another omission in the literature of twentieth-century art: the prehistory and inception of the installation art of the 1960s and 1970s. In order to address this failure to discuss artists' installations in terms of the installation design of the first half of the century, this chapter initiates an examination of the shifts that took place as installation-based art and conceptual practices began. Chapter 6 sets the issues explored in *The Power of Display* in relief with its analysis of several Museum of Modern Art exhibitions of the 1980s and 1990s.

In addition to filling a void in the art historical literature by treating installation design as an aesthetic medium and by investigating these exhibition designs as representations, I delineate one important aspect of the prehistory of the institutional, theoretical, and ideological configuration that constitutes the contemporary art apparatus in the United States. Studying the history of paradigmatic exhibitions at MoMA—my analysis features those from 1929 to 1970—is a strategy for framing one component of the contemporary art system in order to understand its historical and ideological limits. In this sense, the book documents the formation of institutional conventions during what I refer to as the "laboratory period" for the Museum of Modern Art and the contemporary art apparatus. My coinage adapts the characterization of MoMA as an "experimental laboratory" by the Museum's founding director, Alfred Barr.[5]

The Power of Display also considers the often-overlooked initial experiments in what have become fundamental areas of contemporary art practice. It is in the installation design of the first half of the twentieth century that the sources of such prac-

tices as viewer interactivity and site specificity, as well as multimedia, electronic, and installation-based work, are to be found.

Throughout the book, questions are raised about the amnesia regarding exhibition design as a twentieth-century artistic and institutional practice. Certainly the decrease in installation experimentation that took place in the 1960s and 1970s has been, in part, the result of the consolidation of conventions within modern art museums and is linked to the institutionalization of contemporary and modern art and the development of convenient professional formulas. But this does not sufficiently explain why this historical amnesia has persisted until very recently. I intend to raise questions about the implications of this collective forgetting for contemporary art.[6]

I founded this inquiry on the premise that all that we experience in the world is mediated by culture and is, in this sense, representation. As with everything we see as culture, exhibitions *are* history, ideology, politics—and aesthetics. These seemingly abstract terms are made manifest in varying degrees in our art and our everyday life, within spectrums of emphasis and in constantly and infinitely changing configurations that constitute our defining discourses.

The Power of Display has been shaped by the following questions: What was the physical context of these objects, images, artifacts, and, in some cases, entire buildings when they were displayed, seen, and institutionalized as exhibitions? How did those installations affect their meanings? What aesthetic, cultural, and political discourses intersected with these exhibitions? What sorts of viewers, or "subjects," do different types of installation designs create? What kinds of museums are constituted by particular installation practices? How do these installations shape the viewer's experience of the cultural ritual of a museum visit? What kinds of art histories, exhibitions, and institutions are produced if the installations of the past have been forgotten? What sort of collective cultural memories does an amnesia regarding exhibition design produce?

The photographs reproduced in this book are fundamental to my agenda to decipher and document a forgotten aspect of the past. It is important to keep in mind that these are the photographs that have survived in archives and then, in many cases, were chosen from among many different possible selections. The Museum of Modern Art's careful documentation of its exhibition history was the primary substratum from which this text was constructed (fig. I.2). MoMA's archives are unusually rich when compared with other archival sources, such as department stores, or other museums, such as the National Museum of the American Indian. As I was in the final stages of preparing this manuscript, the Museum of Modern Art made an exception to its standard policy (which restricts the photographs from MoMA's archives that are reproduced in a publication to 25 percent) and released the installation photographs that are the book's foundation.[7] Such remarkable support from MoMA—and this evidence of the Museum's interest in the significance of installation design—perhaps portends a change in the very practices of the past several decades that I critically examine.

However substantial the Museum of Modern Art's photograph archives may be, the severe limitations of using one or several black-and-white reproductions representing a complex exhibition to construct a history of installations must always be kept in mind when reading this text. Many of these images are presented as bleeds, not only to make visible the often myriad elements of these installations but to prevent the reader from perceiving the photographs as framed pictures and to underscore their status as fragmentary representations.

Another important feature of these reproductions is the almost complete lack of people in the photographs (fig. I.3). The conventions for taking installation photographs are "modernist," in that there are "no subjects in the texts": exhibitions are pic-

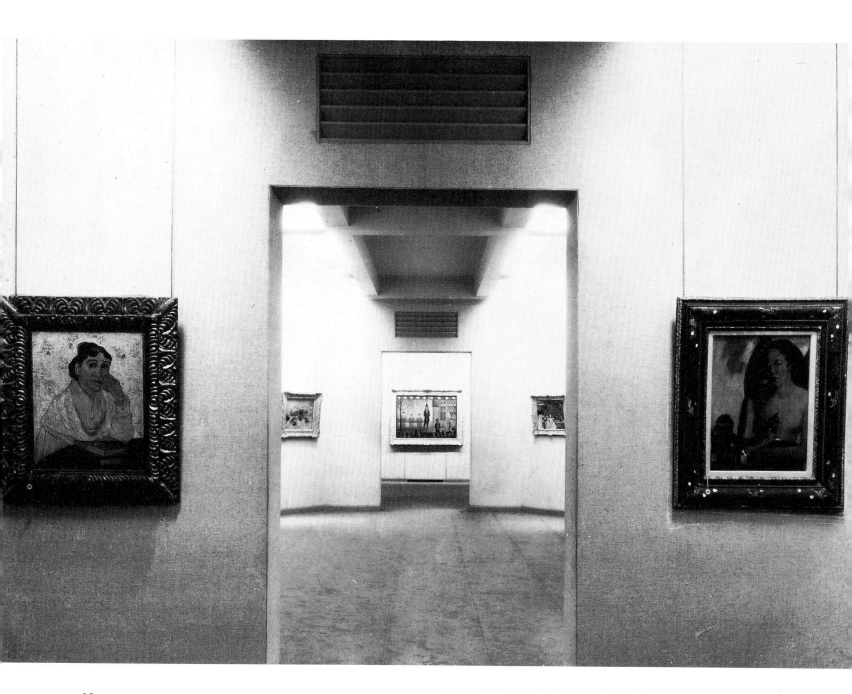

I.2

This installation photograph of the Museum of Modern Art's first exhibition—
Cézanne, Gauguin, Seurat, Van Gogh, held from 7 November to 7 December

1929—is one of 24 black-and-white installation photographs in MoMA's
Photograph Archives; it is the one image reproduced to document the exhi-
bition in this book.

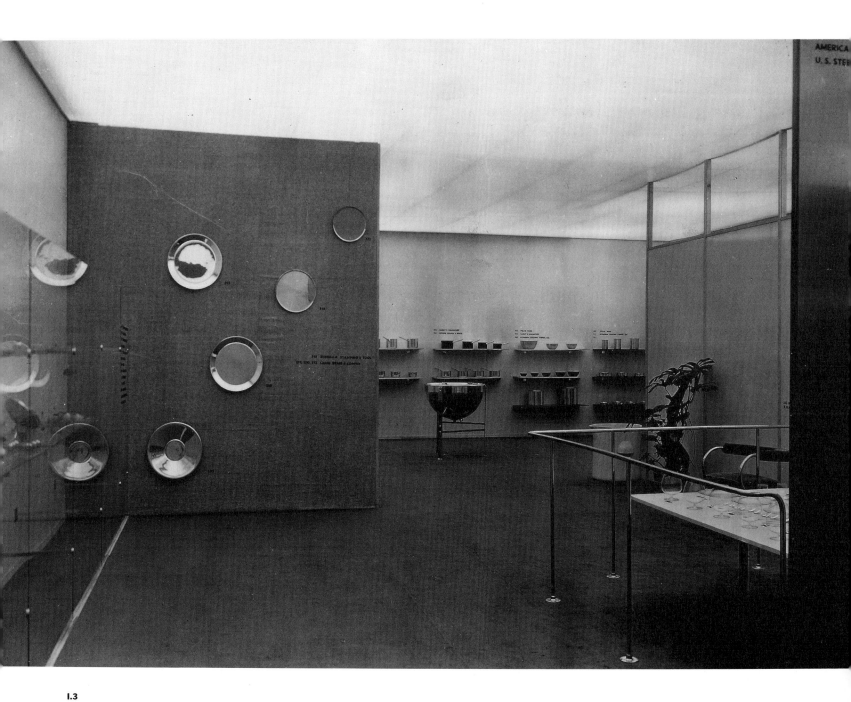

I.3
The convention of photographing exhibitions without viewers, here illustrated by
an installation photograph of *Machine Art,* held at the Museum of Modern Art from
5 March to 29 April 1934.

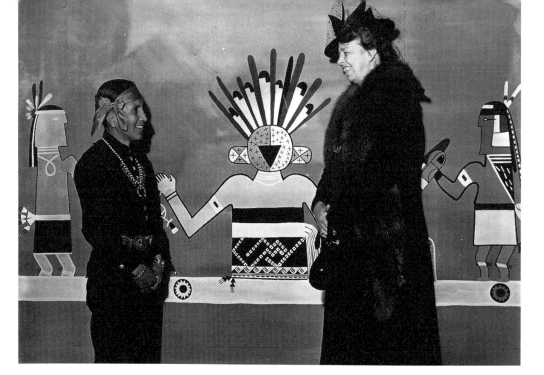

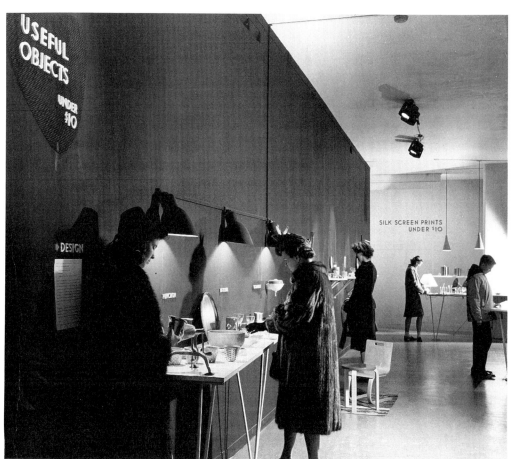

I.4

An exception to the convention of photographing installations without viewers are publicity photographs, such as this image of Eleanor Roosevelt and Fred Kabotie in front of a re-creation of a Hopi mural overseen by Kabotie at *Indian Art of the United States,* held at the Museum of Modern Art from 22 January to 27 April 1941.

I.5

Visitors handling and looking at objects included in *Useful Objects of American Design under $10.00,* Museum of Modern Art, 26 November to 24 December, 1940.

I.6

Children's Holiday Circus of Modern Art, Museum of Modern Art, 8 December 1943 to 3 January 1944.

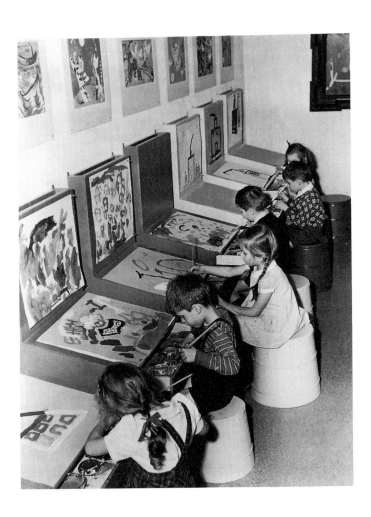

tured for posterity as empty, idealized, and uncluttered by men and women and children wandering through these carefully constructed interiors. The exceptions to this convention are predictable and revealing. Should an exhibition lend itself to such events, there would be publicity shots of visitors to the show, who were, in most instances, museum directors, curators, honored guests, and artists (fig. I.4). Although most installation photographs that did include viewers were taken for public relations purposes, certain types of installations were distinguished by an unusually large number of these photographs. For example, there are numerous images of people moving about and picking up and examining items in MoMA's design shows. Often the figures framed in these displays, suggestive of domestic and commercial spaces, were women (fig. I.5).[8] Another exception to the standard, "empty" installation photograph were those of MoMA's children's holiday carnivals (fig. I.6). These, too, were publicity photos, but the majority of archival images of these installations include the children who played and made art in these exhibits. Both exceptions represent departures from what might have been considered the standard, masculine viewer in a traditional aesthetic exhibition.

Throughout this book, I refer to the "amnesia" and the "memory" of the Museum of Modern Art. My use of these terms does anthropomorphize an institution. But institutions are composed of individuals who create and sustain them and who produce the archives, publications, publicity, and countless practices that include exhibitions. This terminology is therefore applied in order to raise questions about individual responsibility in creating institutional conventions and the historical and ideological processes of a museum. I also refer to the "unconscious" of exhibitions and of the Museum, using the metaphor to suggest that which is present—and powerful—but often unseen, overlooked, and unacknowledged.

Implicit in my approach—and the subject of exhibition design itself—is the belief that all aspects of culture can be read and analyzed as we art historians have been trained to read and analyze the meanings of fine art. The importance of knowing the discourse of a particular field of study should not foreclose the possibility of applying that knowledge elsewhere as appropriate. Art historians therefore can use our in-depth training in the language of the visual to investigate the visual array of the world around us as found in all varieties of objects, materials, and media. The vitality and experimentation that thrived at the Museum of Modern Art during the laboratory years was partly but unmistakably linked to the Museum's presentation of such a worldly variety of modern culture and modern art.

Chapter 1

Framing Installation Design:

The International Avant-Gardes

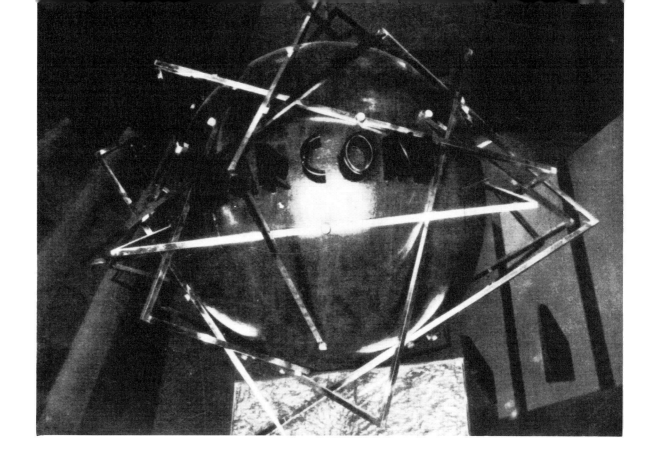

A New Language of Form and a New Ideological Scaffolding for Exhibitions: The Installation Designs of Frederick Kiesler

When reading Herbert Bayer's statement quoted in the epigraph, one wonders why exhibition design's variety of means and powers of communication have been collectively forgotten, for the most part, by the art historical and museum establishment in the United States. Innovative exhibition design flourished in Europe and the United States from the 1920s through the 1960s, with most experimentation taking place through the 1950s. Bayer, like Frederick Kiesler, Lilly Reich, El Lissitzky, and Giuseppe Terragni, was one of many artists, designers, and architects who considered exhibition design to be an important aspect—in some cases the most important aspect—of their work.

Technological innovation, the mass media, site specificity, and viewer interactivity were of particular interest to those creating exhibition designs during these years. These areas of interest and experiments in exhibition technique were reconfigured in much of the work that developed in the late 1960s and early 1970s. The exhibition designs of the international avant-gardes of the first half of the century can be seen as the prehistory of one of the dominant practices of contemporary visual culture: installation art.

Exhibition design has evolved as a new discipline, as an apex of all media and powers of communication and of collective efforts and effects. The combined means of visual communication constitutes a remarkable complexity: language as visible printing or as sound, pictures as symbols, paintings, and photographs, sculptural media, materials and surfaces, color, light, movement (of the display as well as the visitor), films, diagrams, and charts. The total application of all plastic and psychological means (more than anything else) makes exhibition design an intensified and new language.

— Herbert Bayer, "Aspects of Design of Exhibitions and Museums" (1961)

1.1

An homage to Guglielmo Marconi, one of the many display and installations celebrating the power of the mass media, technology, exhibition design, and the Fascist revolution in the 1932 *Exhibition of the Fascist Revolution,* Rome. *Mostra della Rivoluzione Fascista: Guida Storica,* ed. Dino Alfieri and Luigi Freddi, ex. cat. (Rome: Partito Nazionale Fascista, 1932), 249.

In Europe, the parameters for innovative installation design were first established in the 1920s and 1930s. During that same period, the foundations for the mass media were being laid. Artists fascinated with the possibility of creating public exhibition spaces saw installation design as one of many new arenas of mass communication that would transform modern life; others included film, radio, avant-garde theater, advertising, the illustrated press, and picture magazines. Bayer's statement is representative of the pervasive interest among the international avant-gardes in exhibition design as one of myriad creative options for artists, designers, and architects as they ventured forth into what they saw as a new frontier of art and mass communications.

One of the first projects in what was perceived as a new and exciting medium was Kiesler's installation for the 1924 *Internationale Ausstellung neuer Theatertechnik (International Exhibition of New Theater Technique)* at the Konzerthaus in Vienna (fig. 1.2).[1] The *Exhibition of New Theater Technique,* along with *Art History of the Viennese Folk Plays and Music* and *The History of Theater, 1890–1900,* constituted the *Musik und Theaterfest des Stadt Wien (Music and Theater Festival of the City of Vienna),* which was organized to reestablish Viennese leadership in the arts.[2] The theater exhibition, an important event among the international avant-gardes, brought together the work of more than one hundred leading playwrights, stage designers, filmmakers, and artists; among them were El Lissitzky, Leon Bakst, Alexandra Exter, Natalia Goncharova, Fernand Léger, Francis Picabia, Enrico Prampolini, Hans Richter, and Oskar Schlemmer.

Kiesler curated the *Exhibition of New Theater Technique,* which included examples of his own work. But perhaps most significantly for the history of modern art, he invented a new method of installation design, which he called "Leger and Trager" or "L and T" (figs. 1.3 and 1.4). Conceived as an alternative to what Kiesler considered the rigid constraints of traditional exhibition conventions, the L and T system created for installations a new language of form composed of freestanding, demountable display units of vertical and horizontal beams that supported vertical and horizontal rectangular panels. For the Vienna exhibition, some six hundred unframed drawings, posters, marionettes, photographs, designs, and models of avant-garde theater productions were mounted or placed on these L and T elements. The T-type structures had cantilevers that allowed the viewer to adjust the images and objects to his or her eye level and viewing pleasure (see fig. 1.4).

In addition to accommodating viewer interaction, the L and T system departed in a number of ways from conventional exhibition display methods whereby the works of art were mounted on walls and temporary exhibition panels, such as in the 1913 *"Armory Show"* in New York City (fig. 1.5). With the L and T method, artworks were not attached to the walls of the exhibition hall and were therefore physically separated from the room's decorative detailing and architectural interior. Kiesler's freestanding structures brought the works of art into the space of the viewer and created what Kiesler called a "varied transparency."[3] The flexible units could be arranged so that a work could be displayed independently or grouped with others, creating a collage-like installation.

This structural fluidity and play of forms were also engineered into the lighting system. Kiesler's system incorporated electric lightbulbs that could be arranged to highlight or spotlight individual works or groups of works. The installation's color, too, was to vary in order to suit each exhibition. The units, conceived as temporary structures, could be adapted to the specific demands of a particular exhibition space. In 1926 Kiesler had the opportunity to demonstrate the flexibility of his transportable system when he installed another version of the *International Theatre Exhibition* at New York City's Steinway Hall.[4]

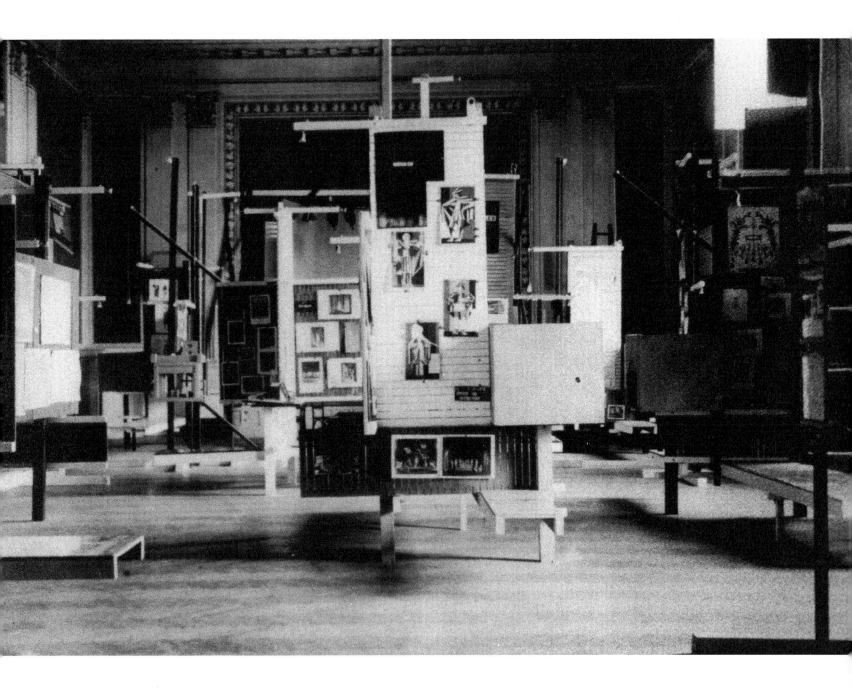

1.2

Frederick Kiesler, *International Exhibition of New Theater Technique*, Konzerthaus, Vienna, 1924.

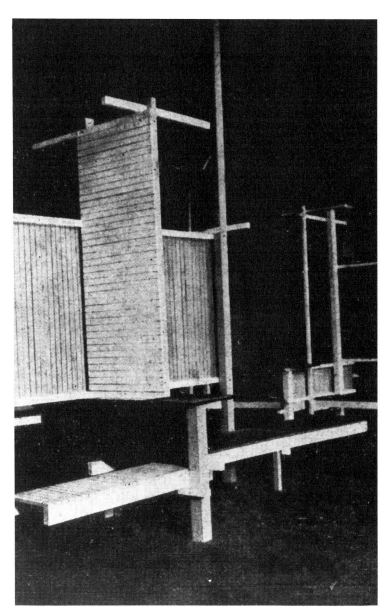

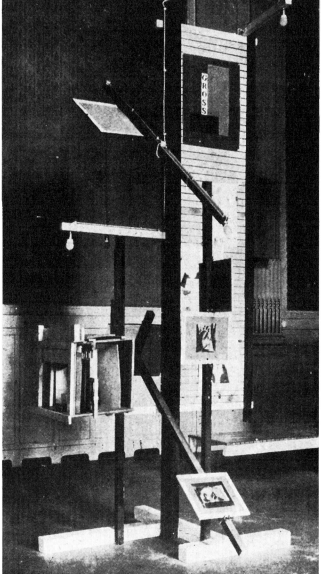

1.3
Kiesler, "L Type" display, 1924, with the "T Type" display are the elements of a
display system that functions like letters of an alphabet; different combinations
create different meanings.

1.4
Kiesler, "T Type" display, 1924.

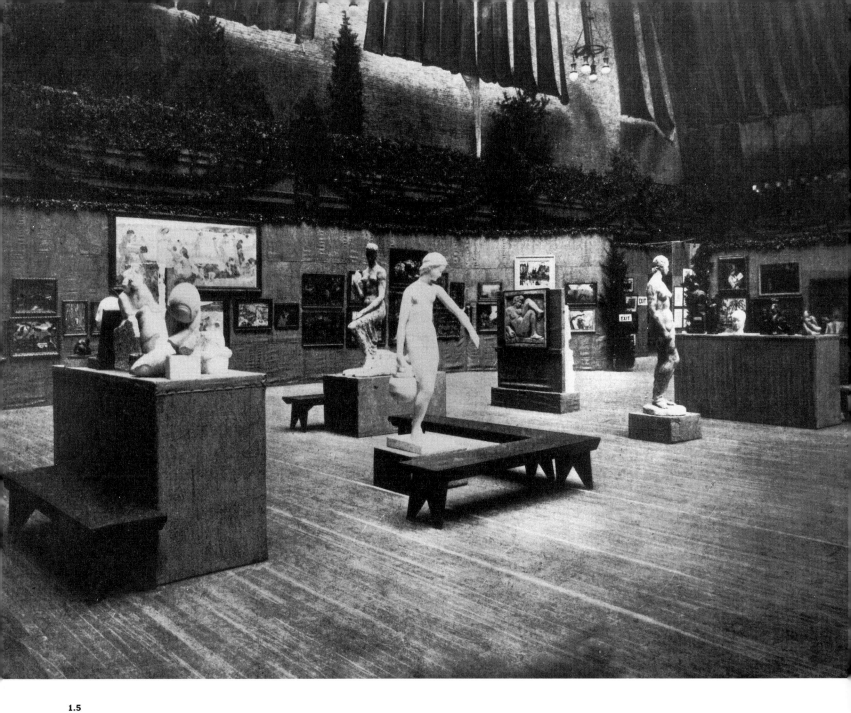

1.5
The "Armory Show," The International Exhibition of Modern Art, Sixty-ninth
Regiment Armory, New York, 17 February to 15 March 1913.

With the L and T system, Kiesler devised a new physical framework for exhibition; less obviously and perhaps more interestingly, he created a new ideological scaffolding for it as well. The separation of the artworks from the architecture of the room allowed a departure from the conventional exhibition and museum practice of placing works of art in relatively dense, tiered installations—what is often referred to as "salon style."[5] The L and T units instead brought the artworks into the space and time of the spectator. The interactive elements set up a framework for viewing art that acknowledged its reception by a viewer as necessary for the creation of meaning. The open, transparent formal properties of the L and T system evoked an ever-expanding, infinite sense of space, consonant with contemporaneous De Stijl, Suprematist, and Constructivist concepts of space and time that abolished the spatial closure and fixed viewpoint of classical perspective.[6] Kiesler's system was therefore a radical departure from traditional exhibition technique and can be read as rejecting both idealist aesthetics and a static, ahistorical approach to art, exhibition design, and the viewer.

Reflecting on his career in 1961, Kiesler stated that "the three years 1922, 1923, 1924 were the most fruitful years of my life."[7] He considered the projects and ideas he created during this period as foundational for all his other work. Kiesler saw his L and T exhibition method as the beginning of the "continuity and multiplicity of an idea" that was explored in all of his painting and sculpture, as well as his architecture, design, theater, and exhibition projects. He specifically linked the L and T system with his "eighteen functions of the one chair" created in 1942 for Peggy Guggenheim's gallery, Art of This Century, in New York City, which was one of the artist's most dramatic and well-known installation projects (fig. 1.6).[8]

At Guggenheim's request, Kiesler created four exhibition areas: a painting "library" and study area (fig. 1.7), a Surrealist gallery (fig. 1.8), an abstract art gallery (fig. 1.9), and a kinetic gallery (fig. 1.10). Throughout these galleries were multiples of Kiesler's "chair," which were used as a single unit or combined with identical units to create variations of painting and sculpture pedestals, chairs, sofas, and tables. The specific meaning of the units was determined by their use, context, and syntax. This innovative multiple, more explicitly than any of Kiesler's other projects, demonstrates his interest in creating "open" systems, projects, and environments in which meanings are shaped by the specific determinants of time, place, and function. That Kiesler choose to call one of his seminal projects L and T is both illuminating and appropriate. As does the furniture multiple, the L and T elements function like letters of an alphabet in which different combinations create different words with different meanings.

The issues Kiesler began to explore in projects such as his L and T exhibition method were theorized in the 1930s in his notion of "Correalism," which he described as an "exchange of inter-acting forces . . . the science of its relationships."[9] Kiesler described art and life as fluid, interactive forces of particular cultures and histories that were ever-changing and evolving. In his "Second Manifesto of Correalism" of 1961, he stated: "The traditional art object, be it a painting, a sculpture, or a piece of architecture, is no longer seen as an isolated entity but must be considered within the context of this expanding environment. The environment becomes equally as important as the object, if not more so, because the object breathes into the surrounding and also inhales the realities of the environment no matter in what space, close or wide apart, open air or indoor."[10] Although Kiesler saw art and life as continuous, evolving manifestations of somewhat mystical "forces of the universe," his concept of Correalism was anti-essentialist, culturally specific, and dependent on a viewer for the creation of meaning.[11]

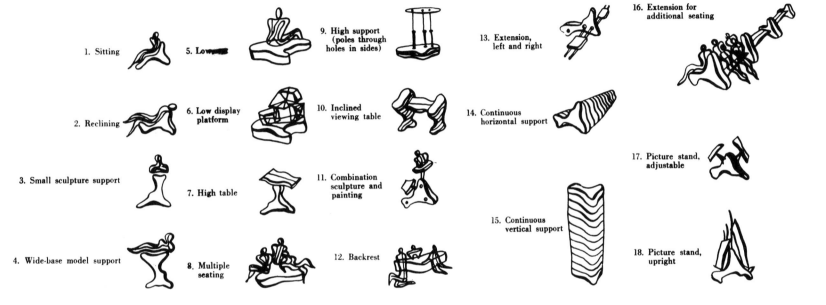

1. Sitting

2. Reclining

3. Small sculpture support

4. Wide-base model support

5. Lo▮▮▮▮

6. Low display platform

7. High table

8. Multiple seating

9. High support (poles through holes in sides)

10. Inclined viewing table

11. Combination sculpture and painting

12. Backrest

13. Extension, left and right

14. Continuous horizontal support

15. Continuous vertical support

16. Extension for additional seating

17. Picture stand, adjustable

18. Picture stand, upright

1.6

Kiesler, *Eighteen Functions of the One Chair*, 1942. Kiesler conceived this
multiple as a single unit or combined with identical units whose specific functions
were determined by their use, context, and syntax.

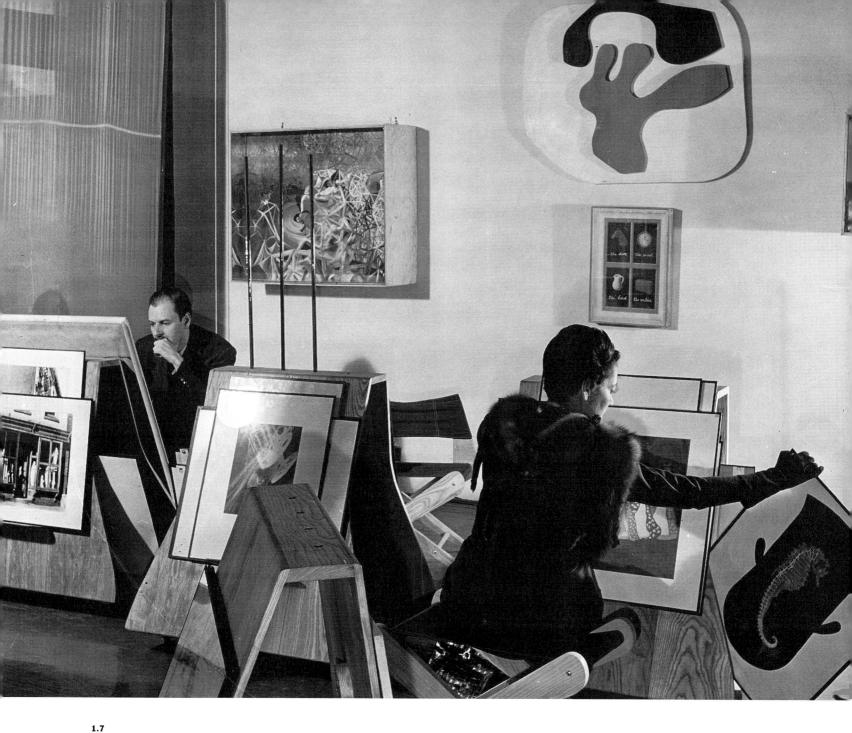

1.7
Visitors looking at works of art in Frederick Kiesler's *Painting "Library" and Study Area,* Art of This Century, New York, 1942.

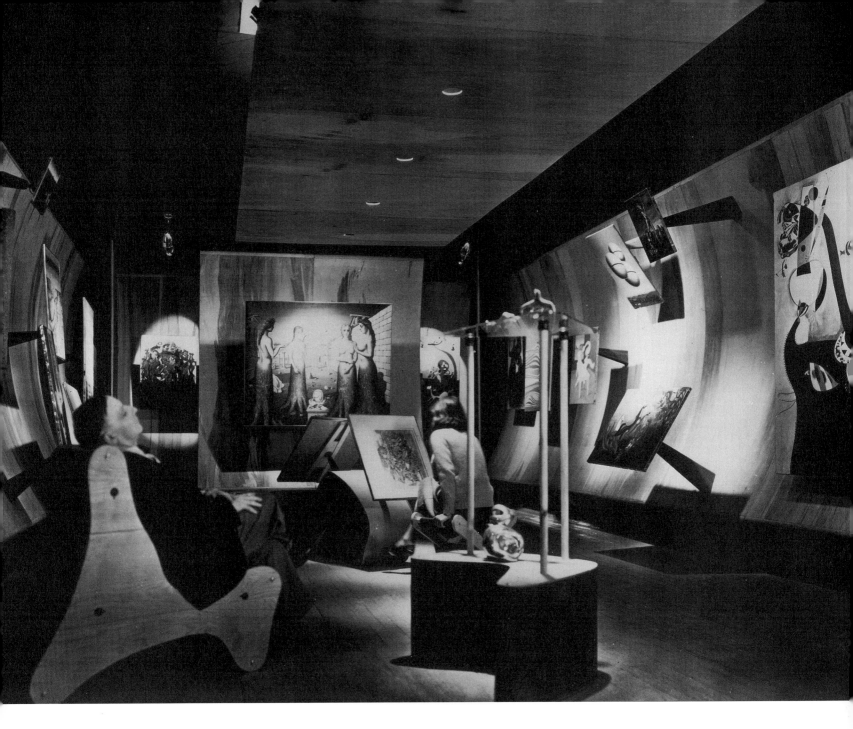

1.8

Kiesler, *Surrealist Gallery,* Art of This Century, 1942. Kiesler is seated on one of
the multiple units he had designed in the *Surrealist Gallery* where lighting was
engineered so that half of the paintings were lit half the time and where every
two minutes a recording of the roar of a train sounded.

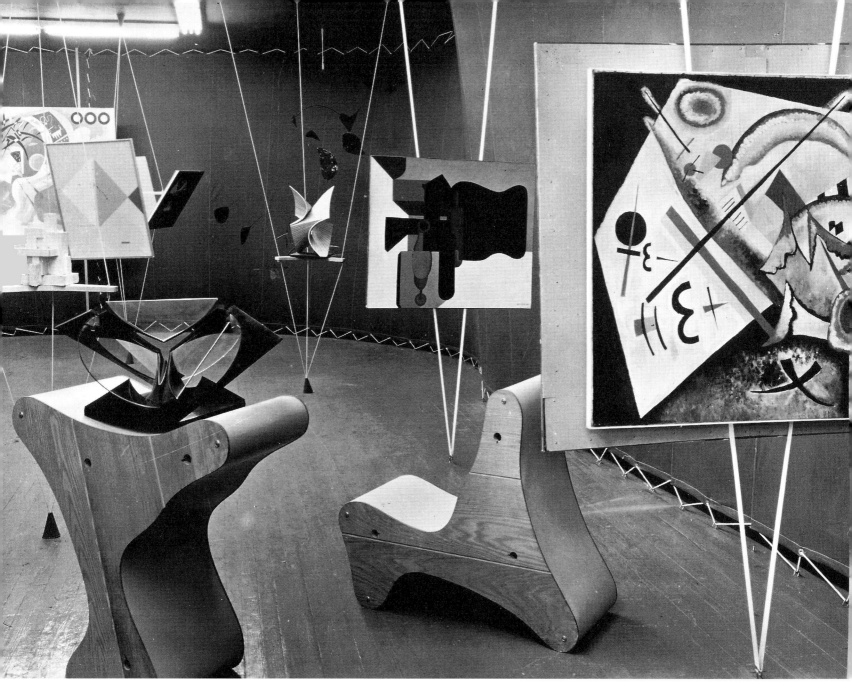

1.9
Kiesler, *Abstract Gallery,* Art of This Century, 1942.

1.10 →
Kiesler, *Kinetic Gallery,* Art of This Century, 1942. Peggy Guggenheim is turning
the wheel to view reproductions of Marcel Duchamp's *Box-in-a-Valise,* 1941.

1.11 →
Kiesler, *City in Space,* Austrian Theater Section, *Exposition Internationale des
Arts Décoratifs et Industriels Modernes,* Paris, 1925.

The Power of Display, or the Avant-Gardes as Exhibition

Soon after the *Exhibition of New Theater Technique*, Kiesler published a description of his new system in *De Stijl*.[12] Theo van Doesburg, the editor of *De Stijl*, had visited the exhibition and in October of that year praised Kiesler in the journal:

I was completely taken by surprise when I faced the "International Theater Exposition of New Theater Techniques" at Vienna. In no city in the world have I seen anything similar to it. In contrast to previous exhibitions, in which art products were hung next to one another without relation, in this method of demonstration the closest relations between the different works were established by their arrangement in space. It is extremely important and fortunate that the Theater and Music Festival of Vienna has found a basic, practical and economical solution to this problem in the exhibition system by Kiesler.[13]

Kiesler incorporated aspects of the L and T system when creating his project most closely affiliated with De Stijl: his 1925 architectural model and exhibition display, *City in Space* (fig. 1.11), for the Austrian theater section of the *Exposition Internationale des Arts Décoratifs et Industriels Modernes* in Paris.[14]

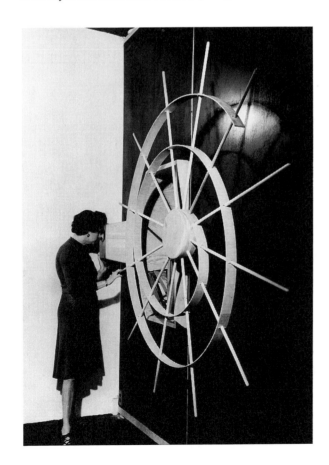

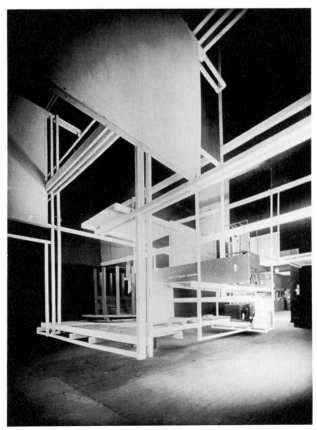

City in Space was a model of a futuristic city composed of red, white, and black horizontal and vertical beams and panels that had a dual function, also serving as the display system for the Austrian theater exhibit models. Kiesler had initially wanted to build a model of what he described as his only "neoplastic building," a horizontal skyscraper outside the Grand Palais where the exposition was held.[15] But the exposition authorities would not agree to it, so Kiesler combined an architectural model of a futuristic city with the needs and requirements of the Austrian exhibition installation.

Kiesler's L and T system and *City in Space* share with the formulations of De Stijl an elementarist approach to composition—the formal lexicon of horizontal and vertical beams and planes, reductive color schemes, and an open, expansive sense of space. These elements were all seen as realizations of the De Stijl utopian vision to redesign the modern world. Kiesler published in *De Stijl* photographs of the installation and his manifesto "Vitalbau-raumstadt-funktionnelle-architecktur" in 1925 and a statement with a photograph of *City in Space* in 1927, as well as an abbreviated version of the manifesto with a photograph in *G* in 1926.[16] In his June 1925 review of the exhibition in *Het Bouwbedrijf,* van Doesburg wrote: "the Austrian section became, regarding exhibition techniques, an example for all other countries."[17]

In addition to Kiesler's project for the Austrian section, the Soviet Constructivists and Productivists made a strong showing at the exposition with Konstantin Melnikov's USSR Pavilion, which housed Aleksandr Rodchenko's furnished interior of a workers' club (fig. 1.12). The historical significance of Rodchenko's contribution, one of the rare fully realized Constructivist interiors, is testimony to the role exhibitions played for the international avant-gardes during the first half of the twentieth century. Temporary exhibitions that presented design prototypes, architectural models, and innovative installation techniques were often the only realizations of projects and ideas which were otherwise too radical, utopian, costly, or technologically difficult.[18] This was particularly the case for work of artists from the Soviet Union, where economic and technological constraints affected many projects. Kiesler's futuristic *City in Space,* for example, modeled a wildly utopian conception: a framework of steel girders was supposed to suspend an entire city several hundred feet above the ground. It was received by members of De Stijl as the realization of a visionary future. According to Kiesler, when van Doesburg and Piet Mondrian encountered him at the exhibition, van Doesburg cried, "You have done what we all hoped one day to do."[19]

The artists, designers, and architects affiliated with De Stijl were representative of the international avant-gardes' interest in the 1920s in what has been described as the "total environment."[20] Exhibitions and their elements were conceived as integrated interiors that were, in many cases, dynamic experiences for viewers who moved through and interacted with the installations. Such conceptions of interiors and exhibitions transformed institutions of reception and distribution of culture. During these years of the international avant-gardes, institutional frameworks such as the museum, the gallery, and the exposition were the creative terrain of artists, designers, and architects.[21] Like the space of the printed page, which was given primacy as artist publications such as *De Stijl, G,* and *Het Bouwbedrijf* multiplied,[22] the public exhibition space was fundamental to avant-garde practice. It can be said that international avant-gardes of the first half of the century were made manifest in their exhibitions.

The power of display was crucial to the international avant-gardes, and its importance to twentieth-century art was foremost in the minds of the individuals working at the Museum of Modern Art during the institution's first several decades. Perhaps the most visible evidence is supplied by the Museum's innovative

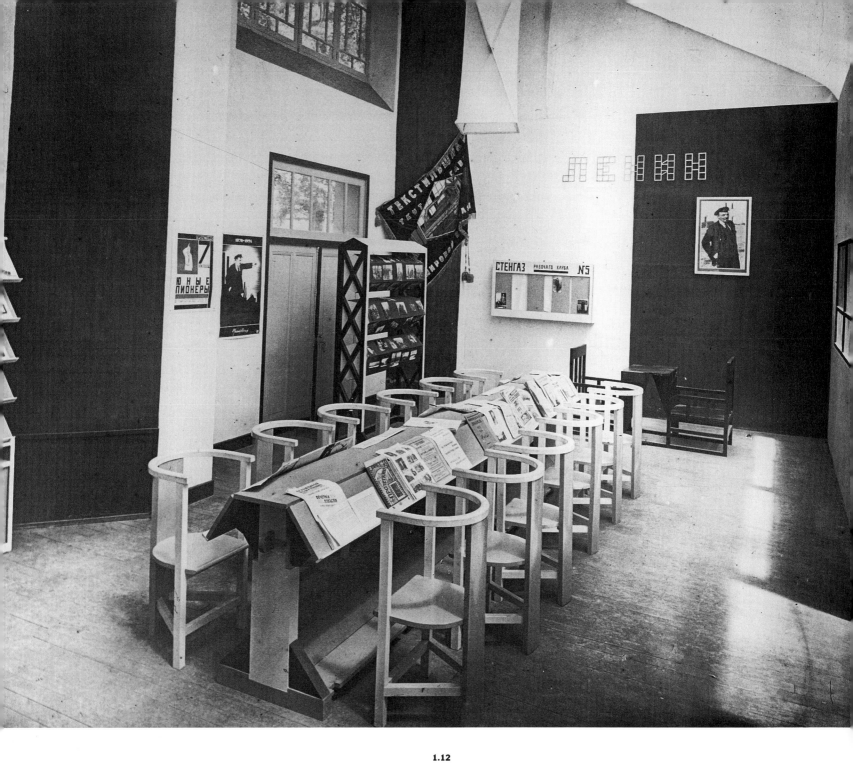

1.12

Aleksandr Rodchenko, *Worker's Club*, Soviet Pavilion, *Exposition Internationale des Arts Décoratifs et Industriels Modernes*, 1925.

exhibition designs produced during these years. The Museum's founding director, Alfred H. Barr, Jr., for example, began his introduction for the famous 1932 *Modern Architecture* catalogue: "Expositions and exhibitions have perhaps changed the character of American architecture of the last forty years more than any other factor."[23]

Viewer-Interactive Installations at the Landesmuseum in Hanover

Alexander Dorner, the innovative director of the Hanover Landesmuseum, had hoped that Theo van Doesburg would create an original exhibition installation when he commissioned him to design what is now generally accepted as the first permanent gallery for abstract art.[24] Dorner, apparently, was not satisfied with van Doesburg's scheme of fenestrated wall and transparent mural on which the abstract work would be hung, so the museum director invited El Lissitzky to install a version of the *Raum für konstruktive Kunst (Room for Constructivist Art),* which he had installed at the 1926 *Internationale Kunstausstellung (International Art Exhibition)* in Dresden.[25]

Lissitzky's abstract art gallery remains the most famous component of Dorner's grand plan for restructuring the Landesmuseum (fig. 1.13).[26] When Dorner became director in 1922, the museum was a paradigm of the traditional nineteenth- and early-twentieth-century museum. Housed in what Dorner's biographer describes as a "Versailles-like palace," the galleries were organized according to the conventions of traditional museum practices.[27] The collections came primarily from five sources and were arranged in a symmetrical salon style (figs. 1.15 and 1.17). In symmetrical installations, works of art are treated as harmoni-

ous room decor. For example, a small rectangular painting on the right side of a fireplace would be balanced by a painting nearly identical in size on the left side of the fireplace. Two small paintings and one large one would be on the left side of a room matching two small paintings and one large on the right side of the room, and so on.

Dorner's plan for the Hanover galleries abandoned many standard museum practices that had dominated Western museology.[28] He did away with symmetrical, salon-style methods and introduced spare, and what were considered "modern," installations (figs. 1.14 and 1.16). Traditionally, collections were arranged according to the fashion of contemporaneous connoisseurship and, since the founding of art history as a discipline in the late eighteenth century, they were also installed in a more "scientific" manner: that is, chronologically and by schools.[29] Influenced by theories of Alois Riegl—particularly the notion of *Kunstwollen,* according to which culture is envisioned as an organic unfolding of aesthetic spirit—Dorner redesigned the museum's schema and made the collections chronological.[30] Riegl's discussion of *Kunstwollen,* however, begins with classical antiquity and ends with the Baroque. In order to deal with so-called primitive and modern art, Dorner modified Riegl's ideas to conceive the process as infinite: he dissolved Riegl's closed historical framework and expanded the collections to include prehistoric and contemporary art.[31] Dorner also emphasized the historical context of the work in his installations, eventually displaying catalogues in the galleries that outlined the history of Western civilization and ended with the statement: "Understand this art not as a competitor with that of our own age; it is born of quite other conditions, but it goes further in its conception than the previous period. Now, get up and look at the exhibitions."[32]

Dorner's strategy for restructuring the Landesmuseum was to create what he called "atmosphere rooms" that were intended to evoke the spirit of each period and to immerse the visitor, as

1.13
El Lissitzky, *Abstract Cabinet*, Landesmuseum, Hanover, 1927 and 1928.

1.14
"Gallery 44," after Alexander Dorner's reorganization of the Hanover Landes-
museum, ca. late 1920s. The bench was designed by László Moholy-Nagy.

1.15
"Gallery 43," before Dorner's reorganization of Landesmuseum, ca. early 1920s.

1.16

First exhibition in "Dome Gallery" after Dorner's reorganization of Landes-
museum, 1930.

1.17

"Dome Gallery," *Reformation Exhibition*, Landesmuseum, 1917.

1.18
Renaissance Gallery after Dorner's reorganization of Landesmuseum, after 1925.

much as possible, in each specific culture.[33] The Renaissance galleries were white or gray to emphasize the cubic character of the rooms and the period's interest in geometric space and perspective (fig. 1.18). In the Baroque galleries, the walls were covered with red velvet and the paintings were in gold frames. The Rococo color schemes were pink, gold, and oyster-white. Dorner's atmosphere rooms displayed a progressively evolving, historically differentiated representation of art and culture. One of final stages of this linear history of different epochs was provided by Lissitzky's *Abstraktes Kabinett (Abstract Cabinet),* which was constructed in 1927 and 1928.

Lissitzky's stated purpose in creating the *Abstract Cabinet* was to do away with the viewer's traditional exhibition experi-

ence: "If on previous occasions . . . [the visitor] was lulled by the painting into a certain passivity, now our design should make the man active. This should be the purpose of my room."[34] Lissitzky's strategy for achieving this was to design gray walls lined with metal slats (in Dresden they had been wood) that were white on one side and black on the other (see fig. 1.13). This type of wall surface shimmered and changed color within a spectrum of white to gray to black as the visitor moved through the room. Lissitzky designed sliding frames containing four works, which could be viewed two at a time. In one corner against two walls was a rectangular sculpture pedestal that was painted black and red. Adjoining this rectangular structure, and next to the wall beneath a window, were table showcases containing four-sided drums that

1.19

László Moholy-Nagy, drawing, *The Room of Our Time,* ca. 1930.

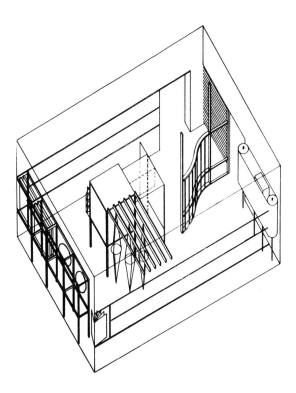

could be rotated by the viewer. Lissitzky had wanted to install a "periodically changing electric light system to achieve the white-gray-black effect, but unfortunately no electric conduits were available in the new exhibition complex."[35]

Although Kiesler's affiliation with De Stijl and his conceptions of Correalism differ from Lissitzky's association with De Stijl and his Soviet constructivist theoretical foundations, the two artists were, broadly speaking, exploring similar concerns. Like Kiesler's L and T system, the *Abstract Cabinet* was conceived as a dynamic, viewer-interactive environment with movable parts and innovative lighting, disengaged from the architectural detailing of the gallery housing the installation. Lissitzky's *Abstract Cabinet,* in a sense, required the presence and reception of a viewer, which, as in Kiesler's work, implied a nonstatic, time-bound approach to the creation of meaning. Also like Kiesler's exhibition designs, Lissitzky's *Abstract Cabinet* became known among the international avant-gardes as a historic, creative contribution.[36]

Perhaps more important to the history of the Museum of Modern Art, both Alfred Barr and Philip Johnson (the Museum's first curator of architecture) visited Lissitzky's installation. Barr reflected in the 1950s that "the *Gallery of Abstract Art* in Hannover was probably the most famous single room of twentieth-century art in the world." Johnson, who wrote that "the *Abstract Cabinet* at the Hanover Museum was one of the most vivid memories and most exciting parts of the Weimar Republic," actually appropriated aspects of Lissitzky's techniques in his own installations.[37] But no one's assessment of the project's significance surpassed the artist's. Lissitzky, like Kiesler, saw his exhibition designs as central to his work. In his autobiographical chronology, which was written a few months before he died in 1941, Lissitzky noted, "1926: My most important work as an artist begins: the creation of exhibitions. In this year I was asked by the committee of the *International Art Exhibition* in Dresden to create the room of non-objective art."[38]

Dorner also commissioned László Moholy-Nagy to design an installation, *Raum der Gegenwart (The Room of Our Time),* which was next to Lissitzky's cabinet and was the last gallery in the evolutionary sequence.[39] *The Room of Our Time,* which Moholy-Nagy began working on in 1930, presented the most recent developments in visual culture; it incorporated photography, film, and reproductions of architecture, theater technique, and design (fig. 1.19).[40] In the center of the gallery was Moholy's *Light Machine,* which projected patterns of abstract light when a button was pressed. Photographs and texts documented the development of industrial design from the Werkbund to the Bauhaus and of modern architecture from Louis Sullivan to Ludwig

Mies van der Rohe. A push button–operated projector was set up to show slides of the newest theater designs and techniques, such as Walter Gropius's design for Erwin Piscator's *Total Theater* and Oskar Schlemmer's *Triadic Ballet.* On one wall was a double glass screen on which two films were to have been shown, one of a documentary nature and the other abstract. The film and slide projection equipment and activating buttons did not function properly, so the room opened in an unfinished state. *The Room of Our Time* was distinguished by the complete absence, with the exception of Moholy's *Light Machine,* of any original works of art. Everything was a reproduction, a model, or documentation.

Surrealist and Dada Experiments

The Room of Our Time was representative of the international avant-gardes' fascination from the 1920s through the 1940s with viewer-activated gadgetry for installations, which was no doubt linked to advances in technology and the growth of the mass media. Although Kiesler had experimented with these ideas in earlier temporary exhibitions,[41] *The Room of Our Time* can be seen as a precursor to Kiesler's permanent installations created in 1942 at Art of This Century in New York, where all four galleries were activated manually or by mechanical devices. There, in every gallery the viewer was offered an interactive and engaged experience with art.

When a viewer entered the *Kinetic Gallery* a beam of light was broken, which triggered a revolving wheel that displayed a series of seven works by Paul Klee. A viewer-activated push-button system enabled the spectator to examine a painting on the wheel for a longer interval. A visitor also could have looked through a peephole while turning another large wheel that set in

motion a sequence of reproductions from Marcel Duchamp's *Box-in-a-Valise* (see fig. 1.10). The *Surrealist Gallery* was a stage set for a sensorially augmented aesthetic experience that affected the viewer's sight, hearing, and touch. Each work had its own spotlight, which went off every two or three seconds; the lighting was engineered so that half of the paintings were lit half of the time. Every two minutes a recording of the roar of a train was sounded. Paintings, mounted on wall hinges, enabled the visitor to tilt them to his or her desired viewing angle (fig. 1.20; see also fig. 1.8). In the *Abstract Gallery* most of the paintings and sculpture were suspended in midair by thin triangular "columns" of cloth tape (see fig. 1.9), which allowed the painting to be tilted or the sculpture to be raised or lowered by the viewer.

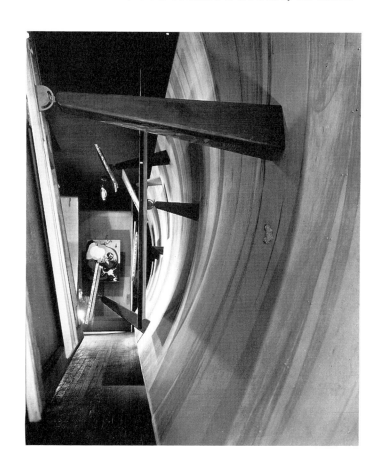

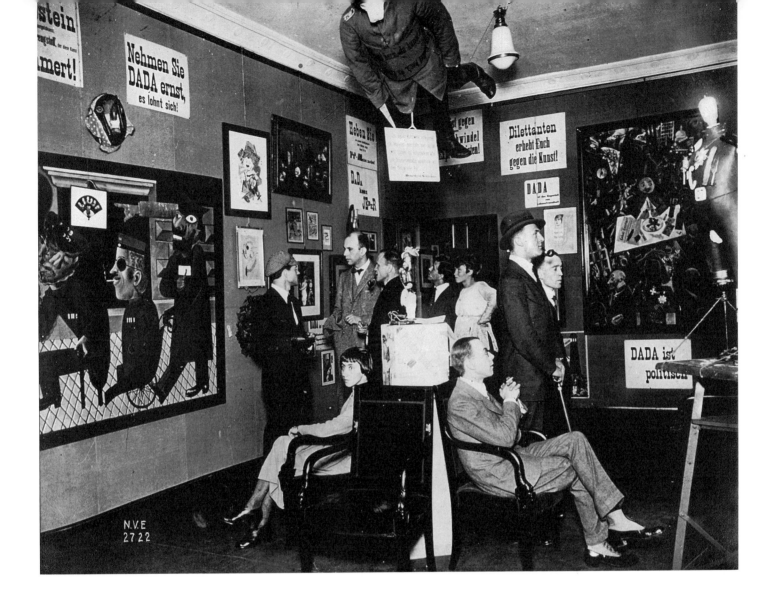

Kiesler's installations for Art of This Century should be understood in relation to the activities more generally of Dadaists and Surrealists, who often treated the entire temporary exhibition as fertile ground for their creativity. Unconventional, chaotic installations were a hallmark of many Dada exhibitions, like that of the 1920 *Erste Internationale Dada-Messe (First International Dada Fair)* held at the Burchard Gallery in Berlin: placards and posters were installed next to the more traditional media, while the memorable "Prussian Archangel" (the figure in a German

1.20 ←
Kiesler, detail of wall hinges that enabled gallery visitors to tilt paintings to desired viewing angle, *Surrealist Gallery,* Art of This Century, 1942.

1.21
First International Dada Fair, Burchard Gallery, Berlin, 1920. *Standing, left to right:* Raoul Hausmann, Otto Burchard, Johannes Baader, Wieland and Margarete Herzfelde, George Grosz, John Heartfield. *Seated:* Hannah Höch, Otto Schmalhausen.

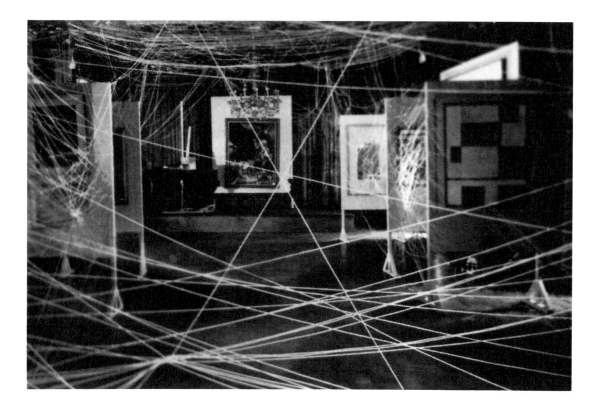

1.22
Marcel Duchamp, *First Papers of Surrealism,* Whitelaw Reid Mansion, New York, 1942.

army uniform fitted with a pig's head) was hung from the ceiling of the first of the two galleries (fig. 1.21).[42]

Art of This Century was created in the 1940s, when it was common for Surrealist exhibitions to be staged as irrational, dreamlike environments. Among the notable examples are Duchamp's installations for the 1938 *Exposition Internationale du Surréalisme (International Exposition of Surrealism)* in Paris and the 1942 *First Papers of Surrealism* exhibition held at the Whitelaw Reid Mansion in New York.[43] At the 1938 exposition, the floor of the central hall was strewn with moss and leaves and 1,200 empty coal bags were hung from the ceiling. For the New York show, Duchamp wove a web of sixteen miles of thread throughout the otherwise traditionally displayed modern paintings (fig. 1.22). In 1947 Kiesler oversaw the installation of the *Exposition Internationale du Surréalisme* at Galerie Maeght in Paris. In the entrance gallery on the first floor, he created a biomorphic environment titled *Salle des Superstitions* within which Duchamp, Max Ernst, David Hare, Joan Miró, Matta, and Yves Tanguy as well as Kiesler himself created individual pieces.[44] While these Dada and Surrealist exhibitions were all temporary installations, Art of This Century was distinguished by its permanence.

As Readers in Texts, Viewers in Exhibitions with "Fields of Vision"

Although Moholy-Nagy's *Room of Our Time* was also conceived as a permanent installation, it was never fully realized. For lack of funds, some components were not installed; others did not operate properly.[45] After Adolf Hitler assumed power as head of the German state in 1933, Dorner's innovations at the Landesmuseum were destroyed. Moholy's and Lissitzky's installations were dismantled and the hundreds of modern works acquired by Dorner were the greatest single source for the famous *Entartete Kunst* exhibition of 1937. In January 1938 Dorner immigrated to the United States; within months, he was appointed director of the Museum of the Rhode Island School of Design.[46]

Dorner had invited Moholy to create *The Room of Our Time* in the summer of 1930 after seeing his contribution to the German Section of one of the most important international exhibitions of the period, the 1930 *Exposition de la Société des Artistes Décorateurs,* held at the Grand Palais in Paris.[47] The German installation was startlingly different from most of the other exhibits, which were done in a Deco-Moderne style. Under the jurisdiction of the Deutscher Werkbund, the section was a showcase for the Werkbund's agenda to promote the new, modern German design and architecture. Walter Gropius, who had resigned from the Bauhaus two years before the show, was commissioned by the Werkbund to oversee the German Section in collaboration with three former Bauhaus members: Herbert Bayer, Marcel Breuer, and László Moholy-Nagy. Gropius, Moholy-Nagy, and Breuer designed one gallery each, and Bayer was given two.

The exhibit was conceived as a community center complete with swimming pool, gymnasium, café bar, dance floor, and reading room, which was supposed to be housed in a ten-story apartment building. Gropius designed the communal rooms (figs. 1.23 and 1.27), Breuer designed a domestic apartment furnished with his designs, Moholy presented a stage and ballet exhibit, a photographic survey of "new buildings," a display of lighting fixtures, and a standardized post office, and Bayer created installations for mass-produced utilitarian objects, fabrics, building materials, applied arts, furniture, and architecture (figs. 1.25 and 1.26).[48] A telling comparison that gives some sense of the impact of the Werkbund exhibition can be made between the machine age swimming pool design by Gropius and the romantic, Deco pool installed at the exposition by Henri and Jacques Rapin (figs. 1.27 and 1.28).

A paradigmatic experiment in the history of exhibition design was Bayer's architecture and furniture gallery, which was intended to demonstrate the integration of design and industrial production. His displays included photo panels of images of architecture tilted at angles from the floor and ceiling, mass-produced chairs hung in rows on the wall, and architectural models. As a preliminary sketch for this installation, Bayer conceived his *Diagram of Field of Vision,* which was reproduced in the Werkbund catalogue (fig. 1.24).[49] This diagram became the foundation for Bayer's approach to installation design. Of particular significance are the diagram's inclusion of a viewer within the exhibition space and the arrangement of panels and objects in relation to the observer's field of vision. Rather than mount images flat against the wall, Bayer tilted the panels above and below eye level.

In 1935, Bayer collaborated with Gropius, Breuer, and Moholy-Nagy to create another dramatic exhibition installation for the *Baugewerkschafts Ausstellung (Building Workers' Unions Exhibition)* in Berlin (fig. 1.29). Expanding his concept of field of vision, Bayer created the *Diagram of 360 Degrees Field of Vision* (fig. 1.30).[50] In the 1935 diagram, Bayer placed the figure on a

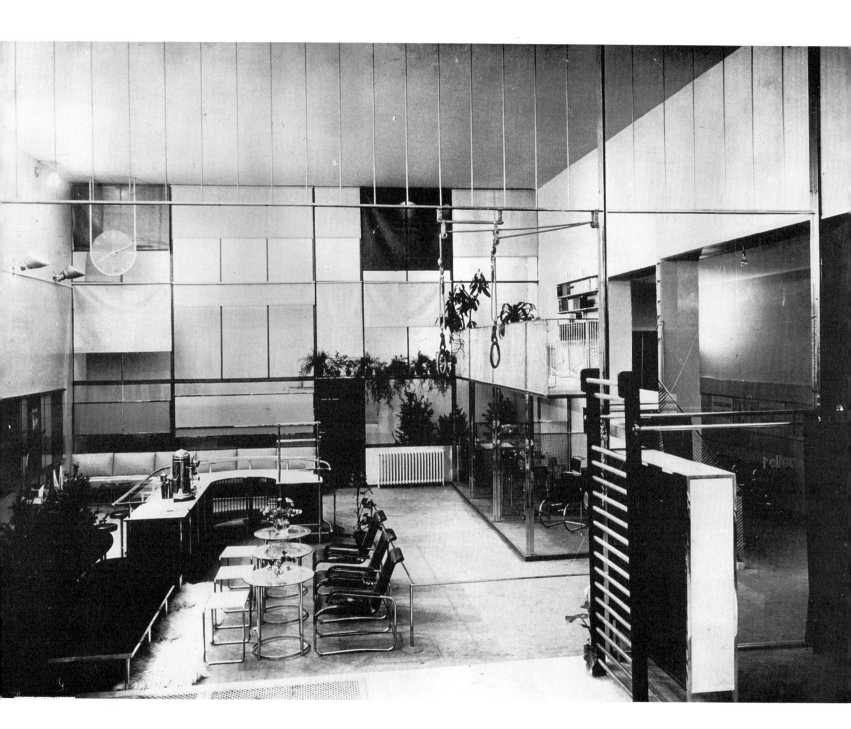

platform several inches off the ground, a position that augmented the viewer's ability to scan the ceiling, floor, and wall panels. Bayer's field-of-vision formula shares with the exhibition techniques of Kiesler and Lissitzky an acknowledgment of the relationship between the viewer and that which is viewed. Unlike the practices of Kiesler and Lissitzky, Bayer's formulation presumes that the viewer is of an ideal height. However, Bayer's installation design is similar to their methods in not being anchored to the physical limits of the room: the exhibited works are not lined up flat against the wall, and the entire installation is designed to create a dynamic exhibition experience. In the *Building Workers' Unions Exhibition,* Bayer created an exhibit where the images were composed of louvers that would turn automatically, thereby presenting alternating images (fig. 1.31). He also guided the visitor through the show by placing cutout footprints on the floor, which in representational terms functioned as a visible trace of the spectators moving through the installation (fig. 1.32).

Bayer's formulations take into account what has come to be referred to in the language of critical theory as "the reader in the text." [51] That is to say, in Bayer's methodology an exhibition is not conceived as existing as a timeless, idealized space. Rather, the exhibition is treated as a representation experienced by an observer who is moving through the space at a specific time and place; and it is through this dynamic interrelation that meaning is presumed to be created. Bayer's, Kiesler's, Lissitzky's, and Moholy-Nagy's installation methods were all intended to reject idealist aesthetics and cultural autonomy and to treat an exhibition as a historically bound experience whose meaning is shaped by its reception.

1.23

Walter Gropius, Deutscher Werkbund installation: café bar and gymnasium, *Exposition de la Société des Artistes Décorateurs,* Paris, 1930.

Bauhaus Exhibition Technique

The Werkbund's German Section is an important example of how exhibitions presented and disseminated the innovations of the international avant-gardes during the 1920s and 1930s, and it exemplifies the importance of exhibition design for the individuals associated with the Bauhaus. In the famous four-page pamphlet published at the founding of the Staatliche Bauhaus in 1919, which carried Lyonel Feininger's *Cathedral* woodcut on the cover and contained Gropius's manifesto and program, Gropius listed under the "principles of the Bauhaus": "New research into the nature of the exhibitions, to solve the problem of displaying visual work and sculpture within the framework of architecture." [52] Although the Bauhaus did not initially have a workshop for exhibition technique, the designing of aesthetic and commercial exhibitions developed as an area of experimentation within the printing workshop when it was run by Bayer from 1925 to 1928. After Bayer's departure, Joost Schmidt took charge, a change that coincided with the departure of Gropius and the appointment in 1928 of Hans Meyer as director.

The Bauhaus under Meyer's leadership moved away from an emphasis on individual and aesthetic creativity to a more collaborative and socially oriented approach. [53] Meyer also restructured the school into four major departments: architecture, commercial-art, interior design, and textiles. The commercial-art department comprised photography, sculpture, printing, and exhibition design, and its emphasis shifted toward advertising and exhibition technique. During the years that Meyer was director of the Bauhaus, the department of commercial art carried out several exhibition-design commissions. [54] Among the best-known was the Junkers and Company installation at the 1928 *Gas und Wasser Ausstellung (Gas and Water Exhibition)* in Berlin, which was created by Schmidt in collaboration with Xanti Schawinsky

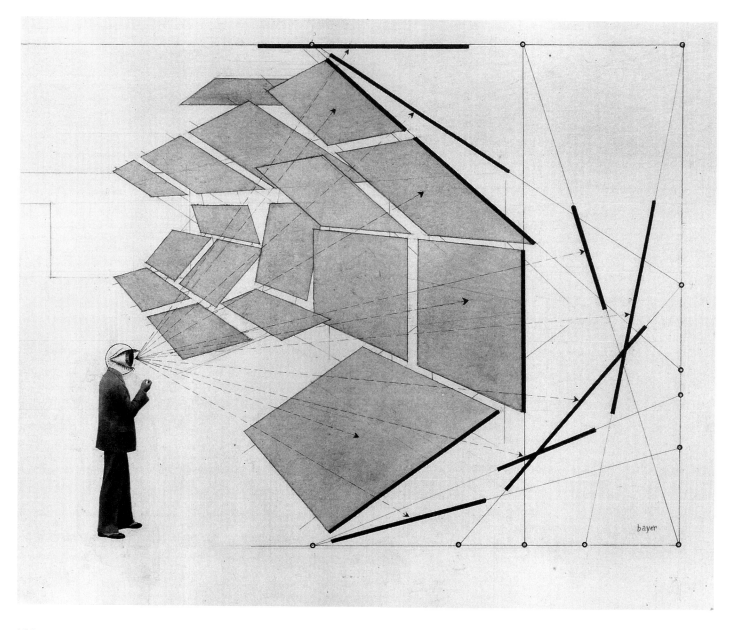

1.24

Herbert Bayer, *Diagram of Field of Vision*, 1930.

1.25

Herbert Bayer, Deutscher Werkbund installation: furniture and architecture

gallery, *Exposition de la Société des Artistes Décorateurs*, 1930.

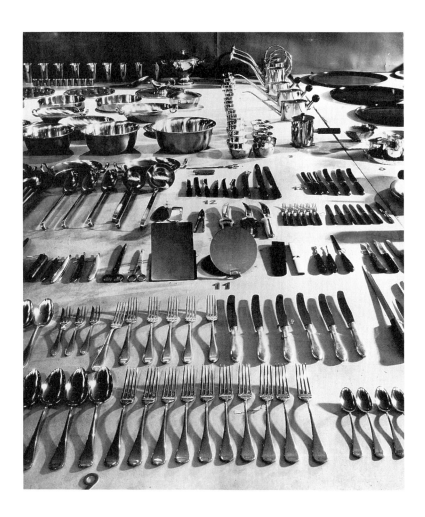

1.26

Bayer and Gropius, Deutscher Werkbund installation: utensils display, *Exposition de la Société des Artistes Décorateurs*, 1930.

1.27 →

Gropius, Deutscher Werkbund installation: gymnasium and pool, *Exposition de la Société des Artistes Décorateurs*, 1930.

1.28 →

Henri and Jacques Rapin, swimming pool, *Exposition de la Société des Artistes Décorateurs*, 1930.

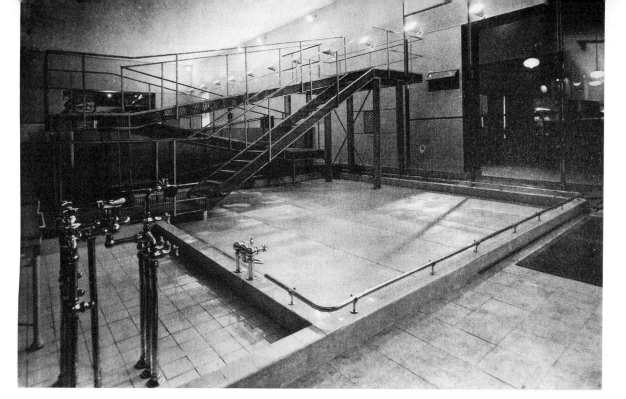

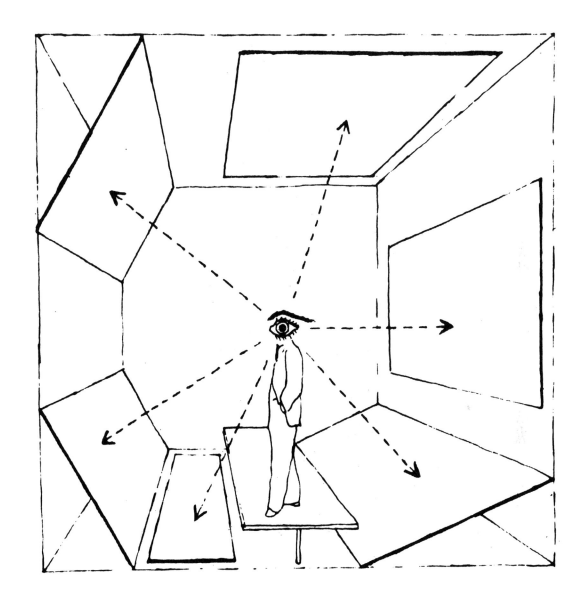

1.29

Herbert Bayer, Walter Gropius, and László Moholy-Nagy, *Building Workers' Unions Exhibition,* Berlin, 1935.

1.30

Herbert Bayer, *Diagram of 360 Degrees Field of Vision,* 1935.

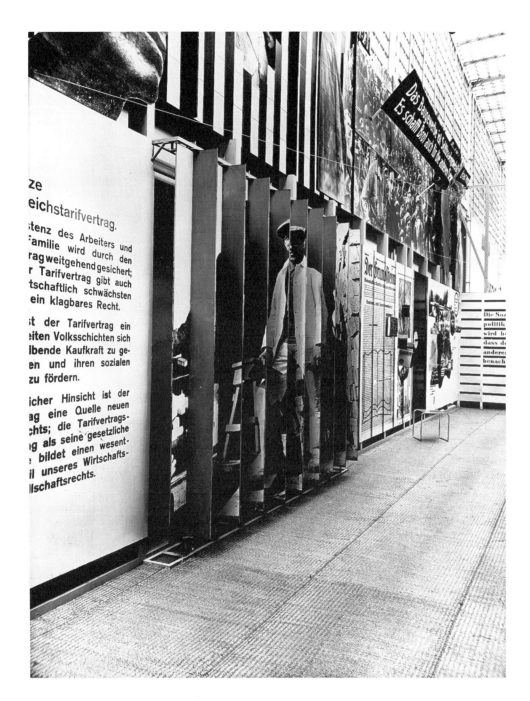

1.31

Bayer, Gropius, and Moholy-Nagy, louvers exhibit, *Building Workers' Unions Exhibition*, 1935.

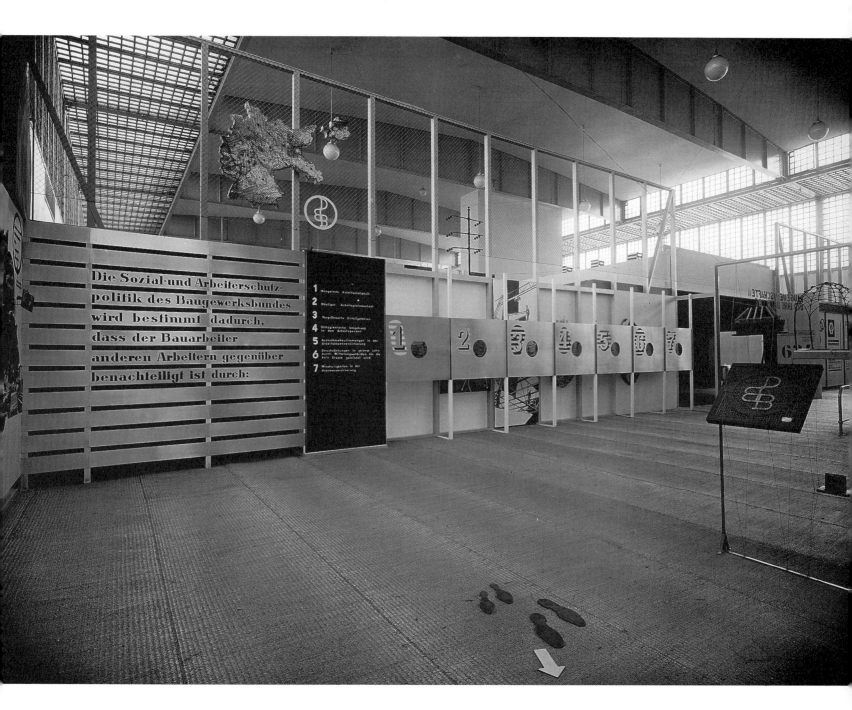

1.32

Footsteps and arrows on the floor were used to direct the viewer through Bayer,
Gropius, and Moholy-Nagy's *Building Workers' Unions Exhibition,* 1935.

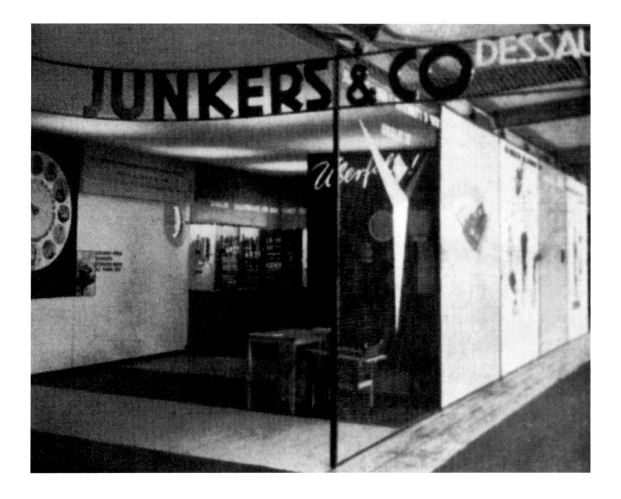

1.33
Xanti Schawinsky and Johan Niegeman, installation: Junkers and Company, *Gas and Water Exhibition,* Berlin, 1928.

The Exhibitions of Ludwig Mies van der Rohe and Lilly Reich

and Johan Niegeman (fig. 1.33) and was featured in the July–September 1928 issue of *Bauhaus.*[55] When Ludwig Mies van der Rohe was the director of the Bauhaus from 1930 to 1933, exhibition design continued under the tutelage of Schmidt within the commercial-art department.

Exhibitions and installations were integral to Mies van der Rohe's work; perhaps his most famous creation was a temporary exhibit, the German State pavilion built for the *Exposición Internacional de Barcelona (International Exposition of Barcelona)* in 1929.[56] In a typical example of Mies's aloof attitude regarding the politi-

cal implications of his work, he described the project as "just a representational room, without any specific purpose." But the pavilion was most certainly an honorific display of Germany as a modern, progressive, industrial nation.[57] Unhampered by functional or economic constraints, Mies's use of the expensive materials (chromium, polished onyx, Tinian green marble, travertine, and gray, green, and etched glass) and his inclusion of two reflecting pools (the one for sculpture was lined with black glass) created a rational yet crystalline structure of shimmering surfaces, reflected light, and mirroring materials that displayed a rich, hygienic, technologically advanced vision of modern Germany—created solely for a temporary exposition.

This temporary pavilion was also where Mies fully realized his free plan, in which, according to Philip Johnson in his 1947 catalogue on Mies, "space is channeled rather than confined—it is never stopped, but is allowed to flow continuously."[58] Mies's treatment of space was seminal to twentieth-century architecture and typified the concerns of architects affiliated with the international avant-gardes during the first half of the century. This conception of space was, not surprisingly, also fundamental to the innovations that were taking place in exhibition design. Like the installations of Kiesler, Lissitzky, and Bayer, Mies's asymmetrical spatial arrangements, articulated by freestanding planes and columns, enhanced the sense of movement within an interior and, implicitly, acknowledged inhabitants or viewers moving within and through a structure. Bayer actually wrote of the shift from axial to asymmetrical organization of space in both aesthetic and commercial exhibition displays.[59] Indeed, designers' consciousness of viewers moving within and through a gallery reached its most literal manifestation in the exhibitions of Bayer, most obviously in his placement of footsteps on the floor in the *Building Workers' Unions Exhibition* of 1935.

This free-flowing sense of space was evident in Mies's commercial and industrial exhibition installations, which were well-known within the international avant-gardes and were written about and reproduced in journals, magazines, and newspapers.[60] Of particular importance to the Museum of Modern Art's exhibition practices were Johnson's articles and his 1947 Mies retrospective at MoMA, in which Johnson treated Mies's exhibition technique as fundamental to the history of modern architecture and design.[61] Johnson was influenced by those earlier installations and has acknowledged his indebtedness to both Mies and Mies's partner, Lilly Reich. Fascinated with the work of both, he wrote that the installations of Mies and Reich have "given this field new importance, turning the display of objects into an art."[62]

The career of Lilly Reich has been overshadowed by that of her famous partner. Reich, however, was among the most important exhibition designers of her time, both for her independent projects and for her collaborations with Mies.[63] Before she began collaborating with Mies in the late 1920s, Reich had a well-established career as an architect and a clothing, furniture, and exhibition designer. She became a member of the German Werkbund in 1912, was the first woman elected to its board of directors in 1920, and helped organize important Werkbund exhibitions—including the 1914 exhibition in Cologne and the *Applied Art* exhibition that was sent to the Newark Museum in 1922. At the *International Exposition* in Barcelona in 1929, Reich was the artistic director of twenty-five of the German exhibits.[64]

The exhibition designs of Reich are exceptional for a number of reasons, the most obvious being the simple fact of their creation by a woman when the fields of architecture and design were so dominated by men. But Reich holds another, more idiosyncratic distinction, with specific bearing on the history of exhibition design and of the Museum of Modern Art: she is the only artist who has been given an exhibition at MoMA in which the primary medium examined was the installation itself. In 1996 the Museum, departing from its present institutional practices and

conventions, featured an exhibition documenting installation designs (fig. 1.34).[65]

One of the purposes of the MoMA retrospective was to reinstate Reich's prominence as a designer and architect and to show her involvement with some of the most important exhibitions of the first half of the century. The 1927 exposition *Die Wohnung (The Dwelling)* held in Stuttgart was such a show. Mies was the director of this largest and most ambitious undertaking of the Werkbund, which included the Weissenhof Housing Settlement of model homes and apartment buildings that were built on a hill overlooking the city. Reich oversaw the layout and organization of the exhibition halls in the center of town; in the MoMA installation, the one photomural included in the show was of *The Dwelling*'s central hall, which faced the viewer when he or she entered the exhibition (see fig. 1.34). The eight exhibition areas Reich created for *The Dwelling* included those for industrial products, model kitchens, textiles, fabrics, furniture, wallpapers, linoleum, and plate-glass displays; the latter two were collaborations with Mies.[66]

These exhibits were among Mies and Reich's most important installations and offered a paradigmatic approach to exhibition design. In the *Spiegelglashalle (Plate-Glass Hall)* (fig. 1.36), commissioned by the glass industry, Mies and Reich created spaces with walls of etched, clear, olive-green, and gray sheets of glass and different-colored linoleum flooring. These interiors were furnished and suggested living areas for working, relaxing, and dining.

The exhibition designs for *The Dwelling* exemplified the display practices of Mies and Reich: the installation was constructed of and shaped by what was exhibited. The displays were marked by clean, spare arrangements of products and materials; they were often organized in series that emphasized their mass-produced, manufactured character. This method not only foregrounded the exhibited elements but made visible the exhibition's language of form. Mies and Reich's self-reflexive exhibition technique forced the viewer to see the installations. In a sense, both the materials and the display itself became the exhibition's content.

This self-reflexive design strategy was even more dramatically realized in Mies and Reich's unusual installation for the silk industry exhibit at the 1927 *Die Mode der Dame (Women's Fashion)* exhibition in Berlin. Known as *Café Samt und Seide (The Velvet and Silk Café)* (fig. 1.35), this exhibit was composed of a curved maze of room-size chromed-steel tubular frames that provided the armatures on which were draped gold, silver, black, and lemon-yellow silk, together with black, orange, and red velvet. Within these opulent walls of rich, boldly colored fabric were grouped Mies's leather tubular MR chairs with tables also designed by Mies, providing a place for visitors to relax over coffee. As in *The Plate-Glass Hall*, here the content of the exhibition created the installation.

In the 1931 *Deutsche Bauausstellung (German Building Exposition)*, Mies oversaw the famous *Section C, Die Wohnung unserer Zeit (The Dwelling in Our Time)*. Reich, one of seven members of *Section C*'s advisory committee, was responsible for a model house, two apartments, and an installation of apartment furnishings; she was also director of the *Materials Show*. The latter comprised some twenty-four exhibits, including the wood exhibit where Reich laid finished wood veneers against walls and stacked rough-hewn slabs of wood on the floor (fig. 1.37). What could today be described as a Minimalist installation is prevented from appearing as pure abstraction by the names of the manufacturers printed in lettering on the walls. Johnson, in an article published in the *New York Times*, praised the exposition as an aesthetic and organizational model and declared: "The art of exhibiting is a branch of architecture and should be practiced as such."[67]

Installation as Exhibition, as Abstraction, as Denial of the Political

Mies and Reich's construction of installations from the elements displayed, simply and economically, magnified the visibility of both an exhibit's "content" and its "form." But in some instances this approach functioned to create abstracted, self-reflexive displays whose meanings were engendered by the framework of the exhibition's institutional structure, which was often explicitly political. Institutional frameworks, of course, always shape the meaning of exhibitions. If this institutional armature is not addressed or countered in some way within the installation design, the exhibit becomes merely an element within the constitution of its larger program. The dynamic is enhanced with an exhibition whose subject is abstracted, and this was certainly the case with the 1929 Barcelona Pavilion; though Mies considered it a "room without any specific purpose,"[68] it was undeniably a symbol of modern Germany. The problematic relationship between self-referential exhibition design and meaning was even more evident in the 1934 Nazi propaganda exhibition Deutsches Volk/ deutsche Arbeit (German People/German Work), which promoted National Socialist doctrines of race and labor.

Mies was initially supposed to oversee the architectural organization of German People/German Work, but Hitler ordered that he be removed from the position.[69] In the end, Mies and Reich—along with Walter Gropius, Herbert Bayer, and Joost Schmidt—contributed to the exhibition but were not publicly acknowledged (fig. 1.38). One of Reich's exhibits for German People/German Work, the glass industry display, had until recently been attributed to Mies. Representative of her dramatic installations created of the materials to be exhibited, she placed

huge curved sheets of glass in series. She and Mies designed glass, mining, industrial, and domestic exhibits for the show. One section of the mining exhibit, situated in a massive hall, was built of the materials on display and simply consisted of three massive walls: one of pale pink and beige rock salt; another, brownish-black bituminous coal; and the third and largest, a jewel-like black anthracite coal (fig. 1.39). According to Alfred Speer, who thought the installation distinctive, Hitler was angered by the exhibition design and hated it.[70]

Much has been written about Mies's political or, perhaps more precisely, apolitical approach to architecture—and to installation design. In the early 1930s, Mies's bold forms and rich materials were seen by more than one observer to be somewhat compatible with the monumental and classical predilections of the Third Reich.[71] Johnson, who initially admired Hitler and flirted with fascist politics, speculated on the survival of modern architecture in Germany in his much-cited 1933 article, "Architecture in the Third Reich," where he observed that some "young men in the party" were "ready to fight for modern art." He had hopes for Mies, whom he described as an apolitical architect, "respected by the conservatives" and one of the finalists in the Reichsbank competition.[72]

It appears that the National Socialists came to power in Germany at a rather inopportune moment for Mies: that is, at the peak of his career. Mies's cavalier attitude toward the Nazis is well documented, and during the first several years of the regime he was able to work and did accept commissions from the government.[73] In August 1934 he reluctantly signed a proclamation sponsored by Goebbels listing prominent cultural leaders supporting Hitler.[74] In 1973 his assistant Herbert Hirche remembered discussing with Mies his work for the 1937 Reichsausstellung der deutschen Textil- und Bekleidungswirtschaft (Imperial Exposition of the German Textile and Garment Industry): "now that the Textile Exhibition is sponsored by the Nazis, how can you justify your continued participation when you so little share their views?"

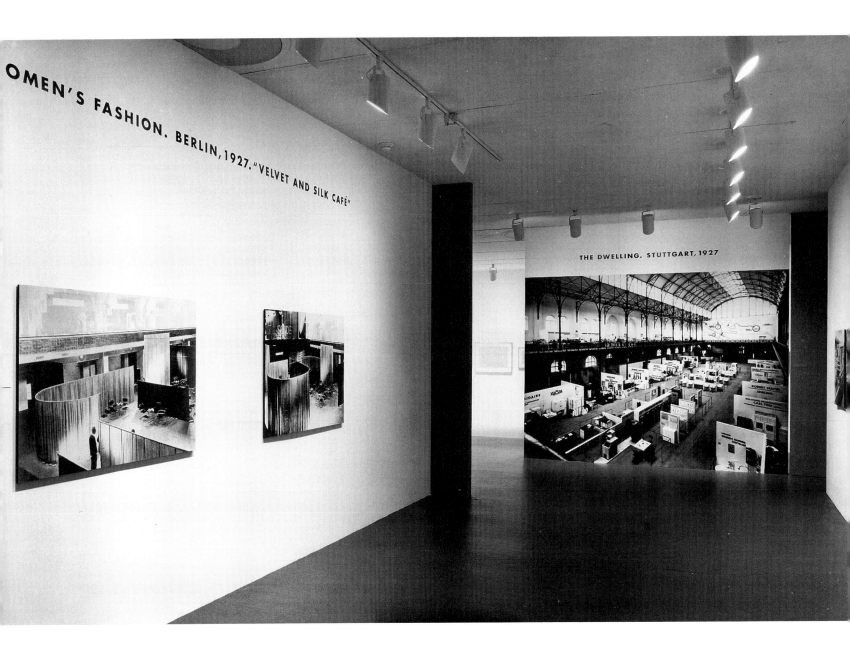

1.34
Matilda McQuaid, *Lilly Reich: Designer and Architect,* Museum of Modern Art,
7 February to 7 May 1996.

1.35

Mies van der Rohe and Lilly Reich, *The Velvet and Silk Café, Women's Fashion Exhibition,* Berlin, 1927. Black-and-white photographs convey no sense of this exhibition's striking colors. Gold, silver, black, and lemon-yellow silk and black, orange, and red velvet were draped on chromed-steel tubular frames to create this maze of spaces in which viewers were enveloped by opulent walls of rich, boldly colored fabric. Mies's leather and tubular MR chairs and tables provided a place for visitors to relax over coffee.

1.36
Ludwig Mies van der Rohe and Lilly Reich, *Living Room: Plate-Glass Hall, The Dwelling,* Stuttgart, 1927.

1.37
Mies van der Rohe and Lilly Reich, *"Material Show": Wood Exhibit, The Dwelling in Our Time,* Berlin, 1931.

1.38
Walter Gropius, view of hall showing information desk, *Nonferrous Metals Exhibition, German People/German Work,* Berlin, 1934.

1.39
Mies van der Rohe and Lilly Reich, *Mining Exhibit, German People/German Work,* 1934.

Mies had replied, "It's only a lousy silk show, after all! What is so political about chiffons?"[75]

Judging from the evidence, it seems clear that if Mies could have continued working in Germany, he most likely would never have left. It was only after he and Reich were replaced by Ernst Sagebiel, who had been appointed by Hermann Goering to oversee the 1937 Berlin textile exhibition, that Mies realized it was unwise for him to remain in Germany. He surreptitiously "borrowed" his brother's passport and immediately fled the country.[76] The frank comments of Johnson summarize succinctly what seems to have been the situation: "Nazis schmatzis, Mies would have built for anyone."[77]

Reich's relation to National Socialism is somewhat more ambiguous. There has simply been much less research done on this question.[78] She, like Mies, worked for the National Socialists and most likely sought government commissions. Unlike Mies, she remained in Germany throughout Hitler's reign and until her death in 1947.[79]

Mies's aestheticized relation to politics was what led him to be appointed director of the Bauhaus in 1930, replacing his Socialist colleague Hannes Meyer. It was thought that perhaps with Mies at the helm, the institution could be preserved. But the Nazis nonetheless closed the school in 1933. Among the legacies of the Bauhaus remains its development of exhibition design. "Exhibition Technique" is among the Bauhaus departments documented in the catalogue of the 1938 Museum of Modern Art *Bauhaus* exhibition. The catalogue includes a chronology of exhibitions held at the Bauhaus as well as reproductions of installations created by Bauhaus members after they had left, such as the Werkbund exhibition of 1930.[80] Exhibition design also figured prominently at "the New Bauhaus" founded in 1937 by Moholy-Nagy in Chicago, which was dissolved and restructured into the School of Design in Chicago in 1939 and subsequently became the Institute of Design in 1944.[81]

New Vision: Photography as Exhibition

During the 1920s and 1930s, exhibition design at the Bauhaus, and within the international avant-gardes in general, was one of many areas in which photographic experimentation was taking place. Photography, however, was not taught at the Bauhaus until 1929; it was instituted after the departure of Gropius, Bayer, and Moholy-Nagy in 1928. Moholy-Nagy, who promoted the "new photography"—what he called the "New Vision," which involved experimentation in new perspectives, techniques, and uses of the medium—was surely an influence at the school during his tenure.[82] Walter Peterhans, who directed the photo department from 1929 to 1932, treated the medium very differently, promoting a more practical and realistic approach and stressing an efficient use of technical processes.[83] However widely the attitudes of the school's faculty toward the medium diverged, the integration of photography within exhibition design (as well as graphics and advertising) was always an important aspect of the Bauhaus.

Projects like Bayer, Gropius, and Moholy-Nagy's installation at the Berlin *Building Workers' Unions Exhibition* in 1935 were conceived as interior landscapes providing dramatic close-up and bird's-eye perspectives characteristic of New Vision photography. Bayer's field-of-vision exhibition technique enhanced the possibilities for New Vision vantage points within the show. Gropius's raised walkways, similar to those he had constructed for the 1930 Werkbund exhibition in Paris, gave the spectator bird's-eye views of the installation (see fig. 1.23). Some exhibited elements could only be seen by leaning over railings; the viewer then saw the tilted images and skewed perspectives that were hallmarks of New Vision photography (see fig. 1.29). Peephole constructions and large-scale photographs provided un-

usual close-up displays of materials. The exhibition design as well as the photographs used within the installation presented the modern world—and the modern worker—from exciting new, dramatic perspectives.

In Germany during the 1920s, there were a number of photography exhibitions that mirrored the post–world war photo industry boom and the international avant-gardes' experimentation with photography.[84] The most important of these, *Film und Foto (Film and Photography),* organized by Deutscher Werkbund in Stuttgart in 1929, presented photography and film as mediums that were revolutionizing modern perception and culture.[85] Although *Film und Foto* is primarily significant in being the most ambitious exhibition of New Vision photography at the time, bringing together approximately one thousand avant-garde, anonymous, and professional photographs from Europe and the United States, its creators also experimented with exhibition technique. Gustav Stotz, a Werkbund administrator, oversaw the exhibition with the aid of an international team of advisors that included El Lissitzky, Edward Steichen, Edward Weston, Piet Zwart, Hans Richter, and Sigfried Giedeon.

Among the most celebrated aspects of *Film und Foto* was the innovative installation created by Moholy-Nagy in the exhibition's first gallery, designated "Room One" (fig. 1.40). On the walls and on exhibition panels, Moholy-Nagy arranged on white mats and without captions all kinds of photographs: artistic, anonymous, news, advertising, scientific, and commercial. Central to Moholy-Nagy's curatorial agenda was the inclusion of different photographic techniques, such as New Vision close-up and bird's-eye views, photograms, simultaneous projections, X-rays, and microscope photography. Moholy-Nagy's approach and method of display suited a room-size photo essay dealing with the diverse ways of picturing the modern world that the camera could provide. Stripped of any textual information, devoid of hierarchy in the display, without gimmicks or emphasis of a par-

ticular print, and presented on a black grid of support panels, the installation focused on the variety of visual possibilities for the "camera eye." In the exhibition's Soviet section, Lissitzky installed scaffold structures reminiscent of Kiesler's earlier L and T method (fig. 1.41). These horizontal and vertical beams created a skeleton of supports on which photos were hung at varying heights, providing both bird's-eye and close-up perspectives for the viewer. The Soviet section also included innovative film-viewing contraptions designed by Sergei Eisenstein.

The Mass Media as the Method and the Message: The 1928 *Pressa* Exhibition

Another exhibition that celebrated the possibilities of photography, but dealt specifically with publishing and the press, was the Soviet section at *Der Internationalen Presse-Ausstellung (International Press Exhibition),* held in Cologne in 1928.[86] This exhibition's historical importance lies primarily in its groundbreaking design. More than any other exhibition of the 1920s, the Soviet pavilion at *"Pressa"* dramatically introduced exhibition design as a new discipline within the field of visual communication—and as an artistic endeavor in its own right.

The Soviet pavilion provided what must have been an astonishing new type of public spectacle. Its theme, the history and revolutionary power of the press within the Soviet Union, took the form of a dynamic walk-through stage set that also introduced its audience to new photographic techniques, such as giant photographs and photomontages, and new materials, such as cellophane and Plexiglas. Lissitzky designed the pavilion in col-

1.40

László Moholy-Nagy, *Room One, Film und Foto,* Stuttgart, 1929.

laboration with approximately thirty-eight members of a collective that included artists and graphic, stage, and agitprop designers, among whom were Aleksandr Naumov, Elena Semenova, and Sergei Senkin (Senkin accompanied Lissitzky to Cologne for the installation).

The pavilion was divided into twenty sections, including *The Constitution of the Soviets, Trade Unions, Lenin as Journalist, Censure and Freedom of the Press, Worker and Farmer Correspondents,* and *The Reading Room.* These sections contained 227 exhibits produced by the thirty-eight members of the collective as well as a photomural, titled *The Task of the Press Is the*

Education of the Masses, created by Lissitzky and Senkin; it was eleven feet high and seventy-two feet long and was divided into sections by red triangular banners (fig. 1.42). The Soviet pavilion was paradigmatic on a number of levels, the most important being that the installation design itself was a realization of its subject: the power of the new mass media, the new materials, and the new technologies that were moving the Soviet Union into a revolutionary new era.

Lissitzky designed many of the exhibits within the first room; in addition to the photomural he created with Senkin, he created the two central exhibit stands, *The Constitution of the*

1.41
El Lissitzky, cinema section with film-viewing devices, *Film und Foto,* 1929.

Soviets and *The Newspaper Transmissions* (fig. 1.43). The *Trans-missions* exhibit took the form of newspaper presses. Examples of Soviet newspapers and posters were mounted on floor-to-ceiling conveyor belts that wrapped around rotating cylinders. The visitor had to walk past the six mechanical transmissions to reach the centerpiece, *The Constitution of the Soviets,* composed of a star-shaped scaffolding studded with six spinning globes, running text, and electric spotlights. According to the catalogue (which Lissitzky also designed), the ellipse that capped the star represented the Soviet landmass and the six globes signified the six republics, connected by the sentence wrapped

around the structure: "Workers of the World, Unite!"[87] Three spotlights on the bottom of the structure magnified its red color and created a dynamic play of shadows on the ellipse's ceiling.

Bayer, who created a relatively modest installation of books for German section of *Pressa,* later described Lissitzky's installation:

A revolutionary turning point came when El Lissitzky applied new-constructivist ideas to a concrete project of communication at the "Pressa" Exhibition in Cologne in 1928. The innovation is in the use of a dynamic space design instead of unyielding symme-

try, in the unconventional use of various materials (introduction of new materials such as cellophane for curved transparency), and in the application of a new scale, as in the use of giant photographs."[88]

While criticizing Lissitzky's plan as somewhat "chaotic" and championing a more organic, flowing, and rational approach to exhibition technique, Bayer nonetheless saw his encounter with Lissitzky's *Pressa* exhibition as a turning point in his artistic career. It was his introduction to the vast possibilities of exhibition technique: "from there I started to think about exhibition design."[89]

Like the exhibitions of Bayer, Kiesler, and Moholy-Nagy, as well as Lissitzky's *Room for Constructivist Art* and *Abstract Cabi-*

net, the *Pressa* installation implicitly acknowledged the role of the viewer in the creation of meaning by providing a stage-like experience for the spectator. This was precisely the description Jan Tschichold gave when writing about the success of the Soviet pavilion in 1931: "The room thus became a sort of stage on

1.42

El Lissitzky and Sergei Senkin, mural, *The Task of the Press Is the Education of the Masses,* Soviet pavilion, *Pressa,* Cologne, 1928.

1.43 →

El Lissitzky, central exhibit, *The Constitution of the Soviets* and *The Newspaper Transmissions,* Soviet Pavilion, *Pressa,* 1928. This installation design was a realization of its subject: the power of the new mass media, new materials, and new technologies that were transforming the modern world.

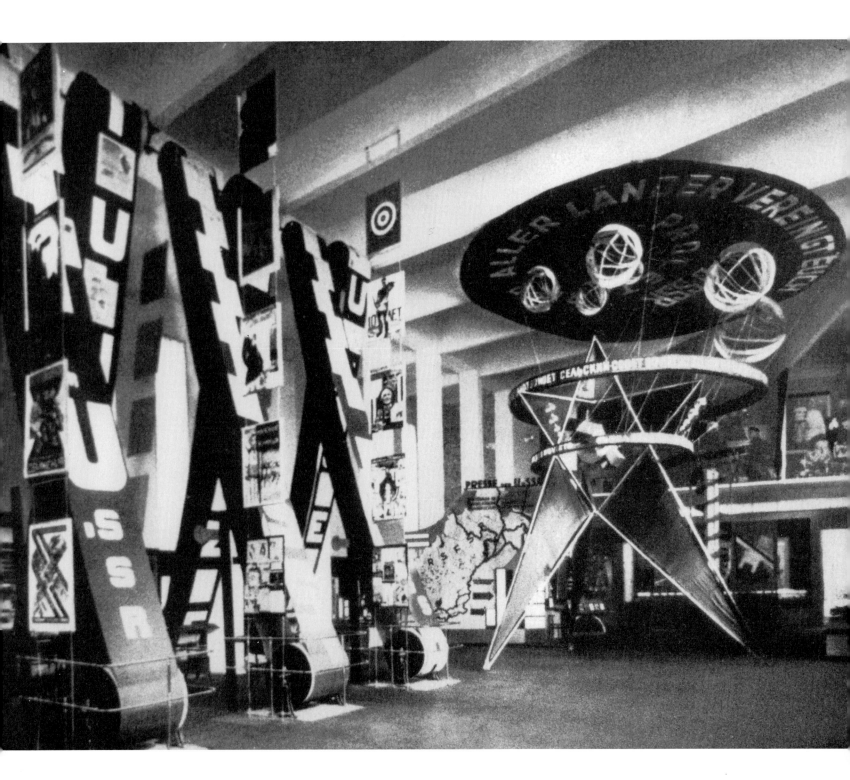

which the visitor himself seemed to be one of the players. The novelty and vitality of this exhibition did not fail; this was proven by the fact that this section attracted by far the largest number of visitors, and had at times to be closed owing to over-crowding."[90] Lissitzky was awarded a medal from his government in honor of *Pressa*'s success.

After *Pressa,* Lissitzky designed the Soviet pavilion for the 1930 *Internationalen Hygiene-Ausstellung (International Hygiene Exhibition)* in Dresden and the Soviet section of the 1930 *Internationalen Pelzfach Ausstellung (International Fur Trade Exhibition)* in Leipzig, where the techniques developed at *Pressa* were deployed. Lissitzky described himself during these years as a "pioneer of the artistic construction of our exhibitions abroad with their new political responsibility."[91] From the late 1920s until his death in 1941, exhibition design in the service of the Soviet political agenda became a primary focus for Lissitzky. Although these exhibitions dealt with the mass media, technology, commerce, trade, and evaluations of the modernization of everyday life, they were constructed mainly as political propaganda. At the beginning of this period, Stalin consolidated his power, instituting the first five-year plan in 1928. In 1932 a resolution dissolving the diverse artistic factions that had been tolerated since the revolution was adopted, and Soviet cultural policy was redirected toward a stringent Social Realism.[92]

Lissitzky's resolute commitment to the Soviet state as it transformed from revolutionary communism to Stalinist totalitarianism raises questions regarding his collaboration with the Soviet government. Unlike Mies, who took an apolitical stance, Lissitzky was an avowedly political individual. Judging from his letters and writings, it seems that Lissitzky's faith in Marxism was unwavering. He saw his exhibition designs as his "political responsibility," and throughout his autobiographical chronology Lissitzky refers to his service to the state. (In fact, one of his earliest accomplishments was the design of the first Soviet flag in 1917.)[93] Whether he was fully aware of the atrocities of Stalin and what his attitude was toward the Soviet totalitarian state are matters not adequately documented; this area needs more research and exploration.[94]

Installation Design in Italy and the Art of Propaganda

The Soviets were not alone in the deployment of exhibition design as a political instrument. The innovative exhibition techniques of the 1920s were, by the 1930s, finding wide use as political propaganda within Fascist Italy. In fact, one of the most important attempts to represent Fascist ideology in visual form was the 1932 exhibition in Rome celebrating the tenth anniversary of Mussolini's march on Rome, the *Mostra della Rivoluzione Fascista (Exhibition of the Fascist Revolution)* at the Palazzo delle Esposizioni.[95] Rationalist architects Adalberto Libera and Mario De Renzi encased the exterior of the turn-of-the-century exhibition palace within a dark red cube thirty meters in length and affixed four oval, burnished copper *fasci littori* onto the facade. These massive fasciae, emblems of the Italian Fascist Party, were twenty-two meters high, of oxidized laminated copper; set against the deep red cubic form of the building, they transformed the Palazzo into a striking architectural symbol of the dictatorial regime (fig. 1.44).

On the first floor of the palace, twenty exhibition rooms, designed by artists and architects in collaboration with historians and writers, traced the history of Italian Fascism from 1914 to 1932. On the second floor, three exhibition rooms featured publication displays as well as an homage to the inventor of the radio (which, like exhibition design, was a relatively new medium

for mass communication). Described in the catalogue as a "grande glorificazione plastica di Marconi," [96] the exhibit—most likely a reinterpretation of Lissitzky's *Constitution of the Soviets*—consisted of a globe encased in a metal armature of radio waves in the shape of stars (fig. 1.45). Diverse aesthetic factions of the Italian cultural community were represented throughout the exhibition. The first-floor galleries were executed in styles that included conventional vitrines and displays as well as adaptations of avant-garde exhibition techniques.

Libera was given the centerpiece of the exposition: the *Sacrario,* or the shrine to the martyrs of the Fascist regime. On the lower register of the *Sacrario*'s dramatically dark circular room ran pennants of Fascist Action Squads (fig. 1.46). Above this, and almost reaching to the ceiling, were six bands of three rows each that wrapped around the room; they were composed of the repeated inscription of a single white luminous word, "Presente." (The lit inscriptions were achieved through backlighting.) A massive metal cross, rising from what the catalogue described as a luminous "blood red" pedestal, was inscribed with the illuminated words "Per La Patria Immortale." [97] The Fascist anthem played softly, the sound coming from speakers hidden in the walls. The dramatic exhibition design conflated what could be read as a "timeless" neoclassicism with symbology of Christianity to create a shrine for men who died for a very historically specific form of Italian Fascism.

Very different from the austere classical drama of Libera's shrine was the most famous of the exhibition rooms, which drew particular attention as an example of the international avant-gardes' experimentation with exhibition technique: Rationalist architect Giuseppe Terragni's *Sala O.* Dedicated to the Fascist March on Rome in 1922, the moment when Mussolini grasped power, the dynamic interior space was covered with murals that exploited the formal innovations of Cubism and Futurism as well as avant-garde typographic techniques and photomontage (figs.

1.44

Adalberto Libera and Mario De Renzi, facade of *Exhibition of the Fascist Revolution,* 1932, as reproduced in *Mostra della Rivoluzione Fascista: Guida Storica,* ed. Dino Alfieri and Luigi Freddi, ex. cat. (Rome: Partito Nazionale Fascista, 1932), 66.

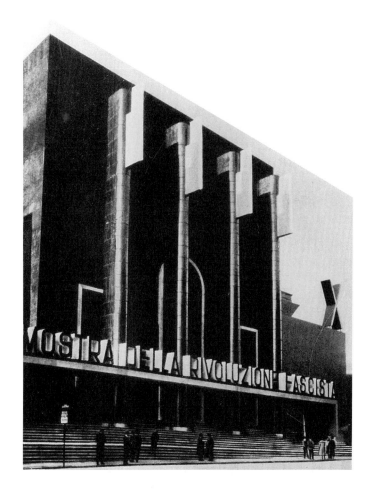

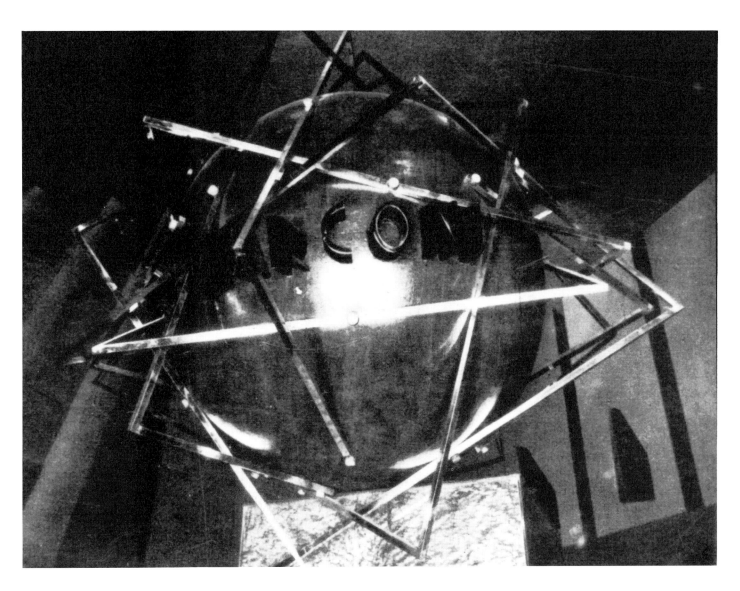

1.45
Page of 1932 *Exhibition of the Fascist Revolution* catalogue showing exhibit in
honor of Guglielmo Marconi. Alfieri and Freddi, *Mostra della Rivoluzione Fascista,*
249.

1.46 →
Adalberto Libera, *Sacrario, Exhibition of the Fascist Revolution,* 1932, where
a massive metal cross rose from what the show's catalogue described as a
luminous "blood-red" pedestal. This installation also had sound: the Fascist
anthem played softly (speakers were hidden in the walls).

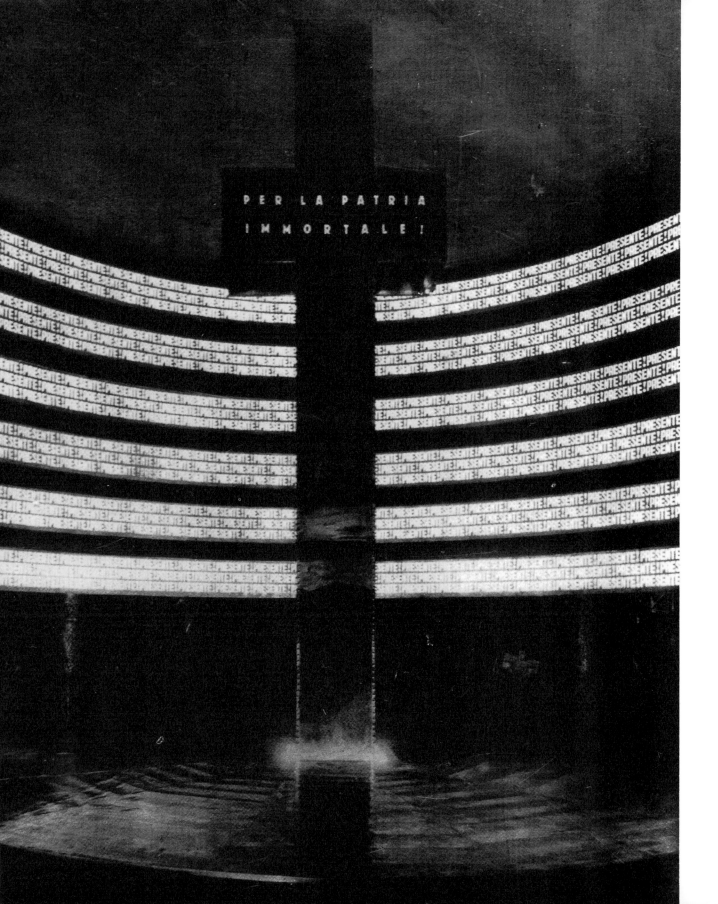

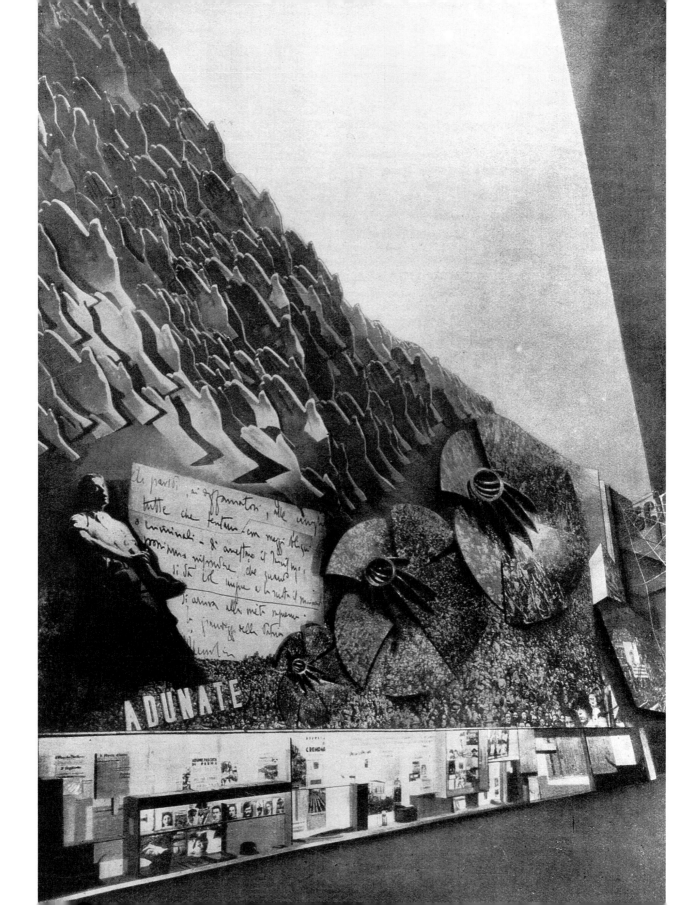

1.47, 1.48

Giuseppe Terragni, *Sala O:* an installation dedicated to the fascist March on Rome
in 1922, *Exhibition of the Fascist Revolution*, 1932.

1.47 and 1.48). A massive photo-fresco diagonally bisected the room along the axis of an "X" painted on the ceiling, representing the fascist year ten. In the photo-fresco's lower right-hand section was an image of a crowd of thousands, which in the midsection was shaped into a three-dimensional construction representing machine turbines. At the top of the fresco were three-dimensional silhouettes of hundreds of hands. At the left-hand corner stood an image of *il Duce* next to the handwritten message, "See how the inflammatory words of Mussolini attract the people of Italy with the violent power of turbines and convert them to Fascism." The installation's diagonals, the fragmented three-dimensional forms of the wall murals, and the thrust of the photo-fresco partition, which was visually echoed by its turbines and hundreds of three-dimensional hands, created an explosive-looking visual spectacle aiming for effects similar to "the inflammatory words" of Mussolini and what was conceived as the dynamic power of *il Duce*'s March on Rome.

However dramatic Terragni's *Sala O* may have been as a propaganda spectacle for the Mussolini regime, the mural nonetheless reveals the effects of Italian Fascism: the individual is one of thousands of infinitesimal elements that create the political machine, here represented as turbines. Mussolini, portrayed as a giant—and the only distinguishable person—who presides over the masses, is captioned as the source of the state's power;

1.49

Edoardo Persico and Marcello Nizzoli, *Gold Medals Room, Italian Aeronautics Exhibition,* Milan, 1934.

ironically, however, the indistinguishable citizenry are represented as the engines, one might say the true source of power, that drive the Italian Fascist state.

Interest in avant-garde exhibition design remained vital in Italy during the 1930s. One such example was the *Sala delle Medaglie d'Oro (Gold Medals Room)* designed by Edoardo Persico and Marcello Nizzoli for the 1934 *Mostra dell'Aeronautica (Italian Aeronautics Exhibition)* in Milan (fig. 1.49).[98] A commemoration of the wartime achievements of Italian aviators who had received the prestigious Gold Medal, the installation's armature was a gridlike scaffolding that had become a versatile standard in exhibition structures. Extending from floor to ceiling were slender white lattices onto which artifacts, photographs, and text panels were mounted and seemed to float in space, an appropriate formulation for an exhibit celebrating the accomplishments of the Italian air force. Persico and Nizzoli's formulation achieved the elegance and the sense of dematerialized support structure that was inchoate in Kiesler's L and T system and that was explored in Lissitzky's *Film und Foto* installation (see fig. 1.41). Gropius was reportedly "spellbound" when he visited the *Gold Medals Room,* which looked very similar to the installation he created with Schmidt for the *Nonferrous Metals* exhibit at *German People/German Work* that same year (see fig. 1.38).[99]

Another important arena for exhibition technique in Italy during the 1930s were the *Triennales.*[100] One of the most important of these exhibitions, the 1936 *Triennale* in Milan, included a spectrum of design solutions. The show was organized according to themes dealing with design, architecture, and technology, and the installations were dominated by the presence of the Rationalist grid and modular structures. Franco Albini and Giovanni Roman created a gridded installation for the *Mostra dell'Antica Oreficeria Italiana (Exhibition of the Antique Italian Goldsmith's Shop)* that was reminiscent of Persico and Nizzoli's *Gold Medals Room.* Max Bill's *Sezione Svizzera (Swiss Section),*

an exhibit of design objects, architecture, and photographs, was innovative in its use of color accents and its suspension of abstract forms and display units, which created a floating, pristine, geometric layout of elements and space. Nizzoli, Persico, and Giancarlo Palanti created the *Salone d'Onore (Salon of Honor),* a starkly classical homage to the Fascist state that looked like a "pittura metafisica" stage set with Lucio Fontana's classicist nike and horse sculpture inscribed with the words of Mussolini as the centerpiece.

Although the level of experimentation and international importance of installation design in Europe diminished after World War II, an interest in exhibition technique could still be found, primarily in design and industrial exhibitions and international expositions such as the 1947 *Exposition Internationale de l'Urbanisme et de l'Habitation (International Exposition of City Planning and Housing)* in Paris and the 1951 Milan *Triennale.*[101]

While exhibition design first became an important feature of aesthetic practice within the European avant-gardes of the 1920s, from its inception in 1929 the Museum of Modern Art presented dramatic and creative installations and continued to do so long after this activity had waned in Europe. Like the experimentation of the international avant-gardes, exhibition designs for purely aesthetic installations, for the display of modern design and architectural prototypes, and for political propaganda were an integral part of the reception and promotion of modern art and culture at the Museum of Modern Art until 1970. But unlike the geographically scattered and institutionally diverse exhibition designs of the international avant-gardes, the installation experimentation at MoMA was concentrated within one institution and was, very particularly, an American (i.e., U.S.-specific)[102] realization of modern culture. Analyzing the Museum of Modern Art's exhibitions from 1929 to the 1990s provides a paradigmatic case study of the institutionalization of modern and contemporary art in the United States.

Chapter 2

Aestheticized Installations for Modernism, Ethnographic Art, and Objects of Everyday Life

Creating Installations for Aesthetic Autonomy: Alfred Barr's Exhibition Technique

The Museum of Modern Art's founding director, Alfred Barr, did not select the paintings for the Museum's inaugural exhibition, *Cézanne, Gauguin, Seurat, van Gogh*—but he did install them. A. Conger Goodyear, the Museum's founding president, chose the works for the show, which was held from November 7 to December 7, 1929 (fig. 2.1).[1] Its installation may now look utterly unexceptional; this manner of presenting paintings has become so conventional that its significance may be completely invisible. But it marked the beginning of several decades of innovative exhibition design at the Museum of Modern Art. *Cézanne, Gauguin, Seurat, van Gogh* also contributed to the introduction of a particular type of installation that has come to dominate museum practices, whereby the language of display articulates a modernist, seemingly autonomous aestheticism.

For this first exhibition, Barr—who perhaps more than any other individual has influenced the reception of modern art in the United States—thought it important to experiment with the installation. The young director did not completely eliminate traditional, symmetrical conventions of installing pictures according

Hanging pictures is very difficult, I find, and takes a lot of practice. . . . I feel that I am just entering the second stage of hanging when I can experiment with asymmetry. Heretofore I followed perfectly conventional methods, alternating light and dark, vertical and horizontal.

—Alfred H. Barr, Jr., to Edward S. King, letter (10 October 1934)

There is no such thing as a neutral installation. A work of art is so much like a person—the same work of art reacts differently at different phases of history. Installation is a very complicated exciting subject.

—René d'Harnoncourt, in "Profiles: Imperturbable Noble" (1960)

2.1

Museum of Modern Art's inaugural exhibition, installed by Alfred H. Barr, Jr., *Cézanne, Gauguin, Seurat, van Gogh*, Museum of Modern Art, New York, 7 November to 7 December 1929. Alfred Barr installations such as this one enhanced a sense of the work of art, the exhibition, and the viewer's autonomy. This type of installation method has become so standard that its language of form goes unnoticed and seems "invisible" to most viewers. But, as is the case with all exhibitions, this is a representation in its own right.

to size and shape. There were, for example, arrangements such as the large van Gogh *Irises* placed in between two very small self-portraits and framed by two landscapes nearly identical in size. For the most part, however, Barr departed from traditional display methods of treating paintings as room decor and presenting them "skied," in salon-style installations.

In keeping with the new installation methods for painting and sculpture that were being developed within the international avant-gardes during the 1920s and 1930s, Barr covered MoMA's walls with natural-color monk's cloth and eliminated skying. Installing paintings at approximately eye level on neutral wall surfaces in spacious arrangements became a common practice during the 1930s. Previously, even in avant-garde exhibitions, paintings were almost always hung very close to one another in traditional interiors and were skied. Two of the best-known modern art installations of the first quarter of the twentieth century—the 1913 *Armory Show* in New York and the Kazimir Malevich gallery at the *0.10: The Last Futurist Exhibition of Paintings* in Petrograd in 1915 and 1916—were arranged in this manner (figs. 2.2 and 2.3).[2] With the establishment of the spacious, modern display method as the standard in the 1930s and 1940s, it has become relatively rare for a collection of modern art to be installed according to a skied plan; one such exception is found at the Albert C. Barnes Foundation in Merion, Pennsylvania.[3]

Barr's wife, art historian Margaret Scolari Barr, was emphatic in a 1974 interview about the importance of his innovative exhibition technique for MoMA's first show.

It occurred to me that I have not made it clear . . . what was so novel about this kind of exhibition. What was novel, apart from the choice of paintings . . . was how they were installed . . . they were installed on plain walls; if the walls were not totally white then they were the palest gray, absolutely neutral. And in the most novel way they were installed not symmetrically. . . . [I]n

1932 still in Paris pictures were being hung symmetrically and by size, not by content, not by date . . . and they were "skied." Whereas in the Museum, right there in that first show in the Fall of 1929, there were no pictures above other pictures, all the walls were neutral, and the pictures were hung intellectually, chronologically. . . . Previously, the walls would be either paneling or else they would be brocade—red brocade, blue brocade, green brocade which would suck the color out of the pictures. Instead, the idea was to let the pictures stand on their own feet.[4]

Beaumont Newhall, who was hired as MoMA's librarian in 1935 and later served as the director of the photography department from 1940 to 1947, helped Barr install the 1935 *Vincent van Gogh* exhibition (fig. 2.4). In a recollection published in 1979, he also emphasized Barr's exhibition technique.

The van Gogh *exhibition, like so many of Alfred's shows, was more than a superb loan collection. The pictures were not hung symmetrically by size, with the largest in the middle of the wall, the next largest at the ends and the smallest in between, as in most museums of the time. No, the pictures were hung in logical sequence depending on style and period, well spaced so they did not impinge upon one another, and with explanatory labels. Alfred believed that an exhibition should elucidate as well as give aesthetic pleasure. The labels for this show, besides giving title, date, and name of lender, contained excerpts from van Gogh's letters to his brother Theo, often describing the very picture on display. Alfred asked me to help tack them up. The Good Samaritan label included a small mounted photograph of the Delacroix painting upon which van Gogh had based his painting.*[5]

Although there were no labels in the first show, didactic labels had become a hallmark of Barr's exhibition technique by the time of the *van Gogh* exhibition and were another indicator of

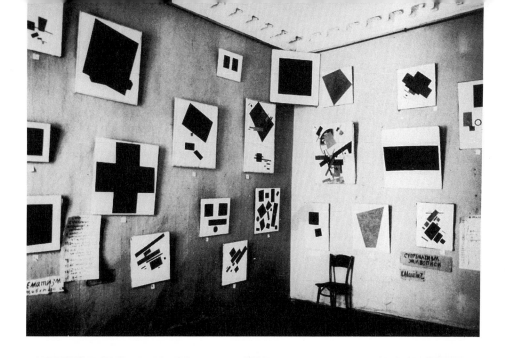

2.2

0.10: The Last Futurist Exhibition of Paintings, Petrograd, 1915–1916.

2.3

The "Armory Show," The International Exhibition of Modern Art, Sixty-ninth
Regiment Armory, New York, 17 February to 15 March 1913.

Barr's curatorial departure from decorative exhibition installations. Margaret Barr stressed the importance of the type of labeling her husband introduced: "The labels that my husband used to write were not only labels for each picture, but they were general intellectual labels to make people understand what they were seeing . . . they explained the general nature . . . of that room or of the whole exhibition. . . . Such a thing had never been done before."[6] These Alfred Barr exhibitions did not consist of artworks in decorative, or even vaguely stylistic, arrangements; they were compositions in which wall labels explicitly linked the works of art historically and conceptually, making visible the unity and coherence of the show. Barr's labels enhanced the sense of the exhibition as an entity unto itself.

When asked about the neutral, non-skied installation method inaugurated at MoMA, Philip Johnson, who was curator of MoMA's architectural department from 1932 to 1934, stated simply: "That was Alfred Barr." Johnson, whose installation designs for MoMA's 1932 *Modern Architecture* and 1934 *Machine Art* shows are among the rare exhibition installations that have retained a prominence in both the art and the architectural literature, quickly added that "Alfred Barr and I were very close. We didn't do anything separate."[7] Having met in the spring of 1929 when Johnson was a classics major at Harvard and Barr was teaching at Wellesley, the two men were friends and colleagues whose relationship was founded on their passion for modern art and architecture.[8] By the summer of 1929 Barr had accepted the directorship of the Museum. In September of the following year, after he had finished his degree, Johnson moved to New York, where he and the Barrs rented apartments in the same building. Both men had traveled, individually and together, throughout the Continent during the late 1920s and early 1930s, and their creative exhibition methods were conceived within the context of the museological innovations taking place in Europe. Johnson in

1993 outlined the genesis and formulation of his and Barr's new installation method:

Alfred Barr and I were very impressed with the way exhibitions were done in Weimar Germany—at the Folkwang Museum in Essen especially (fig. 2.5). That's where they had beige simple walls and the modern was known there. It wasn't known in this country at all. For instance, here all our museums had wainscoting. Of course, that's death to a painting. It skys the painting. That was the big battle in hanging paintings. . . . The Metropolitan got used to skying pictures because of those idiotic dados. But if you let the wall go down it's much better. You naturally look slightly downward. So if you sky a picture you're in trouble. Since then everybody's hung their paintings low. . . . Barr thought beige, that brownish stuff that he used, the monk's cloth, was the most neutral thing he could get. After some time, the modern design people got hold of it and made it white paint. . . .´ They painted the walls white. . . . Before that it was always the cloth. And, of course, the cloth was much better. Because it doesn't leave marks and the beige color was far better for painting than white. Never, never use white for painting. Then your frame is much brighter than your picture. . . . If the area around the painting is brighter than the painting you're taking away from the painting. This is what Alfred felt. . . . And so the Folkwang Museum especially impressed us and in Basel what impressed us was the sparsity of the hanging which Alfred tried to use . . . of course we knew those famous rooms of Alexander Dorner in Hanover. Essen, on the other hand, was a more reactionary, normal museum and they still hung paintings low, against neutral backgrounds, without trim, and in an architectural manner.[9]

Johnson also discussed the problems of installing an exhibition in MoMA's first building, a townhouse on Fifth Avenue,

2.4
Alfred H. Barr, Jr., *Vincent van Gogh,* Museum of Modern Art, 4 November 1935 to
5 January 1936. One of Barr's didactic labels thumbtacked to walls can be seen
in this photograph.

2.5
Folkwang Museum, Essen, ca. 1934.

where "we just had little office rooms to do things in." These commercial offices, in what was known as the Heckscher Building, underwent slight renovations to ensure that walls within the existing interiors were unobstructed. Architectural detailing such as pilasters were eliminated, and the rooms' corners were chamfered to provide additional space for hanging paintings. These renovations were an attempt to encase these interiors in a neutral, monk's-cloth, aesthetic "shell." By May 1932, the Museum had moved to a larger building on 53rd Street, which also was renovated with monk's-cloth walls. Reflecting on these first exhibitions—in what from today's perspective were extremely modest inaugural galleries—Johnson in retrospect agreed with Barr that they were experimenting with the new field of exhibition design.[10]

The placement of paintings on neutral-colored walls at just below eye level and at relatively widely spaced intervals created a "field of vision" (to use Herbert Bayer's term; see chapter 1) that facilitated appreciation of the singular artwork. These changes let the paintings "stand on their own," as Margaret Barr put it, somewhat anthropomorphically.[11] In Barr's "modern" installations, works of art were treated not as decorative elements within an overpowering architecture but as elements within an exhibition whose aesthetic dimension took precedence over architectural and site-specific associations. Even the wall labels, however historical, served as documents underscoring the aesthetic validity of an exhibited work. (During these years one of MoMA's primary challenges was, of course, to promote the acceptance of modern art in the United States.) Barr strove to create seemingly autonomous installations in neutral interiors for what was conceived as an ideal, standardized viewer. The various elements of these shows were explicitly woven together conceptually by the inclusion of wall labels. All of these conventions enhanced the perceived autonomy both of the works of art and of the exhibition.

The logic that shaped an installation such as the *van Gogh* exhibition was aesthetic: style, chronology within this style, and the subjects constituting the oeuvre. This method of installation would dominate Barr's exhibition technique throughout his career. In one of the rare documents in which Barr wrote about his installation technique, he described the 1940 *Italian Masters* exhibition as being arranged in an "almost perfect chronological sequence. . . . No effort of any kind was made to suggest a period atmosphere, either by wall coverings or accessories. In other words, the works of art were considered as objects valuable in themselves and isolated from their original period."[12] Observing Barr's exhibitions with some historical perspective, we see these aestheticized, autonomous, "timeless" installations created for an ideal viewer as modernist representations in their own right.[13]

Barr did more than place paintings and sculpture in spare, beige installations: he staged a seemingly autonomous site for a stationery, ideal viewer. In Barr's exhibitions, the viewing subject was presumed to fit a specific standard and to match an ideal height. Such an arrangement treated the viewer as an immobile, atemporal being (fig. 2.6). Both the work of art and the viewing subject were framed in these suggestive, neutral interiors as if each were unfettered by other social formations. It is extremely suggestive that this installation method has become the norm within twentieth-century modern museum practices, so common and so standardized that its language of form and its function as a representation have become transparent and invisible. But this conventional manner of displaying modern culture and art is itself far from neutral: it produces a powerful and continually repeated social experience that enhances the viewer's sense of autonomy and independence.

2.6
Alfred H. Barr, Jr., looking at Alexander Calder, *Gibraltar* (1936), in 1967.
Photograph: © Dan Budnik.

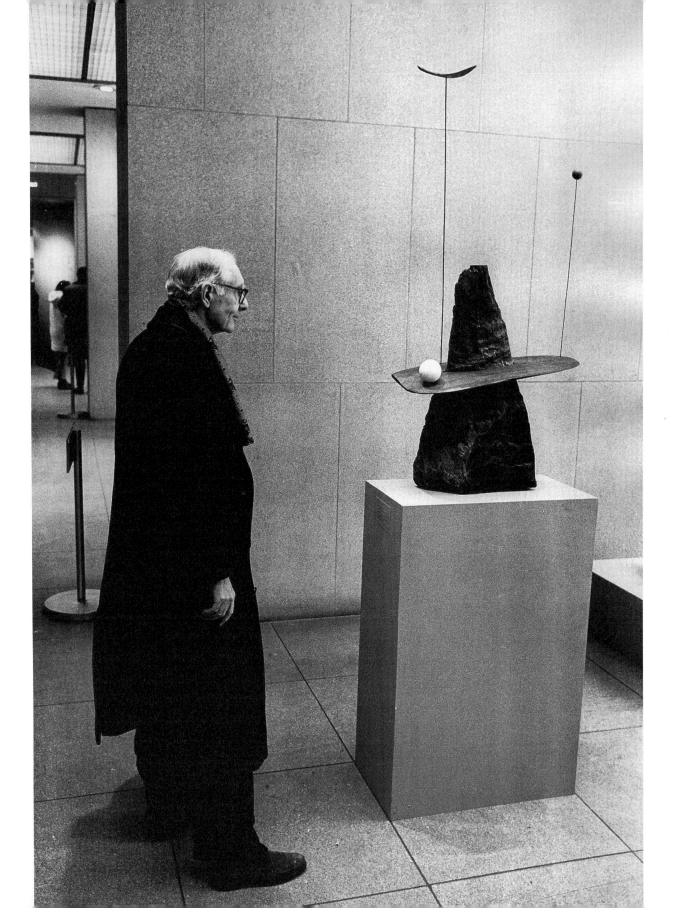

2.7
El Lissitzky, *Abstract Cabinet,* Landesmuseum, Hanover, 1927 and 1928.

This is not to say that Barr's installation design was the only option for presenting modernism within the international avant-gardes. Lissitzky's *Room for Constructivist Art* of 1926 and *Abstract Cabinet* of 1927 and 1928 also provided aestheticized installations for painting and sculpture that were autonomous in the sense of being disengaged from the original architectural features of the site (fig. 2.7).[14] But however much Lissitzky's creations were aestheticized interiors for abstract works of art, his method produced a dynamic, interactive space for the viewer. Lissitzky's viewer-interactive cabinets, composed of walls that flickered as the visitor moved through the space, made visible the fact that the reception of art occurs within an ever-changing interaction between the viewer and the artwork. It was one of his stated intentions for his *Room for Constructivist Art* that "now our design should make the man active."[15] Lissitzky's installations suggested that the reception of art is inextricably intertwined with a particular viewer at a particular moment and thus, by implication, with the processes of history—a very different ideological perspective from that of Barr. Lissitzky's method was not surprising, given his commitment to historical materialism

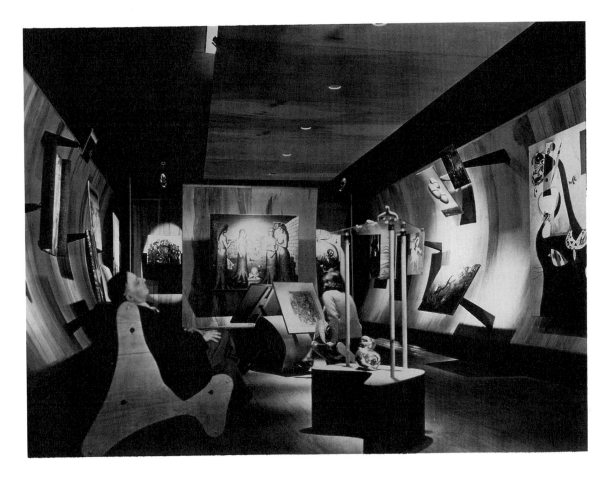

2.8

Frederick Kiesler, *Surrealist Gallery,* Art of This Century, 1942.

and the Soviet revolution, which by the late 1920s would become explicit in his exhibitions and writings.[16]

Kiesler's interactive L and T system for installing works of art, created in 1924 and 1926, also set up a dynamic relationship with the viewer, as did his interactive installations for Art of This Century (see chapter one). Like the adjustable levels of his L and T system, in Art of This Century's *Surrealist Gallery* movable supports were used to mount the paintings so that the visitor could tilt them to the positions he or she desired for viewing (fig. 2.8). Kiesler defined the theoretical armature for his work—what

he called "Correalism"—as "the science of relationships."[17] He specifically stated that the "traditional art object, be it a painting, a sculpture, or a piece of architecture, is no longer seen as an isolated entity but must be considered within the context of this expanding environment. The environment becomes equally as important as the object."[18] Even Alexander Dorner, whose theoretical foundation for the installations at the Landesmuseum was Alois Riegel's *Kunstwollen,* nonetheless placed works of art in historically suggestive interiors, which he called "atmosphere rooms" (see fig. 1.18).[19] Such placement of works in contextually

specific installations was an approach that Barr has stated he very consciously avoided when creating the 1940 *Italian Masters* exhibition.

It should be obvious that Alfred Barr's installation method—neutral-colored walls, with paintings hung at a standardized height and with sculptures placed on white or neutral-colored pedestals—created a very different ideological space and different spectator than those produced by Lissitzky, Kiesler, or Dorner. The viewing subject in these Barr installations was treated as if he or she possessed an ahistorical, unified sovereignty of the self—much like the art objects the spectator was viewing. These spare installations isolated the individual art object, creating a one-on-one relationship with the viewer. If the visitor's height was within the ideal range imagined by Barr, then object and subject were, to anthropomorphize these artworks, "face to face" or "eye to eye" with each other (see fig. 2.6). The result is a magnified awareness of the object's, and the individual's, independence. This aestheticized, autonomous, seemingly "neutral" exhibition method created an extremely accommodating ideological apparatus for the reception of modernism in the United States, where the liberal democratic ideal of the autonomous, independent individual born to natural rights and free will is the foundation of the mythology of the American dream.

That installations which frame and isolate the individual and the individual work of art have become the standard not only in the United States but within twentieth-century museological practices in general must be considered in relation to the rise of the modern museum and the development of modern subjectivity.[20] The creation of the museum in the West involved the shift from private, aristocratic collections to public, democratic ones. In many cases, this transformation of private collections in the late eighteenth and early nineteenth centuries was directly linked to the dissolution of a monarchy and establishment of a liberal democratic capitalist state; the Louvre provides perhaps the most famous example. It is important—and revealing—that the institutionalization of modernism within museums for modern art coincided with new installation practices that would magnify the viewer's sense of autonomy and individual experience, characteristics particularly significant for the modern sense of self in a liberal democracy. Moreover, the relation of these now standard installations to their viewers is complicated by their decontextualization: the interiors with their seemingly neutral settings foster a sense of aesthetic experience as something segregated from other spheres of life. Modern installations reveal much about fundamental modern aesthetic myths, such as genius, taste, and a conception of art as something universal and timeless.[21]

From today's perspective, Barr's installations for MoMA's first exhibition and the *van Gogh* show may seem unimportant and unremarkable. But what may appear to be only slight departures from existing conventions of picture hanging marked the beginning of aggressive and exciting experimentation in the field of installation design at the Museum of Modern Art. During these early decades of MoMA's history, the Museum's directors and curators were exploring how to institutionalize modern art in what I have called a "laboratory period" of museum conventions and installation techniques. As we have seen, Barr himself characterized the Museum as an "experimental laboratory," and almost thirty years later his successor, René d'Harnoncourt, agreed.[22] Comparing the exhibition techniques tested during the laboratory years at MoMA with the ones that have survived these experimental decades reveals the reduced spectrum of installation methods and the *institutional boundaries* of what has come to be the modern art museum in the United States.

In 1959 Barr installed an exhibition that demonstrated the acceptance of the conventions he had helped to institute earlier in his career. For this exhibition, *Toward the "New" Museum of Modern Art,* Barr skied paintings to dramatize the Museum's lack of space for its collection and its financial problems (fig. 2.9).[23]

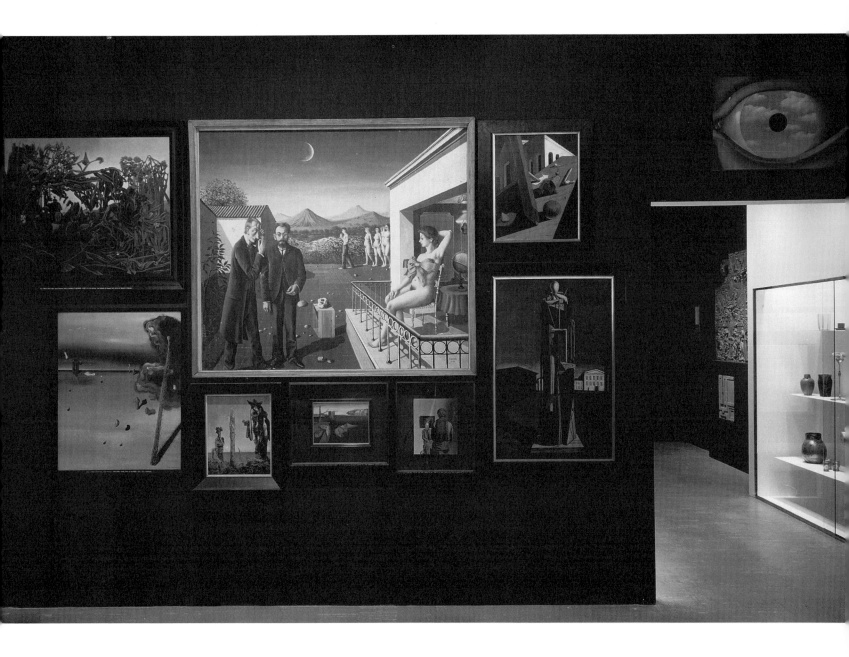

2.9

Alfred H. Barr, Jr., *Toward the "New" Museum of Modern Art*, Museum of Modern Art, 16 November to 29 November 1959. This "skied" method was the standard at the beginning of the century, but several decades later, in this exhibition, Barr used it to articulate and publicize institutional crisis.

The exhibition was timed to inaugurate MoMA's "Thirtieth Anniversary Drive" to raise $25 million, for which the Museum published a brochure with a section titled "The Museum's Invisible Collections." This "crowded" installation, which would have seemed perfectly conventional at the beginning of the century, now publicized institutional crisis.

The waning of experimentation in installation at the Museum of Modern Art in the 1960s and 1970s is related in part to an extremely significant change in policy that occurred in 1953. Previously, most works in the Museum's collection were eventually to be transferred to other institutions or sold. The collection was to possess, as A. Conger Goodyear put it, "the same perma-

2.10

Kurt Varnedoe with the assistance of Jerome Neuner, painting and sculpture galleries, Museum of Modern Art, 1997.

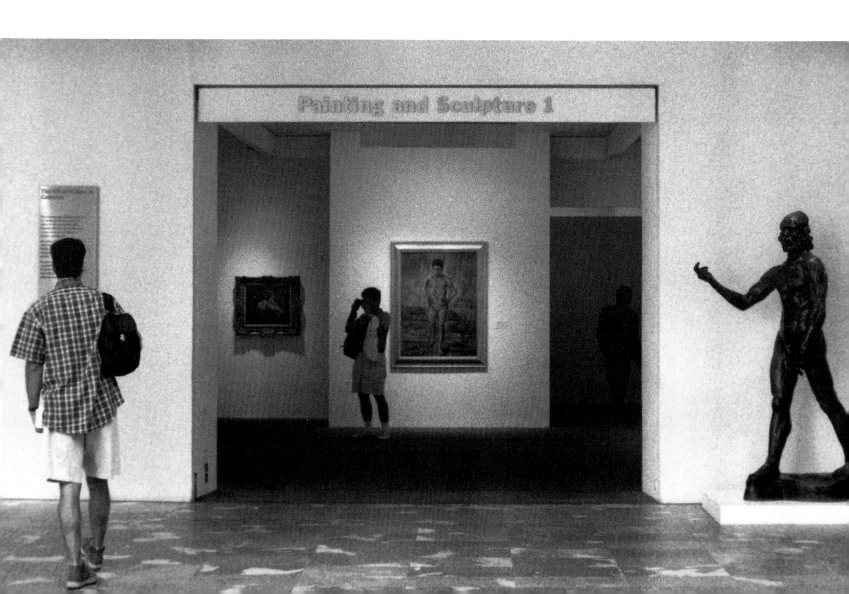

nence that a river has."[24] In February 1953, however, John Hay Whitney, MoMA's chairman of the board, announced that the Museum had decided to keep its acquisitions and would set aside special galleries for this permanent collection. On October 8, 1958, the Museum opened the first "permanent" installation of its collections in the second-floor galleries (fig. 2.10).[25] These galleries house the masterpieces of modern art, and idealized installations would perhaps be deemed appropriate for the display of such classics. This prominent addition to the Museum's mission certainly augmented the power and presence of the non-skied installations created within seemingly neutral interiors, which all worked to emphasize the autonomy of modern art and culture.

Alfred Barr's Multidepartmental Plan

True to the experimentation within the international avant-gardes during the first half of the century, Barr's modernist installation technique was merely one of a range of options being explored by himself and his colleagues at the Museum of Modern Art. Although MoMA's directors and staff had agendas and ideological considerations specific to the United States, they shared with their colleagues and predecessors in Europe an awareness of the representational diversity of exhibitions. This attention to the meanings of the installations was no doubt related to their conscious role in creating conventions for a new type of institution: the modern art museum. Using an approach to museology similar to Dorner's and that of the artists and architects creating innovative installations for the large international exhibitions, Barr envisioned exhibitions diverse in both theme and display methods

that would deal with "primitive" and premodern art, popular culture, film, architecture, photography, design, and the modernization of everyday life.

This catholic approach to the institutionalization of modern art was outlined in Barr's "1929 Plan."[26] When Barr was invited by MoMA's founding trustees to be director of the Museum, he was asked to map out the Museum's scope and policy. The young director came up with a long-range proposal whose framework included the following departments: painting and sculpture, prints and drawings, commercial art, industrial art (posters, advertising layout, packaging, etc.), film, theater design (arts and costumes), photography, and a library of books, photographs, slides, and color reproductions. In 1941 Barr recollected: "The plan was radical not so much because it was departmentalized (most large museums are), but because it proposed an active and serious concern with the practical, commercial, and popular arts as well as with the so-called 'fine' arts."[27] According to Barr, the trustees agreed to a museum of modern painting and sculpture but told him that "the multidepartmental program was too ambitious and if announced might confuse or put off the public and our potential supporters and that anyway the committee was primarily interested in painting so that consideration of such things as photography and furniture design would have to be indefinitely postponed." Barr was disappointed but accepted the response, which he rationalized: "from a practical point of view [it] made a good deal of sense." With the approval of the trustees, however, Barr made additions to the Museum's charter: "to encourage and develop the study of modern art" and "the application of such art to manufacture and the practical life." He believed this "left the door legally open" for the implementation of the departments that were added through the years.[28] His amendment also led to the subsequent experimental exhibitions of the Museum's early years.

Barr's theoretical foundations are usually discussed in relation to the influence of one of his undergraduate professors at Princeton, medievalist Charles Rufus Morey.[29] Morey treated art history as a discipline with an independent internal development: art was examined in terms of an organic evolution of styles. Although Morey followed an evolutionary theoretical model, he rejected the privileging of one style or art over another and his writings dealt with applied and fine art on equal terms.[30] According to Barr, "The first anticipation of the plan . . . was a course given by Professor C. R. Morey of Princeton. . . . This was a remarkable synthesis of the principal medieval visual arts as a record of a period of civilization: architecture, sculpture, paintings on walls and in books, minor arts and crafts were all included." Barr considered Morey's and his own methodology to be what he called "synthetic"—an approach that shaped his early teaching career and his tenure at MoMA.[31] It is also standard for those evaluating Barr's early methodological development to take into consideration his visits with the international avant-gardes in Europe and the Soviet Union during the late 1920s and early 1930s. Particularly important was his 1927 trip to the Bauhaus, which Barr described as a "fabulous institution, where all the modern visual arts—paintings, graphic arts, architecture, the crafts, typography, theater, cinema, photography, industrial design for mass production—all were studied and taught together in a large new modern building. . . . Undoubtedly it had an influence not only upon the plan of our Museum which I was to prepare two years later but also upon a number of exhibitions."[32] Although the literature dealing with Barr generally acknowledges that his approach to modern culture included both popular and fine art and the commercial and aesthetic spheres, the degree to which Barr's "high and low" perspective—and specifically the 1929 Plan—shaped MoMA's agendas and exhibition installations has been ignored.

Barr believed that the the 1929 Plan was first realized to some degree in the 1936 exhibition *Cubism and Abstract Art,* where the entire "curatorial staff helped me prepare sections on architecture, posters and typography, photography, films, furniture and theater."[33] In *Cubism and Abstract Art,* modernist paintings and sculpture were displayed as a pinnacle of nineteenth-century and early-twentieth-century styles that subsequently proliferated and diversified within twentieth-century fine art, design, advertising, film, and architecture. The exhibition's structure was linear and logical, literally visualized in Barr's famous flowchart (fig. 2.11). The chart not only served as the cover for the *Cubism and Abstract Art* catalogue, but the exhibition galleries were studded with charts that marked the beginning of each stylistic section: "From Impressionism to Fauvism," "Analytical Cubism," "Futurism," "Constructivism." At the entrance hall, for example, beneath the lettering on the wall, "Cubism 1906–10," a flowchart and a descriptive wall label introduced the viewer to Cubism.

For the most part, *Cubism and Abstract Art*'s historical importance has been seen by the art historical and modern museum establishment as an influential paradigm of stylistic analysis.[34] But the full title of this exhibition, which filled the Museum's four-story townhouse, was *Cubism and Abstract Art: Painting, Sculpture, Constructions, Photography, Architecture, Industrial Art, Theater, Films, Posters, Typography.* The exhibition was also an attempt to document, however modestly, the diverse innovations that had taken place within the international avant-gardes. In one gallery on the fourth floor, for instance, each of the four walls was designated according to style: "German" and "Bauhaus," "Purism," "De Stijl," and the "influence of Cubism" and the "influence of Suprematism." The installation was constructed of documentary photographs, film stills, books, journals, posters, objects, didactic labels, a painting, and an

architectural model. The German section included small photographs of Walter Gropius's Dessau Bauhaus, Oskar Schlemmer's theater costumes, and a chess set by a student of the Bauhaus, Josef Hartwig (2.12). The gallery documented important exhibition and installation designs, such as the photograph of Lissitzky's *Abstract Cabinet* in the German section, the catalogue cover of the Soviet pavilion at *Pressa* in the Suprematist section, and a photograph of Kiesler's *City in Space* in the De Stijl section. Like Herbert Bayer, who at the *International Exposition des Arts Décoratifs* mounted Bauhaus chairs in a series on the wall, Barr mounted one chair each by Marcel Breuer, Le Corbusier, and Gerrit Rietveld on the walls (fig. 2.13). In the Purism section there was a model of Le Corbusier's Villa Savoye.

Practical limitations prevented Barr from presenting more than documents and token examples of avant-garde architecture, design, and exhibition techniques, and those restrictions should be considered when assessing Barr's formalist exhibition methods. But the entries included in *Cubism and Abstract Art* were evidence of Barr's awareness of the international avant-gardes' experiments in exhibition design. Barr's theoretical interests in style and his actual restraints shaped the presentation of the exhibition's paintings, sculpture, publications, posters, architecture, furniture, and design objects. Separated from their original contexts or represented by documentary photographs, these selected entries were reinscribed within an aesthetic framework— as a canvas within a frame. Thus the Le Corbusier model of Villa Savoye provided the visitor with an exhibition experience closer to viewing sculpture than to touring the simulated reality of the modern world; the latter was enjoyed by visitors to a full-scale exhibition interior, like the *Esprit Nouveau Pavilion* at the *Exposition des Arts Décoratifs et Industriels Modernes* of 1925. Nor did Barr duplicate the installation experience of Bayer's Werkbund gallery for the *Exposition de la Société des Artistes Décorateurs* (fig. 2.14). Bayer's rows of identical chairs on the wall

2.11

Alfred H. Barr, Jr., flowchart, reproduced on the jacket of the original edition of the catalogue: Alfred H. Barr, Jr., *Cubism and Abstract Art* (New York: Museum of Modern Art, 1936).

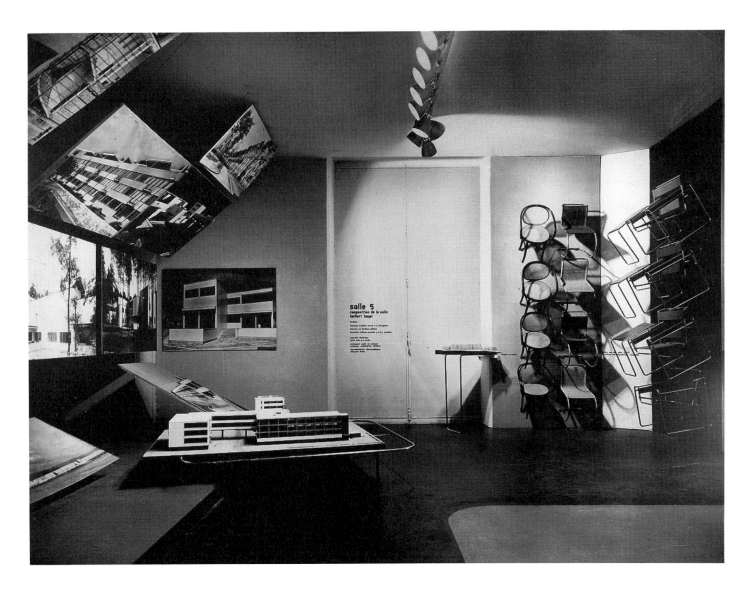

2.12 ←

Alfred H. Barr, Jr., German section, *Cubism and Abstract Art,* Museum of Modern Art, 2 March to 19 April 1936.

2.13 ←

Barr, wall-mounted chairs, *Cubism and Abstract Art,* 1936.

2.14

Herbert Bayer, Deutscher Werkbund installation: furniture and architecture gallery, *Exposition de la Société des Artistes Décorateurs,* Paris, 1930.

in the 1930 exhibit made visible the standardization and mass production that were important components of the Werkbund agenda to present design prototypes for the modern world. To be sure, hanging a Breuer chair on the wall was an unusual formulation for an American museum curator in the 1930s. However, at MoMA, the meaning of the Breuer chair was reduced to its aesthetic dimensions—to being an art object mounted on a wall. This perception was reinforced by the De Stijl chair by Rietveld and the "Purist" chair by Le Corbusier mounted on neighboring walls, representing their respective styles.

Despite *Cubism and Abstract Art*'s practical limitations and Barr's reliance on a master narrative of style, within which the various agendas of the international avant-gardes were reinscribed, the exhibition was a groundbreaking introduction to the spectrum of avant-garde experimentation. This presentation of the diverse practices of the international avant-gardes was one of several important subtexts of the show. Inchoate in the exhibition were many of the ideas that were soon to be realized in MoMA's installations. Barr's idealized installations, created for the autonomous artwork and a standardized viewer, represented merely one exhibition technique among many. The variety of MoMA's installations during these years is seen, for example, in the Museum's architecture and design shows. Two years after *Cubism and Abstract Art,* Bayer, in collaboration with Walter and Ise Gropius, curated the *Bauhaus* exhibition at MoMA. Not only were Bauhaus ideas and creations presented, but the exhibition itself was representative of the school's involvement with innovative installation design. Bayer created an installation that actually expanded many of the ideas of his European projects. Over the next several decades, MoMA's directors and curators would create a variety of architecture and design installations: they would present signs from the city streets, build houses in the Museum's garden, and display cars in its galleries.

Barr's interest in the didactic dimension of *Cubism and Abstract Art*—the flowchart, wall labels, and galleries titled according to style—took independent form in a supplementary exhibition for *Picasso: Forty Years of His Art* (1939–1940). One of MoMA's most unusual didactic exhibits, it was installed in the sixth-floor gallery that was reserved for Museum members and Advisory Council. Designed by Frederick Kiesler and Sidney Janis, the *Visual Analysis of the Paintings by Picasso* consisted of reproductions of Picasso paintings—fragmented, dissected, drawn with diagrams mounted on interconnected wooded panels that mapped out the development of Picasso's work (fig. 2.15).[35] The silhouette of a group of interconnected panels suggested an arrow, as the last in the series was somewhat triangular. This show-and-tell approach to Cubism was a strikingly literal manifestation of the educational component of MoMA's early exhibitions.

The *Visual Analysis of Paintings by Picasso* is representative of Barr's and his colleagues' sensitivity to the reception of exhibitions. Barr, in particular, was interested in the broad range of the Museum's audiences and in creating different types of installations and publications for different publics. In a 1933 report to the Museum trustees, Barr delineated the types of audiences, which included the trustees (and museum committees, such as the advisory committee), "the 400" (critics, scholars, collectors, dealers), the social group (museum members, the wealthy, the "socially inclined"), the action group (business people "who want to 'do something' about what they see . . . the people who build gasoline stations in the international style" or "have murals painted in office buildings"), students, and the general public.[36] The *Visual Analysis* exhibit was created for a particular selection of viewers who would have access to the members' galleries on the sixth floor of the museum: the trustees, the 400, the social group.

In the second *Cubism and Abstract Art* exhibition, in 1942, Barr created didactic exhibits reminiscent of the Picasso *Visual*

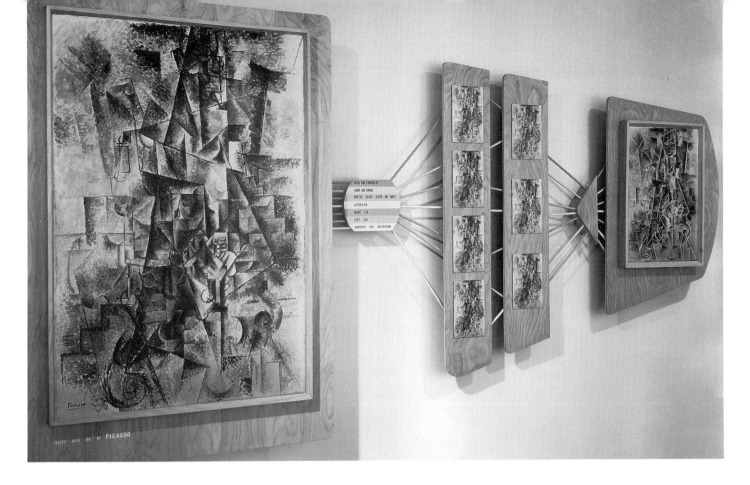

2.15

Frederick Kiesler and Sidney Janis, *Visual Analysis of the Paintings by Picasso,*
Penthouse Gallery, created in conjunction with exhibition, *Picasso: Forty Years of
His Art,* Museum of Modern Art, 15 November to 7 January 1940.

Analysis show; but in this case they were produced for the general public, in miniature, and they dealt with various styles. Installed under Mondrian paintings, for example, were wall labels with text and eight small reproductions of other Mondrians that mapped the artist's development from realism to abstraction. Victor D'Amico, who developed MoMA's education department, created another innovative type of pedagogical installation for yet a different audience: children.[37] Initially D'Amico established the *Young People's Gallery* in 1939, where high school students would curate shows, artists would present demonstrations, and children would take studio classes. These activities expanded to include more elaborate "children's carnivals" from 1942 to 1960 (figs. 2.16 and 2.17). The installations included some works of art, but they were primarily exhibition playrooms with artwork on the walls, where children painted on easels, molded clay, and cut and pasted materials on specially designed tables and desks. These carnivals were one of a number of educational projects the Museum initiated in the late 1930s; the first was a high school art appreciation program in 1937. The development of MoMA's education department reflected increasing interest in the educational dimension of museums in the United States during the late 1930s and the 1940s.[38]

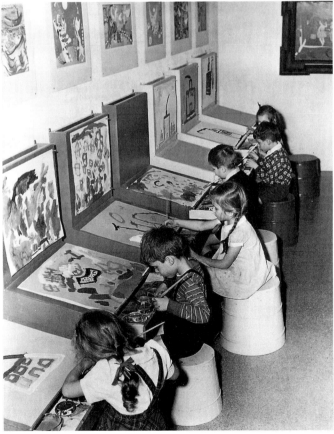

2.16, 2.17
Victor D'Amico, *Children's Holiday Circus of Modern Art,* Museum of Modern Art,
New York, 8 December 1943 to 3 January 1944. These annual holiday exhibitions
were open only to children until 1949, when D'Amico opened them to adults
as well.

One of the explicit yet understated functions of the 1936 *Cubism and Abstract Art* exhibition was to countermand the dissolution of Cubism, abstraction, and avant-garde experimentation due to the restrictions imposed by the totalitarian regimes in Germany and the Soviet Union.[39] Nevertheless, in both the catalogue and within the installation design, Barr disavowed any political or social analysis of art. In what is probably the most famous review of the catalogue, "The Nature of Abstract Art," Meyer Schapiro challenged Barr, criticizing his approach for being "unhistorical" and not tethered to the "conditions of the moment."[40] In fact, in the catalogue's introduction Barr does mention some historical background. He discusses the Nazi and Soviet dismantling of the avant-garde and then dedicates the essay and exhibition "to those painters of squares and circles (and the architects influenced by them) who have suffered at the hands of philistines with political power."[41] But except for these introductory remarks, which in no way connect the analysis of the objects with their historical conditions, Barr ignores the political and historical implications of the work exhibited and of the show itself. Within the decade, curators at the Museum of Modern Art would be engaging in political work, though not the type of political analysis sought by Schapiro: they would put their exhibition design in the service of explicit political propaganda in the series of famous wartime shows (discussed in chapter 4), which included *Road to Victory* (1942), *Power in the Pacific* (1943), and *Airways to Peace* (1945).

Cubism and Abstract Art (1936) also contained the elements of an exhibition technique that was a counterpoint to Barr's evolutionary stylistic framework. On the one hand, his method was time-bound in the sense that it was founded on self-reflexive development. On the other hand, there were aspects of Barr's installation that presented modern art as a timeless and universal language. In several places, Barr juxtaposed "primitive" and premodern pieces with modernist painting and sculpture.

This was a relatively common practice among the avant-gardes in the early twentieth century; the 291 exhibition installed in 1914 by Edward Steichen of "primitive objects," works by Braque and Picasso and "Negro" sculpture exhibitions held at the Whitney Studio Club in 1923, and the Surrealist object exhibition at the Charles Ratton Gallery in Paris in 1936 are just three examples.[42] In the first gallery, "Cubism 1906–10," an African Gabon "ancestral figure" (n.d.) was displayed next to Picasso's painting *Dancer* (1907–1908), and an African Cameroon mask (n.d.) was placed in between Picasso's *Head of a Woman* (1909–1910) and Cubistic bronze *Head* (1909) (fig. 2.18). In the Italian Futurism section, a white plaster cast of the *Nike of Samothrace* (135 B.C.E.) on a relatively high pedestal towered over Umberto Boccioni's *Unique Forms of Continuity in Space* (1913) (fig. 2.19).

Exhibitions structured to articulate a universalist presentation of culture thrived during MoMA's first several decades. Ambitious and innovative techniques emphasizing the timeless aspects of modern art were explored soon after *Cubism and Abstract Art*—in fact, *Timeless Aspects of Modern Art* was the title of a 1948–1949 MoMA exhibition. This approach was central to Barr's very next major show: *Fantastic Art, Dada, Surrealism* of 1936 and 1937 included not only Dada and Surrealist painting and sculpture but also premodern art and artifacts, folk art, children's art, comics, and "the art of the insane" (fig. 2.20). Even more obviously than his evolutionary and stylistic arrangements of artworks in neutral, idealized spaces, the universalist exhibition technique Barr created for *Fantastic Art, Dada, Surrealism* presented art, and the viewing subject, as timeless. Although various installation designs were employed at the Museum of Modern Art during its first several decades, these are the two types that have survived MoMA's laboratory years and have come to dominate institutional practices within the American museum establishment.

2.18
Barr, "Cubism 1906–10," *Cubism and Abstract Art,* 1936.

2.19
Barr, Italian Futurism section, *Cubism and Abstract Art,* 1936.

2.20 →
Alfred H. Barr, Jr., *Fantastic Art, Dada, Surrealism,* Museum of Modern Art,
7 December 1936 to 17 January 1937.

Timeless Works of Art and Native American Living Traditions

The exhibition of MoMA's first several decades that most explicitly and dramatically staged the universality of modern art was *Timeless Aspects of Modern Art,* which was held from November 1948 to January 1949. Created by René d'Harnoncourt (who was then director of the curatorial department and who would become director of the Museum in 1950), *Timeless Aspects of Modern Art* celebrated the twentieth anniversary of the Museum by bringing together a spectrum of material, from ancient artifacts to contemporary art by modern masters. A label in the orientation gallery introduced the viewer to the premise of the show: "modern art is not an isolated phenomenon in history but is, like the art of any period, an integral part of the art of all ages. The exhibition also serves as reminder that such 'modern' means of expression as exaggeration, distortion, abstraction, etc., have been used by artists since the very beginning of civilization to give form to their ideas." Next to this statement of purpose was a timeline that ran from 75,000 B.C.E. to 1948 and a map of the world indicating where the exhibition's objects were found or made. On the neighboring wall was a huge ground plan of the exhibition: the fifty-six works in the show were reproduced along a dotted line marking the viewer's path of circulation.[43] On the opposite wall, the exhibition of artworks began with a Sung dynasty *Dragons and Landscape* (thirteenth century), Paul Cézanne's *Pines and Rocks* (ca. 1895), Pablo Picasso's *Ma Jolie* (1912), and Giovanni Battista Piranesi's *Prison Interior* (1740). The galleries, for the most part, were darkened and many of the works were spotlit. This dramatic lighting worked to decontextualize the art objects, evoking a crepuscular and "timeless" sense of space, out of which the individual pieces emerged. Approxi-

mately midway through the show, in the "emotional content" section, a dramatically lit Romanesque crucifix served as a climax within the exhibition tour (fig. 2.21).

The theatrical installation for *Timeless Aspects of Modern Art* developed by d'Harnoncourt resulted from his having spent nearly a decade experimenting with the display conventions of several institutional models—the art museum, the natural history museum, the trade fair, and commercial displays. D'Harnoncourt's background was very different from Barr's Ivy League education and trips to the Bauhaus and the Soviet Union. Instead, his exhibition methods were shaped by diverse professional experiences that enabled him to hone his skills as a curator, dealer, diplomat, field-worker with Native Americans, and showman.[44] Though born into a titled Austrian family, d'Harnoncourt was penniless; he studied philosophy and chemistry and obtained his aesthetic education by visiting museums, collecting, dealing, and curating.

When d'Harnoncourt moved to Mexico in 1926, he earned a living as a freelance commercial artist, creating window displays and acting as a purchasing agent for American and Mexican collectors interested in Latin American art. Within a year he was working for the Sonoma News Company, a store that handled curios; he introduced Mexican Indian lacquer, pottery, and textiles to the business and even curated an exhibition of the work of Diego Rivera, José Clemente Orozco, and Rufino Tamayo on the premises in 1927. Funded by the company's owner, Frederick Davis, d'Harnoncourt began working with elder Mexican folk artists who were skilled in traditional crafts methods. D'Harnoncourt supplied materials, showed them quality antiques, and offered to buy all the "good" pieces, which he would then trade. The venture was a "success."[45] The elder craftsman then began teaching the young people of their communities, and d'Harnoncourt was asked by the Mexican Ministry of Education to help preserve Mexican cultural traditions—which seemed to be van-

2.21

René d'Harnoncourt, *Timeless Aspects of Modern Art,* Museum of Modern Art,
16 November 1948 to 23 January 1949.

ishing under the pressures of adapting traditional artifacts for the tourist trade. D'Harnoncourt's activities demonstrate the nexus of capitalist and humanist interests shaping the Native American arts and crafts revival—and its market—during the 1920s, 1930s, and 1940s.[46]

In 1930, under the auspices of the Ministry of Education, d'Harnoncourt curated a massive arts and crafts exhibition of approximately one thousand items that opened in Mexico City and traveled to several U.S. museums, including the Metropolitan Museum in New York (fig. 2.22).[47] The exhibition's folk art installation looked very much like a bazaar, with plates, textiles, objects, and paintings skied on the walls and with pottery, figu-

rines, and baskets on tables. (The contemporary art section was arranged according to the new contemporary art installation conventions, in that paintings were hung at eye level.) D'Harnoncourt's work with the Mexican government led to a job in 1936 with the U.S. Department of the Interior's newly formed Indian Arts and Crafts Board. The ambitious exhibition that developed as a result of his work with the Indian Arts and Craft Board was the first that d'Harnoncourt created for the Museum of Modern Art—*Indian Art of the United States.*[48]

This exhibition was first held at the Golden Gate International Exposition in San Francisco in 1939, and a more comprehensive version was installed at MoMA two years later.[49] The

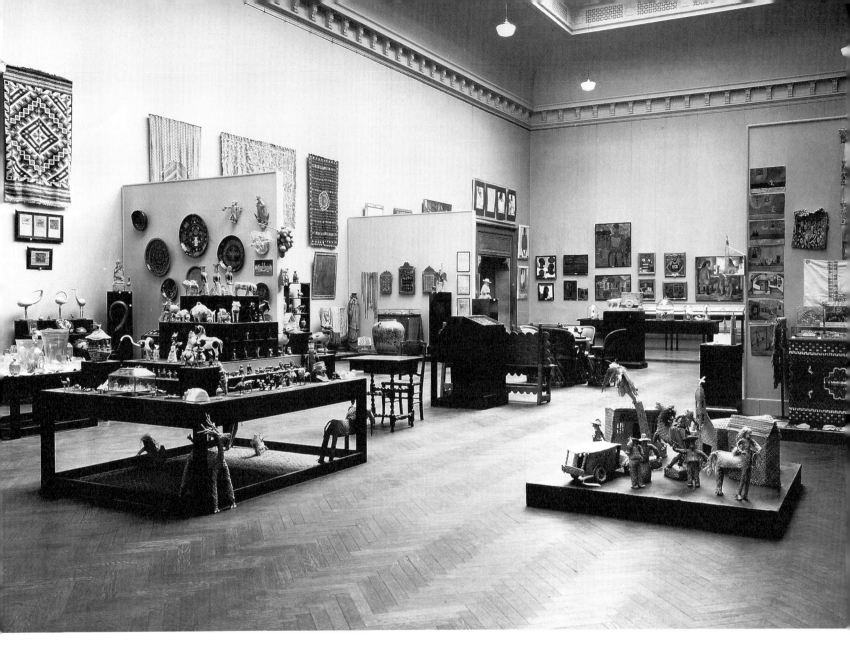

2.22
René d'Harnoncourt, *Mexican Arts*, Metropolitan Museum of Art, New York,
13 October to 9 November 1930.

Indian Arts and Crafts Board, created in 1935 as part of the Roosevelt administration's New Deal, was established to promote an appreciation of Native American culture and to create vehicles for financial independence among the economically depressed tribes "through the development of Indian arts and crafts and the expansion of the market for products of Indian art and craftsmanship."[50] In the catalogue preface, Eleanor Roosevelt wrote that the exhibition was produced to "acknowledge" the United States's "cultural debt not only to the Indians of the United States but to the Indians of both Americas."[51] The text by d'Harnoncourt and Frederic H. Douglas, who was curator of Indian Art at the Denver Museum, began with an apology to the indigenous peoples of the Americas:

For four centuries the Indians of the United States were exposed to the onslaught of the white invader, and military conquest was followed everywhere by civilian domination. . . . In many cases it was simply the result of a complete lack of understanding of Indian life[.] . . . Only in recent years has it been realized that such a policy was not merely a violation of intrinsic human rights but was actually destroying values[.] . . . In recognition of these facts, the present administration is now cooperating with the various tribes in their efforts to preserve and develop those spiritual and artistic values in Indian traditions that tribes consider essential.[52]

The show's purpose was to recognize Native American traditions, both historical and contemporary, as a part of the United States' cultural past, present, and future. D'Harnoncourt, who had been doing fieldwork with various Native American tribes since 1936—researching present conditions and setting up production standards and avenues of marketing and distributing handcrafts—had a firsthand knowledge of individuals, communities, and traditions. He had become an advocate for the preservation of American cultures as well as a promoter of quality artifacts for the contemporary marketplace. One of the purposes of the Indian Arts and Crafts Board was to dismantle prejudices commonly held by those within mainstream U.S. culture, who believed that Native American products were cheap trinkets for the tourist trade and that Native Americans themselves fit the stereotypes of Hollywood movies. D'Harnoncourt's managerial policies rejected generalized procedures and instead "involved background research; careful consideration of the past history and present condition of each tribe; and most important of all, close contact and cooperation with local Indian leaders."[53]

D'Harnoncourt's respect for the diversity of tribal communities and his awareness of the changes and adaptations of traditional and contemporary Native American art shaped his San Francisco and New York installations of the exhibition. Although there is no evidence that tribal representatives contributed to the overall conception or direction of the exhibition, they were commissioned to create specific exhibits and ceremonies. It is obvious that *Indian Art of the United States* was a propaganda spectacle for New Deal Native American policy and an advertisement for the commodities that these communities produced. Nonetheless, the exhibition remains by far the most "successful" presentation of Native American culture and ethnographic artifacts exhibited at the Museum of Modern Art; it was also one of the most creative installations ever presented at MoMA.

The exhibition filled the entire three floors of the Museum (MoMA moved to its present 53rd Street building in 1939) and was divided into three sections: "Prehistoric Art," "Living Traditions," and "Indian Art for Modern Living." A thirty-foot totem pole created for the exhibition by Haida carvers John and Fred Wallace stood outside MoMA's entrance. Inside the Museum, the show began with the "Prehistoric" section on the third floor, at whose entrance was a map of prehistoric North America, five feet high and five and a half feet wide, that indicated Native American cul-

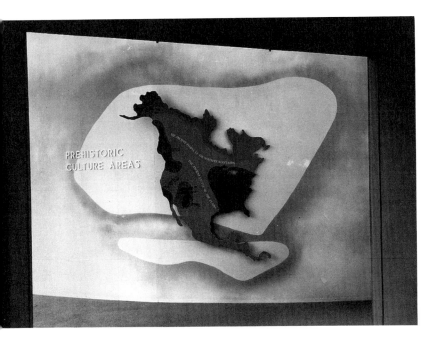

tural areas (fig. 2.23). This was one of the large maps and didactic panels created by the Works Progress Administration that introduced the three sections and major subdivisions of the show. As was the case with all of d'Harnoncourt's installations, pedestals and vitrines were built to fit precisely the dimensions of the objects and displays. (This kind of meticulous precision became a hallmark of d'Harnoncourt's installations. It became his practice to draw every object in the show, and then every grouping, and finally every gallery view, which he called "vistas.")[54]

Indian Art of the United States was marked by a diversity of exhibition techniques, ranging from aesthetic, formalist displays to ethnographic contextualizations and reenactments of rituals. According to d'Harnoncourt, for the third-floor prehistoric section, archaeological information in most instances was scarce, so he stressed aesthetics and kept displays simple. He believed the visitors' "main impression of the prehistoric section . . . will be of a collection of sculpture and ceramics displayed with classic simplicity in rather severe white-walled rooms."[55] In these installations, artifacts were displayed on pedestals and in vitrines in the same manner as were great masterworks of modernism, but some areas also included visual accents. The "Mimbres Pottery" section was designated with a wall painting displaying the same type of decorative patterning (fig. 2.24). The "Master Sculptors of the Adena and Hopwell Mounds" section included a floor-to-ceiling photomural of a carved figure. In "prehistoric" divisions where there was documentation, the exhibits were elaborate re-creations. In one gallery, reproductions of sixteenth-century Pueblo murals were painted on adobe plaster-covered panels by Hopi artists Charles Loloma, Herbert Komoyousie, and Victor Cootswytewa. High school students at the time,

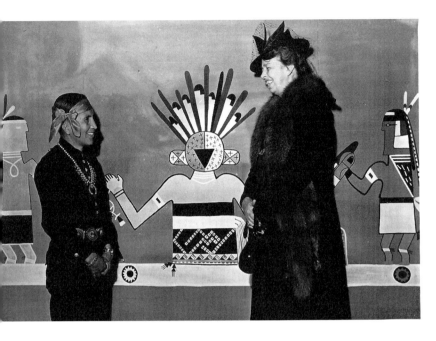

2.25

Fred Kabotie and Eleanor Roosevelt standing in front of re-creation of sixteenth-century Hopi murals supervised by Kabotie and painted by Charles Loloma, Herbert Komoyousie, and Victor Cootswytewa, *Indian Art of the United States*, 1941.

they were supervised by Fred Kabotie, who was a highly respected artist and employee of the Indian Service of the Department of Interior (fig. 2.25).[56] These panels were fitted within a gallery to make small, low-ceiling rooms where dim lighting came through a square hole in the center of each ceiling, in order to create a setting similar to the Pueblo ceremonial chambers. The Hopi chambers were followed by large galleries, flooded with natural light, displaying re-creations of Southwestern pictograph rock paintings. (An expedition had been organized in conjunction with the exhibition to obtain photographs for the pictograph facsimiles from Barrier Canyon, Utah, which were painted by WPA artists.) The largest of these life-size reproductions on canvas was fourteen feet high and ran sixty feet, creating a curved wall around the room that was similar to its original setting (fig. 2.26).

The second floor, devoted to "Living Traditions," also began with a large introductory map. Unlike the more generalized presentation of objects in the prehistoric section, "Living Traditions" was organized according to nine groups of tribal cultures; each category was composed of tribes that had closely related ways of living, and each group was given its own gallery. Creating an effect analogous to that of Dorner's atmosphere rooms, d'Harnoncourt chose wall colors and exhibition materials that were consonant with the geographical and cultural context of what was being displayed.[57] For example, "the proportions and lighting of the main part of the Northwest Coast room," which was darkly lit with wooden walls, were chosen, according to d'Harnoncourt, because they "suggest the interior of a huge wooden house of the region" (fig. 2.27).[58]

In the Navaho exhibit, ponchos and blankets were draped on cylinders rather than mannequins (fig. 2.28). These draped cylinders were arranged on orange-colored platforms of varying heights set against a sky-blue background wall—creating an abstracted tableau that suggested figures in a desert landscape. D'Harnoncourt's abstracted approach to contextualization and his decision to not use mannequins avoided associations with natural history habitat groups, which might have suggested that Native Americans were being presented as specimens.

In the "Living Traditions" section, d'Harnoncourt's atmosphere rooms were one of two types of installations he created. D'Harnoncourt described his method as follows: "Objects that are essentially part of a costume or tribal activity for which they were made are usually grouped . . . to suggest their original use. Other objects having a strong esthetic value independent of their setting have been singled out and shown one by one, as highlights of the styles of the different areas."[59] An example of this aesthetic presentation was the California section, where the baskets were treated as fine art and displayed on designed-to-proportion pedestals.

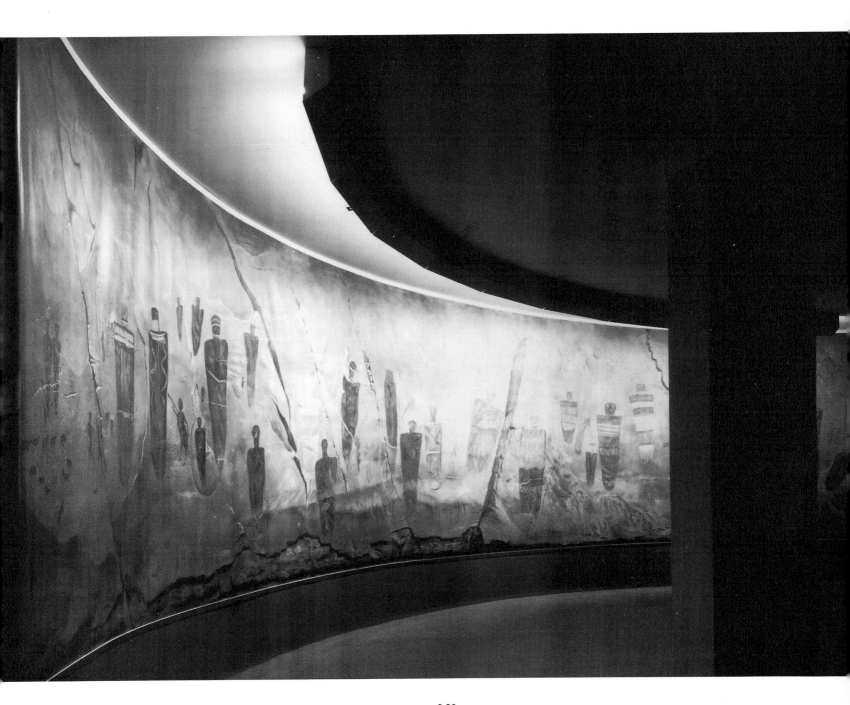

2.26
Re-creation of pictographs discovered at Barrier Canyon, Utah, painted by WPA artists, *Indian Art of the United States*, 1941.

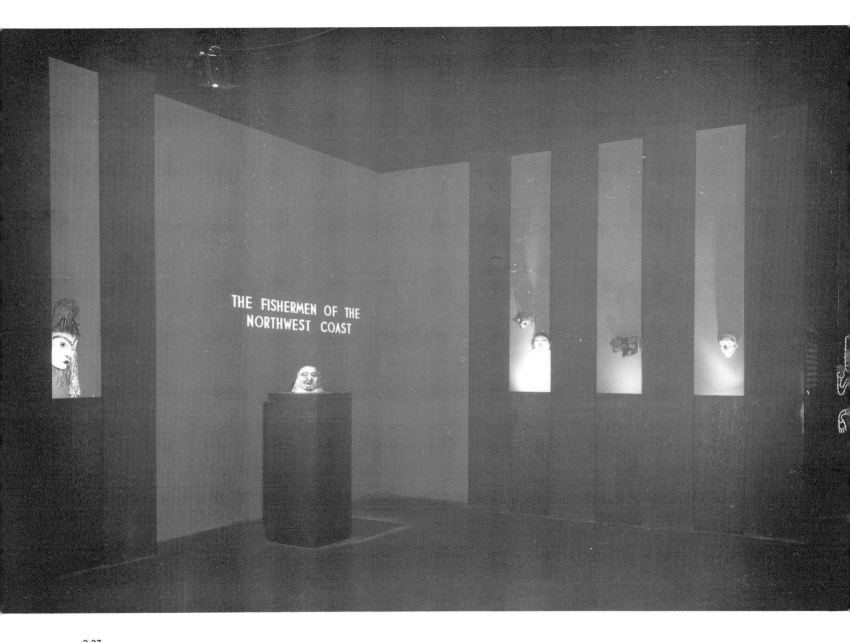

THE FISHERMEN OF THE
NORTHWEST COAST

2.27
D'Harnoncourt with Klumb, "Northwest Coast" section, *Indian Art of the United States*, 1941.

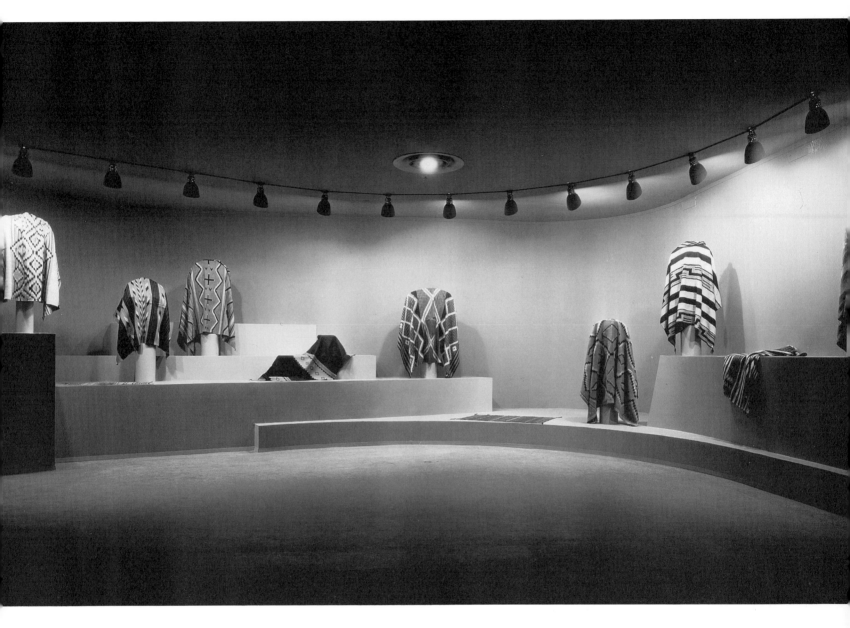

2.28
D'Harnoncourt with Klumb, Navaho poncho and blanket installation, *Indian Art of the United States,* 1941. The platforms were orange, the background wall sky-blue.

The first floor, "Indian Art for Modern Living," was set up to make visible the commercial potential of Native American art and products.[60] The installation included many wood-panel vitrines that looked like modern shop windows and commercial displays (fig. 2.29). The section began with a large wood-panel case containing an evening cape, dress, and ski suit made of materials and handiwork of the Crow and Seminole tribes. Both outfits were produced by Swiss designer Fred A. Picard, who was best-known for his adoption of Swiss handiwork for ski apparel and had shops in Sun Valley, San Moritz, and New York.[61] The designer, who preferred to be referred to simply as "Picard," had an exclusive contract to include his designs in the exhibition; more significantly, they were created in collaboration with Native American artisans and received tremendous publicity in the mainstream and fashion press. Many, many news stories remarked on Marlene Dietrich, Susan Hayward, and the "scores" of other Hollywood leading ladies who were asking the designer for Indian-inspired sportswear. Jewelry, pottery, contemporary watercolors, and home furnishings were also displayed in this section.

The near-impossibility of arranging rituals and performances that are respectful to the cultures and the people creating them was overcome somewhat by setting up special areas for performances and demonstrations by sand painters, dancers, and silversmiths who strictly adhered to tribal practices and rituals. The Navaho sand painters, among whom were Charley Turquoise and Dinay Chilli Bitsoy, worked in a roped-off area where museumgoers could observe them from a slight distance every day except Mondays from 12:30 to 5:30 and on Wednesday evenings from 7:30 to 9:30 (fig. 2.30). Each painting took at least several days to create and then was destroyed in a ceremony that included chanting. In preparing for the exhibition, a memo was sent to the staff of the Museum explaining that sand painting was a ritual and for those creating the paintings represented a mysterious force.[62] The staff was instructed not to take photographs or speak to the sand painters during the ceremony.

Publicity concerns apparently led to a compromise: photographs were taken early in the ritual, before its power was in full force.[63] Joseph Campbell visited the exhibition and in one of his televised lectures described watching "these men take colored sand in their hands and with great precision prepare these marvelous paintings." According to Campbell, the artists made changes in the ritual for this museum presentation: "they would always leave out one detail. . . . This is to protect those who are dealing with the painting from its power. They are not supposed to have the power turned on." Campbell then related that when the sand painters were asked (he doesn't specify by whom), " 'Couldn't you just complete one painting, complete this one for instance?' " in reply "they laughed and they said, 'If we finish this one, tomorrow morning every woman in Manhattan would be pregnant.' "[64]

Indian Art of the United States as an exhibition and as an installation was among the achievements Barr chose to remember at d'Harnoncourt's memorial in 1969. In a rare public assessment of his successor, Barr praised his colleague's installation, which "avoided both the purely aesthetic isolation and the waxworks of the habitat group," as well as his judicious arrangement to have "Navaho sand painters" working "in a Museum gallery but without scenery."[65]

The installations of *Indian Art of the United States* were distinctive because d'Harnoncourt foregrounded the representational implications of an exhibition design, by employing diverse installation methods. D'Harnoncourt believed that there was no such thing as a "neutral installation."[66] And in his first exhibition at the Museum of Modern Art, d'Harnoncourt deliberately made visible the fact that different installation strategies could be deployed within a single exhibition in order to produce varied mean-

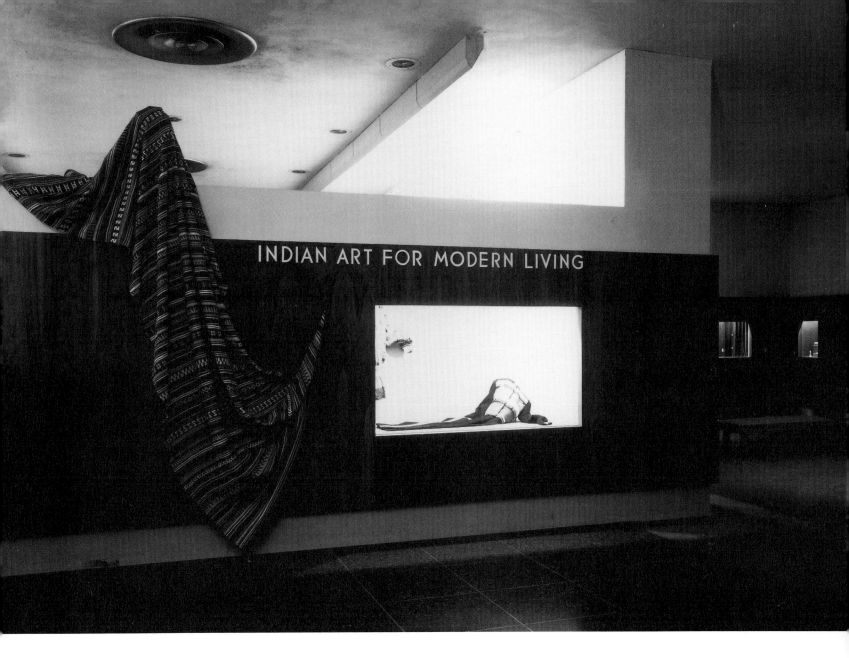

INDIAN ART FOR MODERN LIVING

2.29
D'Harnoncourt with Klumb, "Indian Art for Modern Living" section: Wood-panel case containing cape, dress, and ski suit made of materials and handiwork of the Crow and Seminole tribes and produced by designer Fred A. Picard, *Indian Art of the United States*, 1941.

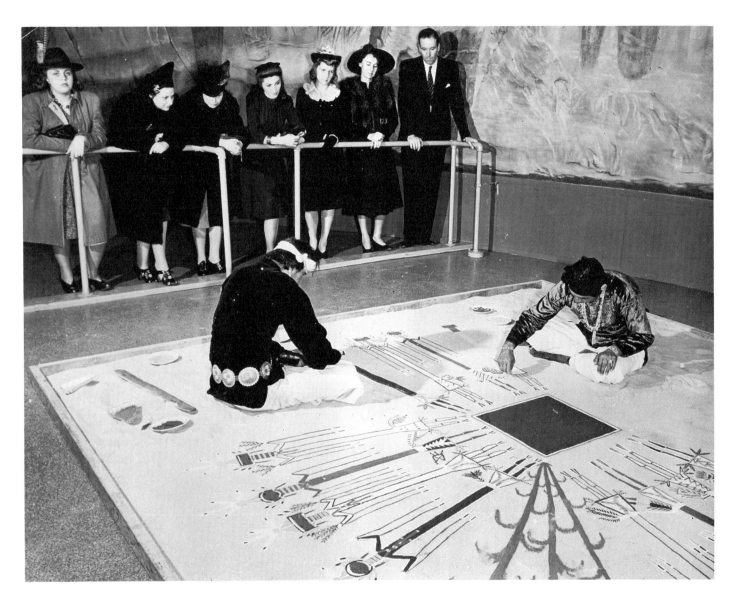

2.30

Navaho sand painters at *Indian Art of the United States*, 1941.

ings and emphases for the objects on view. In the prehistoric section, for instance, installation techniques differed markedly from one gallery to another. The visitor would move from modernist galleries displaying figures, tools, and ceramics in the "classic simplicity" of "severe white-walled rooms" (see fig. 2.24) to dramatic historically specific re-creations of the pictograph rock paintings and the painted Pueblo chambers (see figs. 2.25 and 2.26).[67] The methods of presentation were chosen for aesthetic, cultural, commercial, political, and practical reasons.

The varied display methods in such an exhibition also made visible the way institutional conventions create meaning. The visitor, traveling through the three floors of galleries, would view Native American culture exhibited as art in the modernist-aesthetic exhibits, as ethnographic artifact in the historical re-creations, as contemporary tradition in the atmosphere rooms, as a fashionable commodity in the commercial "Indian Art for Modern Living" galleries, and as part of a Native American ritual in the reenactment areas. This diversity of installation techniques made an acknowledgment of the institutionalizing processes part of the viewer's experience of the show, as it disrupted a unified, totalized presentation of these objects and their cultures as "exhibition."[68]

The realizations of installation techniques also foregrounded the institutional processes at work. In the "Living Traditions" section, the tableaux made visible the connection of the displayed objects to specific cultures and contexts beyond any museum exhibition, emphasizing that the artifacts were endowed with extra-aesthetic meanings and functions. These tableaux were not exacting re-creations, as in the prehistoric simulations, nor were they embellished with aggressively visible didactic materials. In the Navaho blanket and poncho exhibit, d'Harnoncourt did not create a diorama or try to replicate a Navaho scene (see fig. 2.28). The draped cylinders, as we have

seen, did not realistically represent Navaho people in ponchos but instead evoked figures standing on cliffs in the desert landscape. This abstracted, nonrealistic installation harmoniously tethered these objects to their function as clothing for desert dwellers while simultaneously manifesting the tableau's function as museum presentation. A realistic diorama, habitat group, or period room is viewed as if it is a window or a realistic image that is "looked into," which in turn renders invisible the work done by the museum. The shorthand, abstracted technique d'Harnoncourt created in these Navaho tableaux, in contrast, incorporated an awareness of these specimens' displacement from their original context and their institutional reinscription within an art museum display.[69]

It is clear from his work and his writings that d'Harnoncourt considered exhibition technique to be a vital field in its own right. At the beginning of his career, when d'Harnoncourt began developing the *Indian Art* exhibition, he wrote about installation design as a creative medium, describing the show as a "chance to do a really fine piece of creative work." He described himself as a "co-designer," "as an artist" collaborating with the architect Henry Klumb.[70] On retiring in 1968, d'Harnoncourt had plans to write what he considered to be the first comprehensive publication devoted to the history of exhibition installation.[71] Despite those intentions, there is no evidence that d'Harnoncourt closely followed the practices of his European and Soviet contemporaries. In the 1940s, d'Harnoncourt criticized installations that overpowered the objects with devices like strings and arrows or turned the exhibition into a "peep show."[72] In the 1960s he praised Steichen for his work on the *Road to Victory, Power in the Pacific,* and *The Family of Man* exhibitions.[73]

In 1945 d'Harnoncourt assessed the importance of installation design for art and science museums during the previous twenty years. He saw the power of display as a means to trans-

form these institutions from mere "depositories" of treasured objects into vital cultural centers.[74] D'Harnoncourt then wrote of the significance of installations in the natural history museum—an institution whose practices were closely affiliated with his own exhibition experiments and innovations.

The Natural History Museum and the Creation of "Primitive" Art

It seems safe to assume that one of the most important areas of influence and interest for d'Harnoncourt as he developed his installation methods was the natural history museum. Several of d'Harnoncourt's exhibitions involved collaboration with natural history and social science institutions. For example, the catalogue of the San Francisco version of *Indian Art of the United States,* written by George Vaillant, was a project involving d'Harnoncourt, the Indian Arts and Crafts Board, the American Museum of Natural History, and the Rockefeller Foundation.[75] In his comments about the important experimentation taking place regarding exhibition practices in art and science museums, d'Harnoncourt specifically mentioned anthropology exhibits and the issues affecting displays for scientific fields such as biology and mineralogy.[76] Many of the new techniques, such as the use of color to evoke context in art galleries, were being instituted for the first time at the American Museum of Natural History during the 1940s, when d'Harnoncourt was experimenting (just across town) with these ideas at the Museum of Modern Art.[77]

From today's perspective, *Indian Art of the United States* might look more like an exhibition at a natural history museum than one at a modern art museum. Geography, history, and func-

tion determined the layout of the show, leading to groupings such as "The Prehistoric Art of the Pacific Coast" or "Precision Tools from New England." The exhibition, however, was a testimonial to the aesthetic dimension of these cultures. Everything—tools, baskets, blankets, jewelry, and rituals—was brought under the rubric of art. Sections and subdivisions had titles such as "The Prehistoric Art of the Pacific Coast," "The Sculpture of Key Marco Florida," and "Indian Art for Modern Living." *Indian Art of the United States* was a landmark in the history of modern museums in the United States as one of the most ambitious, and highly publicized, contributions to the institutional foundation of the newly formed field of "primitive" and ethnographic art.[78]

The aesthetic appreciation of tribal and non-Western artifacts began to take hold during the first decade of the twentieth century among artists, dealers, and collectors within the international avant-gardes.[79] By the 1920s the assimilation of such artifacts as artworks had become a commonplace in avant-garde publications and gallery exhibitions. This taxonomic shift from artifact to art occurred within art and science museums, for the most part, in the 1930s and 1940s (although there were some earlier exceptions such as the Folkwang Museum, where there were installations of ethnographic and modern art as early as 1914) (see fig. 2.5).[80] As part of its agenda to present modern culture to the American public, in 1933 the Museum of Modern Art held a show of Aztec, Mayan, and Incan objects titled *American Sources of Modern Art,* followed by *African Negro Sculpture* in 1935, and the Museum continued to mount exhibitions devoted exclusively to ethnographic artifacts through the 1950s.

The American Museum of Natural History held its first exhibition of art in 1939 (figs. 2.31 and 2.32).[81] The museum initiated sporadic art and "masterpieces of the collection" exhibits in the 1940s and 1950s, and in every subsequent decade the American Museum of Natural History has increased its number

of art exhibitions. In Paris, the Trocadéro held its first art exhibitions of what had previously been deemed ethnographic specimens in the 1930s. It was also during the years 1928 to 1934 that the Trocadéro's collections were rearranged.[82] The exhibition halls were separated from study rooms. The cluttered hodgepodge of densely packed galleries filled with dusty, haphazardly labeled exotica was reorganized into a more rational and aesthetic scheme with vitrines and displays more spaciously arranged. Objects were paired with more precise labels, and particularly fine specimens were featured for aesthetic appreciation. The Trocadéro, together with its new installation method, was absorbed into the Musée de l'Homme. The old "Byzantine" Trocadéro was razed and the new grand Musée de l'Homme, instituted from 1937 to 1939, presented a more universalized and domesticated vision of the diversity of cultures on display.[83]

Like the Trocadéro, most natural history museums in Europe and in the United States began altering their permanent installations in the 1930s to make visible the aesthetic qualities of what were considered particularly beautiful specimens. In the United States, the Buffalo Museum of Natural Science exemplifies these changes in display practices.[84] From the museum's inception in 1861 until the 1930s, all the anthropological collections were displayed according to categories of materials and human technology and all cultures were intermixed. In 1937 a grant from the Rockefeller Foundation facilitated the rearrangement of the collections, the purchase of new acquisitions, and the subsequent creation of the Hall of Primitive Art, which opened in 1941.[85] In the 1940s the American Museum of Natural History incorporated aesthetic installations into its permanent displays. In 1944 the museum's Hall of Mexican and Central American Archaeology was rearranged to incorporate the aesthetic dimension of many of the objects within the collection (see figs. 2.54 and 2.55). This method remains one of a variety of installation techniques that are practiced at the museum today.[86]

This shift in installations at natural history museums received press coverage as part of a 1941 controversy about the vitality of New York's museums. Park Commissioner Robert Moses made a much-publicized comment that the city's museums were unpleasant places—"musty," stuffy, and intimidating to the public—and the press heralded d'Harnoncourt's *Indian Art of the United States* as the grand exception with its dramatic, magnetic installations.[87] One writer in particular compared d'Harnoncourt's "clever displays" with the "labyrinth of cluttered shelves and overcrowded cases" of the Museum of the American Indian, whose spaces were representative of traditional national history museum arrangements like those of the old Trocadéro. The Museum of the American Indian was declared the best collection "in the world" but was empty save for "a handful of students and professors"; by contrast, at the Museum of Modern Art "thousands" were paying to see similar works that were brought to life, thanks to d'Harnoncourt's modern exhibition methods.[88]

The staging of an exhibitions like *Indian Art of the United States* at the Museum of Modern Art, the development of aesthetic concerns and new methods of display within natural history museums, the presentation of exotica and artifacts in art institutions, and the general taxonomic shift taking place in the definitions of art and artifact are consonant with the fluidity within the field of installation design as practiced by art and natural science museums from the 1930s through the 1960s. This institutional fluidity is apparent in d'Harnoncourt's innovative use of installation techniques now associated primarily with natural history museums, such as providing elaborate didactic material, ritual reenactments, representational re-creations, and tableaux.[89] D'Harnoncourt, however, was not the only curator at the Museum of Modern Art during the late 1930s and early 1940s whose exhibitions incorporated what are now considered to be science museum display practices.[90] Beaumont Newhall, who at that time was the Museum's librarian, directed one of the

most important exhibitions created at MoMA during these years: *Photography: 1839–1937* of 1937, a show in which the displays, in many instances, looked like those found in natural history museums.[91]

2.31

First exhibition of art at the American Museum of Natural History, *Ancient and "Primitive" Art from the Museum's Collections,* 1939.

2.32 →

Detail of case containing Benin bronzes, *Ancient and Primitive Art from the Museum's Collections,* 1939.

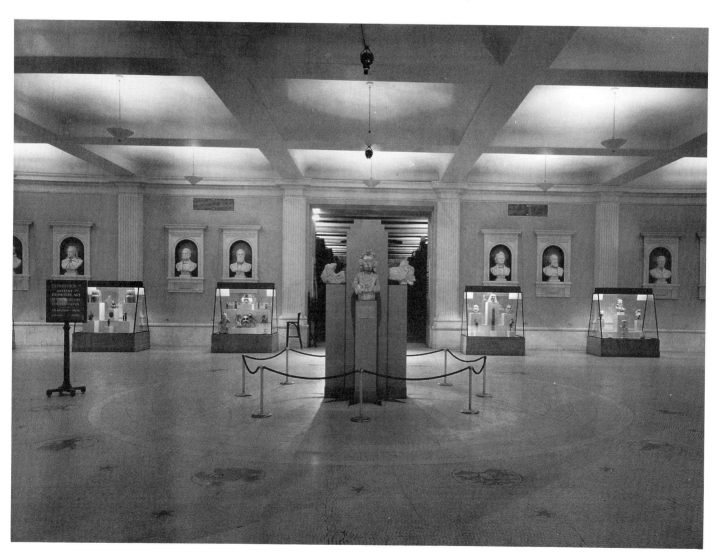

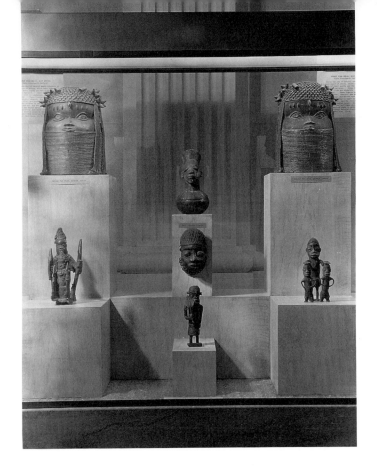

Beaumont Newhall's "New Vision" and the Triumph of Camera Aesthetics

MoMA's first historical survey of photography was as ambitious in its scope as the 1936 *Cubism and Abstract Art* exhibition; *Photography: 1839–1937*, too, filled the four floors of the Museum. Newhall's installation presented photography both as an aesthetic medium and as a technological innovation that was shaping the modern world—and the display methods reflected this diversity (fig. 2.33). The installations created included "atmo-

sphere rooms," which were staged to evoke historical periods and qualities associated with the different types of photographs. The show began with the daguerreotype gallery, where walls were "morocco-leather" brown and vitrines were lit from within and encased in red velvet (fig. 2.34).[92] The calotype room was next, where the walls were dark blue and mounts were light blue (fig. 2.35). In the modern French photography section, the walls were grey and green, and photos were on mounts installed in a series under plate glass.

Newhall also installed a series of didactic, viewer-interactive exhibits; such displays were, and still are, the province of science and natural history museums. These exhibits explained the technical processes of the medium, such as depth of focus and color photography (fig. 2.36). There were displays of different types of modern cameras as well as camerae obscurae and photographs of camerae lucidae (which were owned by what was documented as "The Science Museum in London"). In the galleries devoted to press and scientific photographs, images were installed in groups on mats or in light boxes. Of all the Museum of Modern Art's photography exhibitions, Newhall's *Photography: 1839–1937* was the most diversified treatment of the medium and offered the greatest range of its possible methods of display. Newhall's presentation of technological exhibits, atmosphere rooms, and installations incorporating photographs produced for the mass media and scientific purposes can be seen as evidence of his interest in László Moholy-Nagy's concept of "New Vision" photography.[93]

Although the exhibition seemed to be evidence of the Museum of Modern Art's commitment to photography, a department devoted to the medium was not created until 1940, with Newhall as curator. On December 31 of that year, *Sixty Photographs: A Survey of Camera Esthetics* opened at the Museum. Curated by Newhall and Ansel Adams, the exhibition featured, as its title indicated, the aesthetics of photography. Very different from the

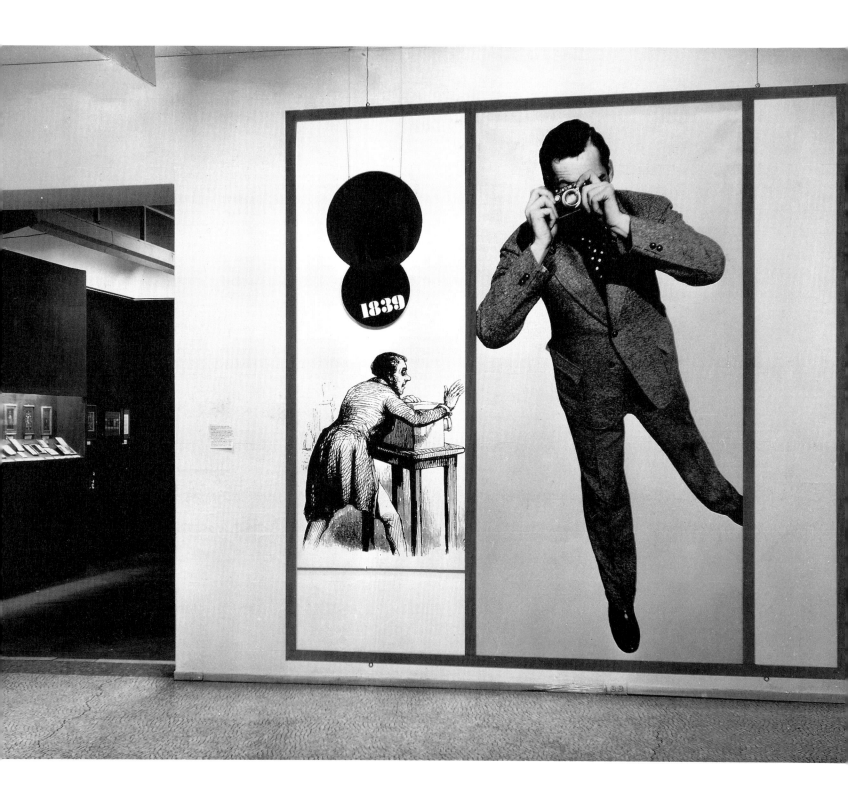

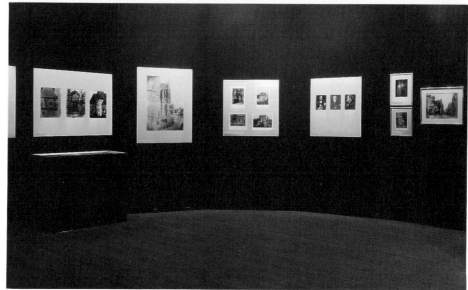

2.33 ←

Beaumont Newhall, entrance exhibit by Herbert Matter, *Photography: 1839–1937,*
Museum of Modern Art, 17 March to 18 April 1937.

2.34

Newhall, daguerreotype gallery, *Photography: 1839–1937,* 1937. Walls were
"morocco leather" brown, and vitrines were lit from within and encased in red
velvet.

2.35

Newhall, calotype gallery, *Photography: 1839–1937,* 1937. Walls were dark blue
and mounts were light blue.

displays presenting the medium's spectrum of uses and the diverse installations found in the 1937 show, *Sixty Photographs* was an exhibition of black-and-white photography framed as fine art in white mats and installed at a standard height in neutral-colored galleries (fig. 2.38). But, as was typical of the experiments in installation found at MoMA during its first several decades, there was one departure from this type of display. In the section of New Vision photographs, the images were not mounted on the wall; instead, similar-size prints in white mats were suspended in a grid of wire hung from the ceiling (fig. 2.37), which perhaps was an allusion to the grid display technique used by Moholy-Nagy in "Room One" of the famous 1929 exhibition, *Film und Foto* (see fig. 1.40).

An announcement for the show in the *Bulletin of the Museum of Modern Art* stated that color, commercial, scientific, and advertising works were deliberately excluded from this exhibition and that "these and other exclusions have not been intended as criticism. This is but the first of a series of exhibitions." The sixty photographs were to "represent, without chronology, a range of vision from objective, almost literal, interpretation of fact to ab-

stract creation of form by the cameraless shadowgraph." Different printing methods were included—such as calotype, albumen and platinum processes, and photogravures—and the exhibition's images were described by the show's curators as "individual expressions," meant to serve as "clear evidence of an understanding of the qualities, limitations, and possibilities of photography."[94]

Although photography installations during MoMA's next several decades were often composed of matted images, framed or set behind glass and presented in a "modern" manner, experimentation in display techniques continued. Sometimes this was simply slight variations on a modernist installation method, such as Newhall's use of a suspended grid to display the New Vision photography in the 1940 show. But many of the exhibitions during the laboratory years had relatively unusual installations, as was the case for the 1943 exhibition *Action Photography,* which was curated and installed by Nancy Newhall (Beaumont's wife and the acting curator from 1942 to 1945, when Beaumont served in the military).

Action Photography, after a brief historical introduction, was divided into three sections: "Highspeed Photography," "Normal Exposure," and "Prolonged Exposure." Like Bayer's installation of photographs in the 1930 Werkbund exhibit at the *Exposition de la Société des Artistes Décorateurs* (see fig. 1.25) and the 1938 *Bauhaus* exhibit at the Museum, unmatted and unframed individual images or series and groups of images on large supporting mats folded out from the gallery walls. Newhall's use of the series format was no doubt intended to make visible ideas related to the passage of time. Displays were placed in dynamic arrangements, some of which were mounted catty-corner. Such installations most likely were intended to suggest movement and to enhance the show's theme. The exhibition also included a didactic exhibit of a stroboscope, a type of lamp that is used for speed-flash photography.

2.36
Newhall, "Depth of Focus" exhibit, *Photography: 1839–1937,* 1937.

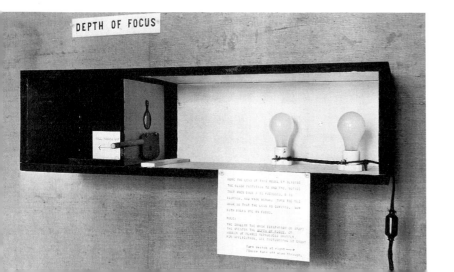

The most dramatic of MoMA's photography installations were curated by Edward Steichen, who was director of the photography department from 1947 to 1962. (Newhall's tenure at the Museum was relatively brief, interrupted by his years of military service and ending with his departure from MoMA in 1947.)[95] During Steichen's years as director, MoMA's galleries became venues for the kind of photography that was flourishing in American picture magazines. Photographs were often installed without mats in dense and varied arrangements reminiscent of the types of layouts found in newspapers and magazines.

Steichen's involvement with the presentation of photography at the Museum actually began during World War II when he produced the hugely popular, propagandistic photo-spectacle, *Road to Victory* in 1942 (discussed more fully in chapter 4).[96] This type of exhibition was a walk-through photo-essay with enlarged images installed without frames or mats, mounted flush against the wall or on specially constructed panels and display structures. This approach to the medium was exemplified by the 1949 show *The Exact Instant,* which included three hundred news photographs; they were presented as bold wall-size murals mounted on the walls in diverse groupings without mats, in historical displays in vitrines (as was the case with daguerreotypes), and on the pages of actual newspapers and tabloids tacked on gallery walls in dense installations. Composed of the images published in photojournalistic stories, beginning with a fourteen-by-thirty-foot mural of an atom bomb in the Museum's foyer, they contrasted with the first section's images of "children in the schoolroom, on the playgrounds," and "juvenile delinquents." In many ways this exhibition was a precursor of the most famous Steichen exhibition, the 1955 *Family of Man.* While *The Exact Instant* included many of the themes of this later show, the two differed in tone: *Family of Man* was somewhat romantic, whereas *The Exact Instant* was much more hard-hitting in showing the dark side of human nature and a much greater percentage of its images portrayed crime, violence, and personal and natural disasters.

Until 1970, photography in the galleries at the Museum of Modern Art was displayed in installations appropriate for a spectrum of applications that ranged from fine art to the ephemera of everyday life. That year marked a disappearance of the diverse types of display techniques for—and the diverse types of examinations of—the medium. In the 1970s—when John Szarkowski was director of the department, having succeeded Steichen in 1962—the photography shows at the Museum of Modern Art were consistently installed in predominantly white or sometimes neutral-colored galleries with images set in white mats, framed at a standard height. The 1976 *Harry Callahan* exhibition is a paradigmatic example of this type of installation (fig. 2.39).

There were no more exhibitions dealing with photography's contribution to the mass media, like the 1965 exhibition *The Photo Essay,* which was curated by Szarkowski and installed by the Museum's graphics coordinator, Kathleen Haven (fig. 2.40). As was appropriate for the subject of the show, displays included tear sheets from glossy magazines, preliminary photo proofs, light boxes for transparencies, unmatted photographs arranged in varied magazine-like groupings on the walls, and captions outlining the picture-story process. There were no longer exhibitions that emphasized the technological capacities of the medium, like the 1943 show *Action Photography.* And there were no idiosyncratic displays to enhance thematic subjects, like the 1970 exhibition *Protest Photography,* which was the last to suggest the diversity of photo exhibition and installation possibilities at the Museum. *Protest Photography,* selected by Szarkowski and held during anti–Vietnam War protests and the New York artists' strike, was a selection of images documenting the "activities of young people this month" in the United States. Unframed black-and-white prints were tacked on the wall in rows; the dates of the events depicted in the photographs were given as captioning

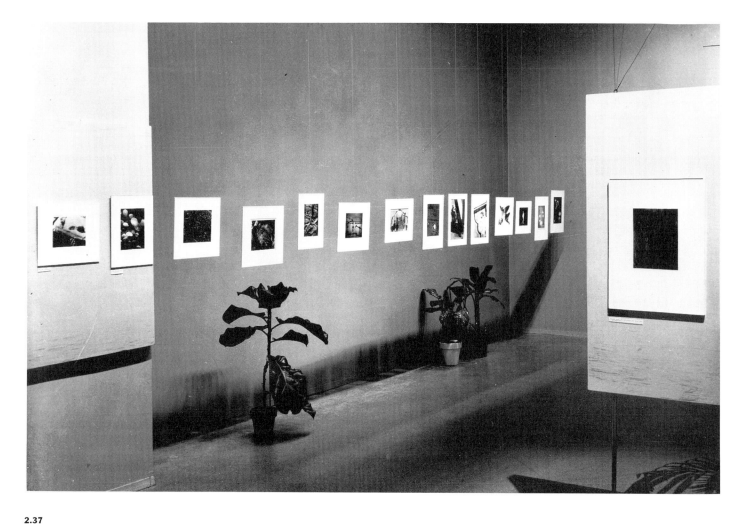

2.37
Ansel Adams and Beaumont Newhall, prints on grid suspended from ceiling, *Sixty Photographs: A Survey of Camera Esthetics,* Museum of Modern Art, 31 December 1940 to 12 January 1941.

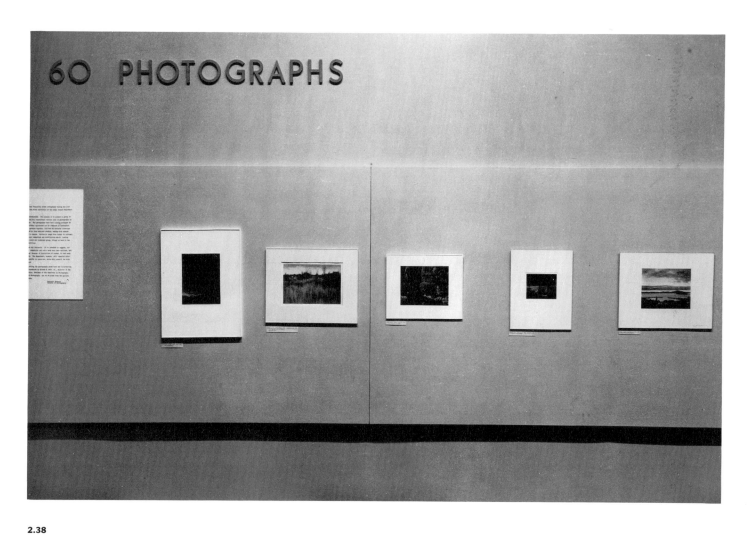

2.38

Adams and Newhall, prints on wall, *Sixty Photographs*, 1940–1941.

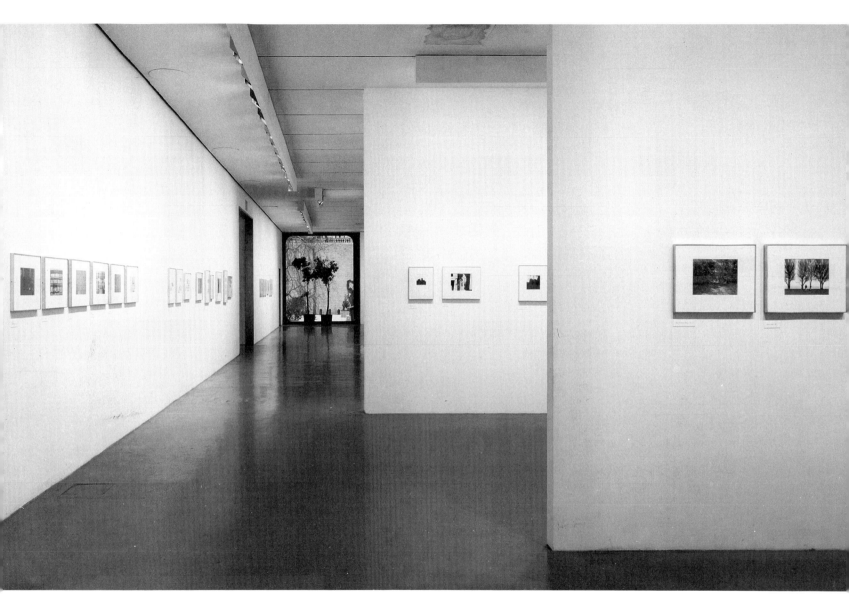

2.39

John Szarkowski, *Harry Callahan*, Museum of Modern Art, 30 November 1976 to
8 February 1977.

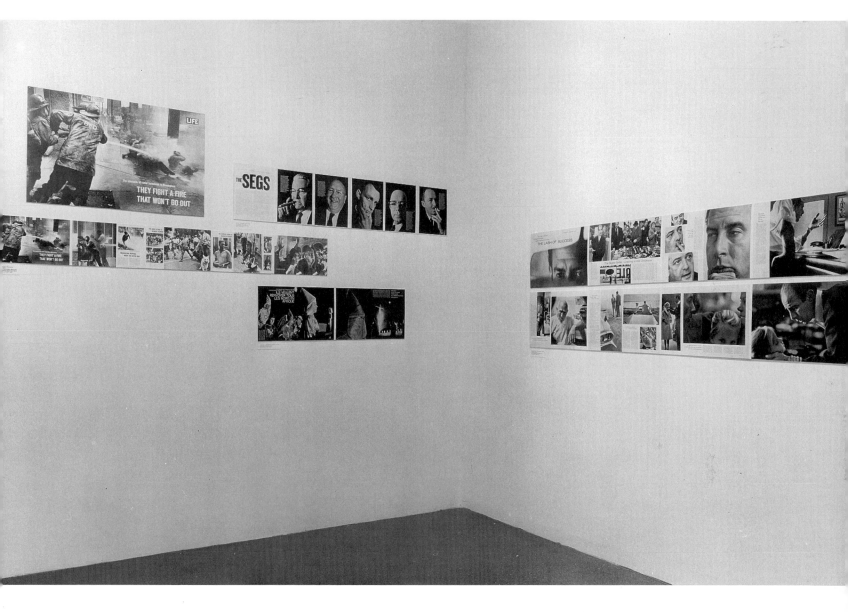

2.40
Designer: Kathleen Haven; curator: John Szarkowski, *The Photo Essay,* Museum of
Modern Art, 16 March to 16 May 1965.

devices. The last image in the show, isolated on one wall, was the famous photograph of the woman crying over a body at Kent State.[97]

For the past twenty-five years, the Museum of Modern Art's photography department has presented exhibitions that feature the aesthetics of photography, which is, of course, a fundamental area for those creating exhibitions in an art museum to explore. But aesthetics is only one aspect of a complex medium. And exhibitions such as the 1970 *Photo-eye of the 20s* and the 1978 *Mirrors and Windows* have, without exception, reinscribed photography within modernist—and avowedly formalist—installations.[98] This approach to the medium has been continued by Peter Galassi, who succeeded Szarkowski as director of the Department of Photography in 1991. Since 1970, the photo department's installation methods, with rare exception, have consistently worked to establish exclusively formalist and aestheticized exhibition conventions—and appreciation of the medium—within the Museum (2.41).

2.41
Peter Galassi with the assistance of Jerome Neuner, photography galleries, Museum of Modern Art, 1997.

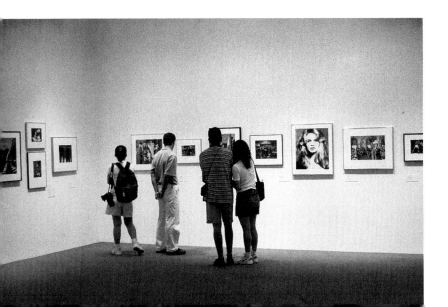

René d'Harnoncourt's Vistas and Affinities and the Museum of "Primitive" Art

A survey of the history of installations at MoMA makes clear that the shift in the late 1960s and early 1970s to limit the range of display techniques was in part related to the consolidation of display conventions as the Museum's institutional practices were established. This conclusion can be drawn from an examination of the methods of individuals whose careers span many decades at the Museum. After *Cubism and Abstract Art,* for example, Barr did not experiment with display techniques; he installed his exhibitions in the non-skied modern manner he had begun to devise in the Museum's inaugural show. D'Harnoncourt (who was director of the Museum until his death in 1968, which was caused by a car accident) later mounted some exhibitions that were more reductively aestheticized than *Indian Art of the United States.* This was particularly the case in the 1950s and 1960s, when d'Harnoncourt came to share with Barr an interest in displaying the aesthetics of the modern that, in some instances, superseded other interests. But d'Harnoncourt's concern for the aesthetic dimension of the works of art and culture on display did not keep him from conceiving extremely innovative installations that were demonstrations of exhibition design as a creative field in its own right, as seen in his second major exhibition at MoMA, the 1946 *Arts of the South Seas.*

Arts of the South Seas was a turning point in d'Harnoncourt's installation method. In this exhibition and catalogue, produced in collaboration with two professors at Columbia University, Ralph Linton and Paul S. Wingert, d'Harnoncourt consciously began to depart from many of the didactic conventions of natural history and art museums that he had deployed in *In-*

dian Art of the United States.[99] The approach he devised, which centered on "vistas," would shape all of his future exhibitions. D'Harnoncourt described how his exhibition technique changed as he was working on *Arts of the South Seas:*

During the last twenty years a great deal of attention has been given to the display methods used in museums of art and science. A great effort was made to convert these institutions from mere depositories of beautiful, valuable, or interesting objects into active cultural centers that enable the visitor to see each object as part of a larger complex and to understand the nature of the entire field of art or science represented by the collection. . . . While planning the exhibition Arts of the South Seas *at The Museum of Modern Art, we became aware of the inadequacy of traditional display methods to show the inter-relations between many Oceanic cultures and have therefore developed a new method of presentation to give the visitor greater opportunities for visual comparison. This method is based on the recognition that the field of vision of the visitor does not have to be limited to the units that are in the path of his immediate physical progress through the exhibition and that at any given point vistas should be open to him into those sections of the exhibition that have affinities with the displays in the unit in which he stands.*[100]

Traditional displays, according to d'Harnoncourt, do not visually articulate the ideas and relations between objects and groups; they must compensate "through literary devices such as captions or guidebooks." D'Harnoncourt believed that "such literary methods are a poor substitute for the experience of visual comparison," and he therefore avoided arrows and didactic material—which were commonplace in an Alfred Barr installation. Vistas were to be a visually compelling but nonetheless "scientific" solution to the problem of "the visual presentation of large fields of research."[101] Evidence of the importance the Museum

attributed to d'Harnoncourt's new installation method was the publicity it received in the show's press releases, as well as its citation in the acknowledgments of the catalogue.[102]

The practical display technique of vistas rested on a theoretical concept, "affinity," which D'Harnoncourt most likely adopted from his colleague and collaborator Robert Goldwater. D'Harnoncourt and Goldwater worked together on a number of projects and exhibitions, many of which were instrumental in establishing the acceptance of so-called primitive objects as fine art in the United States.[103] Affinity provided the theoretical underpinning of Goldwater's influential book *Primitivism in Modern Painting,* which was first published in 1938.[104] Given that in many instances there was no evidence of a "primitive" object's direct influence on modern artists and that the West's assimilation of these artifacts separated them from their original context, Goldwater came up with the concept of affinity to align cultural objects that look somewhat similar but are wholly unrelated in indigenous function and meaning. D'Harnoncourt refers to the affinity between Native American craft and modern design in his discussion of "Indian Art for Modern Living" in the catalogue of *Indian Art of the United States,* but he does not develop the concept fully until the 1946 exhibition.[105]

Arts of the South Seas brought together artifacts from Australia, New Guinea, Melanesia, Micronesia, and Polynesia; this geographic area was divided into twenty cultural areas. The regions were mapped onto a chart that grouped them into areas of stylistic affinity: "natural forms simplified," "natural forms geometricized," "natural forms exaggerated and distorted" (fig. 2.42). The chart was included in the catalogue, and maps of the region marked with areas of affinity were mounted throughout the show. The exhibition was structured as a network of atmospheric galleries whose wide entrances, wall partitions, and display structures permitted the viewer to compare and harmonize the contents of one area or gallery with that of another (fig. 2.43).

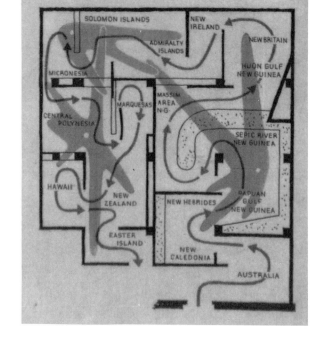

2.42
René d'Harnoncourt, chart of affinities reproduced in catalogue: Ralph Linton and Paul S. Wingert in collaboration with René d'Harnoncourt, *Arts of the South Seas* (New York: Museum of Modern Art, 1946), 9.

2.43
D'Harnoncourt, diagram of vista from Solomon Island section to Polynesian section to Easter Island section, *Arts of the South Seas,* reproduced in "Art of the South Seas," *Architectural Forum* 84, no. 5 (May 1946), 98.

The viewer experienced the exhibition as a series of vistas that organically unified the show, making visible these so-called affinities. In the Solomon Islands galleries, for example, the viewer could look past a waist-high wall partition studded with artifacts into the Polynesia gallery and past this to the Easter Island section (fig. 2.44). These overlapping vistas allowed the spectator to associate the objects in the three areas that shared similar formal characteristics, functions, and choice of materials.

Contextualization of the objects was attempted by painting the gallery walls, display structures, and ceilings in hues of eleven different colors that were intended to be representative of each area—for example, the "dark green of the jungle . . . the sand color and red rock of the Australian desertland." The galleries were also lit with different types of light to evoke, for instance, "the white light of the coral islands" and "a dim jungle light."[106] When we now try to imagine the experience of these galleries by looking at black-and-white photographs, what is lost is the dramatic use of rich and vivid color and the diverse lighting that can be seen in the several color transparencies remaining in MoMA's archives.

2.44
D'Harnoncourt, vista from Solomon Islands galleries to Polynesia and Easter Island galleries, *Arts of the South Seas*, Museum of Modern Art, 29 January to 19 May 1946. Photograph: Ezra Stoller © Esto.

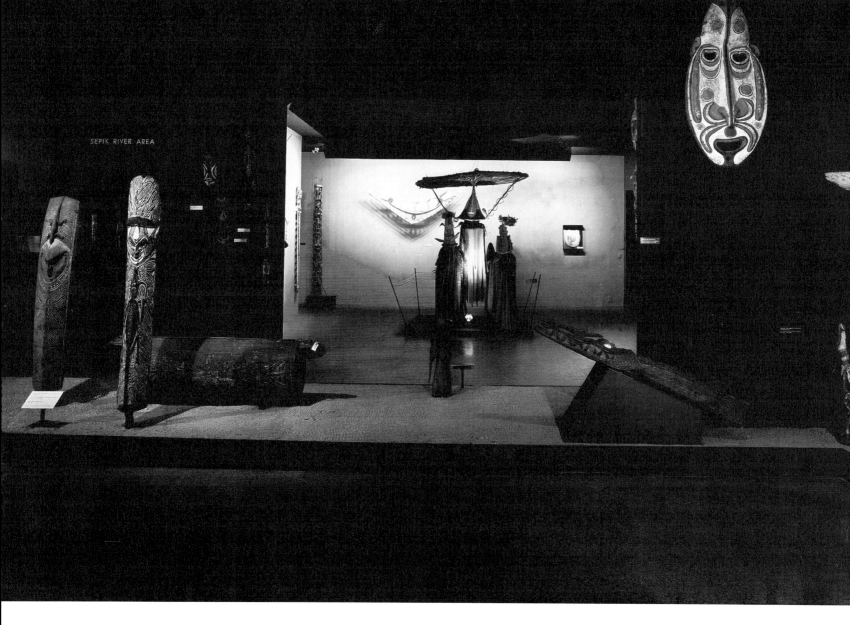

2.45
D'Harnoncourt, Sepik River area gallery, *Arts of the South Seas,* 1946.

2.46

D'Harnoncourt, Marquesas Islands section, *Arts of the South Seas,* 1946.

In some sections, there were suggestive display devices, such as bamboo poles and pebbled pedestals. In the gallery dealing with the Fly and Sepik River regions of New Guinea, masks were mounted on bamboo poles, and artifacts and figures were placed on a very low and curved pedestal whose display surface was covered with sand and whose shape evoked that of a river (fig. 2.45). In the Marquesas Islands section, there were wall drawings of individuals with tattoos who were holding fans and spears similar to those displayed nearby; this juxtaposition was intended to instruct viewers visually about these exhibited objects' context and function (fig. 2.46). Didactic material was present, but it was visually unobtrusive and kept to a minimum. All objects had identifying labels and at each section regional maps were marked with areas of affinity. Because of these various display strategies, the viewer traveled from one atmospheric space to another.[107] D'Harnoncourt in fact likened the viewer's experience to that of a traveler moving from one country to another, observing contrasts between and similarities of cultures.[108]

D'Harnoncourt conceived this exhibition technique in order both to highlight the aesthetic validity of the art of the South Seas and to give the viewer some sense of these objects' cultures. He wrote in the catalogue: "The growing realization in our art world that a work of art can best be appreciated in the context of its own civilization, together with the increasing interest in art shown by many scientists, holds a great promise." Although this new method was devised for an installation whose displays were supposed to evoke every object's indigenous culture, d'Harnoncourt noted that each area of affinity is "based on the character of the objects themselves and does not attempt to show the historic process of distribution of these trends."[109]

Arts of the South Seas was an exhibition rife with ambience; the diverse lighting, wall colors, and innovative displays created a viewing experience composed of subtle allusions. But what the exhibition did not suggest was the transformation of meanings that occurs when such artifacts are reinscribed in a modern art museum. In *Arts of the South Seas* only one method of installation technique was deployed, as opposed to the varied techniques in *Indian Art of the United States.* Sole reliance on vista displays created a harmonious and organic unity within the exhibition and achieved a masterfully designed show, but unlike the earlier exhibition *Arts of the South Seas* failed to foreground the way an art museum in the 1940s functioned to create meaning. The viewer's experience in *Indian Art of the United States* was structured to make visible the ways different displays create different meanings, whereas the spectator in *Arts of the South Seas* had to "actively" piece together the diverse sections of the show. Both of these approaches, however, are quite different from the twentieth-century convention of installing objects and images isolated in neutral-colored interiors at eye level to suggest a timeless, universalist aesthetics. The latter type of display not only presents culture as decontextualized but similarly "creates" a more static, atemporal viewer.

A singular and unified installation method was created and aesthetics reigned in d'Harnoncourt's 1954 *Ancient Art of the Andes.* The exhibition was a more decontextualized presentation than that of *Arts of the South Seas.*[110] The most publicized—and paradigmatic—display was "the gold room," a large vitrine filled with Inca, Chimu, and Mochica jewelry and ornaments. Perhaps more dramatically than any other element of the show, this particular exhibit highlighted the precious and beautiful qualities of the show's artifacts.

More aestheticized and decontextualized presentations of ethnographic artifacts were practiced within institutions affiliated with MoMA and d'Harnoncourt. The Museum of Primitive Art, founded in 1957 with Nelson Rockefeller as president, d'Harnoncourt as vice president, and Goldwater as acting director, would further institutionalize aestheticized displays as the standard method for showing so-called primitive objects.[111] For the inaugural exhibition, d'Harnoncourt created an absolutely modernist setting for sixty objects: a selection from the museum's collection whose dates spanned four thousand years and whose origins spanned the globe (fig. 2.47). These figurines, statues, tools, and utensils were spotlit, placed on white pedestals, and spaciously arranged throughout white-walled and grey-carpeted galleries. A conservative critic who reviewed the show ironically articulated the failings of this installation while simultaneously revealing his intolerance of other cultures: he criticized it for "ha[ving] the effect of underscoring an almost oppressive sameness in the works of art. The quality which I have called 'otherness' in primitive art separates it ultimately from our fundamental concerns, so that it can never, I believe, assume a role equal to the work of our own culture[.] . . . It is in the effort to disguise and domesticate this otherness that the manner of exhibition takes on an esthetic function, a rather dubious function I think."[112]

This extremely formalist exhibition technique, which isolated and decontextualized the artifact, was the predominant method for shows curated under the auspices of the Museum of Primitive Art. There were, however, important and ambitious exceptions to this practice—including d'Harnoncourt's exhibition design for *The Art of the Asmat: The Michael C. Rockefeller Collection,* held from September 11 to November 6, 1962, which was impressive in its elaborate departure from the types of installations that were possible in the modest galleries of the Museum of Primitive Art (figs. 2.49 and 2.50).[113] *The Art of the Asmat* was housed in a specially erected pavilion in MoMA's garden. Constructed in collaboration with architect Justin Henshell and director of MoMA's architecture and design department Arthur Drexler, the pavilion had a dirt floor and exhibits both inside and outside the structure to evoke Asmat practices. To those viewing this massive hut, surrounded by Asmat ceremonial poles, from the exterior it looked somewhat as if part of an Asmat village had been transplanted in the Museum's garden.

However dominant the technique of isolating individual objects in spare, neutral-colored interiors, there were often one or two installations within an exhibition at the Museum of Primitive Art that departed from this norm, such as the small rectangular pool that was constructed for *The Art of Lake Sentani* in order to evoke the lake itself.[114] The installation history of this museum reveals a consistency of creative efforts to contextualize the works exhibited: it appears, however, that practical and space constraints often limited the installations. In the end, the more decontextualized and formalist installations created at the Museum of Primitive Art would become the standard and would be adopted by the institution that absorbed these collections in 1971, the Metropolitan Museum of Art (fig. 2.48).[115] Even when attempts have been made to retain some vestiges of context at the Metropolitan, the results are much less effective than d'Harnoncourt's temporary installations. Take, for example, the line of

ancestor poles that are isolated in a massive, skylit gallery in the Michael C. Rockefeller Wing (fig. 2.51). These poles were similarly installed for the 1962 *Art of the Asmat,* but in MoMA's garden they were placed next to the evocative pavilion to deliberately mimic how they would be found outside an Asmat hut. The contrast points to the challenges of creating effective permanent museum displays.

D'Harnoncourt's theoretical framework for ethnographic exhibitions would also live on at MoMA in a very different manner long after he had left the Museum. The 1984 exhibition *"Primitivism" in Twentieth Century Art: Affinity of the Tribal and the Modern* was founded, as its title indicates, on the concept of affinity.[116] The stated intention of the show's organizers—William Rubin, who was essentially d'Harnoncourt's "successor," and Kirk Varnedoe, who similarly can be seen as Rubin's—was to make a case for the affinities between "primitive" and twentieth-century art.[117] The show began with the statement (written on its first wall label) that the presentation would be unabashedly modernist. The ethnographic artifacts would be examined not in terms of their indigenous cultures and meanings, but in relation to "resemblances" that are (as the label for Picasso's *Demoiselles d'Avignon* put it) "fortuitous, representing affinities rather than influences on modern art" (1.52).[118]

Rubin and Varnedoe's installation was produced in collaboration with designer Charles Froom, with the assistance of MoMA's in-house production manager Jerome Neuner.[119] The galleries were painted a variety of colors and were arranged with massive display cases and vitrines (fig. 2.53). Didactic wall labels identified objects and drove home the likenesses that the show's curators set out to demonstrate. These galleries were not atmosphere rooms, such as d'Harnoncourt or Dorner might have created. The ethnographic pieces were intermixed with the modern ones and they often shared the same display units, making a contextually evocative installation impossible. (The fourth and

2.47

Curator: Robert Goldwater; installation: René d'Harnoncourt, inaugural exhibition, *Selected Works from the Collection,* Museum of Primitive Art, New York, 20 February to 19 May 1957.

2.48
Curator: Julie Jones; director of design: Stuart Silver with exhibition designer, Cliff
LaFontaine, Michael C. Rockefeller Wing, Metropolitan Museum of Art, New York,
1997.

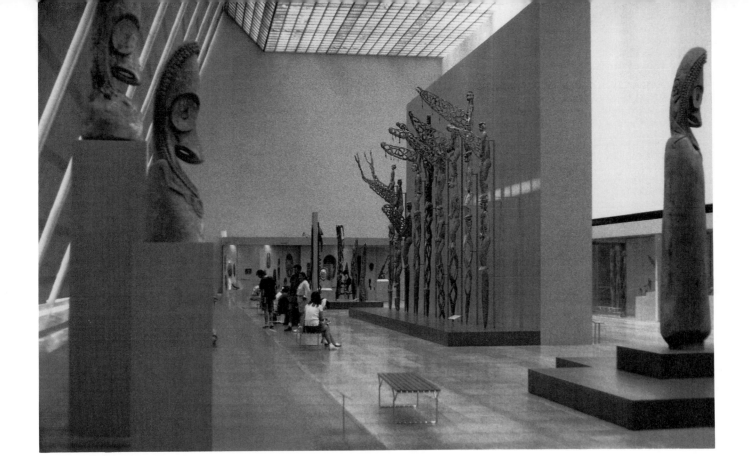

2.49 ←

Pavilion designed by Justin Henshell and Arthur Drexler and constructed at the east end of the garden of the Museum of Modern Art for the Museum of Primitive Art exhibition *Art of the Asmat: The Michael C. Rockefeller Collection,* 11 September to 5 November 1962.

2.50 ←

René d'Harnoncourt, installation within interior of pavilion constructed for the Museum of Primitive Art exhibition *Art of the Asmat,* 1962.

2.51

Curators: Douglas Newton and Michael Gunn; director of design: Stuart Silver with exhibition designer, Cliff LaFontaine, Michael C. Rockefeller Wing, Metropolitan Museum of Art, 1997.

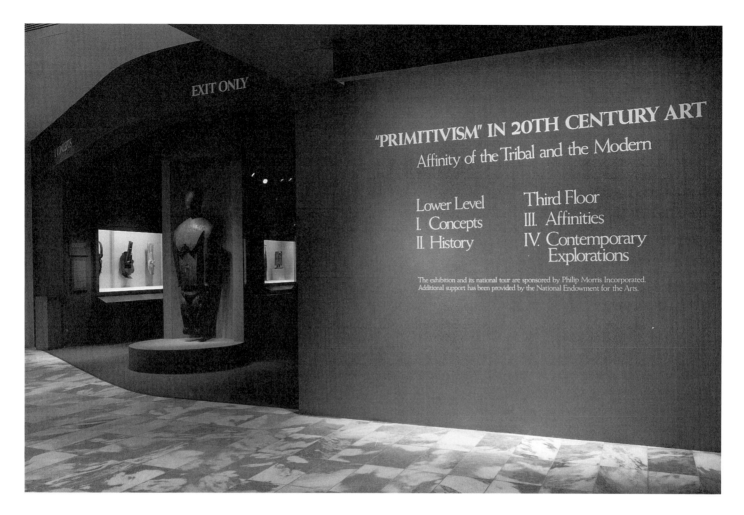

2.52

William Rubin and Kurt Varnedoe, created in collaboration with designer Charles
Froom and the assistance of production manager Jerome Neuner, entrance,
"Primitivism" in Twentieth Century Art: Affinity of the Tribal and the Modern, Mu-
seum of Modern Art, 19 September 1984 to 15 January 1985.

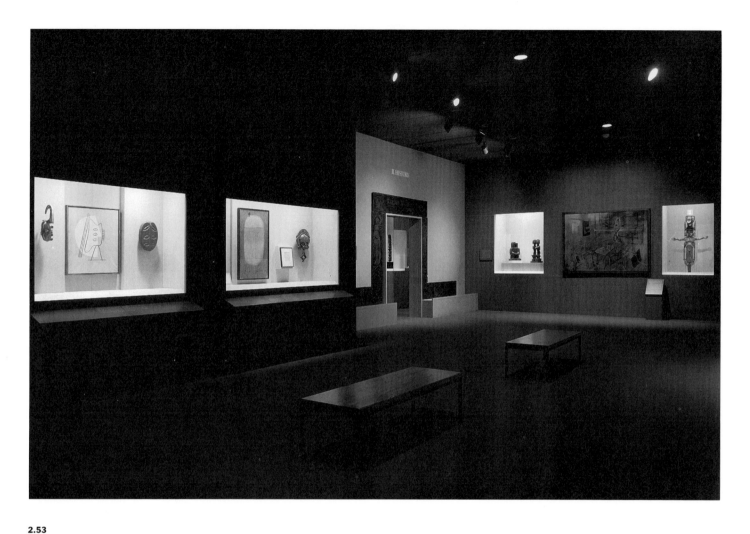

2.53
Rubin, Varnedoe, and Froom with Neuner, massive display cases, *"Primitivism" in Twentieth Century Art,* 1984–1985.

final section of the show, "Contemporary Explorations," which did not include ethnographic objects, mainly comprised installations by contemporary artists.)

Rubin introduces the subject of primitivism in the catalogue preface by stating that primitivism is the "invisible man" of art scholarship. This is a very interesting choice of words, for the entire premise of the show, its theoretical substructure, and aspects of its installation technique were institutionalized—albeit somewhat differently—by his predecessor, René d'Harnoncourt. D'Harnoncourt, however, is cited only once in a footnote in the nearly seven-hundred-page catalogue.[120] Although Robert Goldwater is acknowledged throughout the catalogue—as he should be, given his groundbreaking book, *Primitivism in Modern Painting,* and his contribution to the field—in Rubin's and Varnedoe's discussions of affinity, they make no mention of Goldwater's formulation of the concept. The omission of d'Harnoncourt's work from the museum's practices and institutional memory becomes particularly vivid when considering the *"Primitivism"* show and is representative of the contemporary museum establishment's amnesia regarding the history of installation design.

Unlike *Indian Art of the United States,* the installation of *Primitivism* in 1984 included no evaluations of modern Western culture's appropriation of ethnographic objects as art, nor this enterprise's relation to colonialism, nor acknowledgment that many of these artifacts were part of "living traditions"—to use d'Harnoncourt's term.[121] Certainly a formal or aesthetic evaluation of ethnographic and modern works of art is valid, but compared with the work of Rubin and Varnedoe, the exhibitions of d'Harnoncourt and his colleagues were more directly and effectively engaged with the complex issues of displaying non-Western and American cultural artifacts within art museums.

Yet the exhibitions held during MoMA's first several decades contributed to the Museum's grand project to universalize what was exhibited in its galleries by christening these objects modern art. MoMA's universalizing tendency functioned to domestic and tame all displayed artifacts for aesthetic appreciation and cultural assimilation.[122] The universal humanism found at MoMA was similar to that displayed in Paris in the 1930s when, as discussed above, the collections of the Trocadéro were reinstalled within the new Musée de l'Homme. Both museums drew on an image of the human race that flourished after World War II, when institutions such as the United Nations and UNESCO promoted a vision of a like-minded and related global humanity.[123] However simplistic this vision of "the family of man" (to borrow the title of MoMA's famous 1955 exhibition) may at times have been, these installations must be understood in relation to the dominant anthropological discourses within aesthetic and scientific communities during the first half of the century.

The concept of affinity, with its universalizing implications that infused all of d'Harnoncourt's and Goldwater's exhibitions and writings, was viewed at the time as a more tolerant and enlightened view of humanity and as a rejection of early modern racist evolutionary theories. Most late-nineteenth- and early-twentieth-century natural history and ethnographic collections were exercises in ranking civilizations from the primitive to the more highly evolved.[124] In the United States, by the beginning of the twentieth century anthropologists were mounting significant challenges to racist theoretical models. Some sense of the trajectory of this discourse can be gleaned from the changing reception of the ideas of Franz Boas, whose mature work was founded on a cultural and contextual understanding of human differences and who helped begin the attack on evolutionary theories of culture. In the 1920s, however, there was a backlash against the cultural anthropology espoused by Boas and his colleagues as racist and eugenic studies thrived once again. By the late 1930s in the United States, Boas's theoretical method had regained its influence in anthropology and the social sciences in general. But during this same time, racist social theories were thriving among

the ultraright. Finally, in response to the rise of Nazism, scientific communities managed to muster enough support to pass declarations against racism, such as the 1938 American Anthropological Association resolution condemning German "scientific" racism.[125] Yet even as late as 1950, UNESCO was challenged by geneticists and anthropologists regarding its landmark statement on racial equality and to appease these reactionary scientists UNESCO actually modified the statement in a 1951 version.[126]

Although these changes in scientific discourses regarding issues of race influenced exhibition techniques only indirectly, the attendant shift in emphasis from evolutionism to cultural anthropology during the 1940s directly affected contemporary display practices at the American Museum of Natural History and the types of installations d'Harnoncourt was creating at MoMA. Before Albert Parr became director of the American Museum of Natural History in 1942, the museum had been what one scholar described as "an illustrated appendix to the *Origin of the Species.*"[127] But Parr believed evolution to be a "finished issue" and redirected the institution toward the field of ecological biology and "the study of the relations of living things with each other and their environment."[128] This shift in theoretical direction was reflected in the changes that Parr made in the museum's policy regarding display practices. As director of Yale's Peabody Museum, his previous appointment, Parr had been known within the museum world for his innovative exhibition methods. During Parr's tenure at the Museum of Natural History, the galleries' wall colors were no longer limited to the traditional buff and oatmeal grays. The annual report stated that these colors' so-called neutrality was being "challenged by many institutions, especially among the art galleries" and that the museum would now use color appropriate for the "atmosphere" of the museum displays.[129] The changes that Parr initiated in the museum's theoretical direction and display practices were taking place during the

years that d'Harnoncourt was experimenting with similar ideas in *Indian Art of the United States* and *Art of the South Seas.*

A key aim of Parr's reorganization of the museum was to establish aesthetic appreciation as an important element of the permanent collections. This was first realized in the Hall of Mexican and Central American Archaeology, which was remodeled in 1944 (figs. 2.54 and 2.55).[130] The hall's densely spaced aisles, composed of vitrines filled with objects and freestanding specimens, were replaced by more spacious galleries; now both aesthetic and didactic displays included elegant cases with interior lighting as well as vitrines with clearly labeled exhibits.

The individuals who promoted the assimilation of ethnographic objects as art during the first half of the twentieth century argued for the acceptance of these artifacts as equal—if not superior—to the fine art of the West. Accompanying this rejection of the belief in the inferiority of non-Western cultures was humanistic faith in an essential human nature. This universalizing humanism was institutionalized within the museum community in the United States and Europe during the widespread establishment, reorganization, and refurbishment of art and science museums that took place in the 1940s and 1950s.[131]

Even though d'Harnoncourt's atmosphere rooms and vistas were intended as a means of embedding the objects of study within an expansive network of cultural contexts, his approach, particularly in the later work, often entailed the presentation of aesthetic universality. The methodology of d'Harnoncourt, like that of Barr, tended in some instances to disengage ideas and the materials of culture from historical processes. In Barr's case, art is conceived as having a self-contained evolution, separate from the determinants of the artwork's particular historical context. For d'Harnoncourt, art and artifacts were often seen to share timeless qualities that exist irrespective of the specificity of their cultures and histories. The difference between the two methods is visible in their didactic charts: Barr's *Cubism and Ab-*

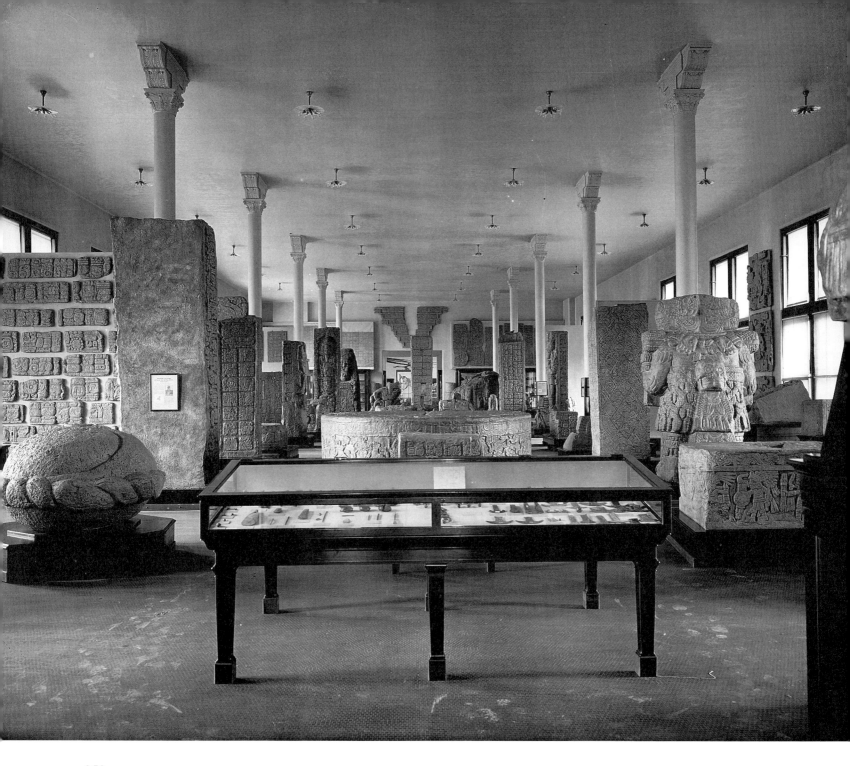

2.54

Hall of Mexico and Central America, American Museum of Natural History, ca. 1900.

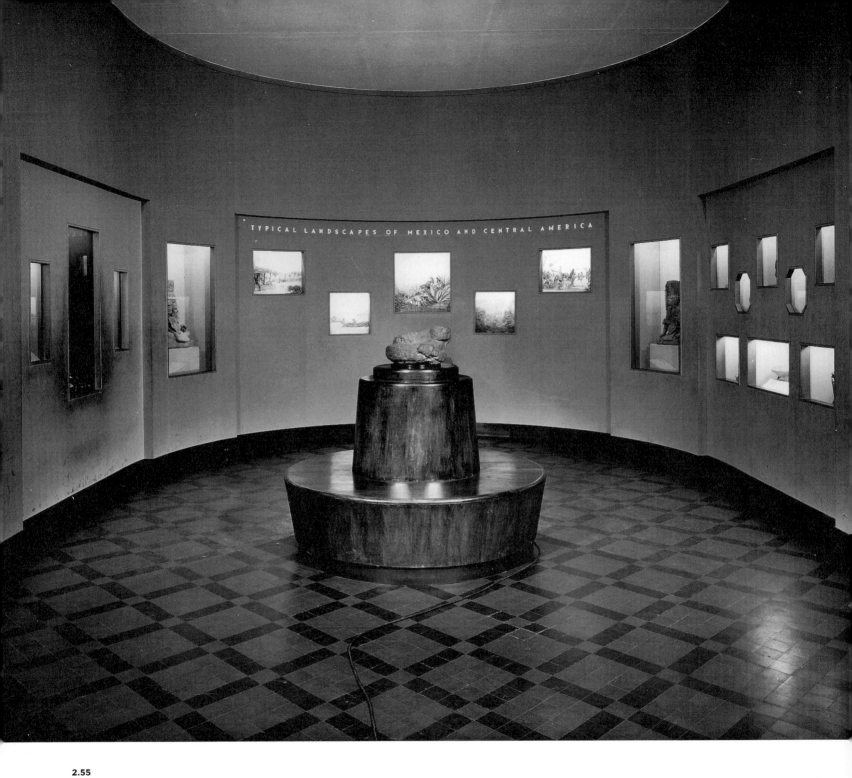

TYPICAL LANDSCAPES OF MEXICO AND CENTRAL AMERICA

2.55
Foyer of Hall of Mexico and Central America after rearrangement of the galleries,
American Museum of Natural History, June 1945.

2.56
Alfred H. Barr, Jr., flowchart reproduced on the jacket of the original edition of the
catalogue: Alfred H. Barr, Jr., *Cubism and Abstract Art* (New York: Museum of
Modern Art, 1936).

2.57
René d'Harnoncourt, chart of affinities reproduced in catalogue: Ralph Linton and
Paul S. Wingert in collaboration with René d'Harnoncourt, *Arts of the South Seas*
(New York: Museum of Modern Art, 1946), 9.

stract Art flowchart and d'Harnoncourt's chart of affinities for
Arts of the South Seas (figs. 2.56 and 2.57). Barr's flowchart
signifies continuity and progress, a forward movement of culture
through time. It is also worth noting that arrows were used to
lead the viewer through *Cubism and Abstract Art,* literally provid-
ing direction through the exhibition's linear presentation of art
history. In d'Harnoncourt's chart, which was mounted on walls
throughout *Arts of the South Sea*'s galleries, the different areas
of affinity are represented by biomorphic forms. The chart cap-
tures the conceptual framework of the show as atemporal and
composed of organic totalities.

Timeless Works of Art and the Objects of Everyday Life

MoMA's most obvious demonstration of its universalist exhibi-
tion technique, d'Harnoncourt's 1949 *Timeless Aspects of Mod-
ern Art,* was also the exhibition that most simply and obviously
presented the concept of affinity.[132] Its radical decontextualiza-
tion of the artworks, which was achieved by spotlighting objects
in darkened galleries; its vast scope, which included pieces span-
ning eighty millennia; its extreme stylistic comparisons, such as
a thirteenth-century plate from Persia paired with an Henri Ma-
tisse—all concisely represented the concept of affinity (see fig.

2.21). But analyzing this radically decontextualized exhibition more than forty years later makes clear the historical limitations of d'Harnoncourt's method. Ancient objects whose meaning is lost to us, medieval utensils, Christian religious images, and art objects made by modern masters were reduced to one meaning—stylistic resemblances providing evidence of the essential nature of humanity. D'Harnoncourt's elaborate attempt to demonstrate the capacity of art to transcend its cultural and historical limitations was unequivocable proof of its inability to do just that.

The following statement about affinity was printed in the orientation gallery and in all the material associated with *Timeless Aspects of Modern Art:*

The problem of understanding the affinities between works of art is not unlike that of understanding affinities between people. All of us are familiar with the experience of meeting persons who remind us strongly of someone we have known before. This experience can be based on likeness of features and body or on similarities in ways of thinking and acting. Both the physical and the mental similarities are sometimes accidental, sometimes the result of basic relationships such as kinship or similar environment.[133]

In *Timeless Aspects of Modern Art* and in d'Harnoncourt's last show at MoMA, the 1968 *Picasso Sculpture* exhibition (also organized according to affinities of form and content), the concept of affinity gains a more overtly anthropomorphic dimension.[134] This emphasis signifies more than mere analogy; rather, it makes explicit the inextricable link between a faith in the essential nature of a human being and a faith in the essential nature of a work of art.

Discussing the creation of the Picasso installation and his approach to designing exhibitions, d'Harnoncourt said, "The first thing that you see should have some moving content . . . it should be filled with human content."[135] In the first gallery of the Picasso show stood a central figure, *Man with Lamb,* which faced the viewer, one on one (fig. 2.58). There was a partition on either side of *Man with Lamb,* and four sculptures on each side of the partition: an organically shaped figure, a hand, a skull, and a rooster. All of these sculptures (even those that were not human forms or merely fragments of human figures) were displayed in such a way that they seemed uncannily anthropomorphic—which was one of the consistent and striking features of all the works in the show. It was as if d'Harnoncourt was now trying to go beyond demonstrating affinities between the exhibited objects to fostering an affinity, a kind of human relationship, between the viewer and the work of art.[136]

This first gallery was dramatically symmetrical. As already described, the central figure, *Man with Goat,* was framed by partitions on either side. The floor tiles marked out a perfectly symmetrical grid. The ceiling had been rebuilt into a clean white grid composed of boards. The clarity of the grid of the floor, the grid of the ceiling, the symmetrical wall partitions, and the bricks that composed the pedestals articulated a dramatically rational, classical sense of space. This exactingly "gridded" space is reminiscent of images of Renaissance humanism as visualized, for instance, in Raphael's Vatican Stanza frescos or his *Marriage of the Virgin* fresco (1504)—a likeness that d'Harnoncourt might call an affinity. Although produced for historically different contexts and purposes, MoMA's gridded space also represented a controlled, rational universe shaped by universal laws of nature and the human mind. Augmenting this timeless, neoclassical sense of space was the color scheme, as everything in the Picasso gallery was done in shades of white and buff: the walls, the ceilings, the curtains, the floor, the pedestals.

Groupings of "anthropomorphized" objects framed within neoclassical, neutral-colored—what might be called idealized—

2.58
René d'Harnoncourt, first gallery, *The Sculpture of Picasso,* Museum of Modern
Art, 11 October 1967 to 1 January 1968.

2.59 →
D'Harnoncourt, *The Sculpture of Picasso,* 1967–1968.

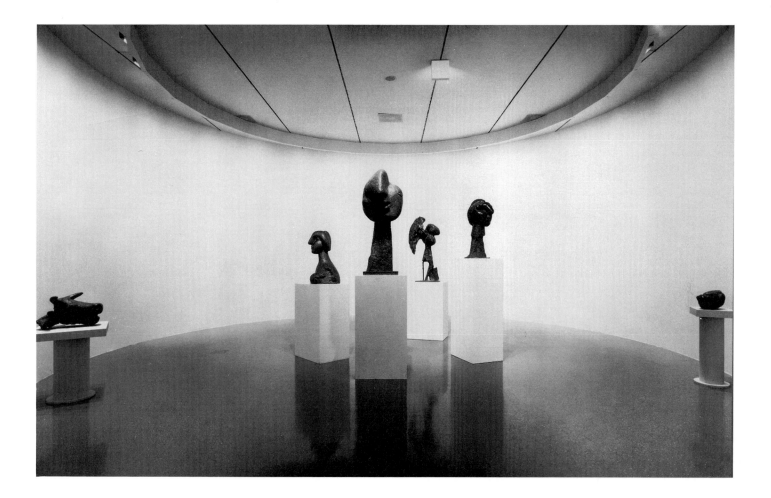

installations characterized the entire show. For example, d'Harnoncourt also constructed a gallery for a series of white monumental heads (fig. 2.59). The scale of these heads was huge, so he designed a circular gallery with a white board ceiling to convey what d'Harnoncourt considered to be an infinite sense of space. The enormous heads thus appeared on scale with the gallery dimensions and were more likely to be viewed as if they were entire figures. The room was completely white, the pedestals were white, the sculptures were white—again putting human sculptural figures in a gallery that suggested a timeless place. The show was introduced with the following label: "The arrangement

of the exhibition is not strictly chronological. Works are grouped by affinities of form and content. Picasso once said, 'The several manners I have used in my art must not be considered as an evolution, or as steps toward an unknown ideal. . . . All I have ever made was made for the present and with the hope that it will always remain in the present.' "[137] This severely rational, classicistic installation of an eternal present could have been titled "The Timeless Aspects of Picasso's Sculpture."

Highly aesthetic exhibitions like *The Sculpture of Picasso* and *Timeless Aspects of Modern Art* remained, nonetheless, simply options within a spectrum of possibilities at the Mu-

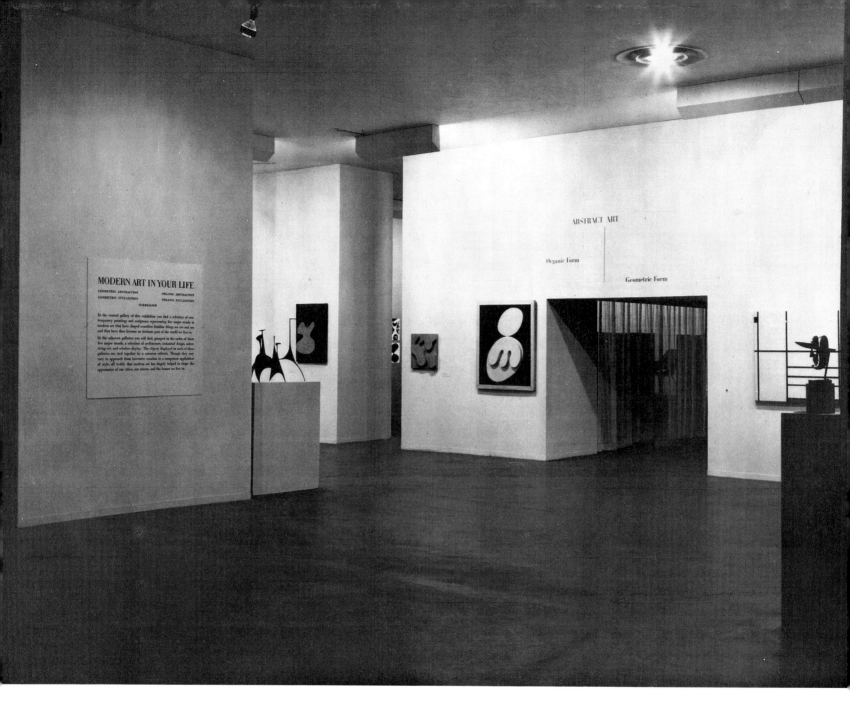

2.60

René d'Harnoncourt in collaboration with Robert Goldwater, entrance, *Modern Art in Your Life,* Museum of Modern Art, 5 October to 4 December 1949.

seum—and within d'Harnoncourt's own approaches. These, after all, were the laboratory years at MoMA. *Timeless Aspects of Modern Art,* one of the Museum's twentieth-anniversary exhibitions, was held from November 1948 to January 1949 in tandem with a very different exhibition: *Modern Art in Your Life,* which was also designed by d'Harnoncourt but in collaboration with Robert Goldwater, who wrote the catalogue. *Modern Art in Your Life* was "designed to show that the appearance and shape of countless objects of our everyday environment are related to, or derived from, modern painting and sculpture, and that modern art is an intrinsic part of modern living."[138] The exhibition began with a wall label that explained the unusual installation (fig. 2.60):

In the central gallery of this exhibition you find a selection of contemporary paintings and sculpture representing five major trends in modern art that have shaped countless familiar things we see and use and that have thus become an intrinsic part of the world we live in. In the adjacent galleries you will find, grouped in the order of these five major trends, a selection of architecture, industrial design, advertising art, and window display. The objects displayed in each of these galleries are tied together by a common esthetic. Though they may vary in approach from inventive creation to a competent application of style, all testify that modern art has largely helped to shape the appearance of our cities, our streets, and the homes we live in.[139]

The viewer entered the exhibition by walking through a low-ceiling corridor, created by sheer curtains on either side, that led to the central gallery where paintings and sculptures were arranged in five sections labeled "Geometric Abstraction," "Geometric Stylization," "Organic Abstraction," "Organic Stylization," and "Surrealism and the Fantastic." The exhibition was set up so that the spectator could view fine art in the central gallery and then move to an auxiliary gallery displaying corresponding architecture, design, applied art, and objects of everyday use (figs. 2.61 and 2.62). Though the formula was simple, the installation effectively involved the viewer in making visual connections, as *Arts of the South Seas* had also done. In *Modern Art in Your Life,* this creation of relationships between the works in the central

2.61

D'Harnoncourt, exhibition plan, *Modern Art in Your Life,* reproduced in *Interiors* 109, no. 4 (November 1949), 97.

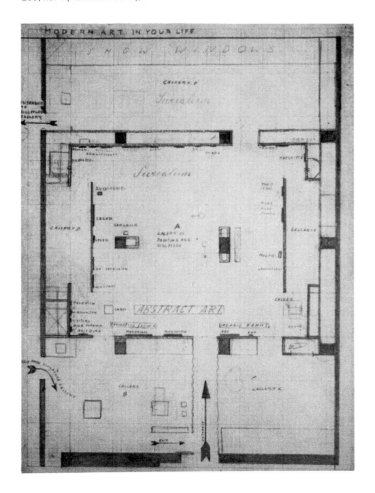

135

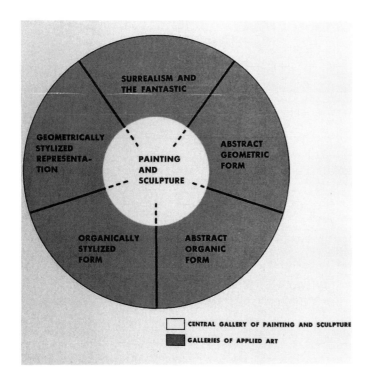

2.62

D'Harnoncourt, chart reproduced in second edition of the catalogue: Robert Goldwater in collaboration with René d'Harnoncourt, *Modern Art in Your Life*, 2nd ed. (New York: Museum of Modern Art, 1953), 44.

2.63 →

D'Harnoncourt, Surrealism gallery, *Modern Art in Your Life*, 1949, which included six full-scale re-creations of Surrealist department store window displays.

2.64 →

D'Harnoncourt, entrance to Surrealism gallery, *Modern Art in Your Life*, 1949.

and auxiliary galleries was itself the subject of the show: that is, art's relationship to everyday life.

On the wall opposite the entrance, which was an eye-catching blue, were Surrealist paintings by Salvador Dalí, Max Ernst, and Yves Tanguy. Between the Dalí and the Tanguy was an entrance that led to darkened gallery with black walls (fig. 2.64). Inside this darkened gallery were spotlit Surrealist-inspired posters, book jackets, advertisements, and six full-scale re-creations of New York City department store window displays (fig. 2.63).[140] In the central gallery, the white wall opposite the blue Surrealist one (which contained the exhibition entrance) was divided into two sections: "Geometric Abstraction" and "Organic Abstraction." (For the "Geometric" and "Organic Abstraction" galleries, one of the curtains of the corridor formed one "wall.") The "Geometric Abstraction" section included examples such as Piet Mon-

drian and Theo van Doesburg paintings and a Naum Gabo sculpture. Its auxiliary gallery displayed a cover of *Life* magazine, a Kleenex box, textiles, a model of MoMA's building, and a Marcel Breuer chair. The "Organic Abstraction" section included works by Jean Arp, Alexander Calder, Joan Miró, and Isamu Noguchi. The corresponding gallery was painted light blue. On a long, low platform was a tableau of furniture by Charles Eames, Dan Cooper, and the team of Antonio Bonet, Juan Kurchan, and Ferrari Hardoy. Suspended behind this platform was a chart of furniture form silhouettes designed by George Nelson.

On returning to the main gallery, from the gray wall of the "Geometric Stylization" section—between paintings by Amédée Ozenfant and Fernand Léger—the viewer could see through the auxiliary gallery entrance to a wall papered with what looked like subway tiles on which were hung posters by A. M. Cassandre and

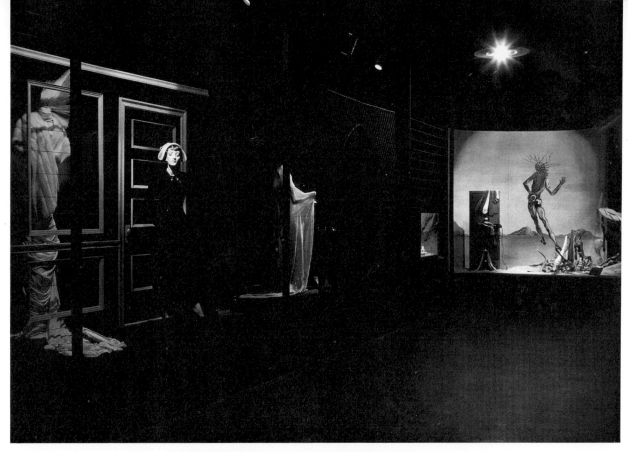

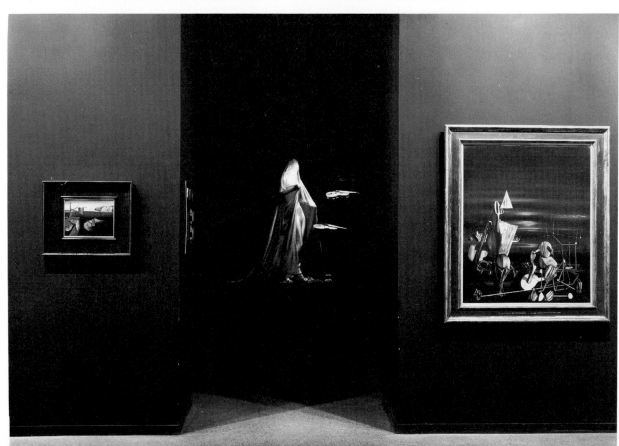

McKnight Kauffer (figs. 2.65 and 2.66). To one side of the simulated subway wall was a display of pots and pans; on the other side were stylized mannequins produced in Paris in 1929 that were reminiscent of the Léger and Alexander Archipenko works installed in the central gallery. The "Organic Stylization" section brought together the work of Picasso, Paul Klee, Joan Miró, and Henry Moore and led to an auxiliary gallery containing a Bonwit Teller window display by Gene Moore, an advertisement by Ben Shahn, a book jacket for Norman Mailer's *The Naked and the Dead,* and an Alvin Lustig textile.

This show was in many ways a descendent of the exhibitions promoting industries, products, and design that were created by Herbert Bayer and Lilly Reich, those celebrating the revolutionary culture of the Soviets produced by El Lissitzky and Aleksandr Rodchenko, and the visionary architectural exhibits designed by Le Corbusier and Walter Gropius. The earlier exhibition installations introduced prototypes for the modern world installed in what must have seemed like futuristic settings, promising an aesthetic and practical revolution. MoMA's show displayed not a utopian future but the modern present. The exhibition was not a catalyst for the transformation of commonplace: it was proof that the fabric of everyday life was already modern.

An examination of *Modern Art in Your Life*'s Surrealist galleries casts some light on the trajectory of installation experimentation at MoMA. Barr's *Fantastic Art, Dada, Surrealism* was organized according to chronology and style (see fig. 2.20). For example, nineteenth-century proto-Surrealist paintings by Thomas Cole, Johann Fuseli, and Odilon Redon were installed together, as were all the sixteenth-century paintings.[141] In the twentieth-century galleries, work was divided into stylistic areas of organic abstraction (which included the work of Arp, Picasso, Miró, and André Masson) and realistic Surrealism (which included the work of Dalí, René Magritte, and Max Ernst). Barr's

exhibition was the catalyst for Fifth Avenue department stores to create Surrealist-inspired windows, which were in turn re-created in d'Harnoncourt's 1949 exhibition.

In the 1968 exhibition *Dada, Surrealism, and Their Heritage,* curator William Rubin eschewed all pre-twentieth-century prototypes, the art of children, and the art of "the insane," as well as popular culture such as comics that were in Barr's original show.[142] Rubin disavowed the myriad anti-aesthetic references found in d'Harnoncourt and Goldwater's show. There were no advertisements, no shop windows, no objects or documents from everyday life. Inappropriately for its Surrealist subject, the installation was exclusively formalist and aesthetics was separated from the commonplace, from history, from those vital sources of inspiration that infuse art with vitality and power.

Rubin and Barr had actually discussed the installation methodology for this show. Barr wrote a memorandum to Rubin in the summer of 1966 after reviewing the outline for a Dada and Surrealism show. For the Surrealist section, Barr suggested that Rubin "sacrifice chronology and start out with abstract surrealism (Arp, Miro, Masson, Ernst, Picasso, 1925+), follow that with illusionistic surrealism (Ernst, Man Ray, Tanguy, Picasso, 1927+, Magritte, Dali, Oelze, Dominguez, Seligmann, Paalen, Delvaux, etc.)." Rubin wrote back, "I am going to take up your excellent suggestion."[143] But what Rubin did with Barr's suggestion is very revealing. Although style did shape the broad divisions of the catalogue and the installation, the exhibition was organized primarily by artist. There was a Schwitters gallery, a Duchamp gallery, a Giacometti gallery, an Arp gallery, and so on. The entrance made visible the methodology of the installation (fig. 2.67). On either side of the entrance were two large Matta paintings and on the lintel above the doorway was printed the show's title. The passageway created a vista with a view of one Francis Picabia painting. That a single artist was featured at the

2.65

D'Harnoncourt, Geometric Stylization section, *Modern Art in Your Life*, 1949.

2.66

D'Harnoncourt, entrance to Geometric Stylization section, *Modern Art in Your Life*,

1949.

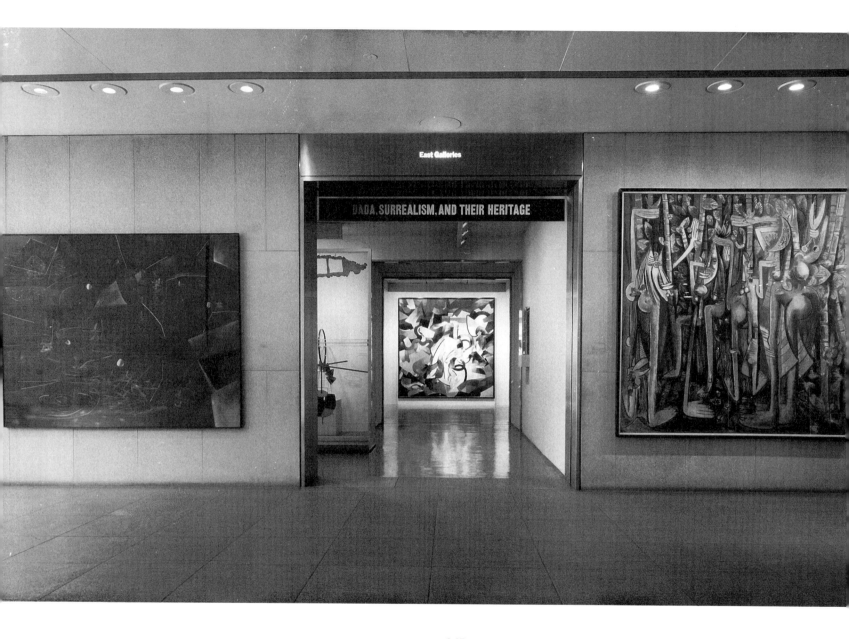

East Galleries

DADA, SURREALISM, AND THEIR HERITAGE

2.67
William Rubin, entrance, *Dada, Surrealism, and Their Heritage*, Museum of
Modern Art, 27 March to 9 June 1968.

2.68 →
Rubin, sculpture arranged by René d'Harnoncourt, Salvador Dalí gallery, *Dada,
Surrealism, and Their Heritage*, 1968.

entrance and in the first vista articulated the inscription of Surrealism under the signatures of various masters that took place throughout the exhibition.

Rubin's methodology was most apparent in one of the show's more adventurous installations, the Dalí room (fig. 2.68). Darkened, with spotlit paintings and objects such as *Venus de Milo with Drawers* (which was on a pedestal in the center), this gallery evoked the dreamlike, cinematic dimension of Surrealism, but it also harkened back to the darkened Surrealist gallery of *Modern Art in Your Life*. Although Rubin must have admired d'Harnoncourt's exhibition methods because he had him arrange the sculpture for the show, like his response to Barr's suggestion, Rubin's appropriation of d'Harnoncourt's assistance is revealing.[144] Rather than a display of re-created store windows and commonplace and commercial objects—which had fit the Surrealist belief that Surrealism was not an art style but a way of life—Rubin's dark Surrealist gallery functioned as a shrine to one artist's vision.

The type of exhibition that William Rubin created for *Dada, Surrealism, and Their Heritage* would become the standard at the Museum beginning in the 1960s and 1970s. The spectrum of diversity of installation design found in the work of Barr, d'Harnoncourt, the Newhalls, and their colleagues disappeared from MoMA's institutional practices and memory. What d'Harnoncourt referred to in 1964 as Barr's vision of "the Museum as a laboratory in whose experiments the public is invited to participate" would survive only a few more years.[145]

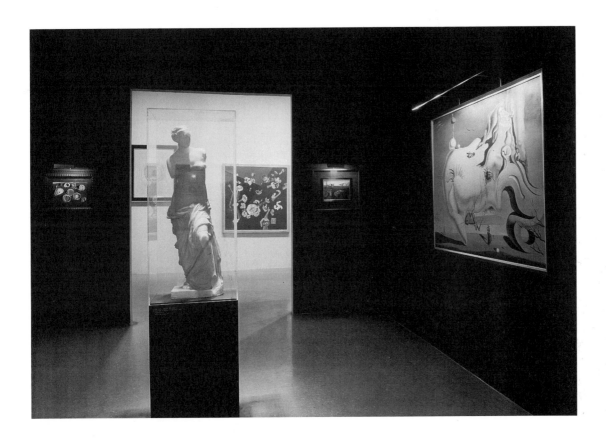

Chapter 3

Installations for

Good Design and

Good Taste

The *Bauhaus* Debacle

In 1938 Alfred Barr took a giant step closer to realizing his vision of a museum truly representative of modern culture, presenting "the practical, commercial, and popular arts as well as . . . the so-called 'fine' arts."[1] In one of the most ambitious undertakings since the founding of the Museum of Modern Art, MoMA opened an exhibition devoted to what Barr had described as that "fabulous institution": the Bauhaus.[2] The founding director of the Bauhaus, Walter Gropius, and a former Bauhaus student and master, Herbert Bayer, were enlisted as curators. In keeping with the ideas and methods explored at the Bauhaus, Bayer devised an elaborate and innovative installation. The catalogue was, in many ways, even more ambitious than the show, documenting aspects of the Bauhaus that would be impossible to include in a gallery installation; as a result, it was the most expensive that the Museum had published to date.[3] MoMA's commitment to the exhibition was evident in that half of the Museum's annual exhibition budget was slated for the show; the final costs were higher, by half, than had been allocated.[4] The importance of the show was also demonstrated by the political and personal risks run by those producing it. Adolf Hitler had closed the Bauhaus in 1933, and the situation in Germany made shipping works to the United States difficult and in some cases dangerous. Many former Bauhäuslers were afraid to donate work for fear of retribution; Bayer himself had difficulty getting out of Germany.[5] Artists' names were omitted from the catalogue and the show in order to protect them.[6] But despite the financial costs, the political risks, the am-

Shoppers who have been dismayed at the price tags on this year's gift suggestions may take heart after a tour of the useful objects exhibition that opens today at the Museum of Modern Art.

—Mary Roche, "Useful Objects Exhibit Is Opened" (1946)

Bloomingdale's Presents Organic Design Furniture and Furnishings . . . Created for the World of the Present, Sponsored by the Museum of Modern Art . . . Sold Exclusively by Us in New York[.] Visit Our Exciting Exhibit Which Shows All of This New Furniture in Rooms and Settings for Today's Living. Fifth Floor, Lexington at 59th.

—Full-page advertisement, *New York Times* (1941)

3.1
Designer and curator: Herbert Bayer; curator: Walter Gropius, entrance, *Bauhaus 1919–1938,* 1938–1939.

bitious installation, and the intellectual investment in the catalogue and exhibition, the show was viewed by the public, the critics, and Museum itself as a failure.

Barr and his colleagues were surprised by the critical reception. After all, the Bauhaus had been closed since 1933 and was seen by Barr and the Museum staff as a relatively uncontroversial subject. The exhibition was expected to be a straightforward undertaking, one that would honor a respected cultural institution and present the Bauhaus and its pedagogical methods to the United States and its schools.[7] The installation, which was not "just an accumulation of objects," was expected to be a very ingenious presentation, displaying the ideas of the Bauhaus to the public in an exciting and appealing way.[8] Realistically, however, Bayer was handicapped by having to set up the exhibition in the somewhat confining galleries on the concourse level of Rockefeller Center. These were MoMA's temporary quarters during the years of its move from the townhouse on 54th Street to its present building on 53rd. Bayer made the most of his field-of-vision display techniques and his use of new design materials. Still, a great deal of the exhibited material was limited to photo documentation of buildings, performances, and objects; there were also sections devoted to examples of student study projects. But even this somewhat didactic material, which was only one aspect of the exhibition, should have been of sufficient interest to make a successful show.

Bauhaus 1919–1928 was divided into six sections: "The Elementary Course Work," "The Workshops," "Typography," "Architecture," "Painting," and "Work from Schools Influenced by the Bauhaus" (fig. 3.2). At the entrance (fig. 3.1) a reproduction of Lyonel Feininger's famous *Cathedral of Socialism,* which had graced the cover of Gropius's founding *Bauhaus Manifesto,* was hung from two strings suspended from the ceiling. To the visitor's right was an architectural model of the Dessau Bauhaus. Wall labels were red, while many of the display elements and structures were creamy white, black, and gray, with accents of deep blue and red.[9] Pop culture clichés punctuated the installation. A drawing of a pointing hand was occasionally used as a directional sign for the visitor, as were gray footprints and circulation paths that had been painted on the floors (figs. 3.6, 3.9). To one side of the entrance stood a white corrugated-paper room divider supported by slender white stanchions (fig. 3.4). The panel's curved shape mimicked the flow of viewer traffic, and its visual properties echoed those of a paper sculpture that was hung from the ceiling.

In the first gallery to the left was an introductory exhibit intended to make Bauhaus theory visible. On the wall was a dark silhouette of a hand, above which was written "The Bauhaus Synthesis"; below, "Skill of Hand"; to its right, "Mastery of Form"; and to its left, "Mastery of Space" (fig. 3.3).[10] Exhibits, photographs, and wall labels were tilted at angles from the walls (fig. 3.5). Floor displays such as woven rugs were positioned at angles tilted off the floor, which was painted with patterns demarking these display areas. The installation's structural elements and "furniture" were, in many instances, organic in form and arranged in dynamic configurations, such as a curved tabletop suspended by string and glass box vitrines stacked at different angles (figs. 3.7 and 3.8). The use of plastics, cord, thin support posts, and innovative display structures added a modern-looking transparency and spaciousness to the show. In the stagecraft section, a peephole was made noticeable by the addition of wall drawings of a pointing finger above it and of an eye below (fig. 3.9). The viewer could look through this peephole (which was actually a rectangular slot) to see one of the most-publicized aspects of the exhibition: a display of mechanical, spinning robots dressed in costumes designed by Oskar Schlemmer.

All of these exhibition methods—the transparent materials, the primary color accents, the string display supports, the

floor painting, the tilted and curved exhibits, the mechanical peep show, and the pop culture clichés—created a dynamic language of form that staged a dialogue with the viewer and acknowledged the visitor's presence in the exhibition (see fig. 3.9). As in previous installations in Europe such as the 1930 *Exposition de la Société des Artistes Décorateurs,* Bayer put into practice his theories about a "new discipline" of "visual communication" in which "the total application of all plastic and psychological means" would create an "intensified and new language."[11]

But what was the message of this exhibition as seen by the American public and critics? What went wrong with this innovative, exciting, dynamic, ambitious, expensive homage to what, for the most part, was considered a historic institution of twentieth-century culture? With the advantage of more than fifty years of hindsight, we now see that the Museum audiences could not "read" this show. It seemed chaotic, confused, didactic, gimmicky, illegible. Bauhaus art, design, and architecture were respected by many of the critics who hated the show, but the way the exhibition's elements were put together—the installation's language of form—was indecipherable and somehow beyond the ability of American audiences to assimilate.

Edward Alden Jewell in the Sunday *New York Times* agreed with Barr that the Bauhaus had an important message for the American public and praised the Bauhaus as "a living idea [that] continues to be oracular" and whose influence was "fruitful and widespread." But he then declared the exhibition a "fiasco." The show, and particularly the installation, was deemed "chaotic," "voluminously inarticulate," "disorganized promiscuity," and "bewildering in the multiplicity of its items . . . somewhat like an old-fashion fire sale." Jewell considered the work debased by Bayer's "recourse to that cheap sidewalk device of footprints painted on the floor"; thanks to the installation, "the material— often of deep intrinsic significance—takes on the aspect of a jazzed, smart potpourri of dated modernist 'isms.'" The critic

complained that the viewer is only left with a headache and vertigo.[12] The following Sunday, the *Times* published two damning letters. One described the Bauhaus as "the finest thing in existence," but the author was "bewildered by the mix-up arrangement that no footprints and floor patterns could help." The longer and more notorious letter was from a former Bauhaus student, Natalie Swan, who denounced the "exhibition in the caverns of Radio City" as "a final danse macabre." (Barr believed that Swan was working for Frederick Kiesler, who was perhaps unhappy about his representation at the Museum.)[13]

3.2
Herbert Bayer, plan, *Bauhaus 1919–1938,* Museum of Modern Art, 7 December 1938 to 30 January 1939.

3.3

Bayer, exhibit illustrating "The Bauhaus Synthesis," *Bauhaus 1919–1938,*
1938–1939.

3.4 →

Bayer, corrugated-paper room divider, *Bauhaus 1919–1938,* 1938–1939.

3.5 →

Bayer, labels and exhibits tilted at angles from walls, *Bauhaus 1919–1938,*
1938–1939.

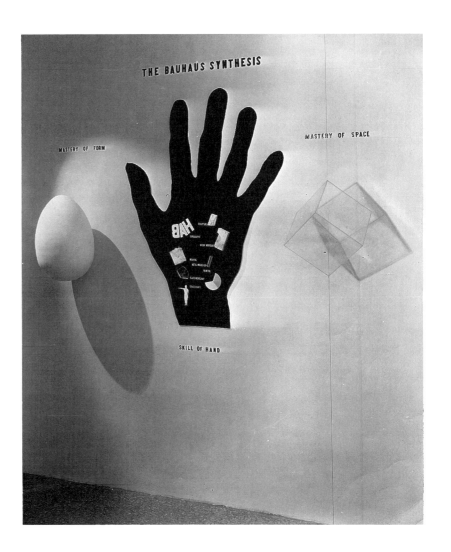

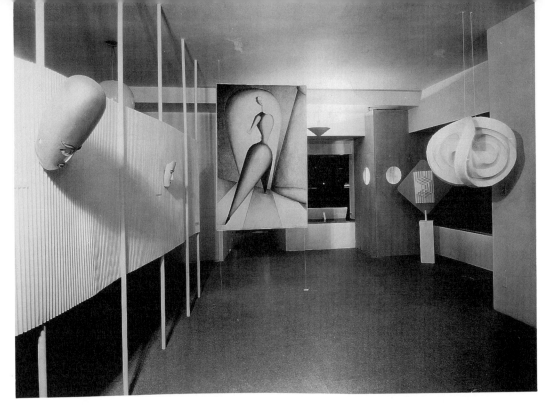

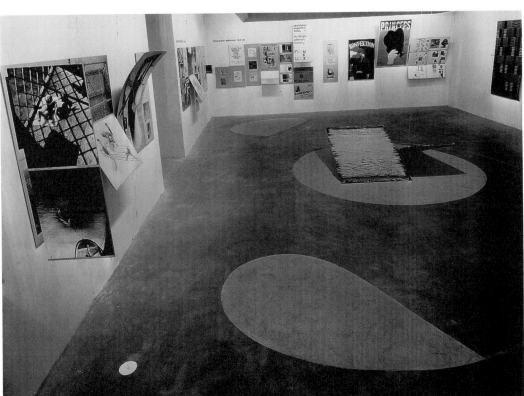

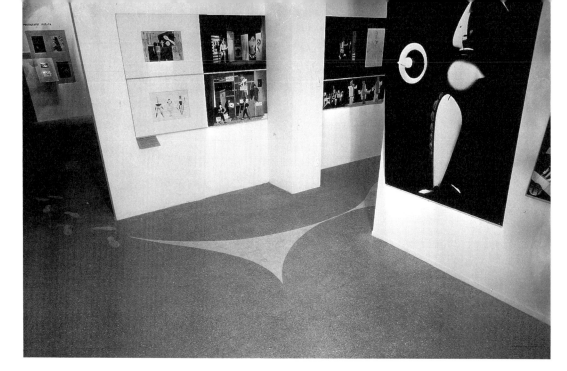

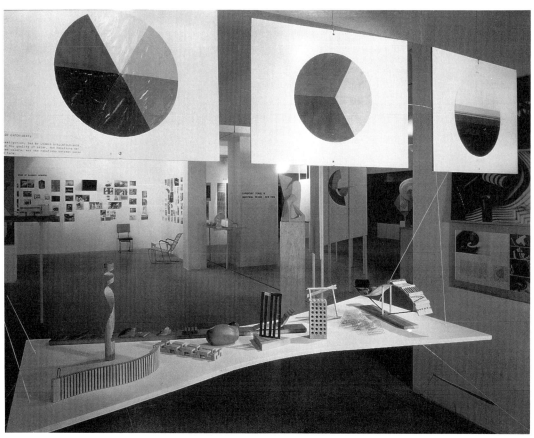

3.6 ←

Bayer, painted footprints and directional patterns on floor, *Bauhaus 1919–1938,* 1938–1939.

3.7 ←

Bayer, curved tabletop suspended by string, *Bauhaus 1919–1938,* 1938–1939.

3.8

Bayer, stacked glass box vitrines, *Bauhaus 1919–1938,* 1938–1939.

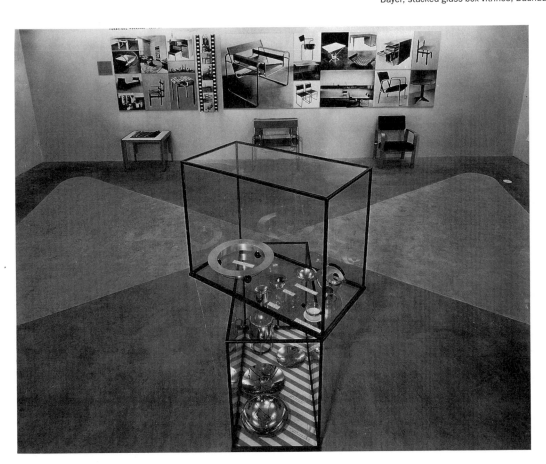

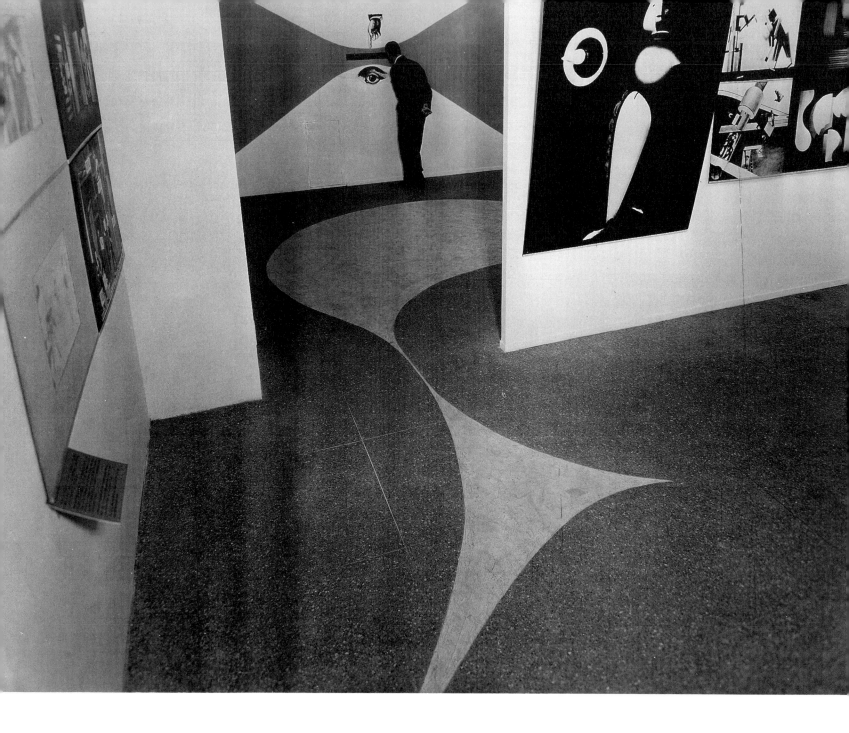

3.9
Bayer, *Bauhaus 1919–1938*, 1938–1939. Photograph of Herbert Bayer looking
into peephole.

James Johnson Sweeney also believed in the Bauhaus's place in history and wrote in the *New Republic* that the Bauhaus produced "some of the finest industrial designs of the present century." But, like Jewell and many of his colleagues, he found the Museum at fault: "the Museum of Modern Art can scarcely be said to do justice to the ideas behind the Bauhaus and the influence it has exerted. . . . [A] greater critical frankness and more stringent selection would have been less confusing." He too singled out the installation, suggesting that "a more modest descriptive tone throughout the display might have made it clearer to the average visitor."[14] Such comments were found in the pages of the art magazines as well. The critic for the *Art News* gave a mixed review of the work produced at the Bauhaus but flatly condemned Bayer's installation methods, calling the display "a maze" that made no sense; she even faulted Bayer's assimilation of Bauhaus training in color properties, questioning his use of "too intense red" for the wall labels.[15]

There were, of course, conservative critics who saw little value in the Bauhaus or in anything associated with it, like Royal Cortissoz of the *New Herald Tribune*.[16] Henry McBride of the *New York Sun,* in the first sentence of his review, called the show a "forlorn gesture" and emphasized that it was "clumsily installed." He dismissed the Bauhaus as merely a "well-advertised" movement; even though "international entanglements" might tempt the viewers to be "extra kind" to these artists, they should face the fact that the work was "essentially heavy, forced and repellant."[17]

Most of the reviewers discussed the closing of the Bauhaus by the Nazis. The critic of the *Daily Worker* offered a novel interpretation, seeing the Bauhaus's "expulsion by Hitler as a cue to its high cultural value."[18] Barr and Gropius, in their personal correspondence, had discussed the problem of how anti-German sentiment might affect the reception of the show. Even more disturbing was Barr's concern that the exhibition would be seen by some as "Jewish-Communist."[19] Although prejudice and nationalism may have colored the responses of some individuals who disliked the show, these do not seem to have been the dominant factors.

There actually were several very favorable reviews. Lewis Mumford in the *New Yorker* hailed the show as "The most exciting thing on the horizon." The critic for the *Magazine of Art,* acknowledging the contribution of the Bauhaus, praised Bayer for his "fresh and vigorous" and clear installation.[20] And even though Emily Genauer in the *New York Post* criticized the fine art produced at the Bauhaus, arguing that painting and sculpture are not the stuff of science and mathematics, most of her review applauded the "enormous . . . scope" of the school and its "unbelievably great . . . effect on the whole course of modern art, architecture, housing, industrial design, textiles, advertising, typography and pottery." Genauer specifically praised "the effectiveness of Bauhaus principles of exhibition technique" as seen in the way Bayer worked with

the museum's not too spacious galleries, and the very fact that the result is not confusing, that there are clarity, emphasis and drama in the arrangement (even the floors, traditionally not part of the exhibition, are decorated with painted guide lines, footprints and abstract forms which not only direct the visitor step by step through the exhibition, but bear artistic relation to the physical shapes of each gallery and the type of objects displayed in it).[21]

Despite these positive reviews, it is significant that in the final analysis the show was judged a failure. Barr's correspondence reveals that he thought the exhibition a disaster.[22] But brilliant showman and resilient professional that he was, Barr swung into action, taking the offensive in mounting what nowadays we call "damage control." Lux Feininger was commandeered to de-

fend the exhibition in response to Jewell's review in the *New York Times,* as were other former Bauhäuslers.[23] This resulted in Barr, as well as a Bauhaus graduate and a student of Josef Albers from Black Mountain College, publishing letters in the *Times* on the following Sunday.[24] Barr also wrote a report that was sent to the trustees and the Museum's advisory committee. Titled "Notes on the Reception of the Bauhaus Exhibition," it outlined the objectives of the show and tabulated the reviews under the categories of "Hostile," "Unfavorable," "Favorable," and "Enthusiastic."[25] Barr informed the trustees and the committee that the exhibition was a popular success and that it had a far larger attendance than any show presented in the temporary quarters. (It must be kept in mind, however, that the Museum had been in those temporary quarters for only two years.) Barr suggested that critics who really knew the field, like Mumford (who was the sole critic in Barr's "enthusiastic" category and who had contributed to a Museum catalogue in 1932), loved the show—and he included a copy of Mumford's review, just in case they had overlooked it.[26] Furthermore, he argued that many of the reviewers were "amusingly contradictory," like Cortissoz, who ended a scathingly negative review with the sentence, "The Modern Museum has never better demonstrated its function as a laboratory for the analysis of latter-day experimentation."[27]

Barr's attempt to put the show's reception in the best possible light for the trustees was duplicated in a more public way by John McAndrew, curator of Architecture and Industrial Art, in an issue of the Museum of Modern Art's *Bulletin* devoted to the *Bauhaus* exhibition.[28] Like Barr, McAndrew presented the exhibition as merely controversial and the reviews as contradictory, thereby attempting to neutralize the negative responses. Had Barr and McAndrew had recourse to the terminology of the early 1990s, they might have characterized the show and its reception as demonstrating the pluralism of the cultural landscape.[29]

In retrospect, the *Bauhaus* reviews seem markedly different from standard exhibition reviews of today, for the writers foregrounded the installation itself—evidence of its visibility to critics, artists, curators, museum administrators, and, one would presume, the public. This visibility of the installation is related to an awareness of the spectator interacting with the displays. During MoMA's fledgling years, the viewer's presence was, in this specific sense, acknowledged by museum curators and administrators more than it generally is today.[30] The evidence of this awareness is borne out in the *Bauhaus* installation: in Bayer's painted footprints on floor, in his elements that mimic visitor circulation, and in his exhibits tilted to accommodate the viewer's "field of vision."

Pairing Plato with Machine Parts: The *Machine Art* Show

There was another reason Barr and his colleagues were alarmed about the failure of the *Bauhaus* exhibition: the Museum of Modern Art's 1934 *Machine Art* show. That previous landmark exhibition devoted to design, curated by the director of MoMA's architecture department, Philip Johnson, had been an unqualified success. Like the *Bauhaus* exhibition, the show was composed of six sections: "Industrial Units," "Household and Office Equipment," "Kitchenware," "House Furnishings and Accessories," "Scientific Instruments," and "Laboratory Glass and Porcelain." Comparable in size to the *Bauhaus* exhibition, which contained approximately seven hundred items, *Machine Art* was composed of approximately six hundred. But the earlier show was a very different and, in a sense, simpler project, with a more

clear-cut agenda. Everything in the show was included for one reason: its beauty.

Both the art and mainstream presses loved the exhibition—and they loved Johnson's elegant, aestheticizing installation. The exhibition catalogue begins with a quote from Plato celebrating ideal beauty: "straight lines and circles, and shapes, plane or solid, made from them by lathe, ruler and square. These are not, like other things, beautiful relatively, but always and absolutely."[31] This Platonic, idealist aesthetic was manifest in every detail of the exhibition.

The entire three floors of MoMA's townhouse were redesigned to create an aesthetic shrine to the beauty of "machine art." Panels were erected and walls were encased in shining steel, copper, canvas, and linen (figs. 3.10 and 3.11). Neutral colors and diverse textures dominated, but some walls were painted pale blue, pale pink, dark red, and rust red. In a 1994 interview Johnson recalled: "It was painted a good deal and the pale pink and the pale blue came from Corbusier, of course. He used those wall colors combined with white. So the use of different colors was a Corbusier thing. And, of course, I was influenced by him at the time." Johnson's great influence, however, was Mies, and in exhibition design that necessarily also involved the work of his partner Lilly Reich: "My colors are those of Mies, they are much cut down. Mies didn't use primary colors . . . I wasn't really interested in color. More in texture and neutrality and sand color and natural marble."[32]

Johnson created a dropped canvas ceiling with concealed lighting, an innovation about which he was particularly pleased: "My big thing was dropping the ceiling. I put all the lights in between there. So there were no lights. The whole ceiling was lit. Oh, it was lovely, terrific."[33] The geometrically harmonious installation composed of glass shelving, wall panels, display tables, and bent metal railings hid the townhouse's architectural details and transformed the galleries into a light and airy ordered universe appropriate for the presentation of ideal objects. The varied wall fabrics, the rich metals, and the structures of grainy wood and glass, enhanced by occasional details such as deep blue and black velvet display cloths, enveloped this environment in a veneer of elegance that was crystalline, metallic, tactile, and luxurious—yet also simple, spare, pure, and rational.

Machines and machine parts were placed on pedestals. Domestic, scientific, and industrial wares and equipment were placed individually and in series within specially designed glass cases and on display tables (fig. 3.12). A square gallery was completely dark except for low overhead spotlights aimed at laboratory beakers and petri dishes arranged on a square table in the middle of the room that was covered in black velvet (fig. 3.13). The beakers were arranged in tight rows and caught the light dramatically. In one gallery, nicknamed by the press the "jewel room," a handful of tiny screws was placed on blue velvet in a glass vitrine that was sunk into the wall.

Johnson created Machine Art's modernist installation during the years that Barr was perfecting his similarly modernist nonskied, neutral background method of display. In part, it reflects his ongoing dialogue with Barr; but Johnson also felt that his rich, spare installation was inspired by "Weimar design," "Bauhaus design," and Mies van der Rohe and Lilly Reich's installations (see figs. 1.34, 1.35, and 1.36), specifically their 1927 silk and glass shows in Stuttgart and Berlin and their industrial exhibits at the 1929 Barcelona International Exposition and the 1931 Berlin Building Exposition.[34] Johnson reviewed the Berlin exposition for the New York Times and declared of Mies and Reich's impressive showing there as well as in Barcelona: "The art of exhibiting is a branch of architecture and should be practiced as such."[35]

Interestingly, the critics writing about the Machine Art show agreed with Johnson and treated his installation as a "branch of architecture" and an art form in its own right. When confronted with the Machine Art exhibition, Jewell of the New York Times had

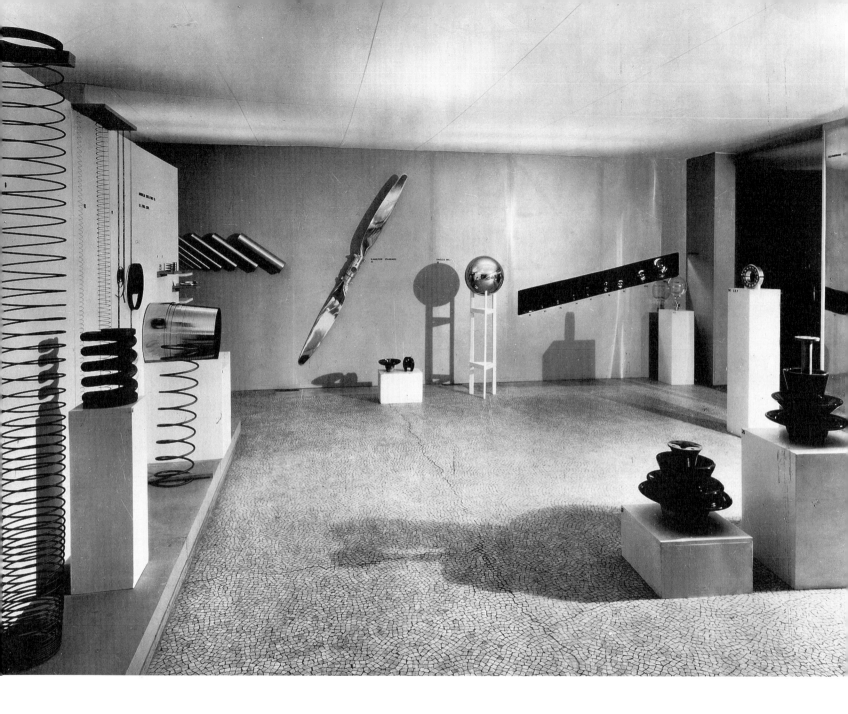

3.10, 3.11

Philip Johnson, *Machine Art,* Museum of Modern Art, 5 March to 29 April 1934.
Neutral colors and diverse textures dominated, but walls were painted pale blue,
pale pink, dark red, and rust red.

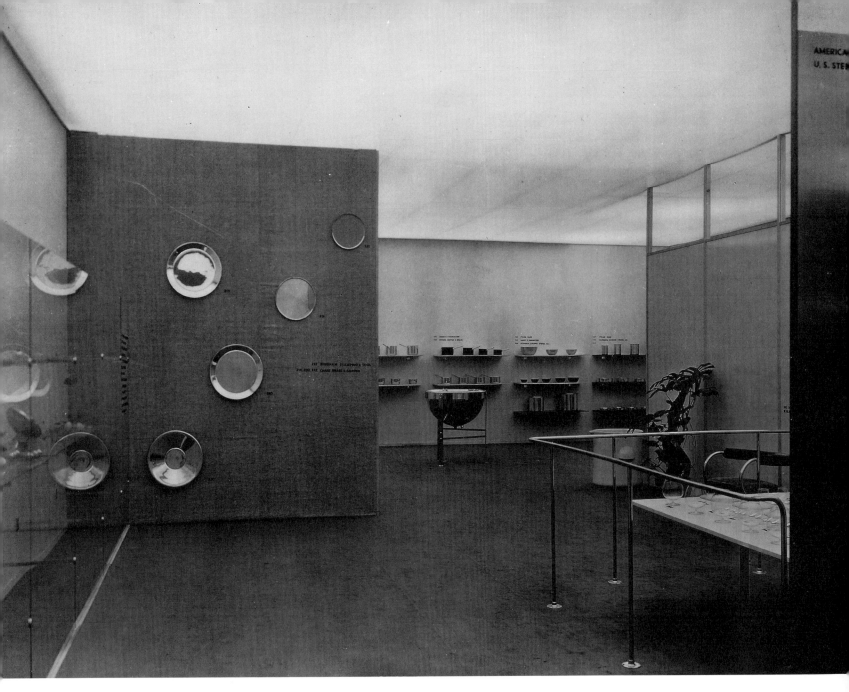

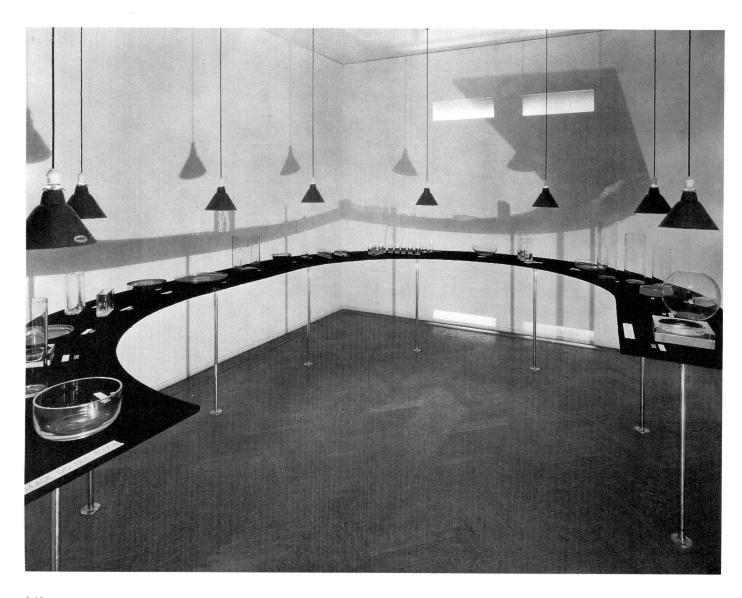

3.12
Johnson, glassware on display tables, *Machine Art,* 1934.

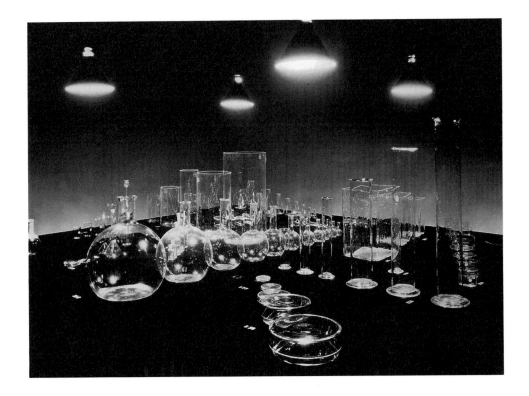

3.13
Johnson, laboratory glassware spotlit on black velvet, *Machine Art,* 1934.

high praise for the show—and the installation: "first of all, the exhibition is splendidly installed. . . . *The Machine Art* show must certainly be said to constitute Philip Johnson's high-watermark to date as an exhibition maestro."[36] The importance of the installation was emphasized in most of the reviews in newspapers and art magazines. Joseph W. Alsop, Jr., in the *New York Herald Tribune* detailed elements of Johnson's "special method of exhibition."[37] A similarly meticulous description of the display technique was found in the *Art Digest,* where the better part of an article was devoted to an illuminating description of the installation.

The entire floor plan of the museum and the surfaces of the walls have been changed by factitious muslin ceilings, movable screens, panels and spur walls of aluminum, stainless steel and micarta, and by coverings of oilcloth, natural Belgian linen and canvas painted pastel blue, pink and gray. Three methods of display have been employed: isolation (single pieces displayed like statues on pedestals); grouping (the massing of series of objects such as saucepans, water glasses and electric light bulbs), and variation (a different type of stand, pedestal, table and background for each object or series of objects). This style of installation, planned from the standpoint of the observer, tends to avoid the diffusion of interest which is so common to huge displays.[38]

Even the conservative critics who four years later hated the *Bauhaus* show and who had difficulty accepting the very of concept "machine art," such as Henry McBride, found Johnson's exhibition technique rewarding. McBride promised readers they'd be "bedazzled": "The only art in the present show is that contributed by Philip Johnson. . . . Mr. Johnson learned his trade in Germany, but now, I swear, he beats the Germans at their own game. He is our best showman, and possibly the world's best. I'll say 'world's best' until proof to the contrary be submitted. He has such a genius for grouping things together and finding just the right background and the right light . . ."[39] Reflecting on the success of his *Machine Art* installation some sixty years later, Johnson said, "I think the installation far outweighed the objects. You couldn't not notice it. Obviously the installation was most powerful."[40]

The excitement and publicity surrounding the show was magnified by a visitor poll and contest to determine the most beautiful machine art object.[41] Amelia Earhart, John Dewey, and Charles R. Richards (the director of the Museum of Science and Industry) also participated as judges who made their personal selections: they chose a large thick steel spring for first prize, an aluminum outboard propeller for second, and ball bearings for third. The public made different choices, selecting a triple mirror, a bronze boat propeller, and finally an aluminum airplane propeller. The contest secured the exhibition maximum press. The *New York Times* alone ran six articles dealing with the show.[42] When asked about the visitor poll, Johnson said, "Those things are all PR."[43]

The visitor poll and contest, however, signify much more than a mere publicity stunt. Their importance is related to Johnson's and his colleagues' consciousness of the viewer in the exhibition. Although this installation of objects on pedestals was very different from the viewer-interactive *Bauhaus* exhibition, and though *Machine Art* was obviously shaped by an idealized aesthetics, the show fostered a dialogue with those who came to see it.[44] The incorporation of the visitor's poll destabilized the myth of "timeless beauty" and subjected this machine art to the prejudices of a specific viewer in a specific culture. There was a viewer in this exhibition's text and he or she was wandering through the galleries, deciding whether some ball bearings or a propeller should win best-in-show.

But what was the reason for *Machine Art*'s spectacular success and the collective delight that the American critics and public found in machine parts lined in rows? The difference between the critical reception of the *Machine* show and that of the *Bauhaus* exhibition is particularly ironic in light of the singling out—by Johnson as well as the reviewers—of the Bauhaus as the paradigm of the machine aesthetic. Certainly an aspect of this contrast had to do with the somewhat didactic and documentary character of the *Bauhaus* exhibition compared with the easy elegance of *Machine Art*. Johnson remembers: "They were trying to do the history of the school. They would show one object, I would show a hundred. It's just a showmanship thing on my part. I was just trying to fill up the space with a gorgeous installation."[45]

Johnson's method had a more seamless, architectural quality that was different from Bayer's presentation of diverse design elements. Judging from contemporary accounts, Johnson's installation was indeed "gorgeous," but some of its appeal may also have come from the show's reinforcement of an ahistorical understanding of culture. The primary agenda of the exhibition was to reveal the timeless essence of the most mundane of objects. If the viewer could get past the fact that these were nuts and bolts on display, the installation provided a familiar, idealized environment for the enshrinement of timeless beauty, consonant with the modern mythology of art as universal.

But there was another important difference that helps explain the dissimilar receptions of the two shows. Despite the reputation of the Bauhaus and the emphasis on Bauhaus principles

in American schools like Black Mountain College, it was a German institution. *Machine Art,* in contrast, featured the products of American industry. An exhibition preview published in the Museum's bulletin promised that all of the items selected for the *Machine Art* show would be made or distributed in the United States.[46] Studding the walls throughout the exhibition in clear, legibly sized black lettering were the names of U.S. companies: Aluminum Company of America, U.S. Steel Corporation, Bingham Stamping and Tool, America Sheet and Tin Plate Company, American Radiator Company (see fig. 3.11). This lettering identified the manufacturers of the exhibited objects and the wall partitions, a practice that Johnson no doubt adopted from that of European international expositions such as the installations of Mies and Reich. There was no other didactic material on the walls or pedestals except for the numbers of the objects, which matched very specific descriptions in the catalogue. *Machine Art,* in other words, put on display U.S. know-how at its best. After all, America's cultural authority had not been founded on modern masterworks but was built of industry, automobiles, and assembly-line products. A telling comment regarding the aesthetic reputation of the United States during the first half of the century was Duchamp's famous observation: "The only works of art America has given are her plumbing and her bridges."[47]

In *Machine Art* we have two poles of modern culture—art and industry—unified and framed within an idealized environment. Even though a viewer to the show might have had difficulty finding aesthetics in the parts of a machine, the installation's language of form was the language of the people. Unlike the *Bauhaus* show, which destabilized the cultural codes of its viewers, *Machine Art,* on very fundamental levels, was legible and was easily located within what could be called the American viewers' ideological framework. However unconventional the concept of "machine art" perhaps may have seemed to some of the show's viewers, the notion was articulated through an installation that presented aesthetics as timeless. Such an installation gave the viewer an experience that affirmed the modern myth of art as eternal and effaced the fact that the appreciation of "objects for art's sake" in institutions such as the museum or the gallery is a cultural ritual particular to the modern era.

That *Machine Art* lives on and thrives within the Museum to this day testifies to the power of this type of installation and the durability of this framework for institutionalizing modern culture. One hundred objects from the exhibition were purchased by MoMA, and they form the nucleus of the Museum's design collection.[48] At the entrance to MoMA's architecture and design galleries there has long been a vitrine containing items from *Machine Art,* which has served synecdochally to represent the entire architecture and design collection.[49] Although MoMA's curators would explore diverse design agendas and the Museum would be a laboratory for installation experimentation during the decades following the *Machine Art* show, Johnson's 1934 modernist aesthetic and exhibition technique came to dominate as the standard at the Museum in later years.[50]

There was another, very subtle component of *Machine Art* that would prove portentous for the history of the Museum. The objects included in *Machine Art* were not only made in the United States: they were things that could be bought in the United States as well. Included in the catalogue was a checklist of manufacturers—and in some instances designers—as well as prices, if available. Some reviewers noted the exhibition's similarity to department store displays—the *New Yorker* likened the galleries to a hardware store.[51] And it was reported that visitors transgressed museum codes of behavior and went so far as to handle and test the products, check prices, and attempt to make purchases.[52] In other words, they were shopping. A statement in the *Museum Bulletin* made the point that an additional purpose of the show was "to serve as a practical guide to the buying public."[53] This somewhat secondary dimension of the *Machine Art*

show would prove to be the most powerful influence on the design department at the Museum of Modern Art for the next several decades.

Window Shopping at the Museum: The *Useful Objects* Shows

At the time that Johnson was proposing his idea for a *Machine Art* show, both he and Barr agreed that the Museum should mount an industrial design show that would discriminate between "good modern design and modernistic cosmetics or bogus streamlining." [54] Modern design was an integral part of both Barr's "1929 Plan" for the Museum and, more generally, his understanding of modern art and culture. When Barr had been a young instructor at Wellesley, he gave his students the assignment of purchasing "well-designed 'useful objects' from ten-cent stores for a class exhibition." [55] Barr noted that Johnson felt the idea of machine art would "catch the public eye," and Johnson himself recalled that machine art "sounded like a more poetic title. . . . It was inspired by the machine. We didn't just show useful objects which could perfectly well have been handicraft. I wanted to emphasize the art history of the pure machine." [56] Barr, who had something slightly different in mind, wanted to call the show *Useful Objects*. [57]

In 1938, the same year as the *Bauhaus* exhibition, The Museum of Modern Art mounted its first *Useful Objects* exhibition: *Useful Household Objects under $5*. Edgar J. Kaufmann, Jr., who would become director of MoMA's industrial design department in 1946, acted as a consultant to the Museum committee that selected items for the exhibition. [58] Low-priced, machine-made, mass-produced household articles were arranged in installations that evoked, in a simple and minimal style, both store and home. There were elements of simulated domestic interiors, like a window with venetian blinds and a table arranged with "objects under five dollars" (fig. 3.14). Along some of the gallery walls were display counters with long metal legs and flowing, organic contours that mimicked viewer circulation. Curved panels of corrugated white cardboard, like those used in the *Bauhaus* exhibition a few months later, created alcoves for dark, kidney-shaped tables whose contours also visually echoed the movements of the visitors. The show was set up for easy travel to seven venues, including an art association, three colleges, two department stores, and one specialty shop that handled furniture, pottery, textiles, metalware, and glass. That the installations were somewhat modest and shaped by limited budgets was completely appropriate for an exhibition founded upon the concept of low cost.

However modest, the show was a success—not merely on the level of good press and favorable reviews, but in the extremely practical and financial terms of commerce and business. Manufacturers and prices had been listed on the exhibition labels. As a result, significant numbers of visitors sought these objects from local distributors, with some consumers requesting them directly from manufacturers. Some wholesalers actually opened new retail outlets as a direct result of this exhibition. [59] Manufacturers whose goods were not included in the show contacted the Museum, requesting that their wares be selected if there ever was another such exhibition. *Useful Objects* was a realization of the Museum's charter to educate the public about all aspects of modern visual culture, but it also directly affected manufacturing and consumption. The show's success was secured by foregrounding the visitor's role as consumer and by presenting modern culture as modest, down-home, democratic housewares. In these respects, *Useful Objects* was a very American manifestation of the international avant-gardes' agenda to redesign the modern world. Except for two years during World War

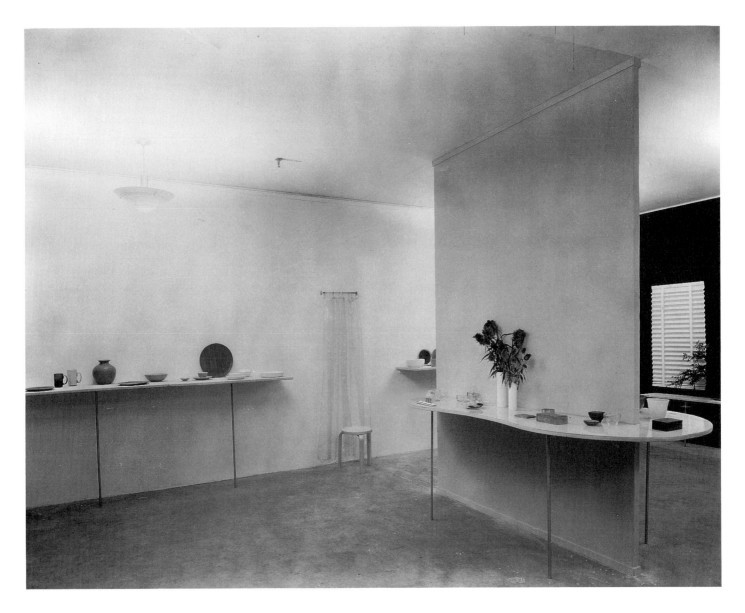

3.14
Useful Household Objects under $5.00, Museum of Modern Art, 28 September to
15 November 1938.

II, variations of the 1938 show were to be an annual event at the Museum until 1950, when a related but more ambitious annual design show was instituted.

The 1939 *Useful Objects* exhibition featured items with a price limit of ten dollars and was held at Christmas time to influence and make the most of holiday shopping. For this exhibition, the gallery walls and ceiling were deep blue and the objects were lit by spotlights. But more significantly in the creation of the show, the installation display structures, like the useful objects, were packaged to travel. Learning from their experience the previous year, the Museum staff consciously devised an installation that would easily go on the road. The display tables were lightweight birch and portable (fig. 3.15). The table legs were rectangular framelike structures that wrapped around the white and dark-colored table tops like handles on a basket. Display elements were light, easily demountable, and adaptable to a variety of space constraints. Local newspaper reviews noted this modern transportable display method, describing the various elements of its construction in great detail. In the Springfield, Massachusetts, *Sunday Union and Republican,* a reporter wrote about the "12 uniform tables 5 1/2 feet long made of birch in natural finish, with white tops for display. Each table is hung from 2 supports, which are closed rectangles of narrow wooden stripping standing on the shorter side. This is something like the principle of a suspension bridge." Such keen interest in what might be considered mundane aspects of the installation was quite different from the approach of today's exhibition reviews, as was the unabashed acceptance of the compatibility of aesthetics and commerce. The article in the Springfield paper continued: "See the objects; better still, buy them."[60] As the *Daily Iowan* pointed out, there was merit in the integration of art, commerce, and the objects of everyday life: "entirely aside from the commercial angle that attaches to such an exhibit, the display will do more than anything

we've heard of recently to prove to the public that art is not always snobbish."[61]

The 1940 and subsequent *Useful Objects* shows continued the shopper-friendly Christmastime schedule. The 1940 exhibition, however, included only objects produced in the United States. White tables that looked like counters were set against the dark blue exhibition walls or were hung from the ceiling with white cord. The lighting fixtures, arranged in series, were visually dominant, their whiteness standing out against a dark-colored ceiling. Here and in all the *Useful Objects* shows, the display method encouraged visitors to behave in ways quite outside the usual social codes for museums. Each object had its price and manufacturer's label. Each could be handled, lifted, and tested by the viewer, who in this Museum installation became the consumer (fig. 3.16).

The 1940 show was acclaimed by the *Art News* as the best such show to date. In comparing the show with *Color Prints under $10* (which was held at the Museum simultaneously), the writer focused on the installation method, declaring that "the whole presentation of the products of industrial design steals the show." The writer then suggested that Kress and Woolworth's call in the Museum to assemble their wares.[62] The *New York Times* happily announced a "rare occurrence, a really practical museum exhibit"; and in another article, *Times* critic Edward Alden Jewell noted that these American goods were from "democratically miscellaneous" retailers, including haute department stores and the local five-and-dimes.[63] Such favorable press continued through later *Useful Objects* exhibitions, as reviews were punctuated with comments about the democratic and useful character of the show. There was always a reminder to the reader that purchases could not be made in the Museum; but the exhibition was a shopping aid, with stores and prices cited in a checklist. A typical headline read: "Modern Museum Again Holds Christmas Sale."[64]

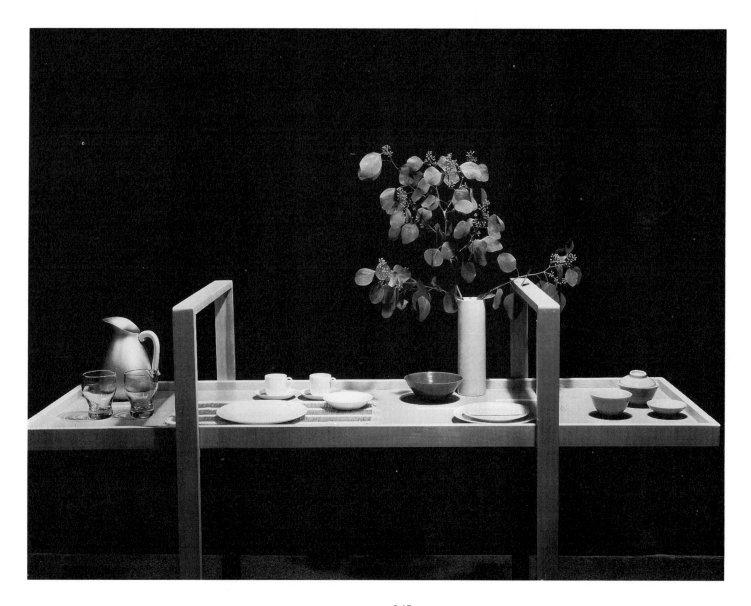

3.15
Items on portable display table, *Useful Objects of American Design under $10.00,*
Museum of Modern Art, 7 December 1939 to 1 January 1940.

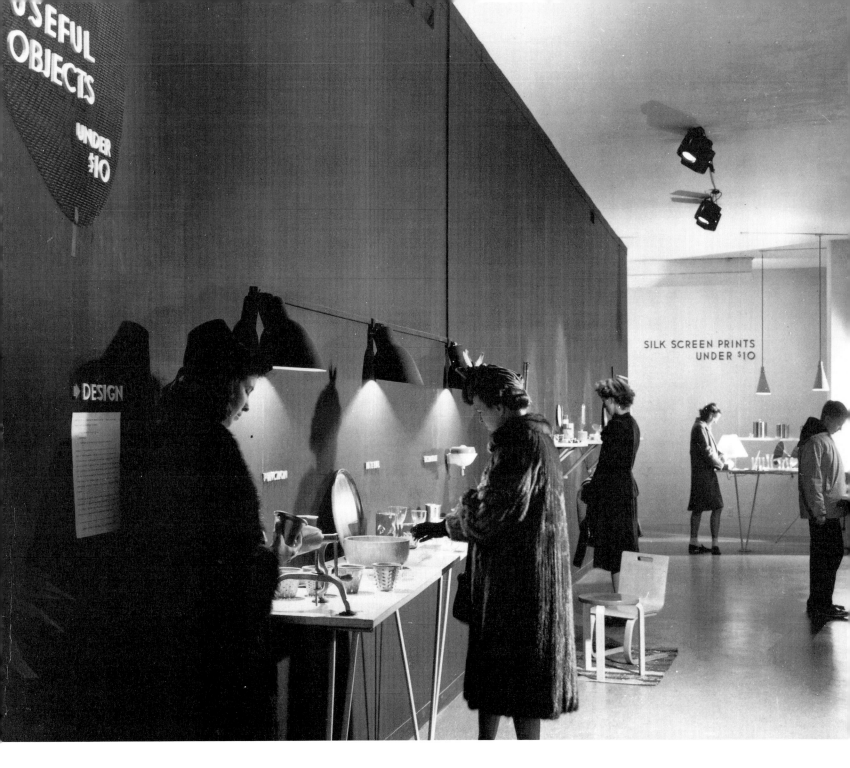

3.16
Visitors handling and looking at objects in *Useful Objects of American Design
under $10.00,* Museum of Modern Art, 26 November to 24 December 1940.

The war brought to center stage the subtle nationalistic dimensions of these exhibitions. *Useful Objects in Wartime* (1942–1943) conformed to federal wartime rationing regulations.[65] In keeping with the Museum's sensitivity to the viewer, or rather to the consumer, MoMA had gone so far as to send questionnaires to men and women in the services to help determine what, from their point of view, would be good to include in the show; the War Production Board also provided recommendations.

With the opening of the next show in 1945, the Museum announced that the following year's *Useful Objects* show would bestow on "the chosen" products a "seal of approval" that manufacturers would be authorized to use. Like the *Machine Art* show of the previous decade, three awards would also be given. Eliot Noyes, director of the Museum's Department of Industrial Design, described the prize as "neither a cash award nor a gold medal, but an 'Oscar' type symbol."[66] The exhibition catalogue, which was distributed nationally, functioned as a consumer purchasing guide for useful things whose price was now capped at twenty-five dollars. The seal, the awards, and inclusion in the purchasing catalogue were coveted by manufacturers and received much publicity; the seal itself was an aesthetic version of a Good Housekeeping seal.

All of these *Useful Object* shows were given spare installations, with items often placed on counters and tables and with walls studded with coat hangers and hung with pots and pans, as if the Museum were a store or boutique. Most of the installations had deep blue walls with white or natural-color display furniture; in many ways, they could be seen as low-budget interpretations of Johnson's *Machine Art* installation. The 1947 show, which had been enlarged, and inflated, to *100 Useful Objects of Fine Design for under $100,* was perhaps the closest *Useful Objects* ever came to the luxury of *Machine Art.* That quality was owed not so much to the enhancement of the purchase price as to the installation created by Mies van der Rohe, who at

the time was having a retrospective at the Museum (fig. 3.17). This 1947 version was distinguished by an elegance, spaciousness, and clarity of form—all consonant with the retrospective installed in the adjacent galleries. Characteristically, Mies displayed objects in repetitive series, and furniture was arranged in simple groupings. White display tables were brilliant formulations of economy of form. Placed against walls, the tables were created by fixing one sheet of wood upon another, forming a T. Reminiscent of Mies and Reich's silk installations, fabrics were stretched onto large rectangular screens. In this show, MoMA's exhibition technique came full circle, for it was Mies and Reich who had influenced MoMA's installation design parameters, both indirectly through their role in creating the field of installations design and directly through their impact on the work and efforts of Johnson.

For the 1948 exhibition, "useful" was dropped from the title because toys were included. In 1949 the show, now titled *Design Show: Christmas 1949,* was selected from the influential modern home furnishings exhibition *For Modern Living* that had been held the previous fall at the Detroit Institute of Arts and curated by architect and designer Alexander Girard. This collaboration was representative of the commitment of U.S. museums to modern industrial design; such exhibitions proliferated from the 1920s through the 1950s.[67] The Newark Museum presented the Werkbund's *Applied Arts* exhibition in 1922, organized by Reich; and in 1928 and 1929 the museum produced shows titled *Inexpensive Articles of Good Design,* which, like MoMA's shows, were also scheduled at Christmastime and aimed at holiday shoppers.[68] In the late 1920s the Metropolitan Museum collaborated with Macy's and installed furniture displays in the store. The Metropolitan's selections reflected a more "moderne," Art Deco aesthetic than that found at MoMA's *Machine Art* show, which was based upon an "industrial" vision of the International Style. The Walker Art Center opened its Everyday Art Gallery in

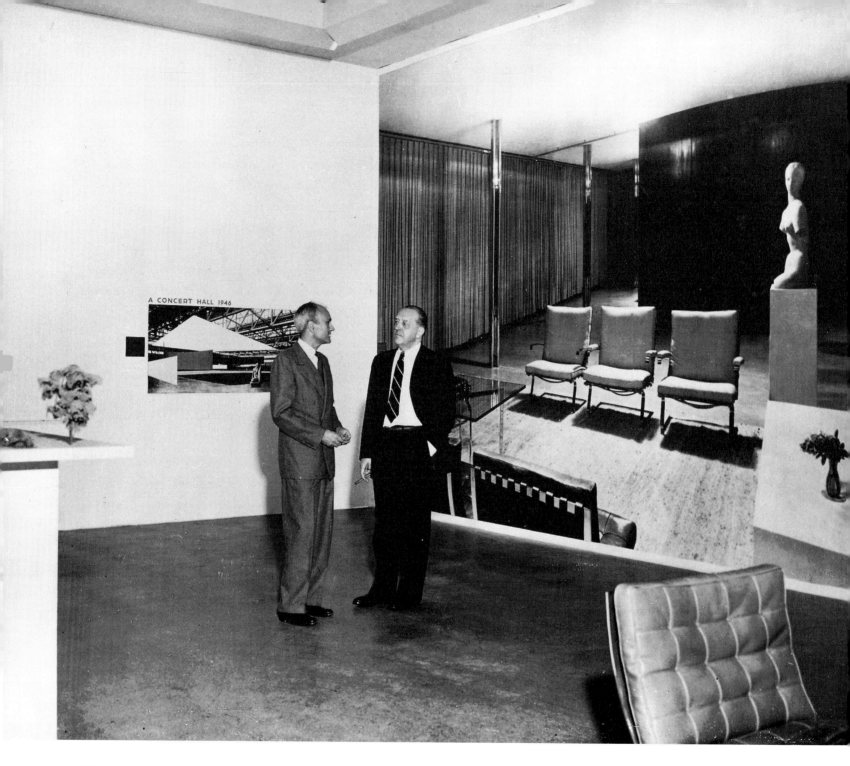

3.17
Mies van der Rohe and Philip Johnson at *Mies van der Rohe Retrospective,*
Museum of Modern Art, 16 September 1947 to 25 January 1948.

1946; in the same year, it began to publish the first journal dealing with everyday objects, the *Everyday Art Quarterly* (renamed *Design Quarterly* in 1958). The Akron Art Institute staged four exhibitions in 1946 and 1947 titled *Useful Objects for the Home.* In the 1950s the Institute of Contemporary Art in Boston held useful object shows, and in 1954, in an exercise similar to Barr's formative assignment at Wellesley, students at Pratt put together a good design project with objects costing from one cent to one dollar.[69] Of all these institutions, it was, in the end, the Museum of Modern Art that most fully integrated the practices and agendas of the department store with the museum and paired American popular taste with the avant-garde.

MoMA's Merger: The Department Store and the Museum

Soon after the first *Useful Objects* exhibition in 1940, the Museum created its industrial design department with Eliot Noyes as director. Noyes, who had been a student and then an apprentice of Walter Gropius and Marcel Breuer, inaugurated the department in 1940 with a furniture, fabrics, and lighting contest titled *Organic Design in Home Furnishings.*[70] The project was undertaken when individuals from Bloomingdale's approached the Museum about working with designers recommended by MoMA's staff. Building on this idea, twelve other department stores were brought in, with Bloomingdale's leading the venture. The stores sponsored the production of the prize-winning designs and then had the rights to sell them. The competition brought innovative designers from both North and South America into direct contact with manufacturers and merchants. The show was heralded as groundbreaking for American design and much commotion was

made about the strange and original winner of first prize, Eero Saarinen and Charles Eames's now-famous molded plywood chair.[71]

The installation, designed by Noyes, received as much notice as the biomorphic Saarinen-Eames collaboration. MoMA's entire first floor and a series of galleries on the second were used; a temporary addition with a terrace was built in the garden. Most of the show was composed of room settings, which resembled domestic interiors and patios (fig. 3.18)—the type of arrangement that has become standard in retail furniture showrooms. These areas were intermingled with exhibits such as explanations of the history of design or the structure of a chair (fig. 3.19). Both the installations and the visitors' code of conduct were hybrid, combining the art gallery with the commercial store. The reviewers took delight in the fact that visitors could touch, move, and even sit in the exhibits.[72]

At the show's entrance, a spare oval-shaped mobile set against a large, white silhouette of a hand was dramatically spotlit. Designed by McKnight Kauffer, this image of hand and mobile was the icon of the show; it was reproduced on the catalogue cover and used in department store displays (fig. 3.20).[73] Mounted on the wall next to the entrance ramp were photographs, didactic labels, and chairs tracing the history of design and of the chair; they extended from the middle of the nineteenth century to the most recent creations (see fig. 3.19). The very same type of chairs had been mounted on the wall by Bayer in the 1930 Werkbund exhibit to suggest industrial production (see fig. 1.25) and by Barr in his 1936 *Cubism and Abstract Art* to isolate examples of a particular style (see figs. 2.12 and 2.13). Here, Noyes installed the chairs not only to display the development of styles but also to introduce consumers to purchasable products.

At the end of the ramp was an exhibit that, from today's perspective, may seem somewhat gimmicky. But most of the

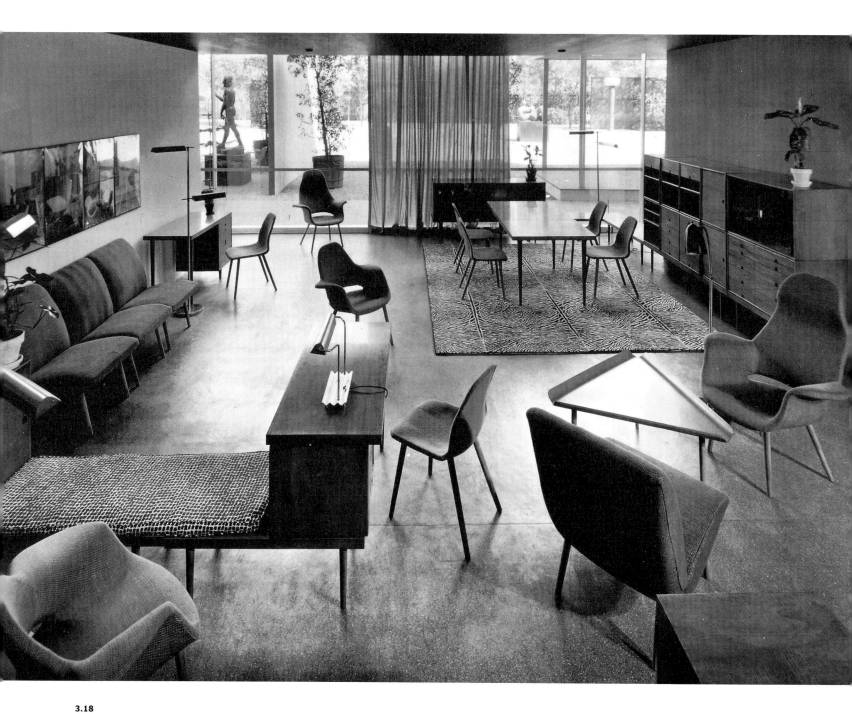

3.18
Eliot Noyes, room settings, *Organic Design in Home Furnishings,* Museum of
Modern Art, 24 September to 9 November 1941.

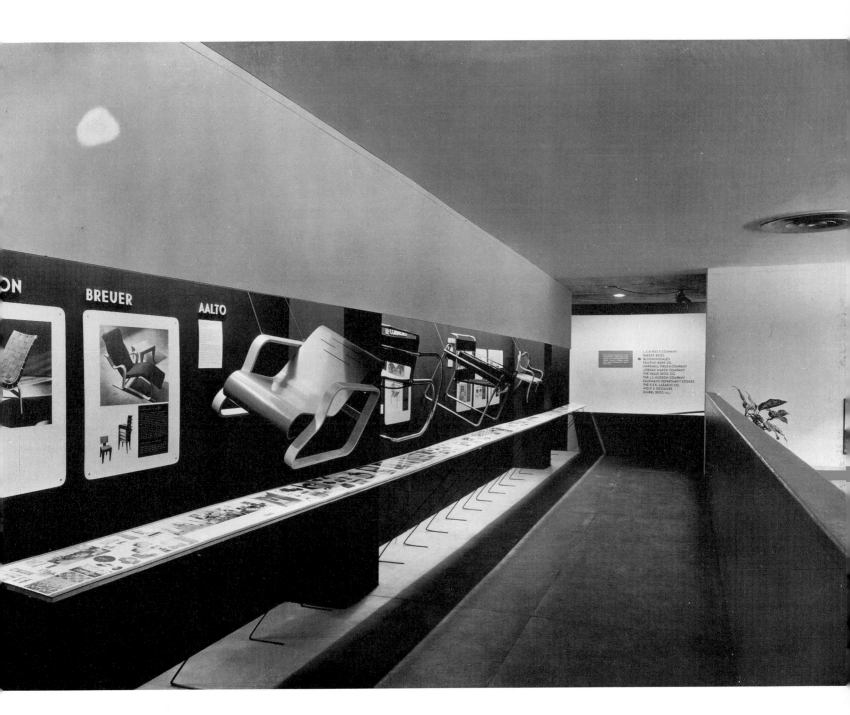

3.19
Noyes, display of chairs, *Organic Design in Home Furnishings*, 1941.

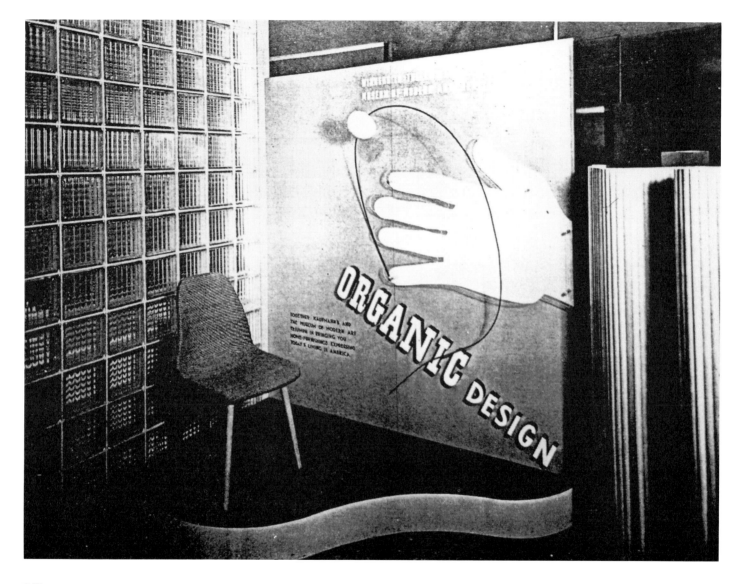

3.20
Organic Design display, Kaufmann's Department Store, Pittsburgh, 1941.

show's reviewers described it with high praise and in similar terms. Inside a display cage was a picture of a big gorilla hovering over an actual broken-down, stuffed, traditional armchair that was labeled, "Cathedra Gargantua, genus Americanus. Weight when fully matured, 60 pounds. Habitat, the American home. Devours little children, pencils, fountain pens, bracelets, clips, earrings, scissors, hairpins, and other small flora and fauna of the domestic jungle. Is rapidly becoming extinct."[74] Mounted on the wall near this "monstrosity" were some of the new chair designs, cut open to reveal their construction and the advances of design technology.

Noyes's MoMA exhibition technique was judged "spectacular" and "brilliantly installed" by the press.[75] The Bloomingdale's installation was given to competition winners Oskar Stonorov and Willie von Moltke, who created an extravagant display that included simulations of a two-room modern house and a three-room traditional colonial home, complete with picket fence, yellow linoleum walkway, fake grass, and trees. Colonial and modern facades were built, as was an outdoor patio. However much they provided an ersatz experience, the displays were an attempt to manifest the way these designs might be assimilated into the fabric of everyday American life—a point that was featured in the show's publicity. MoMA's founding president, A. Conger Goodyear, was quoted in the *New York Sun* declaring what "ought to be carved over the entrance to every museum and . . . on the wall immediately in front of its director's desk. . . . 'Art is bringing beauty into daily life.'"[76] I. A. Hirschmann, vice president of Bloomingdale's, spoke of the store's benefiting from the "dynamic resources of the Museum of Modern Art to produce home furnishings for everyday people in everyday life." Hirschmann's remarks, which were repeatedly recycled in the press, specifically tied the competition to vast ambitions, for the United States "must become . . . the second Europe."[77] He praised the accomplishments of the New Deal in housing and reminded manufactur-

ers that they had not as yet done their part to contribute to this program of social change.

Although the *Organic Design* competition, like its *Useful Objects* predecessors, was international in scope, the project was a decidedly American capitalist enterprise. An image that makes visible the role of the Museum of Modern Art in assimilating avant-garde culture within the United States was found in the pages of New York newspapers. Featured in a series of Bloomingdale's ads published in conjunction with the *Organic Design* show was Kauffer's silhouette of a hand, identical to the one found at the entrance of the *Organic Design* exhibition and provocatively similar to the black silhouette of a hand that had opened MoMA's *Bauhaus* exhibition two years before (figs. 3.21 and 3.22).[78] But the hand in the newspapers did not symbolize Bauhaus theory; instead, it advertised Bloomingdale's merchandise: "Bloomingdale's Presents Organic Design Furniture and Furnishings . . . Created for the World of the Present, Sponsored by the Museum of Modern Art . . . Sold Exclusively by Us in New York."[79] Turned to the side, white instead of black, and placed not only on the Museum's walls but in a corporate sponsor's advertisement, this image makes visible MoMA's transmutation of avant-garde strategies in its effort to foster the adoption of modern design in the United States.

In 1950 the Museum exhibited the results of another design contest, the *International Competition for Low-Cost Furniture*, which involved designers from thirty-two countries and close to three thousand entries. The project was sponsored by the Museum Design Project, which was a nonprofit organization set up by representatives of the trade; they in turn sponsored the development of the designs and sold the mass-produced pieces in some 266 stores in the United States. Perhaps the clearest picture of the exhibition comes from an ad published in the *New York Times* by Sachs, a member of the Design Project:

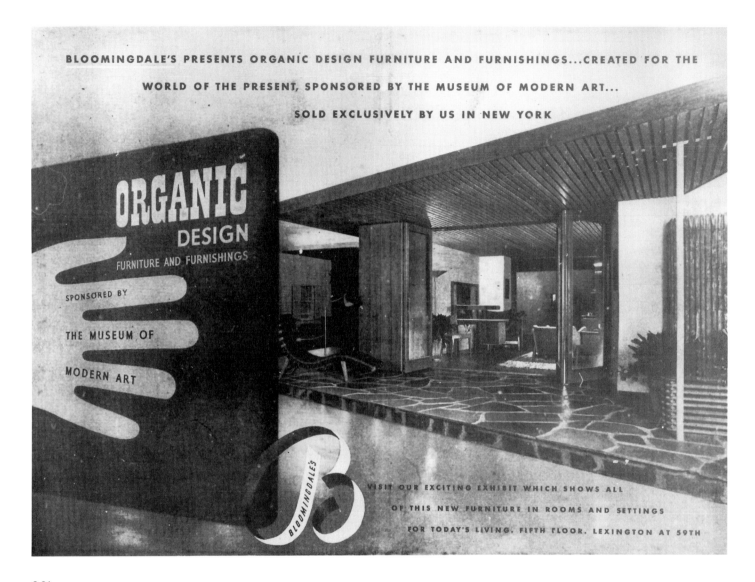

3.21
McKnight Kauffer's image of a hand that was the icon of *Organic Design* show reproduced in Bloomingdale's advertisement published in the *New York Times* (28 October 1941, 26).

Two Great Institutions Join Hands. The Museum of Modern Art and Sachs Quality Stores are co-sponsors of one of the most significant developments in the furniture world in two centuries. Together, these forward-looking institutions sponsored an International Competition in Low Cost Furniture Design. . . . You can see the prize winners at the Museum of Modern Art and Sachs Quality Stores . . . and you can buy them only at Sachs-Quality in all New York. . . . The Museum of Modern Art gladly joined us in this world-wide adventure in better living. The United Nations endorsed it. There were almost 3000 entries submitted by designers of 32 nations.[80]

3.22

Herbert Bayer's image of a hand at the introduction of *Bauhaus 1919–1938*, 1938–1939.

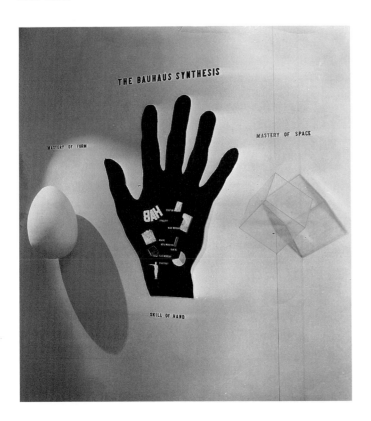

Although the competition created a great deal of publicity, it received less press than *Organic Design,* and the MoMA installation was virtually undocumented.[81] The exhibition of note was not at MoMA but at Sachs, where George Nelson produced a display that included a time line of the history of design covering the previous fifty years. This lack of emphasis at the Museum was most likely due to the fact that this was the year the Museum introduced its most ambitious program involving modern design: the *Good Design* exhibitions, which were the climax of MoMA's incorporation of American commerce and industry within its galleries.[82]

The *Good Design* Experiment

The *Good Design* shows were a series of competition exhibitions that ran from 1950 to 1955 and were the result of a partnership between the Museum of Modern Art and the Chicago Merchandise Mart, a wholesale merchandising center housed in "the world's largest building."[83] Edgar Kaufmann and two other jurors selected the best designs from the Mart's home furnishing showrooms. Leading designers and architects exhibited these designs at the Mart in January, timed to coincide with the winter home furnishing market; additional selections were added to the exhibition in June, to meet the summer market. Manufacturers and retailers attended the January and June shows, and the exhibits remained open to the public throughout the year. The Museum of Modern Art, which had less space, selected the best items from the summer exhibition and opened a modified version of *Good Design* in the winter of the same year. *Good Design* at MoMA became an annual winter design show similar to the Christmastime *Useful Objects;* it was presented by the Museum

as the earlier, more modest exhibition's offspring.[84] Like another of its precursors, *Organic Design, Good Design* was the result of the commercial sector suggesting a collaboration with the Museum. In this instance, representatives of the Mart requested the Museum's assistance in presenting displays of modern furnishings in its exhibition area.[85]

In the *Good Design* publicity copy, which was repeatedly recycled in the press, much was made of the identical ages of these two great institutions: both were exactly twenty years old.[86] That seeming coincidence points to a more significant parallel, for as institutional types, they share simultaneous origins. Both the museum and the department store arose in the nineteenth century.[87] Both are institutions of modernity and modern capitalism. And both the museum and department store are created for visual delectation and display—one, traditionally, for an original, timeless, aesthetic experience; the other for mass-produced, commonplace, commercial exchange. The museum and the department store are two sides of the same coin, each clarifying and defining the parameters of its "other"; that interrelationship is made obvious in these collaborative shows.

During these "laboratory years," when avant-garde culture was just beginning to be brought into the museum, the great divide that separates high culture from low, the original from the mass-produced, the commercial from the aesthetic was extremely permeable. This was possible, in part, because the institutional conventions for sequestering avant-garde culture within the walls of a museum were still in the process of being formed. When considering the development of the museum and the department store, we must keep in mind that the history of modernity has involved a dynamic, constant reconfiguration of the relationship between the institutions of so-called high and low culture, between commerce and art. The situation during the first several decades at MoMA, however, was quite distinct from that of today. In the *Useful Objects* shows and the *Organic* and *Good Design* exhibitions, we see a kind of instability and fluidity that disappeared as these institutions' particular boundaries were established.[88] That earlier time was a period of creative experimentation, provocative exhibitions and installations, and unabashed commerce and publicity.

During the first half of the twentieth century, the display practices of the museum and department store underwent related transformations. Similar to the move away from skied, salon-style arrangements in museums and the development of spacious, eye-level installations in neutral-colored galleries, in the 1890s and the first few decades of the twentieth century presentational conventions in department stores changed. Rather than the floor-to-ceiling shelving and cabinetry, displays between five and five and one-half feet in height were adopted. The nineteenth-century practice of draping, stacking, and piling goods gave way to spacious eye-level display tables and counters (figs. 3.23 and 3.24).[89] Neutral colors of creamy white and greens were also favored for the interiors.[90] A more sleek and finished look was achieved both in the museum and in the department store during these years due to technical advances. The use of vitrines with inset lighting added drama and an elegance that worked equally well for displays of sculpture and of clothing.

In the thirties, forties, and fifties, "free-flow" interiors for department stores were promoted as more modern and effective than traditional store layouts, where displays were arranged in rigid "waffle" rectangular patterns.[91] The "free-flowing" curvilinear display and traffic patterns opened up vistas and views (as did the eye-level display arrangements). These were also the decades when open vistas and flowing display and traffic patterns were deployed within art museums and international avant-garde exhibitions such as those of Bayer and d'Harnoncourt. In his essays on exhibition technique, Bayer specifically argued for organic and flowing interior spaces.[92] He contrasted this new approach with that of traditional nineteenth- and twentieth-

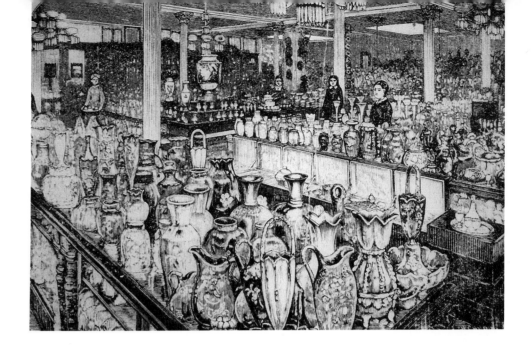

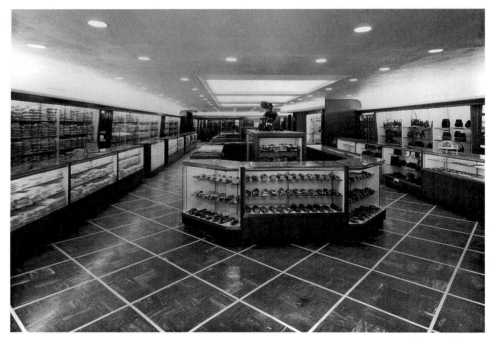

3.23
Macy's fine art, china, and silver room, interior of 14th Street store, New York, 1883.

3.24
Designers: S. S. Silver and Co. Inc., Woolf Brothers department store, Kansas City, Missouri. The New-York Historical Society Collections, 1949.

century exposition architecture, where the rigidly symmetrical display arrangements mimicked the architectural contours of the building and restricted the viewer's movement and vistas (figs. 3.25 and 3.26). Bayer cited the 1930 German Werkbund exhibition in Paris as one of the first successful realizations of this new, viewer-sensitive exhibition technique.

The installation methods instituted during these years, both in the department store and museum, disavowed the architecture of the site and instead emphasized the displays as creating an environment that promoted interaction between the objects and the viewers. These similarities in display practices and the blurring of institutional boundaries were foregrounded in the *Good Design* exhibitions.

The agenda of *Good Design,* as outlined by René d'Harnoncourt, then director of the Museum, was to "stimulate the appreciation and creation of the best design among manufacturers, designers, and retailers for good living in the American home." The criterion for eligibility was simply "if it can be bought in the U.S.A. market."[93] Kaufmann also stressed commercial criteria: "*Good Design* does not represent the best that our designers are capable of; it can show only the best that they have been able to get across in our community—for it is limited to purchasable products." He continued, "*Good Design* serves the public as a buying guide."[94]

The *Good Design* shows manifested an even greater permeability of institutional boundaries between the museum and the store than had MoMA's previous design exhibitions. This was very much a partnership, with MoMA making aesthetic decisions and the Mart footing the bill. The installations featured by the press were those at the Mart, in part because the first showing was always in Chicago during the winter season. It is not insignificant that *Good Design*'s exhibition calendar was determined by the markets, not the museum. The promotional kit available to *Good Design* retailers from the Mart for a fee included an iden-

tification tag, labels, advertisements, and suggestions for window displays (fig. 3.27). All of these items possessed the *Good Design* logo, which was a black circle in an orange square. The press, in general, gave its blessing to this marriage of commerce and art. One such reviewer marveled: "when a museum displays purchasable products . . . its influence . . . can be measured only in terms of the half dozen chairs, the set of cocktail glasses, and the television set the average visitor may buy within the next decade. But when that same museum displays products in a wholesale building, its influence on each visitor will be measured in a steady stream of orders by the dozen, by the gross, and even by the hundreds."[95]

The jury for the first *Good Design* exhibition included Alexander Girard and Meyric Rogers, curator of decorative art of the Art Institute of Chicago. The two installations, which were variations of similar design solutions, were created by Charles and Ray Eames (fig. 3.28). The exhibition spaces were organized into "pavilions," each designated by brilliant color schemes and created with materials provocatively varied and contrasting in color, texture, and connotation. The vast geometric gallery spaces were divided by folding screens, vertical blinds, chains, wire, and an assortment of partitions composed of string, rope, and metal. Light was also used to define and separate areas.

At the Mart, an entrance passageway was formed by black steel gates and a line of orange trees. The visitor then entered the "Hall of Light," where masterpieces from the past—which included a thirteenth-century Madonna, a Kandinsky abstraction, and a selection of colonial household tools—were installed next to a photomural (fig. 3.29). The mural had a vast white background accented with a sparse, geometric layout of close-ups, details, and tiny silhouettes of historical examples of great design: a pair of scissors, a classical Greek vase, and a Thonet chair. At MoMA, the Eameses arranged an introductory furniture grouping that also included a Constantin Brancusi sculpture, a

3.25

Diagram of the 1930 Deutscher Werkbund exhibition at the *Exposition de la Société des Artistes Décorateurs,* Paris, 1930, chosen by Herbert Bayer to exemplify an installation design whose success is due to its dynamic quality and open plan, which enhances the flow of viewer traffic. "Fundamentals of Exhibition Design," *P.M. (Production Manager)* 6, no. 2 (December 1939–January 1940), 19.

3.26

Diagram reproduced by Bayer in "Fundamentals of Exhibition Design" (21) to exemplify an unsuccessful installation design of a traditional exhibition with rigid symmetry.

Julio González sculpture, several examples of ancient and tribal artifacts, and selected pieces of furniture and household items (fig. 3.30). In the first gallery, both installations had long, low "bridges" of Masonite, stretched between pillars, which functioned as dramatic display tables, dividing and unifing the spaces (fig. 3.31). Low, small square tabletops floated on a grid of support structures that also divided exhibition spaces geometrically.

Both installations were distinguished by brightly colored painted and papered walls, columns, and display surfaces. At MoMA the colors tended to be red, green, and chartreuse. Some of the unusual selections included fuchsia crepe paper, gold Chinese wallpaper, Japanese lined writing paper, and brown French book paper studded with tiny white stars. Both installations were punctuated by touches variously organic, handmade, and mass-produced, such as dried desert weeds, household utensils, metal shelf supports, and Japanese kites.

The exhibitions, and the installations, were received as "successes." Critics noted the excitement generated by the

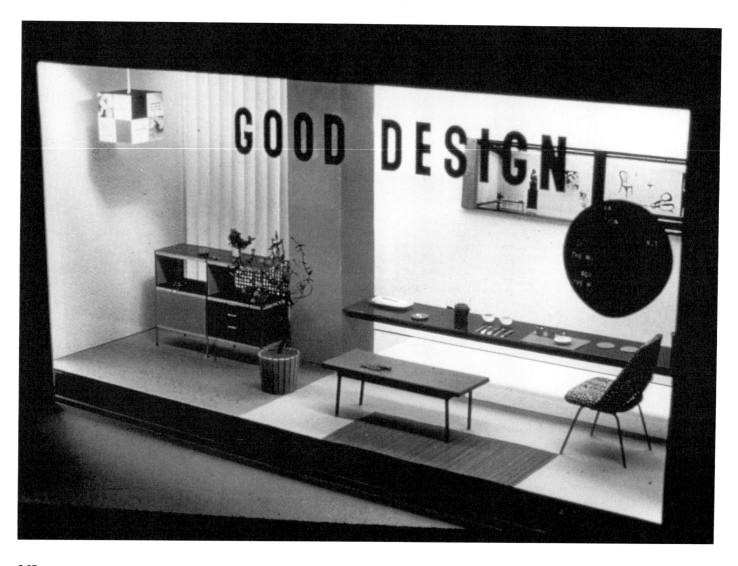

3.27
Herbert Matter, *Good Design* window display, Carson Pirie Scott, Chicago, 1950.

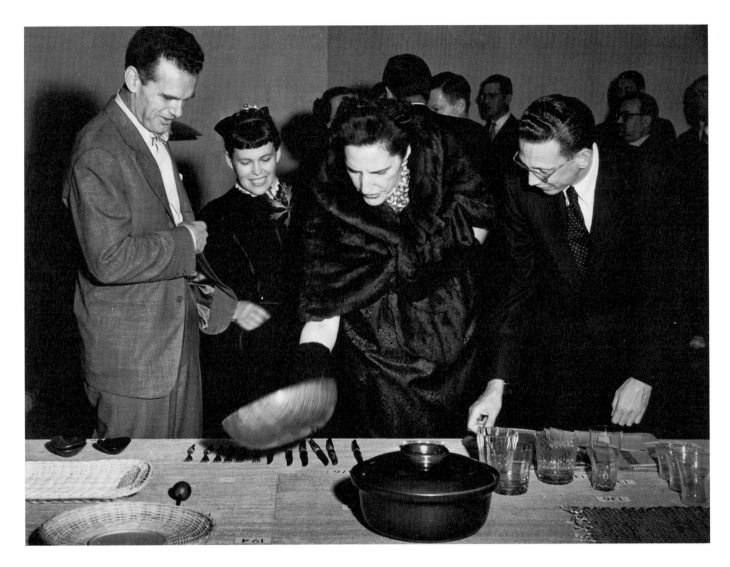

3.28

Charles and Ray Eames, Dorothy Shaver, and Edgar Kaufmann, pictured (*left to right*) at *Good Design,* Museum of Modern Art, 1950.

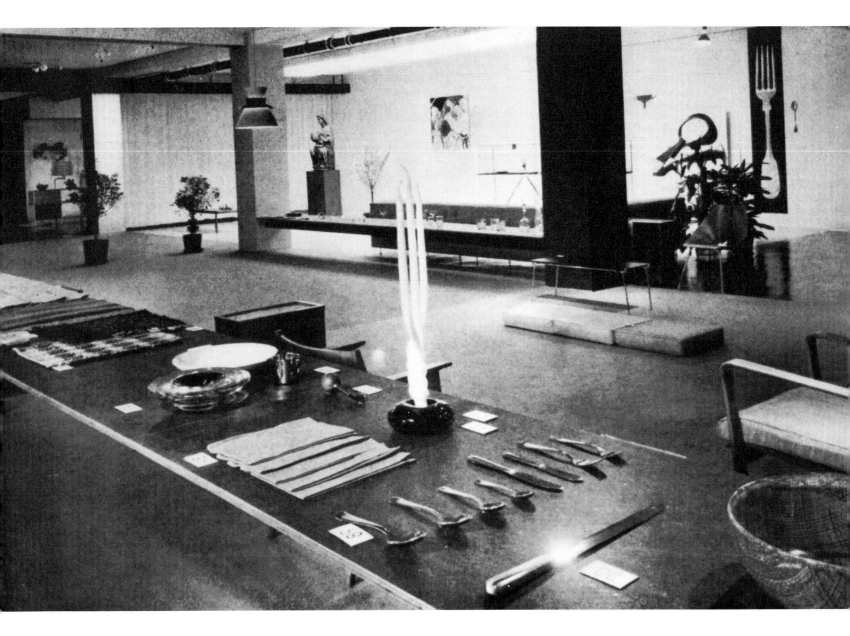

3.29
Charles and Ray Eames, entrance, "Hall of Light," *Good Design,* Merchandise
Mart, Chicago, 1950.

3.30
Charles and Ray Eames, introductory grouping at entrance, *Good Design,* Museum
of Modern Art, 21 November 1950 to 28 January 1951.

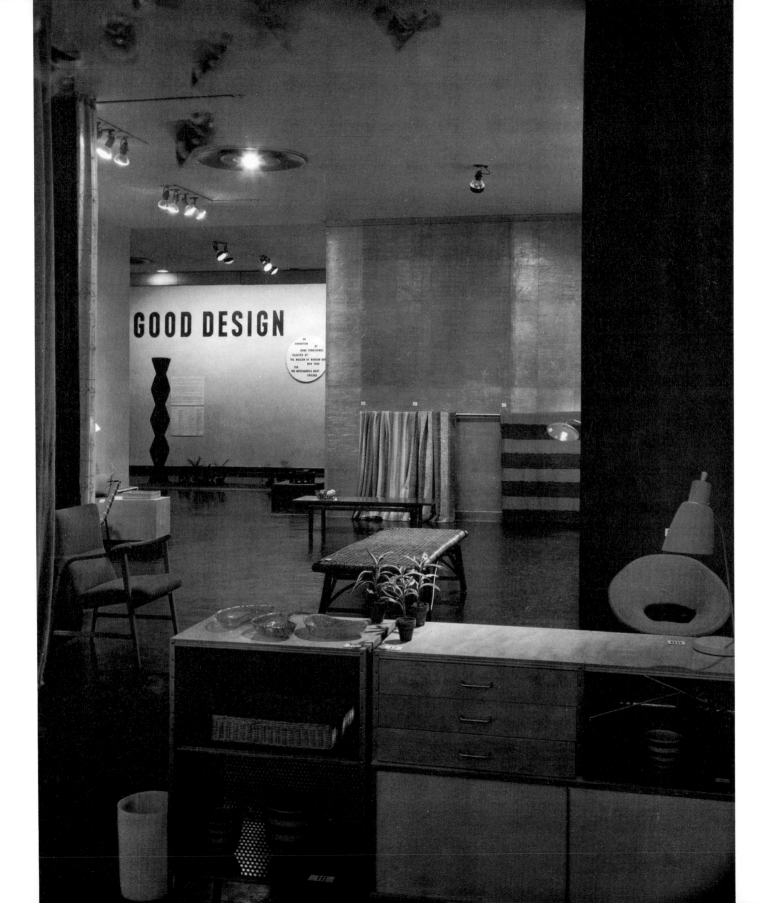

3.31
Charles and Ray Eames, *Good Design,* Museum of Modern Art, 1950–1951.

Throughout the 1950s and 1960s the Eameses designed and installed the interiors and furniture groupings for Herman Miller showrooms (figs. 3.32)—and in many cases the products and furnishings presented at Herman Miller were the very objects shown in *Good Design.*[97] The Eames firm did other department store installations, including a display for Macy's in 1951.

During these years of what could be called the *Good Design* movement, the museum and its counterpart, the commercial store, used virtually interchangeable languages of display. In the case of "progressive" showrooms like Herman Miller and Knoll Associates, the presentation was identical. The Eameses incorporated works of art and domestic details like books and plants in the Herman Miller installations as they had done for the *Good Design* shows. The viewer experienced a furniture display at Herman Miller and one at the Museum of Modern Art as very similar—but not identical. The Museum visitor, as a consumer, was denied instantaneous gratification; before making a purchase, he or she had to use the information available at MoMA to seek out a retailer. The meaning of the objects in the Museum was also shaped by the imprimatur of MoMA. However, this imprimatur is precisely what the *Good Design* seal and publicity package transposed to the marketplace.

The second *Good Design* installations, created by Danish architect Finn Juhl, were similar to those of the Eameses in his use of transparent room dividers and an overall geometric, spacious simplicity. But Juhl's color schemes were different—described by critics as more muted yet bright. One writer gave a detailed description: "Juhl used fresh but gentle colors, floors of brick tile meeting pale cocoa mats, a trellis of white wood backed by green, column sides of white, clear orange, light blue, a lemon yellow wall, a transparent partition of water green glass."[98] The Masonite bridge elements of the year before were used again, and Juhl also installed a photomural of a floor-to-ceiling enlargement of what was identified as a "seven thousand year old pot."[99]

show.[96] Merchants responded by requesting that their merchandise be included in the project and designated "good designs." That *Good Design* was mounted annually until 1955 attests to the inaugural exhibition's positive reception. No doubt a key component in the enthusiasm for these exhibitions was that visitors understood the social codes of the shows and felt "at home." Elegant yet playful, geometric and colorful, both installations looked very similar to the types of interiors the Eames office had designed and would continue to design for commercial stores.

3.32
Charles and Ray Eames, Herman Miller showroom, Los Angeles, 1950.

Juhl's MoMA installation, as was the case with that of the Eameses, presented a variation of the opening exhibition at the Mart (figs. 3.33 and 3.34).

Paul Rudolph's installations for the 1952 exhibitions received particular attention from the press. *Architectural Record* declared that the "installation gets raves."[100] Rudolph's exhibitions were at once geometric, austere, elegant, and theatrical, and the medium he used to stage this high drama was light. His spotlights and contrasting patterns of dim and bright lighting functioned almost as tangible architectural elements. Rudolph has clarified that it was Richard Kelly, the lighting consultant, who suggested the "uneven lighting" and who proposed, "Why not make it like a forest?" Rudolph "thought it was a wonderful idea."[101]

Both the Mart and the Museum installations were in neutral tones, and this in turn accentuated the objects and furnishings on view. In both displays, Rudolph exploited new translucent and transparent materials such as clear plastic string, semitransparent wire mesh sprayed with plastic cocoon (a military invention that he learned of in the navy), and sheer scrimlike fabrics. From these new materials, he created a variety of translucent partitions and elements that directed the viewer through the shows. Dropped ceilings, raised platforms, and long, low shelving that ran against the walls, as well as rectangular rugs, enhanced the sense of an ordered geometric space.

In the Mart installation, two inverted half circles formed the entranceway, which Rudolph described as an "entry gate that you could look through" (figs. 3.35 and 3.36).[102] The semicircular partitions were made of translucent string, allowing views into other sections of the exhibition. The display elements worked to prescribe a route, seen by one writer as "a ghostly frame—colorless and transparent as water—fit[ting] over the exhibition and direct[ing] the spectator's progress . . . [and as] a mysterious shaded maze punctuated by bright pools of light and shimmering, veil-like partitions."[103]

Over forty years later, Rudolph assessed the installation:

It happened to be the first exhibition that I ever made. In retrospect I would like to think that the exhibition did not get in the way of what was exhibited. (Some people whose furniture was placed in dim spots perhaps would not agree with me.) It allowed one to make an exhibition that highlighted certain things. Some viewers have five minutes, others have five days, and you have to answer to both groups and I believe that exhibition answered that question.[104]

The Museum of Modern Art's previous *Good Design* installations had simply been variations of the ones at the Mart; however, Rudolph made changes in the MoMA version because of the building's large number of windows and the different quality of light (fig. 3.37). As a result, the press, which usually featured the Chicago show, took more notice of the one in New York. *Interiors* raved about Rudolph's prolific talent:

In New York, as in Chicago, light is what Rudolph uses to demarcate paths and emphasize objects. The difference is that the New York light is keyed higher. It is in effect a white interior ranging from pearly to dazzling luminescence. The Chicago design is dim, grayed, forest-like, with lighted areas like pools of sunshine— dazzling, but not capable of changing a visual balance weighted for darkness. Also Rudolph scorned to repeat his devices. The ceiling lights in Chicago mostly sprang through dark metal eggcrates; in New York tubes of light are shielded behind translucent Synskin Polyplastex in wooden grid frames that serve as dropped ceilings, while windows, similarly shielded, have been transformed into light-diffusing Mondrians of appropriate scale.[105]

3.33

Finn Juhl, transparent room dividers, *Good Design*, Museum of Modern Art,
27 November 1951 to 6 January 1952.

3.34

Juhl, *Good Design*, Museum of Modern Art, 1951–1952.

3.35 ←

Paul Rudolph, ground plan, *Good Design*, 1952.

3.36 ←

Rudolph, *Good Design*, Merchandise Mart, Chicago, 1952.

3.37

Paul Rudolph, *Good Design*, Museum of Modern Art, 23 September to
30 November 1952.

Rudolph's use of geometric partitions and his somewhat prescriptive yet open layout is vaguely reminiscent of another MoMA exhibition whose installation was much talked about and whose message was about art and everyday living: d'Harnoncourt's 1949 *Modern Art in Your Life.* But a comparison between the *Good Design* show and d'Harnoncourt's exhibition demonstrates how different their messages were. In *Modern Art in Your Life* the viewer was supposed to look at an example of high art in the central gallery and then move to an auxiliary gallery and view objects of everyday life that looked in some way similar to the fine art, thus connecting a Piet Mondrian and a Kleenex box, or a Joan Miró and an Eames chair. At *Good Design* the presentation was little different from that of a high-quality store and the

objects were exactly what such a store might display. In *Modern Art in Your Life* the viewer was intended to have the revelation that modern art was not an alien phenomenon but something more familiar to the viewer than at first supposed. In the *Good Design* shows the everyday objects were raised to the level of fine art and, consistent with the consumer culture that thrived in the 1950s, the exhibitions were meant to educate the viewer about what to buy.

The 1953 *Good Design* exhibition was even more theatrical than Rudolph's design of the previous year. The architect, Alexander Girard, exaggerated the design solutions of his predecessors and created a completely black-and-white installation (fig. 3.38). The galleries were darkened and ceiling and walls were painted

3.38
Alexander Girard, *Good Design,* Merchandise Mart, Chicago, 1953.

black. The floors were black vinyl and cork; the partitions were covered with velvety, light-absorbing black flocked paper. The display surfaces were white and were the only areas illuminated, except for selected partitions of Styrofoam that seemed to be lit from within. A critic writing for *Interiors* perhaps best describes the effect:

In the mysterious blackness of the space the exhibits were the focus of attention, sometimes in tanks of light, sometimes on low platforms like straight spotlighted rivers floating above the black floors, sometimes—in the case of fabrics—stretched tight over their own little display tables. Most inventive of the spectacular devices was a central structure of Dow Chemical's Styrofoam, a glowing snow palace in strict Mies style, populated with glassware, exquisite butterfly-strewn Japanese paper, and in places pierced with knives and forks. Black vinyl-impregnated Dodge Cork covered the floor, dark velveted flock papers, the partitions.[106]

Girard's installations were composed of these reservoirs of light—the display tables, the raised platforms, the shelf partitions—on which, of course, were the reasons for all of this drama: the objects and furnishings. Despite the spectacular installations, the designs themselves were judged in general by the press as somewhat conservative. Allusions were made to its perhaps being a more conservative, traditional time. The *New York Times* critic wrote of "restraint rather than revolution."[107]

The same year as the Girard show, MoMA staged a De Stijl exhibition that was installed by Gerrit Rietveld.[108] Its paintings, drawings, furniture, models, and photo documentation were arranged as a De Stijl environment. In one section, assorted models, furniture, and partitions related to Rietveld's Schroeder House (1924) were placed on a room-size platform that lay flat on the floor. Among the elements arranged on this platform were

a raised, seemingly floating, horizontal panel displaying photo documentation; a vertical partition for drawings and photographs; two chairs; a table; and a pedestal with a model of the Schroeder House. A Rietveld fluorescent lamp hung from a rectangular ceiling panel that ran parallel to the floor. This installation was related to the earlier De Stijl and international avant-garde environments, which were also ancestors of the Girard installation—and, for that matter, all of the *Good Design* exhibitions.[109] However much they ultimately differed from the De Stijl environments, these postwar *Good Design* installations staged a modern reorganization of space to create massive museum showcases for consumer goods.

There were three more *Good Design* exhibitions after the 1953 show. The 1954 show was held only at the Mart, where it had another dramatic installation designed by Girard. Additionally, a *Good Design* retrospective—a "Fifth Anniversary" exhibition—was held at the Mart in 1954 and at MoMA in February and March of 1955. These anniversary installations were created by Daniel Brennan and A. James Speyer, who also designed the last *Good Design* exhibition at the Mart in the winter of 1955. During these last two years of *Good Design,* there was a winding down of enthusiasm for the project. It was a sign of this change that in 1954 the Merchandise Mart held an exhibition titled *Today in Tradition* simultaneously with the *Good Design* show.

The last *Good Design* exhibition was marked by the presence of what Kaufman described in *Interiors* as "industrial designs that hardly qualify as home furnishings . . . [an] indication of the broadening scope of *Good Design.*"[110] These designs included a table TV set, plastic telephones, a portable children's wooden play yard—the leisure-time gadgetry that are symbols of postwar consumer culture. Although these types of objects were occasionally present in previous years—Betty Pepis of the *New York Times* commented in 1951 that the show did have a very small section with a couple of radios, but there were still no "tele-

vision sets in evidence"[111]—it was this dimension of postwar good design and of consumer culture that now grasped the imagination of the Museum of Modern Art.

Postwar Consumer Culture: From Automobiles to Signs in the Street

In the fall of 1951, MoMA brought into its galleries the icon of U.S. postwar consumer culture, the machine that every American could make his or her own, and the signifier of the individual's personal style—the car. Philip Johnson installed eight automobiles in the first-floor galleries and adjacent garden, among which were a 1939 Bentley, a 1948 MG, and a 1951 Jeep. The interior galleries were painted sky blue; the outdoor area was covered with a white canopy.[112] Not surprisingly, there was great interest in the concept of auto design. A symposium held at the Museum for *Eight Automobiles* was such a hit that *Harper's* magazine suggested the Museum find larger quarters for these events in the future: too many people had been turned away.[113] Johnson himself recognized this show as one of his "successes." When asked about his ability to create exhibitions that seemed to capture the public imagination, Johnson said he wasn't always so good at that: "It looks that way because I did the *Machine Art.* It was a hit. . . . And I hit it right with the *Eight Automobiles*.[114]

For the next decade, the Museum continued showing what the *Eight Automobiles* brochure described as "hollow, rolling sculpture" within its walls.[115] In 1953 *Ten Automobiles* was installed in the garden, a show that featured sleek continental designs. In the 1966 *Racing Car* show, automobiles were set on raised platforms within the galleries. Models of cars were on ped-

estals and photo documentation was on the walls. One exhibition that ran from December 1972 to January 1973 featured only one automobile, the Cisitalia. The very last in this series of auto shows was the *Taxi Project* of 1976. The ambitious installation included actual taxis in darkened galleries. Walls were painted with a cityscape silhouette, and elements such as a life-size "taxi stand" and "Dial-a-Taxi" added to the mise-en-scène. These years seemed to mark the end of MoMA's commitment to innovative design exhibitions and installations, and these car shows were among the last reflecting such concerns.[116]

In the 1960s, there was another exhibition that signaled the end of the laboratory period at MoMA: the *Design for Sport* exhibition of 1962. Like the automobile shows, *Design for Sport* was devoted to good design of leisure time. Created in cooperation with *Sports Illustrated* magazine, this exhibition was housed in a massive eighty-square-foot tent pitched in the Museum's sculpture garden (fig. 3.39). The Museum staff collaborated with the magazine editors, who advised them on the sports equipment's standards of performance. A special section of *Sports Illustrated*'s May 14, 1962, issue doubled as the exhibition catalogue.[117] In its introduction, Arthur Drexler, the director of MoMA's Department of Architecture and Design, described *Design for Sport* as continuing the series of exhibitions devoted to useful objects. The installation was a mixture of idiosyncratic and traditional displays: a small plane was mounted on a tripod, a racing car and sailboat were display on low pedestals, and on the white walls of gallery-like alcoves were mounted bicycles, baseball masks, hockey sticks, footballs, and guns. The exhibition, which was held in spring and summer months, had a holiday, leisure-time quality—one might even call it carnivalesque. This type of exhibition was not totally new to the Museum; its precursors included the annual children's Christmas carnivals and the 1953 toy show. But *Design for Sport,* like all the *Useful Objects*

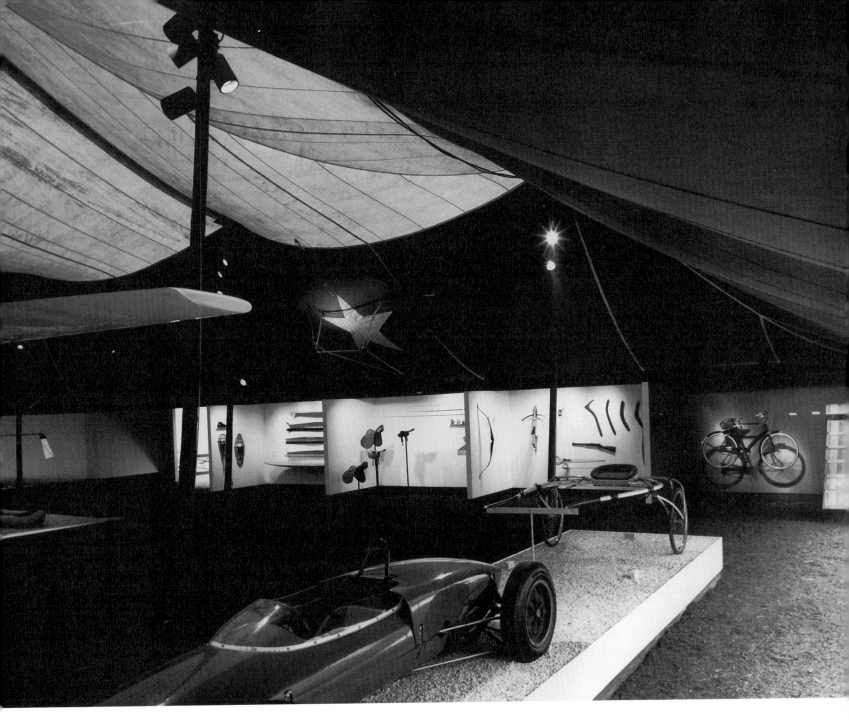

3.39
Arthur Drexler, *Design for Sport,* 15 May to 19 July 1962.

3.40
Mildred Constantine and Philip Johnson, photographs of signs, *Signs in the Street,* Museum of Modern Art, 23 March to 2 May 1954.

3.41, 3.42
Constantine and Johnson, signs in sculpture garden, *Signs in the Street,* 1954.

exhibitions before it, provided the spectator with instructive walks through installations where the commodities of everyday life were sanctioned as paradigms of modern art and design.

MoMA's exhibitions of the 1950s and 1960s reached into myriad arenas of the everyday—even to the signs in the street, which was the name of a 1954 exhibition. *Signs in the Street* developed out of a 1953 Yale University design seminar and professional conference whose subject was contemporary sign-

age.[118] The MoMA exhibition was a collaboration that involved Yale University; the Museum; Philip Johnson, who was then director of MoMA's Department of Architecture and Design; and Mildred Constantine, an associate curator of the department.

The agenda of *Signs in the Street* was to straighten out the "chaos" of modern thoroughfares. The exhibition began with an example of exactly what needed to be corrected: the very first thing the viewer saw when entering the show was a wall-size pho-

tomural of the area just outside of the Museum, the northwest corner of Fifth Avenue and 53rd Street. The photograph featured a jam-packed street sign, and the mural had a big "X" drawn on it. Countering this emblem of the chaos of the streets, MoMA's first-floor galleries were filled with well-designed, Museum-approved signage. In one section there were photographs of fifteen signs mounted on the wall, and painted on the wall above each photo was one of the "well-designed" letters from the sign (fig. 3.40). The sculpture garden was filled with what could be described as pop art: a lit Shell sign, a CBS sign, an F. W. Woolworth Co. sign, a British bus stop, and an arrow design for Northland, a shopping center near Detroit (figs. 3.41 and 3.42).

In keeping with the Museum of Modern Art's close relations to industry during these years, *Signs in the Street* was created with the collaboration of the Rohm and Haas Company. In

producing the show, Constantine paired "an active artist concerned with graphic lettering with a company interested in getting into the field. . . . Through Robert Haas we commissioned Alvin Lustig to create four or five letter forms in Plexi which were backlighted." Reflecting on the show some twenty-five years later, Constantine concluded that as a result of the exhibition, corporate sign production was improved; she had witnessed a detectable change in U.S. signage.[119]

Signs in the Street was a particularly American approach to street life and design. In Britain during the mid-fifties, a series of exhibitions held at the Institute of Contemporary Arts and Whitechapel Gallery, such as the 1953 *Parallel of Life and Art* and the 1956 *This Is Tomorrow,* presented subjects similar to MoMA's everyday life and signs in the street shows.[120] The British installations, which involved many of the members of the Independent Group, presented the chaos of modern life as serendipity. Their post-Surrealist delight in the chance encounters of the everyday was very different from the rational, didactic, and commercial agendas of *Signs in the Street*—the distinguishing features of all MoMA's variations on the useful objects theme.

Setting Standards for Modern Architecture

Of all the exhibitions during MoMA's laboratory years, the most ambitious in sheer size were the series of full-scale houses that were built in a lot adjacent the Museum's garden during the late 1940s and mid-1950s. Marcel Breuer built a small house for a middle-class suburban family in 1949, Gregory Ain built a middle-class development house in 1950, and in 1954 Junzo Yoshimura

built a traditional Japanese home and garden. The Museum had staged some seventy architecture exhibitions before the Breuer house; without exception these consisted primarily of models, drawings, and photographs that were presented in varied arrangements. Given that history, the ambition of these undertakings is particularly striking; they perpetuated the international avant-gardes' practice of creating full-scale buildings or parts of buildings that existed only for exhibition.

The Museum of Modern Art's architecture program was founded with Philip Johnson and Henry-Russell Hitchcock's landmark *Modern Architecture* exhibition of 1932, which introduced International Style architecture to the American public.[121] The installation, designed by Johnson, was composed of architectural models, drawings, and documentary photographs.[122] The exhibition was divided into three sections. The first, "Modern Architects," introduced the work of Gropius, the Bowman brothers, Le Corbusier, Raymond Hood, Howe and Lescaze, Richard Neutra, Mies van der Rohe, J. J. P. Oud, and Frank Lloyd Wright. The second, "The Extent of Modern Architecture," presented international designs that had been influenced by the work of International Style pioneers. The third, "Housing," examined the problem of providing adequate, well-designed housing for the modern world.

Gallery walls were covered in neutral-colored monk's cloth, which was also fitted to the model display tables to create a tablecloth effect (fig. 3.43). (The exception to this was the presentation of the work of Wright, who had designed his own display structure.) Photographs with widths from two to five feet were hung on the walls. Labels, drawings, and plans placed in between the photographs were identical in height, creating a frieze running just below eye level around the gallery walls. *Modern Architecture* was MoMA's first traveling show, and Johnson wrote installation instructions directing that the photographs be "hung in the same manner as paintings."[123] The installation was spare and clas-

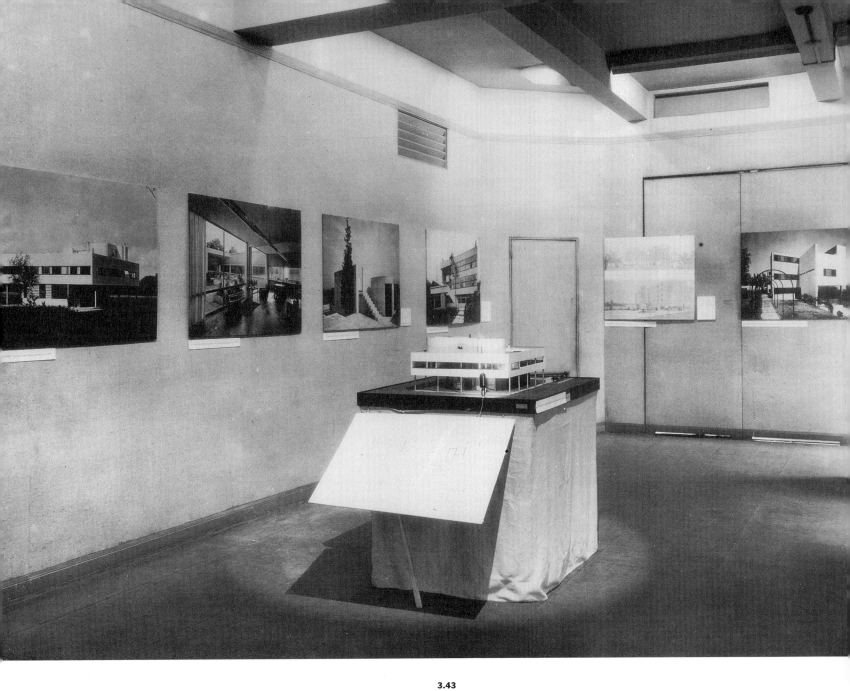

3.43
Philip Johnson, *Modern Architecture: International Exhibition,* Museum of Modern
Art, 10 February to 23 March 1932.

sical, dominated by neutral colors and black-and-white photographs. The display technique—typical of the installation methods Johnson would explore throughout his career—treated the photographs as paintings and the models as sculpture.

Johnson felt that he was quite limited in what he could do at that time in the "little office rooms" that were the galleries of the Museum's first building (*Modern Architecture* was MoMA's last exhibition at this location). Nonetheless, he experimented with exhibition technique and has reflected on his process:

I worked on the photographs more than on the models because the models just filled the whole room and there was nothing you could do but put the model there. . . . So I spent my time making the photographs as big as I could for the rooms that we had and making the labels these stripes that would run from the top to the bottom of the photo. . . . I had the photographs especially photographed and especially turned back over the outside, folding over to the back of the photograph, so as not to have frames. This was the first time that had been done. . . . The photographs float then. That was Alfred Barr's or my idea. It was very hard to execute. I had it all done in Germany specially. But I didn't realize how dull that monk's cloth was. . . . I could only show a Mondrian or something snappy on it.

Johnson's dissatisfaction with the dull look of the monk's cloth in this exhibition was one of the reasons for his experimentation with wall surfaces and color in *Machine Art*.[124]

Modern Architecture triggered a debate within the confines of the architectural community itself.[125] The more general critical response was mixed, and attendance at the show was modest. All of this is in great contrast to the influence of the exhibition. *Modern Architecture* retains legendary importance within the history of modern architecture in the United States; and, not unrelatedly, it has set the standard for the architecture installations presented at the Museum of Modern Art for over sixty-five years.

Although architecture exhibitions at MoMA have mainly been exhibitions of photographs and models, during MoMA's first several decades there were imaginative variations on this relatively constricting display format. One of the very first exhibitions, *America Can't Have Housing,* in 1934 was unusual in installation and in theme. Sponsored by MoMA, the New York City Housing Authority, the Housing Section of the Welfare Council, Columbia University Orientations Study, and the Lavanburg Foundation, the show's agenda was pragmatic: to acknowledge the existence of slums and to help "advance the solution of the housing problem."[126] Philip Johnson supervised the exhibition and G. Lyman Payne of the Housing Authority was the technical director. Architect I. Woodner-Silverman designed the installation with the help of Walker Evans, who assisted with the selection and display of photographs; and Carol Aronovici of the Housing Research Bureau of New York City wrote the show's texts.

The first section of the installation, composed of thirty exhibits in numbered sequence, ran like a narrative and outlined the need for slum clearance and the possibilities for creating satisfactory, low-cost housing.

The introductory statements set against photo documents of the city's history directly addressed the viewer: "Has this generation the courage, skill and vision to plan the city worthy of the new age?" (fig. 3.44).[127] The show also included sections composed of drawings, photographs, and models of the work of the New York City Housing Authority and successful architectural projects and proposals submitted to the Public Works Administration. But it was the reconstruction of three rooms of a recently

3.44
Designer: I. Woodner-Silverman; selection and display of photographs: Walker Evans; texts: Carol Aronovici; supervisor: Philip Johnson; technical director: G. Lyman Payne, introduction, *America Can't Have Housing,* Museum of Modern Art, 15 March to 7 November 1934.

3.45
Woodner-Silverman with Evans and Aronovici, third section: photographs, drawings, and models of "successful" architectural projects and proposals submitted to the Public Works Administration, *America Can't Have Housing*, 1934.

demolished slum tenement (thirteen by twenty-eight feet, complete with personal belongings such as clothes and furniture) and its counterpoint, three model rooms of a well-designed and -furnished low-cost apartment, that received the most attention in the press. Johnson designed the modest modern apartment and Macy's provided the furnishings. The Museum staff apparently went so far in its quest for realism as to add live cockroaches to the slum simulacrum.[128] According to Johnson, getting Macy's to donate the furniture "wasn't hard, because I put their label on every piece." The cockroaches, however, turned out to be a problem. As Johnson remembers: "People complained and we took them out. After all, people don't have cockroaches just because they are poor. That's an insult" (fig. 3.45).[129]

Another departure from the traditional photo and model architectural show was Drexler's 1957 *Buildings for Business and Government,* which included six projects by leading architects. Drexler created a diorama-like installation by keeping the galleries dark, using dramatic spotlights, and staging visual illusions through massive photomurals, models, and simulated building fragments. The result was described in one review as a "make-believe," real-life effect.[130] A photomural of the Colorado landscape was installed in such a way as to create the illusion that this image was part of the landscape of Skidmore, Owings, and Merrill's Air Force Academy model in front of it.

The displays contained actual fragments of the building elements, such as the twenty-foot floor-to-ceiling section of glazed brick that simulated part of Eero Saarinen and Associates' General Motors Technical Center. The floor and ceiling mirrors that buttressed a mock wall of Mies and Johnson's Seagram's tower provided the viewer the "sensation of [the] tangible reality of [a] 38-story building." The exhibit of Edward Stone's U.S. Embassy in New Delhi had a ceiling of aluminum discs through whose meshes shone bright simulated sunlight, illuminating a gallery marked off by a white lacelike cement screen wall. The installa-

tion was declared dazzling, spectacular, and magnificent by *Interiors,* and it was among the most ambitious of MoMA's photo and model exhibitions.[131]

Houses in the Museum's Garden

Despite these departures from the photo-document and model installations, the Museum's architecture exhibitions remained somewhat limited in design invention. The contrast with that norm is what made the 1949 *House in the Garden* such a dramatic undertaking (fig. 3.46). According to a 1948 Museum report, MoMA was going to build Breuer's *House in the Garden* because it had "found that the public is apathetic towards an exhibition of photographs of architecture. A scale model increases their interest, but it is obvious that proportion and enclosed space cannot be shown except at full size." This report also stated that "each year a house will be built by a different famous architect of the modern field."[132] The exhibition continued the Museum's commitment to improve contemporaneous housing, which began with the *Modern Architecture* show. The proposal brochure for the *House in the Garden* stated it simply: "Not Enough Houses: Adequate housing is undoubtedly the primary architectural problem today and is of vital concern to all."[133] The Breuer house was described in the *Museum Bulletin* by the exhibition's curator, Peter Blake, as "a moderately priced house . . . fitted to the requirements of a typical American family."[134] The house was fully furnished and landscaped, complete with Eames furniture, bathroom fixtures, sandbox, ashtrays, and— quite unlike the average middle-class home—works of fine art by Georges Braque, Fernand Léger, and Paul Klee.

The Breuer house was followed the next year by a one-story house by Ain, and then finally in 1954 by Junzo Yoshimura's Japa-

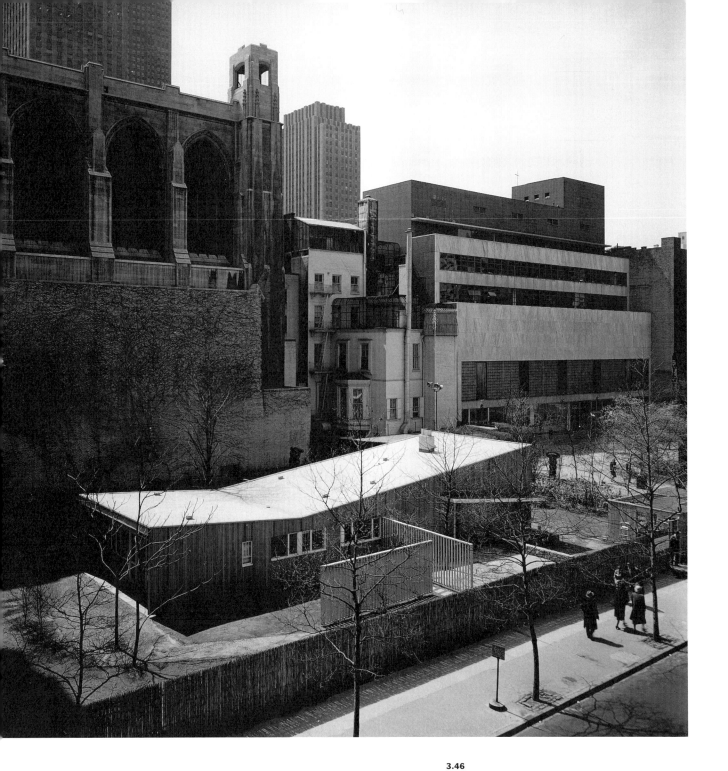

3.46
Curator: Peter Blake; Marcel Breuer, *House in the Garden,* Museum of Modern
Art, 1949. Photograph: Ezra Stoller © Esto.

nese house and tea garden. Modeled after sixteenth- and seventeenth-century prototypes, this home for a scholar, government official, or priest was built in Japan by Yoshimura in 1953 and then dismantled and shipped to the United States (figs. 3.47 and 3.48). The installation was even more elaborate than the previous houses in the garden.[135] Actual rocks and earth were brought from Japan, and workers had difficulty finishing on time. Nonetheless, the house opened with ceremonies that included colorful decorations, musicians playing Buddhist music, and a priest performing a Shinto ceremony. Throughout the two years of the summer and fall months during which the house was open, much press and fanfare about the show continued.

The house was a symbol of the healing of U.S. relations with Japan. In the fall of 1954, the premier of Japan, Shigeru Yoshida, came to the United States seeking $100 million in U.S. aid; in covering this news story, the *New York Times* featured Yoshida's visit to MoMA's house in the garden.[136] Lewis Mumford declared the house the best building in Manhattan, wrote a long essay on the brilliance of this type of architecture, and lamented that the project should ever be torn down.[137] *Vogue, Harper's Bazaar,* and *Mademoiselle* used it as a backdrop for fashion features.[138] The full spectrum of the press took notice, including architecture magazines, newspapers, and popular culture venues like *Life,* which christened the show a "Japanese Hit."[139]

On entering the garden, visitors made their way to the entrance, where they were asked to take off their shoes and don paper slippers (which they could keep as souvenirs). Viewers then wandered through this detailed representation of a building and garden that might never in "real life" be built, a type of exhibition architecture that was one of the most important aspects of the international avant-gardes.

The Museum of Modern Art's commitment to bringing aspects of everyday life into the sanctuary of the museum is representative of the way everything in our culture, if framed within an aesthetic institution, can be transformed into art. The act of placing something on a pedestal or within a museum elucidates the production of meaning within the myriad frameworks of culture; the process is revealed when a urinal becomes Duchamp's *Fountain,* or a shower curtain becomes an object of *Good Design,* or a car becomes "rolling sculpture," or a twentieth-century Japanese house built after sixteenth- and seventeenth-century prototypes becomes MoMA's exhibition house in the garden. Art perhaps exemplifies most paradigmatically how meaning and value are created in our culture. And the laboratory years at MoMA can be seen as a massive demonstration not only of the power of display but also of the dynamics of signification, showing how anything can be transformed into art.

With the exception of the several pop-culture car and gadget exhibitions held at the Museum during the 1960s and 1970s, the *Japanese House* was an extravagant finale to the years of experimentation at the Museum. Although Drexler would install a permanent design collection in the elegant Philip L. Goodwin Galleries when they were established in 1964, these displays were—and continued to be to this day—singularly aestheticizing (fig. 3.49). The temporary exhibitions, with the exception of the car and sport shows, were reduced to pictures on walls and objects on pedestals. The commercial counterpart to the museum, the department store, went underground; and it was in a sense reconfigured, a safe distance from the galleries, across the street at the thriving Museum Design Store.[140] The dimensions of design and architecture that are bound to function, consumption, social issues, and commerce were buried. By the 1970s, visual delectation, which of course had always been a primary element of these complex installations of the laboratory years, was, with rare exception, the only thing permitted in the galleries. The "other" aspects of modern architecture and design, which created a more subtle, imbricated understanding of art and life, were banished somewhere within the unconscious of the Museum.

3.47

Prime Minister Shigeru Yoshida, John D. Rockefeller III, and René d'Harnoncourt, standing in front of Japanese exhibition house, Museum of Modern Art, 7 November 1954.

3.48 →

Architect: Junzo Yoshimura; garden executed by Tansai Sano in collaboration with Yoshimura, *Japanese House in the Garden,* Museum of Modern Art, 16 June to 21 October 1954; 26 April to 16 October 1955. Photograph: Ezra Stoller © Esto.

3.49
Terence Riley, Philip L. Goodwin Galleries, Museum of Modern Art, 1996.

Chapter 4

Installations for Political Persuasion

Exhibition as National Covenant:
The *Road to Victory*

A big exhibition of photographs has been held in Paris, the aim of
which was to show the universality of human actions in the daily life
of all the countries of the world: birth, death, work, knowledge, play,
always impose the same types of behaviour; there is a family of Man.
. . . We are at the outset directed to this ambiguous myth of the
human "community," which serves as an alibi to a large part of our
humanism. . . .

This myth of the human "condition" rests on a very old mysti-
fication, which always consists in placing Nature at the bottom of
History. Any classic humanism postulates that in scratching the his-
tory of men a little, . . . one very quickly reaches the solid rock of a
universal human nature. Progressive humanism, on the contrary,
must always remember to reverse the terms of this very old impos-
ture, constantly to scour nature, its "laws" and its "limits" in order
to discover History there, and at last to establish Nature itself as
historical.

— Roland Barthes, "The Great Family of Man" (1957)

I learned my politics at the Museum of Modern Art.

— Nelson A. Rockefeller

Among the movie stars, French wines, soap powders, and food,
Roland Barthes introduces the Museum of Modern Art's *Family
of Man* exhibition as myth in his famous collection of essays, *My-
thologies*.[1] A landmark in the fields of critical theory, cultural
studies, and criticism, *Mythologies* set a precedent for reading
both art and popular culture as representations whose genesis
and reception are shaped by ideology and history. In the collec-
tion, Barthes provides a model for reading all aspects of culture,
and Barthes's decision to write about a Museum of Modern Art
exhibition as a paradigm of myth is telling.

Barthes, however, chose not just any Museum of Modern
Art exhibition but the famous *Family of Man* exhibition directed
by Edward Steichen—the last in a series of political and propa-
gandistic shows mounted at the Museum during World War II and
the cold war. These shows—which include the *Road to Victory*
(1942), *Power in the Pacific* (1945), and *Airways to Peace*
(1943)—are distinguished from other MoMA exhibitions in that a
small number of critics and historians (Barthes the most famous)
have analyzed them as representations in their own right. This
literature has been inspired by the blatant political agendas of
the shows. The ideological dimensions of the Museum's institu-
tional framework, which were more subtly articulated in, say, one
of Alfred Barr's exhibitions of abstract paintings, were highly visi-
ble in these exhibitions. It has always been obvious that every-
thing in these wartime and cold war installations—from the
construction of the walls to the images and elements within
them—was intended to persuade.

In June 1941 the Central Press news service wired a story
that was picked up by many U.S. newspapers: "The latest and

strangest recruit in Uncle Sam's defense line-up is—the museum!" It quoted the Museum of Modern Art's president of the board, John Hay Whitney, discussing the "museum as a weapon in national defense."[2] As was the case with most museums in the United States during World War II, the Museum of Modern Art responded to the national crisis with a series of wartime exhibitions and programs. They included conventional shows composed of heroic and propagandistic images such as *Art in War* (1942), *The United Hemisphere Poster Competition* (1942), and *U.S. Army Illustrators of Fort Custer, Michigan* (1942); educational exhibits such as *Wartime Housing* (1942), *Camouflage for Civilian Defense* (1942), and *Art Education in Wartime* (1943); and parties and entertainment for the troops that were sponsored by Museum patrons.[3] But within the first year of the United States' entry into the war, the Museum of Modern Art distinguished itself as a powerful champion in the war effort with the *Road to Victory* exhibition.[4] Described in the June 1942 Museum *Bulletin* as a "procession of photographs of the nation at war," the show was conceived and "directed" by Edward Steichen, with captions written by his brother-in-law Carl Sandburg and an installation design by Herbert Bayer.[5] In two celebratory articles, *New York Times* critic Edward Alden Jewell enthusiastically declared the exhibition "stupendous," stating that to characterize the exhibition as "a procession of photographs" was "a colorless understatement"; he insisted that "it would be no exaggeration to say that the Museum of Modern Art has not, since its career began, performed a more valuable service to the public."[6]

The press and public were, with rare exception, ecstatic about this exhibition of black-and-white photographs. The response was particularly extraordinary in that photography in the 1940s did not have the audience or the market it does today. As Jewell wrote, "the art world is prone to dismiss photographs, however good they may be."[7] But what made these photographs exciting was their installation design. The show was a walk-through panorama. The viewer followed a prescribed route created by a walkway or ramp, along either side of which were individual photographs and massive photomurals captioned with Sandburg's text (figs. 4.1 and 4.2). "The most sensational exhibit of photographs that ever was shown in these parts," wrote the critic of *The Worker;* it was a "show of inspiring purposes," according to the *New York Herald Tribune.*[8] *PM Daily* told their readers, "Everyone with two eyes and a heart should go at once to the Museum of Modern Art on West 53rd Street to see 'Road to Victory.' "[9] The enthusiastic newspaper reviews were recycled in the *Bulletin of The Museum of Modern Art* as well as in rousingly affirmative articles published in *Art News* and *Art Digest.*[10]

The exhibition was organized as if it were a national folktale. The story was linear, the message obvious, the tone both sentimental and militaristic. As was repeatedly described in literature published by the Museum and others, "Each room is a chapter, each photograph a sentence."[11] At the exhibition entrance stood a wooden folk art American eagle set against a star-studded background, one star for each of the forty-eight states. There was also an already-famous quotation from Franklin Delano Roosevelt outlining "the four freedoms": "freedom of speech and expression," "freedom of every person to worship God in his own way," "freedom from want," and "freedom from fear." After this introductory section, the grand romanticizing epic began.

As the viewer moved into the exhibition proper, he or she faced a photo of virgin forest in Oregon, three portraits of Native Americans, an image of a buffalo, and a large mural of Zion National Park (see fig. 4.1). Presenting a much more simplistic and abbreviated analysis of U.S. and Native American history than that found in René d'Harnoncourt's *Indian Art of the United States* of 1941, the Sandburg text ran, "In the beginning was virgin land and America was promises—and the buffalo by the thousands pawed the Great Plains—and the Red Man gave over to an endless tide of white men in endless numbers with a land

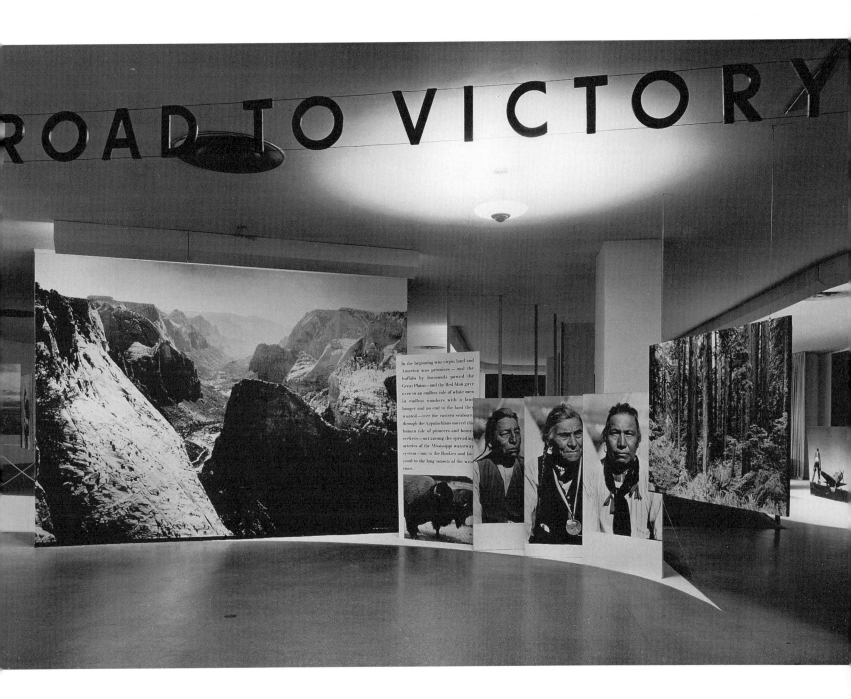

4.1
Designer: Herbert Bayer; curator: Edward Steichen, first gallery, *Road to Victory*,
Museum of Modern Art, 21 May to 4 October 1942.

hunger and no end to the land they wanted." In the beginning of the *Road to Victory,* as in the Bible, there was nature and then there was "man"—the stage was set and the viewer found himself or herself on it.

The spectator then followed the pathway to see photographs of expansive country, endless wheat fields, patterned farmlands—images that conjure up thoughts of manifest destiny. The photos included farmers plowing fields and carrying corn, a young girl with a calf, and a farm couple laughing. Sand-

4.2

Bayer, model, *Road to Victory,* 1942.

burg's text, which was quoted ad infinitum in the press, read: "The earth is alive. The land laughs. The people laugh. And the fat of the land is here." [12] The viewer continued through this narrative of nature tamed by culture to pictures of American communities, which mainly featured people in small towns: a carpenter at work, a family resting in the living room, 4-H girls making music, little children eating corn bread (fig. 4.3). The next section expanded to display sources of government-sponsored industrial power: the dams and generators that "bring light and power to homes and factories." So that another chance to continue the theme of nature being mastered by culture would not be missed, these images included such captions as "electric-dynamic wild horses tamed to help man." Next were the images of war arsenals, of battleships under construction, and of factories for "big guns," as well as of the welders, mechanics, and bridge builders.

The visual pace then changed and the viewer faced a large photomural of scores of people at an "America First" meeting, captioned "It can't happen to us," "We've got two oceans protecting us," "The United States is not in the slightest danger of invasion" (fig. 4.4). The viewer turned a corner and reached the first dramatic climax of the exhibition. As *PM* described the experience: "You round this mural with its slogan 'It can't happen to us' to be smashed in the teeth by the great dramatic picture surprise of the show. (You'll have to go see this for yourself.)" [13] What *PM* would not describe to its readers were two large photographs, adjacent to one another, filling the peripheral vision of the viewer. On the left was a Dorothea Lange photo of a farmer with a halo-like cloud encircling his head; on the right, an image of the destroyer *Shaw*'s magazine exploding at Pearl Harbor on which was printed "December 7, 1941" (fig. 4.5). Underneath the picture of Pearl Harbor was a photograph of Japanese Ambassador Nomura and Peace Envoy Jurusu laughing. The farmer was captioned, "War—they asked for it—now, by the living God, they'll get it";

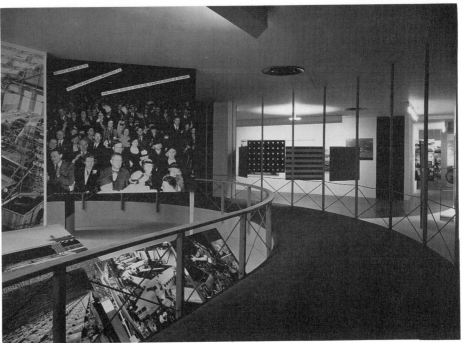

4.3

Bayer and Steichen, American communities, *Road to Victory*, 1942.

4.4

Bayer and Steichen, "America First" meeting, *Road to Victory*, 1942.

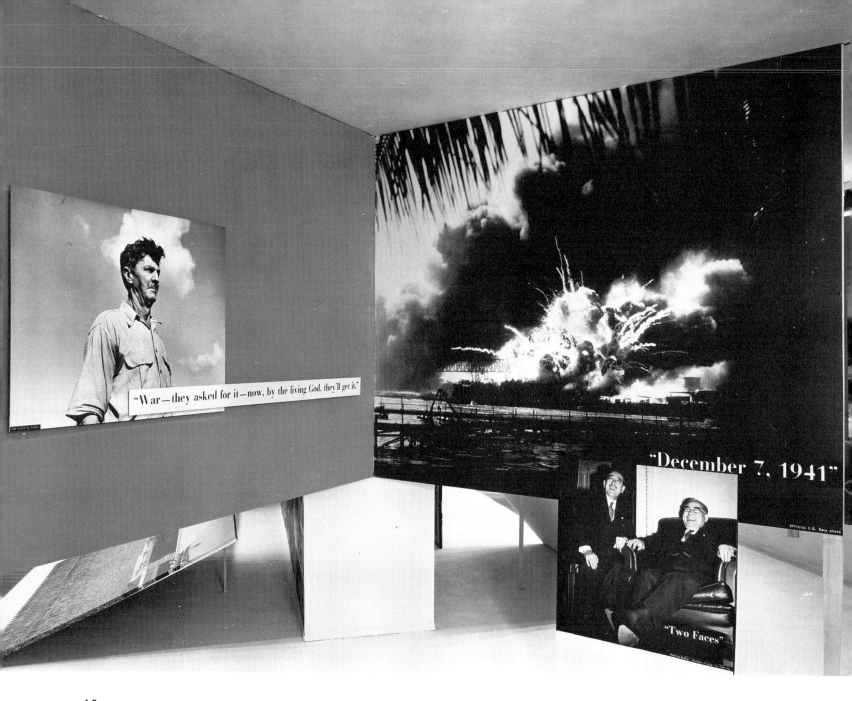

4.5
Bayer and Steichen, Pearl Harbor, *Road to Victory*, 1942.

the Japanese leaders were labeled with a propagandistic pun, "Two Faces."

In the next section the road turned into a ramp, raising the viewer a few feet off the gallery floor as he or she passed images of the armed forces, which included a photo of President Roosevelt shaking hands with a military officer and a life-size cutout of a bayonet-carrying soldier (fig. 4.6). A series of photographs of sea and sky studded with ships and planes (images similar to the kind Steichen would soon be producing for the federal government) made for a beautifully abstract, expansive vision of nature marked by technology (fig. 4.7).[14] Finally the show culminated in a massive curving photomural, twelve by forty feet, of dense rows of tightly packed marching soldiers (fig. 4.8), reminiscent of the ambitious photomontages of the international avant-gardes, such as the one Giuseppe Terragni created as a symbol for Mussolini's "March on Rome" (see fig. 1.47), El Lissitzky and Sergei Senkin's photo-fresco *The Task of the Press Is the Education of the Masses* (see fig. 1.42), and Herbert Bayer's and László Moholy-Nagy's mural for the *Building Workers' Unions Exhibition* (see fig. 1.29). Portraits of seven couples who appear to be agrarian, middle-aged or older, and, with one exception, Caucasian were either superimposed on the mural or suspended in front of it, the latter forming with the mural a semicircle. The caption read, "America, thy seeds of fate have borne a fruit of many breeds . . . —tough strugglers of oaken men—women of rich torsos . . ." (the largest photo was of a man and a broad-chested woman set against a clear sky); "their sons and daughters take over—tomorrow belongs to the children."

To us some fifty years later, the *Road to Victory* looks like a romantic and obvious exercise in wartime propaganda. At the time, however, it was seen as an inspiring portrait of America, and it typified the kind of imagery that was so prevalent and popular in the United States during the early years of the war. The show was, in one respect, an ambitious reworking of the docu-

mentary photography that had developed during the 1930s under the aegis of the Farm Securities Administration. Most of the non-militaristic images in the exhibition came from the FSA. Roy Stryker, the agency's director, assisted Steichen in obtaining pictures and the FSA printed all the government agencies' photographs.[15] Many of the FSA's photographs were cropped, all of their captions were changed, and the gritty documentary meanings were altered when reinscribed within the universalizing narrative of the *Road to Victory*. For example, the original caption sent to the Museum for one of the couples set against the mural of marching men was "Newly arrived farmer and his wife on the Vale-Owyhee irrigation project, Malheur county, Oregon. He tried to get an F.S.A. loan but was refused and says, 'It'll be harder without the loan but he guesses he'll make it.' May 1941. [Russell] Lee."[16] This was, of course, very different from the mural's evocation of their future sons and daughters. The farmer who is presented as saying, "War—they asked for it—now, by the living God, they'll get it" was a Texan who had been forced to become a migratory worker because of the mechanization of farming.[17] But Steichen and Sandburg were not unusual in appropriating and resituating these photographs. This type of transformation was becoming commonplace among some of the most powerful clients of the FSA, the picture magazines—and the *Road to Victory* was nothing if not a three-dimensional transposition of a glossy magazine's picture story.

The 1930s through the 1950s were the heyday of the picture magazines, and this exhibition must be understood in relation to the creation of the big photo-essays in the newspapers and the development of magazines such as *Life* and *Look*. All of the photographs exhibited in *Road to Victory* were either from a government agency or from a press or news photo service—in other words, from the same sources on which newspapers and magazines drew. The FSA was created in 1937, one year after *Life*'s first issue. As early as 1938, the FSA began modifying its

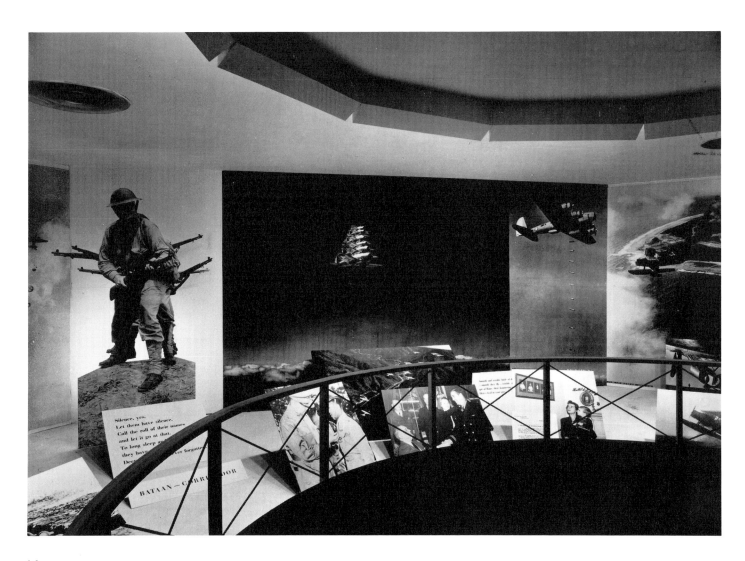

4.6
Bayer and Steichen, slightly larger-than-life-size soldier, *Road to Victory,* 1942.

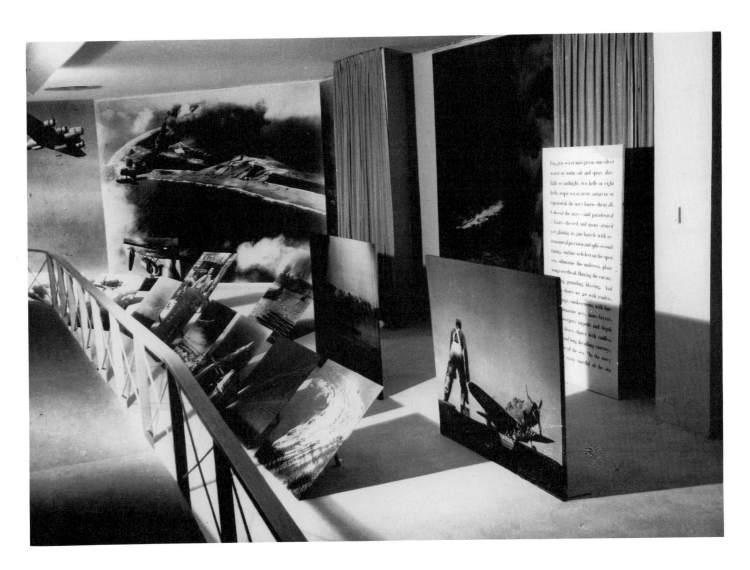

4.7
Bayer and Steichen, sea and sky with ships and planes, *Road to Victory,* 1942.

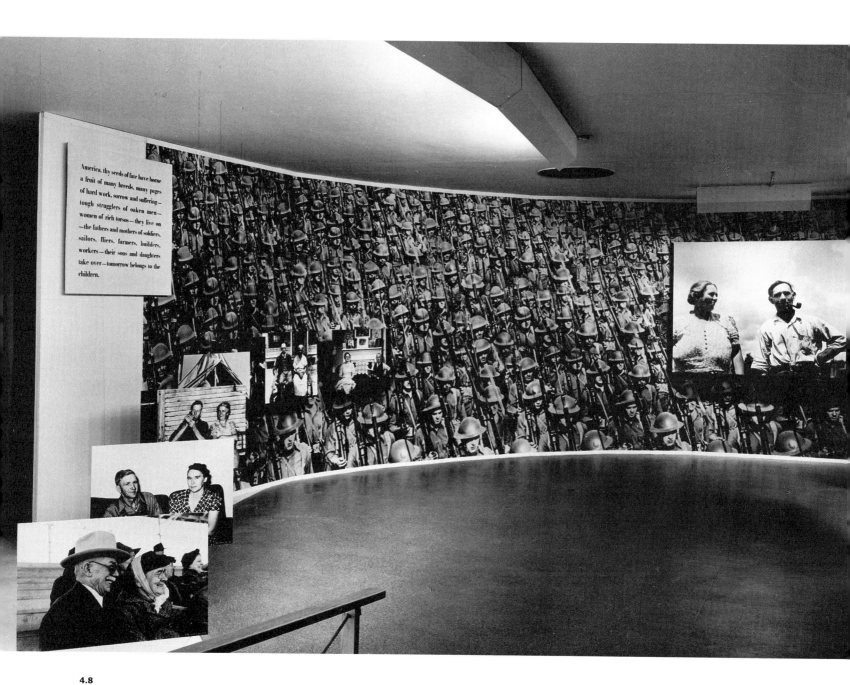

America, thy seeds of fate have borne a fruit of many breeds, many pages of hard work, sorrow and suffering—tough strugglers of oaken men—women of rich torsos—they live on—the fathers and mothers of soldiers, sailors, fliers, farmers, builders, workers—their sons and daughters take over—tomorrow belongs to the children.

4.8
Bayer and Steichen, photomural of marching soldiers, *Road to Victory*, 1942.

production to suit the needs of its mass-circulation clients; the agency told its photographers to avoid "single isolated shots" and aim for picture sequences because "the best picture editors everywhere are developing" this new practice.[18] Many years later, Roy Stryker and Nancy Wood compared FSA images with traditional news photos: "The newspicture is a single frame; ours, a subject viewed in series. The newspicture is dramatic, all subject and action. Ours shows what's back of the action. It is a broader statement—frequently a mood, an accent, but more frequently a sketch and not infrequently a story."[19] By 1942, very much in keeping with the vision of peace and plenty found in *Road to Victory,* Stryker was encouraging his photographers to move away from images of poverty-stricken Americans and the type of photos whose purpose was to rally support for Roosevelt's New Deal. He directed them instead to take photographs of "people with a little spirit[;] . . . young men and women who work in our factories[;] . . . the young men who build our bridges, roads, dams, and large factories[;] . . . pictures of men, women and children who appear as if they really believed in the U.S."[20]

Glossy magazines like *Vogue* and *Vanity Fair,* as well as advertisements created by J. Walter Thompson, were the venues for Steichen's work during the decades before he "retired" in 1938 and then turned his energies to *Road to Victory.* In the years after his retirement, Steichen is almost always described as returning to his Connecticut home and caring for his delphiniums; however, he continued to do assignments for magazines—and he also began to develop innovative ideas about exhibitions.[21] When he saw the *International Photographic Exposition* of 1938, Steichen was particularly impressed with the FSA section and went so far as to write a short article about it for *U.S. Camera,* praising these images' "storytelling" quality.[22] He was also thinking about a huge photo show that would be a portrait of America to cover the walls of New York's Grand Central Station. According to his assistant, photographer Wayne Miller, Steichen

had wanted to do "a big show on America—the spirit of America, the face of America."[23] In 1941 Steichen was invited to work on a "large-scale photography exhibit on national defense" at the Museum of Modern Art. At about the same time he tried to reactivate the commission he had held in the photographic division of the U.S. Army during World War I, but he was refused because of his age.[24] In January 1942, however, Steichen did receive a commission from the navy to oversee a unit of war photographers; but he was first ordered to serve his country by completing the *Road to Victory.*[25]

Steichen and the designer of *Road to Victory,* Herbert Bayer, were well matched. In their early years, Bayer and Steichen were nurtured within the circles of the international avant-gardes, and, by the 1920s, both had enthusiastically embraced the commercial sector. Bayer, like Steichen, created advertising and worked for corporate clients, some of which were identical to Steichen's—Bayer had served as art director at German *Vogue* and J. Walter Thompson. Both of these artists were schooled in the business of capturing the imaginations of a popular-culture, "mass" audience. And consistent with his attitude toward the role of the artist in the modern world, Bayer created installation designs for aesthetic as well as commercial exhibitions in Europe and the United States.

Although Bayer was greatly admired in the art world for his installation methods, his strategies in MoMA's *Bauhaus* exhibition some four years before *Road to Victory* had been seen by the American public as arcane and chaotic. The *Bauhaus* show's "dynamic" installation and arrangement of objects and images were received as merely confusing. In *Road to Victory,* Bayer's methods were dramatically reworked to great popular success; every element in the show was clearly set in place to tell a very different story. Now all ambiguity was abolished and the viewer's movements were controlled with absolute and unswerving clarity. There was only one way to go through this exhibition—and it was

down the road to victory. The visitors' circulation pattern was very much the message of the show itself.

As the FSA photographs in *Road to Victory* had been reframed to portray an idealized population who would achieve unequivocal military triumph, so too were Bayer's installation methods transposed to suit the agendas of the show. This was in keeping with Bayer's belief that his installation methods could be adapted to any idea, be it "enlightenment, advertising, education."[26] One of Bayer's fundamental principles is to treat the gallery as a dynamic, time-bound space filled with individuals moving through the exhibition. The entire installation, from the walls and floors to the objects and images, was shaped to the physical limits, movements, and vision capabilities of an active human being. Circulation patterns, graphic signs, and interactive devices were meant to guide and engage the viewer. The strategies and methods deployed depended on the purpose of the particular exhibition. Since the Deutscher Werkbund show of 1930, all of Bayer's installations were founded on his "field of vision" theory (see chapters 1 and 3). *Road to Victory* was another variation of this method, shaped to the needs of a particular project.

Here, Bayer's techniques were deployed to create a story's sentences and chapters that were arranged for maximum psychological and emotional impact. Simple determinants such as image size enhanced the narrative drama. Pictures of canyons, prairies, and wheat fields were often huge photographs, like the vast spaces they were representing (see fig. 4.1). In contrast, the community section was a patchwork of smaller photographs that ran on either side of a narrow corridor depicting different types of Americans doing different kinds of things. The scale and placement of these images put them in an intimate relationship with the spectator (see fig. 4.3).

The participatory element was central to the agenda of the show, as described by Monroe Wheeler: "Our purpose in preparing this exhibition was to enable every American to see himself as a vital and indispensable element of victory."[27] Appropriately, there were several mirrorlike arrangements. At one point on the ramp, the viewer walked alongside a photo panel of a soldier walking across a ramp, almost as if the photo were a shadow or a companion of the visitor. At another point the viewer came face to face with a photo cutout of a larger-than-life-size soldier braced with a bayonet (see fig. 4.6), creating a sense of battlefield confrontation. But the figure was also on a pedestal-like hill, as if it were a traditional war memorial. This particular photo cutout marked a rare moment in the exhibition when death was explicitly acknowledged. Its caption, which was printed on a tablet-sized panel, read: "Silence, yes. Let them have silence. Call the roll of their names." That participatory aspect of the exhibition, which was part of the show's patriotic appeal, was enthusiastically taken up by the press. One typical description of this photographic march of soldiers ran: "They look so real, grinning and talking in the picture, that you'll say 'Hyah fellas!'—and proudly, 'That's our guys!'"[28]

Bayer painted the ceiling, walls, and floor white, creating a seamless neutral background for the photographs. He described his design: the "traditional exhibition space of vertical wall [was] enlarged by including a whitewashed floor" where the visitor walked over a raised ramp that extended the angle of vision.[29] Bayer also created a sense of traveling from lower regions of the earth to being almost airborne, an apt trajectory given the idealist model of history shaping the show. The road began in front of a photo of a river canyon and virgin forest where the spectator was actually looking at a picture of a valley (see fig. 4.1). Next, the viewer was surrounded by images of flat fields, and then moved past the photographs of the towns and the factories (see fig. 4.3) until reaching the pivotal Pearl Harbor chapter (see fig. 4.5). The images of war followed, as the viewer moved up a ramp to be lifted several feet above the gallery floor and brought eye level with photos of planes in the sky (see fig. 4.7). From below,

tilted on angles from the floor, were pictures of ships at sea. The viewer then moved to the final encircling mural of troops on the march, on which was superimposed photos of mothers and fathers at home (see fig. 3.8). The message was one of a fated victory and a certain future; in other words, an idealist and determinist covenant with what had been and what will be was manifest in every nail, piece of wood, caption, and photograph in this installation design.

Murals for the Masses and Imaginary Resolutions

The final section of *Road to Victory* culminated with a photomural of a crowd scene, a convention that had become a keystone of the propagandistic exhibitions created for large public audiences during the 1920s and 1930s. These murals portraying scores, sometimes thousands, of people were tours de force of spectacular visual effects. The sheer scale and novelty of the experience often was enough to seduce audiences. It was Lissitzky's "*Pressa*" installation of 1928 that had influenced the young Bayer and lead him to formulate his theories about exhibition design.[30] *Pressa* contained a massive photomural, *The Task of the Press Is the Education of the Masses,* that showed a collage of people working, meeting, taking pictures, and transforming their society; the face of Lenin, unavoidably prominent, was in the midst of the crowds (see fig. 1.42). In Lissitzky's conception, the press and the masses of people, who remained distinguishable as individuals, were portrayed as the power that would fuel the new age. In the massive photomontage created by Terragni for the *Exhibition of the Fascist Revolution* of 1932, the lower half of the mural portrayed a crowd composed of thousands molded into

a three-dimensional turbine (see fig. 1.47). This Fascist image was revealingly articulate: the individual was dehumanized and functioned as an infinitesimal element in the Fascist machine.

Bayer's first large installation photomural was created in collaboration with Moholy-Nagy for the 1931 *Building Workers' Unions Exhibition.* This crowd scene was a celebration of labor unions and, appropriately, the mural was of a scale that allowed the workers' faces to be visible (see fig. 1.29). Like the Terragni installation, the mural featured the image of a single full-size figure—but in this case it was one of the workers, and his size matched that of his colleagues in the front of the crowd scene. Interestingly, when Bayer created a montage of "the masses" for a brochure for the National Socialist exhibition *Deutschland Ausstellung (The German Exhibition),* he superimposed photographs of three everymen on an image of a crowd.[31] The scale of the crowd photograph, however, blurred any sense of individual humanity and created instead an indistinguishable multitude.

The *Road to Victory* mural was similar to that of the *Buildings Workers' Unions Exhibition* in its treatment of a collectivity: the size of the crowd and the scale of the superimposed portraits of the farmer couples retained a sense of the individuality appropriate for a propagandistic exhibition about a democracy. In the MoMA mural, however, the soldiers were in identical uniforms, locked in military pose, and densely packed, creating a sense of a fabric of humanity that contrasted with the more individualizing portraits of the farmer couples. The mural was also similar to the Terragni montage in being curved and in giving the viewer a sense of inclusion and of movement upward and forward in an exhibition dealing with the theme of marching to victory. However different the political messages of these murals, their creators often used similar formulas in experimenting with political persuasion as exhibition. These photomurals also presented interpretations of the concept of the "masses" that were being developed during these early years of "mass culture"—a term that would gain cur-

rency in the 1950s.[32] Significantly, exhibition design was seen as important in managing these new types of public images for this new type of audience.

It was clearly the masses that propaganda exhibitions like the *Road to Victory* were playing to. This was not a show created for Alfred Barr's "400," those art world cognoscenti who would become members of the Museum. The *Road to Victory* was created for as large and general an audience as would attend a Museum of Modern Art exhibition. And it was the promise of expanded audiences made possible by the fledgling mass media that so fascinated artists like Steichen and Bayer. Exhibitions like *Road to Victory* were seen by their creators to be—like picture magazines, films, and radio—marvelous inventions of a new age, a perspective that lead Bayer, as we have seen, to write of exhibition design as "an apex of all media and powers of communication."[33]

But what the creators, reviewers, and spectators considered to be the "persuasive" and "engaging" qualities of *Road to Victory,* revisionist historians have criticized. Both Christopher Phillips and Maren Stange have cited Bayer's statement that an exhibition installation should be designed in a way "parallel with the 'psychology of advertising.'"[34] Stange has specifically described this method as "radical manipulation of the viewer. . . . Bayer valued narrative for its associations in viewers' minds with other media and their fictive pleasures. . . . Like the movies, it was meant to be viewed in a crowd. And, like advertising, it . . . commodified and quantified the esthetic experience it offered."[35] With fifty years' hindsight regarding the "achievements" of advertising and propaganda, Stange's description seems quite apt. But the creators of *Road to Victory* never attempted to camouflage that the exhibition was an extravagant exercise in political persuasion. Bayer strove to make his work like advertising, and the show was celebrated precisely because it was hard-core propaganda.

It is perhaps more productive to consider why such an obviously manipulative show was such a success. But the answer may be extremely obvious as well, for the exhibition gave the visitor, nostalgic for peacetime and uncertain about the horrors and the outcome of the war, what he or she wanted to see: a heroic present and a glorious future. Phillips, when writing about several of these wartime and cold war exhibitions at MoMA, has suggested that rather than reading these exhibitions as nothing more than "sheer manipulation . . . one can also see in their enthusiastic reception that familiar mass-cultural phenomenon whereby very real social and political anxieties are initially conjured up, only to be quickly transformed and furnished with positive (imaginary) resolutions."[36]

In keeping with such a reading, this propagandistic exhibition can be understood as a Barthesian myth. The show's imaginary resolution to national crisis can be illuminated by Barthes's well-known discussion of a 1950s *Paris-Match* cover.[37] Published during the years when the French colonies in Africa were fighting for independence, the cover featured a "Negro in a French uniform" saluting, with eyes uplifted, the tricolor. "All this," wrote Barthes, "is the *meaning* of the picture." Myth comes into play when Barthes considers "that France is a great Empire, that all her sons, without any colour discrimination, faithfully serve under her flag, and that there is no better answer to the detractors of an alleged colonialism than the zeal shown by this Negro in serving his so-called oppressors." Barthes sees this cover magazine cover as myth, which, he concludes, is "*depoliticized speech.*" But Barthes is not writing of the obvious politics of a soldier in uniform or the theme of military success in an exhibition like *Road to Victory;* rather, he is referring to "*political* in its deeper meaning, as describing the whole of human relations in their real, social structure, in their power of making the world[.] . . . Myth does not deny things . . . ; simply, it purifies them, . . . it gives them a natural and eternal justification."[38]

Road to Victory was mainlining to the hearts and minds of Americans a quick fix to calm their very real fears about world war. The exhibition, originally conceived in 1941, was intended to help eliminate vestiges of what had been a powerful isolationist movement before the bombing of Pearl Harbor, as seen in the "America First" photograph (see fig. 4.4). The show presented a rosy picture of unity in diversity, with its token photographs of people of color and collage of predominantly rural but also suburban communities. But it was the installation design that made *Road to Victory* more than a mere picture of patriotism. Beginning with the "Four Freedoms" at the entrance of the show, the individual could choose to walk the high road, side by side with other citizens to an assured future. The experience of moving through the exhibition was an imaginary foray in participatory democracy. The visitor's role as a participant in a cultural ritual—which is an element of any visit to any art gallery—was just more obvious in MoMA's wartime and cold war exhibitions like *Road to Victory*.[39]

In some respects, *Road to Victory*'s appeal was not so different from that of mainstream cinema, like the 1939 movie with the yellow-brick road that had so captured the imagination of the American public. One of the exhibition's messages was that there is no place like home, and all you need is the inspiration to see that the U.S. heartland is paradise.[40] Like the Hollywood movies that were being made during the war years, *Road to Victory* was a sanitized, patriotic portrayal of war.[41] It contained no images of young G.I.'s with their brains blown out, no hospitals filled with U.S. amputees, no Japanese children maimed by American soldiers. Instead, the MoMA visitor saw images of soldiers marching and doing tasks and stunningly beautiful views of sea and sky spotted with boats and planes. These wholesome and abstracted pictures proffered an emotional disengagement from the lived experience of war—a telling irony for an exhibition whose success was founded on its brilliant psychological and emotional manipulation. But the Museum was not alone in its pretty-as-a-picture version of war. This was, in fact, the only image available; films and photographs of the horrors of war would not have passed government censors in 1942.[42]

In the early years of World War II, the newly formed Pentagon kept all of the more difficult war photographs in a secret file referred to as the "Chamber of Horrors." It was only near the end of the war that some of the more graphic images were released. Not until September 1943 was a dead American pictured in the pages of *Life,* and not until 1945 was "the blood of an American soldier . . . first shed on the pages" of the magazine.[43] (The photo, by Robert Capa, was of a dead G.I. lying next to a pool of his own blood. The editors blotted out the soldier's face.) As historian George Roeder describes it, "the United States government rationed photographs of the American dead more stingily than scarce commodities such as sugar, leather shoes, and rubber tires." It was only very late in the war that government censors began releasing some of the more unsightly photographs, a strategic move intended to combat what they feared to be public complacency.[44] Nonetheless there remained throughout the war pictures that could not pass military censorship, such as photos of soldiers with mental illness, pictures of men wounded in the genital area, and images deemed particularly horrific. Only the enemy was depicted in terms of mass death. Images were also censored that might disturb the fragile and carefully constructed public image of unity in diversity. When several U.S. magazines published a photo of African American soldiers dancing with Caucasian women in England, the War Department responded by censoring all photographs of black soldiers socializing with white women.[45]

Although none of the creators of *Road to Victory* would have seen it this way, in a sense standing behind their benign picture of war was a government censor. Of course, none of the grisly pictures of war would have been desired by Steichen for his exhibition of 1942. But the source materials for the show were sifted

from a network of federal information agencies, corporate photo services that were shaped by government policy, and commercial publications that reproduced the images from these agencies and services. This network of government and commercial institutions, together with exhibitions like *Road to Victory,* created a vast interrelated archive of images that became the public's mirror and memory of itself and its time.

An Alliance of Culture and Politics: MoMA and the U.S. Government

The Museum's involvement with the U.S. government—its production of propaganda and its deployment of culture as an instrument of politics—is an important aspect of the Museum's history. In his history of MoMA, *Good Old Modern,* Russell Lynes summarizes the World War II and cold war years:

In a sense the Museum was a minor war industry, and, like other such enterprises, entered into contracts with the procurement bureaus of the federal government. Its product was cultural, to be sure. It executed thirty-eight contracts with the Office of the Coordinator of Inter-American Affairs, the Library of Congress, the Office of War Information, "and other agencies" before the war was over, and the contracts added up to $1,590,234.[46]

Lynes cites nineteen American painting shows that were sent to Latin America for political purposes, as well as many exhibitions with seemingly apolitical themes such as the 1948 *International Competition for Low-Cost Furniture Design.* There were, of course, more obviously political projects like the 1942 *United Hemisphere Poster Competition.* The most active vehicle for this type of collaboration was the circulating exhibitions program, which included these latter two exhibitions as well as *Road to Victory.*[47] After its MoMA installation, *Road to Victory* was repackaged into two traveling editions, one large and one small, and four copies of the latter were produced. The Museum's biggest customer for this type of cultural exchange was the Coordinator of Inter-American Affairs, Nelson A. Rockefeller, who resigned from his post as MoMA's president to accept this position.[48]

One of the best-known quotations associated with the Museum is Rockefeller's remark, "I learned my politics at the Museum of Modern Art."[49] There are a number of ways that this statement can be read, but it certainly points to the cross-bred interests of the U.S. government and the Museum of Modern Art. Rockefeller's career is representative of the alliance between culture and politics that was nurtured at the Museum of Modern Art during these years. John Hay Whitney worked for the Office of Strategic Services during World War II, René d'Harnoncourt came to the Museum as a representative of a federal agency when he installed *Indian Art of the United States,* and MoMA's executive secretary in 1948 and 1949, John W. Braden, worked for the Central Intelligence Agency (which replaced the OSS) from 1951 to 1954.[50]

In the next big photo show Steichen curated for MoMA, the military and Museum alliance was even more apparent. This exhibition, *Power in the Pacific,* was mounted for the U.S. Navy.[51] Captain Steichen, as he now liked to be called, had been directing the naval photograph unit and all the images in this show were by the photographers of the U.S. Navy, Marines, and Coast Guard. The installation was designed by Lieutenant George Kidder Smith, who had been an architect and photographer before the war. And just as the show's relationship to the military was much more obvious in *Power in the Pacific* than in *Road to Victory,* so too was its likeness to magazine spreads. A somewhat less innovative installation than Bayer's, this exhibition consisted of

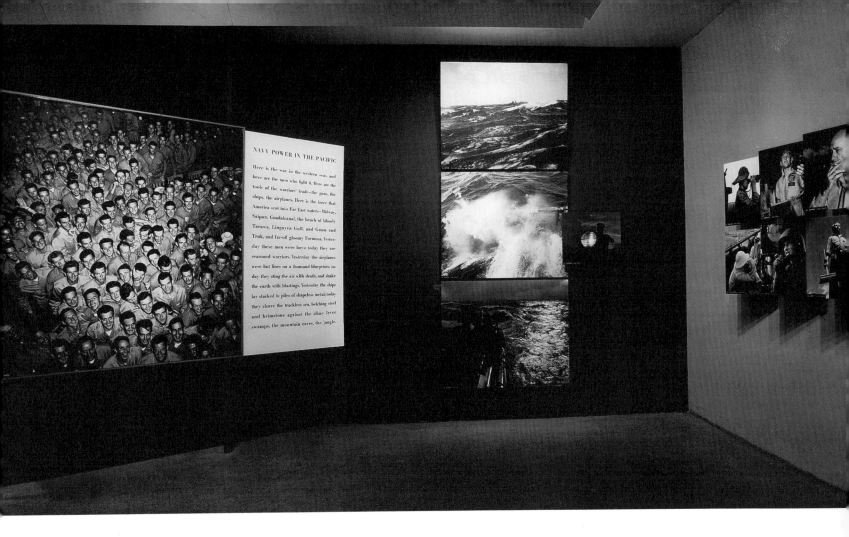

4.9
Designer: George Kidder Smith; curator: Edward Steichen, first gallery, *Power in the Pacific,* Museum of Modern Art, 23 January to 20 March 1945.

photo enlargements arranged in groupings flat on the wall as if they were magazine layouts. These arrangements were, in many cases, set against dark walls and were spotlit with overhead track lights. Some sections literalized the imagery; for example, next to the caption "Now, here was this Jap battleship doing tight circles, so I peeled" were five photographs of a Japanese battleship encircling a photograph of a pilot. And unlike *Road to Victory,* the keynote crowd photograph *began* the show. In this case, the large photograph was of a sea of sailors' smiling faces looking up at the camera—and the viewer. It was captioned: "Here is the war in Western seas, and here are the men who fight it. . . . Yesterday these men were boys; today they are seasoned warriors" (fig. 4.9).[52]

Power in the Pacific, like its predecessor, was a crowd-pleasing success. Its imagery was similar to that of the second half of *Road to Victory* and identical to the navy picture books that Steichen published after the war.[53] But *Power in the Pacific* was more representative than *Road to Victory* of the full spec-

4.10
Smith and Steichen, photos of wounded men, war prisoners, and wrapped bodies,
Power in the Pacific, Corcoran Gallery of Art, Washington, D.C., 1 to 29 December
1945.

trum of war imagery, which in 1945 was available from government agencies, photo news services, and the picture press. This was a very different moment in the conflict; consequently there were some token sobering photographs of wounded men, war prisoners, and wrapped bodies lined up in rows at a shipboard funeral (fig. 4.10). These images would never have been found on the *Road to Victory*.

The Sovereign Individual in "One World": *Airways to Peace*

While the *Road to Victory* metaphorically took place on land, and *Power in the Pacific* on the sea, the 1943 sequel to *Road to Victory* took to the sky. A preliminary title was *New Roads to Victory*, but the show was finally called *Airways to Peace;* it continued MoMA's immense success in presenting this new type of walk-through exhibition whose prototype was *Road to Victory*.[54] Although there were some photographs in *Airways to Peace,* the show mainly featured maps. Monroe Wheeler, director of publications and exhibitions, who was also a part-time consultant for the coordinator's office in Washington, curated the exhibition. Bayer designed the installation and Wendell Willkie—failed Republican presidential candidate in 1940 and, at the time of the show, special U.S. diplomatic representative—wrote the exhibition's text.

The agenda of *Airways to Peace: An Exhibition of Geography for the Future* was "to orient" the public to the new air age. The power and promise exhibited in *Road to Victory* not only was expanded beyond the earth but was bolstered with the facts of history and the imprimatur of science. The exhibition was conceived and structured to engage and educate the viewer about the "new uses of the airplane" that created "a global war" in which the "vast vague geography of the past" was transformed "into one small indivisible globe."[55] At the entrance was a wall-size photo mural of sky and clouds. Near the top of the image was an airplane from which two lines ran downward to a picture of a falling Icarus (fig. 4.11). Above the mural was the show's title and in extremely large type, but not quite as large as "Airways to Peace," was "Text by Wendell L. Willkie." The introduction read:

We have always known two kinds of geography. Nature drew the oceans, continents, mountains, rivers and plains. Men etched in cities and national boundaries. For our well-being, we have tried to harmonize natural and man-made geography.

But the modern airplane creates a new geographical dimension. . . . the world is small and the world is one. The American people must grasp these new realities if they are to play their essential part in winning the war and building a world of peace and freedom.[56]

From the first moment of experiencing the exhibition, the viewer was implicated in the drama, just like the viewer who walked through *Road to Victory*. In *Airways to Peace,* however, the visitor was directly challenged with the responsibility of understanding the ideas of the show to make it possible for the United States to win the war, peace, and freedom.

Bayer designed the installation so that the viewer might imagine he or she was walking through a cartographic space, an interactive three-dimensional map (figs. 4.12 and 4.13). Every aspect of the design was selected to foster associations with the experience of flight. Most of the interior walls of the Museum's second floor had been removed. Cord was strung from floor to ceiling, creating networks that divided areas and directed viewer circulation. Floor-to-ceiling poles served as supports for pictures, creating see-through curved walls that also guided the visitor.

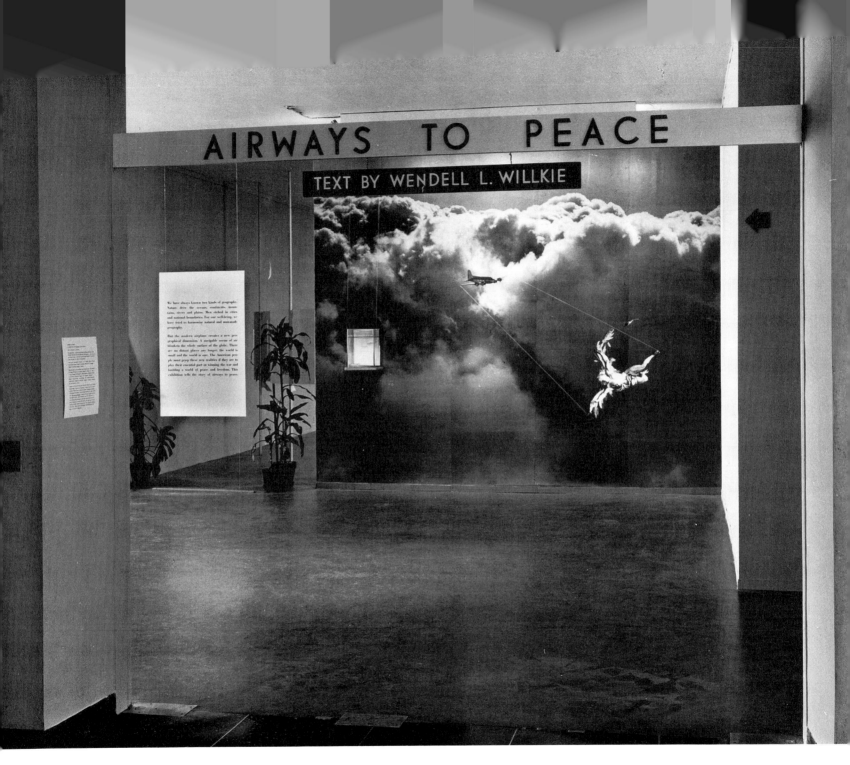

4.11

Designer: Herbert Bayer; curator: Monroe Wheeler, entrance, *Airways to Peace*, Museum of Modern Art, 2 July to 31 October 1943.

4.12

Bayer, model, *Airways to Peace*, 1943.

4.13

Bayer, *Airways to Peace*, 1943.

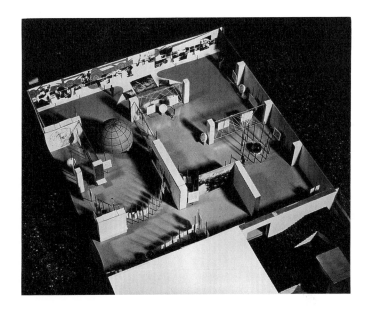

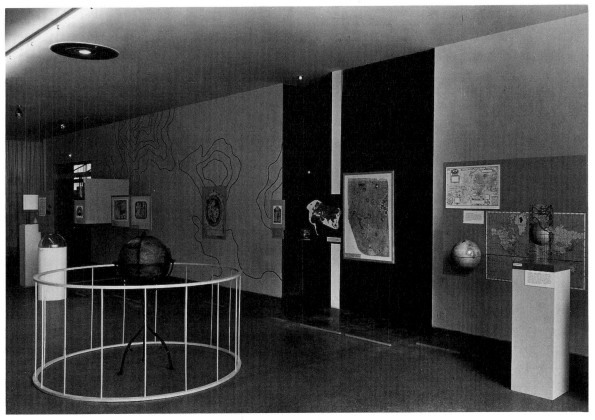

The transparency and lightness of these various see-through structures were enhanced by Bayer's use of Plexiglas in many exhibits. All of this worked to create an appropriate atmosphere for the show: spacious, airy, and light-filled. In one section contour lines were drawn over an entire wall, transforming it into a kind of map. The cords of the space dividers often mimicked the lines of large maps nearby. The color scheme was described by Bayer as "unified" and composed of hues "typical of physical maps."[57] The installation strategies used for very different purposes in the *Bauhaus* and *Road to Victory* exhibitions were deployed in *Airways to Peace* to give the viewer an experience akin to walking through a huge cartographic space.

Enhancing the viewer's involvement with the installation was the inclusion of movable and interactive globes. A fifteen-minute film about the Sikorsky helicopter that was screened on a wall of the exhibition every day was intended to emphasize the individual's relationship to the air power of the future. Museum publications suggested that the private citizen would soon be owning these crafts and that after the war, the helicopter would cost little more than the price of an average car. Wheeler initially had hoped that the Sikorsky company would lend the Museum a helicopter that might ascend from the garden every day as an added attraction to the exhibition.[58]

The exhibition was arranged roughly chronologically. After the entrance mural, the viewer turned into the first section, which was a history of mapmaking, captioned "How Has Man Drawn His World." On view were thirty maps and globes, both originals and reproductions; among these were "the earliest known map," the Ga-Sur Clay Tablet, ca. 2500 B.C.E.; a reproduction of "Ptolemy's Map," ca. 150 C.E.; the "oldest globe," created in 1492; President Roosevelt's globe; and contemporaneous polar projections. One of the central ideas of the show was the failure of the Mercator map, which was presented as the standard since the six-

teenth century. This is a flat map and, like all such maps, it greatly distorts relationships and scale. One exhibit compared a globe to a Mercator map of exact scale at the equator. Greenland in the latter appeared to be approximately ten times larger than the Greenland of the globe. The viewer was warned that such flat maps "are misleading unless their specific purpose is understood"; only globes were said to be exactly accurate.[59] That, of course, is an oversimplification, and the show failed to address it: however more exacting a globe may be when compared with a Mercator projection, it too will be inaccurate.

Another map exhibited as fraudulent, the Mackinder's map, was the propagandistic linchpin of the exhibition. "Mackinder's Famous Map," described as the "most important map of German geopolitics," was a Mercator projection with "Eurasia" at its center and "North America relegated to the "outer crescent." This error, according to the captions in *Airways to Peace,* was to be a source of Germany's ultimate defeat. According to Wheeler, "Germany's lack of the global concept" was "the basic flaw in their strategy. They planned their conquest on Mercator maps and relegated the United States to the fringe of their world."[60]

What is particularly ironic in this analysis of "Germany's tragic misinterpretation of geopolitical theory" is that the United States and the Allied powers had found themselves without proper maps at the beginning of the war.[61] The Army Map Service, cooperating closely with its British counterparts, was forced into high gear to create accurate maps. In fact, according to cartographic historians, "the primary purpose of the early bomber raids was to obtain photography suitable for map-making."[62] U.S. and international archives and libraries were scoured for serviceably accurate sources. Historical cartography became of great interest, and a show like *Airways to Peace* is an intriguing manifestation of these concerns. President Roosevelt's fifty-inch

globe, displayed in the exhibition with great fanfare and media attention, was described in a MoMA press release as "designed as an instrument for military strategy." It had been a 1942 Christmas gift from the U.S. Army (a duplicate had also been given to Churchill). According to an exhibition wall label, before the Roosevelt globe had been created, "the largest printed globe then in existence was an English thirty-inch globe, badly out of date; nothing was manufactured in this country except small globes for schools."[63]

After the section on the history of maps, the viewer moved to the "Progress in Flight" section. The sixty photographic enlargements included pictures of Leonardo da Vinci's designs, nineteenth-century balloons, the Wright brothers' Kitty Hawk, and Lockheed fighters. The visitor then neared the far end of the gallery and mounted a ramp running parallel to this wall to view a ninety-foot mural. A silhouette of a "full-size Liberator bomber" was painted on the wall and studded with photographs of the war as experienced from the air, land, and sea (fig. 4.14). In keeping with Bayer's "field of vision" formula, the viewer looked down from the ramp onto aerial photographs laid on the floor. After traversing the ramp, which ran only alongside the back wall, the viewer entered the "Global Strategy" section. Wall labels outlined the failure of Germany's strategies and the German use of misleading maps for propagandistic purposes. Hemispheres—actually sections of globes with the map drawn on the inside surface—rendered the military strategy theories of the Allies and Axis in the language of cartography (see fig. 4.14).

It was in this "Global Strategy" section that the viewer reached the much-publicized centerpiece of the show, a fifteen-foot "outside-in" globe (figs. 4.14 and 4.15). Designed by Bayer, this wooden globe hung from the ceiling had a map of the world painted on its inside surface. Some of the areas in the lower portion, which should have been rendered as water, were cut away

to permit passage in and out of the sphere. As it was described in the Museum *Bulletin,* "Less than half of the conventional globe can be seen at one time; and, as we have seen, all flat maps must distort. But when the land areas are shown on the inside of a sphere, one can more readily see all the continents in their true relationship in one glance."[64] Bayer wrote that the "field of vision" is "greatly extended" when the "eye of the visitor" was "approximately in [the] center." More simply, as *Newsweek* put it, you saw "the entire world at a glance."[65]

The museum visitor who experienced *Airways to Peace* was encouraged to feel as if he or she stood at the center of the world—and as if the viewer were a world unto him- or herself. Perhaps more than any other element of an installation designed during the laboratory years at the Museum of Modern Art, this globe reinforced the mythology of an autonomous, sovereign subjectivity. The viewer's unhampered visual access to "the world" is related a belief in free will. Here being master of one's own fate took the form of the viewer's ability visually and imaginatively to capture the world "at a glance." That expression is somewhat exaggerated: no viewer could see the entire globe at once with a single set of eyes. But whether the aim is literally achievable is not important; what is revealing and essential is the desire to create for the individual an experience of empowered autonomy.

This expanded vision was offered on a smaller scale in a number of more traditionally sized globes cut in half that had maps on the inside of the hemisphere (see fig. 4.14). These were the exhibits that displayed the various Allied and Axis strategies. The hemispheres were sized perfectly to encircle the viewer's head, creating a perspective of empowered vision. Like the "outside-in" globe, these exhibits secured viewers within a worldview according to which the individual was central and sovereign. This perspective was inscribed within an exhibition that implicated viewers in the fate of their nation's future, assuring them that the

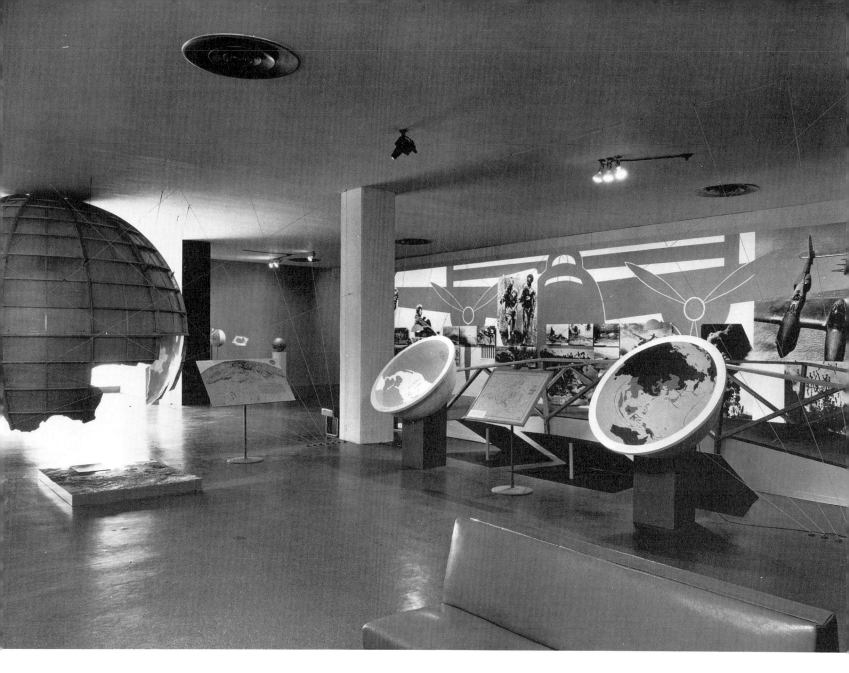

4.14
Bayer, foreground: "Global Strategy" section, *Airways to Peace*, 1943.

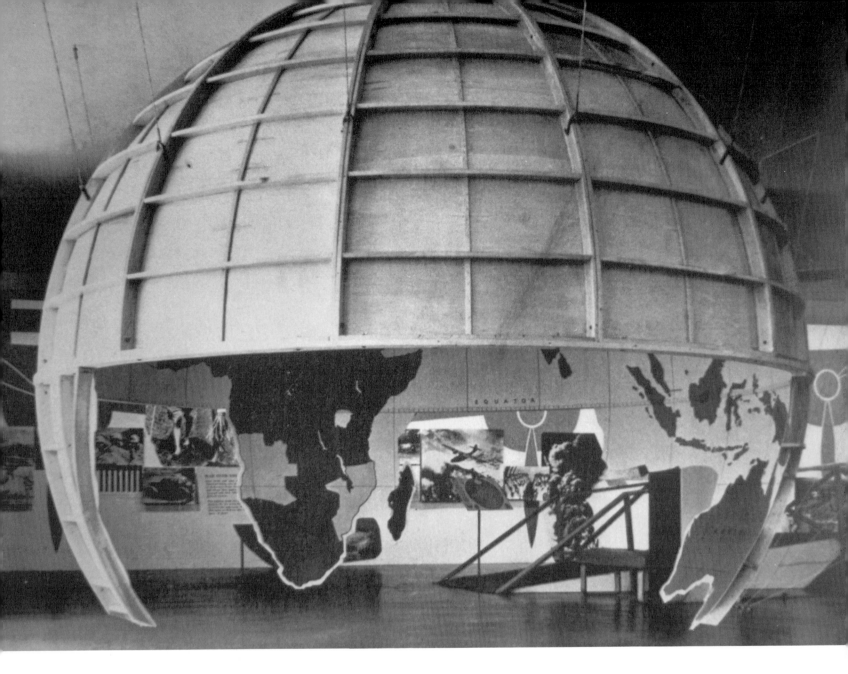

4.15

Bayer, "outside-in" globe, *Airways to Peace*, 1943. This globe was intended to
give the viewer an empowered and sovereign experience of seeing, as *Newsweek*
put it, "the entire world at a glance."

enemy did not know and see what the MoMA visitors could know and see. Each viewer's patriotic responsibility in the war effort was invoked and his or her fears of defeat were ameliorated through an extremely engaging and innovative cultural excursion.

The concluding sections of the *Airways to Peace* included polar maps showing the "air routes of the future," studies of the atmosphere by Bayer, and, at the very end, a photomural of approximately twenty-five children, who were initially to be of various races but somehow ended up appearing to be only white (fig. 4.16).[66] The children are posed looking up at the camera and the viewer, a type of composition that two years later would serve as the introductory mural of *Power in the Pacific*.

Airways to Peace did not possess the emotional impact of *Road to Victory*. There were virtually no sentimental photographs and no romanticizing Sandburg prose. However, it did offer the wonder of technology manifest in the new aircraft, the scientific

4.16

Bayer, photomural of children, *Airways to Peace*, 1943.

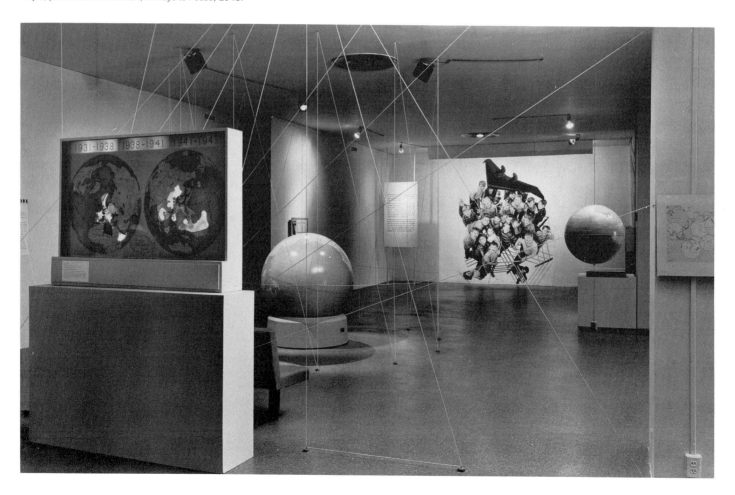

assurance of the new cartography, a futuristic installation design by Bayer, and text by Wendell Willkie. Willkie's life had become a symbol of the new air age and global politics. And his text, very different from that of Sandburg, was not so much an emotional salve as an utopian manifesto for the present and the future. Since the summer of 1942, Willkie had been touring the world, by plane, on behalf of the U.S. government. He flew around the globe in forty-nine days, and his diplomatic exploits—extravagantly covered in the media—were summarized in his 1943 bestseller, *One World*.[67] Its publication was extremely well-matched and well-timed with the show.

Assessing *Airways to Peace* in the *New York Herald Tribune*, Willkie said, "nothing could do more to convince people of what I tried to show in my book 'One World.'"[68] The frontispiece of *One World* was a map showing Willkie's destinations and global air route, which included Baghdad, Chengtu, Yakutsk, Fairbanks, Minneapolis, New York, Puerto Rico, Natal, and Khartum. More than a diplomat's travelogue, *One World* was a paean to a world united thanks to the miracle of airpower. Arguing against all forms of isolationism and imperialism, Willkie envisioned the united Allies winning the war and afterward a united world establishing a lasting peace. The instrument ensuring this vision of freedom and peace for everyone, according to Willkie, would be the United Nations, which had just been instituted in January 1942. It was this grand and utopian vision of unfettered freedom, unity in diversity, and global peace that structured the show. In the preliminary outlines for the exhibition, the conclusions emphasized the problems and the politics of war and peace.[69] In its final version, *Airways to Peace* stressed Willkie's promise of universal freedom and lasting peace—ideas that both looked back to *Road to Victory* and looked forward to postwar universal humanism, the glory days of the United Nations and UNESCO, the culture of the cold war, and the last in this series of crowd-pleasing exhibitions at the Museum of Modern Art.

The Family of Man

In 1955 Steichen "directed" *The Family of Man*, which has been described as the "greatest photographic exhibit of all time."[70] Everything about the show was cast in superlatives, from its creator's ambitions—Steichen called it "the most ambitious and challenging project photography has ever attempted"[71]—to its reception by an ecstatic press. In scores of laudatory comments, reviewers praised "the most elaborate photographic layout in history" and "the most important photographic show ever held in this city." They remarked on the event's coverage ("probably the most widely publicized of any photograph exhibition ever held in this country," "heavier press coverage than any comparable 'artistic' event in our history") and flatly stated, "no photographic exhibit has ever created such excitement."[72] Some writers compared the "gargantuan" exhibition with the wonders of the world, for it evoked "the feeling of having stepped into the Grand Canyon or the Carlsbad Caverns or something equally monumental."[73] One columnist foresaw the hard- and softcover books published in conjunction with the show becoming "as much a part of the family library as the Bible."[74]

Most writers felt compelled to recite a litany of statistics, perhaps to demonstrate with hard facts the unprecedented importance of the show. In various ways, they underscored the record-breaking attendance; "in the first two weeks 35,000 viewers flocked to see it," and "more than a quarter of million people jammed the museum to see *The Family of Man*."[75] There were recitations of the number of catalogues sold: "only three weeks after publication, the dollar edition alone was brought by a quarter of a million people."[76] The number of images included was religiously cited: by the Museum's count, an "astronomical total of more than two million prints was amassed," but some publica-

tions inflated this to three and four million.[77] The final number of pictures in the MoMA installation was "503 from 68 countries." But of course none of these contemporary statistics could take into account the show's subsequent history: the ten different editions of *The Family of Man*—a total of approximately 150 exhibitions—that were installed around the world well into the 1960s.[78]

Like its predecessors of the 1940s, *The Family of Man* was a panoramic installation, and many of its images were selected from the work of the great photojournalists of the day. Its visual language was common to most Americans, who were intimately familiar with the popular picture magazines. At MoMA the 503 photographs were displayed in an exhibition designed by Paul Rudolph.[79] Steichen was assisted by Wayne Miller, Sandburg wrote the prologue, and Dorothy Norman collected quotations that formed the exhibition's text. Steichen's dream of creating an exhibition about "the spirit of America, the face of America," which had inspired *Road to Victory,* was internationalized in *The Family of Man.*[80] Responding to the global consciousness of the 1950s, Steichen expanded his horizons to compose a portrait of humanity. He envisioned the show "as a mirror of the universal elements and emotions in the everydayness of life—as a mirror of the essential oneness of mankind throughout the world."[81] Or as Wendell Willkie might have said more simply, it depicted "one world."

For anyone who had frequented the Museum of Modern Art during the laboratory years, the themes of *The Family of Man* were familiar. The vision of the individual and of humanity found in the 1940s propaganda exhibitions was here in excess. The earlier nationalistic and wartime agendas were now subsumed within a more universalist, timeless worldview that had a forthright religious message. The essence of humanity was presumed to be heterosexual and patriarchal, with values and expectations matching those of a 1950s middle-class American family. When the viewer climbed up the staircase to approach the exhibition, he or she passed a "prologue" of uplifting images that were meant by the show's creators to represent timelessness caught by the "camera's eye and the photographer's hand": they began with a mural of a telescope photo of Orion, followed by a photograph of a naked child lying in the leafy ground cover of an ancient redwood forest, and then a photo of a mask from the Ice Age paired with that of a contemporary tribeswoman.[82] At the top of the stairs, installed opposite the exhibition entrance, was a wall-size photomural of a stream flowing into the ocean, presumably at dawn, paired with a small photo of a pregnant woman's torso; they were captioned "Let there be Light, Genesis 1:3" (fig. 4.17).[83]

However much the images selected by Steichen and Miller represented diverse societies and faiths and however many folk and ethnic sources were drawn upon by Norman in choosing the quotations, the tone of the show remained predominantly Christian.[84] With the exception of the Bhagavad Gita, there were no references to non-Christian sacred texts. Most of the non-Western sources were secular, anonymous, or from folk and mythic traditions, cited as "Sioux Indian," "Maori," "African Folk Tale," and so on. Steichen did not, as he intended, transcend nationality and religion; *The Family of Man* portrayed instead a notion of civilization over which a very particular Western god presides. The religious moralism implied in the exhibitions of the 1940s reached full force in this 1955 show. As Sandburg wrote, *The Family of Man* was a "camera testament."[85] Biblical quotations were key elements of the exhibition's narrative, and reviewers' seemingly hyperbolic comparisons with the Bible were, therefore, not so far-fetched.

Crowds of people came to see the show, and as was a standard feature of these exhibitions, crowds were portrayed in the show. The inside walls of the entrance doorway were papered with a crowd photomural, but unlike the images found in *Road to Victory* or *Power in the Pacific,* this crowd was a multitude (figs.

4.17

Designer: Paul Rudolph; curator: Edward Steichen, assisted by Wayne Miller and
Dorothy Norman, foyer outside MoMA's exhibition galleries, *The Family of Man*,
Museum of Modern Art, 24 January to 8 May 1955.

4.17 and 4.18). As was appropriate for an exhibition about a liberal ideal, the people were represented as a humanity whose tiny faces were for the most part distinguishable. Passing through the entranceway, the viewer was framed on either side by the crowd photo, and, in a sense, took his or her place among this photographic gathering of people.

Once inside the exhibition the visitor turned to the left to read Sandburg's introduction; its handwritten script reinforced an inclusive, intimate relationship with the viewer.

*There is only one man in the world
and his name is All Men.
There is only one woman in the world
and her name is All Women.
There is only one child in the world
and the child's name is All Children.
A camera testament, a drama of the grand canyon of humanity,
an epic woven of fun, mystery and holiness—here is the Family
of Man!*

Next to the Sandburg text was a familiar-looking photograph of a river canyon—familiar, that is, if the viewer had seen *Road to Victory* (see figs. 4.1, 4.18). But instead of being the National Park photo shown in 1942, it was an image of the landscape of China. In keeping with the more universal horizons of *The Family of Man,* to one side of the canyon photo (where the images of Native Americans were placed in *Road to Victory*) was a small portrait by Eugene V. Harris of a young Peruvian flute player. This "theme photo" of an impish flutist was repeated throughout the show and was featured in publicity materials, *The Family of Man* books, and the press. According to Rudolph, the flutist was Steichen's idea: "The flutist was a kind of symbol, a kind of musical note." Rudolph compared it to "the cinema" and saw it as an

element enhancing a sense of "passing through time and space." [86] At the base of the mural was a photo of two lovers lying in the grass. As was the case for the entire exhibition, the landscape of nature was humanized. Natural phenomena, such as water, were metaphors for the flow of human life. Culture, in *The Family of Man,* was nature.

Rudolph reflected on his installation design some forty years later:

The Family of Man *was a very important thing for me because I had never really considered the idea of heightening the experience that one has in an exhibition in relation to what the exhibition is intended to say and tell. . . . Exhibition design can deal very much with storytelling, unlike architecture. I was fascinated with the idea of the psychology of space and what could be manipulated in purely architectural terms, by this I mean space and light, vistas, space, color, and sequence.*

Having seen MoMA installations such as *Arts of the South Seas,* Rudolph was impressed with d'Harnoncourt's vista technique. When asked about *Road to Victory,* Rudolph said, "I thought it was a marvelous exhibition." [87]

The Family of Man installation's colors were muted, mostly grey. That was simply one element in a complex constellation; the resulting experience lent itself to cinematic comparisons. Rudolph believes the design had "a little bit to do with moviemaking. But at the same time it was very much itself. I would like to think

4.18

Rudolph and Steichen, entrance, *The Family of Man,* 1955. Photograph: Ezra Stoller © Esto.

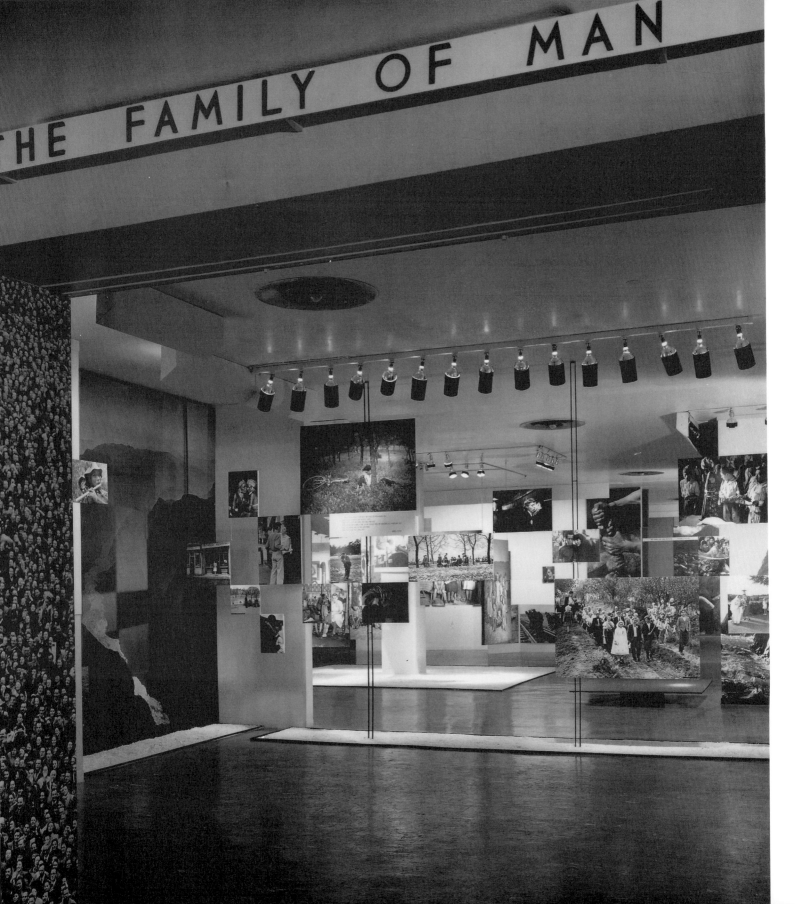

4.19

Preliminary wall arrangements for photographs included in *The Family of Man*.

the installation didn't interfere with the subject of the photographs and only heightened them." The exhibition was, however, a collaboration between a relatively young architect and an elder impresario, and Rudolph admits, "I thought some of [Steichen's] ideas were incredibly corny and still do. We had real battles." One of those battles dealt with the number of photographs. Rudolph remembers: "I'll never forget it. He had three thousand photographs. I told him we'd show at most three-fifty to four hundred. We worked with a large model and I could show him."[88] The final count was approximately five hundred photos (fig. 4.19).

Rudolph saw it necessary in *The Family of Man* installation to emphasize "telling a story, or in other words, to heighten the emotional aspect of the content of the photographs. There were sections which were, of course, Steichen's way of giving the exhibition organization and it was up to me to figure out a way to physically arrange these sections."[89] There were thirty-seven thematic sections (fig. 4.20). And fulfilling his intention, many of Rudolph's design solutions mirrored the photographs' subject matter; the exhibition possessed a narrative flow connecting these diverse themes.[90]

To the right of the first section, with its Chinese canyon photo and Sandburg quote, was a transparent wall that offered a panoramic view of the exhibition. Displayed in front of this wall, mounted on metal rods, were photographs of couples and weddings; these were called "the lovers" and "marriage" sequences (see fig. 4.18). Rudolph saw the "main entry" as a "series of photographs on one plane, with openings where you could see vistas of the rest of the show"; together they created visual "solids and voids, a screen made of photographs." The viewer then moved to what one might expect to find somewhere in an exhibition with a family theme, "the pregnancy temple." Rudolph had created an "all white" exhibition space on a slightly raised circular platform, with walls and ceiling of diaphanous curtains, lit with overhead florescent lighting, all of which were elements chosen for the obvious feminine associations.[91] The visitor could enter this rotunda to view photographs of pregnant women, a woman in labor, a child at birth, and nursing mothers displayed on the scrimlike curtain.

In these first two sections of The Family of Man, we see that Rudolph reworked formulations and transposed aspects of his 1952 Good Design installations. He recognized the connection between them: "These two exhibitions were certainly related to each other. They both deal with tonality of light, color, and emphasis."[92] In all of these installations, Rudolph deployed an alphabet of forms—circles, hemispheres, rectangles, and squares—to construct wall surfaces, shape exhibition space, and direct visitor circulation (see figs. 3.35 and 4.20). Like his earlier installations, Rudolph's design for The Family of Man was distinguished by its use of transparent materials, invisible or slight support structures, dramatic lighting, and dark and light-colored walls. In Good Design Rudolph's language of form created what might be described as abstracted table settings on which were placed the goods to be consumed, whereas in The Family of Man the exhibition elements enhanced the narrative of

the photographs. In these respects, Rudolph's exhibition technique in Family of Man can be compared with Bayer's. In some instances there were idiosyncratic arrangements, such as "cutout" photos of several figures; in another example, the photograph of a tree being cut down was placed on the ceiling above one laid on the floor of birds in flight over water. There were at least two photo panels hung from the ceiling by chains that could be moved or "swung" by the viewer. One of these panels had a photograph of a young man and woman kissing on a swing on one side, an old man and woman on a swing on the other.[93]

After the "pregnancy temple," the viewer wandered through a maze of sections where the family theme was conveyed in mothers and children, children playing, disturbed children, and fathers and sons. At this point the visitor reached the centerpiece of the show. Hanging from the ceiling and lit more brightly than other elements were giant enlargements of families from Sicily, Japan, Bechuanaland, and the United States (fig. 4.21). Captioned "With all beings and all things we shall be as relatives—Sioux Indian," these portraits gathered together one big international family to present most clearly to the viewer the family of man.[94] This centerpiece was treated as if it were a three-dimensional sculpture. The enlargements were double-sided, to allow viewing from any angle, and the viewer presumably would walk around it to visually embrace this central core. The floor area below the photographs was marked off by a square of white pebbles.

The exhibition narrative up to this point was obvious, developing from prehistoric time (nature) to love, marriage, birth, children, parents, and then the multigenerational family unit: the family of man. There was, of course, no room in this narrative for matriarchies or different kinship structures or nonheterosexual couples and relationships. There were no pictures of the divorced or dysfunctional. The diversity of the globe—which was becoming ever-more apparent to the exhibition's audience, thanks to images just like these that were being brought into their homes by

4.20

Rudolph, plan for *The Family of Man*.

4.21 →

Rudolph and Steichen, centerpiece of family portraits, *The Family of Man*, 1955.

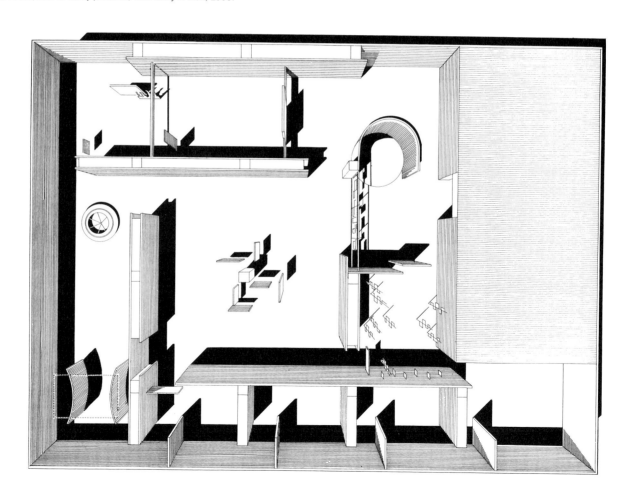

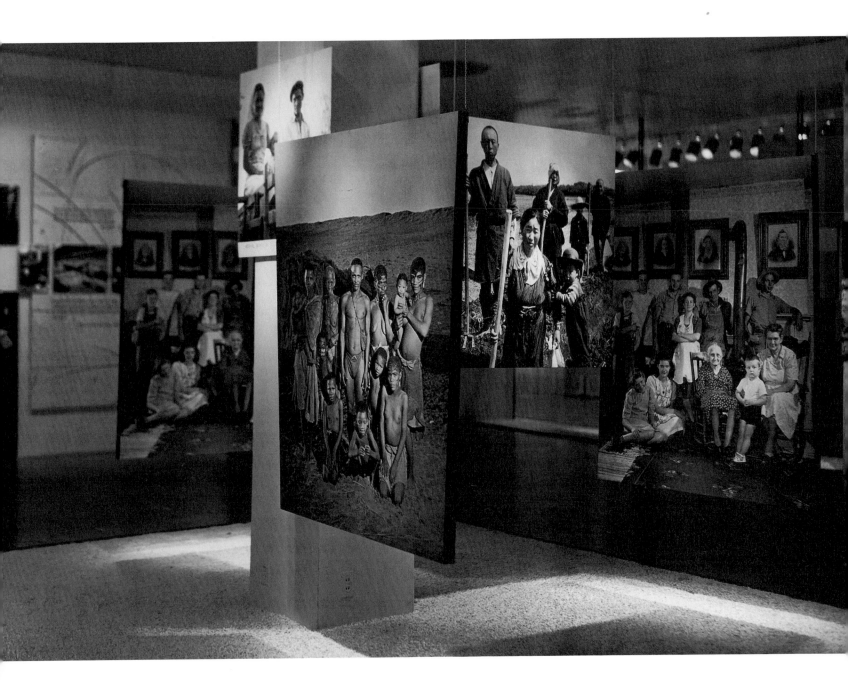

the picture press and by television—was reduced to a sameness in the particular family photographs displayed.

The viewer next wandered through a variety of sections that were less linear than the story of heterosexual love, breeding, and family that had preceded them. The sequences were arranged according to universalized themes: land, work, woman's work, adult play, classical music, jazz and blues, dance, folk music, food, ring-around-the-rosy, relationships (fig. 4.22). The ring-around-the-rosy exhibit was composed of photographs of children from twelve countries playing this game, which was described as universal. The photos were mounted on two circular bases supported by stanchions, forming a structure that had a likeness to a merry-go-round.[95]

The installation solutions were diverse, as was deemed appropriate for the subject matter. Photographs were installed in myriad arrangements—at eye level, above the viewer's head, in dynamic layouts as seen in the dancing and music section, and as huge, solid, dramatic wall murals such as a massive Ansel Adams photo in the landscape section that pictured Mount Williamson with acres of rocks in the foreground. The show had a tempo that worked to engender a kind of emotional roller-coaster ride. The layout, tone, and pace changed as the viewer moved from the extremely joyous themes of music and merrymaking to the more thoughtful sections dealing with human relations, education, and death. For that last exhibit, the viewer passed through a narrowed space created by two curved partitions lined with photographs of graveyards, funerals, and individuals mourning (see fig. 4.22). The caption read, "Flow, flow, flow, the current of life is ever onward—Kobodaishi." Past the curved passageway, mounted on the far wall, was a large photomural of crowds on Fifth Avenue. On reaching the mural at the end of the "death sequence," the viewer turned to the left and saw on a distant wall a photograph of the inside of a church, its altar's crucifix bathed in light. Throughout the exhibition there were panoramic vistas

such as this, where images and themes were visually and metaphorically layered.

The viewer then entered a narrow corridor of galleries where the themes stayed somber: religious expression, loneliness and compassion, aspirations, hard times, famine, inhumanities, revolt, teens, human judgments, voting, government, faces. In the "faces" exhibit, nine individual portraits representing diverse races and ages were placed on a dark wall (fig. 4.23). At the center at eye level was a mirror, where more explicitly than anywhere else in the show the visitor saw him- or herself as a member of "the family of man." The exhibit made Steichen's often-used looking glass metaphor tangible: "When people come out of this show they'll feel that they've looked in a mirror; that we're all alike."[96] Rudolph remembers that he thought this element was a bit heavy-handed: "Now it seems quite corny. Really, if you didn't understand by that time in the exhibition that 'The Family of Man' was you, I think it was unnecessary."[97] Once it was installed, Steichen and Miller quickly came to the same conclusion: "We found that it turned out to be corny and wrong."[98] Seen as too literal and obvious, the mirror was removed within the first two weeks of the show.[99]

After the "faces" exhibit, the viewer continued down the corridor past a single, narrow photo enlargement of a dead soldier and entered the last gallery of this corridor's sequence. The room was darkened and its walls painted red; there the viewer confronted what was exceptionally dramatic in an exhibition where every other image was black and white—a large, lit, color transparency of an exploding hydrogen bomb (fig. 4.24).[100]

The visitor then walked into the more light-filled and spacious galleries to face portraits of elderly couples that were mounted at right angles from the gallery wall, each captioned with Ovid's "We two form a multitude" (fig. 4.25). When the viewer moved further into the gallery, he or she realized that these portraits were mounted on the surface of a huge photomu-

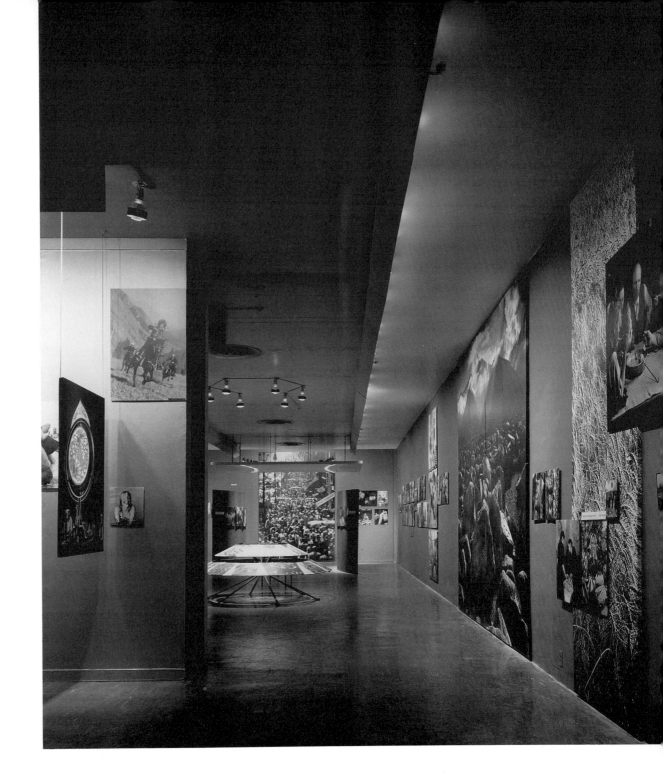

4.22
Rudolph and Steichen, vista of several thematic sections, *The Family of Man*,
1955.

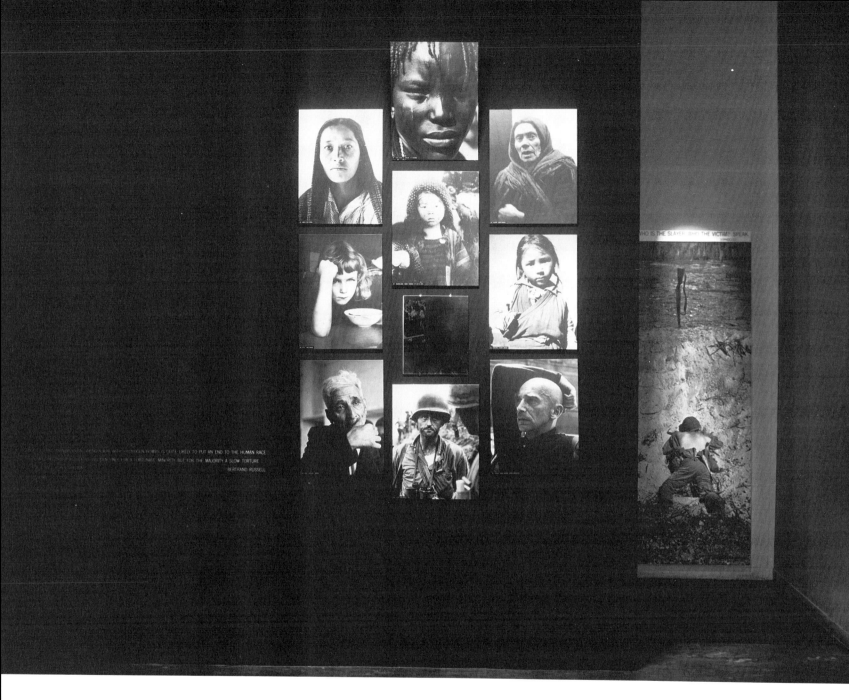

4.23

Rudolph and Steichen, "faces" exhibit, *The Family of Man*, 1955. The mirror was removed by Steichen during the first two weeks of the exhibition because it was seen as too literal and too obvious in terms of the ideas of the show.

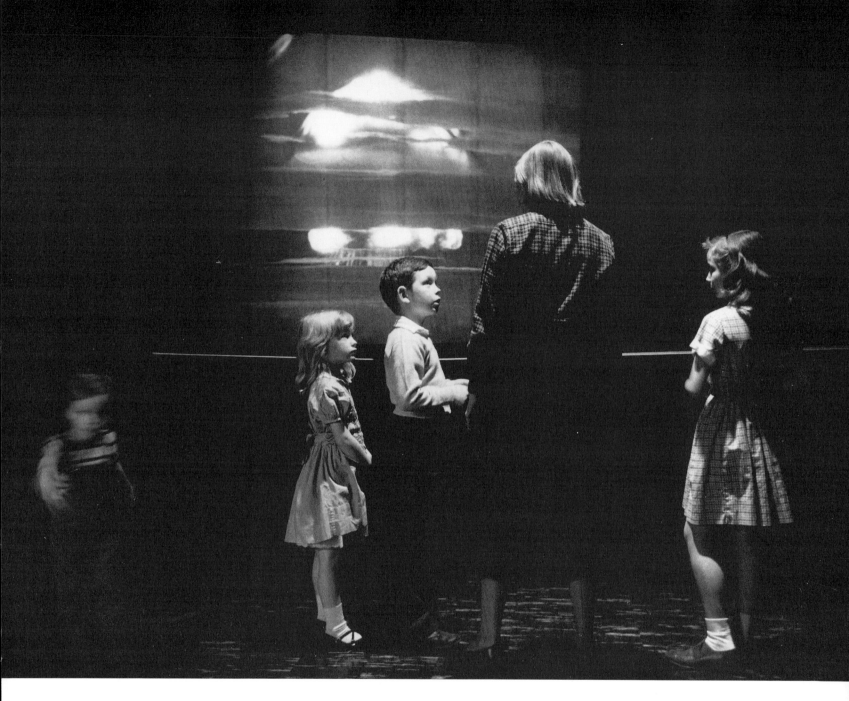

4.24

This is one of what were called "photographic footnotes"—taken by Wayne Miller of his family viewing *The Family of Man*—that were included in the hardcover version of the exhibition catalogue. Pictured are Joan Miller and the Miller children (*left to right*): Peter, Dana, David, and Jeanette. The image of an H-bomb was the only color photograph (a lit transparency installed in a dark gallery) included in the exhibition. Photograph: © Wayne F. Miller, Magnum Photos Inc.

4.25
Rudolph and Steichen, photomural of UN delegates, with portraits, *The Family of Man*, 1955.

ral of delegates at the United Nations. This climatic installation was to some extent *The Family of Man*'s counterpart to the marching soldiers and parents mural of *Road to Victory*. There, the final mural had assured the viewer that the young fighting men would achieve victory in war; here, the viewer moved past the wartime imagery and a presentation of nuclear threat to a picture symbolic of lasting peace. It completed the story, and, in a sense, laid to rest the fears that had begun thirteen years ago in the *Road to Victory* exhibition.

Just past the UN mural and at a right angle to it was a photo enlargement of the lower half of a young woman walking in water. This anonymous half-figure seemed to be wearing nothing but a spray of flowers that cascaded down her legs and strategically covered her lower torso (see fig. 4.25). The viewer could look past

the aged couples to this image of youthful, fertile, feminine beauty before entering the final section, the "magic of child-hood," where the walls were in hues of pink. Mounted on white poles in a playful, helter-skelter arrangement were photographs of happy children (fig. 4.26).[101] Rudolph described some of the factors that shaped this final section: "How to end the show was a difficult thing. You couldn't end with the atom bomb. It was about the idea of childhood and was a rebirth. It was done in pinks, warm color. It was light."[102] To complete the sense of clo-

4.26

Rudolph and Steichen, "magic of childhood" section, *The Family of Man,* 1955. The walls in this section were painted pink.

sure, the show ended with a symbolic return to nature: a photo of the churning surf of the sea.

That this last section was called the "magic of childhood" is particularly revealing, because much of the success of *The Family of Man* lies in its theatrical sleight of hand. The show introduced an idyllic picture of nature and humanity, then moved to a more complicated scenario of loneliness, grief, war, and the hydrogen bomb. At the juncture just before the darkened gallery with the bomb image, next to the group of portraits where (in the show's earliest weeks) the viewer came face to face with his or her own reflection, was a caption by Bertrand Russell: "the best authorities are unanimous in saying that a war with hydrogen bombs is quite likely to put an end to the human race. . . . there will be universal death—sudden only for a fortunate minority, but for the majority a slow torture of disease and disintegration . . ." It was just enough to strike a little terror in the viewer, compounded by the next gallery's dramatic, big, full-color picture of an atomic explosion. But, true to the form of popular melodrama, the viewer passed through these frightening moments and walked into light-filled galleries to find the picture-perfect happy ending: parents, the United Nations, and playful children.

The Magic of the Art of Exhibition

The show, however, was not merely theater. *The Family of Man* was structured to create dramatic tension founded on the very real fears of its audience and then, through the magic of the art of exhibition, to dissolve these fears by displaying a joyous present and bright future. This was the narrative structure and the key to the success of *Road to Victory* and, to some extent, of *Airways to Peace*. When considering this exhibition some forty years later, we must remember that *The Family of Man* opened two years after the end of the Korean War and ten years after World War II, during the first decade of the ominously named atomic age. The diversity of the globe and the racial tensions in the United States were realities that were increasingly apparent. The cold war was at its height; the differences between the peoples of the world and such phenomena of war as the hydrogen bomb were experienced—and *seen*, thanks to the power of the mass media—by most Americans as a very real threat. *The Family of Man* offered a portrait of humanity that acknowledged, in order to domesticate and tame, all of the great and common fears of an era.

Although the idealized image of the mid-1950s in the United States as a moment of relative peace and consumer plenty retains a degree of validity, the other, darker dimensions of the time were very present in Steichen's mind when he was creating the show. Within months of the opening at MoMA, Steichen described *The Family of Man* as "an article of faith—an antidote to the horror we have been fed from day to day for a number of years."[103] In films about the exhibition, Steichen's awareness of these *other* dimensions of the 1950s, specifically in relation to nuclear weapons, is made quite clear. In one case he begins, "In a world that is dominated by headlines dealing with issues of fear and hatred, it is maybe good to take off a few moments to look at ourselves as human beings, as members of the family of man."[104] In the several films where he leads the viewer through *The Family of Man* installations, Steichen questions why there must be such a horrible weapon and ends one with a plea against nuclear weapons.[105] That he chose an image of the then highly publicized hydrogen bomb—just tested for the first time in March 1954 and one thousand times more powerful than the bomb dropped on Hiroshima—is significant. There were two sections of the MoMA installation devoted to this issue: one, the dark climax of the show; the other, midway through the exhibition,

an arrangement of photographs of scientists, white-collar workers, and corporate meetings (fig. 4.27). The quotations captioning these images, which were part of the work section, included one from the U.S. Atomic Energy Commission: "Nuclear weapons and atomic electric power are symbolic of the atomic age: On one side, frustration and world destruction: on the other, creativity and a common ground for peace and cooperation."

Miller believes that Steichen's desire to create an exhibition like *The Family of Man* developed during World War II and that the show has to be understood in its historical context:

Remember, this exhibition followed the years of WW II. . . . We were coming apart at the seams: the concentration camps, the Russian caualties, the depravity of humanity, the postwar shock and disorientation. Steichen was aware that an exhibition of war photographs didn't affect people in the sense that after seeing the show, people went out and had drinks and that was that. . . . This approach was a better way to have people realize the futility of war. In The Family of Man, *he was emphasizing the fact that war is not an answer and we have to think about peace. . . . Look that time, it was a different world, but then the show was meaningful and there were real struggles were going on. . . . Steichen was a romantic. He wanted to sing the American dream. He felt that there was more love than hate in the world. . . . He was trying to talk about love; these were delicate threads of life that he had great respect for. . . . He believed that photography was uniquely qualified . . . to say things about the world that other media could not do.*[106]

However sentimental and limited *The Family of Man* appears today, it is important to realize that it also was, on many levels, a much-needed call to respect the diversity of the world's population.[107] That this 1955 exhibition included an image of women in France voting takes on greater significance if the viewer knows that it was only in 1946 that French women were finally granted the franchise. The photographs—of Jews being marched through the Warsaw Ghetto by German soldiers,[108] or of a dignified-looking black man speaking to a crowd in South Africa, or of a jam-packed Indonesian trolley painted with "All People are created Equal"—cannot be discounted as merely displaying sentimental humanism. Images of diverse peoples must have resonated strongly in a country that only a decade before had imprisoned its own citizens because of their Japanese heritage and that had long assigned African American and Caucasian American individuals to socially sanctioned separate and unequal rights and fates.

In 1955 the United States was an overtly racist society, and the postwar civil rights movement was gaining force.[109] *Brown v. Board of Education* had just struck down segregation in the schools in 1954: 1955 marked the beginning of the fight to institute that ruling. The exhibition's photo of a young African American boy walking with his arm around a blond Caucasian American boy must have struck viewers in 1955 with particular force. But a photograph of a lynched African American man—chained to a tree at his neck and torso, his tied arms yanked and extended out from his scarred body and his head twisted to the side—proved to be too graphic an image to remain part of this portrait of the family of man (fig. 4.28).

This 1937 image, *Death Slump at Mississippi,* by an "unknown" photographer, was removed during the first two weeks of the show, at the same time as the mirror. Miller explains,

Steichen and I found that spectators were hesitating in front of that photograph. It became a disruption to the overall theme of the exhibition. We wanted the photographs to work together. Although it was a very, very important photograph. . . . We observed the traffic flow. . . . We wanted this exhibition to flow . . . and the photograph was a stumbling block. People stumbled. It

4.27

Rudolph and Steichen, *The Family of Man*, 1955. This section included a quotation from the U.S. Atomic Energy Commission: "Nuclear weapons and atomic electric power are symbolic of the atomic age: on the one side, frustration and world destruction: on the other, creativity and a common ground for peace and cooperation."

4.28

Rudolph and Steichen, *The Family of Man,* 1955. The "inhumanities" section included this 1937 image, *Death Slump at Mississippi* by an "unknown" photographer, which was removed during the first two weeks of the exhibition because its inclusion interrupted the smooth flow of visitors moving through the show. People were clustering and pausing in front of this photograph.

*was a fantastic picture. It just didn't work there. . . . We were
dealing with a piece of music and this was a discordant note.*[110]

I found no discussion of this removal in press reports or the Museum's archives. In fact, several weeks after *The Family of Man* opened, *Life* magazine ran a cover story about the exhibition that included this image among the twenty photographs selected from the more than five hundred constituting the show.[111] According to Miller, the decision to eliminate the photograph was his and Steichen's: "We observed the reactions of the crowds. Steichen and I talked about it. . . . If Steichen had other pressures on him, I had no idea. He didn't mention anything to me."[112] This photograph, another installed next to it (in what was called the "inhumanities section") of several individuals being shot by a firing squad, and the atom bomb image were never included in the book, which thus documented a significantly more manageable and tame version of the show. (There was one exception to this: a relatively rare hardcover edition that included an installation photograph of the image of the atom bomb.) Important to the history and influence of *The Family of Man* is the fact that the standard version of the catalogue did not include the photograph.

The years during which *The Family of Man* was created must be considered distinct from the moment of the show's opening in 1955 and the time of its circulation as a traveling show through the 1960s. Civil rights were in the public eye in the United States in 1955 and became increasingly visible during the following years, but as Miller remembers it, "this did not have too much impact" on Steichen as he worked on the show during the first half of the decade. The political events that did have an affect, according to Miller, were the Army-McCarthy hearings that were being televised as the two men selected images for the exhibition:[113]

The biggest thing, I think, was Senator Joe McCarthy. He was a tremendously divisive force. This was a rotting away of the foundations of our democracy. . . . There was a great sense of lack of faith and of fear. It was not only McCarthy, but he was symbolic of it. This affected Steichen to an appreciable degree. As we were working, we wondered should we change this and that because of McCarthy and Steichen said: "Hell, no!" For example, we included a picture of Oppenheimer and Steichen said, "We are showing Oppenheimer as a teacher and not as a political figure"; and there were other things that were considered to have a liberal sense. Steichen resisted any effort to soften or dilute the images he believe might be exposed to the threat of attack by McCarthy. This threat was real. . . . It was a real worry.[114]

In the mid-1950s there was perhaps no more reassuring message to the American public than *The Family of Man*'s paternal and patriarchal vision of the world. Allan Sekula has described the exhibition as a "more or less unintentional popularization of the then-dominant school of American sociology, Talcott Parson's functional structuralism."[115] In Parson's version of patriarchy the nuclear family is viewed as the most efficient family form: the father is the active, idea person, working in the public sphere, and the mother is the emotional caretaker whose domain is the home. This worldview certainly shaped the parameters of the show. However, the dynamics of *The Family of Man*'s appeal and success become even more interesting when one realizes that Parson's theories were being challenged at the very moment of the exhibition.

In 1955 Parsons published *Family, Socialization, and Interaction Process* in response to assertions that there was "a decline of the family." In fact, the United States during the postwar years was "shaken by the rate of divorce," and a campaign was initiated to stabilize the traditional American family.[116] In 1948 President Harry S. Truman authorized a national conference at

the White House on family life. Civic and religious organizations set up clinics, counseling services, workshops, and institutes on marriage and the family. By 1955 this increase in the divorce rate had temporarily subsided somewhat.[117] Nonetheless, in the mid-1950s problems like juvenile delinquency and public insecurities about family standards (or what later would be called "family values") seemed so pressing that in 1955 a Senate judiciary subcommittee on juvenile delinquency was formed.[118] Films like *Blackboard Jungle* and *Rebel without a Cause* were playing in movie houses, and rock and roll, particularly in the figure of Elvis Presley, was being widely assailed as a bad influence on America's youth.[119] Eight years after the exhibition, Betty Friedan, in her classic *The Feminine Mystique,* revealed that the pretty pictures of family life in the 1950s were a smoke screen hiding profound discontent among the women of the United States, who were trying to cope with their restrictive options after the relative freedom of the war years.[120] The success of *The Family of Man* lies in part in its presentation of a clear and solid vision of the traditional American family at a moment when those "traditions" were beginning to show cracks in their foundations.

The rare negative reviews of the show in 1955 came from writers who thought *The Family of Man* was not art at all but anthropology, sociology, or worse, journalism.[121] And there were infrequent musings in some reviews that perhaps people were not all exactly the same; one of the most critical assessments came from Hilton Kramer in *Commentary.* In "Exhibiting the Family of Man," Kramer lashes out against what he considers a sentimental "visual morality play" that does not deal with the political realities of a world in crisis. He sees *The Family of Man* as a "reassertion in visual terms of all that has been discredited in progressive ideology." However apt many of his criticisms may be, Kramer reveals his insensitivity with phrases like "old women gawking" and he makes the disturbing comment "that if races are 'as relatives' in any sense, they are political relatives." What

most concerns Kramer is that *The Family of Man* left the "art of photography exactly where it was before, suffering from widespread confusion about its aesthetic status." He indicts Steichen for contaminating photography with this "ideological infection," ending with a tirade against the "onslaught of mass pictorial journalism."[122]

Roland Barthes, writing "The Great Family of Man" at about the same time in response to the show's Paris installation, also criticizes the *The Family of Man* for its degraded humanism and sentimental moralizing. While Kramer's aim is to preserve the aesthetic status of photography from the contamination of mass culture, Barthes is more concerned with *The Family of Man*'s celebration of the "ambiguous myth of the human 'community.'" According to Barthes, the universal humanist myth "functions in two stages: first the difference between human morphologies is asserted, exoticism is insistently stressed, . . . the image of Babel is complacently projected over that of the world. Then, from this pluralism, a type of unity is magically produced[.] . . . Of course this means postulating a human essence, and here is God re-introduced into our Exhibition." What Barthes argues for instead is a "progressive humanism" that "must always remember to reverse the terms of this very old imposture, constantly to scour nature, its 'laws' and its 'limits' in order to discover a History there, and at last to establish Nature itself as historical."[123]

During the past fifteen years, revisionist historians have followed Barthes's call to history when appraising *The Family of Man.*[124] There remains little doubt that the United States Information Agency editions, like the one Barthes visited in Paris, were intended to promote American cold war agendas and were sent to many extremely strategic venues. After all, *The Family of Man* became quite an undertaking for the USIA. The agency commissioned four smaller-format versions and eventually bought the original show that had been circulating domestically and sent this arsenal of exhibitions to approximately eighty-four foreign ven-

ues.[125] Possibly the most celebrated of *The Family of Man* installations was the Moscow showing in 1959, which was featured in the U.S. government's cold war, public relations extravaganza, the *American National Exhibition.* Although it has become generally accepted that *The Family of Man* was a cultural weapon of the cold war, what needs to be stressed is that these government collaborations with MoMA were no secret: *The Family of Man's* sponsorship by the USIA was, at the time, widely publicized.[126]

In the first several decades of the Museum of Modern Art, relations between the federal government and the Museum were strong and have been a well-known part of the institution's history. But the situation thereafter became somewhat complicated. By the late 1940s and early 1950s, the U.S. government was facing strong opposition to federal sponsorship of the arts. After having suffered a number of attacks by reactionary members of Congress and by conservative groups, the State Department canceled exhibitions and curtailed sponsorship of modern culture. As early as 1947, Secretary of State George C. Marshall declared, "No more taxpayers' money for modern art."[127] Most of this opposition was linked to fears that the artists were affiliated with the political "left-wing," or that modern art itself was an avant-garde form of Bolshevism. The exploits of Congressman George Dondero as a McCarthy-era cultural antagonist and the art world's defenses of modern culture—such as Alfred Barr's 1952 *New York Times Magazine* article, "Is Modern Art Communistic?"—were key battles in these struggles.[128]

What changed in the 1950s and 1960s was the character of the collaboration between the State Department and the Museum of Modern Art. When the federal government stopped supporting modern art, the Museum began to take the lead as U.S. cultural ambassador. In 1952 MoMA's Circulating Exhibitions Program, which had deteriorated in the years just after the war, was restored to prominence thanks to a five-year grant from the Rockefeller Fund. Very much the brainchild of Nelson Rockefeller,

the refurbished program—no longer primarily national, but now international in scope—reflected his political and economic interests. In 1956 this entity was transformed into MoMA's powerful International Council.[129] One of the most obvious examples of MoMA's responsibilities during these years was its purchase of the U.S. pavilion for the *Venice Biennale.* Throughout the history of the *Biennale,* all the national governments involved owned their respective pavilions, with the exception of the United States (which has never owned the pavilion). In 1954 the Museum of Modern Art purchased the U.S. national pavilion and owned it until 1962.[130]

What was not public information regarding the collaborations at this time between the U.S. government and the Museum was revealed in the late 1960s. The Museum of Modern Art and other cultural institutions had received moneys from CIA dummy foundations. The foundation in MoMA's case was the Whitney Trust set up by John Hay Whitney, the former chairman of the Museum's Board of Trustees, who some twenty-five years before this revelation had called the museum a "weapon in national defense."[131]

Although modern art was generally denied federal support in the late 1940s and 1950s, making it necessary for the cultural weapons of the cold war to be supported secretly by the CIA, *The Family of Man* was an exception. More representative of the situation was the fate of the U.S. painting exhibition sent to Moscow along with *The Family of Man.* The painting exhibition barely passed the congressional censors; only when President Eisenhower declined to recall the painting show did it survive.[132] *The Family of Man* encountered no such opposition and, as already described, its inclusion in the *National Exhibition* was applauded by the American press.[133]

The exhibition's global success is related to what was described in a press release as *The Family of Man's* "radical departure" from traditional photography exhibitions, "in so far as it

stresses the art of photography as a universal language in recording the world we live in."[134] This grand attempt to achieve a universal language can be set against the early experiments in exhibition design of the 1920s and 1930s and the international avant-gardes of the first half of the century. In the first decades of the twentieth century, it was abstract art that was supposed to transcend language and cultural associations. It was abstract painting that artists such as Piet Mondrian, Wassily Kandinsky, and Kazimir Malevich initially envisioned as the universal language of the modern world. Paradoxically, by the second half of the century it became clear that fine art's other—popular culture, advertising, and the mass media—was supplying the universal language of international communities. By the 1920s and 1930s, artists such as Bayer and Steichen had realized the potential power and creativity of the new mass media, and their seemingly infinite and universal audiences lead Bayer to see exhibition design as part of this cultural spectrum and as the "apex of all media and powers of communication."[135] That the exhibition seen by the most people and surpassing all others in mythic stature and fame would have as its subject universality itself could not have been more appropriate.

However aptly The Family of Man may have expressed the utopian aspirations of the international avant-gardes of the first half of the century, the reality came through in one of the most telling stagings of the exhibition, in South Africa. At the entrance was an exhibit added by the show's corporate sponsor, which was described in one of the company's publications as a "large globe of the world encircled by bottles of 'Coca-Cola' [that] created a most attractive eye-catching display and immediately identified our product and organization with 'The Family of Man' sponsorship."[136] At this particular installation, there was no getting around it: Steichen's and Wilkie's dream of "one world" had transmogrified into the universal markets of Coke.

As was the case with the most successful shows during the laboratory years at MoMA, the exhibition design of The Family of Man reinscribed the innovations of international avant-gardes within a language of form mirroring the "common sense," or dominant ideology, then prevailing in the United States. The Family of Man installation, unlike the difficult Bauhaus show, was embraced by the American public. Its drama was familiar, its promise reassuring. The show's photojournalistic realism and vision of a humanity whose character matched a mythic 1950s American ideal made it a perfect vehicle to promote the State Department's interests at a time when modern art was off-limits to such support.

The problems of The Family of Man seem obvious some forty years later: its hard-core patriarchy, its cloying sentimentalism, its domestication of the other. Even its title's noninclusive language leaves out more than half of the world's population. But the show can also be seen as a fledgling articulation of what was then a relatively new type of awareness of a global humanity, which had developed in the 1920s and 1930s thanks to technological advances and the development of the mass media. This declaration of the equality of and respect for all humanity is founded on possibly the most "enlightened" and influential idea to take hold within modernity. Its clear articulation in The Family of Man is central to the exhibition's long-lasting popular success.

But the universalism of The Family of Man, which reduces all peoples of the world to one very historically limited concept of essence, also shares much with the equally new and equally reductive meanings associated with the masses and mass culture.[137] It was during the 1940s and 1950s that the vast and diverse configurations of the mass media were deemed a singular mass culture and the complex and myriad audiences of the world were reduced to a monolith.[138]

The scores of simultaneous editions of The Family of Man, which circulated for years nationally and internationally, marked

4.29

Still photo of cast of *Father Knows Best,* one of the first of what would become a dominant form for representing modern life in the United States: the family situation comedy. During the years *The Family of Man* was installed at MoMA and then presented in its various versions as an international traveling exhibition, *Father Knows Best*—which ran as original shows from 1954 to 1960, and then in reruns from 1961 to 1963—was among the most popular television shows in the United States. This picture-perfect patriarchy starred Robert Young as Jim Anderson (*center*) and (*from left to right*) Lauren Gray as Kathy Anderson ("Kitten"), Elinor Donahue as Betty Anderson ("Princess"), Billy Gray as James Anderson, Jr. ("Bud"), and Jane Wyatt as Margaret Anderson.

an attempt to achieve the kind of simultaneous collective reception that is the province of electronic mass media. It is no coincidence that during these years television was becoming widely available. At the time of the MoMA installation, the *New York Times* was praising a new kind of TV show, titled *Wide, Wide World.* Its first episode was described as a "panorama of life in North America," and this broadcast was particularly noteworthy because the "picture travelogue" was live. The cameras in forty locations around the United States, Mexico, and Canada "provided absorbing glimpses of people of the three nations at work and at play."[139] In *The Family of Man* exhibitions, installation design was pushed to its 1955 technological and practical limits in order to achieve the kind of global dominion that was to be so easy, so suitable for a television screen. And it was the medium of television that would come to present the dominant images of modern family life (fig. 4.29).[140]

The installation designs of *The Family of Man, Road to Victory, Power in the Pacific,* and *Airways to Peace* differ from MoMA's shows of the late 1960s and after in that their creators acknowledged the institutional processes of the art of exhibition and were fully aware of the power of display.[141] In MoMA's laboratory years, Steichen, Bayer, Rudolph, and their colleagues did not consider the gallery a neutral container for aestheticized images and objects. Like the objects and images exhibited, the installations were viewed as creations that manifested agendas and ideas and involved politics, history, capitalism, commerce, the commonplace, and, of course, aesthetics.[142]

As was also true in displays of painting, sculpture, design, and architecture during MoMA's first several decades, these political and photographic exhibitions were not separated from other, nonaesthetic institutional discourses—in this case, those of the mass media and the U.S. government. Such forthright political and mass cultural associations would, by 1970, be banished from the galleries of the Museum of Modern Art. When John

Szarkowski replaced Steichen as director of the photography department in 1962, the gallery wall soon became a neutral field for framed prints, and photography appeared only as fine art. Szarkowski's successor, Peter Galassi, with rare exception, has faithfully perpetuated his predecessor's formalist art of exhibition.[143]

Steichen and his colleagues may have been blind to the limitations of what Barthes would call their "classic humanist" agendas, but they did realize that the art of exhibitions could be a powerful and political business.[144] These men and women also exploited the fact that the gallery was not immune to the dynamics of popular and corporate culture. But their more forthright, complicated, impure, innovative, ambitious, and sometimes "corny" exhibitions of MoMA's laboratory years would disappear, leaving only traces in the archives of the Museum—and *The Family of Man* book, which continues to sell by the millions.[145]

Chapter 5

Installation Design and Installation Art

Activism in the Artworld and the Art Workers Coalition

Politics at the Museum of Modern Art in the 1940s and 1950s meant wartime propaganda exhibitions, government poster competitions, and traveling shows selling images of the American humanist dream. In the late 1960s and early 1970s, it meant defending the Museum against the criticisms and demands of artists. Not that such controversies were absent from MoMA's previous history; however, none of those earlier battles compares with what took place within and around the walls of the Museum during these years.[1] Fulfilling its role as a paradigm of modern art institutions, the Museum of Modern Art became a target—and a stage—for the political agitations of artists as they voiced dissent against war, racism, and sexism, as well as other socially sanctioned conventions such as the political dimensions and institutional limits of the modern art museum.

The political fireworks started on January 3, 1969, when Takis (Takis Vassilakis), with the help of several other artists and friends, removed his *Tele-Sculpture* (1960) from a MoMA exhibition, *The Machine at the End of the Mechanical Age*.[2] Takis and these artists and friends took *Tele-Sculpture* from the gallery and carried it into the Museum's garden, which they declared a "neutral territory" as the Museum staff surrounded them.[3] Upset that he had been represented in the exhibition only by this one particular piece, which was owned by the Museum, Takis had requested that guest curator Pontus Hulten omit his work from the show. Failure to heed the request led to the art-jacking and to Takis standing in the Museum garden, demanding that *Tele-Sculpture* never be shown again without his permission and that

"Revolution" was the most often-used word I ran into this summer.

—Philip Leider, "How I Spent My Summer Vacation or, Art and Politics in Nevada, Berkeley, San Francisco, and Utah" (1970)

If you are an artist in Brazil, you know of at least one friend who is being tortured; if you are one in Argentina, you probably have had a neighbor who has been in jail for having long hair, or for not being "dressed" properly; and if you are living in the United States, you may fear that you will be shot at, either in the universities, in your bed, or more formally in Indochina. It may seem too inappropriate, if not absurd, to get up in the morning, walk into a room, and apply dabs of paint from a little tube to a square of canvas. What can you as a young artist do that seems relevant and meaningful?

—Kynaston L. McShine, catalogue for *Information* (1970)

MoMA hold an open meeting to discuss the relationship between artists and the Museum. The episode concluded with Bates Lowery, the Museum's director, agreeing that the piece would not be returned to the show and promising to consider arrangements for such a meeting. This venture into the aesthetic domain of artists' rights and activist performance was the catalyst for the founding of the Art Workers Coalition.

On January 5 a group of artists and critics—which included Farman and Willoughby Sharp (who were among the art-jackers), as well as Gregory Battcock, Hans Haacke, and Tsai—issued a formal statement to the Museum. This core group then called a meeting attended by some forty artists, and similar weekly meetings became a source of activism during the next several months. Lowery had agreed to meet with six artist representatives; but when more than six artists and critics showed up for the meeting Lowery canceled and rescheduled for the 28th. In the intervening days, the artists and critics compiled "Thirteen Demands," which were signed by what was now called the Art Workers Coalition (AWC). They called for a public hearing on the topic of "the museum's relation to the artist and to society," the establishment of an area of the Museum devoted to the accomplishments of Black artists, free admission, a committee of artists to be selected annually who would have curatorial responsibilities to arrange Museum exhibitions, and the employment of staff members who were able to facilitate nontraditional art both within and outside the Museum's walls. Also listed among the demands were requests that the Museum declare its position on copyright legislation, that artists be paid rental fees for the exhibition of their work, and that MoMA appoint an individual to handle artists' grievances.

These events culminated on March 30 when about three hundred artists and critics packed into the Museum garden for what was called an artists' open meeting but was in fact more of a demonstration. Although the arts community was to be admitted through the garden gate, many of those attending pushed through the main entrances. The crowd listened to speeches and the "Thirteen Demands," which were delivered through a bullhorn while demonstrators carried signs such as "Bury the Mausoleum of Modern Art" and passed out assorted handbills.

But the Museum—no stranger to the art of propaganda and masterful public relations—had brought its own materials to the demonstration. A special packet was handed out to the press and to the Museum's estimated 6,500 visitors that day by some forty staff members who were also instructed to engage in conversations with the artists.[4] The packet included a letter from Lowery saying, "I hope that your visit today will not be inconvenienced by the artists's demonstration[.] . . . For some time we have been discussing the relationship of museums and artists and the responsibilities of museums to the community and society."[5] Lowery then promised the creation of a "Special Committee on Artists Relations"—to be composed of artists, filmmakers, architects, historians, and museum administrators—whose sessions would be open to the public. Several pages of information explained Museum policy and a financial chart illustrated the Museum's budget and deficit. The event ended peacefully and, as was to be the case throughout these years, was covered extensively by the press.[6]

There was a tremendous amount of activity and interchange between the Museum and its artist communities during the next year. Committees were set up within the Museum, such as the one concerning MoMA's relationship to women artists. Promises were made and broken, such as MoMA's pledge to establish an African American center. And in the end, very little policy was changed, except that for a brief period the Museum allowed free admission one day a week.[7] If nothing else, these artist confrontations certainly stimulated awareness and discus-

sions among the trustees and the Museum staff, who often shared the artists' concerns. The final outcome of the exchanges between the AWC and MoMA was a series of prolix meetings, letters, demands, and memos.

The more visually dramatic dimension of this history was the transformation of the Museum's entrances, lobby, and galleries into stages for demonstrations, sit-ins, and agitprop performance. Joseph Kosuth and other AWC members printed replicas of MoMA's annual passes marked "art workers," which were distributed in front of the MoMA on March 22.[8] The Museum countered by passing out handbills explaining that certain individuals were admitted free, such as school children, underprivileged groups, and artists in the collection. One of the more graphic and infamous "performances" was the Guerrilla Art Action Group's *Call for the Immediate Resignation of All the Rockefellers from the Board of Trustees of the Museum of Modern Art*—or, as it was referred to in the press, the "blood bath" of November 1969 (figs. 5.1, 5.2, and 5.3).[9] Several GAAG members dressed in suits and street clothes walked into the Museum lobby, threw one hundred copies of "The Demands of GAAG of November 10, 1969," on the floor, ripped at each other's clothes, screamed what GAAG later described as "gibberish" except for the one distinguishable word "rape," and burst sacks of beef blood that had been concealed under their clothes.[10] The artists threw themselves on the floor, writhing and moaning in the pools of blood; they then stood up, put on their coats, and left, leaving behind stunned museum guards and visitors. The latter spontaneously applauded. The purpose of the action, outlined in the leaflets thrown on the floor, was a call for the resignation of the Rockefeller family because of its involvement in corporations producing war materials.

Another unparalleled event at MoMA took place the day that eight performance artists decided to take off their clothes and dance and loll about the sculptures in the Museum's garden while the chief security guard begged them to get dressed. Yayoi Kusama, one of the nude performers, declared their serious purpose was to protest the Museum's lack of modernity, again calling MoMA a "mausoleum of modern art."[11]

Among the protests of greatest note were those in response to the cancellation by the board of trustees of MoMA's sponsorship of a poster depicting the 1969 massacre at My Lai. According to Irving Petlin, then a member of the Art Workers Coalition, Arthur Drexler, who was representing the Museum at an AWC meeting, had agreed to pursue the possibility that MoMA and the AWC cosponsor a poster condemning the massacre.[12] As Petlin remembers it, when the AWC poster committee—composed of Petlin, Frazier Dougherty, and Jon Hendricks—finally showed the maquette to Drexler, he immediately took it to a Museum board meeting then in session. But Drexler returned shaken, saying that the board would have no part of it and holding the board's president, William Paley, and board member Nelson Rockefeller primarily responsible for killing the project. The Museum's version of events—published in a press release, "The Museum and the Protest Poster," dated January 8, 1970—described the meetings with the AWC, but told the end of the story very differently: "Mr. Paley said that he could not commit the Museum to any position on any matter not directly related to a specific function of the Museum[.] . . . He offered to bring the subject before the Board of Trustees during its next meeting on January 8th." According to the press release, Drexler and Elizabeth Shaw of MoMA's public relations department subsequently conveyed this information to the poster committee, but because time had already been reserved for the printing press, "staff members of the committee urged the artists to proceed independently. That is what they decided to do."[13]

 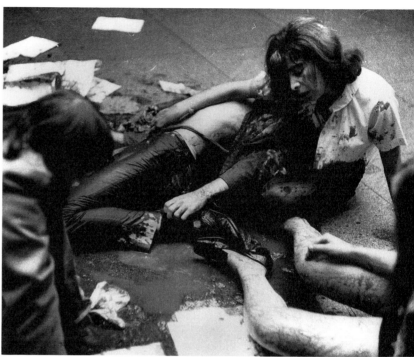

A CALL FOR THE IMMEDIATE RESIGNATION OF ALL THE ROCKEFELLERS FROM THE BOARD OF TRUSTEES OF THE MUSEUM OF MODERN ART

There is a group of extremely wealthy people who are using art as a means of self-glorification and as a form of social acceptability. They use art as a disguise, a cover for their brutal involvement in all spheres of the war machine.

These people seek to appease their guilt with gifts of blood money and donations of works of art to the Museum of Modern Art. We as artists feel that there is no moral justification whatsoever for the Museum of Modern Art to exist at all if it must rely solely on the continued acceptance of dirty money. By accepting soiled donations from these wealthy people, the museum is destroying the integrity of art. These people have been in actual control of the museum's policies since its founding. With this power they have been able to manipulate artists' ideas; sterilize art of any form of social protest and indictment of the oppressive forces in society; and therefore render art totally irrelevant to the existing social crisis.

1. According to Ferdinand Lundberg in his book, *The Rich and the Super-Rich*, the Rockefellers own 65% of the Standard Oil Corporations. In 1966, according to Seymour M. Hersh in his book, *Chemical and Biological Warfare*, the Standard Oil Corporation of California—which is a special interest of David Rockefeller (Chairman of the Board of Trustees of the Museum of Modern Art)—leased one of its plants to United Technology Center (UTC) for the specific purpose of manufacturing *napalm*.

2. According to Lundberg, the Rockefeller brothers own 20% of the McDonnell Aircraft Corporation (manufacturers of the Phantom and Banshee jet fighters which were used in the Korean War). According to Hersh, the McDonnell Corporation has been deeply involved in *chemical and biological warfare research*.

3. According to George Thayer in his book, *The War Business*, the Chase Manhattan Bank (of which David Rockefeller is Chairman of the Board)—as well as the McDonnell Aircraft Corporation and North American Airlines (another Rockefeller interest)—are represented on the committee of the Defense Industry Advisory Council (DIAC) which serves as a liaison group between the *domestic arms manufacturers* and the International Logistics Negotiations (ILN) which reports directly to the International Security Affairs Division in the *Pentagon*.

Therefore we demand the immediate resignation of all the Rockefellers from the Board of Trustees of the Museum of Modern Art.

New York, November 10, 1969
GUERRILLA ART ACTION GROUP

Supported by:
The Action Committee for
Art Workers Coalition

Silvianna Jon Hendricks
Poppy Johnson Jean Toche

November 10, 1969: Silvianna, the artist/filmmaker and a member of A.W.C., participated in this action only. The Action Committee of the Art Workers Coalition put their stamp on the manifesto as a way to show their support. GAAG was always a separate group from A.W.C.

COMMUNIQUE

Silvianna, Poppy Johnson, Jean Toche and Jon Hendricks entered the Museum of Modern Art of New York at 3:10 pm Tuesday, November 18, 1969. The women were dressed in street clothes and the men wore suits and ties. Concealed inside their garments were two gallons of beef blood distributed in several plastic bags taped on their bodies. The artists casually walked to the center of the lobby, gathered around and suddenly threw to the floor a hundred copies of the demands of the Guerrilla Art Action Group of November 10, 1969.

They immediately started to rip at each other's clothes, yelling and screaming gibberish with an occasional coherent cry of "Rape." At the same time the artists burst the sacks of blood concealed under their clothes, creating explosions of blood from their bodies onto each other and the floor, staining the scattered demands.

A crowd, including three or four guards, gathered in a circle around the actions, watching silently and intently.

After a few minutes, the clothes were mostly ripped and blood was splashed all over the ground.

Still ripping at each other's clothes, the artists slowly sank to the floor. The shouting turned into moaning and groaning as the action changed from outward aggressive hostility into individual anguish. The artists writhed in the pool of blood, slowly pulling at their own clothes, emitting painful moans and the sound of heavy breathing, which slowly diminished to silence.

The artists rose together to their feet, and the crowd spontaneously applauded as if for a theatre piece. The artists paused a second, without looking at anybody, and together walked to the entrance door where they started to put their overcoats on over the bloodstained remnants of their clothes.

At that point a tall well-dressed man came up and in an unemotional way asked: "Is there a spokesman for this group?" Jon Hendricks said: "Do you have a copy of our demands?" The man said: "Yes but I haven't read it yet." The artists continued to put on their clothes, ignoring the man, and left the museum.

NB:—According to one witness, about two minutes into the performance one of the guards was overheard to say: "I am calling the police!"
—According to another witness, two policemen arrived on the scene after the artists had left.

New York, November 18, 1969
GUERRILLA ART ACTION GROUP
Jon Hendricks
Poppy Johnson
Silvianna
Jean Toche

Despite these difficulties the AWC pulled the poster project together and distributed over fifty thousand free copies in the first printing. When the poster was produced that January, the coalition staged a "lie-in" at the Museum; other members carried copies of the poster while standing in front of Picasso's *Guernica.* Photographs of the action were reproduced in the pages of national publications such as *Newsweek.*[14] The poster was used in subsequent protests against the Museum, often stamped with a statement saying that it had been censored by the Museum of Modern Art.[15]

Although MoMA became the scene of myriad artist protests, it was by no means alone on the institutional battlefront. Catalyzed by the invasion of Cambodia and the killing of student protesters at Kent State, a group of New York artists, critics, and dealers called for a "Strike Against Racism, Sexism, Repression, and War" on May 22, 1970.[16] New York galleries and museums were asked to close, and the Whitney and Jewish Museums complied. The Modern compromised by suspending admission fees and by screening the film *Hiroshima-Nagasaki,* which had just been released by the U.S. government and comprised footage taken in Japan in 1945 just after the atomic bombs had been dropped.[17] Frank Stella, who was having a retrospective, closed his exhibition for the day. The Metropolitan, in contrast, refused to participate and several hundred protesters staged a sit-in on its steps. As was typical of artist and museum confrontations during these years, despite the volatile situation there were no arrests and there was no violence. The demonstration lasted all day, however, and in response the Met defiantly kept the museum open an additional five hours. Museum staffs were often in sympathy with the protesters, as was indicated in this case by reports that "instead of a riot . . . light refreshments were served by curators . . . and an ambiguous calm was preserved."[18]

Almost no modern art institution was immune to political protest activity during these years. In the autumn of 1968, there also had been an art boycott in Chicago to protest the violence of the Chicago police and the policies of Mayor Daley during the Democratic convention that summer. Many galleries closed while others, following the lead of Richard Feigen Gallery, held protest exhibitions. Seemingly every major international exhibition was stymied by protests and withdrawals, and in some instances the institutions were driven to cancellations and temporary closings. These included the 1968 *Venice Biennale,* the 1968 *Documenta,* and the 1969 *Bienal de São Paulo.*[19] The Palais des Beaux-Arts in Brussels was occupied for two weeks by some 250 artists who were demanding artist participation in the policies of the institution. Among other incidents was Annette Giacometti's cancellation of the Alberto Giacometti retrospective at the Orangerie in Paris, which had been scheduled to open in October 1968.[20] Giacometti was Swiss, and Annette Giacometti's decision was a protest against the French government's deportation of foreign artists in the wake of the student and worker uprisings of the previous May.

The protests in the United States and abroad involved a broad spectrum of issues, including the war in Southeast Asia, racial and gender equality, artists' copyright, museum policy, and free admission. The agendas and incidents were factionalized and often involved highly disparate and at times antagonistic individuals and perspectives. Nonetheless, commonalities existed amid the diversity: these offensives were waged against the traditional limits and political dimensions of institutions dealing with modern art. Their interrogation of the institutions of art was generated within a social landscape in which intellectuals, artists, writers, students, and numerous other communities were challenging the values and priorities of Western culture. It was within this aesthetic and political framework that the 1970 *Information* exhibition was installed at the Museum of Modern Art.

A Shift in Responsibilities: The *Information* Show and Conceptual Art at MoMA

More than any other exhibition held at the Museum of Modern Art, *Information* manifested the issues of this brief and volatile moment in modern art history. In the show's press release, curator Kynaston McShine cautioned viewers to leave behind their prejudices, renounce inhibitions, reassess culturally conditioned responses, and reevaluate their ideas about art.[21] The show was originally conceived as "'an international report' of the work of younger artists," its title serving as a conceptual umbrella under which the diverse work could be gathered.[22] More significant than the officially decreed subject matter were the strategies deployed and the agendas made visible in the work produced for the exhibition—which are highlighted when we consider this show in terms of MoMA's history of installation design.

Unlike the procedure followed in almost all of the exhibitions previously held at the Museum, in *Information* the works of art were not selected by a curator. Instead, some 150 artists were asked to send in proposals to create pieces for the show. McShine reviewed these proposals and facilitated site-specific works of art—a practice representative of a new model for international group shows as seen during the previous year in landmark exhibitions such as *Live in Your Head: When Attitudes Becomes Form, Op Losse Schroeven: Situaties en Cryptostructuren (Square Pegs in Round Holes: Situations and Cryptostructures),* and *Prospect '69.*[23] Like those European exhibitions, *Information* was an arena for Conceptualism's challenges to the institutions of art.

The artists invited to show at *Information* also represented something new: a breed of "artist-worker" who wrote texts as would critics, installed shows as would curators, printed publications as would publishers, and sold and distributed their work as would dealers. These "cultural producers" were consciously creating work that engaged the institutions within which art is displayed, distributed, and received. In the wake of a consolidation of the art market—thanks to Pop Art and, not unrelatedly, the art world's ongoing flirtations with popular culture—these artists deployed new Conceptual strategies to question the frameworks within which aesthetic meaning and value are generated and maintained.

This erosion of traditional roles and conventions within the art world was not restricted to artists' practice; it simultaneously altered the responsibilities of curators, writers, and dealers, as well as the dominion of aesthetic institutions. For the *Information* show, McShine's curatorial role was realigned. Instead of a traditional catalogue with essays and illustrations, the Museum published a collection of artists' proposals and Conceptual pieces that also included a seemingly random selection of timely photos, presumably representative of the information age. Lucy Lippard, for example, submitted what she called "Conceptual Criticism" rather than a traditional essay; it was published with the pieces by the other "artists" in the exhibition, all arranged alphabetically according to the contributor's last name.[24]

Among this new breed of cultural producers exhibiting in the show was Art & Language, the group of artists whose journal *Art-Language* was their art, as was their individual and collaborative essays, books, installations, pieces, and projects.[25] At *Information,* Art & Language was represented solely by catalogue entries. Among the many other artists included who created texts and books as works of art were Adrian Piper, Hanne Darboven, Carl Andre, and Ed Ruscha. The work of the collaborative Art &

Project consisted of the exhibitions held in their gallery in Amsterdam as well as their journal, *Art & Project,* which was displayed as their contribution to *Information.* Robert Barry, who was also included in *Information,* conceived an exhibition at Art & Project in 1969: for the duration of his show, notices were posted and the gallery was closed. At *Information* he was represented by a statement describing an event on March 4, 1969, when a liter of argon was returned to the atmosphere. Dan Graham exhibited variations on his poem *Schema* as it was reproduced in different publications. The poem documents the particular printing and design specifications: the number of lines, the size of the page, the layout, and so on. Walter de Maria's contribution included a wall-size enlargement of a review of his work published in *Time* magazine (fig. 5.5). Hans Haacke's work often involved a statistical analysis of the art system, and one of these pieces was his contribution to the *Information* show (fig. 5.7).

At the *Information* show, the visibility of the institution's relation to the exhibition design—and the curator's role in its creation—was minimal. McShine designed the installation with the assistance of Charles Froom, who was at that time MoMA's production manager.[26] The gallery walls were painted white, and the Museum's vast spaces were divided with huge wall partitions, angled symmetrically (fig. 5.6; see also fig. 5.5). The installation "furniture" consisted of white tables and pedestals, as well as white beanbag chairs for the viewers. In this exhibition, the galleries became a vast, white, seemingly neutral container for the artist-directed installations. The idea of an amorphous museum gallery shaped by the artists' installations and by the spectators' interactions with these sites was seen even in the use of the unconventional beanbag chairs whose malleable forms were shaped by those who used them. Although McShine conceived the placement of works according to the artists' proposals, this certainly was not exhibition design as it had been known during MoMA's laboratory years.

At the entrance of *Information* was a Plexiglas screen onto which was printed the exhibition's title as well as photo prints of modern-looking information machines, such as radios, televisions, telephones, film projectors, and typewriters (fig. 5.4). But also at the entrance, capturing not only the viewer's attention but his or her response, was Haacke's *MoMA Poll* (fig. 5.7). On the wall above two Plexiglas vitrines was printed:

Question:
Would the fact that Governor Rockefeller
has not denounced President Nixon's
Indochina policy be a reason for you not
to vote for him in November?
Answer:
If "yes"
please cast your ballot into the left box,
if "no"
into the right box.

Each visitor had been given a ballot at the Museum entrance. The color of the ballot was color-coded according to his or her status as a full-paying visitor, a member of the Museum, a holder of a courtesy pass, and so on. The two Plexiglas ballot boxes were fitted with automatic counting devices.

It is telling that the first thing a viewer encountered at *Information* was Haacke's *MoMA Poll.* Placing the work at the entrance of the exhibition was, of course, central to its effectiveness and had been part of the artist's conception of the piece.[27] More significantly, visitors' polls had been common at MoMA during its first several decades. Perhaps the most famous was at the *Machine Art* exhibition, where the visitors' choices of the most beautiful objects were publicized and compared with those of the celebrity judges, who included Amelia Earhart and John Dewey. But at *Information* it was not the institution of the Museum of

Modern Art that was staging a dialogue with its viewers: that role was now commandeered by the artist. In this appropriation of what had been the Museum's institutional domain, Haacke's *MoMA Poll* is paradigmatic of a shift that was taking place within the modern art museum generally—and very specifically within the institutional conventions of the Museum of Modern Art.

To be sure, the question in Haacke's visitor poll was very different from those of the *Machine Art* and *Good Design* shows. The latter Museum polls were exercises in consolidating standards of taste, beauty, and "good design" while simultaneously expanding the consensus on such judgments to include the opinions of the Museum's audience. However much they were involved with industry, commerce, and the historical specificity of a particular viewer's response, their purpose was, in the final analysis, to validate a Kantian notion of taste and modernist aesthetics.

Haacke's piece, in contrast, disrupted the viewer's modernist aesthetic experience by confronting him or her with politics. The *MoMA Poll*'s question must be understood in terms of the specific political contexts of 1970, in particular that of the United States and that of MoMA as an institution. These issues, as well as his association with the Art Workers Coalition, were Haacke's concerns when he formulated the piece:

Due to my involvement in the Art Workers Coalition I had a sharpened political sense. The United States invasion of Cambodia, the responses to the invasion, the demonstrations inside the art world such as the Art Strike and so forth as well as the killing of Kent State student protesters by the National Guard, all of this led me to feel I could not participate in the exhibition without referring to these political events and without relating them to some of the leading trustees of the Museum.[28]

Nelson Rockefeller, whose mother was one of the founders of the Museum, was a trustee from 1932 until his death in 1979, with a brief break from 1941 to 1945. During his tenure, he served terms as president and chairman of the board. Rockefeller and his family had been a focus of the previous year's demonstrations, such as the GAAG "blood bath" action of November 1969. At the time of the *Information* show, Rockefeller was running for reelection as governor of New York State and was proclaiming himself a "peace candidate" who in 1968 had called for the withdrawal of American troops; however, he was simultaneously supporting the Nixon administration, which had just ordered the invasion of Cambodia.[29] Haacke remembers, "He didn't want to commit himself because he didn't want to alienate two opposing segments of the electorate. . . . But he, being part of the Republican political establishment, was implicated in what happening in Indochina."[30]

In the *MoMA Poll,* Haacke expanded the aesthetic framework of the work of art to include the institutional domain of the museum by highlighting the political affiliations of the museum's governing body and support structure. By making a political question a work of art and by asking the viewer to consider the political responsibilities of MoMA's source of financial support and executive leadership, this poll challenged the presumption that aesthetic experience and art institutions are immune to political considerations. Of course, not all the visitors to *Information* would know about Rockefeller's role in the Museum; Haacke was aware that his work would have different audiences, which would include those who would understand the full implications of the question. Anyone familiar with the events in the art world during the previous year would have known that Rockefeller had often been singled out in art and museum protest activity and subsequent publicity.[31]

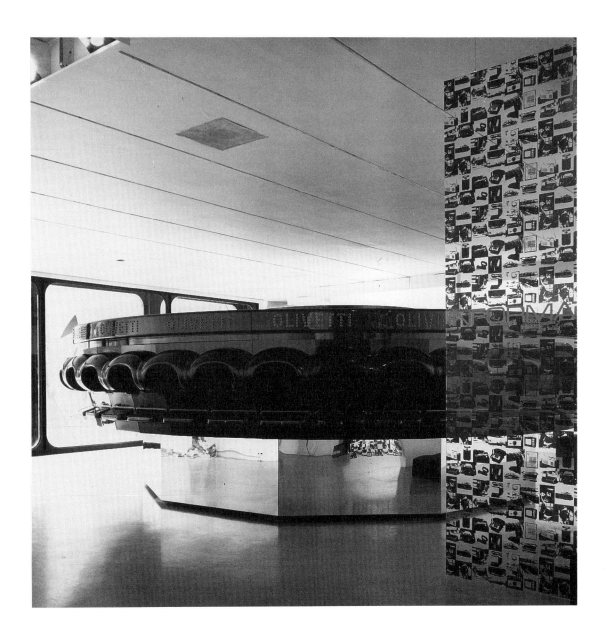

5.4
Olivetti, "visual jukebox" designed by Ettore Sottsass, at the entrance of *Information*, Museum of Modern Art, New York, 2 July to 10 September 1970.

5.5 ➜
Kynaston McShine with the assistance of Charles Froom, *Information*, 1970.

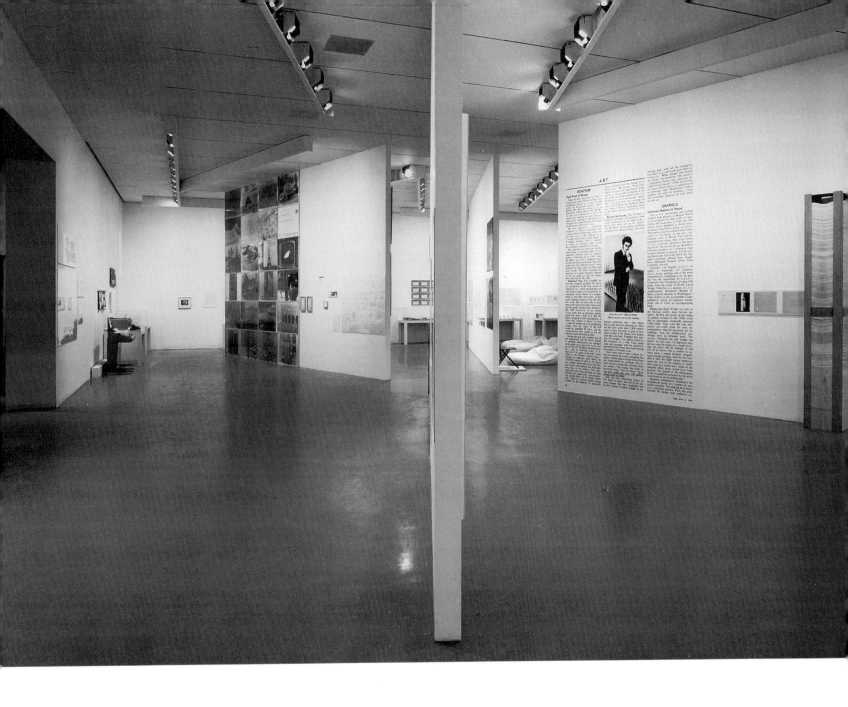

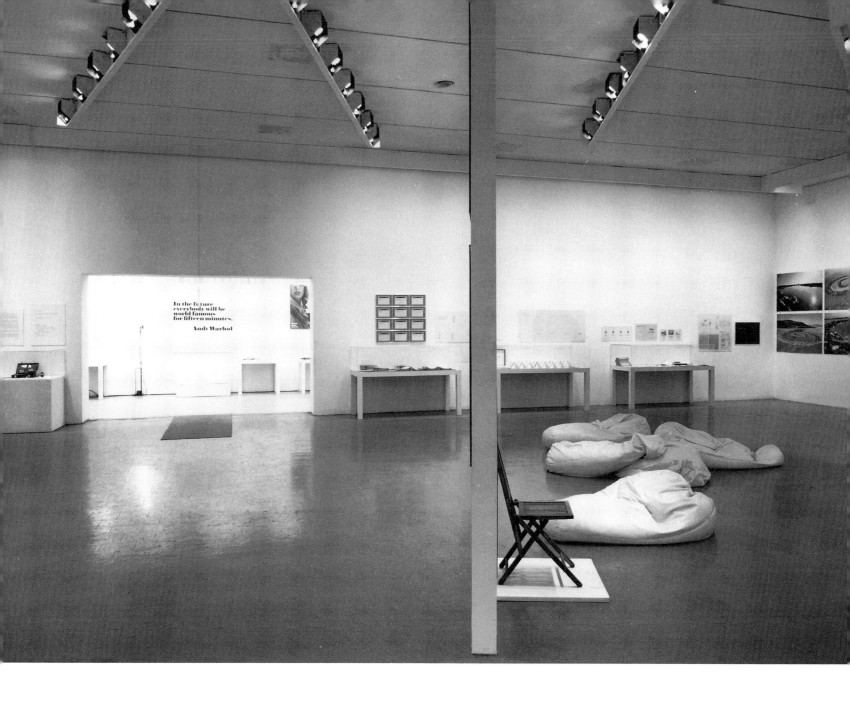

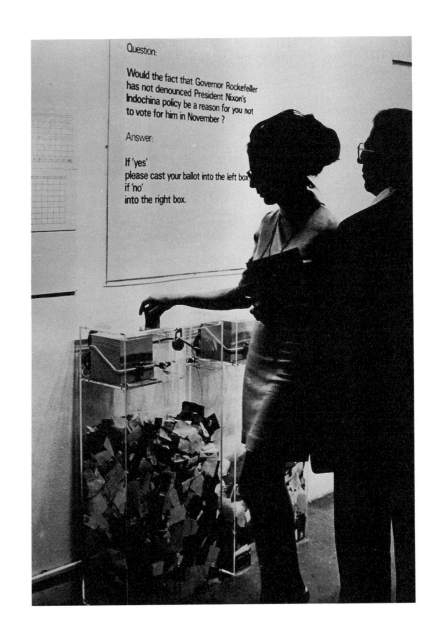

Question:

Would the fact that Governor Rockefeller has not denounced President Nixon's Indochina policy be a reason for you not to vote for him in November ?

Answer:

If 'yes'
please cast your ballot into the left box
if 'no'
into the right box.

5.6 ←

McShine with Froom, *Information*, 1970. Visible are the beanbag chairs for visi-
tors to sit on and Joseph Kosuth's *One and Three Chairs* (1965).

5.7

Hans Haacke, *MoMA Poll*, 1970.

The *MoMA Poll* is a very early example of this artist's groundbreaking investigations regarding the political and economic determinants that shape the art world. Haacke's visitor poll is also representative of the concerns of Conceptual artists working in the late 1960s and early 1970s and their exploration of the institutional frameworks of their field. Not all Conceptual practice has such an overt political message and explicit institutional critique. Nonetheless, all of the works in the *Information* exhibition reflected a dramatic change taking place within the contemporary gallery and modern museum that was related to the proliferation of Conceptual and installation art.

The *Information* show's exhibition design departs significantly from those of MoMA's laboratory years; it was shattered into a plurality of individual sites and installations that were, in a sense, inscribed within the signatures of the artists. The framework for the artists' work expanded, both in its physical space and in its ideological domain. The installation design, previously the responsibility of the Museum as an institution, was now incorporated within the creative dimensions of the artists' pieces. Similarly, the hard-nosed political question of Haacke's *MoMA Poll* marked a shift in jurisdictional lines. In keeping with these changes, Haacke deliberately deployed the services of the Museum and its personnel. The artist designed the poll ballots, but he requested that MoMA have them printed as they would other official Museum paraphernalia; Haacke also requested that Museum guards hand out the color-coordinated tickets.

This absorption of the Museum's institutional processes within the domain of the individual artist's work was even more evident in Vito Acconci's installation, *Service Area* (figs. 5.8 and 5.9). For the duration of the exhibition, Acconci had all of his mail forwarded to the Museum. The idea was to use the Museum of Modern Art as his post office box. Acconci participated in the piece by coming to the Museum to pick up his mail. The actual installation included a table, his mail, and an explanatory state-ment and calendars mounted on the wall. Acconci's description of the piece was also printed in the catalogue: "Since I am in a show at the museum, I can use that show as a service. My space in the museum functions as a 'post-office box.' . . . Because the mail is at the museum, on exhibit, the museum guard's normal services are used to guard against a 'federal offense': his function shifts to that of a mail guard."[32] Like the Haacke piece, Acconci's *Service Area* redirected the functions of the Museum personnel and inscribed them within the dynamics of the artist's installation. Perhaps more explicitly than any other piece included in *Information, Service Area* framed the institutional processes within the signature of an individual artist, making explicit what was implicit in all of the other contributions.

In contrast to the seemingly uninflected exhibition technique deployed by McShine for *Information,* the artist installations manifested a variety of strategies, reminiscent of the spectrum of techniques deployed at the Museum of Modern Art during its first several decades—and providing an ironic contrast, for during the late 1960s and early 1970s the variety and innovation previously found in MoMA's own installation design were disappearing. The *Information* show is a rare example of a site-specific group exhibition at MoMA, and it marks the pivotal moment when the creativity and accountability of a show's exhibition techniques were being transferred from the preserve of the museum to that of the individual artist. This shift had profound implications for the modern art museum's institutional responsibility.

Like the installations of MoMA's laboratory years, the individual artist's installations at the *Information* show ranged from the modernist and aesthetic to the political and didactic. Bernhard and Hilla Becher's photo piece, Mel Bochner's wall drawing, Lawrence Weiner's statement and photos, Siah Armajani's column of a computer printout of all the digits between zero and one, and John Latham's distillation of Clement Greenberg's modern-

5.8, 5.9

Vito Acconci, *Service Area*, 1970.

ist classic, *Art and Culture,* into liquid form preserved in a small vial: such works challenged the conventional morphology of an artwork but remained nonetheless images and objects placed on the wall and in the gallery for aesthetic assessment. However much these pieces were composed of anti-aesthetic materials, their presentation and concerns contrasted with explicitly political and didactic projects such as Haacke's political polling site or the series of newspapers Erik Thygesen printed and distributed to viewers during the show. Thygesen also posted an information board studded with a selection of alternative newspapers, magazines, and journals.

Another work that challenged the conventional morphology of an art object but remained traditional in its viewer relationship was Joseph Kosuth's *One and Three Chairs* (1965), consisting of a photograph of a chair, an actual chair, and a dictionary definition as wall statement (see fig. 5.6). An autonomous piece in that it is not shaped by its site, *One and Three Chairs* was created to be observed by an ideal subject, who is not supposed to sit on the chair.

The Group Frontera piece was representative of a very different mode of address (fig. 5.10). Like the Haacke and Thygesen pieces, the installation created by this Argentinean collaborative was interactive; the visitor, in a sense, completed the work, which was ever-changing throughout the duration of the exhibition. The installation consisted of a recording booth where visitors could enter, sit on Sears furniture, and be videotaped as they answered a series of questions, such as "What is pleasure for you? How do you define power? What do you do to imagine things? Do you repeat an action daily? Why? Could you be friends with a homosexual? Why?" A delayed videotape would then be played on a bank of monitors in the nearby gallery. Group Frontera's contribution to the catalogue discussed the importance of television, challenged the mythology of genius, and ended with the statement: "All individuals are creators, but what they create

is not necessarily forcefully incorporated into the cultural framework. The introduction of a micro-medium into the mass media is necessary."[33]

There were a variety of viewer-interactive installations in the show. Like Group Frontera, Helio Oiticica built an environment within the gallery walls. Visitors could actually climb up to rest and sit in Oiticica's *Barracão Experiment 2,* a twelve-foot-high "nest" composed of two-by-fours and burlap. Set up in another gallery was a piece consisting of four green telephones where viewers could pick up a receiver to hear tape-recorded poems and messages from the likes of William Burroughs, Ted Berrigan, Bobby Seale, John Cage, Abbie Hoffman, and Weatherwoman Bernardine Dohrn. One such message included Kathleen Cleaver's account of the slaying of Black Panther Bobby Hutton in a confrontation with West Coast police. The messages and poems were selected by John Giorno, were changed daily, and could also be heard by the public at large if they dialed 212-956-7032.[34] Adrian Piper's *Context no. 7* consisted simply of a three-ring notebook and a pen on a pedestal. A wall statement asked the viewer to "write, draw, or otherwise indicate any response suggested by this situation (this statement, the blank notebook and pen, the museum context, your immediate state of mind, etc.) in the pages of the notebook beneath this sign."[35] This piece, like those by Haacke and the Acconci, required the cooperation of the Museum's personnel. A Museum guard was posted near the piece during the entire show to replace the pen and notebooks when necessary.

The viewer was also acknowledged in the catalogue, where two blank pages were labeled "Blank pages for the reader, please provide your own text or images . . . In the future everybody in the world will be world famous for fifteen minutes.—Andy Warhol."[36] A wall label with the Warhol quote in large lettering was installed by McShine as an appropriate statement for the theme of the show (see fig. 5.6), as was a Stockholm Moderna Museet

5.10
Group Frontera installation, *Information*, 1970.

poster on which was printed "Poetry must be made by all!"[37] These wall statements were presumably meant to be samplings from the democratic information age, but the visitor was not engaged by them directly as, for example, he or she was in the Piper piece.

A copy of the My Lai poster was also posted above a doorway—and reproduced in the catalogue. But there was no mention of it in the press coverage, nor does there seem to have been any significant reaction to its appearance. When asked about the inclusion of the poster some twenty-five years later, McShine said that he had no recollection of displaying it.[38] Perhaps it seemed a small gesture at the time, after a year and a half of continual, dramatic artists' actions and protests directed at the Museum of Modern Art. *Information* opened on July 2, only one and a half months after the citywide artists' strike, when Frank Stella closed his MoMA exhibition for the day and the Museum screened an antiwar film. No doubt in response to this activity, John Szarkowski had curated the *Protest Photographs* exhibition, which opened the day after the artists' strike and closed on June 2, exactly one month before *Information* show opened.

The posters as well as a great deal of the Conceptual work in *Information* were experiments in alternatives to what was considered the precious, elite, aesthetic object. An ephemeral, populist agenda was visible in most of the projects and installations. Stanley Brouwn's exhibit was his calling card, and it was suggested that viewers write or phone him and that these communications would themselves be Conceptual art. Christine Kozlov exhibited a telegram she sent to the curator containing "no information": "the particulars relating to the information not contained herein constitute the form of the action."[39] Paul Pechter passed out handbills with his home address in case viewers wanted to send him a stamped self-addressed envelope so that they might receive information about the whereabouts of unlabeled "devices" he had placed about the installation.[40]

Installation Strategies of the Laboratory Years and of Conceptual Art

The *Information* show has an interesting relationship to the didactic, documentary exhibitions of MoMA's laboratory years. Those earlier exhibitions—composed of photographs, texts, wall statements, diagrams, and statistical documents—were realizations of the Museum's pedagogical function; they were installation experiments in giving the viewer "information." They often addressed the visitor directly in wall statements and texts and were populist examinations of the issues of everyday life. This type of installation technique was used in scores of shows at MoMA. It was relatively inexpensive and worked well for subjects such as art appreciation, film, and theater design; it was particularly common in architecture shows, such as the 1934 *America Can't Have Housing* (see figs. 3.44. and 3.45). But these methods were also found in such diverse exhibitions as the 1936 *Cubism and Abstract Art* (see figs. 2.12 and 2.13), the 1943 *Airways to Peace* (see figs. 4.11–4.16), and a 1945 exhibition that presented an idiosyncratic history of dress, *Are Clothes Modern?*[41]

In the 1960s and 1970s, the plethora of didactic materials and exhibition techniques of MoMA's earlier decades disappeared from the installation designs of the Museum of Modern Art (with the exception of the architectural documentation). At about the same time, these materials and techniques were reconfigured in the actual form and substance of Conceptual art. A great deal of Conceptualism (though not all Conceptual work) involved presenting the viewer with information about a particular political or social topic by using anti-aesthetic materials from everyday life such as texts, charts, and photo documentation. Such works often directly addressed the viewer with statements and

questions. This documentary, informational type of Conceptualism, and other work that merely used these materials as anti-aesthetic media, were represented in the creations found at *Information.*

The documentary and didactic exhibition techniques of MoMA's early years also shared with a great deal of Conceptual art the practice of documenting sites outside the art museum. Like Conceptual art, they often set up a dialogue between the gallery and the world beyond of the walls of the museum. The agendas of those exhibitions and of Conceptual art were, of course, quite different. During the Museum's first several decades, such documentation was usually pedagogical or was intended to substitute for what could not, for economic or practical reasons, be included. In Conceptual art of the late 1960s and early 1970s, this dialogue with the world outside of the art museum was consciously redirected to address exhibition conventions and to reevaluate the limits of aesthetic institutions. At the *Information* show, there were artworks placed outside MoMA and throughout the installation that called attention to the institutional boundaries of the Museum. Stig Broegger had placed eight wooden platforms at sites in Denmark and New York City, and his installation consisted of one of these platforms as well as photo documentation of the other locations. Daniel Buren had his signature striped posters displayed on New York City buses. Douglas Huebler installed *Location Piece #6* and *#28,* which were photo documents of sites in the United States. Photo documentation of Michael Heizer's *Displaced—Replaced Mass* and Robert Smithson's *Spiral Jetty* were also included in the show.

To compare the Conceptual art at *Information* with MoMA's documentary exhibition strategies is not simplistically to equate these very different practices. During MoMA's early decades, curators, designers, and architects did explore—and took great advantage of—the ways that the meanings of an exhibition and the meanings of the objects within that exhibition were tailored to suit the institutional agendas associated with a show. Just when individuals curating and designing Museum of Modern Art installations ceased treating exhibition designs as representations governed by not only aesthetic considerations but also ideological, historical, economic, and political ones as well, Conceptual artists were diligently challenging the premise that an art exhibition was an apolitical, autonomous aesthetic site. In other words, artistic practice became more self-consciously political regarding the workings of the institutions of art at the moment when the Museum of Modern Art in particular, and modern museums in general, were disavowing these realities in their installation practices. Ironically, the examination of the ideological dimensions of an exhibition by Conceptual artists simultaneously circumscribed the political within the domain of the individual artist, thereby releasing the institution from any such responsibility and fostering the myth of an aesthetic institution as a neutral site.

Corporate Sponsorship and the *Spaces Show*

The entrance of the *Information* show exemplified this rearrangement of ideological responsibility within exhibitions at the Museum of Modern Art. In addition to Haacke's *MoMA Poll,* it featured another exhibit that was related to the transformation of the modern museum: the huge, circular, black and silver "visual jukebox" bedecked with its company name—Olivetti (see fig. 5.4). The "jukebox"—whose avant-garde ancestors were those film-viewing contraptions created by Sergei Eisenstein for *Film und Foto* in 1929 (see fig. 1.41)—was installed to accommodate the exhibition's film program. Designed by Ettore Sottsass, this "information machine" consisted of forty individual booths with

screens onto which more than forty films were shown (ten at a time) during the show. The films, which were also screened individually in the Museum's auditorium, included the work of Vito Acconci, Andy Warhol, Hanne Darboven, Michael Snow, Hollis Frampton, Yoko Ono, and a collective called Yippies USA. The Olivetti machine and Haacke's poll, both of which had received particular attention in the press, were signposts marking the new parameters of the modern art museum exhibition.

The visual jukebox, which was *lent* by Olivetti, was only one example of the highly visible corporate presence at *Information*. At the Group Frontera booth, a prominent sign stated that "The Group Frontera experience has been made possible through the courtesy of J. C. Penney Co. Inc." (see fig. 5.10).[42] Similarly, the *Information* press release thanked ITT World Communications for Telex machines and Xerox Corporation for a telecopier. But this collaboration with corporate America was relatively slight when compared with the other site-specific group exhibition held at MoMA, the 1969 *Spaces* show.

The *Spaces* exhibition, curated by Jennifer Licht and consisting of six environments created by artists, boasted of the joint efforts of some twenty-one companies.[43] The Museum even distributed a separate press release containing appropriate thanks and acknowledgments to such businesses as General Electric, Electro-Voice Incorporated, and the Manhattan Gardener Limited.[44] The exhibition, officially described as six artist projects that dealt with the issue of space, was similar to *Information* in that the artworks were not selected for the exhibition and proposals were submitted for the site. But unlike *Information*—which was a collection of catalogue entries, individual pieces, site-specific installations, environments, and projects—*Spaces* was composed of discrete environments: six separate installations that required a substantial amount of materials and technical backup from the corporations and businesses.

As was typical of most Conceptual group shows of the late 1960s and 1970s, *Spaces* showed no evidence that the standards and conventions of the art world were being reevaluated in terms of a more inclusive politics of gender or race. However, all six environments did challenge the traditional parameters of the work of art and of the museum gallery. Michael Asher built a white, empty, "silent" room where the walls, ceiling, and floor were fitted with acoustical panels. The light was dim and the sounds muffled. In Larry Bell's gallery, the walls, floor, and ceiling were painted black and the room was dark except for a subtle line of light that could be perceived. In the second month of the exhibition, freestanding vacuum-coated glass panels were installed. Dan Flavin's piece consisted of a gallery lined with large yellow and green fluorescent light units. Robert Morris built four Cor-Ten steel cubes at eye-level height that filled the gallery and created trenches for viewer circulation. These cubes were filled with soil and planted with miniature fir trees that diminished in size, giving the impression of distant vistas. The installation was refrigerated and lit with florescent "grow lights," creating an artificial atmosphere appropriate for this display of nature as a spectacle of culture. Pulsa, a collaborative group of seven artists, placed strobe lights and small speakers in the Museum's sculpture garden; the devices were activated by stimuli created by weather, people, and ambient sound (fig. 5.11). Their equipment and materials were placed in a glass gallery at one end of the garden. Franz Erhard Walther's piece was made of the traditional aesthetic material, canvas; but he used it to line the gallery and make body wrappings and receptacles that the visitor could curl up in or try on during specified periods when Walther was in the gallery (fig. 5.12).

The corporate contributions at *Spaces* and *Information* were not unusual. Business communities had often been friendly participants in twentieth-century art and had been particularly

5.11
Pulsa, *Untitled,* materials and equipment in gallery next to sculpture garden installation, *Spaces,* Museum of Modern Art, 30 December 1969 to 1 March 1970.

5.12
Franz Erhard Walther, *Instruments for Process, Spaces,* 1969–1970.

prominent in the history of MoMA as seen in such important exhibitions as *Machine Art,* where manufacturers supplied the "machine age" art, and the *Good Design* series, which was cosponsored by the Merchandise Mart. But the highly visible corporate presence at *Information* and *Spaces* marked the change that was taking place in the late 1960s and early 1970s as corporations began to *underwrite* art exhibitions.[45]

Philip Morris, which was instrumental in this new development, began its fine art program in 1965 with the traveling *Op and Pop* exhibition.[46] Although there had been earlier corporate sponsorship, such as Coca-Cola's support for the international *The Family of Man,* in the late 1960s and early 1970s this practice was becoming more pervasive; by the 1980s, it would become an essential element and source of power within the art world. One of the first major contemporary exhibitions underwritten by a corporation was, paradoxically, a show composed of work that was critical of the institutions of art, the important 1969 *Live in Your Head: When Attitude Becomes Form.* The catalogue for the exhibition is printed with "An exhibition sponsored by Philip Morris Europe" in letters as bold as the show's title, a prominence that, once the conventions of corporate sponsorship were set, would become unusual.[47] Like *Spaces* and *Information, When Attitude Becomes Form* was composed of work by artists who were consciously and critically reevaluating aesthetic institutions. The art constituting these international site-specific exhibitions, found throughout Europe and the Americas, can be seen as realizing institutional critiques that are extensive and diverse but nonetheless related. It is therefore particularly ironic and telling that at this precise moment when Conceptual artists were challenging the ideological, political, and economic determinants of art, the corporation was emerging as a full partner in creating exhibitions, playing an essential role in the modern art museum.

Another feature of this reconfigured aesthetic landscape is that as museum exhibitions were being treated as neutral frameworks for artist installations, the corporation—hardly a neutral entity—enters as a cosponsor of the museum exhibition. This is not to say that there is a direct and causal link between the corporate support of the contemporary museum, the change in contemporary museum installation practices in general, and the aestheticized, autonomous version of modernism that has been the standard at the Museum of Modern Art for close to three decades. Rather, it is important to recognize the interrelatedness of these phenomena. MoMA's current practice of treating exhibition design as an aesthetic experience that is ideologically, politically, and economically neutral represents a new type of cultural apparatus that attracts corporate sponsorship. The development of this symbiotic relationship has helped determine essential elements of the contemporary art world as we now know it.

There is yet another paradox. However indispensable corporations now are in the production of museum exhibitions, their presence has become, in a very important sense, less visible. Although these exhibitions are advertisements for their corporate sponsors, current guidelines bar the corporation from being overtly acknowledged in the subject matter of the exhibition or from taking an active role in the exhibition itself, as sponsors had done in the past. Corporations that underwrite exhibitions are to have absolutely no involvement in producing the show; however, it is common knowledge that museum programs are shaped with an eye to the type of exhibitions that will receive corporate patronage. In effect, with the changes that took place in the 1960s and 1970s art apparatus, the corporation—and the power that it wields—went underground.

Information, which marks a critical moment in MoMA's history, clearly displays those changes. The show, a paradigm of site-specific Conceptual exhibitions, was the first and last Conceptual group show at MoMA in the 1970s. Perhaps this is related in some small part to the show's very mixed press reception. Although there were reviewers like *New York Maga-*

zine's John Gruen who found the show "altogether fascinating," there was an equal share of criticism that was brutal.[48] The loudest response came from the man who at this point in his career had established himself as the art world's curmudgeon-in-residence, Hilton Kramer of the *New York Times,* who decreed the *Information* show an "intellectual scandal!" and grumbled, "What tripe we are offered here!"[49]

After the *Information* exhibition, the Museum of Modern Art relegated this type of Conceptual work to the *Projects* series, which was started the following year with a Keith Sonnier video installation. In keeping with the new institutional practices that were introduced with the *Information* show, for each *Projects* exhibition the Museum invited a single artist to install a piece or an exhibition in a gallery. Among the artists who created these installations were Mel Bochner, Nancy Graves, and Sam Gilliam. Even more prominently than the *Information* or *Spaces* shows, the *Projects Rooms* transferred the creative and ideological dimensions of an installation design to an individual; the exhibition was inscribed more overtly within the artist's signature.

Treating the Museum as a neutral, aestheticized framework for artists' work has become the standard at MoMA, whether this involves a one-person show or a group exhibition. In 1997, at the Museum of Modern Art the visibility of the institution's role in the production of meaning has disappeared. The museum exhibition's social, historical, and political dimensions have been eclipsed; no longer is there self-conscious participation in the power of display. The vital and complex dynamics within which culture is configured now are unseen and unacknowledged.

Chapter 6

Conclusion:

The Museum and the Power of Memory

MoMA's Spectrum of
Installation Designs

From MoMA's inception in 1929 until 1970, visitors to the Museum could experience a spectrum of installations that included the aestheticized, seemingly neutral interiors for modernist painting and sculpture created by Alfred Barr; the varied displays, similar to those of natural history museums, found in René d'Harnoncourt's ethnographic art exhibitions; the propagandistic, walk-through photo narratives like the wartime *Road to Victory* show; the galleries virtually identical to those of commercial showrooms and stores that were created for the 1950s *Good Design* series; the interactive play spaces of the "children's carnivals" initiated by Victor D'Amico; and the full-scale houses built in the Museum's garden in the 1940s and 1950s.

Looking back upon these decades, one is faced with the question: Why has the complexity and variation of exhibition design disappeared from the galleries of the Museum of Modern Art? The installation diversity of MoMA's first few decades no doubt was related to the fact that the institutional conventions for a museum of modern art were then in the process of being formed. As institutional practices become stable and as curators, designers, and architects develop professional formulas, perhaps experimentation necessarily lessens. Certainly Barr's exploration of display techniques came early in his career, when he formulated "unskied," modern installations—and the exhibition in which he was most experimental was the 1936 *Cubism*

I was just interested in the memory of the institution of the Museum of Modern Art.... I think that my work always addresses this notion of what is unsaid in the institution or the public sites in which it is placed and so I just wanted to uncover that history and those issues.

— Dennis Adams (1993)

6.1
Herbert Bayer, woman looking at stagecraft exhibit through peephole at *Bauhaus 1919–1938*, The Museum of Modern Art, New York, 7 December 1938 to 30 January 1939.

and Abstract Art. While d'Harnoncourt engaged more intensely with the creation of installations and his approach was more varied, the exhibition technique of his first show at MoMA, the 1941 *Indian Art of the United States,* represented the way a museum as an institution creates meaning more effectively than did his subsequent exhibitions. As seen in his last exhibition, the 1969 *The Sculpture of Picasso* show, where the works were presented in idealized galleries painted in neutral tones, many of these later installations were stylistically masterful, but they did not foreground the institution as a framework for the production of meaning as had *Indian Art of the United States.*

The change in the Museum of Modern Art's installation practices in the 1960s is also linked to another aspect of the institutionalization of modern art: the creation of permanent installations for masterpieces. Until the mid-1950s, MoMA functioned much like a Kunsthalle.[1] It owned a collection, but one that was changeable—what MoMA's first president, A. Conger Goodyear, described as retaining the kind of "permanence that a river has,"[2] with new acquisitions flowing in and the old flowing out. In 1953 MoMA's holdings were designated as a permanent collection, which was first installed in a "permanent installation" in 1958.[3] Devoting a good deal of the Museum's space to what were deemed the classics of modern art brought consistency and stability to installation practices—which was due, in part, to the neutral-colored galleries and spacious arrangements so favored by Barr that became the standard display method for the permanent collection. This type of installation enhances the sense that these works of art are exemplars of an ideal canon.

That institutional conventions were stabilized and experimentation was subsequently reduced does not, however, sufficiently explain why the earlier range of installation designs disappeared. A survey of MoMA's exhibition history reveals that certain types of installations perceived as "successful" were the ones to survive this period of experimentation. Herbert Bayer cre-

ated a dynamic and modern exhibition design for the 1938 *Bauhaus* exhibition, but its visual language was disturbing and inaccessible to the visitors and was criticized by the press (fig. 6.1). The "failure" of the *Bauhaus* show is a telling contrast to the "success" of the aestheticized, luxurious, seemingly timeless interiors for industrial objects created by Philip Johnson for the 1934 *Machine Art* show. The difference between the two makes visible an important part of MoMA's exhibition history. However diverse the installation design activity throughout these first several decades, there remained boundaries that could not be crossed. When they were, as in the *Bauhaus* show, MoMA rejected such presentational techniques. Yet in 1942 Bayer reformulated many of his ideas that had "failed" in the Bauhaus show to create the photographic propaganda panorama *Road to Victory*—thereby accommodating his design strategies to create installations that were legible and acceptable to MoMA's audiences. Both Johnson's *Machine Art* and Bayer's *Road to Victory* "made sense" to the critical and general publics, as they revealed aspects of American ideology and culture in the 1930s and early 1940s.

The Creation of Viewing Subjects

Within the varied installation activity of MoMA's first several decades, very particular kinds of interiors and viewing experiences were staged for the visitor; in this sense, very particular kinds of "subjects" were constructed. In the *Machine Art* show, Johnson produced an aestheticized installation for an idealized viewer, just as Barr had done throughout his career. Among the strongest examples of the way exhibitions create their viewing subjects was the propagandistic exhibition *Airways to Peace:* there the visitor wandered through a maplike space packed with information

about a war that was sure to be won and a humanity that was destined to be "one," thanks to technology and modern cartography. The show's centerpiece, the "outside-in" globe, gave the viewer a visual and physical experience that suggested a sense of self that was sovereign, autonomous, and empowered. Related to the theme and installation design of *Airways to Peace* was perhaps the most successful of all MoMA exhibitions, the 1955 *Family of Man* exhibition; at one point in that installation, viewers faced a mirror. Although this display was soon removed because it was *too* obvious, Steichen initially included it to ensure that the visitor understood the central idea of *The Family of Man*—that the viewer was a member of a universal humanity.

The elimination of the mirror reveals another aspect of installation design and the modern ritual of visiting museums. However evident the message of *The Family of Man* may have been, the mirror made it just too conspicuous, too heavy-handed, too literal, *too visible.* This incident reminds us that most successful installation designs—those that become convention—become invisible as they are incorporated into and reinforce acceptable ideologies.

A very specific type of spectator was created in MoMA's highly successful exhibitions, and that viewer continues to be created in the installations at MoMA today (fig. 6.2). As a survey of the exhibitions of the Museum of Modern Art reveals, these spaces are constructed to enhance the individual's sense of autonomy and his or her humanist essence. From the very broad view of humanity's civilizations and their myriad conventions for appreciating images and objects of value and beauty, it is important to consider this ritual of modernity in which individuals visit museums to contemplate creations, one on one, in neutral interiors that are arranged to emphasize the autonomy of the viewer and that which is viewed.

In creating a particular kind of viewer, the *Useful Objects* and *Good Design* installations were successful in a slightly dif-

ferent way. These exhibitions staged settings familiar to the museum-going public (fig. 6.3). The visitor quite simply recognized the visual codes of these installations, which evoked store and home. Although the commercial aspects of these displays could be considered unseemly or inappropriate for a museum, MoMA's audiences accepted this slippage in institutional boundaries. Similarly, Marcel Breuer's *Exhibition House* in the Museum garden, presented as a "moderately priced" model house for the "typical American family," staged an experience akin to visiting a suburban model home for possible purchase.[4]

These architecture and design shows reinforced the individual's identity as consumer and encouraged the exercise of his or her "free will" in the "free market." In keeping with the majority of installations created at MoMA, these exhibitions validated very particular notions of modern subjecthood, such as autonomy, a universal essence, and personal liberty. The Museum of Modern Art is one of the most prominent and important cultural institutions in the United States, and a visit to its galleries has provided the viewer, throughout the Museum's history, with a visual experience that endorses a sense of self-determination and individual sovereignty. In a sense, the Museum of Modern Art, composed of its myriad exhibitions, is a dynamic monument where each visitor experiences confirmation of the "American Dream."

Staging Institutional Invisibility

The installations produced at MoMA since 1970 fall into a very narrow band within the spectrum of possibilities that characterized the early years of the Museum's history. For close to three decades, MoMA has maintained an installation standard that presents art and culture primarily as autonomous aesthetics. A

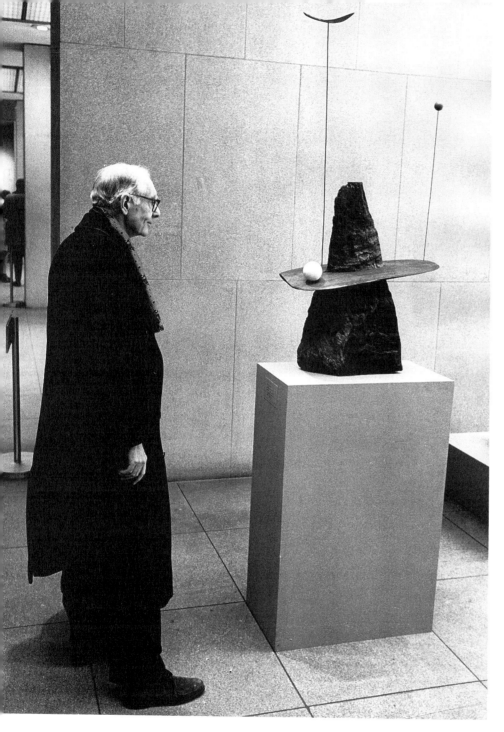

6.2

Alfred H. Barr, Jr., looking at an Alexander Calder sculpture, *Gibraltar* (1936), in 1967. Photograph: (c) Dan Budnik. In this ritual of modernity, individuals visit museums to contemplate creations, one on one, in neutral-colored interiors, arranged to emphasize the autonomy of the viewer and that which is viewed.

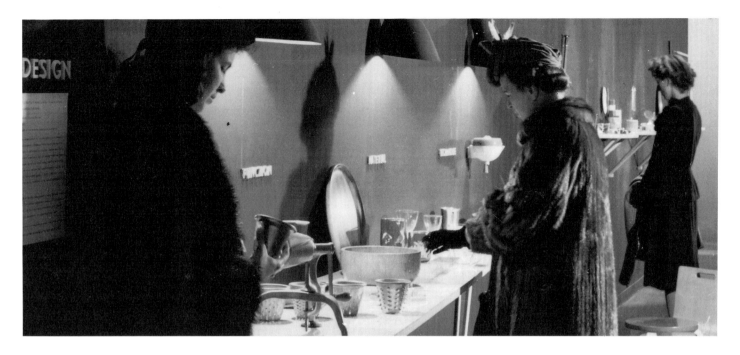

6.3
Visitors handling and looking at objects included in *Useful Objects of American Design under $10.00,* Museum of Modern Art, 26 November to 24 December 1940.

formal and "purely" aesthetic presentation of modern art is certainly valid, but there are many other possible ways to constitute art and culture in modernity. Departures from displays that treat installations as neutral, transparent frameworks have been installation-based art for which the artists are seen as responsible. By producing such a limited range of installations, the Museum of Modern Art has disavowed institutional responsibility for how exhibition design functions as a language of form manifesting—as do all cultural institutions and practices—aesthetic, social, and political concerns. It is particularly important for an art institution to address these more complex aspects of modern culture because the vitality of aesthetic practice is generated from its relationship to these elements.

MoMA's inability to acknowledge the ideological dimensions of art and culture contributes to a contemporary art apparatus that, in many arenas, sustains a myth of art as idealized aesthetics created by the free will of inspired, autonomous individuals. MoMA's seemingly neutral, aestheticized presentation of art and culture works well, for example, with the current dependence on corporate underwriting of the arts. Although the perception of aesthetics as ultimately disengaged from the politics, economics, and everyday life can be found in many arenas of the contemporary art apparatus, this is especially visible at the Museum of Modern Art.

Challenges to MoMA's institutional practices during the 1980s and 1990s have come from artists who produced installa-

tions at the Museum. This is seen in the work of individuals invited to create installations as part of the *Projects* series,[5] such as Dennis Adams's 1990 exhibit titled *Road to Victory*. Adams's project demonstrated with particular vividness how MoMA's installation practices and institutional domain differ in recent years from those during its first several decades.

Exhibition Design as the Artist's Signature: Artists' Projects and Choices

For his 1990 *Project,* which was prepared during the months leading up to the "Desert Storm" war, Adams actually recycled elements and images from MoMA's 1942 *Road to Victory* exhibition.[6] When entering the gallery, the visitor faced a series of dark glass vitrines that formed a kind of blockade or gateway through which those entering the room had to walk (fig. 6.4). The

vitrines departed from convention in that the glass was dark, the cases were empty, and a platform of darkened glass was inset at the base of each structure. The viewer saw no work of art in these glass vitrines; rather, he or she saw reflections of Edward Steichen's aerial reconnaissance photographs on the glass bases. (The actual photos were set into the underside of the vitrine.) This created what the artist considered a "displacement of what might be normally found in a vitrine in a museum."[7] The gallery's back wall was painted black, and a large floor-to-ceiling wall partition jutted out from the far corner of the room, on which was mounted a huge photo of the 1942 *Road to Victory* installation (fig. 6.5). The image, tilted to the side, was of the sequence of panoramic air and sea photographs that the visitor to the 1942 show looked at from the ramp. If the viewer looked behind the partition, he or she would have seen on the gallery's back wall a

6.4

Dennis Adams, *Road to Victory,* in exhibition titled by the artist *Road to Victory* and by the Museum *Project 25: Dennis Adams*, Museum of Modern Art, 12 December 1990 to 26 February 1991.

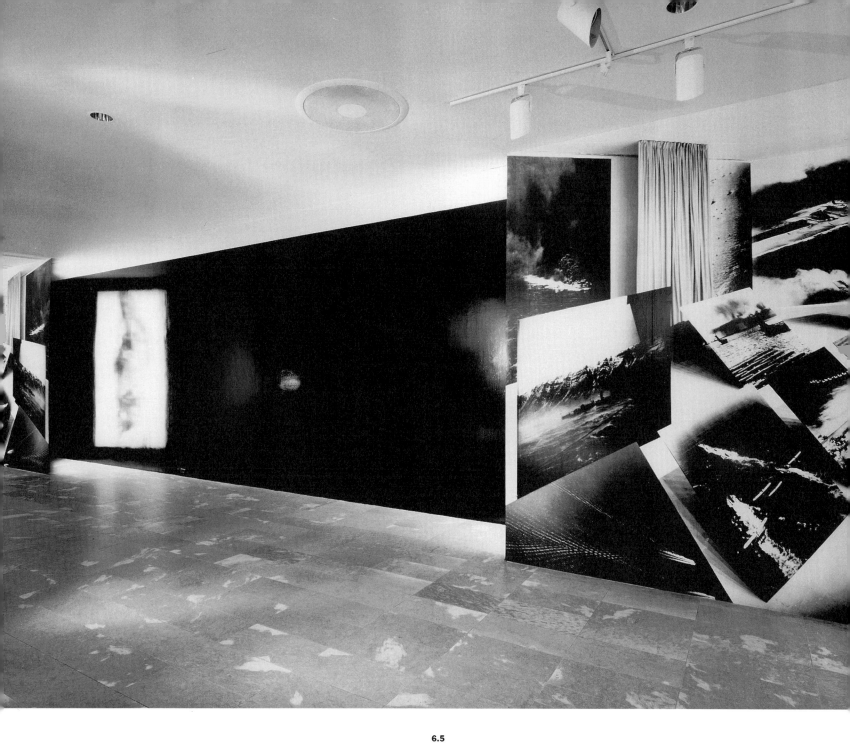

6.5
Dennis Adams, *Cocoon,* in *Road to Victory, Project 25: Dennis Adams,*
1990–1991.

hazy reflection of an image of a U.S. Army soldier covered with Desert Storm camouflage netting. The reflection was from a light box set into the back of the partition.

Although the artist prepared the project during the months when President George Bush was threatening Saddam Hussein with war, as fate would have it war was declared several days before his show opened. Though the exhibition obviously dealt with issues of the Museum of Modern Art in wartime, when asked about his intent regarding the project and whether this was an antiwar statement, Adams replied:

It was not an antiwar exhibition. I was just interested in the memory of the institution of the Museum of Modern Art at a moment in history when it directly began to intersect with the real, social, and political world. That's an incredible moment really when a museum begins to step into another direction completely. I think that my work always addresses this notion of what is unsaid in the institution or the public sites in which it is placed and so I just wanted to uncover that history and those issues.[8]

To "uncover that history and those issues" is a valiant endeavor, in light of MoMA's inability to acknowledge the implications of its past installations.

In his use of archival photographs and his revision of installation conventions, Adams re-presented an aspect of the Museum's history that MoMA as an institution and the art world in general has forgotten. Throughout his work, Adams explores institutional and cultural amnesia.[9] By using displacement and presenting fragmentary aspects of the forgotten past, he attempts to make visible what can be called the "unconscious" of institutions and sites. Adams's *Road to Victory* was an experiment in recalling MoMA's previous involvement with politics and propaganda, and in this respect the piece did succeed. The *Project Room* installation, however, remained an individual artist's statement and could not transcend the cultural and institutional apparatus by which it was constrained. Though the piece took on the then-current political crisis and the history of MoMA's response to such crises, the Museum itself remained resistant to Adams's challenge.

In examining this dynamic, we must acknowledge that curators initiate the production of such installations, as Kynaston McShine had done when he invited the artists to create projects for the *Information* show.[10] Curators select artists such as Adams to produce installations knowing that this work often challenges the very institutions that support the project. A museum must, in a sense, sanction these artists' projects; yet the responsibilities and agendas of this work are perceived to be those of the artist, not the institution. In most installation-based art produced in a museum, the creativity and institutional responsibility of the curator as "cultural producer" disappears. This was the case for all the installations of MoMA's *Project Room* series.

One component of Louise Lawler's 1987 *Project Room* provides another example of an artist's installation that dealt with MoMA's institutional conventions: specifically, it involved framing a visual fragment of a museum gallery installation within the "signature" of an installation by an artist (fig. 6.6). This particular piece was composed of three identical photographs of a view of a MoMA gallery and a MoMA visitors' bench. The image in triplicate was of a portion of a Miró painting and a bench that matched the one in front of the photographs. Lawler's installation—which also appropriated the work of a male, modernist "master"—visually displaced an element of the Museum's collection within a work by an individual artist.[11]

Since the latter half of the 1980s, the art world has shown a heightened awareness of installation design; this has often taken the form of alternatives to the predominantly modernist institutional practices of the previous two decades.[12] Many installations have become more innovative, often taking into ac-

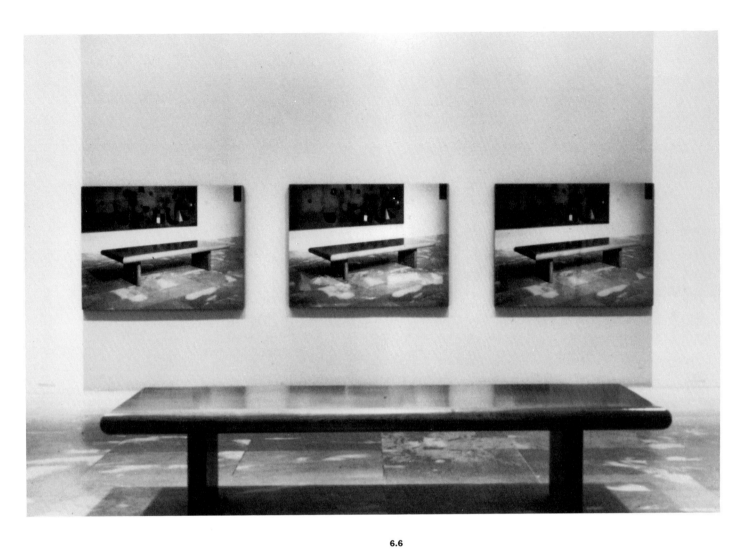

6.6
Louise Lawler, *Untitled,* in exhibition titled by the artist *Enough* and by the
Museum *Projects: Louise Lawler,* Museum of Modern Art, 19 September to
29 November 1987.

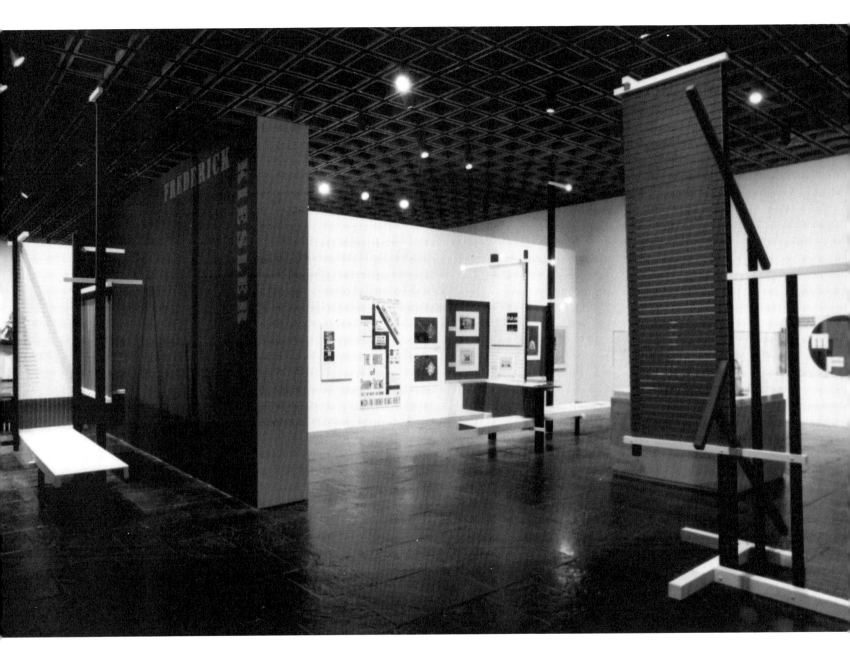

6.7
Architects: Christian Hubert and Andie Zelnio; curator: Lisa Phillips, entrance, with
reconstructions of Frederick Kiesler's L and T displays by Thomas Weingraber,
Frederick Kiesler, Whitney Museum of American Art, New York, 18 January to 16
April 1989.

6.8
Hubert and Zelnio, partial reconstruction of Kiesler's *Surrealist Gallery* at Art of
This Century, *Frederick Kiesler,* 1989.

6.9
Hubert and Zelnio, *Frederick Kiesler,* 1989.

count a work's original context and display as curators and designers experiment with creative and historically accurate shows. For the New York presentation of the Frederick Kiesler retrospective in 1989, architects Christian Hubert and Andie Zelnio, working with curator Lisa Phillips at the Whitney Museum of American Art, created an exhibition design evocative of Kiesler's work that included reconstructed sections of the artist's installations (figs. 6.7, 6.8, and 6.9).[13] For the exhibition *On the Passage of a Few People through a Rather Brief Moment in Time: The Situationist International, 1957–1972,* several institutions staged installations that suggested the avant-garde strategies and agendas of the Situationist International.[14] One element of architect Zaha Hadid's exhibition design for *The Great Utopia: The Russian and Soviet Avant-Garde, 1915–1932,* held at the Guggenheim Museum in 1992 and 1993, was an interpretation of the famous *0.10* installation that involved skied arrangements of paintings and painted geometric patterns on the walls and floor.[15] Among the most ambitious of these shows was the 1989 *Stationen der Moderne (Stations of the Modern)* held at the Berlinische Galerie; it included twenty re-creations of exhibitions of the German avant-gardes, ranging from the 1910 Brücke exhibition to the 1969 Berlin *Land Art* show.[16]

Although the discourse of contemporary and historical exhibition design has increased within the art world during the past ten years, the Museum of Modern Art, as an institution, has not participated in these practices nor recognized the changes associated with postmodernism. The exception was the Lilly Reich exhibition held in 1996 (see fig. 1.34). This departure from MoMA's standard practice is explained in part by the Museum's ownership of the Reich archives and by the fact that so much of the artist's major contributions were installations. At the entrance of the show the viewer faced a photomural of the installation Reich created for the central hall of *The Dwelling* exhibition held in Stuttgart in 1927. For the MoMA show, the galleries' floors were cov-

ered with red, black, and creamy-white linoleum, a choice that, according to a wall label, was "inspired" by Reich's use of this material in her exhibition designs. Four large photo panels of Reich installations as well as a model of Reich and Mies van der Rohe's apartments created for the 1931 Berlin exhibition *The Dwelling in Our Time,* a re-creation of a chair and table, and many drawings and documentary photographs made up this modest show. The exhibition, curated and installed by Matilda McQuaid, associate curator of the Department of Architecture and Design, was unusual in that it both took as its subject the art of installation and illustrated that art in its exhibition design.[17]

MoMA's participation in contemporary exhibition design has primarily taken the form of invitations to artists to rearrange the collection. In 1987 Barbara Kruger was invited by photography curator Susan Kismaric to create an exhibition that could deal with any aspect of the Museum's collection.[18] Deciding to work only with photographs, Kruger created *Picturing Greatness,* which was an installation composed of portraits of great modern masters. At the entrance of the gallery, she installed a floor-to-ceiling wall statement in bold letters (fig. 6.10). It read, in part, "The pictures that line the walls of this room are photographs of mostly famous artists, most of whom are dead . . . almost all are male and almost all are white. These images of artistic 'greatness' are from the collection of this museum."[19]

Kruger's piece was an intervention in the canon of modernist masters so celebrated in the collection and practices of the Museum of Modern Art. Like Adams's *Road to Victory* and Lawler's *Project Room,* it raised questions regarding the usual presentation and reception of exhibitions without altering the institutional practices of the Museum. Although not itself a departure from the standard display conventions, Kruger's *Picturing Greatness* did lead to the initiation of projects that were experiments in exhibition design: MoMA's continuing *Artist's Choice* series.

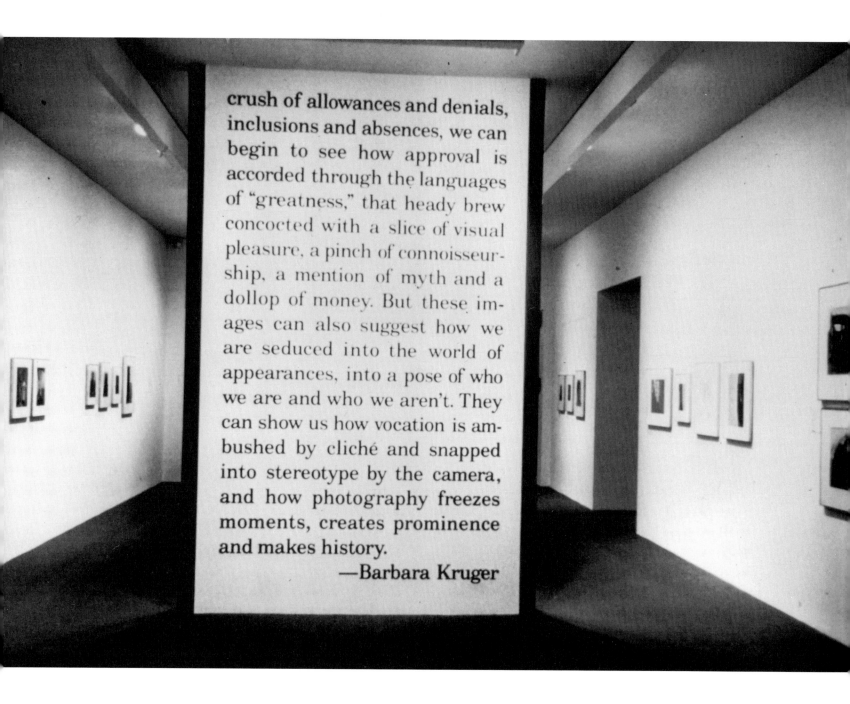

crush of allowances and denials, inclusions and absences, we can begin to see how approval is accorded through the languages of "greatness," that heady brew concocted with a slice of visual pleasure, a pinch of connoisseurship, a mention of myth and a dollop of money. But these images can also suggest how we are seduced into the world of appearances, into a pose of who we are and who we aren't. They can show us how vocation is ambushed by cliché and snapped into stereotype by the camera, and how photography freezes moments, creates prominence and makes history.

—Barbara Kruger

6.10
Barbara Kruger, *Picturing Greatness*, Museum of Modern Art, 24 December 1987 to 12 September 1988.

For the *Artist's Choice* exhibitions, artists are invited to create a small show from the Museum's collection. Many of these artists have been selected with the expectation that they would depart from MoMA's current installation practices. The first in the series was a Scott Burton rearrangement of MoMA's Brancusis in 1989. Chuck Close created an *Artist's Choice* exhibition in 1991 by putting together a portrait show in a variation of a salon-style installation. Making use of shelves, overlapping images, and densely packing the framed images as many contemporary artists, such as Allan McCollum, do in their installations, Close exaggerated the features of the salon-style exhibition technique, creating in the process a sharp contrast to the Museum's standard display methods.

The Power of Display as the Artists' Domain: The *Dislocations* Exhibition

The most dramatic demonstration of how the Museum of Modern Art has shifted the ideological and political dimension of an installation from the institution to the individual artist was the 1992 *Dislocations* show. Perhaps more than any other exhibition since *Information, Dislocations* promised innovations akin to those produced by the free-wheeling experimentation of the Museum's first several decades. Curator Robert Storr's catalogue description of *Dislocations* as a visit to "unfamiliar territory" similar to Dorothy's experience in the *Wizard of Oz* recalls McShine's advice to viewers of the *Information* show, some twenty years before, to expect a refreshingly unconventional experience and to leave behind their expectations and prejudices.[20] But unlike MoMA's earlier exhibitions that provided cinematic wartime narratives for the viewer to travel through, or the architecture and design shows that simulated a redesigned modern world, or the educational exhibits that provided a kind of walk-through book, or the evocative ethnographic presentations that introduced non-Western cultures to MoMA's visitors, *Dislocations* was the most elaborate and ambitious display of the circumscribed institutional boundaries of the Museum of Modern Art.

The structure of *Dislocations* was similar to that of *Spaces*. Artists were invited to create environments within the Museum that were supposed to challenge the traditional viewing experience. Louise Bourgeois created a room-size contraption of two, very phallic, oil tanks that slowly moved back and forth as the dual cylinder collapsed and expanded. Chris Burden installed *The Other Vietnam Memorial*. The title, of course, refers to the Vietnam Veterans Memorial in Washington that lists the 58,000 members of U.S. services killed and missing in action. Burden's memorial consisted of a central twelve-foot pole on which were hinged massive copper "pages" inscribed with the names of some three million Vietnamese who also died in that war. Ilya Kabakov constructed a bridge for the viewer to traverse the gallery, which looked like a surreal version of a drab Moscow meeting hall in disarray. In Bruce Nauman's video and installation, the image of a bald white man was seen on monitors and projected on the wall while he blasted at the viewers: "Eat me, Hurt me, Feed me, Help me . . . Feed Me, Eat me, Anthropology . . . Help me, Hurt me, Sociology." Sophie Calle's piece was scattered throughout the Museum in the empty spaces left by paintings in the Museum's collection that were in conservation or on loan. Texts and drawings mounted on the blank walls were composite meditations about the missing works, culled from MoMA's staff.

The only artists who interpreted *Dislocations* as an opportunity to dislocate the very site-specific institutional traditions of the Museum of Modern Art were David Hammons and Adrian Piper, who raised the issue of race and the creation of a canon by the Museum. Hammons installed a life-size photo re-creation

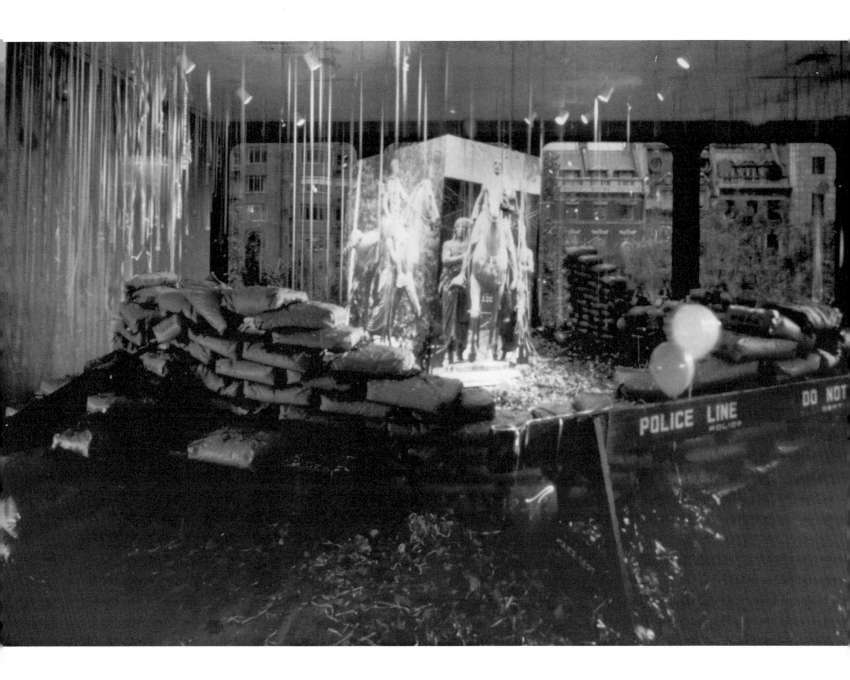

6.11
David Hammons, *Public Enemy,* 1992, in *Dislocations,* Museum of Modern Art, 16
October 1991 to 7 January 1992.

6.12

Adrian Piper, *What It's Like, What It Is, No. 3*, 1992, in *Dislocations*, 1991–1992.

of the equestrian statue of Theodore Roosevelt—and the Native American and Black African figures who walk beside him and clasp his stirrups—that stands outside the American Museum of Natural History (fig. 6.11). The photo monument was surrounded by actual sandbags, police barricades, dynamite, and toy armaments. With dried leaves strewn on the floor, wild chartreuse and gold wallpaper on the gallery walls, and colored streamers and balloons hanging from the ceiling, the installation, titled *Public Enemy,* literally and metaphorically brought the "outside inside." [21] Like Kruger, who considered gender and race in her installation *Picturing Greatness,* Hammons took on the Museum's participation in the creation of a canon primarily composed of the artwork of only one race. The mise-en-scène suggesting happening, party, and revolution is perhaps an allusion to the very fact that African Americans such as Hammons and Piper would exhibit at MoMA and be invited to enter what Storr described in the *Dislocations* exhibition pamphlet as the "mansions of modernism's overarching house." [22]

While Hammons offered the viewer a sense of liberatory celebration, Piper created a searingly memorable Kubrick-like stage set to exhibit racial stereotypes in this institution that has helped construct the canon of modern art as almost exclusively the domain of those who are white (fig. 6.12). Everything in the Piper gallery was electric white. Bleachers lined the walls, creating a Minimalist environment and providing seats for the viewers. Dead center was a modernist pillar. But at eye level, on each side of the pillar, was a monitor playing a videotape of a Black man repeating, "I'm not pushy, I'm not sneaky, I'm not lazy, I'm not noisy, I'm not vulgar, I'm not rowdy, I'm not horny, I'm not scary. I'm not shiftless, I'm not crazy, I'm not servile, I'm not stupid, I'm not dirty, I'm not smelly, I'm not childish, I'm not evil." Yet however challenging Piper and Hammons's *Dislocations* might have been their installations provoked questions without changing the rules of the game as it is played at MoMA.

Dislocations was nothing more than seven one-person shows. These seven "unconventional" environments remained the responsibility and territory of the individual creators. To be sure, in all such installations the Museum must allow the controversial piece to be presented. And the importance for this exhibition of Storr's selection of Hammons and Piper should not be discounted. Their very inclusion was an endorsement of the kinds of questions raised by their work. Nevertheless, the institutional apparatus that supports exhibitions like *Dislocations* generally receives such challenges to the canon and history of the Museum simply as offerings within a diverse pluralism that can accommodate the political and institutional questions of Hammons and Piper along with the psychosexual concerns of Bourgeois and existential consumerism of Nauman. The paradox of the contemporary aesthetic apparatus is that it allows the Museum to appear engaged with complex ideological issues while the institution—on a deep, structural level—remains utterly impervious.

Despite the occasional and temporary alliance with some of the most important and politically engaged artists of our time, for close to thirty years the Museum of Modern Art has resisted incorporating the implications of these artists' work within its institutional structure. The changes that took place at MoMA in the late 1960s and early 1970s are representative of a fundamental and pervasive transformation within art institutions that has made the art world what it is today.

The Museum of Modern Art, however, bears the burden of being the paradigm: it is the most visible and extreme manifestation of the modern art museum. Ironically, the museum that is supposed to be the arbiter of modern visual culture is blind to its own cultural history. The Museum of Modern Art is an institution where amnesia reigns. And this book is an attempt to begin to restore the power of memory.

6.13
Painting and sculpture galleries, Museum of Modern Art, 1997.

Notes

When there is an uninterrupted series of references to a single source within a paragraph, the citation appears at the last in the series.

Preface

1. Two such examples are *Artifact: African Art in Anthropology Collections,* 2nd ed., ex. cat. (New York: Center for African Art; Munich: Prestel Verlag, 1989), and Eberhard Roters, Bernhard Schulz, et al., *Stationen der Moderne: Die bedeutenden Kunstausstellungen des 20. Jahrhunderts in Deutschland,* ex. cat. (Berlin: Berlinische Galerie, 1989). For a discussion that includes examples of exhibitions and publications since the 1980s that have dealt with exhibition design, see Mary Anne Staniszewski, "Introduction: Installation Design: The Political Unconscious of Art Exhibitions," in "Designing Modern Art and Culture: A History of Exhibition Installations at the Museum of Modern Art" (Ph.D. diss., City University of New York, 1995), 1–19. In most of this literature, exhibition installations are not treated as representations in their own right. Exceptions include Christopher Phillips's 1982 article, "The Judgment Seat of Photography," *October* 22 (Fall 1982), 27–63, which was important to my initial formulation of this book.

2. Although installation design has not figured within traditional art histories, the documentation is more substantial in architecture and design histories. While most architecture and design historical surveys do not deal with installation design, monographic studies of architects and designers often do; see Staniszewski, "Designing Modern Art and Culture."

 More unusual are installation design compilations such as Richard P. Lohse's *Neue Ausstellungsgestaltung, Nouvelles conceptions de l'exposition, New Design in Exhibitions* (Zurich: Verlag für Architektur, 1953) and George Nelson's *Display* (New York: Interiors Library, 1953). There is also a body of literature, marginally related to the framework of this book, consisting of technical manuals such as Misha Black, ed., *Exhibition Design* (London: Architectural Press, 1950).

 Bruce Altshuler's *The Avant-garde in Exhibition: New Art in the Twentieth Century* (New York: Harry N. Abrams, 1994) is representative of the increasing interest in the history of exhibitions; a number of collections are now being produced that deal with issues of display. See particularly *Thinking about Exhibitions,* ed. Reesa Greenberg, Bruce W. Ferguson, and Sandy Nairne (London: Routledge, 1996).

3. I am using the term "international avant-gardes" to refer to the various groups and collectives that were formed throughout the twentieth century (such as Dada, Surrealism, De Stijl, the Bauhaus, the Soviet Projects, and the Situationist International). These diverse groups were involved in experimentation that tested the institutional limits of fine art and envisioned culture as a means of social transformation. In many instances this involved a reevaluation of autonomous aestheticized practice and attempts to integrate art into everyday life. Peter Bürger, in *The Theory of the Avant-Garde,* trans. Michael Shaw (Minneapolis: University of Minnesota Press, 1984), originally published in German in 1974, defines the "historical avant-garde" as the pre–World War II artist associations that recognized the limitations of what he defines as modernism—that is, aestheticized, seemingly autonomous practice. Avant-garde practice, according to Bürger, involved rejecting the concept of aesthetic autonomy, with the intention to destroy the boundaries between art and life. My use of "international avant-gardes" is less reductive, as it characterizes the broad range of work that often involved a critique or expansion of the institutional limits of autonomous aestheticized practice and acknowledges the diversity and contradictions within the avant-gardes of the twentieth century. For example, I consider De Stijl abstract painting to be representative of the international avant-gardes even though aesthetic considerations predominate, and I consider post–World War II initiatives like the Situationist International to be contributors to the international avant-gardes.

4. Because the criterion for inclusion in the discussion was the type of installation design, the selection may seem idiosyncratic. Thus, important exhibitions like Alfred Barr's 1936 *Fantastic Art, Dada, Surrealism* are not featured, whereas smaller exhibitions like the *Useful Object* shows are examined in great detail.

5. See Russell Lynes, *Good Old Modern: An Intimate Portrait of the Museum of Modern Art* (New York: Atheneum, 1973), 212; René d'Harnoncourt, "Foreword: The Museum of the Future," from "Profile: The Museum of Modern Art," *Art in America* 52, no. 1 (February 1964), 25; and Alfred H. Barr, Jr., "Present Status and Future Direction of The Museum of Modern Art," August 1933 (confidential report for Trustees only), 2, The Museum of Modern Art Archives, New York, Alfred H. Barr, Jr. Papers (AAA: 3266;122).

6. Implicit in the issues explored and the questions raised in the text is an engagement with the semiological and historical dimensions of representations. This approach, which forecloses any possibility of a transparency between form and content, language and meaning, and intention and reception, acknowledges the historicity of all meanings. My examinations of the installations of the Museum of Modern Art are therefore not meant to be definitive statements about these exhibitions, nor is my analysis supposed to reveal a reductive notion of false consciousness. Rather, my investigation of these exhibitions takes into account some of the institutional and historical processes within which the meanings of these installations are created.

7. The granting of my request for an exception to the Museum's policy was decided by the Publications Advisory Committee. Patterson Sims, deputy director for Education and Research Support, oversaw the committee and demonstrated characteristic integrity—in this instance in regard to questions of research on the history of the Museum. Mikki Carpenter, director of the Department of Photographic Services and Permissions and a member of the committee, has also been invaluable throughout this permissions process.

8. As I was preparing this manuscript for publication, I encountered two works that examine related issues in a significant way. Mark Wigley's *White Walls, Designer Dresses: The Fashioning of Modern Architecture* (Cambridge, Mass.: MIT Press, 1995) is an extremely important examination of the convention of the white, seemingly neutral, modern interior and the feminine. And in a discussion, Evelyn Hankins outlined some of her ideas about the feminine and installation design in Manhattan museums during the first half of the century from her forthcoming Ph.D. dissertation, "Home for the Modern, Modern Homemaking: Engendering Modernist Display in New York City, 1913–1939" (Stanford University). Another text that raises questions about gender and interiors is the collection of essays from the 1991 symposium "Sexuality and Space": *Sexuality and Space,* ed. Beatriz Colomina (New York: Princeton Architectural Press, 1992).

Chapter 1

Introduction: Framing Installation Design: The International Avant-Gardes

Chapter epigraph: Herbert Bayer, "Aspects of Design of Exhibitions and Museums," *Curator* 4, no. 3 (1961), 257–258.

1. *Internationale Ausstellung neuer Theatertechnik,* ed. Frederick Kiesler, ex. cat., Konzerthaus, Vienna (Vienna: Wurthle und Sohn, 1924).

2. For a discussion of the music and theater festival, see R. L. Held, *Endless Innovation: Frederick Kiesler's Theory and Scenic Design* (1977; reprint, Ann Arbor, Mich.: UMI Research Press, 1982), 21–24.

The term "exhibition technique" was used by the international avant-gardes to refer to creative exhibition design. An analogous term, "theater technique," was also used for creative stagecraft and theater design.

3. Kiesler's "Notes on Designing the Gallery," manuscript, 1942, Kiesler Estate Archives, 2, cited in Cynthia Goodman, "The Art of Revolutionary Display Techniques," in *Frederick Kiesler,* ed. Lisa Phillips, ex. cat., Whitney Museum of American Art, New York (New York: W. W. Norton, 1989), 65.

4. *International Theatre Exposition,* organized by Frederick Kiesler and Jane Heap, ex. cat. (New York: Theater Guild et al., 1926).

5. The following is a selection of texts dealing with modern exhibition and museum display practices. In the late 1980s and 1990s, interest in the history of museum and gallery installation practices is reflected in such publications as *Thinking about Exhibitions,* ed. Reesa Greenberg, Bruce W. Ferguson, and Sandy Nairne (London: Routledge, 1995); *Exhibiting Cultures: The Poetics and Politics of Museum Display,* ed. Ivan Karp and Steven D. Lavine (Washington, D.C.: Smithsonian Institution Press, 1990; Tony Bennett, *The Birth of the Museum: History, Theory, Politics* (London: Routledge, 1995); Andrew McClellan, *Inventing the Louvre: Art, Politics, and the Origins of the Modern Museum in Eighteenth-Century Paris* (Cambridge: Cambridge University Press, 1994); Manfield Kirby Talley, Jr., "The 1985 Rehang of the Old Masters at the Allen Memorial Art Museum, Oberlin, Ohio," *International Journal of Museum Management and Curatorship* 6, no. 3 (September 1987), 229–252; and Carol Duncan, "From the Princely Gallery to the Public Art Museum," in *Civilizing Rituals: Inside Public Art Museums* (London: Routledge, 1995), 21–47. Duncan's essay draws largely from Carol Duncan and Alan Wallach, "The Universal Survey Museum," *Art History* 3 (December 1980), 447–469.

In some instances, these texts build on earlier publications, such as Germain Bazin's *The Museum Age,* trans. Jan van Nuis Cahill (Brussels: S. A. Editions; New York: Universe Books, 1967), esp. chaps. 5–12, and Niels von Holst, *Creators, Collectors, and Connoisseurs: The Anatomy of Artistic Taste from Antiquity to the Present Day* (New York: G. P. Putnam's Sons, 1967). Another important text in the literature of installation design, particularly regarding the issues I address in this chapter, is Samuel Cauman's *The Living Museum: Experiences of an Art Historian and Museum Director—Alexander Dorner,* intro. Walter Gropius (New York: New York University Press, 1958), 100–105. Also see the introduction and first chapter of Mary Anne Staniszewski, "Designing Modern Art and Culture: A History of Exhibition Installations at the Museum of Modern Art" (Ph.D. diss., City University of New York, 1995), i–82.

6. For an interesting study of the modern revival of axonometric drawing among artists and architects in the 1920s and its relationship to De Stijl, Suprematist, and Constructivist concepts of "optical release" and infinitely expanding, nonperspectival space, see Yves-Alain Bois, "Metamorphosen der Axonometrie/Metamorphosis of Axonometry," *Daidalos: Berlin Architectural Journal,* no. 1 (15 September 1981), 44.

7. Quoted in T. H. Creighton, "Kiesler's Pursuit of an Idea," *Progressive Architecture* 42 (July 1961), 109.

8. Ibid., 115–116.

9. Frederick J. Kiesler, "On Correalism and Biotechnique: Definition and Test of a New Approach to Building Design," *Architecture Record* 86, no. 3 (September 1939), 61.

10. Frederick Kiesler, "Second Manifesto of Correalism," *Art International* 9, no. 2 (March 1965), 16.

11. Kiesler, "On Correalism," 60–75. He elaborated: "the only human experiences that can be inherited by children are those of customs and habits by way of: training and education, thus 'social heredity'" (61).

12. Frederick Kiesler, "Ausstellungssystem: Leger und Trager," *De Stijl* 6, nos. 10–11 (1925), 137–140.

13. Theo van Doesburg's 24 October 1924 statement is quoted in "New Display Techniques for 'Art of This Century' Designed by Frederick J. Kiesler," *Architectural Forum* 78, no. 2 (February 1943), 50.

Although most De Stijl exhibition installations in the 1920s were not radically innovative, artists affiliated with De Stijl were exploring what has been described as a total environment; several were creating exhibition displays for aesthetic and commercial purposes. See Nancy J. Troy, *The De Stijl Environment* (Cambridge, Mass.: MIT Press, 1983).

14. *Exposition Internationale des Arts Décoratifs et Industriels Modernes: Catalogue Général Officiel,* ex. cat. (Paris: Grand Palais, 1925).

15. Dieter Bogner, "Kiesler and the European Avant-garde," in Phillips, *Frederick Kiesler,* 50.

16. Frederick Kiesler, "Manifest. Vitalbau-Raumstadt-Funktionnelle-Architektur," *De Stijl* 6, nos. 10–11 (1925), 141–147; "L'Architecture Élémentarisée," *De Stijl* 7, nos. 79–84 (1927), 101–102; "Die Stadt in der Luft," *G* 5 (April 1926), 10.

17. Theo van Doesburg, "Het Hollandsche paviljoen op de Exposition des Art Decoratifs te Parijs," *Het Bouwbedrijf* 2, no. 6 (June 1925), 221; trans. as "The Entry of The Netherlands and Other Pavilions," in *Theo van Doesburg: On European Architecture: Complete Essays from Het Bouwbedrijf, 1924–1931,* trans. Charlotte I. Loeb and Arthur L. Loeb (Basel: Birkhäuser Verlag, 1986), 52.

18. For discussion of this issue see, for example, Stephen Bann, "Russian Constructivism and Its European Resonance," and Christina Lodder, "Constructivism and Productivism in the 1920s," both in *Art into Life: Russian Constructivism, 1914–1932,* ex. cat. (Seattle: Henry Gallery, University of Washington; New York: Rizzoli, 1990), 99–116, 213–218.

19. Quoted in Creighton, "Kiesler's Pursuit," 110.

20. See Troy, *The De Stijl Environment.*

21. Although the same actors—artists, designers, and architects—may create projects that function in this way today, these frameworks are now the jurisdiction of an institution's administrators, curators, and staff.

22. Beatriz Colomina investigates the importance of publicity, publications, and the media in terms of modern architecture in her excellent study of these issues, *Privacy and Publicity: Modern Architecture as Mass Media* (Cambridge, Mass.: MIT Press, 1994).

23. See Alfred H. Barr, Jr., foreword to *Modern Architecture—International Exhibition,* Henry-Russell Hitchcock, Philip Johnson, and Lewis Mumford, ex. cat. (New York: Museum of Modern Art, 1932), 12; this catalogue was also published as Henry-Russell Hitchcock, Alfred H. Barr, Jr., and Lewis Mumford, *Modern Architects* (New York: W. W. Norton, 1932).

Beatriz Colomina makes this very point in her discussion of MoMA's *Modern Architecture* show; see *Privacy and Publicity,* 204.

24. See Cauman, *The Living Museum,* and see also Monica Flacke-Knoch, *Museum-konzeptionen in der Weimarer Republik: Die Tätigkeit Alexander Dorners im Provinzialmuseum Hannover* (Marburg: Jonas Verlag, 1985).

25. See Kai-Uwe Hemken's "Pan-Europe and German Art: El Lissitzky at the 1926 Internationale Kunstausstellung in Dresden," in *El Lissitzky, 1890–1941: Architect, Painter, Photographer, Typographer,* ed. Frank Lubbers, ex. cat. (Eindhoven: Municipal Van Abbemuseum, 1990), 46–55. Hemken gives a detailed description of the Dresden cabinet, which Hemken distinguishes as the *Room for Constructivist Art.* The 1928 Hanover cabinet, which Hemken refers to as the *Abstract Cabinet,* was modeled after the Dresden installation. Hemken includes a description of the ceiling, which was illuminated by an overhead light source and fitted with muslin. Half of this muslin scrim was blue and half was yellow. Hemken quotes Lissitzky's description: one half of the ceiling was "coldly lit, the other warmly" (47 n. 12), citing El Lissitzky's manuscript, "Demonstrationasräume," in the Archives of the Sprengel Museum Hanover, 362. This text is also reprinted with a slightly different translation in Sophie Lissitzky-Küppers, *El Lissitzky: Life, Letters, Texts,* trans. Helene Aldwinckle and Mary Whittall, rev. ed. (1967; London: Thames and Hudson, 1980), 366–367, where it is titled "Exhibition Rooms" and cited as "typescript in the Niedersächsisches Landesmuseum, Hanover, published in *Die zwanziger Jahre in Hannover,* Hanover, 1962."

26. For analyses of Dorner's curatorial methodology as director of the Landesmuseum, see Cauman, *The Living Museum,* 43–118, and Yves-Alain Bois, "Exposition: Esthetique de la distraction, espace de démonstration," *Les Cahiers du Musée National d'Art Moderne,* supplément catalogue 5, no. 29 (Autumn 1989), 57–79.

27. Cauman, *The Living Museum,* 30.

28. Although dense, salon-style installation method was the standard when Dorner began to restructure the Landesmuseum's collection, in 1857 John Ruskin wrote the article "The Hanging of Pictures" (see *The Lamp of Beauty: Writings on Art by John Ruskin,* ed. Joan Collins [Oxford: Phaidon, 1980], 289–290), in which he suggested installing paintings in one line and not in tiers as was conventional practice. By the late nineteenth century there were instances of more spacious installations of paintings, but the practice did not become common until the 1930s; see Talley, "1985 Rehang of the Old Masters," 239–240.

29. See Duncan's discussion of what she calls the "new art historical hang" in "From the Princely Gallery to the Public Art Museum" in *Civilizing Rituals,* 21–47; see note 6 in general for literature dealing with this history, in particular McClellan, *Inventing the Louvre.* Also see *The Genesis of the Art Museum in the 18th*

Century, ed. Per Bjurström (Stockholm: Nationalmuseum, 1993). For a text histori-cizing art and its institutions as a development of modernity, see Mary Anne Stani-szewski, Believing Is Seeing: Creating the Culture of Art (New York: Penguin, 1995).

30. For an English translation of Alois Riegl's writings, see The Problems of Style: Foundations for a History of Ornament, trans. Evelyn Kain (Princeton: Princeton University Press, 1992).

31. Dorner claims to have found Riegl's theories too reductive once he had em-barked upon his revision of the Hanover collections and had become more in-volved with the ideas of the modern artists of the twenties and thirties. In The Way beyond "Art": The Work of Herbert Bayer, rev. ed. (New York: New York Univer-sity Press, 1958), 17–18, Dorner claims that Riegl's idealist philosophy was in the end inadequate, that his "rearrangement of the Hanover collections became ever more relativistic," and that he was able to express these reevaluations in the modern installations created by Lissitzky and Moholy-Nagy. Dorner goes on to attri-bute further development of his theories to American Pragmatism and the work of John Dewey (to whom The Way beyond "Art" is dedicated) and Joseph Ratner. Dorner's interest in American Pragmatism developed after he had left Hanover and had settled in the United States. Cauman is also critical of Riegl's theories, but both Dorner and Cauman acknowledge Riegl's seminal influence on Dorner.

32. Quoted in Cauman, The Living Museum, 93.

33. Ibid., 88.

34. Quoted in Lissitzky-Küppers, El Lissitzky: Life, 366.

35. Quoted in Cauman, The Living Museum, 104, and cited from a "typescript in the Niedersächsisches Landesmuseum, Hanover, published in Die zwanziger Jahre in Hannover, Hanover, 1962," in Lissitzky-Küppers, El Lissitzky, 367.

36. Cauman lists responses to the room, including Sigfried Giedion's 1929 article "Live Museum," Der Cicerone 21, no. 4 (1929), 103–105, which is undated in the Cauman text; see The Living Museum, 106–108.

37. Both quoted in ibid., 108, 106. The Dresden installation, and presumably the Hanover cabinet, had a scrim ceiling and were illuminated from sources hidden by this scrim (see Hemkin, "Pan-Europe and German Art"), formulations that John-son used in his 1934 Machine Art exhibition.

38. Quoted in Sophie Lissitzky-Küppers et al., El Lissitzky, ex. cat. (Cologne: Gale-rie Gmurzynska, 1976), 89.

39. Cauman, The Living Museum, 102–104. For discussion of Dorner's theories in relation to The Room of Our Time, see note 31 above and Victor Margolin, "The Transformation of Vision: Art and Ideology in the Graphic Design of Alexander Rod-

chenko, El Lissitzky, and László Moholy-Nagy, 1917–1933," vol. 1 (Ph.D. diss. Union Graduate School, 1982), 258–260.

40. Margolin, "The Transformation of Vision," 259.

41. For the 1926 Société Anonyme exhibition at the Brooklyn Museum, Katherine Dreier was interested in creating a model apartment for the future, a completely modern environment like Lissitzky's Room for Constructivist Art and Abstract Cabi-nets; she invited Kiesler, who had recently arrived in the states, to do the installa-tion. Kiesler conceived a Telemuseum, which would have walls of "sensitized panels" that would "act as receiving surfaces for broadcasted pictures" and where there would be "built-in 'shrines' for original masterpieces that will be con-cealed behind walls and revealed only occasionally." In keeping with his notion of a dynamic environment, he envisioned that "The use of pictures as a permanent wall decoration will be discarded practice." This Telemuseum was to be installed in one's home, where "through the dials of your Teleset you will share in the owner-ship of the world's greatest art treasures" (Kiesler, Contemporary Art Applied to the Store and Its Display [New York: Brentano's, 1930], 121). Kiesler did not com-plete the construction in time for the Brooklyn show, but a version of the Tele-museum was installed at the Anderson Galleries in New York in January 1927. The installation has been described as a dark room containing a button that, when pressed, would make visible illuminated reproductions of masterworks such as the Mona Lisa. See Ruth L. Bohan, The Société Anonyme's Brooklyn Exhibition: Katherine Dreier and Modernism in America (Ann Arbor, Mich.: UMI Research Press, 1982), 62.

42. See John Willett, Art and Politics in the Weimar Period: The New Sobriety, 1917–1933 (New York: Pantheon, 1978), 50–54; Eberhard Roters, Bernhard Schulz, et al., Stationen der Moderne: Die bedeutenden Kunstausstellungen des 20. Jahrhunderts in Deutschland, ex. cat. (Berlin: Berlinische Galerie, 1988), 156–183; Bruce Altshuler, "DADA ist politisch: The First International Dada Fair, Berlin, June 30–August 25, 1920," in The Avant-Garde in Exhibition: New Art in the Twentieth Century (New York; Harry N. Abrams, 1994), 98–115.

43. See Altshuler, "Snails in a Taxi: International Exposition of Surrealism, Galerie Beaux-Arts, Paris, January–February, 1938," in The Avant-Garde in Exhibition, 116–155.

44. See Goodman, "Revolutionary Display Techniques," 71–76.

45. Cauman, The Living Museum, 109–111, and Margolin, "The Transformation of Vision," 259–260.

46. Cauman, The Living Museum, 118–122, 128; Elaine S. Hochman, Architects of Fortune: Mies van der Rohe and the Third Reich (New York: Weidenfeld and Nic-olson, 1989), 295, 277, 296.

47. On Dorner's invitation to Moholy-Nagy, see Cauman, The Living Museum, 109; Margolin, "The Transformation of Vision," 257–259.

See Charles Hairon, *Société des Artistes Décorateurs: Catalogue du 20e Salon,* ex. cat. (Paris: Grand Palais des Champs-Elysées, 1930). For plates, see Marcel Chappey, ed., *Le XXème Salon des Artistes Décorateurs,* 2 vols. (Paris: Vincent Fréal, 1930). See also Richard P. Lohse, *Neue Ausstellungsgestaltung, Nouvelles conceptions de l'exposition, New Design in Exhibitions* (Zurich: Verlag für Architektur, 1953), 20–27; Hans M. Wingler, *The Bauhaus: Weimar, Dessau, Berlin, Chicago,* ed. Joseph Stein, trans. Wolfgang and Basil Gilbert, rev. ed. (1962; Cambridge, Mass.: MIT Press, 1986), 566–567; and vol. 2 of *The Walter Gropius Archive: An Illustrated Catalogue of the Drawings, Prints, and Photographs in the Walter Gropius Archive at the Busch-Reisinger Museum, Harvard University,* ed. Winfried Nerdinger (New York: Garland; Cambridge, Mass.: Harvard University Art Museums, 1990).

48. The Gropius Archive and Lohse document that the post office was designed by "Vorhoelzer" and, according to the Gropius Archive, Breuer's installation was a collaboration with Gustav Hassenpflug; see Nerdinger, *Gropius Archive,* 2:71 and Lohse, *Neue Ausstellungsgestaltung,* 20.

49. For an overview of Bayer's exhibition design methodology see Bayer, "Aspects of Design," 257–287; Herbert Bayer, "Fundamentals of Exhibition Design," *PM (Production Manager)* 6, no. 2 (December 1939–January 1940), 17–25; and Bernard Rudofsky, "Notes on Exhibition Design," *Interiors and Industrial Design* 106, no. 12, (July 1947), 60–77.

50. For figure 1.30, see note 49.

51. See, for example, *The Reader in the Text: Essays on Audience and Interpretation,* ed. Susan R. Suleiman and Inge Crosman (Princeton: Princeton University Press, 1980).

52. Quoted in Wingler, *The Bauhaus,* 30–32.
For background on the theoretical development of the Bauhaus, see *German Expressionism: Documents from the End of the Wilhelmine Empire to the Rise of National Socialism,* ed. and annot. Rose-Carol Washton Long, trans. Nancy Roth (New York: G. K. Hall, 1993), 191, 245–261; Marcel Franciscono, *Walter Gropius and the Creation of the Bauhaus in Weimar: The Ideals and Artistic Theories of Its Founding Years* (Urbana: University of Illinois Press, 1971), 134–152.

53. See Wingler, *The Bauhaus,* 139–165.

54. Hannes Meyer created an unusual exhibition display—a large glass case, his "Co-op Vitrine"—for the *Internationale Ausstellung des Genössenschaftswesens und der sozialen Wohlfahrtspflege (International Exhibition of Cooperative Products and "Socialist Welfare Work"),* in Ghent in 1924 and Basel in 1925, which was filled with repetitive arrangements of mass-produced goods. See, for example, K. Michael Hays, "Co-op Vitrine and the Representation of Mass Production," in *Modernism and the Posthumanist Subject* (Cambridge, Mass.: MIT Press, 1992), 25–53, and Klaus–Jürgen Winkler, *Der Architekt Hannes Meyer: Anschauungen und Werk* (Berlin: Verlag für Bauwesen, 1989), 50–51.

55. See "junkerskoje 'gas un wasser,'" 1; Hans Riedel, "veranwortung des schaffenden," 2–7; E. Giménez Caballero-Madrid, "Lob des Plakates," 8–9; all in *Bauhaus* 3, no. 3 (July–September 1929). For a brief discussion of the installation techniques deployed by artists such as Bayer, Schmidt, Schawinsky, and Moholy-Nagy, see Ute Brünig, "Typophoto," in *Photography at the Bauhaus,* ed. Jeannine Fiedler (Cambridge, Mass.: MIT Press, 1990), 204–237.

56. *Exposición Internacional de Barcelona,* ex. cat. (Barcelona: Seix y Barral, 1929).

57. Ludwig Mies van der Rohe, "Mies Speaks," *Architectural Record,* no. 144 (December 1968), 451; Hochman, *Architects of Fortune,* 55. The exhibition was initially organized to emphasize industry; however, the English and French governments decided to erect separate national pavilions and Germany followed suit. The paint company I. G. Farben financed the pavilion; see Sandra Honey et al., *Mies van der Rohe: European Works* (London: Academy Editions; New York: St. Martin's Press, 1986), 62.

58. Philip Johnson, *Mies van der Rohe,* ex. cat. (New York: Museum of Modern Art, 1947), 58.

59. See Bayer, "Aspects of Design" and "Fundamentals of Exhibition Design."

60. For an interesting discussion of the way Mies's reputation was founded on publications and exhibitions of the 1920s, see Beatriz Colomina, "Mies Not," unpublished paper to be included in the forthcoming *The Presence of Mies* (Princeton Architectural Press).

61. Philip Johnson, "In Berlin: Comment on Building Exposition," *New York Times* 9 August 1931, sec. 8, p. 5, reprinted in *Philip Johnson: Writings* (New York: Oxford University Press, 1979), 49; "The Berlin Building Exposition of 1931," *T-Square* 2, no. 1 (January, 1932), 17–19, 36–37, reprinted in *Oppositions* 2 (January 1974), 83–85; "Architecture in the Third Reich," *Hound and Horn* (October–December 1933), 137–139, reprinted in *Writings,* 52; and *Mies van der Rohe.*

62. Johnson, *Mies van der Rohe,* 49. Johnson's involvement with Mies's work is well known. That interest in the work of Mies and his partner, Lilly Reich, was confirmed and elaborated on during an interview with the author, January 1994.

63. See Matilda McQuaid, with an essay by Magdalena Droste, *Lilly Reich: Designer and Architect,* ex. cat. (New York: Museum of Modern Art; distr. New York: Harry N. Abrams, 1995); Sonia Gunther, *Lilly Reich, 1885–1947* (Stuttgart: Deutsche Verlag-Anstalt, 1988).

64. Gunther is very specific in her attribution of exhibits; see *Lilly Reich.* Gunther and McQuaid (*Lilly Reich*) agree in attributing the Barcelona exhibition to both Reich and Mies. See *Internationale Ausstellung Barcelona 1929: Deutsche Abteilung,* ex. cat. (Berlin: Reichsdruckerei, 1929).

65. See McQuaid, *Lilly Reich;* the show was held from 7 February to 7 May 1996.

66. See McQuaid, *Lilly Reich,* 22.

67. Johnson, "In Berlin," 49.

68. Mies van der Rohe, "Mies Speaks," 451.

69. Hochman, *Architects of Fortune,* 209–210.
 My discussion of Mies van der Rohe and his relationship to German politics follows the analysis of Elaine Hochman's *Architects of Fortune* and Richard Pommer's "Mies van der Rohe and the Political Ideology of the Modern Movement in Architecture," in *Mies van der Rohe: Critical Essays,* ed. Franz Schulze (New York: Museum of Modern Art, 1989), 96–145. Both are in-depth and thoughtful examinations of Mies and his relationship to German politics.

70. Speer, interview with Hochman, 1974; see Hochman, *Architects of Fortune,* 213.

71. See Hochman, *Architects of Fortune;* Pommer, "Mies and Political Ideology"; George Nelson, "Architects of Europe Today: 7—van der Rohe, Germany," *Pencil Points* 16, no. 9 (September 1935), 459.

72. Johnson, "Architecture in the Third Reich," 53. On Johnson's relationship to these issues, see Franz Schulze, *Philip Johnson: Life and Work* (New York: Alfred A. Knopf, 1994), 89–90, 106–115, 128–146.

73. Hochman's book is an excellent study precisely of this question; *Architects of Fortune,* 210–211. Gropius and Schmidt created the installation for the 1934 "Nonferrous Metals" exhibit, *Deutsches Volk/deutsche Arbeit,* in Berlin; see Lohse, *Neue Ausstellungsgestaltung,* 72–73, and Hochman, 210–211.

74. See the proclamation that appeared in the *Völkischer Beobachter* on 18 August 1934, translated in Hochman, *Architects of Fortune,* 222–224.

75. See Hochman, *Architects of Fortune,* 282–283 n. 1 (Hochman's conversation with Herbert Hirche on 10 August 1973).

76. Ibid., 271–288; McQuaid, *Lilly Reich,* 39–41; Magdalena Droste, "Lilly Reich: Her Career as an Artist," in McQuaid, *Lilly Reich,* 57.

77. Quoted in Hochman, *Architects of Fortune,* 283 n. 74 (interview with Johnson).

78. An important exception to this is the presentation Esther da Costa Meyer gave at the Museum of Modern Art panel organized in conjunction with a retrospective, *Lilly Reich: Women, Design, and Collaboration,* and held on 17 March 1996. Da Costa Meyer raised questions regarding Reich's acceptance of commissions during the Nazi regime—for example, the German textile industry exhibit for the 1937 *Exposition internationale des arts et techniques appliqué à la vie moderne (International Exposition of Arts and Techniques Applied to Modern Life).*

79. See chronology, McQuaid, *Lilly Reich,* 61–62. The issue of Reich's remaining in Germany was raised at the 1996 Museum of Modern Art panel discussion (see note 78), particularly in relation to Esther da Costa Meyer's presentation. Reich did visit Mies in the United States, but returned to Germany. Panelists speculated that perhaps it was more difficult for a woman to obtain the necessary papers and support to leave Germany.

80. *Bauhaus 1919–1928,* ed. Herbert Bayer, Walter Gropius, and Ise Gropius, ex. cat. (New York: Museum of Modern Art, 1938), 156. For chronology and reproductions, see 158–159, 207–216.

81. For a chronology of the New Bauhaus in Chicago see Wingler, *The Bauhaus,* 581–613. For the integration of exhibition design within the New Bauhaus at its inception, see Sybil Moholy-Nagy, *Moholy-Nagy: Experiment in Totality,* intro. Walter Gropius (Cambridge, Mass.: MIT Press, 1969), 148. László Moholy-Nagy's theories related to exhibition design are documented in *The New Vision: From Material to Architecture,* trans. Daphne M. Hoffman (New York: Brewer, Warren, and Putnam, 1930), which was published in a revised edition as *The New Vision: Fundamentals of Design, Painting, Sculpture, Architecture* (New York: W. W. Norton, 1938) and combined with an autobiographical essay as *The New Vision and Abstract of an Artist* (New York: Wittenborn, Schulz, 1946). These publications are revised and expanded versions of *Von Material zu Architektur,* Bauhausbücher no. 14 (Munich: Albert Langen Verlag, 1929), which was based on his teaching of the Bauhaus preliminary course.

82. See László Moholy-Nagy, *Painting, Photography, Film,* trans. Janet Seligmann (Cambridge, Mass.: MIT Press, 1969), originally published as *Malerei, Photographie, Film,* Bauhausbücher no. 8 (Munich: Albert Langen Verlag, 1925), and his "Production-Reproduction" (1922), "Unprecedented Photography" (1927), and "Photography in Advertising" (1927), reprinted in *Photography in the Modern Era: European Documents and Critical Writings, 1913–1940,* ed. Christopher Phillips (New York: Metropolitan Museum and Aperture, 1989), 79–93.

83. See Walter Peterhans, "Zum gegenwartigen Stand der Fotografie," *ReD* 3, no. 5 (1930), 138–40, translated as "On the Present State of Photography," in Phillips, *Photography in the Modern Era,* 170–174.

84. For an overview of the photography exhibitions in the 1920s and 1930s, see Ute Eskildsen, "Exhibits," in *Avant-Garde Photography in Germany, 1919–1939,* ex. cat. (San Francisco: Museum of Modern Art, 1980), 35–46; Eleanor M. Hight, "Encounters with Technology: Moholy's Path to the 'New Vision,'" in *Moholy-Nagy: Photography and Film in Weimar Germany,* ex. cat. (Wellesley, Mass.: Wellesley College Museum, 1985), 39–45; Christopher Phillips, "Resurrecting Vision: European Photography between the World Wars," in *The New Vision: Photography between the World Wars,* ex. cat. (New York: Metropolitan Museum, 1989), 65–108.

85. The following publications were published in conjunction with "Film und Foto": *Foto-Auge,* ed. Franz Roh and Jan Tschichold (Stuttgart: Akademischer Verlag Dr. Fritz Wedekind, 1929); Werner Graff, *Es kommt der neue Fotograf!* (Berlin: Hermann Reckendorf, 1929); and Hans Richter, *Filmgegner von Heute—Filmfreunde von Morgen* (Berlin: Hermann Reckendorf Verlag, 1929).

86. For documentation of this exhibition see, for example, Lissitzky-Küppers, *El Lissitzky: Life,* 84–87, plates 203–216; Sophie Lissitzky-Küppers, "Lissitzky in Cologne," Elena Semenova, "From My Reminiscences of Lissitzky," and Jean Leering, "Lissitzky's Importance Today," all in Lissitzky-Küppers et al., *El Lissitzky,* 11–22, 23–24, 34–46; and Peter Nisbet, *El Lissitzky, 1890–1941,* ex. cat., Harvard University Art Museums and Busch-Reisinger Museum, Cambridge, Mass. (Dresden: Verlag der Kunst; London: Thames and Hudson, 1987), 35–38.

87. Sample pages of the catalogue by A. Chalatow et al., *Union der Sozialistischen Sowjet-Republiken,* ex. cat. (Cologne: Pressa Koln, 1928), are reprinted in Lissitzky-Küppers, *El Lissitzky,* 145–151.

88. Bayer, "Aspects of Design," 267.

89. Herbert Bayer, interviews with Arthur Cohen, 1981 and 1982, 18, Archives of American Art, Smithsonian Institution, Washington, D.C.

90. Jan Tschichold, "Display That Has DYNAMIC FORCE: Exhibition Rooms Designed by El Lissitzky," *Commercial Art* (London) 10, no. 55 (January 1931), 22.

91. Lissitzky-Küppers et al., *El Lissitzky,* 89. For a survey of Lissitzky's exhibition designs, see Lissitzky-Küppers, *El Lissitzky: Life.*

92. See *Art into Life,* esp. Jaroslav Andel, "The Constructivist Entanglement: Art into Politics, Politics into Art," 223–239.

93. See Lissitzky's letters and writings in Lissitzky-Küppers, *El Lissitzky: Life,* and see his chronology in Lissitzky-Küppers et al., *El Lissitzky,* 88–90.

94. In his autobiographical chronology for the year 1930 (Lissitzky-Küppers et al., *El Lissitzky,* 88–89), Lissitzky refers to the "political responsibility" of his exhibition designs and throughout the chronology he documents his service for the state. Benjamin H. D. Buchloh, in "From Faktura to Factography" (*October* 30 [Fall 1984], 82–119), presents a close reading of Lissitzky's *Pressa* installation and raises questions regarding Lissitzky's, as well as Rodchenko's, artistic responsibility regarding their work for Stalin's regime. For example, *USSR in Construction* was a propaganda monthly to which both Lissitzky and Rodchenko contributed. Buchloh points out that in 1933 the journal featured Rodchenko's Constructivist photographs of the White Sea Canal. Rodchenko's photographs, however, give no indication that the canal was built by individuals in forced labor camps where more than one hundred thousand workers died.

95. *Mostra della Rivoluzione Fascista: Guida Storica,* ed. Dino Alfieri and Luigi Freddi, ex. cat. (Rome: Partito Nazionale Fascista, 1932). For an inventory of state archives, see Gigliola Fioravanti, *Partito Nazionale Fascista Mostra della Rivoluzione Fascista* (Rome: Archivio Centrale dello Stato, 1990). For analysis of this exposition's exhibition designs, see for example, Giorgio Ciucci, "L'autorappresentazione del fascismo: La mostra del decennale della marcia su Roma," *10 Rassegna (Allestimenti/Exhibit Design)* 4, no. 10 (June 1982), 48–53; Dennis P. Doordan, *Building Modern Italy: Italian Architecture, 1914–1936* (New York: Princeton Architectural Press, 1988), 129–141, 157–158; Diane Yvonne Ghirardo, "Italian Architects and Fascist Politics: An Evaluation of the Rationalist's Role in Regime Building," *Journal of the Society of Architectural Historians* 39, no. 2 (May 1980), 109–134; Thomas L. Schumacher, *Surface and Symbol: Giuseppe Terragni and the Architecture of Italian Rationalism* (New York: Princeton Architectural Press; London: Architecture, Design, and Technology Press; Berlin: Ernst und Sohn, 1991), 171–176, 273–274; Richard A. Etlin, *Modernism in Italian Architecture, 1890–1940* (Cambridge, Mass.: MIT Press, 1991), 407–417.

96. Alfieri and Freddi, *Mostra della Rivoluzione Fascista,* 2.

97. Ibid., 228.

98. The *Sala delle Medaglie d'Oro* is one of the rare installations discussed, for example, in Kenneth Frampton, *History of Modern Architecture,* rev. and enlarged ed. (1980; London: Thames and Hudson, 1985), 206–207. See also Doordan, *Building Modern Italy,* 124–125.

99. Doordan, *Building Modern Italy,* 125 n. 23, cites *Edoardo Persico: Scritti d'architettura (1927/1935),* ed. Giulia Veronesi (Florence: Vallecchi, 1968), 192 and Vittorio Gregotti, *New Directions in Italian Architecture* (London: Studio Vista, 1968), 21.

100. For a history of the Triennales, see Doordan, *Building Modern Italy,* 113–121, 142–147, 156–158; Giacomo Polin, "La Triennale di Milano, 1923–1947: Allestimento, astrazione, contestualizzazione," *10 Rassegna (Allestmenti/Exhibit Design)* 4, no. 10 (June 1982), 34–47.

101. For an overview of the installations of 1940s and the early 1950s, see George Nelson, *Display* (New York: Interiors Library, 1953); also see Lohse, *Neue Ausstellungsgestaltung.*

102. "American" is an imperfect adjective because it applies to both North and South America. I am using it specifically to refer to the United States.

Chapter 2

Aestheticized Installations for Modernism, Ethnographic Art, and Objects of Everyday Life

Chapter epigraphs: Alfred H. Barr, Jr., "Letter to Edward S. King," 10 October 1934, MoMA Archives: AHB Papers (AAA: 2165;411). King was a research associ-

ate at the Walters Art Gallery in Baltimore in 1934 and went on to become a curator and its director. Gregory T. Hellman, "Profiles: Imperturbable Noble," *The New Yorker,* 7 May 1960, p. 104.

1. See Margaret Scolari Barr, interview with Paul Cummings, 22 February 1974 and 8 April 1974, 18–20, Archives of American Art, Smithsonian Institution, Washington, D.C. (AAA).

2. One of the most important modern art shows in New York preceding MoMA's inaugural exhibition was that of the Société Anonyme held at the Brooklyn Museum in 1926. The exhibition was installed by Katherine Dreier, the Société's founder, in the modern manner of neutral-colored walls and non-skied arrangements. She did, however, create four model rooms of a middle-class domestic interior to show that it was important to live with modern art. There was a parlor, dining room, library, and bedroom arranged with furnishings from the Brooklyn department store Abraham and Strauss. See Ruth L. Bohan, *The Société Anonyme's Brooklyn Exhibition: Katherine Dreier and Modernism in America* (Ann Arbor, Mich.: UMI Research Press, 1982), 49–66, figs. 16, 25–29; *The Société Anonyme and the Dreier Bequest at Yale: A Catalogue Raisonné,* ed. Robert L. Herbert, Eleanor S. Apter, and Elise K. Kennedy (New Haven: Yale University Press, 1984), 8–10.

3. I interviewed Nicholas King, director of education at the Barnes Foundation, on 27 May 1997, and he outlined and clarified the facts about the Foundation. Established in 1925, the Barnes Foundation comprises the private collection of Albert C. Barnes. Throughout his life (Barnes died in 1951), the collector created installations of what he called "wall ensembles," which he likened to music ensembles and envisioned as a teaching tool. Barnes was extremely concerned with presenting meaningful skied arrangements and choosing colors for the galleries' walls in relation to the works exhibited. Documentation of Barnes's ideas regarding installation design can be found in his letters to John Dewey in the archives of the Albert C. Barnes Foundation, Merion Station, Pennsylvania. For background on the collection, also see Violette de Mazia, *The Barnes Foundation: The Display of Its Art Collection* (Merion Station, Pa.: V.O.L.N. Press, 1983).

4. Margaret Barr, interview with Cummings, 18–21.

5. Beaumont Newhall, "Alfred H. Barr, Jr.: He Set the Pace and Shaped the Style," *Art News* 78, no. 8 (October 1979), 134–135.

6. Margaret Barr, interview with Cummings, 19.

7. Philip Johnson, interview with author, 6 January 1994.

8. For a chronology of Barr's and Johnson's early years at MoMA, see Rona Roob, "Alfred H. Barr, Jr.: A Chronicle of the Years 1902–1929," and Margaret Scolari Barr, "Our Campaigns," both in *Our Campaigns,* special issue of *New Criterion* (1987), 1–19, 23–74.

9. Johnson interview. Johnson could not remember what museum in Basel he visited; it was most likely the Kunstmuseum Basel. For background on the Folkwang Museum in Essen, see Carmen Luise Stonge, "Karl Ernst Osthaus: The Folkwang Museum and the Dissemination of International Modernism" (Ph.D. diss., City University of New York, 1993).

10. Johnson interview. In a monograph, *The International Style: Exhibition 15 and the Museum of Modern Art,* ex. cat., Columbia University Graduate School of Architecture, New York, Columbia Books of Architecture 3 (New York: Rizzoli/CBA, 1992), Terence Riley states that the Heckscher Building contained columns that had to be removed. According to Johnson, there were no columns, just pilasters in the original structure.

11. Margaret Barr, interview with Cummings, 19.

12. Alfred H. Barr, Jr., "Brief Analysis of Installation of 'Italian Masters' at the MoMA," ca. 1940, 1–2, MoMA Archives: AHB Papers (AAA: 3260;354).

13. I am defining "modernism" in terms of nineteenth- and twentieth-century art, where the aesthetic and formal concerns predominate. An exemplar of this practice would be an abstract painting created for exhibition in an art gallery. This type of work would be distinguished, for example, from practice that is an attempt to dismantle boundaries between art and other spheres of life, such as a political poster designed by an artist to be posted in the streets.

14. For a description of the 1926 and 1928 cabinets, see chapter one; and for a detailed account of their similarities and differences, see Kai-Uwe Hemken, "Pan-Europe and German Art: El Lissitzky at the 1926 Internationale Kunstausstellung in Dresden," in *El Lissitzky, 1890–1941: Architect, Painter, Photographer, Typographer,* ex. cat. (Eindhoven: Municipal Van Abbemuseum, 1990), 46–55.

15. See Sophie Lissitzky-Küppers, *El Lissitzky: Life, Letters, Texts,* trans. Helene Aldwinckle and Mary Whittall rev. ed. (1967; London: Thames and Hudson, 1980), 366.

16. Ibid., passim.

17. Frederick Kiesler, "On Correalism and Biotechnique: Definition and Test of a New Approach to Building Design," *Architectural Record* 86, no. 3 (September 1939), 61.

18. Frederick Kiesler, "Second Manifesto of Correalism," *Art International* 9, no. 2 (March 1965), 16.

19. Samuel Cauman, *The Living Museum: Experiences of an Art Historian and Museum Director, Alexander Dorner,* intro. Walter Gropius (New York: New York University Press, 1958), 88.

20. See chapter 1 for sources on the history of the modern museum, esp. notes 5, 28. For texts that specifically link the creation of the modern sense of self and

the institution of the modern museum, see Mary Anne Staniszewski, *Believing Is Seeing: Creating the Culture of Art* (New York: Penguin, 1995); Tony Bennett, *The Birth of the Museum: History, Theory, Politics* (London: Routledge, 1995); and Andrew McClellan, *Inventing the Louvre: Art, Politics, and the Origins of the Modern Museum in Eighteenth-Century Paris* (Cambridge: Cambridge University Press, 1994).

21. I suggest correspondences for modern subjectivity, modern installations, and modern aesthetic myths in *Believing Is Seeing*.

22. See Russell Lynes, *Good Old Modern: An Intimate Portrait of The Museum of Modern Art* (New York: Atheneum, 1973), 212. In his notes and writings Barr describes the Museum in terms of experiments and as a laboratory; see, for example, "Present Status and Future Direction of the Museum of Modern Art," August 1933 (confidential report for trustees only), 2, 10, MoMA Archives: AHB Papers (AAA: 3266;122, 131). René d'Harnoncourt, "Foreword: The Museum of the Future," from "Profile: The Museum of Modern Art," *Art in America* 52, no. 1 (February 1964), 25.

23. According to Lynes, Barr called this exhibition "A Bid for Space" (*Good Old Modern,* 393); see Alfred H. Barr, Jr., "Chronicle of the Collection of Painting and Sculpture" in *Painting and Sculpture in the Museum of Modern Art, 1929–1967* (New York: Museum of Modern Art, 1977), 627–643.

24. A. Conger Goodyear, *The Museum of Modern Art: The First Ten Years* (New York: A. Conger Goodyear, 1943), 83–84.

25. Though included on the Museum's "List of Exhibitions of The Museum of Modern Art," there is no photo documentation of this permanent collection installation.

Kirk Varnedoe, Chief Curator of MoMA's Department of Painting and Sculpture, outlines in detail this change in the Museum's policy in "The Evolving Torpedo: Changing Ideas of the Collection of Painting and Sculpture of The Museum of Modern Art," in *Studies in Modern Art,* vol. 5, *The Museum of Modern Art at Mid-Century, Continuity and Change,* series ed. John Elderfield (New York: Museum of Modern Art; dist. New York: Harry N. Abrams, 1995), 12–73.

For a close reading of MoMA's permanent collection galleries in 1978 and a treatment of the visitor's experience as cultural ritual, see Carol Duncan and Alan Wallach, "The Museum of Modern Art as Late Capitalist Ritual: An Iconographic Analysis," *Marxist Perspectives* 1, no. 4 (Winter 1978), 28–51; another version of this article was published as "MoMA: Ordeal and Triumph on 53rd Street," *Studio International* 194, no. 988 (1978), 48–57. For the history of the Museum's acquisition policy, see Lynes, *Good Old Modern,* 291.

26. For an outline of the 1929 Plan, written in retrospect, see Alfred H. Barr, Jr., "1929 Multidepartmental Plan for The Museum of Modern Art: its origins, development, and partial realization," August 1941, 1–11, MoMA Archives: AHB Papers (AAA: 3266;68–80). For a history of the early years of the Museum, with an appendix devoted to the 1929 Plan, see Goodyear, *Museum of Modern Art,* 137–139.

27. Barr, "1929 Plan," 4 (AAA: 3266;73). For an analysis of Barr's plan, see Sybil Gordon Kantor, "Alfred H. Barr, Jr., and the Establishment of the Culture of Modernism in America" (Ph.D. diss., City University of New York, 1993), 20–23, 215–220.

28. Barr, "1929 Plan," 5–6, 7–8 (AAA: 3266;74–75, 75–76). The phrase "to manufacture and the practical life" is exactly what Barr wrote.

29. For examples of authors who refer to Charles Rufus Morey's influence on Barr, see Kantor, "Barr and Modernism," 20–23, 215, 372; Irving Sandler, introduction, and Amy Newman, "The Visionary," in *Defining Modern Art: Selected Writings of Alfred H. Barr, Jr.,* ed. Irving Sandler and Amy Newman (New York: Harry N. Abrams, 1986), 7–47, 49–51.

30. Morey's approach is similar to Alois Riegl's methods and his theory of *Kunstwollen.* Interestingly however, in *Medieval Art* (New York: W. W. Norton, 1942), Morey does not refer to Riegl or cite him in the book's bibliography. For a discussion of Riegl in relationship to Darwin, see the foreword by Rolf Winkes to *Late Roman Art Industry,* by Alois Riegl, trans. Rolf Winkes (Rome: Giorgio Bretschneider Editore, 1985), xii–xxiv.

31. Barr, "1929 Plan," 2 (AAA: 3266;71).

32. Ibid.

33. Ibid., 7 (AAA: 3266;76).

34. See, for example, Irving Sandler, *The Triumph of American Painting: A History of Abstract Expressionism* (New York: Harper and Row, 1970), 12; Robert Rosenblum, foreword to *Cubism and Abstract Art,* by Alfred H. Barr, Jr. (1936; reprint, Cambridge, Mass.: Harvard University Press, Belknap Press, 1986), 1–4; Griselda Pollock, *Vision and Difference: Femininity, Feminism, and the Histories of Art* (London: Routledge, 1988), 18–19; and particularly Susan Noyes Platt, "Modernism, Formalism, and Politics: The 'Cubism and Abstract Art' Exhibition of 1936 at the Museum of Modern Art," *Art Journal* 47, no. 4 (Winter 1988), 284–295.

35. The analysis, visual devices, and plan were conceived by Sidney Janis; the exhibit design was by Frederick Kiesler, Laboratory of Design-Correlation, School of Architecture, Columbia University.

36. See Barr, Jr., "Present Status and Future Direction," 4–6 (AAA: 3266; 124–126).

Barr reveals a consciousness of the education and class of these audiences, but he does not consider gender or ethnic background.

37. For background on the development of MoMA's education department, see Lynes, *Good Old Modern,* 167–171.

38. These children's carnivals were most likely influenced by John Dewey's learning-by-doing educational theories, which were gaining prominence within the

museum field during the late 1930s and 1940s in the United States. This is discussed in Carol Morgan, "From Modernist Utopia to Cold War Reality: A Critical Moment in Museum Education," in *Studies in Modern Art,* vol 5. According to Morgan, D'Amico had heard Dewey lecture at Teacher's College of Columbia University; see Morgan, "From Modernist Utopia," 155. D'Amico, who was one of a committee of authors for *The Visual Arts in General Education: A Report of the Committee on the Function of Art in General Education* by the Progressive Education Association (New York: D. Appleton Century Company, 1940), mentions Dewey in relation to self-expression and democracy on pages 7 and 151. For an overview of the increasing concern in the United States at that time regarding the educational dimension of the art museum, see Terry Zeller, "The Historical and Philosophical Foundations of Art Museum Education in America," in *Museum Education: History, Theory, and Practice* (Reston, Va.: National Art Education Association, 1989), 10–89. Zeller examines the modification of the purely aesthetic approach to presenting works of art in U.S. museums and the spread of educational exhibitions and programs that also involved what was considered the social philosophy of art museums. In 1941 Barr alludes to contemporary theories that promote the social usefulness of the museum in a democracy; see Barr, "1929 Plan," 11 (AAA: 3266;80). For extremely interesting discussions of museum education programs and visual education, particularly in relation to several MoMA exhibitions examined in this text and the display practices of the American Museum of Natural History, see Ann Reynolds, "Visual Stories," in *Visual Display: Culture beyond Appearances,* ed. Lynne Cooke and Peter Wollen (Seattle: Bay Press, 1995), 83–109, 318–324, and "Resemblance and Desire," *Center: A Journal for Architecture in America: Regarding the Proper* 9 (1995), 90–107. For an overview of MoMA's educational department during D'Amico's tenure, see Victor D'Amico, *Experiments in Creative Art Teaching: A Progress Report on the Department of Education, 1937–1960* (New York: Museum of Modern Art, 1960; dist. Garden City: Doubleday and Company, 1960).

39. See Platt, "Modernism, Formalism, and Politics," for discussion of the political situation in Europe in relation to the staging of *Cubism and Abstract Art.*

40. Meyer Schapiro, "The Nature of Abstract Art," *Marxist Quarterly* 1 (January–March 1937), 78–97.

41. Barr, *Cubism and Abstract Art,* 18.

42. For example of early exhibitions and installations that placed ethnographic art with modern art, see Stonge, "Osthaus," 113–144, 149, 162, 228; Jill Lloyd, *German Expressionism: Primitivism and Modernity* (New Haven: Yale University Press, 1991), 7–12; Jean-Louis Paudrat, "From Africa," in *"Primitivism" in Twentieth Century Art: Affinity of the Tribal and the Modern,* ed. William Rubin, ex. cat. (New York: Museum of Modern Art, 1984), 1:152–164.

43. The show's plan and didactic material were reprinted in a visitor pamphlet: Museum of Modern Art, *Timeless Aspects of Modern Art: The First of a Series of Exhibitions Marking the Twentieth Anniversary of the Museum of Modern Art,* ex. pamphlet (New York: Museum of Modern Art, 1949), n.p.

44. Information related to d'Harnoncourt's early career has been drawn from Robert Fay Schrader, *The Indian Arts and Crafts Board: An Aspect of New Deal Indian Policy* (Albuquerque: University of New Mexico Press, 1983); Lynes, *Good Old Modern,* 264–283; and MoMA Archives: René d'Harnoncourt Papers.

45. These judgments regarding the quality of the crafts are discussed in Schrader, *Indian Arts and Crafts Board,* 126.

46. For discussion of the complexities of such evaluations regarding the criteria for quality of the Native American arts and crafts and for historical overviews of the absorption of Native American arts and craft within mainstream U.S. culture, see Edwin L. Wade, "The History of the Southwest Indian Ethnic Art Market" (Ph.D. diss., University of Washington, 1976), and "The Ethnic Art Market in the American Southwest, 1880–1980," in *Objects and Others: Essays on Museums and Material Culture,* ed. George W. Stocking, Jr., History of Anthropology 3 (Madison: University of Wisconsin Press, 1985), 167–191; Jamake Highwater, "Controversy in Native American Art," and Edwin L. Wade, "Straddling the Cultural Fence: The Conflict for Ethnic Artists within Pueblo Societies," both in *The Arts of the North American Indian: Native Traditions in Evolution,* ed. Edwin L. Wade (New York: Hudson Hills Press, 1986), 221–242, 243–254.

In 1936 d'Harnoncourt was working for the U.S. government's Indian Arts and Crafts Board, which also established Native American arts and crafts standards. For a sample case study of the process, see Schrader, *Indian Arts and Crafts Board,* 131–132, which offers an analysis of the standards devised for silver products of the Navajo, Pueblo, and Hopi tribes. However much the Indian Arts and Crafts Board may have intended total collaboration with Native American communities, it is revealing that the first meeting organized to establish silver standards was attended by museum directors, dealers, traders, and manufacturers—but no Native American artists.

47. *Mexican Arts* traveled to a number of U.S. museums and was held at the Metropolitan Museum from 13 October to 9 November 1930. Installation photographs of exhibitions at the Metropolitan Museum of Art are in the photograph and slide library.

48. D'Harnoncourt was general manager of the Indian Arts and Crafts Board at the time of the show and joined the Museum staff in 1944 as vice president in charge of foreign activities and director of the Department of Manual Industries; see Lynes, *Good Old Modern,* 270.

49. A book conceived in conjunction with the San Francisco exhibition was published after the show had closed: George C. Vaillant, *Indian Arts in North America* (New York: Harper and Brothers, 1939). For information regarding the San Francisco show see Schrader, *Indian Arts and Crafts Board,* 163–198, and MoMA Archives: RdH Papers.

For examinations of this exhibition that provide substantial historical background, see Schrader, *Indian Arts and Crafts Board;* W. Jackson Rushing, *Native American Art and the New York Avant-Garde: A History of Cultural Primitivism* (Austin: University of Texas Press, 1995), esp. 104–120, which is a reworking of his ar-

ticle "Marketing the Affinity of the Primitive and the Modern: René d'Harnoncourt and 'Indian Art of the United States,'" in *The Early Years of Native American Art History,* ed. Janet Catherine Berlo (Seattle: University of Washington Press; Vancouver: University of British Columbia Press, 1992), 191–236; Diana Nemiroff, "Modernism, Nationalism, and Beyond: A Critical History of Exhibitions of First Nations Art," in *Thinking about Exhibitions,* ed. Reesa Greenberg, Bruce W. Ferguson, and Sandy Naire (London: Routledge, 1996), 411–436; Michael Leja, *Reframing Abstract Expressionism: Subjectivity and Painting in the 1940s* (New Haven: Yale University Press, 1993), 86–88.

50. "The Indian Arts and Crafts Board Act," 27 August 1935; reprinted in Schrader, *Indian Arts and Crafts Board,* 299.

Indian Art of the United States was representative of radical changes taking place within the United States regarding the status of Native Americans. The federal Office of Indian Affairs—under the direction of John Collier, who became commissioner of the OIA in 1933—set out to reverse U.S. Indian policy, which had been essentially unchanged since the 1880s. Collier wanted what has been described as "the political, economic, and cultural decolonization of Indian peoples in the United States" (Thomas Biolsi, *Organizing the Lakota: The Political Economy of the New Deal on the Pine Ridge and Rosebud Reservations* [Tucson: University of Arizona Press, 1992], xx). Fundamental to these changes was the Indian Reorganization Act of 18 June 1934, which granted Native Americans the legal right to establish tribal self-governing units. Previously, tribes had been wards of the state. The New Deal Indian policy was intended in the short term to provide economic relief for reservations and in the long term to promote self-government and the preservation of Native American cultures and resources. But these policies, however humane and well intended, were conceived by government specialists and were not generated from the Native American communities. For an intelligent case study of the complexities of Indian New Deal policy, see Biolsi, *Organizing the Lakota.*

51. Eleanor Roosevelt, foreword to *Indian Art of the United States,* by Frederic H. Douglas and René d'Harnoncourt, ex. cat. (New York: Museum of Modern Art, 1941), 8.

52. Douglas and d'Harnoncourt, *Indian Art,* 9.

53. Schrader, *Indian Arts and Crafts Board,* 129. Despite this policy, there is also evidence that Native American communities were not integrated into policy-making structures established by the New Deal; see note 46.

54. Many of these drawings are preserved in MoMA Archives: RdH Papers, *Art of Installation* series.

55. René d'Harnoncourt, "Living Arts of the Indians," *Magazine of Art* 34, no. 2 (19 February 1941), 72, 76.

56. See Rushing, "Native American Art," 110–111.

57. Dorner's galleries at the Landesmuseum in Hanover represented a sequential move through history, whereas all of MoMA's second-floor galleries were synchronic, representing cultures and their traditions that were being practiced in 1941.

58. D'Harnoncourt, "Living Arts of the Indians," 77.

59. Ibid., 76.

60. According to Rushing, this section was divided into three galleries: contemporary painting and sculpture; Indian art as a didactic object of study, in which the formal qualities of this art were compared to modern life; and Native American contributions to the decorative arts. There are no installation photographs of the contemporary art or the didactic study galleries. The contemporary art, however, is reproduced in the catalogue; see d'Harnoncourt and Douglas, *Indian Art;* Vaillant, *Indian Arts in North America.* Rushing cites documents in the Indian Arts and Crafts Board Archives; see *Native American Art,* 112–114 nn. 92–95. Considering the dates of these IACA-written documents and MoMA's photo archive, they most likely document the San Francisco installation or were proposals.

61. See MoMA Archives: Public Information Scrapbooks 37A, 48, and General I, for magazine and newspaper clippings documenting the tremendous press response to the products of "Indian Art for Modern Living," particularly regarding the designs of Native Americans and Picard.

62. Monroe Wheeler to "Entire Staff," memorandum, 18 March 1941, MoMA Archives: Records of the Registrar Department, *Indian Art of the United States,* MoMA Exhibition #123.

63. For documentary and press photographs of Hosteen Totoko, Joe Lee, and their assistant, Gilbert Sandoval, performing this ceremony, see MoMA Photographic Archives: installation photos, *Indian Art of the United States,* MoMA Exhibition #123. Also see MoMA Archives: Public Information Scrapbook General I.

64. The television series *Transformations of Myth through Time* was published in book form: see Joseph Campbell, *Transformations of Myth through Time* (New York: Harper and Row, 1990), 35.

65. Alfred H. Barr, *A Tribute: October 8, 1968, Sculpture Garden, the Museum of Modern Art* (New York: Museum of Modern Art, [1968]), n.p.

66. Hellman, "Profiles: Imperturbable Noble," 104.

67. D'Harnoncourt, "Living Arts of the Indians," 76.

68. The 1988 *Art/Artifact* exhibition organized by New York's African Center consisted of African art displayed in different types of modern Western installations. It was a much more self-conscious project than *Indian Art of the United States* in regard to the institutionalization of art and artifact. The principal agenda of the show was precisely to display how installation design creates meaning. The sec-

ond edition contains installation photographs: *Art/Artifact: African Art in Anthropology Collections,* 2nd ed., ex. cat. (New York: Center for African Art; Munich: Prestel Verlag, 1989).

69. In a number of discussions, rhetorical tropes are used to read exhibition installations, and especially museum habitat groups and room decors. See Ann Reynolds, "Reproducing Nature: The Museum of Natural History as Nonsite," *October* 45 (Summer 1988), 109–127; Johanne Lamoureux, "Exhibitionitis: A Contemporary Museum Ailment," in *Theatergarden Bestiarium: The Garden as Theater as Museum* (Cambridge, Mass.: MIT Press, 1990), 114–127; Stephen Bann, "Poetics of the Museum: Lenoir and Du Sommerard," in *The Clothing of Clio: A Study of the Representation of History in Nineteenth-Century Britain and France* (Cambridge: Cambridge University Press, 1984), 77–92. Although I have found these arguments interesting, they did not provide a fruitful direction to pursue in considering d'Harnoncourt's varied installation techniques.

70. Schrader, *Indian Arts and Crafts Boards,* 168.

71. Eleanor Freed, "The Alchemy of Picasso," *Houston Post,* 24 September 1967, as cited in Mordechai Omer, "The Art of Installation: Biographical Notes," unpublished manuscript, 63, MoMA Archives: RdH Papers, box I.

72. René d'Harnoncourt to David H. Stevens, director of the Rockefeller Foundation, letter, 7 December 1945, as cited in Mordechai Omer, "The Art of Installation: Part II, Selected Exhibitions," unpublished manuscript, 31, MoMA Archives: RdH Papers, box I; Helman, "Imperturbable Noble," 104.

73. Bayer designed *Road to Victory* and *Power in the Pacific.* Paul Rudolph designed *Family of Man.* For d'Harnoncourt's praise of Steichen, see his foreword to *Steichen the Photographer,* texts by Carl Sandburg et al., ex. cat. (New York: Museum of Modern Art, 1961), 7–8.

74. D'Harnoncourt, letter to Stevens, cited in Omer, "The Art of Installation II," 29.

75. See Vaillant, *Indian Arts in North America.* Vaillant also wrote the catalogue for the first exhibition of fine art held at the American Museum of Natural History; see *Masterpieces of Primitive Sculpture: By Their Arts You Shall Know Them,* ex. cat., Guide Leaflet Series of the American Museum of Natural History 99 (New York: American Museum of Natural History, 1939).

76. D'Harnoncourt, letter to Stevens, cited in Omer, "The Art of Installation II," 29–31.

77. See *The American Museum of Natural History: 76th Annual Report for the Year 1944* (1 May 1945), 35–36.

78. See MoMA Archives: Public Information Scrapbooks 37A, 48, and General I, to gain some sense of the tremendous media response to this exhibition; judging from this evidence, the magazine, newspaper, and radio reviews were completely positive.

79. My discussion of the assimilation of non-Western artifacts as art has been informed by the following publications: Robert Goldwater, *Primitivism in Modern Painting* (New York: Harper and Brothers, Publishers, 1938) (see also the enlarged edition, *Primitivism in Modern Art* [Cambridge, Mass.: Harvard University Press, Belknap Press, 1986]); James Clifford, "On Ethnographic Surrealism" and "On Collecting Art and Culture," both in *The Predicament of Culture: Twentieth-Century Ethnography, Literature, and Art* (Cambridge, Mass.: Harvard University Press, 1988), 117–151, 215–251; Paudrat, "From Africa" 124–175; Christian F. Feest, "From North America," and Philippe Peltier, "From Oceania," in Rubin, *Primitivism in Twentieth Century Art,* 1:84–97, 99–115; *Modernist Anthropology: From Fieldwork to Text,* ed. Marc Manganaro (Princeton: Princeton University Press, 1990); Stocking, *Objects and Others;* and *Art/Artifact.*

An excellent article that provides a summary of much of the bibliography on this subject is Anna Laura Jones, "Exploding Canons: The Anthropology of Museums," *Annual Review of Anthropology* 22 (1993), 201–220. Another text related to these issues is *Museums and the Making of "Ourselves": The Role of Objects in National Identity,* ed. Flora E. S. Kaplan (London: Leicester University Press, 1994), which is a collection of case studies of museums and the articulation of nationhood in emergent nation-states.

80. See Stonge, "Osthaus," 113–114, 149. See also Goldwater's "Chronology of Ethnographical Museums and Exhibitions," in *Primitivism in Modern Painting,* 9.

81. George Vaillant wrote the catalogue, *Masterpieces of Primitive Culture.*

82. For rearrangement of collections at the Trocadéro, see Goldwater, *Primitivism in Modern Painting,* 6–7, and *Primitivism in Modern Art,* 9–15; Clifford, "On Ethnographic Surrealism."

83. Clifford, *Predicament of Culture,* 556. See Clifford's "On Ethnographic Surrealism" for discussion of the Trocadéro and Musée de l'Homme.

84. See R. M. Gramly, "Art and Anthropology on a Sliding Scale," in *Art/Artifact,* 33–40.

85. See ibid. In keeping with the reevaluation of these practices that has taken place in recent years, the collection has returned to a technological model of organization: specimens are occasionally exhibited as masterpieces in temporary exhibits.

86. See *The Reopening of the Mexican and Central American Hall,* pamphlet (New York: American Museum of Natural History, 1944); and American Museum of Natural History, *Annual Report, 1944,* 31–36. James Clifford refers to this technique as "estheticized scientism"; see "Histories of the Tribal and the Modern," *Art in America* 7, no. 4 (April 1985), 164–177, 215.

87. Alan Fisher, "*PM: PM* Photographer Agrees with Moses about Museums . . . After Comparing the Metropolitan with the Museum of Modern Art," *PM* (*Production Manager*), 5 March 1941, 18. See MoMA Archives: Public Information Scrapbook 37A, for articles about this controversy. Fisher wrote that the Metropolitan gave him "museum indigestion. . . . It's cluttered and gloomy and I felt as if I had to whisper all the time. The Museum of Modern Art had just the opposite effect. . . . There all the exhibits were presented and lighted dramatically in an atmosphere of warmth and spaciousness" (18–19).

88. See "Display Makes a Museum: Thousands Pay to See Museum of Modern Art's Clever Displays While Cluttered Heye Museum Stands Empty," *Friday,* 14 March 1941, n.p., in MoMA Archives: Public Information Scrapbook 37A.

89. Although their analysis is beyond the scope of this study, many of d'Harnoncourt's installation formulations for the Museum of Modern Art and the Museum of Primitive Art can be found at other institutions, such as the American Museum of Natural History, particularly in the Hall of Mexico and Central America.

90. A suggestive instance of this "interinstitutional" discourse is Barr's famous flowchart, which took similar form at the American Museum of Natural History in the small permanent exhibit "Family of Tree of the Animal Kingdom" installed in 1925. (See American Museum of Natural History Archives: Special Collections, Photographic Archive, drawer 52.) The "Family Tree" was a three-dimensional flowchart of the animal kingdom. This does not prove direct influence, of course: Barr is drawing on one of the fundamental theoretical models of early modernity, which is found in myriad realizations from Alois Reigl's *Kunstwollen* to Charles Darwin's theory of evolution. But it is highly suggestive that there was a similar need for—and method of visualizing—these similar theoretical models in both aesthetic and scientific museums. That the American Museum of Natural History exhibit was a source for Barr's famous flowchart is an intriguing possibility, but it remains conjecture.

91. Museum of Modern Art, *Photography: 1839–1937,* intro. Beaumont Newhall, ex. cat. (New York: Museum of Modern Art, 1937).

92. At the entrance of the show was a display created by designer Herbert Matter. On one half of a huge transparent plate hung from the ceiling was a life-size photographic enlargement of a cameraman (the negative was Matter's). The other half had no image but it enclosed an image on the wall behind the framed plate of a man with a camera obscura, which was an enlarged wood engraving by H. Emy from "La Grande Ville" (Paris, 1842). When the viewer walked past the transparent plate and viewed the entire wall, he or she saw the complete image of the engraving, which also included a seated woman whose image was being captured by the camera obscura. The woman's image was initially hidden from view by that of the cameraman. Thus this entrance exhibit visualized the framing of the history of photography that was itself the purpose of the show (see fig. 2.33).

93. Christopher Phillips, in his "The Judgment Seat of Photography" (*October* 22 [Fall 1982], 27–63), discusses Newhall's writings in terms of what he sees as a shift from an initial emphasis on the ideas of Moholy-Nagy and a "New Vision" approach to the medium to a later interest in formalism and the connoisseurship of the print as espoused by Alfred Stieglitz.

94. "The Exhibition: Sixty Photographs," *Museum of Modern Art Bulletin* 7, no. 2 (December–January 1940–1941), 5.

95. When Newhall returned from serving in the military, he apparently found that steps were being taken to appoint Edward Steichen as director of the photography department. Newhall was to remain as curator, but he did not want to be a subordinate to Steichen in a department he had founded. Ansel Adams, an aggressive supporter of Newhall, worked to prevent this and to secure Newhall's position as the most senior staff person in MoMA's photography department. For a short history of the department and these particular events, see Lynes, *Good Old Modern,* 154–160, 259–260.

96. See also Phillips, "Judgment Seat of Photography."

97. The checklist of this exhibition identified the image as "Kent, Ohio, Ohio/ Filo—Tarentum, Pennsylvania, *Valley Daily News*"; see Exhibition Binder, which includes documentation of *Protest Photographs,* MoMA Exhibition #929, Records of the Photography Department.

98. There have been innovative photo installations at MoMA, such as Barbara Kruger's installation for *Picturing Greatness,* held from 14 January through 14 April 1988, but they are exceptions. In this case, the exhibition was an artist project—that is, itself a work of art by an artist (see chapters 5 and 6). Kruger's exhibition was the result of a special invitation given to the artist by curator Susan Kismaric of the photo department. *Picturing Greatness* then set into motion the artist-designed exhibitions that became the *Artist Choice* series; they began with a Scott Burton project, *Burton on Brancusi,* which ran from 7 April through 31 May 1989.

99. Ralph Linton and Paul S. Wingert, in collaboration with René d'Harnoncourt, *Arts of the South Seas* (New York: Museum of Modern Art, 1946).

100. D'Harnoncourt, letter to Stevens, cited in Omer, "The Art of Installation II," 29–30.

101. Ibid., 30, 29.

102. See Linton, Wingert, and d'Harnoncourt, *Art of the South Seas;* press release #46129–5, "Arts of the South Seas Opens at MoMA," cited in Mordechai Omer, "René d'Harnoncourt: The Art of Installation," 2, MoMA Archives: RdH Papers, Box IV: *Arts of the South Seas,* MoMA Exhibition #306, Labels.

103. D'Harnoncourt and Goldwater were involved with the founding of the Museum of Primitive Art, which opened in 1957 with d'Harnoncourt as vice president and Goldwater as acting director. Nelson Rockefeller was president. The cata-

logue of the museum's first show was written by Goldwater and the exhibition was installed by d'Harnoncourt. At the Museum of Modern Art, Goldwater wrote the catalogue and d'Harnoncourt created the installation for the 1949 exhibition *Modern Art in Your Life.*

104. See Goldwater, *Primitivism in Modern Painting,* and the publication history given in note 79.

105. See, for example, Douglas and d'Harnoncourt, *Indian Arts,* 185.

106. Wall labels from the memorial exhibition *René d'Harnoncourt: The Exhibitions of Primitive Art,* Museum of Primitive Art, 25 February to 10 May 1970. The exhibition labels and documents of the Museum of Primitive Art are located in the archives of the Department of the Arts of Africa, Oceania, and the Americas, Metropolitan Museum of Art, New York.

 Ludwig Glaeser, curator, Department of Architecture and Design, MoMA, selected and installed the exhibition and Mordechai Omer researched and wrote the wall labels.

107. For in-depth analysis of the exhibition as "a work of art" by anthropologist Gregory Bateson, see his "Arts of the South Seas," *Art Bulletin* 28, no. 2 (June 1946), 199–123. This article also incorporates d'Harnoncourt's response to Bateson's interpretation. For documentation of exhibition installation—with floor plan, color charts, maps, and installation photographs—see "Arts of the South Seas," *Architectural Forum* 84, no. 5 (May 1946), 97–104.

108. Press release #46129–5, "Arts of the South Seas Opens at MoMA," cited in Omer, "René d'Harnoncourt: The Art of Installation," 2.

109. Linton, Wingert, and d'Harnoncourt, *Art of the South Seas,* 8, 9.

110. In *Ancient Art of the Andes,* objects such as pottery and figures were spotlit in darkened galleries. Jewelry was installed in cloth-lined vitrines. Textiles were covered with glass in vitrines sized to the specific pieces. The meticulously designed installation emphasized that these were extremely valuable, aesthetic objects. The most obvious and most publicized example was what was called the "Gold Room." The "Gold Room" was a large glass case whose inside walls were covered with forty-seven plaques of gold; it was filled with gold collars, bracelets, a mask, head ornaments, and figures.

111. In the preface of the first exhibition catalogue, Nelson Rockefeller, president of the board of trustees, explained the choice of the word "primitive" for the museum:

These indigenous arts—the arts native to man everywhere—have in the last half-century called forth increasing admiration and enthusiasm in the Western World. If we accept for them the adjective "primitive," we do so because it is generally accepted. Like "gothic" long ago, and "modern" more recently, it was once a term of disapproval; and like them it has become a term of historical description and of praise. So-called

primitive art is now recognized as the esthetic equal of the arts of the highly developed civilizations of the Orient and the West. (Preface to *The Museum of Primitive Art: Selected Works from the Collection* [New York: Museum of Primitive Art, 1957], n.p.)

112. Hilton Kramer, "Month in Review," *Arts* 31, no. 8 (May 1957), 43.

113. Another important exception to the formal, decontextualized installation technique, also designed by d'Harnoncourt, was *The Nelson A. Rockefeller Collection of Mexican Folk Art,* 21 May to 31 August 1969. See installation photographs by Charles Uht from the Museum of Primitive Art. The Museum of Primitive Art's non-art collections were transferred in 1978 to The Metropolitan Museum of Art, New York. They are located in the Department of the Arts of Africa, Oceania, and the Americas.

114. *The Art of Lake Sentani* was held from 16 September 1959 to 7 February 1960. See installation photographs by Charles Uht from the Museum of Primitive Art. The Museum of Primitive Art's non-art collections were transferred in 1978 to The Metropolitan Museum of Art, New York. They are located in the Department of the Arts of Africa, Oceania, and the Americas.

115. The Museum of Primitive Art collections of art were transferred in 1978 to The Metropolitan Museum of Art, New York, as The Michael C. Rockefeller Memorial Collection. They are located in the Department of the Arts of Africa, Oceania, and the Americas.

116. See Rubin, *"Primitivism" in Twentieth Century Art.*

117. I am using the term "successor" very loosely, in regard to these individual's public visibility as well as to the types of exhibitions each created. D'Harnoncourt was a curator who became director of the Museum, whereas Rubin was a department head, as Varnedoe now is. Rubin also retains the title of director emeritus of the Department of Painting and Sculpture.

118. Wall label, *"Primitivism" in Twentieth Century Art,* referring to Picasso's *Demoiselles d'Avignon.* Wall labels of *"Primitivism" in Twentieth Century Art* are now kept in the Department of Painting and Sculpture files, Museum of Modern Art, New York.

 For the best-known reviews of the show, and the letters and critical exchanges they generated, see Clifford, "Histories of the Tribal and the Modern," and Kirk Varnedoe, "On the Claim and Critics of the 'Primitivism' Show," *Art in America* 73, no. 5 (May 1985), 11–21; Thomas McEvilley, "Doctor Lawyer Indian Chief: 'Primitivism' in Twentieth Century Art at the Museum of Modern Art," *Artforum* 23, no. 3 (November 1984), 54–60, and responses in *Artform* by William Rubin, Varnedoe, and McEvilley (23, no. 5 [February 1985], 42–51) and by Rubin and McEvilley (23, no. 8 [May 1985], 63–71). These (except for Varnedoe's *Art in America* essay) are conveniently reprinted in *Discourses: Conversations in Postmodern Art and Culture,* ed. Russell Ferguson et al. (New York: New Museum of Contemporary Art, Cambridge, Mass.: MIT Press, 1990), 339–424.

119. Although hiring designers and architects to create exhibition installations became a common practice during the 1980s and 1990s, the hiring of a designer—in this case, Charles Froom for the *Primitivism* show—was relatively unusual for the Museum of Modern Art. The professionalization of the field of installation design—in terms of the development of in-house exhibition designers and production managers—begins to consolidate in the late 1960s and early 1970s in the United States. For example, the National Gallery of Art in Washington, D.C., created its Design and Installation Department in 1974. New York's Metropolitan Museum of Art had a Display Department that oversaw aspects of exhibition production from 1949, but this was instituted as the Exhibition Design Department in 1966, renamed the Design Department in 1971. From the available documentation in MoMA's *Bulletins* and annual reports, during the years 1955 and 1956 Jean Volkmer was designer and coordinator of exhibitions, but then became a Museum conservator. Froom was MoMA's exhibition production manager from 1969 to 1972 in MoMA's Department of Production (since 1996, he has been chief designer in the Design and Installation Department at the Brooklyn Museum of Art [a department founded in 1968]). In the late 1970s and early 1980s, Fred Coxen was production supervisor and Jerome Neuner was production manager of the Department of the Exhibition Program. In 1987, MoMA's Department of Exhibition Production was formed. Sometime in 1990 or 1991 it was renamed the Department of Exhibition Production and Design; in 1994 and 1995, it became the Department of Exhibition Design and Production. Since 1990, Neuner has been director of this department. Charles Froom, interview with author, 22 December 1997; Jerome Neuner, interview with author, 7 November 1997.

120. For the Rubin quote, see *"Primitivism" in Twentieth Century Art,* 1:ix. D'Harnoncourt is mentioned in note 20 of Kirk Varnedoe's "Abstract Expressionism," *"Primitivism" in Twentieth Century Art,* 2:654. In this footnote Varnedoe does acknowledge "a need for a full account" of display methods for tribal arts during the 1920s, 1930s, and 1940s, and he describes D'Harnoncourt as "a decisive figure in formulating a new installation aesthetic for tribal art."

121. While such matters were absent from the exhibition itself, a number of contributions to the catalogue did examine some of these issues; see Rubin, *Primitivism in Twentieth Century Art.*

122. These exhibitions were representations of what James Clifford has called "anthropological humanism," which he describes as a specific variation of humanism reserved for the ethnographic that "begins with the different and renders it—through naming, classifying, describing, interpreting—comprehensible. It familiarizes" ("On Ethnographic Surrealism," 145). Clifford contrasts anthropological humanism with what he refers to as the "ethnographic surrealism" of the 1920s and 1930s, though he does not consider the two mutually exclusive. Practiced within Surrealist circles such as those involved with the journal *Documents,* ethnographic surrealism is that which "attacks the familiar, provoking the irruption of otherness—the unexpected" (145).

Although what Clifford characterizes as ethnographic surrealism thrived within various Surrealist factions of the international avant-gardes during the years that MoMA was introducing ethnographic art to the United States, this ap-

proach was obviously very different from the universalizing aesthetics enshrined at the Museum.

123. For background and related issues, see chapter five's discussion of Wendell Wilkie's wartime best-seller, *One World,* and the phenomenal success of the *Family of Man* exhibition in the 1950s.

124. On the prevalence of racist evolutionary theory within anthropology and the challenges to this perspective, see George W. Stocking, Jr., "Philanthropoids and Vanishing Cultures: Rockefeller Funding and the End of the Museum Era in Anglo-American.Anthropology," in Stocking, *Objects and Others,* 112–42; Stocking, "Ideas and Institutions in American Anthropology: Thoughts toward a History of the Interwar Years," in *Selected Papers from the American Anthropologist,* ed. George W. Stocking (Washington, D.C.: American Anthropological Association, 1976), 1–53; Stocking, *Race, Culture, and Evolution: Essays in the History of Anthropology* (New York: Free Press, 1968); Elazar Barkan, *The Retreat of Scientific Racism: Changing Concepts of Race in Britain and the United States between the World Wars* (Cambridge: Cambridge University Press, 1992); Franz Boas, *Race, Language, and Culture* (1910; reprint, New York: Macmillan, 1940).

125. See "American Anthropological Association Resolution on Racial Theories," *American Anthropologist* 31 (1939), 303; reprinted in Stocking, *Selected Papers from the American Anthropologist,* 467.

126. In part as a response to the genocide that took place during World War II, the United Nations passed a resolution for UNESCO to initiate a program to disseminate "scientific facts designed to remove what is generally known as racial prejudice." The result was UNESCO's 1950 statement on race. After it was criticized, particularly by conservative physical anthropologists and geneticists who believed there was insufficient evidence to support the view that human intelligence does not differ according to racial groupings, a modified statement was issued in 1951. See UNESCO, *The Race Question in Modern Science: Race and Science,* rev. ed. (1951; New York: Columbia University Press, 1961), esp. "Action by Unesco," "Statement of 1950," and "Statement of 1951," 493–506.

Racist arguments have again gained national prominence and again been attacked as this manuscript was being finished, particularly in regard to Richard J. Herrnstein and Charles Murray's *The Bell Curve: Intelligence and Class Structure in American Life* (New York: Free Press, 1994). Herrnstein and Murray argue that an individual's intelligence is related to his or her so-called race. *The Bell Curve* was a national best-seller and gained a great deal of media as well as scholarly attention. See *The Bell Curve Debate: History, Documents, Opinions,* ed. Russell Jacoby and Naomi Glauberman (New York: Times Books, 1995), and *The Bell Curve Wars: Race, Intelligence, and the Future of America,* ed. Steven Fraser (New York: Basic Books, 1995).

127. This statement by Clark Wissler was cited by John Michael Kennedy, "Philanthropy and Science in New York City: The American Museum of Natural History, 1868–1968" (Ph.D. diss., Yale University, 1968), 242. Kennedy is a good source for the institutional changes Parr made at the museum. See also *The American*

Museum of Natural History: 74th Annual Report for the Year 1942 (1 May 1942), 17–21, and Ann Reynolds's discussion of Parr's theories and exhibition practices in "Visual Stories," 83–109, 318–324.

128. Kennedy, "Philanthropy and Science," 241.

129. American Museum of Natural History, *Annual Report, 1944,* 35.

130. For a statement by Parr on the entry of art in the natural history museum, see his "Science, Arts, and Anthropology," in *The Reopening of the Mexican and Central American Hall,* 14–16.

131. For an overview of some of the changes that took place within the Western international museum community, see the UNESCO publication *Museum* 1, nos. 1–2 (July 1948); 1, nos. 3–4 (December 1948); 2, no. 3 (1949); 2, no. 4 (1949).

132. There was no catalogue published in conjunction with this exhibition. A pamphlet that included a plan of the exhibition was available during the show; see Museum of Modern Art, *Timeless Aspects of Modern Art.* Subsequently a teaching manual for students was published by the Museum: Museum of Modern Art, *Teaching Portfolio Number Three: Modern Art Old and New (A Portfolio Based on the Exhibition "Timeless Aspects of Modern Art" Held at the Museum of Modern Art in New York),* René d'Harnoncourt (New York: Museum of Modern Art, 1950).

133. Museum of Modern Art, *Timeless Aspects of Modern Art.*

134. See Roland Penrose, *The Sculpture of Picasso: A Selection from Sixty Years,* foreword Monroe Wheeler, chron. Alicia Legg, ex. cat. (New York: Museum of Modern Art, 1967).

135. *Nine Days to Picasso,* prod. and dir. Warren Forma, text and narr. René d'Harnoncourt (New York: Museum of Modern Art, 1968).

136. When writing about works of art throughout his career, d'Harnoncourt would anthropomorphize artworks, particularly when discussing affinity. For a published example, see d'Harnoncourt's statement in *Teaching Portfolio Number three,* 2, and this chapter's epigraph, Hellman, "Imperturbable Noble," 104.

137. *The Sculpture of Picasso: A Selection from Sixty Years,* wall label no. 2, MoMA Archives: RdH Papers, Labels and Written Information File, Box III.

138. Robert Goldwater in collaboration with René d'Harnoncourt, *Modern Art in Your Life,* ex. cat. (New York: Museum of Modern Art, 1949), n.p. (The catalogue was also published as the *Bulletin of the Museum of Modern Art* 17, no. 1 [1949]; a revised second edition published in 1953 included several pages of installation photographs.)

139. Records of the Registrar Department, *Modern Art in Your Life,* MoMA Exhibition #423.

140. The window displays in *Modern Art in Your Life* included the following: Bonwit Teller by Gene Moore, 1946; Bonwit Teller by Gene Moore, 1944; Bonwit Teller by Tom Lee, 1938; Delman Shoes by Tom Lee, 1949; Lord and Taylor by Harry Callahan, 1945; Saks Fifth Avenue by Marcel Vertés, 1948.

141. Alfred H. Barr, Jr., *Fantastic Art, Dada, Surrealism* (New York: Museum of Modern Art, 1936). In his 1941 outline of the "1929 Plan," Barr mentions that *Fantastic Art, Dada, Surrealism* also incorporated films, photography, furniture, theater, posters, typography, and architecture, as did the *Cubism and Abstract Art* show of that year. In the installation photographs and reviews, however, there is no evidence of the innovative exhibition techniques, like the chairs hung on the wall, that he had created for *Cubism and Abstract Art.*

142. William S. Rubin, *Dada, Surrealism, and Their Heritage,* ex. cat. (New York: Museum of Modern Art, 1968).

143. Alfred H. Barr to William S. Rubin, memo, 12 July 1966, 1, MoMA Archives: AHB Papers (AAA: 2193;653). Rubin to Barr, memo, 18 July 1955, 3, MoMA Archives: AHB Papers (AAA: 2193;651).

144. See Rubin, *Dada, Surrealism, and Their Heritage,* 6.

145. D'Harnoncourt, "Foreword: The Museum of the Future," 25.

Chapter 3
Installations for Good Design and Good Taste

Chapter epigraphs: Mary Roche, "Useful Objects Exhibit Is Opened," *New York Times,* 27 November 1946, 18; full-page Bloomingdale's advertisement, *New York Times,* 28 September 1941, 26.

1. Alfred H. Barr, Jr., "1929 Multidepartmental Plan for the Museum of Modern Art: Its Origins, Development, And Partial Realization," August 1941, 4, MoMA Archives: AHB Papers (AAA: 3266;73).

2. Ibid., 2 (AAA: 3266;71).

3. Alfred H. Barr to Walter Gropius, 3 March 1939, Records of the Registrar Department, *Bauhaus 1919–1928,* MoMA Exhibition #82.

4. The exhibition's expense was documented in several letters in the MoMA Registrar's Bauhaus file: see Elodie Courter to Marcel Breuer, 31 January 1940; Alfred Barr to Marcel Breuer, 9 June 1939; Barr to Gropius, 15 November 1938 and 3 March 1939. Records of the Registrar Department, *Bauhaus 1919–1928,* MoMA Exhibition #82.

5. Gwen Finkel Chanzit, *Herbert Bayer and Modernist Design in America* (Ann Arbor, Mich.: UMI Research Press, 1987), 121; see also 241 (citing 1981 inter-

view of Bayer). On 8 November 1938, Walter Gropius wrote to Alfred Barr about the difficult situation in Germany and explained that Mies van der Rohe felt he could not participate in the exhibition; see also Josef Albers, to Janet M. Henrich, 19 November 1937. Records of the Registrar Department, *Bauhaus 1919–1928*, MoMA Exhibition #82.

6. Alfred H. Barr, Jr., preface to *Bauhaus 1919–1928*, ed. Herbert Bayer, Walter Gropius, and Ise Gropius, essay by Alexander Dorner, ex. cat. (New York: The Museum of Modern Art, 1938), 8.

7. See Alfred Barr, "Notes on the Reception of the Bauhaus," Records of the Registrar Department, *Bauhaus 1919–1928*, MoMA Exhibition #82, and various other documents in Records of the Registrar Department, *Bauhaus 1919–1928*, Exhibition #82: for example, Walter Gropius to Alfred Barr, 8 November 1930.

8. John McAndrew to Charles W. Ross, Jr., 13 October 1937, Records of the Registrar Department, *Bauhaus 1919–1928*, MoMA Exhibition #82.

9. See Talbot F. Hamlin, "Architecture, People, and the Bauhaus," *Pencil Points* 20, no. 1 (1 January 1939), 3–6.

10. In a letter to Walter Gropius (10 December 1938), Alfred Barr suggested changing "Bauhaus Synthesis, Mastery of Form, Mastery of Space, Skill of Hand" to "Bauhaus Idea, Form Design, Space Design, Skill of Hand." Gropius agreed (letter to Barr, 15 December 1938). Bayer later wrote to Gropius (28 December 1938) of changes in labels and installation. Records of the Registrar Department, *Bauhaus 1919–1928*, Exhibition #82. But documentary photographs show Bayer's original version. See, for example, the cover image of the *Bulletin of the Museum of Modern Art*, 6, no. 5 (December 1938).

11. Herbert Bayer, "Aspects of Design of Exhibitions and Museums," *Curator* 4, no. 3 (1961), 257–258.

12. See Edward Alden Jewell, "Decade of the Bauhaus," *New York Times*, 11 December 1938, Art sec., p. 11.

13. Dane Chanase, "Opinions under Postage," *New York Times*, 18 December 1938, 12; Natalie Swan, "Opinions under Postage," *New York Times*, 18 December 1938, 12. In a letter of 14 January 1938, Barr told Natalie Swan that her Bauhaus colleagues were shocked by her letter to the *New York Times*, adding that if they had known that she was working for Frederick Kiesler, they would not have been so astonished. Records of the Registrar Department, *Bauhaus 1919–1928*, MoMA Exhibition #82.

14. James Johnson Sweeney, "The Bauhaus—1919–1928," *New Republic*, 11 January 1939, 287.

15. Martha Davidson, "Epitaph Exhibit of the Bauhaus: Commemoration of a Famous Modern Source of Design," *Art News* 37, no. 11 (10 December 1938), 13, 22.

16. Royal Cortissoz, "Architecture and Some Other Topics," *New York Herald Tribune*, 11 December 1938, sec. 6, p. 8.

17. Henry McBride, "Attractions in the Galleries," *New York Sun*, 10 December 1938, 11.

18. Marcia Minor, "Bauhaus Exhibit at Modern Museum Stirs Wide Interest," *Daily Worker*, 30 December 1938, 7.

19. In these important and lengthy letters, both Barr and Gropius were concerned with politically inspired criticism of the show, be it anti-German, anti-foreign, or anti-Jewish in origin. While considering these views foolish, they agreed that a neutral statement stressing the Bauhaus's apolitical character and radical aesthetic innovations should be posted in the show; whether this was done is not documented. Barr wanted an accounting of the number of Jewish faculty, stating there were none or only one or two (to Gropius, 10 December 1938). Gropius responded, "we should not, in any case, defend ourselves against the Jewish question. I decline to give any arguments with them about this matter. As a fact, we have had only one Jew among 17 artists on the Bauhaus faculty throughout the years and not one on the technical staff, which comprised about 12 people all together. The case is pretty clear, therefore, but I see no reason why we should have to defend ourselves, nevertheless against the foolish point of view of Hitler's" (to Barr, 15 December 1938).

On the same day, Gropius wrote to Herbert Bayer, telling him of Barr's suggestion regarding the Jewish statement. Barr replied as quoted in the text (to Gropius, 19 December 1938). See Records of the Registrar Department, *Bauhaus 1919–1928*, Exhibition #82.

20. Lewis Mumford, "The Skyline: Bauhaus—Two Restaurants and a Theater," *New Yorker*, 31 December 1938, 38; "Bauhaus Post Mortem," *Magazine of Art*, 32, no. 1 (1 January 1939), 40.

21. Emily Genauer, "Bauhaus Exhibit Most Engrossing," *New York World-Telegram*, 10 December 1938, 12.

22. Alfred Barr to Walter Gropius, 3 March 1939. Records of the Registrar Department, *Bauhaus 1919–1928*, MoMA Exhibition #82.

23. Jane M. Henrich, Department of Architecture, to Lux Feininger, 21 December 1938; Josef Albers to Janet M. Henrich, 16 January 1939; Museum of Modern Art to László Moholy-Nagy, telegram, 19 December 1939. Records of the Registrar Department, *Bauhaus 1919–1928*, MoMA Exhibition #82.

24. "Bauhaus in Controversy," *New York Times*, 25 December 1938, Art. sec., p. 12. Letters by Alfred H. Barr, Jr., Leonard Cox, and William F. Reed were published.

25. Alfred H. Barr, Jr., "Notes on the Reception of the Bauhaus Exhibition," 1–3, Records of the Registrar Department, *Bauhaus 1919–1928*, MoMA Exhibition #82.

26. See Mumford, "The Skyline: Bauhaus." Mumford had some affiliation with Museum, in that he had previously contributed essays to two MoMA exhibition catalogues: Museum of Modern Art, *Modern Architecture: International Exhibition,* by Henry-Russell Hitchcock, Philip Johnson, and Lewis Mumford, foreword Alfred H. Barr, Jr., ex. cat. (New York: Museum of Modern Art, 1932) (see also note 121), and *America Can't Have Housing,* ed. Carol Arnovici, ex. cat. (New York: Museum of Modern Art, 1934).

27. Quoted in Barr, "Notes on the Reception," 2–3.

28. See *Bulletin of the Museum of Modern Art* 6, no. 5 (12 December 1938), 2–8.

29. The *Bauhaus* controversy was recycled in yet another venue: *Art Digest* published a selection of *Bauhaus* reviews titled "Bauhaus Criticized," *Art Digest* 13, no. 6 (15 December 1938), 6, 43. Barr's reply was published as "Bauhaus Defended," *Art Digest* 13, no. 7 (1 January 1939), 8.

30. Of course, the considerations regarding the viewer today take different form, such as elaborate didactic labels, acousta-guides, and the relatively recent trend of "reading rooms" with desks and chairs, where catalogues, and in some instance related texts and documentation and computers, are provided for visitors to the show.

31. Museum of Modern Art, *Machine Art,* by Philip Johnson, foreword Alfred H. Barr, Jr., ex. cat., Museum of Modern Art, New York (New York: W. W. Norton, 1934), 1.

32. Philip Johnson, interview with author, 6 January 1994.

33. Ibid.

34. Ibid.

35. Philip Johnson, "In Berlin: Comment on Building Exposition," *New York Times,* 9 August 1931, sec. 8, p. 5, reprinted in *Philip Johnson: Writings,* (New York: Oxford University Press, 1979), 49. Johnson's monograph on Mies integrates the installation designs as important aspects of Mies's work. See Philip Johnson, *Mies van der Rohe,* ex. cat. (New York: Museum of Modern Art, 1947).

36. Edward Alden Jewell, "Machine Art Seen in Unique Exhibit," *New York Times,* 6 March 1934, 21, and "The Realm of Art: The Machine and Abstract Beauty," *New York Times,* 11 March 1934, Art sec., p. 12.

37. Joseph W. Alsop, Jr., "Pots and Sink Going on View as Art as Machinery Exhibit," *New York Herald Tribune,* 5 March 1934, 3.

38. "New York's 'Machine Art' Exhibit Would Have Pleased Old Plato," *Art Digest* 8, no. 12 (15 March 1934), 10. The oddities of punctuation are in the original.

39. Henry McBride, "Museum Show Machine Art in a Most Unusual Display," *New York Sun,* 10 March 1932, 11.

40. Johnson, interview.

41. For one of the many accounts of the contest that included exact figures regarding the poll, see "Woman's Vote Makes Mirror Art Show Victor," *New York Herald Tribune,* 3 April 1934, 12.

42. Jewell, "Machine Art Seen in Unique Exhibit" and "The Machine and Abstract Beauty"; Jewell, "The Realm of Art: A Post-Lenten Revival of Activity," *New York Times,* 8 April 1934, 7; Walter Rendell Storrey, "Machine Art Enters the Museum Stage," *New York Times,* 4 March 1934, 12; Storrey, "Public Disagrees with Art Awards," *New York Times,* 23 April 1934, 15; and Storrey, "Beauty and the Machine," *New York Times,* 17 March 1934, 18.

43. Johnson, interview.

44. As had been true of the *Machine Art* show, the viewers' reactions to the *Bauhaus* exhibition were recorded. A document with "Mr. Barr" written in script on the top of the page contains visitors' comments; Records of the Registrar Department, *Bauhaus 1919–1928,* MoMA Exhibition #82.

45. Johnson, interview.

46. "Machine Art," *Bulletin of the Museum of Modern Art* 1, no. 3 (November 1933), 2.

47. Marcel Duchamp, "The Richard Mutt Case," *The Blind Man* 2 (May 1917), 5.

48. Sidney Lawrence, "Clean Machine at the Modern," *Art in America* 72, no. 2 (February 1984), 135.

49. In 1996 the vitrine was replaced by a wall to accommodate current installations. According to Terence Riley, director of the Department of Architecture and Design since 1992, the architecture and design galleries may be redesigned; but, in any case, eventually "there would be a restored version" of the vitrine (interview with author, spring 1996).

50. During the laboratory years, there were important and dramatic exceptions to this standard, which will be discussed in this chapter. Moreover, Terence Riley has shown interest in historical and contemporary installation design. In 1992 he staged a recreation of MoMA's 1932 *Modern Architecture* exhibition. But this show was presented at the Arthur Ross Architectural Gallery, Columbia University. After Riley's appointment, curatorial assistant Christopher Mount installed several cars in MoMA's galleries in the exhibition *Designed for Speed: Three Automobiles by Ferrari,* which ran from 4 November 1993 to 1 March 1994. Riley's Frank Lloyd Wright retrospective (20 February to 10 May 1994) included partial building fragments, dramatic presentations of models, and innovative installation details that

distinguished the show from MoMA's architectural exhibitions of recent years. And in 1996, associate curator Matilda McQuaid installed the Lilly Reich exhibition, which documented this architect and designer's installation designs (see chapter one). So perhaps the future will bring more departures from the long-dominant exhibition practices.

51. "Talk of the Town: Machine Art," *New Yorker,* 17 March 1934, 18. See also "Machine Art," *Parnassus* 6, no. 5, (October 1934), 27.

52. See, for example, Jane Schwartz, "Exhibition of Machine Art Now on View at Modern Museum," *Art News* 32, no. 23 (10 March 1934), 4.

53. *Bulletin of The Museum of Modern Art,* 1, no. 3 (November 1933), 2.

54. Barr, "1929 Plan," 9 (AAA: 3266;78).

55. Ibid., 2 (AAA: 3266;72).
 The Newark Museum under the leadership of John Cotton Dana presented a groundbreaking program in modern and industrial design. In 1912 it held a Deutscher Werkbund exhibition. In 1928 the Newark Museum staged its first exhibition titled *Inexpensive Articles of Good Design,* a selection of objects from local five-and-dime stores. A similar exhibition followed in 1929. In 1948 *Decorative Arts Today* was composed of a collection of objects costing less than $10, selected from Newark department stores. See Newark Museum Association, *A Survey: Fifty Years of the Newark Museum* (Newark, N.J.: Newark Museum Association, 1959). Johnson said that although he did not see the exhibitions of the late 1920s, Barr did (interview).

56. Barr, "1929 Plan," 9 (AAA: 3266;78); Johnson, interview.

57. While Barr was traveling in 1932, Johnson mounted what would be the precursor to *Machine Art: Objects 1900 and Today,* which compared modern functionalist design with ornate, handcrafted, Art Nouveau examples. By Johnson's own admission, the exhibition received mixed reviews, but within two years similar ideas would find successful realization in the *Machine Art* show. See, for example, Russell Lynes, *Good Old Modern: An Intimate Portrait of the Museum of Modern Art* (New York: Atheneum, 1973), 90; Johnson, interview.

58. Kaufmann's family owned the Kaufmann Department Stores and Frank Lloyd Wright built Fallingwater for his parents. For background on MoMA's departments of Industrial Design and Architecture and Design, see Terence Riley and Edward Eigen, "Between the Museum and the Marketplace: Selling Good Design," in *Studies in Modern Art,* vol. 4, *The Museum of Modern Art at Mid-Century at Home and Abroad,* series ed. John Elderfield (New York: Museum of Modern Art; dist. New York: Harry N. Abrams, 1994), 150–179.

59. "Useful Objects under Ten Dollars," *Museum of Modern Art [Bulletin]* 6, no. 7 (7 December 1939–7 January 1940), 3.

60. " 'Useful Objects' Shown at Museum of Modern Art," *(Springfield, Mass.) Sunday Union and Republican,* 10 December 1939, n.p.; clipping in MoMA Archives: Public Information Scrapbook 38.

61. "Coat Hangers Compete with Picasso," *Daily Iowan,* 12 December 1939, n.p.; clipping in MoMA Archives: Public Information Scrapbook 38.

62. Jeannette Lowe, "Useful Objects under Ten Dollars," *Art News* 34, no. 9 (30 November 1940), 11.

63. "Modern Accessories," *New York Times,* 1 December 1940, sec. 2, p. 7D; Edward Alden Jewell, "Modern Museum Has Two Displays," *New York Times,* 26 November 1940, 21.

64. Elizabeth McCausland, "Modern Museum Again Holds Christmas Sale," *(Springfield, Mass.) Sunday Union and Republican,* 7 December 1941, n.p.; clipping in MoMA Archives: Public Information Scrapbook 38.

65. The Museum actually sold the contents of this show to staff in order, as one memo described it, "to save time, rubber, and gas"; see Miss Carson, memorandum, 16 December 1942, Records of the Registrar Department, *Useful Objects 1942,* MoMA Exhibition #160.

66. "Museum to Honor Trade Designers," *New York Times,* 11 November 1945, 18.

67. For a general discussion of U.S. museums and modern design during these decades, see Arthur J. Pulos, *The American Design Adventure, 1940–1975* (Cambridge, Mass.: MIT Press, 1988), 50–107; David Joselit, "The Postwar Product: The ICA's Department of Design in Industry," in *Dissent: The Issue of Modern Art in Boston,* ex. cat. (Boston: Institute of Contemporary Art; dist. Boston: Northeastern University Press, 1985), 94–105.

68. The Newark Museum had a very active commitment to modern and industrial design; Newark Museum Association, *Fifty Years of the Newark Museum.*

69. From 1935 to 1938, the Boston ICA was an affiliate of MoMA; see Lynes, *Good Old Modern,* 166–167.
 See Christine Wallace Laidlaw, "The Metropolitan Museum of Art and Modern Design, 1917–1929," *Journal of Decorative and Propaganda Arts, 1875–1945,* no. 8 (Spring 1988), 88–103, and Lawrence, "Clean Machine at the Modern."

70. For background, see Riley and Eigen, "Between the Museum and the Marketplace," 154.

71. For newspaper and magazine clippings, see MoMA Archives: Public Information Scrapbook 35C.

72. See, for example, "Organic Design," *Art Digest* 16, no. 1 (15 October 1941), 9; "Modern Art Museum Puts Up Extra Gallery to Show Furniture," *Museum News* 19, no. 8 (15 October 1941), 2.

73. Eliot F. Noyes, *Organic Design,* ex. cat. (New York: Museum of Modern Art, 1941).

74. Quoted in "Museum of Show Prize Furniture," *New York Times,* 22 September 1941, 12. Another version of this description could be found in *Art Digest,* where "Organic Design" quotes the label as ending with a different phrase, "Is far from extinct."

75. See, for example, "Organic Design Show Opens in New York," *Retailing: Home Furnishings* 13, no. 38 (29 September 1941), 44; "Organic Design," *Art Digest;* MoMA Archives: Publicity Information Scrapbook 35C.

76. Quoted in Charles Messer Stow, "Organic Design Gets Its Start in Double Show," *New York Sun,* 26 September 1941, 87.

77. "Art Furniture Will Be Shown," *New York Times,* 22 September 1941, 6. See also "Self Appeasement as a Great Danger," *Retailing: Home Furnishings* 13, no. 38 (22 September 1941), 2.

78. See, for example, advertisements published in the *New York Times:* 28 September 1941, 26; 23 October 1941, 9; and 24 November 1941, 5. See also MoMA Archives: Public Information Scrapbook 53D.

79. *New York Times,* 28 September 1941, 26; ellipses in original.

80. Sachs Quality Stores advertisement, *New York Times,* 17 May 1950, 20; ellipses in original.

81. For example, this exhibition has no installation photographs in the Museum of Modern Art Photographic Archives. MoMA published a modest catalogue: *Prize Designs for Modern Furniture from the International Competition for Low-Cost Furniture Design* by Edgar J. Kaufmann, Jr., ex. cat. (New York: Museum of Modern Art, 1950).

82. This was also the moment when MoMA inaugurated its corporate membership; see editorial, *New York Times,* 2 February 1950, 22. By the early 1970s, the Museum would come to rely on corporate underwriting of exhibitions (see chapter five).

83. *Good Design: A Joint Program to Stimulate the Best Modern Design of Home Furnishings,* ex. pamphlet (Chicago: Merchandise Mart; New York: Museum of Modern Art, 1950), n.p.
 For background on the *Good Design* program, see Riley and Eigen, "Between the Museum and the Marketplace."

84. Edgar Kaufmann, Jr., *Good Design,* ex. pamphlet (Chicago: Merchandise Mart; New York: Museum of Modern Art, 1950); the exhibition ran 22 November 1950 to 28 January 1951. The Museum considered the modest *Useful Objects* exhibition and not the *Bauhaus* show as the significant breakthrough that led to the development of the *Good Design* project. Kaufmann wrote, "This is the first Good Design exhibition in New York. It is the outgrowth of a long development. In 1938 The Museum of Modern Art inaugurated yearly selections of the best modern design in home furnishings available to the American public; twelve years ago the show (called *Useful Objects*) was limited in scope and modestly presented" (n.p.).

85. Pulos, *American Design Adventure,* 110.

86. See, for example, *Good Design* (1950).

87. For the history of the department store, see Robert Hendrickson, *The Grand Emporiums: The Illustrated History of America's Great Department Stores* (New York: Stein and Day, 1979); Michael B. Miller, *The Bon Marché: Bourgeois Culture and the Department Store, 1869–1920* (Princeton: Princeton University Press, 1981); Susan Porter Benson, *Counter Cultures: Saleswomen, Managers, and Customers in American Department Stores, 1890–1940* (Urbana: University of Illinois Press, 1986); and Sarah Phillips et al., *Commerce and Culture: From Pre-Industrial Art to Post-Industrial Value* (London: Design Museum and Fourth Estate, 1989), 35–66.

88. Permeability between commerce and art of course continues to this day, but it is configured differently now than in the 1950s.

89. See, for example, Benson, *Counter Cultures,* 40–41.

90. Norris A. Brisco, *Retailing,* (New York: Prentice-Hall, 1935), 54; and see also Brisco and Leo Arnowitt, *Retailing* (New York: Prentice-Hall, 1942).

91. O. Preston Robinson, J. George Robinson, and Milton P. Mathews, *Store Organization and Operation,* 3rd ed. (Englewood Cliffs, N.J.: Prentice-Hall, 1957), 101–117 (see also the 1938 and 1949 editions). In today's department stores, however, the gridlike, symmetrical plan is the standard.

92. Herbert Bayer, "Fundamentals of Exhibition Design," *PM (Production Manager)* 6, no. 2 (December 1939–January 1940), 17–25, and "Aspects of Design"; Bernard Rudofsky's "Notes on Exhibition Design," *Interiors and Industrial Design* 61, no. 12 (July 1947), 60–77, "is based" on the "notes" of Herbert Bayer (60).

93. *Good Design,* ex. pamphlet (Chicago: Merchandise Mart; New York: Museum of Modern Art, 1953), n.p.

94. Edgar Kaufmann, Jr., and Finn Juhl, "Good Design '51 as Seen by Its Director and by Its Designer," *Interiors* 110, no. 8 (March 1951), 100.

95. Olga Gueft, "Three Judgments Prophetic and Influential: The Merchandise Mart's Exhibition, the AID's Awards, and the Museum of Modern Art's Competition," *Interiors* 109, no. 8 (March 1950), 86.

96. See MoMA Archives: Public Information Scrapbook 89.

97. John Neuhart, Marilyn Neuhart, and Ray Eames, *Eames Design: The Work of the Office of Charles and Ray Eames* (New York: Harry N. Abrams, 1989); Pat Kirkham, *Charles and Ray Eames: Designers of the Twentieth Century* (Cambridge, Mass.: MIT Press, 1995), 143–199, 221–231.

98. Kaufmann and Juhl, "Good Design '51," 100.

99. Ibid., 162.

100. "Good Design 1952: Paul Rudolph's Installation Gets Raves," *Architectural Record* 111, no. 3 (March 1952), 26.

101. Paul Rudolph, interview with author, 27 December 1993.

102. Ibid.

103. "'Good Design' in Chiaroscuro: Paul Rudolph Designs the Mart's Third Exhibition," *Interiors* 111, no. 8 (March 1952), 130.

104. Rudolph, interview.

105. "The New York Version," *Interiors* 112, no. 4 (November 1952), 130.

106. Descriptive caption in "Good Design 1953: First Installment of a Photographic Record," *Interiors* 112, no. 7 (February 1953), 85.

107. Betty Pepis, "Good Design Show Has Subdued Tone," *New York Times,* 19 January 1953, 18.

108. The exhibition *De Stijl 1917–1928* was assembled by a committee of scholars and former members of the De Stijl group; it was exhibited at the Stedelijk Museum in 1951 and the Venice *Biennale* in 1952 before its presentation at MoMA from 16 December 1952 to 15 February 1953. The MoMA bulletin served as the catalogue: *De Stijl 1917–1928, Museum of Modern Art Bulletin* 20, no. 2 (Winter 1952–1953).

109. Rudolph stated that he was very interested and influenced by the work of De Stijl; interview.

110. Kaufmann, "Good Design '51," 100.

111. Betty Pepis, "Exhibition at Chicago Shows New Trends of Many Countries," *New York Times,* 16 January 1951, 36. The 1951 show in particular included

quite a number of appliances, such as stoves, washing machines, vacuum cleaners, and irons.

112. J. F., "Parking Space for Eight Automobiles," *Interiors,* 111, no. 2 (September 1951), 124–125. The article stated that some of the cars were on marble roadway platforms, but Johnson has said that this was not the case (interview).

113. The *Harper's* statement was quoted in the *Museum of Modern Art Bulletin* 17, no. 4 (Summer 1950), 10.

114. Johnson, interview.

115. Quoted in J. F., "Parking Space," 124.

116. In December 1993, however, curatorial assistant Christopher Mount installed a show that was of note more because of its revival of a certain type of exhibition than because of its innovative installation—which presented cars on pedestals. See Mount, *Designed for Speed: Three Automobiles by Ferrari,* pamphlet (New York: Museum of Modern Art, 1993). In the 1990s, there have been indications of some interest in exhibition design from MoMA's architecture and design department; see note 50 above.

117. "Design for Sport," *Sports Illustrated,* 14 May 1962, 42–61. This special section included an article by Fred Smith: "Challenge of Form," 47–54.

118. My discussion of *Signs in the Street* is informed by an interview with Mildred Constantine (16 August 1988). Constantine spoke of the way she and Philip Johnson rode through the streets of Manhattan in a cab looking at the signage. At that time, Constantine was also teaching a course at the New School and sent her students to observe signage on 14th Street.

119. Ibid. Mildred Constantine collaborated with Egbert Johnson and published a book dealing with the issues related to this exhibition, *Sign Language for Buildings and Landscape* (New York: Reinhold, 1961).

120. See *Parallel of Life and Art,* org. and des. Nigel Henderson, Eduardo Paolozzi, Alison Smithson, and Peter Smithson, ex. cat. (London; Institute of Contemporary Arts, 1953); Lawrence Alloway, David Lewis, and Reyner Banham, *This Is Tomorrow,* ex. cat. (London; Whitechapel Art Gallery, 1956). For recent assessment of these exhibitions, see Lawrence Alloway et al., *Modern Dreams: The Rise and Fall and Rise of Pop,* intro. Edward Leffingwell, ex. cat., Institute for Contemporary Arts, London; Clocktower Gallery, New York (Cambridge, Mass.: MIT Press, 1988); Thomas Finkelpearl, Brian Wallis, et al., *This Is Tomorrow Today: The Independent Group and British Pop Art,* ex. cat., Clocktower Gallery, New York (Long Island City, N.Y.: Institute for Art and Urban Resources, 1987).

121. Museum of Modern Art, *Modern Architecture: International Exhibition,* by Henry-Russell Hitchcock, Jr., Philip Johnson, and Lewis Mumford, foreword Alfred H. Barr, Jr., ex. cat. (New York; Museum of Modern Art, 1932); also published as

Henry-Russell Hitchcock, Jr., Philip Johnson, and Lewis Mumford, *Modern Architects,* foreword Alfred H. Barr, Jr. (New York: W. W. Norton, 1932). In 1932, Hitchcock and Johnson also published *The International Style: Architecture since 1922* (New York: W. W. Norton, 1932). In addition, there was a symposium related to the exhibition that was published in *Shelter:* Lewis Mumford, Henry Wright, Raymond M. Hood, George Howe, and Harvey Wiley Corbett, "Symposium: The International Architectural Exhibition," *Shelter* 2, no. 3, (April 1932), 3–9; the same issue included a statement by Frank Lloyd Wright, "Of Thee I Sing," 10–12.

122. One of the rare documents elaborating in detail a Museum of Modern Art exhibition and its installation is Terence Riley, *The International Style: Exhibition 15 and the Museum of Modern Art,* ed. and des. Stephen Perrella, foreword Philip Johnson, pref. Bernard Tschumi, ex. cat., Arthur Ross Architectural Gallery, Columbia University, New York, Columbia Books of Architecture 3 (New York: Rizzoli/CBA, 1992). The exhibition ran from 9 March to 2 May 1992 and was a re-creation of the original 1932 MoMA show.

123. Ibid., appendix 4: "Subscribers Memorandum by Philip Johnson," esp. section titled "Their Installation," 221. It is worth noting that among the exhibition venues, four were department stores such as Sears Roebuck.

124. Johnson, interview.

125. Evaluations of the exhibition's reception have been done by Riley, *International Style,* 85–88, and by Suzanne Stephens, who edited a special section in *Skyline;* "Looking Back at 'Modern Architecture': The International Style Turns Fifty," February 1982, 24–27.

126. Aronovici, *America Can't Have Housing,* n.p.

127. See MoMA Photographic Archives, *Housing Exhibition,* MoMA Exhibition #34d.

128. The Yorkville Advance contributed the full-scale "Old Law Tenement flat." See Museum of Modern Art press release "America Can't Have Housing," October 11, 1934, [Press Releases], MoMA Library. For press reception, see MoMA Archives, Public Information Scrapbooks 2A and 16.

129. Johnson, interview.

130. "A Design Tour de Force Destroys Walls to Turn Illusion into Reality: Arthur Drexler Reconstructs Architectural Substance in a Totally Blacked-out Gallery," *Interiors* 116, no. 10 (May 1957), 135.

131. Ibid., 135, 132–134.

132. "Interim Report: House in the Museum Garden," 12 May 1948, 1, Records of the Registrar Department, "Marcel Breuer House in Museum Garden," MoMA Exhibition #405.

133. *The Museum of Modern Art Builds a House,* ex. pamphlet (New York: Museum of Modern Art, n.d.), n.p.

134. Peter Blake, "The House in the Museum Garden: Marcel Breuer, Architect; Grounds and Interiors Also Designed by the Architect," *Museum Bulletin* 15, no. 4 (1948), 3.

135. Some sense of the detail involved in this installation is conveyed by the following quotation from an information sheet printed at the time of the show:

The garden for the Museum's Japanese House Exhibition was executed by Tansai Sano, and planned by him in collaboration with the architect, Junzo Yoshimura. Mr. Sano is the seventh generation of his family to serve as gardeners at Ryoanji Temple near Kyoto.

For the main garden and pool of the house Mr. Sano selected stones from the mountains near Nagoya. These stones were numbered, marked for position, crated, and shipped to New York with the Exhibition House. White sand of a texture not found in the United States was also shipped to New York. All the plan material is American and was selected here by Mr. Ethelbert Furlong, landscape consultant to the Museum on this project, in collaboration with Mr. Sano.

(From "Plant Materials, Japanese Exhibition House and Garden, The Museum of Modern Art," 1954–1955, MoMA library file, "Japanese Exhibition House," MoMA Exhibition #559.)

136. Dana Adams Schmidt, "Yoshida Is Greeted in Washington by $100,000,000 U.S. Aid Plan," *New York Times,* 8 November 1954, 1, 9.

137. Lewis Mumford, "The Sky Line: Windows and Garden," *New Yorker,* 2 October 1954, 121–129.

138. See *Mademoiselle,* September 1954, 138–142; *Vogue,* 1 September 1954, 179–183, photographs taken by Irving Penn; and *Harper's Bazaar,* October 1954, 136–139, photographs taken by Louise Dahl-Wolf.

139. "Japanese Hit," *Life,* 23 August 1953, 71.
Some of the more well-illustrated articles were *Progressive Architecture* 35, no. 8 (December 1954), 108–113; Arthur Drexler, "House in the Garden," *Interiors* 113, no. 12 (July 1954), 84–85; Betty Pepis, "Japanese House in New York," *New York Times Magazine,* 20 June 1954, 138–139. Responses to the picture essay in the *Times* magazine were published in "Letters," 18 July 1954, 4, and 11 July 1954, 4. For a collection of these reviews, see MoMA Archives: Public Information Scrapbook 74.

140. The Museum of Modern Art has sold items—originally, maps and picture frames—in an area of the Museum since 1930. When MoMA moved into its present location at 11 West 53rd Street in 1939, there was a small sales desk in the lobby where exhibition catalogues, reproductions, greeting cards, and postcards were for sale. The number of items and areas devoted to this activity gradually in-

creased, and in 1964 a second shop, the Museum Store Annex, opened and subsequently occupied various addresses on 53rd and 54th Streets. In 1989 the Museum Design Store opened at 44 West 53rd Street, selling a much-expanded spectrum of merchandise that included home and office furnishing, design objects, personal accessories, and toys. See Museum of Modern Art Press Release, January 1990, Courtesy MoMA Public Information.

All of this store "activity" is very different from the visibly commercial dimensions of modern architecture and design that were integrated within the exhibitions of MoMA's early years.

Chapter 4
Installations for Political Persuasion

Chapter epigraphs: Roland Barthes, "The Great Family of Man," in *Mythologies,* trans. Annette Lavers (New York: Hill and Wang, 1982), 100–101; Rockefeller quoted in Peter Collier and David Horowitz, *The Rockefellers: An American Dynasty* (New York: Signet, 1977), 205.

1. Barthes, "The Great Family of Man," 100–102.

2. Quoted in Russell Lynes, *Good Old Modern: An Intimate Portrait of the Museum of Modern Art* (New York: Atheneum, 1973), 233.

3. For an overview of MoMA's wartime activities, see *Bulletin of the Museum of Modern Art* 10, no. 1 (October–November 1942).

4. The *Road to Victory* was held at the Museum from 21 May to 4 October 1942. In addition to the MoMA exhibition, four copies of a smaller version of the show were created. The larger version traveled to five cultural institutions in the United States in 1943 and the smaller ones traveled to thirteen venues from 1943 to 1944. From 1943 to 1945, three of the smaller copies were shown in Great Britain and Honolulu, Hawaii, under the auspices of the Office of War Information and in Colombia and Uruguay under the auspices of the CIA. See MoMA Archives: "Guide to the Records of the Department of Circulating Exhibitions in The Museum of Modern Art Archives, New York," 115, and "Guide to Activities of the International Program and the International Council of The Museum of Modern Art, New York, 1952–1975, 'Before 1952,'" 2.

5. *Bulletin of the Museum of Modern Art* 10, nos. 5–6 (June 1942), 2. The bulletin served as the catalogue of the show and included Sandburg's text and installation photos of the exhibition; all quotations of Sandburg are taken from this source. For even more complete documentation of the exhibition, see Carl Sandburg, *Home Front Memo* (New York: Harcourt, Brace, 1943), 306–42.

6. Edward Alden Jewell, "In the Realm of Art: War and Peace in Current Shows," *New York Times,* 24 May 1942, sec. 8, p. 5, and "Art in Review," *New York Times,* 21 May 1942, 22.

7. Jewell, "Art in Review," 22. For a discussion of photography's marginal status and market during Beaumont Newhall's tenure and the popular appeal of the exhibition techniques of Steichen, see Christopher Phillips, "The Judgment Seat of Photography," *October* 22 (Fall 1982), 27–63.

8. Edith Anderson, "'Road to Victory'—Portrait of Our Fighting America," *The Worker* 3, no. 21 (24 May 1942), 7; Carlyle Burrows, "In the Art Galleries— Themes of Patriotism, Past and Present," *New York Herald Tribune,* 24 May 1942, sec. 6, p. 6.

9. Ralph Steiner, "Road to Victory: Top Notch Photos from Steichen Show," *PM Daily,* magazine sec. 31 May 1942, 26.

10. *Bulletin of the Museum of Modern Art* 10, nos. 5–6 (June 1942), 21; "Visual Road to Victory," *Art News* 4, no. 9 (August–September 1942), 26–29; "'Road to Victory,'" *Art Digest* 16, no. 17 (1 June 1942), 5.

11. *Bulletin of the Museum of Modern Art* 10, nos. 5–6 (June 1942), 19. This description was taken up by, for example, Christopher Phillips, "Steichen's 'Road to Victory,'" *Exposure* 18, no. 2 (1981), 43.

12. See, for example, Steiner, "Road to Victory"; "'Road to Victory,'" *Newsweek,* 1 June 1942, 64.

13. Steiner, "Road to Victory," 26.

14. Steichen received a commission to command a photography unit for the navy in 1942. See Christopher Phillips, *Steichen at War* (New York: Harry N. Abrams, 1981).

15. Maren Stange, *Symbols of Ideal Life: Social Documentary Photography in America, 1890–1950* (New York: Cambridge University Press, 1989), 135.

16. See "Road to Victory Photos Captions from Stryker," no. 39237-D, Records of the Registrar Department, *Road to Victory,* MoMA Exhibition #182.

17. On the recaptioning of FSA photographs, see Phillips, "Judgment Seat of Photography," 46; Stange, *Symbols of Ideal Life,* esp. chaps. 3 and 4; Roy Stryker and Nancy Wood, *In This Proud Land: America 1935–1943 as Seen in the FSA Photographs* (Boston: New York Graphic Society, 1973), esp. 178; and Ulrich Keller, "Photographs in Context," *Image* 19, no. 4 (December 1976), 1–12.

18. Stange, *Symbols of Ideal Life,* 128 n. 82, cites John Fischer, director of information, to all regional information advisors, memo, 4 May 1938, Box 2, LC.

19. Stryker and Wood, *In This Proud Land,* 8.

20. Stange, *Symbols of Ideal Life,* 133.

21. See Phillips, "Steichen's 'Road to Victory,'" 39.

22. Ibid., 39 n. 12, cites Edward Steichen, "The F.S.A. Photographers," *U.S. Camera Annual* (1939), 44.

23. Phillips, *Steichen at War,* 16.

24. Sandburg, *Home Front Memo,* 307.

25. Phillips, *Steichen at War,* 22.

26. Herbert Bayer, "Fundamentals of Exhibition Design," *PM (Production Manager)* 6, no. 2 (December 1939–January 1940), 17.

27. Mr. Wheeler to Miss Newmeyer, "Steichen Exhibition," memo, 13 May 1942, Records of the Registrar Department, *Road to Victory,* MoMA Exhibition #182.

28. Anderson, " 'Road to Victory.' "

29. Herbert Bayer, *Herbert Bayer: Painter, Designer, Architect* (New York: Reinhold, 1967), 65.

30. Herbert Bayer, "Aspects of Design of Exhibitions and Museums," *Curator* 4, no. 3 (1961), 267.

31. See Ingo Kaul, "Deutschland Ausstellung, 18. Juli bis 16. August, 1936," designer, Herbert Bayer, exhibition prospectus, published in *Gebrauschsgraphik/Advertising Art,* April 1936.

32. For a discussion of historical background of the terms "masses" and "mass culture," see Andrew Ross, "Containing Culture in the Cold War," in *No Respect: Intellectuals and Popular Culture* (New York: Routledge, 1989), 42–64.

33. Bayer, "Aspects of Design," 257–258.

34. Bayer, "Fundamentals of Exhibition Design," 17; Phillips, "Judgment Seat of Photography," 43; Stange, *Symbols of Ideal Life,* 138.

35. Stange, *Symbols of Ideal Life,* 138–139.

36. In citing "sheer manipulation," Phillips was referring specifically to the argument of Allan Sekula; see Phillips, "Judgment Seat of Photography," 45–46.

37. Barthes, "Myth Today," in *Mythologies,* 116–145.

38. Ibid., 116, 143.

39. For a discussion of a visit to the Museum of Modern Art permanent collection galleries as a ritual of power, see Carol Duncan and Alan Wallach, "The Museum of Modern Art as Late Capitalist Ritual: An Iconographic Analysis," *Marxist Perspectives* 1, no. 4 (Winter 1978), 28–51; another version of this article was published as "MoMA: Ordeal and Triumph on 53rd Street," *Studio International* 194, no. 988 (1978), 148–157.

40. For two reviews that discussed the Boston installation of *The Road to Victory* in terms of film, see Elizabeth McCausland, "Camera Aids War Effort: Photographs Illustrate Our 'Road to Victory,' " *(Springfield, Mass.) Sunday Union and Republican,* 31 May 1942, and Amy H. Croughton, "Scanning the Screen," *(Rochester, N.Y.) Times Union,* 28 May 1942; both clippings in MoMA Archives: Public Information Scrapbook 57.

41. In 1944 Warner Brothers produced a propaganda film titled after the exhibition *Road to Victory,* dir. unknown; see records of MoMA Film Study Center.

42. For an excellent discussion of U.S. government's censorship of World War II imagery, see George Roeder, *The Censored War: American Visual Experience during World War Two* (New Haven: Yale University Press, 1993).

43. Ibid., 1.

44. Ibid., 1–41; quotation on 7.

45. Ibid., 57.

46. Lynes, *Good Old Modern,* 237.

47. For an overview of the Circulating Exhibitions Program, see *Museum of Modern Art Bulletin* 21, nos. 3–4 (Summer 1954).

48. Lynes, *Good Old Modern,* 238.

49. Quoted in Collier and Horowitz, *The Rockefellers,* 205.

50. This is just a selective sampling of individuals involved with both the U.S. government and MoMA. See Eva Cockcroft, "Abstract Expressionism, Weapon of the Cold War," *Artforum* 12, no. 10 (June 1974), 39–41.

51. *Power in the Pacific* was held at MoMA from 23 January to 20 March 1945. A smaller version of the show was also created. From 1945 to 1946, the larger version traveled to ten venues and the smaller version to nine. See "Guide to Circulating Exhibitions," 111. Two versions of the catalogue were published: a 144-page hardcover edition, which concluded with a one-page addendum of installation photographs, U.S. Navy, *Power in the Pacific,* comp. Edward Steichen (New York: U.S. Camera Publishing, 1945); and a 32-page paper edition, U.S. Navy, *Power in the Pacific,* ex. cat. Museum of Modern Art, New York (New York: William E. Rudge's Sons, 1945).

52. U.S. Navy, *Power in the Pacific,* 19; U.S. Navy, *Power in the Pacific,* ex. cat., 2. See also MoMA Photographic Archives: installation photos, *Power in the Pacific: Battle Photographs of Our Navy in Action on the Sea and in the Sky,* MoMA Exhibition #275.

53. See Edward Steichen, *The Blue Ghost* (New York: Harcourt, Brace, 1947), and *U.S. Navy War Photographs: Pearl Harbor to Tokyo Harbor* (New York: U.S. Camera, 1946).

54. *Airways to Peace* was held at MoMA from 2 July to 31 October 1943. After the MoMA installation, the exhibition traveled to five venues from 1943 to 1944. See "Guide to Circulating Exhibitions," 57. The *Bulletin of The Museum of Modern Art* 11, no. 1 (August 1943), served as the catalogue; it includes exhibition texts and installation photographs.

For a list of preliminary titles for *Airways to Peace,* see the Records of Registrar Department, *Airways to Peace,* MoMA Exhibition #236.

55. *Bulletin of MoMA* 11, no. 1 (August 1943), 22.

56. Ibid., 3. See also MoMA Photographic Archives: installation photos, *Airways to Peace,* MoMA Exhibition #236.

57. Bayer, *Herbert Bayer,* 56.

58. On Wheeler and for press releases, see the Records of the Registrar Department, *Airways to Peace,* MoMA Exhibition #236. See also *Bulletin of the Museum of Modern Art* 11, no. 1 (August 1943), 23.

59. *Bulletin of the Museum of Modern Art* 11, no. 1 (August 1943), 22.

60. Ibid., 15, 23.

61. Ibid., 23. For background on mapmaking and the history of World War II, see Lloyd A. Brown, *The Story of Maps* (1949; reprint, New York: Dover Publications, 1977), 307–309.

62. See Army Map Service, "Arms and the Map: Military Mapping by the Army Map Service," *Print, a Quarterly Journal of the Graphic Arts* 4, no. 2 (Spring 1946), 3–16; Brown, *The Story of Maps,* 307–309.

63. See press release 43629–25, n.d., "President Roosevelt Lends His Fifty-inch Globe to *Airways to Peace* at The Museum of Modern Art"; *Airways to Peace* wall label. Both in Records of the Registrar Department, *Airways to Peace,* MoMA Exhibition #236.

64. *Bulletin of the Museum of Modern Art* 11, no. 1 (August 1943), 9.

65. Bayer, *Herbert Bayer,* 57; "Pegasus to Planes," *Newsweek,* 12 July 1945, 76.

66. Outline of *Airways to Peace* exhibition, Records of the Registrar Department, *Airways to Peace,* MoMA Exhibition #236.

67. Wendell L. Willkie, *One World* (New York: Simon and Schuster, 1943).

68. "Willkie Sees His Book Illustrated in New 'Airways to Peace' Show," *New York Herald Tribune,* 1 July 1943, n.p.; clipping in Records of Registrar Department, *Airways to Peace,* MoMA Exhibition #236.

69. Records of the Registrar Department, *Airways to Peace,* MoMA Exhibition #236.

70. See the cover blurb of the 1955 paperback edition of *The Family of Man,* cited below. See also, for example, invitation to the Museum of Fine Arts, Boston, installation, MoMA Archives: Records of the Department of Circulating Exhibitions, *The Family of Man,* II.1/58(1) [filing units 8–12]; and The Museum of Modern Art, New York: Edward Steichen Archives.

The Family of Man was held at MoMA from 24 January to 8 May 1955. According to the records of the Museum of Modern Art, in addition to the original exhibition, which was circulated to eight U.S. institutions, two smaller versions were circulated by the Museum and four smaller versions traveled both nationally and, under the auspices of the USIA, internationally from 1955 to 1965. Records conflict as to whether two of these four were the two MoMA traveling shows or new versions made solely for the USIA. In 1957 the master version was sold to the USIA, and it toured the Middle East in 1957 and 1958. In 1965 USIA Copy III was given to the government of Luxembourg and installed at the Common Market headquarters. In 1959 USIA Copy I was included in the *American National Exhibition* in Moscow.

None of the available MoMA archival material documents the three Japanese copies. Wayne Miller gave me a copy of a letter sent to Miller from Porter A. McCray, who was director of MoMA's Department of Circulating Exhibitions, dated 18 January 1957. In this letter, McCray outlines in detail the exhibition's versions and venues; he states that "A large and two smaller versions produced in Japan from negatives produced by the Museum" were being circulated at that time "under the sponsorship of Nihon Keizai Shimbun Publications." The large version had been shown at nine venues; Copy I, five venues; Copy II, six venues. Given that this letter was written while these Japanese versions were circulating, it is possible that these versions were presented at additional sites.

The USIA modified the content of the exhibition for the international tours. According to the master checklists in MoMA's Archives, images that the USIA deemed inappropriate, such as the atomic bomb, were eliminated (see below). Slight modifications in the text were made to appeal to the non-Christian audiences. MoMA's records do not give a consistent accounting of the number of venues in which these five versions were shown.

The U.S. venues documented in MoMA's Archives total 42; however, these records do not document the Corcoran Gallery installation, which is the subject of the film cited below; others may also have been overlooked. There were between 94 and 104 foreign venues, for a total of 137 to 147 documented presentations of *The Family of Man* between the years 1955 and 1962. See "Guide to the Records of the Department of Circulating Exhibitions in The Museum of Modern Art Archives," 77; "Guide to Activities of the International Program and the International Council of The Museum of Modern Art, New York 1952–1975," 11, 15–17; MoMA Archives: CE, *The Family of Man,* II.1/57(1) and 58(1) [filing units 1–12, 2–

12, 3–12, and 12–12]; and Wilder Green to Richard L. Palmer, memo 17 May 1965, "Mr. Weitz's letter regarding *The Family of Man*," 1–7, courtesy, Records of the International Program, MoMA. The photography department's figures are somewhat ambiguous. The department files, which document the master exhibition and five copies, give a total number of 88 venues. I imagine this figure includes international sites. I prefer to rely on the documents from the Department of Circulating Exhibitions and the International Program, as well as Porter McCray's letter. John Szarkowski, director emeritus of the Department of Photography, reviews the exhibit in a Museum of Modern Art publication: see "The Family of Man," in *Studies in Modern Art,* series ed. John Elderfield, vol. 4, *The Museum of Modern Art at Mid-Century: At Home and Abroad* (New York: Museum of Modern Art, 1994), 38–54.

In *Picturing an Exhibition: The Family of Man and 1950s America* (Albuquerque: University of New Mexico Press, 1995), Eric J. Sandeen devotes an entire book to this exhibition and gives close readings of the MoMA installation and its circulating versions. According to Sandeen, because of water damage, the photos for the Moscow installation were created from two sets of prints, as well as some newly developed prints, but he offers no citation for this information (131, 133). Sandeen also discusses the atom bomb image: its exclusion from the book (the paperback editions and, according to Miller, all hardcover editions except the first) and its inclusion in the traveling exhibitions. There are installation photographs documenting the bomb image in the first domestic installation of Copy I at the Georgia Institute of Technology, 15 January to 5 February 1956. According to a note written on a "*Family of Man* Master List," the hydrogen bomb black-and-white photograph was at some point removed from the domestic circulating exhibitions. See MoMA Archives: CE, *The Family of Man,* II.1/57(1) [filing unit 1–12]. It seems fairly certain that this image was removed from USIA presentations; see "*Family of Man* Master List," MoMA Archives: CE, *The Family of Man,* II.I/57(1) [filing units 1–12, 2–12, and 3–12]. The film of the Corcoran Gallery installation (cited below) also seems to confirm that the image was eliminated. In the film, Steichen discusses the "horrible . . . atomic weapon," but there is no image of the bomb and no reference to such an image. Only the series of nine portraits are shown as he continues: "it is written in the faces of these three women, three children, and three men." According to the memo from Wilder Green cited above, the USIA removed certain images deemed inappropriate for certain installations, but these changes always had to be cleared with Steichen.

There was a paperback and a hardcover catalogue/book, and another hardcover version with an addendum. The supplemented hardcover edition, Edward Steichen, comp., *The Family of Man,* prol. Carl Sandburg, ex. cat., Museum of Modern Art, New York (New York: Simon and Schuster, in collaboration with the Maco Magazine Corporation, 1955), had 207 pages, including an addendum of installation photographs: "A Special portfolio of photographs by Ezra Stoller of the *Family of Man* exhibition on the walls of The Museum of Modern Art, New York" (195–207). This portfolio included "photographic footnotes by Wayne Miller," one of which was an image of the hydrogen bomb installation. The shorter paperback and hardcover edition had 192 pages, but the hardcover did not have the telescope photo of Orion and the photo of the sea that were on the inside covers of the paperback: Edward Steichen, *The Family of Man,* prol. Carl Sandburg, ex. cat.,

Museum of Modern Art, New York (New York: Maco Magazine Corporation, 1955). The paperback edition has become the standard for subsequent printings. The paperback and the hardcover edition without the addendum included one installation shot on a double-page spread (4–5). Except for the end pages, title page, and the addendum with the hydrogen bomb image, the paperback and the supplemented hardcover were identical, including their pagination. Neither contained the lynched African American man and the circle of people being shot by a firing squad that had been included in the MoMA installation's "Inhumanities" section. (A "pocket-sized" version of the 1955 paperback edition was also published by the Maco Magazine Corporation that was "the complete book," only smaller in trim size and containing 256 pages.)

According to MoMA Film Study Center records, there were three films documenting the exhibition: a film of the MoMA installation, which included Steichen, Carl Sandburg, and Eleanor Roosevelt, *Family of Man,* 1956, dir. Joseph Scibetta, prod. Robert Northshield and CBS; a film of the 1956 Corcoran Gallery installation, *Family of Man,* n.d., dir. unknown, prod. U.S. Information Service; and a film (now too damaged to be viewed) of the installation at the Minneapolis Institute of Arts, *Family of Man,* 1955, dir. Robert Squier, prod. Stanton Catlin, Philip Gelb, and Robert Squier.

71. Steichen, introduction to *Family of Man,* 3.

72. "Seven Moods of Man," *New York Times Magazine,* 23 January 1955, 22; "Camera Notes," *New York Times,* 23 January 1955, 16; Jacob Deschin, "'Family's' Last Days," *New York Times,* 8 May 1955, sec. 2, p. 17; Hilton Kramer, "Exhibiting the Family of Man," *Commentary,* October 1955, 364; "The Family of Man," *Popular Photography,* May 1955, 81.

73. "The Family of Man," *Popular Photography,* 88–89.

74. Kramer, "Exhibiting the Family of Man," 364, cites a comment made by columnist Bob Considine the previous June.

75. "The Family of Man," *Popular Photography,* 147; Kramer, "Exhibiting the Family of Man," 364.

76. Kramer, "Exhibiting the Family of Man," 364.

77. "The Family of Man," *Popular Photography,* 147; "'Family of Man' Photos," *New York Times,* 25 January 1955, 18.

78. See note 70.

79. The demountable installation design for the circulating versions of *The Family of Man* was designed by Charlotte Trowbridge.

80. Phillips discusses Steichen's early ideas regarding such an exhibition in *Steichen at War,* 16.

81. Steichen, introduction to *Family of Man,* 3.

82. See *The Family of Man* press release, 1, MoMA Archives: CE, *The Family of Man,* II.1/57(1) [filing unit 2].

83. For quotations from the exhibition, see *The Family of Man* catalogues and MoMA Photographic Archives, *The Family of Man,* MoMA Exhibition #569.

84. In a number of the USIA traveling exhibitions eliminations and additions were made with Steichen's approval. The additions were primarily in the prologue, which included several non-Christian "religious" sources that were generally referred to as myths, such as a Hindu creation myth and the Egyptian legend of creation. The photos of the atom bomb and of the lynched African American man were removed. MoMA Archives: CE, *The Family of Man,* II.1/57(1) [filing units 2 and 3].

85. Sandburg, prologue to Steichen, *Family of Man,* 5.

86. Paul Rudolph, interview with author, 27 December 1993. Sandeen also discusses this image in detail; see *Picturing an Exhibition,* esp. 45 (regarding this photograph).

87. Rudolph, interview.

88. Ibid.

89. Ibid.

90. For published floor plans of the exhibition, see "The Family of Man," *Popular Photography,* 148; John Anderson, "The Family of Man," *Interiors* 114, no. 9 (April 1955), 114.

91. Rudolph, interview.

92. Ibid.

93. Steichen swung this panel in the film of the Corcoran Gallery installation of *The Family of Man;* (film, n.d.).

94. Wayne Miller remembers observing the "fascinating" behavior of those viewing this family group section: "Spectators would gather around their own ethnic counterparts: the Blacks, the Orientals, the Swedes." Interview with author, 18 July 1996.

95. This was not a movable exhibit; Miller, interview.

96. " 'The Family of Man,' " *Vogue,* 1 February 1955, 168.

97. Rudolph, interview.

98. Miller, interview.

99. The mirror was not included in the Corcoran installation or, presumably, the other circulating installations; see *The Family of Man* (film, n.d.).

100. Rudolph said that the room with the atomic bomb transparency was painted red (interview), but reviews at that time only described the walls of the room as black or dark. See, for example, Jacob Deschin, " 'Family of Man': Panoramic Show Opens at Modern Museum," *New York Times,* 30 January 1955, 17; and J. Anderson, "The Family of Man," 116. Miller also remembers it as black (interview).

101. This section was designated the "magic of childhood" in the layout published in J. Anderson, "The Family of Man," 115.

102. Rudolph, interview.

103. See Edward Steichen, "The Family of Man," *Picturescope* 3 (July 1955), 7.
Sandeen, who makes much of Steichen's concern with this "horror," founds a great deal of his discussion on the constellation of factors involved with America's fears regarding the hydrogen bomb and the Soviets; on the MoMA installation specifically, see his chap. 3, "Picturing the Exhibition," in *Picturing an Exhibition,* 11–38.

104. *The Family of Man* (film, n.d.).

105. In the Corcoran film (*The Family of Man* [film, n.d.]), Steichen refers to the nine portraits and says that you can see in the faces of the people pictured they "are thinking of the . . . horrible atomic weapon." According to note cards in MoMA's Film Study center describing the film of Minneapolis installation (the film is too damaged to be viewed; *The Family of Man* [film, 1955]), Steichen ends the film with a plea against nuclear weapons.

106. Miller, interview.

107. Steichen received a number of awards, especially from politically liberal organizations, and honors from the American Society of Magazine Photographers. See "Camera Notes," *New York Times* 17 April 1955, 19. The New York Newspaper Guild gave Steichen a special citation; the same group of awards featured one given to Thurgood Marshall for leading the fight against racial segregation. See "New Guild Lists Page One Awards," *New York Times* 16 March 1955, 30. The Urban League cited Steichen for narrating the "Urban League credo with an eloquence seldom before seen or heard": the Urban League was described as "Seeking equality of opportunity for Negroes with all Americans . . . [and working] for the benefit of all peoples, building toward the creation of a true 'Family of Man' " See "Cited by Urban League," *New York Times,* 1 May 1955, 78.
In the Moscow installation, a Nigerian medical student ripped up and attempted to destroy several of the photographs depicting black individuals, claiming that they were unobjective portrayals of the "negro race." See press clippings

in MoMA Archives: Public Information Scrapbook General Y. For press coverage of *The Family of Man,* also see MoMA: Edward Steichen Archives.

108. There were two images of the Warsaw Ghetto in the MoMA installation; only one was included in the hardcover and paperback books.

109. 1955 was the year of Rosa Parks's arrest for refusing to give up her seat on a Montgomery, Alabama, bus to a white man; it was also the year of the much-publicized, racially motivated murder of the African American teenager Emmett Till in Mississippi. Till's murder has been described as the first great media event of the postwar civil rights movement; see David Halberstam, *The Fifties* (New York: Villard Books, 1993), 429–455. Halberstam, a writer whose perspective is "centrist," nevertheless portrays the 1950s as a time that is more complex and dark than its clichéd image of peace and plenty. Halberstam sees racial tensions, the nuclear threat, juvenile unrest, rock and roll, the Beat poets, and the alienation of suburban life as central aspects of the fifties, arguing that these forces laid the foundations for the dramatic social changes that occurred in the 1960s.

110. Miller, interview.

111. See "Common Bond of Man," *Life,* 14 February 1955, 132–143; the image was listed as *Death Slump at Mississippi Lynching* (1937), photographer unknown, 141.

112. Miller, interview.

113. Miller, interview. The "McCarthy era" began on 9 February 1950 when Senator Joseph R. McCarthy gained national prominence with a speech at a West Virginia Republican Women's club in which he claimed that there were Communists in the State Department. His personal influence ended on 4 December 1954, when he was condemned by the Senate for acting contrary to senatorial ethics. One month later, on 24 January 1955, *The Family of Man* opened at MoMA.

114. Miller, interview. J. Robert Oppenheimer, one of the key scientists in the project to develop the atomic bomb and an outspoken opponent of the hydrogen bomb, was a highly controversial figure. In 1953, after having been investigated for being sympathetic to communism and a security risk, he was suspended from the U.S. Atomic Energy Commission. His attorneys appealed the decision in 1954, but the suspension was maintained.

115. Allan Sekula, "The Traffic in Photographs," in *Photography against the Grain: Essays and Photo Works, 1973–1983* (Halifax: Press of the Nova Scotia College of Art and Design, 1984), 89–90.

116. See Mark Poster, *Critical Theory of the Family* (New York: Seabury Press, 1978), 82. See *1947 Britannica Book of the Year: A Record of the March of Events of 1946,* ed. Walter Yust (Chicago: Encyclopaedia Britannica, 1947), 480–492; *1948 Britannica Book of the Year: A Record of the March of Events of 1947,* ed. Walter Yust (Chicago: Encyclopaedia Britannica, 1948), 462–463; *Britannica Book of the Year 1953: A Record of the March of Events of 1952,* ed. Walter Yust (Chicago: Encyclopaedia Britannica, 1953), 438–440; *Britannica Book of the Year 1954: A Record of the March of Events of 1953,* ed. Walter Yust (Chicago: Encyclopaedia Britannica, 1954), 443–445; *Britannica Book of the Year 1955: A Record of the March of Events of 1954,* ed. Walter Yust (Chicago: Encyclopaedia Britannica, 1955), 186–187; *Britannica Book of the Year 1956: A Record of the March of Events of 1955,* ed. Walter Yust (Chicago: Encyclopaedia Britannica, 1956), 422.

117. While the *Family of Man* was installed at MoMA, a battle was being waged in the New York legislature to reform divorce laws. In March 1956, after several years of publicized debate, the "Gordon-Rosenblatt" bill finally passed the state assembly and senate, paving the way for relaxing New York's stringent requirements for divorce. On the increase in postwar divorce rates and the changes in U.S. divorce laws, see Nelson Manfred Blake, *The Road to Reno* (New York: Macmillan, 1962), esp. 1–8, 203–243.

118. *Britannica Book of the Year 1955,* 771.

119. Elia Kazan's *The Face in the Crowd,* released in 1957, provides an interesting alternative portrait of the era. The film treats cynically many of the themes found in *The Family of Man,* such as the power of the mass media, human nature, and marriage.

"Elvis: Story of a Legend," originally titled "Elvis Presley," in the Arts and Entertainment Network television *Biography* series, 1993, includes film and television clips documenting Elvis's notoriety. For example, in an interview on the WRCA television program *Hy Gardner Calling* on 1 July 1956, Elvis denied he was contributing to juvenile delinquency.

120. Betty Friedan, *The Feminine Mystique* (1963; reprint, New York: Dell, 1983).

121. Two contemporary overviews of the press reception, including criticisms of the show, are Deschin, "'Family's' Last Days," and Edwin Rosskam, "Family of Steichen," *Art News* 54, no. 1 (March 1955), 34–37, 64–65.

122. Kramer, "Exhibiting the Family of Man," 366–367.

123. Barthes, "The Great Family of Man," 100, 101.

124. The bibliography on *The Family of Man* is vast. See the bibliography provided in the most in-depth examination of the show, Sandeen's *Picturing an Exhibition* (213–221). Christopher Phillips's work is particularly significant here, for he foregrounds the exhibition installation and acknowledges that *The Family of Man* could examined in terms of Barthesian myth; see "Judgment Seat of Photography," 46–49. Although Phillips does examine the political implications of Steichen's vision of humanity as a weapon of the cultural cold war, Allan Sekula more specifically emphasizes the "sexual and international politics" of *The Family of Man;* see "Traffic in Photographs" (quotation on 95). Describing the show as one of the big guns in the cultural cold war, Sekula points out that the foreign editions were sent to

"hot spots"—like Guatemala City fourteen months after a U.S.-supported coup overthrew a democratically elected government (94).

125. See note 70 above.

126. For a selection of press clips that mention the USIA's involvement with the show, see MoMA Archives: Public Information Scrapbook General Y, *American National Exhibition in Moscow* and MoMA Archives: Records of the Department of International Circulating Exhibitions, SP-ICE-24–59.

Sandeen devotes an entire chapter to this installation; see "*The Family of Man* in Moscow," in *Picturing an Exhibition,* 125–154.

127. Quoted in Peyton Boswell, "Comments: Politicians as Critics," *Art Digest* 21, no. 4 (15 April 1947), 7. For background on the arts, U.S. government, censorship, and the cold war, see Cockcroft, "Abstract Expressionism"; Jane De Hart Mathews, "Art and Politics in Cold War America," *American Historical Review* 81 (1976), 762–787; and Christopher Lasch, "The Cultural Cold War: A Short History of the Congress for Cultural Freedom," in *Towards a New Past: Dissenting Essays in American History* (New York: Pantheon Books, 1968), 322–359.

128. Alfred H. Barr, Jr., "Is Modern Art Communistic?" *New York Times Magazine,* 14 December 1952, 22–23, 28–30.

129. See Lynes, *Good Old Modern,* 383–393.

130. See Lynes, *Good Old Modern,* 385, 439; De Hart Mathews, "Art and Politics," 779; and Michael Kimmelman, "Revisiting the Revisionist: The Modern, Its Critics, and the Cold War," in *Studies in Modern Art,* 4:38–55. Kimmelman, after reviewing the literature dealing with the Museum and the cold war, points out that MoMA ceded responsibility for the *Venice Biennale* in 1956 to the Art Institute of Chicago and in 1960 to the Baltimore Museum of Art.

131. E. W. Kenworthy, "Whitney Trust Got Aid," *New York Times,* 25 February 1967, 1, 10. For related discussion, see Lasch, "Cultural Cold War"; for Whitney quote, see Lynes, *Good Old Modern,* 233.

In an often-cited article, "Abstract Expressionism, Weapon of the Cold War," Eva Cockcroft discusses MoMA's history of collaborations with the federal government and focuses particularly on the interchange of personnel between the Museum and the CIA. Cockcroft outlines the CIA's support of intellectual and cultural institutions during the 1950s and 1960s in order to promote America's public image of freedom while avoiding the complications of congressional censure.

132. De Hart Mathews, "Art and Politics," 778–779.

133. See MoMA Archives: Public Information Scrapbook General Y, and MoMA Archives: Records of the Department of International Circulating Exhibitions, SP-ICE-24–59.

134. Press release, *The Family of Man,* n.d., 1, MoMA Archives: CE, *The Family of Man,* II.1/57(1) [filing unit 1].

This is related to what Sekula considers to be the "main point" of his argument. Above all else, Sekula sees *The Family of Man,* "more than any other single photographic project," as "a massive and ostentatious bureaucratic attempt to universalize photographic discourse," which was in turn was deployed by political and corporate sponsors to secure their respective dominions ("Traffic in Photographs," 90).

135. Bayer, "Aspects of Design," 257–258.

136. *Coca-Cola Overseas,* December 1958, 15; I was lead to this information by Allan Sekula's article "Traffic in Photographs" (95 n. 35): In the Sekula text, however, there are some slight omissions in the wording of the quote.

137. See Ross, "Containing Culture in the Cold War."

138. The dark side of the terms "mass culture" and "masses" or "mass audience" has been discussed by Andrew Ross (ibid.). Ross examines these terms' currency during the cold war climate of the 1940s and 1950s in the United States. Mass culture was associated with political totalitarianism, commercial manipulation, and aesthetic contamination. The masses were seen as a monolith of passive, mesmerized conformists.

139. J. P. Shanley, "Wide World," *New York Times,* 3 July 1955, 9.

140. One such example is the U.S. television show *Father Knows Best* (see fig. 4.29), which began as a radio series in 1949 with Robert Young in the leading role. Young was the only member of the radio cast to be included in the television version. The first TV episode aired 3 October 1954 at 10:00 P.M. In the spring of 1955, CBS canceled the series, but so much audience protest ensued that NBC picked it up the following season and ran it at an earlier hour so that entire family could watch. In the 1959 to 1960 season, *Father Knows Best* was the sixth most popular show in the United States. At that point, however, Young wanted to leave the series, so no more original shows were produced. But CBS showed two years of reruns from 1961 to 1962, which were followed by one year of reruns on ABC in 1963.

In 1959, as a method to promote U.S. savings bonds, the U.S. Treasury Department sponsored an episode in which the children live under a "make-believe" dictatorship for one day to show the importance of "American democracy." The episode never ran. See Tim Brooks and Earle Marsh, eds., *The Complete Directory to Prime Time Network T.V. Shows, 1946–Present,* 4th ed. (New York: Ballantine Books, 1988), 257.

141. Exceptions to this are the artist-curated installations or artist installations; see chapter six.

142. Steichen showed his awareness of the historicity of this exhibition in his sensitivity to the time-bound quality of the show. According to Miller, when representa-

tives from the United Nations wanted Steichen to create a permanent *Family of Man* exhibit there, "He emphatically said, 'No.' Steichen believed that the exhibition should not be enshrined. . . . He recognized that an exhibit like this was something made of board and photo paper and would not survive well over time" (interview). A permanent exhibit of *The Family of Man* was, however, installed on 3 June 1994 by the Ministry of Culture at the Château Clervaux, Luxembourg.

In his interview, Rudolph discussed these aspects of installation design in relation to his work at MoMA: "All architects are interested in installation design because of its creative freedom. Installation design gets to the essence of what a person is really thinking about, which is different from what they are doing 'for real.' An installation is here today and gone tomorrow; a building has to last for many, many years. With installation design you can be freer with ideas. You can get away with murder with an installation design. It's more difficult with a building."

143. In 1991 John Szarkowski became director emeritus of MoMA's Department of Photography and Peter Galassi became chief curator.

A recent exception to the neutral-colored walls and photographs in mats and frames is a small vitrine in which is displayed one issue of *Life* magazine (9 April 1951) open to a four-page picture essay: "Spanish Village: It Lives in Ancient Poverty and Faith," illustrated with photographs by W. Eugene Smith. For a discussion of the history of MoMA's photography department, see Phillips, "Judgment Seat of Photography."

144. *The Family of Man,* of course, was not political in the sense of *Road to Victory* or *Airways to Peace.* Miller, in his interview, stressed Steichen's desire to avoid the overtly political in *The Family of Man* and spoke of the inclusion of the atomic bomb as more "symbolic" than "political." In a very different sense, however, Steichen and Miller's fine-tuning of the exhibition shows an astute awareness and concern for the political limits shaping the framework of the show, one that allowed for the inclusion of photographs such as those of the Warsaw Ghetto but required the elimination of the lynching photograph.

145. As of winter 1998, *The Family of Man* is still in print in a paperback edition. The "millions of copies" figure was given in summer 1993 by a spokesperson for Fireside Touchstone, a division of Simon and Schuster, which was then the book's publisher. In 1995 the then-current Touchstone edition had sold approximately one hundred thousand copies (a figure confirmed by Susan Fleming Holland, vice president and director of publicity, 9 January 1995). In 1996 the book was reprinted by Harry N. Abrams, Inc., New York.

Chapter 5
Installation Design and Installation Art

Chapter epigraphs: Philip Leider, "How I Spent My Summer Vacation or Art and Politics in Nevada, Berkeley, San Francisco, and Utah," *Artforum* 9, no. 1 (September 1970), 40–49; *Information,* ed. Kynaston L. McShine, ex. cat. (New York: Museum of Modern Art, 1970).

1. MoMA has often had to deal with the protests of artists and artists' communities. See Russell Lynes, *Good Old Modern: An Intimate Portrait of the Museum of Modern Art* (New York: Atheneum, 1973), 99–101, 229–231, 438; on the *Tele-Sculpture* incident, see 147.

2. For an overview of the history of MoMA and the Art Workers Coalition, which was born from this confrontation, see MoMA Library, "Art Workers Coalition" ("AWC") file; Therese Schwartz, "The Politicalization of the Avant-Garde," parts 1, 2, and 3, *Art in America* 59, no. 6 (November/December 1970), 96–105; 60, no. 2 (March/April 1972), 70–79; 61, no. 2 (March/April 1973), 67–71; Lucy Lippard, *Get the Message? A Decade of Art for Social Change* (New York: E. P. Dutton, 1984), 1–22; Elizabeth C. Baker, "Pickets on Parnassus," *Art in America* 69, no. 5 (September/October 1970), 30–33, 64–65; Lawrence Alloway, "Art," *Nation* 19 October 1970, 38; and Lynes, *Good Old Modern,* 147.

3. Schwartz, "Politicalization, I," 77–78.

4. Leaflet, 30 March 1969, MoMA Library, "AWC" file.

5. "Statement by Bates Lowery, Director, The Museum of Modern Art," 30 March 1969, MoMA handout, n.p., MoMA Library, "AWC" file.

6. See leaflet, 30 March 1969; also see Robert Windeler, "Modern Museum Protest Target," *New York Times,* 31 March 1969, 33.

7. The MoMA Library's "AWC" file documents these plans and meetings. Also see Women Artists in Revolution, *A Documentary Herstory of Women Artists in Revolution* (New York: Women Artists in Revolution, 1971).

8. See Schwartz, "Politicalization, III," 69.

9. See Lippard, *Get the Message?;* "Ars Gratia Artis?" *Newsweek,* 9 February 1975, 80.

10. GAAG was a committee within the AWC and Jon Hendricks and Jean Toche were its primary members. Virginia Toche, Poppy Johnson, and Joanne Stamerra also were often involved. The November 18 action was done by Hendricks, Toche, Johnson, and Silvianna, a member of the AWC who participated in this GAAG action only. According to Jon Hendricks, GAAG created "actions," not performance art, and he stressed the political engagement of the activity (interview with author, September 1994). For a history of GAAG, see Guerrilla Art Action Group, *GAAG, The Guerrilla Art Action Group, 1969–1976; A Selection* (New York: Printed Matter, 1978); see also Lippard, *Get the Message?;* "Ars Gratia Artia?"

11. McShine, *Information,* 187.

12. Details of the AWC poster meeting and committee were taken from the author's interview of Irving Petlin, 4 November 1993, and two interviews of Hans

Haacke, October 1993, as well as "Ars Gratia Artis" and sources listed in note 2 above.

13. "The Museum and the Protest Poster," Museum of Modern Art press release, 9 January 1970, 3, 4, "AWC" file.

14. "Ars Gratia Artis."

15. Petlin, interview.

16. For background on these events, see sources in note 2 above as well as Maurice Berger, *Labyrinths: Robert Morris, Minimalism, and the 1960s* (New York: Harper and Row, 1989), 107–114.

17. The film was edited by Erik Barnouw and Paul Ronder for the Columbia University Press. See press release, the Museum of Modern Art, 21 May 1970, 1, MoMA Library, "AWC" file.

John Hightower, MoMA's director, made the impolitic statement that the artists' action put them "in the same position of Hitler in the thirties and forties and Stalin in the fifties—and more recently, the Soviet repression of free expression in Czechoslovakia. . . . I cannot help but think those people in the United States who are most responsible for repression would be delighted by the action you are taking for them. . . . I can only urge you not to be guilty of the same repression you are striving so hard to resist" (quoted in Grace Glueck, "500 in Art Strike Sit on Steps of Metropolitan," *New York Times,* 23 May 1970, 19).

18. Baker, "Pickets on Parnassus," 32.

19. For background on these events see ibid. and Schwartz, "Politicalization, I," as well as Lawrence Alloway, " 'Reality': Ideology at D5," *Artforum* 11, no. 2 (October 1972), 30–36; Aracy Amaral, "Art Abroad Sao Paulo: The Bienal Boycott," *Arts Magazine* 44, no. 5 (March 1970), 48–49; Gregory Battcock, "Art and Politics at Venice: A Disappointing Biennale," *Arts Magazine* 45, no. 1 (September/October 1970), 22; and Grace Glueck, "Foes of Biennale Open Show Here," *New York Times,* 25 July 1970, 20.

20. See Schwartz, "Politicalization, I," 102, 103.

21. "Information" press release, no. 69, 1 July 1970, 2–3, MoMA Library, "AWC" file. Kynaston McShine joined the Museum staff as a research assistant in 1959 and was an associate curator at the time of the *Information* show.

22. McShine, *Information*, 1.

23. *Live in Your Head: When Attitudes Become Form: works-concepts-processes-situations-information* was held at the Kunsthalle Berne in the spring of 1969; it opened simultaneously with *Op Losse Schroeven: Situaties en cryptostructuren,* held at the Stedelijk Museum, Amsterdam, and *Project '69,* held in the fall of that year at Stadische Kunsthalle, Dusseldorf. See Philip Morris Europe, *Live in Your*

Head: When Attitudes Become Form: Works-Concepts-Processes-Situations-Information; Wenn Attituden Form Werden: Werke-Konzepte-Prozesse-Situationen-Information; Quand Les Attitudes Deviennent Forme: Oeuvres-Concepts-Processus-Situations-Information; Quando Attitudini Diventano Forma: Opere-Concetti-Processi-Situazioni-Informazione, Harold Szeemann, ex. cat. Kunsthalle, Berne [London, 1969]; and Wim Beeren, *Op Losse Schroeven: situaties en cryptostructuren,* ex. cat. (Amsterdam: Stedlijk Museum, 1969).

24. Lucy Lippard, interview with author, 13 October 1993.

Lippard was one of six women who produced individual projects for the catalogue; others included Hanne Darboven, Yoko Ono, and Yvonne Rainer. Obviously, women were underrepresented in the catalogue and exhibition.

25. See MoMA Photographic Archives: *Information,* MoMA Exhibition #934. Proposals for pieces are in the MoMA Archives: Records of the Registrar Department, *Information,* MoMA Exhibition #934. Many of these were published in the catalogue.

26. Another feature of this reconfiguring aesthetic apparatus that was taking place during the late 1960s and early 1970s was the professionalization of the exhibition design field. United States museums began hiring in-house exhibition designers. Although MoMA has never done this, since the 1990s it has had a department of exhibition design and production. See chapter 2, note 119.

27. Haacke, interviews.

28. Ibid.

29. See, for example, Robert D. McFadden, "Governor Takes 'Strong' Peace Stand," *New York Times,* 28 June 1970, 28.

30. Haacke also recalls reading "a report in the *New York Times,* according to which someone had raised the question of Rockefeller's Vietnam policy. Either he or his spokesperson said that his advisors had not yet quite figured out what the political fallout would be for him if he came down on one side or the other. He wanted to see which way the wind would blow, and he didn't want to commit himself. I don't remember whether this article appeared prior to the opening of the show or after" (interview).

31. Haacke, interview. A sampling of some of the protest materials is in the MoMA Library, "AWC" file.

32. McShine, *Information*, 5.

33. Ibid., 49, 48.

34. Lindsy Van Gelder, "Oppressed? Dial 956–7032," *New York Post,* 4 September 1970, 2.

35. This statement is at the beginning of the notebooks, which are stored at the John Weber Gallery, New York City.

36. McShine, *Information,* 142–143.

37. Ibid., 181.

38. I found no mention of the poster in the *Information* press coverage. None of those interviewed about the show recalled any response to the poster's appearance: McShine, interview with author, 14 October 1993; April Kingsley, interview with author, 15 October 1993; Haacke and Petlin, interviews.

39. See Emily Genauer, "Art and the Artists," *New York Post,* 11 July 1970, 37.

40. See *Information* press release, 1 July 1970.

41. Architect and designer Bernard Rudofsky curated and installed the exhibition, which was held at the Museum from 28 November 1944 to 4 March 1945; see *Museum of Modern Art Bulletin* 12, no. 3 (January 1945), 12–15.

42. This sign is visible in the installation photographs in MoMA Photographic Archives: *Information,* MoMA Exhibition #934.

43. Jennifer Licht, *Spaces,* ex. cat. (New York: Museum of Modern Art, 1969). This exhibition was created with the assistance of Charles Froom, MoMA's production manager.

44. Gregory Battcock, "The Politics of Space," *Arts Magazine* 44, no. 4 (February 1970), 42–43.

45. Among the first Museum of Modern Art exhibitions to be underwritten by corporations were *Four Americans in Paris: The Collections of Gertrude Stein and Her Family,* 19 December 1970 to 1 March 1971, which was supported by Alcoa; *African Textiles and Decorative Arts,* 3 October 1972 to 31 January 1973, which was supported by Exxon Corporation; *Drawings from the Kroller-Muller National Museum, Otterlo,* 24 May to 19 August 1973, which was supported by Heineken Breweries, Van Munching and Co., Inc., Algemene Bank Netherlands, N.V., and KLM Royal Dutch Airlines.

46. For a history of Philip Morris's support of the arts as well as an overview of the development of corporate underwriting of the arts, see Sam Hunter, *Art in Business: The Philip Morris Story* (New York: Harry N. Abrams, 1979), and the pamphlet *Philip Morris and the Arts* (n.p.: Philip Morris Companies, 1986).

47. Philip Morris Europe, *Live in Your Head.*

48. The critical press included Hilton Kramer, "Show at the Modern Raises Question," *New York Times* 2 July 1970, 26, and "Miracle, 'Information,' 'Recommended Reading,'" *New York Times,* 12 July 1970, sec. 2, p. 19; Carter Ratcliff, "New York Letter," *Art International* 14, no. 7 (September 1970), 95; David Shapiro, "Mr. Processionary at the Conceptacle," *Art News* 69, no. 5 (September 1970), 58–61. A very mixed reading was given by Emily Genauer in "Art and the Artist," an article that was syndicated and published in papers such as the New Haven, Connecticut, *Register* and the *International Herald Tribune;* see MoMA Library, *Information* file, MoMA Exhibition #934. The more sympathetic press included Gregory Battcock, "Information Exhibition at the Museum of Modern Art," *Arts Magazine* 44, no. 8 (Summer 1970), 24–27; Douglas Davis, "Information Press," *Newsweek,* 20 July 1970, 47; John Gruen, "New Worlds to Conquer," *New York Magazine,* 6 July 1970, 65.

49. Kramer, "Miracle, 'Information.'"

Chapter 6
Conclusion

Chapter epigraph: Dennis Adams, interview with author, October 1993.

1. Russell Lynes, *Good Old Modern: An Intimate Portrait of the Museum of Modern Art* (New York: Atheneum, 1973), 291.

2. A. Conger Goodyear, *The Museum of Modern Art: The First Ten Years* (New York: A. Conger Goodyear, 1943) 83–84.

3. See MoMA Library Archives, "List of Exhibitions at The Museum of Modern Art." These installations, of course, have always been subject to later revisions. For a detailed account of this aspect of MoMA's history, see Kirk Varnedoe, "The Evolving Torpedo: Changing Ideas of the Collection of Painting and Sculpture of The Museum of Modern Art," in *Studies in Modern Art,* vol. 5, *The Museum of Modern Art at Mid-Century, Continuity and Change,* series ed. John Elderfield (New York: Museum of Modern Art; dist. New York: Harry N. Abrams, 1995), 12–73.

4. Peter Blake, "The House in the Museum Garden: Marcel Breuer, Architect; Grounds and Interiors Also Designed by the Architect," *Museum of Modern Art Bulletin* 15, no. 4 (1948), 3.

5. The *Projects* series became primarily video presentations in the late 1970s, was discontinued in 1981, and then was reestablished in 1986.

6. Adams constructed his installation by using the same images that Steichen used to create *Road to Victory.* Adams selected images from the National Archives, Washington, D.C. Interview with author, October 1993.

7. Ibid.

8. Ibid.

9. For a more in-depth discussion of these issues, see Mary Anne Staniszewski, "The Architecture of Amnesia," in *Dennis Adams: The Architecture of Amnesia,* ex. cat. (New York: Kent Fine Art, 1990), 5–13.

10. The curatorial responsibilities for the Dennis Adams exhibition were somewhat dispersed. Initially, Wendy Weitman, associate curator in the Department of Prints and Illustrated Books, proposed the exhibition. When the exhibitions committee approved and scheduled the show, Laura Rosenstock, assistant curator in the Department of Painting and Sculpture, was designated curator. Laura Rosenstock, interview with author, 23 January 1997.

11. Another element of Lawler's *Project Room* was a pamphlet created by the artist similar to the type of museum paraphernalia that often accompanies an exhibition. (There also a traditional handout, written by curator Cora Rosevear.) Lawler's small publication made reference to the U.S. military's billion-dollar investment in dismantling the government in Nicaragua and to what she described as "enhancements" such as the color-coordinated straws and napkins of MoMA's cafeteria that foster a "distance," a "cleanliness from reality." The pamphlet, printed with the words "Did you take this airplane home?," had instructions on how the visitor could fold it to turn it into a paper plane. Lawler has said she was interested in the "construction of audiences"; she was trying to make visitors aware of the conventional boundaries of viewer expectations and experiences by pointing to details of institutional design that enhance the given framework and by referring to social and political issues beyond the walls of the Museum. Louise Lawler, interview with the author, 24 July 1997.

12. For a brief review of some of the innovative installations of the 1980s and early 1990s, see Mary Anne Staniszewski, "Introduction: Installation Design: The Political Unconscious of Art Exhibitions," in "Designing Modern Art and Culture: A History of Exhibition Installations at the Museum of Modern Art" (Ph.D. diss., City University of New York, 1995), 1–19.

13. Lisa Phillips, *Frederick Kiesler,* ex. cat. (New York: Whitney Museum of American Art, in association with W. W. Norton, 1989). Another more conventional installation was created by curator Dieter Bogner for the show's presentation in Vienna; Dieter Bogner et al., *Frederick Kiesler: Architek, Maler, Bildhauer, 1890–1965,* ex. cat., Vienna Museum Moderner Kunst (Vienna: Locker Verlag, 1988).

14. *On the Passage of a Few People through a Rather Brief Moment in Time: The Situationist International, 1957–1972,* ed. Elisabeth Sussman, ex. cat., Institute of Contemporary Art, Boston (Cambridge, Mass.: MIT Press, 1989). In addition to the Boston installation, the exhibition traveled to the Musée national d'art moderne, Paris, 21 February to 9 April 1989, and the Institute of Contemporary Arts, London, 23 June to 13 August 1989.

15. Paul Wood et al., *The Great Utopia: The Russian and Soviet Avant-Garde, 1915–1932,* ex. cat., Solomon R. Guggenheim Museum, New York, State Tret'iakov Gallery, Moscow; State Russian Museum, St. Petersburg; and Schirn Kunsthalle Frankfurt (New York: Guggenheim Museum; dist. New York: Rizzoli, 1992). In addition to the Guggenheim installation, 25 September to 15 December 1992, the show was installed at the Schirn Kunsthalle, Frankfurt, 1 March to 10 May 1992, and the Stedelijk Museum Amsterdam, 5 June to 23 August 1992.

16. Eberhard Roters, Bernhard Schulz, et al., *Stationen der Moderne: Die bedeutenden Kunstausstellungen des 20. Jahrhunderts in Deutschland,* ex. cat. (Berlin: Berlinische Galerie, 1989). The conception of this exhibition was by Roters and Schulz; Lorenz Dombois designed the re-creation of *Documenta II* and Michael Sellmann and Hanns-Rudolf von Wild that of the *First International Dada Exhibition.*

17. See Matilda McQuaid, with an essay by Magdalena Droste, *Lilly Reich: Designer and Architect,* ex. cat. (New York: Museum of Modern Art; dist. New York: Harry N. Abrams, 1996).

18. Barbara Kruger, interview with author, October 1993.

19. The exhibition wall label is visible in installation photographs in the MoMA Photographic Archive: *Picturing Greatness,* MoMA Exhibition #1472.

20. Robert Storr, *Dislocations,* ex. cat. (New York: Museum of Modern Art; dist. New York: Harry N. Abrams, 1991), 18, and Kynaston McShine, *Information* press release, 2 July 1970, 2.

21. Bringing the "outside inside" was the way artist Muntadas described the Hammons installation to me during the opening of the *Dislocations* show.

22. Robert Storr, *Dislocations,* ex. pamphlet (New York: Museum of Modern Art, 1991), 1.

Bibliography

Archives and Their Abbreviations

American Museum of Natural History, New York. Special Collections, Photographic Archive.

Alfred H. Barr, Jr. Papers, The Museum of Modern Art Archives, New York, placed on film by the Archives of American Art, Smithsonian Institution, Washington, D.C. Cited as MoMA Archives: AHB Papers (AAA: reel #; frame #).

René d'Harnoncourt Papers, The Museum of Modern Art Archives, New York. Cited as MoMA Archives: RdH Papers.

Metropolitan Museum of Art, New York. Photograph and Slide library.

The Museum of Modern Art, New York. Activities of the International Program. Cited as MoMA Archives: Records of the International Program.

The Museum of Modern Art, New York. Photographic Archives. Cited as MoMA Photographic Archives.

The Museum of Modern Art, New York. Public Information Scrapbooks. Cited as MoMA Archives: Public Information Scrapbook [no.].

The Museum of Modern Art, New York. Records of the Department of Circulating Exhibitions. Cited as MoMA Archives: CE, *Exhibition Title*, series #.#/box # (#).

The Museum of Modern Art, New York. Records of the Department of International Circulating Exhibitions. Cited as MoMA Archives: Records of the Department of International Circulating Exhibitions, SP-ICE-#-#.

The Museum of Modern Art, New York. Records of the Registrar Department. Cited as Records of the Registrar Department, *Exhibition*, MoMA Exhibition #XXX.

The Museum of Modern Art Library, New York. Subject files. Cited as MoMA Library, "Subject title" file.

The Museum of Primitive Art non-art collections, Department of the Arts of Africa, Oceania, and the Americas. The Metropolitan Museum of Art, New York.

Edward Steichen Archives, The Museum of Modern Art, New York. Cited as Edward Steichen Archives.

Works Cited

For citations of newspaper articles, see notes.

Adorno, Theodor W. *Aesthetics and Politics*. London: New Left Books, 1977.

Adorno, Theodor W., and Max Horkheimer. *Dialectic of Enlightenment,* trans. John Cummings. 1944. Reprint, New York: Continuum, 1972.

Alfieri, Dino, and Luigi Freddi, eds. *Mostra della Rivoluzione Fascista: Guida Storica.* Ex. cat. Rome: Partito Nazionale Fascista, 1932.

Alloway, Lawrence. "Art." *Nation*, 19 October 1970, 38.

———. " 'Reality': Ideology at D5." *Artforum* 11, no. 2 (October 1972), 30–36.

Alloway, Lawrence, David Lewis, and Reyner Banham. *This Is Tomorrow.* Ex. cat. London: Whitechapel Art Gallery, 1956.

Alloway, Lawrence, et al. *Modern Dreams: The Rise and Fall and Rise of Pop,* intro. Edward Leffingwell. Ex. cat., Institute for Contemporary Art, London; Clocktower Gallery, New York. Cambridge, Mass.: MIT Press, 1988.

Altshuler, Bruce. *The Avant-Garde in Exhibition: New Art in the Twentieth Century.* New York: Harry N. Abrams, 1994.

Amaral, Aracy. "Art Abroad Sao Paulo: The Bienal Boycott." *Arts Magazine* 44, no. 5 (March 1970), 48–49.

"American Anthropological Association Resolution on Racial Theories." *American Anthropologist* 31 (1939), 303. Reprinted in *Selected Papers from the American Anthropologist,* ed. George W. Stocking (Washington, D.C.: American Anthropologist Association, 1976), 467.

American Museum of Natural History. *The American Museum of Natural History: 74th Annual Report for the Year 1942* (1 May 1942). New York: American Museum of Natural History, 1942.

———. *The American Museum of Natural History: 76th Annual Report for the Year 1944* (1 May 1945). New York: American Museum of Natural History, 1944.

———. *The Reopening of the Mexican and Central American Hall*. Pamphlet. New York: American Museum of Natural History, 1944.

Andel, Jaroslav. "The Constructivist Entanglement: Art into Politics, Politics into Art." In *Art into Life: Russian Constructivism, 1914–1932,* 223–239. Ex. cat. Seattle: Henry Art Gallery, University of Washington; New York: Rizzoli, 1990.

Anderson, John. "The Family of Man," *Interiors* 114, no. 9 (April 1955), 114.

Army Map Service. "Arms and the Map: Military Mapping by the Army Map Service." *Print, a Quarterly Journal of the Graphic Arts* 4, no. 2 (Spring 1946), 3–16.

Aronovici, Carol, ed. *America Can't Have Housing.* Ex. cat. New York: Museum of Modern Art, 1934.

"Ars Gratia Artis?" *Newsweek,* 9 February 1975, 80.

Art/Artifact: African Art in Anthropology Collections, intro. Susan Vogel, essays by Arthur Danto et al. Ex. cat. New York: Center for African Art; Munich: Prestel Verlag, 1989.

Art into Life: Russian Constructivism, 1914–1932, intro. Richard Andrews and Milena Kalinovska, essays Jaroslav Andel et al. Ex. cat. Seattle: Henry Art Gallery, University of Washington; New York: Rizzoli, 1990.

Art Workers Coalition Leaflet, 30 March 1969. [New York: AWC, 1969.]

"Arts of the South Seas." *Architectural Forum* 84, no. 5 (May 1946), 97–104.

Baker, Elizabeth C. "Pickets on Parnassus." *Art in America* 69, no. 5 (September/October 1970), 30–33, 64–65.

Bann, Stephen. "Poetics of the Museum: Lenoir and Du Sommerard." In *The Clothing of Clio: A Study of the Representation of History in Nineteenth-Century Britain and France,* 77–92. Cambridge: Cambridge University Press, 1984.

———. "Russian Constructivism and Its European Resonance." In *Art into Life: Russian Constructivism, 1914–1932,* 99–116. Ex. cat. Seattle: Henry Art Gallery, University of Washington; New York: Rizzoli, 1990.

Barkan, Elazar. *The Retreat of Scientific Racism: Changing Concepts of Race in Britain and the United States between the World Wars.* Cambridge: Cambridge University Press, 1992.

Barr, Alfred H., Jr. "Brief Analysis of Installation of 'Italian Masters' at the MoMA," ca. 1940. MoMA Archives: AHB Papers (AAA: 3260;354).

———. Preface to *Bauhaus 1919–1928,* ed. Herbert Bayer, Walter Gropius, and Ise Gropius, 7–10. Ex. cat. New York: Museum of Modern Art, 1938.

———. "Chronicle of the Collection of Painting and Sculpture." In *Painting and Sculpture in the Museum of Modern Art, 1929–1967,* 627–643. New York: Museum of Modern Art, 1977. Reprinted in *Studies in Modern Art,* series ed. John Elderfield, vol. 4, *The Museum of Modern Art at Mid-Century at Home and Abroad* (New York: Museum of Modern Art, 1994), 180–201.

———. *Cubism and Abstract Art,* foreword by Robert Rosenblum. 1936. Reprint, Cambridge, Mass.: Press Harvard University Press, Belknap, 1986.

———. *Defining Modern Art: Selected Writings of Alfred H. Barr, Jr.,* ed. Irving Sandler and Amy Newman. New York: Harry N. Abrams, 1986.

———. Foreword to *Modern Architecture: International Exhibition*, by Henry-Russell Hitchcock, Jr., Philip Johnson, and Lewis Mumford, 12–17. Ex. cat. New York: Museum of Modern Art, 1932.

———. "Is Modern Art Communistic?" *New York Times Magazine,* 14 December 1952, 22–23, 28–30. Reprinted in Barr, *Defining Modern Art,* 214–219.

———. "1929 Multidepartmental Plan for the Museum of Modern Art: Its Origins, Development, and Partial Realization." August 1941. MoMA Archives: AHB Papers (AAA: 3266;68–80).

———. "Notes on the Reception of the Bauhaus." Records of the Registrar Department, *Bauhaus 1919–1928,* MoMA Exhibition #82.

———. "Present Status and Future Direction of the Museum of Modern Art" (confidential report for Trustees only). August 1933. MoMA Archives: AHB Papers (AAA: 3266;121–135).

———. *A Tribute: October 8, 1968, Sculpture Garden.* New York: Museum of Modern Art, 1968.

Barr, Alfred H., Jr, Leonard Cox, and William F. Reed. Letters titled "Bauhaus in Controversy." *New York Times,* 25 December 1938, Art sec., p. 12.

Barr, Margaret Scolari. Interview with Paul Cummings, 22 February 1974 and 8 April 1974. Archives of American Art, New York.

———. "Our Campaigns." *Our Campaigns,* special issue of *New Criterion* (1987), 23–74.

Barthes, Roland. "The Great Family of Man." In Barthes, *Mythologies,* 100–102.

———. "Myth Today." In Barthes, *Mythologies,* 109–145.

———. *Mythologies,* trans. Annette Lavers. New York: Hill and Wang, 1972. Originally published in French (Paris: Editions du Seuil, 1957).

Bateson, Gregory. "Arts of the South Seas." *Art Bulletin* 28, no. 2 (June 1946), 199–123.

Battcock, Gregory. "Art and Politics at Venice: A Disappointing Biennale." *Arts Magazine* 45, no. 1 (September/October 1970), 22.

———. "Information Exhibition at the Museum of Modern Art." *Arts Magazine* 44, no. 8 (Summer 1970), 24–27.

———. "The Politics of Space." *Arts Magazine* 44, no. 4 (February 1970), 42–43.

"Bauhaus Criticized." *Art Digest* 13, no. 6 (15 December 1938), 6, 34.

"Bauhaus Defended." *Art Digest* 13, no. 7 (1 January 1939), 8.

"Bauhaus Post Mortem." *Magazine of Art* 32, no. 1 (1 January 1939), 40.

Bayer, Herbert. "Aspects of Design of Exhibitions and Museums." *Curator* 4, no. 3 (1961), 257–288.

———. "Fundamentals of Exhibition Design." *PM (Production Manager)* 6, no. 2 (December 1939–January 1940), 17–25.

———. *Herbert Bayer: Painter, Designer, Architect.* New York: Reinhold, 1967.

———. Interviews with Arthur Cohen, 1981 and 1982. Archives of American Art, Smithsonian Institution, Washington, D.C.

———. "Notes on Exhibition Design." *Interiors and Industrial Design* 61, no. 12 (July 1917), 60–77.

Bayer, Herbert, Walter Gropius, and Ise Gropius, eds. *Bauhaus 1919–1928.* Preface, Alfred H. Barr, Jr.; essay, Alexander Dorner. Ex. cat. New York: Museum of Modern Art, 1938.

Bazin, Germain. *The Museum Age.* Brussels: S. A. Editions; New York: Universe Books, 1967.

Beeren, Wim. *Op Losse Schroeven situaties en cryptostructuren.* Ex. cat. Amsterdam: Stedlijk Museum, 1969.

Bennett, Tony. *The Birth of the Museum: History, Theory, Politics.* London: Routledge, 1995.

Benson, Susan Porter. *Counter Cultures: Saleswomen, Managers, and Customers in American Department Stores, 1890–1940.* Urbana: University of Illinois Press, 1986.

Berger, Maurice. *Labyrinths: Robert Morris, Minimalism, and the 1960s.* New York: Harper and Row, 1989.

Biolsi, Thomas. *Organizing the Lakota: The Political Economy of the New Deal on the Pine Ridge and Rosebud Reservations.* Tucson: University of Arizona Press, 1992.

Bjurström, Per, ed. *The Genesis of the Art Museum in the Eighteenth Century.* Stockholm: Nationalmuseum, 1993.

Black, Misha, ed. *Exhibition Design.* London: Architectural Press, 1950.

Blake, Nelson Manfred. *The Road to Reno.* New York: Macmillan, 1962.

Blake, Peter. "The House in the Museum Garden: Marcel Breuer, Architect; Grounds and Interiors Also Designed by the Architect," *Museum of Modern Art Bulletin* 15, no. 4 (1948), 3.

Boas, Franz. *Race, Language and Culture.* 1910. Reprint, New York: Macmillan, 1940.

Bogner, Dieter. "Kiesler and the European Avant-garde." In *Frederick Kiesler,* ed. Lisa Phillips, 46–55. Ex. cat. New York: Whitney Museum of American Art, in association with W. W. Norton, 1989.

Bogner, Dieter, et al. *Frederick Kiesler: Architekt, Maler, Bildhauer, 1890–1965.* Ex. cat., Vienna Museum Moderner Kunst. Vienna: Locker Verlag, 1988.

Bohan, Ruth L. *The Société Anonyme's Brooklyn Exhibition: Katherine Dreier and Modernism in America.* Ann Arbor, Mich.: UMI Research Press, 1982.

Bois, Yves-Alain. "Exposition: Esthétique de la distraction, espace de démonstration." *Les Cahiers du Musée National d'Art Moderne, supplement catalogue* 5, no. 29 (Autumn 1989), 57–79.

———. "Metamorphosen der Axonometrie/Metamorphosis of Axonometry." *Daidalos: Berlin Architectural Journal,* no. 1 (15 September 1981), 44.

Boswell, Peyton. "Comments: Politicians as Critics." *Art Digest* 21, no. 4 (15 April 1947), 7.

Brisco, Norris A. *Retailing,* foreword by Samuel W. Reyburn. New York: Prentice-Hall, 1935.

Brisco, Norris A., and Leo Arnowitt. *Retailing.* New York: Prentice-Hall, 1942.

Brooks, Tim, and Earle Marsh, eds. *The Complete Directory to Prime Time Network T.V. Shows: 1946–Present.* 4th ed. New York: Ballantine Books, 1988.

Brown, Lloyd A. *The Story of Maps.* 1949. Reprint, New York: Dover Publications, 1977.

Brown, Milton. *The Story of the Armory Show.* New York: Abbeville Press, 1988.

Brünig, Ute. "Typophoto." In *Photography at the Bauhaus,* ed. Jeannine Fiedler, 204–237. Cambridge, Mass.: MIT Press, 1990.

Buchloh, Benjamin H. D. "From Faktura to Factography." *October* 30 (Fall 1984), 82–119.

Bürger, Peter. *Theory of the Avant-Garde,* foreword by Jochen Schulte-Sasse, trans. Michael Shaw. Minneapolis: University of Minnesota Press, 1984.

Caballero-Madrid, E. Giménez. "Lob des Plakates." *Bauhaus* 3, no. 3 (July–September 1929), 8–9.

Campbell, Joseph. *Transformations of Myth through Time.* New York: Harper and Row, 1990.

Cauman, Samuel. *The Living Museum: Experiences of an Art Historian and Museum Director, Alexander Dorner,* intro. Walter Gropius. New York: New York University Press, 1958.

Chanzit, Gwen Finkel. *Herbert Bayer and Modernist Design in America.* Ann Arbor, Mich.: UMI Research Press, 1987.

Chappey, Marcel, ed. *Le XXème Salon des Artistes Décorateurs.* 2 vols. Paris: Vincent Fréal, 1930.

Ciucci, Giorgio. "L'autorappresentazione del fascismo: La mostra del decennale della marcia su Roma." *10 Rassegna (Allestimenti/Exhibit Design)* 4 (June 1982), 48–53.

Clifford, James. "Histories of the Tribal and the Modern." *Art in America* 7, no. 4 (1 April 1985), 164–177. Reprinted in Clifford, *The Predicament of Culture,* 189–214, and in *Discourses: Conversations in Postmodern Art and Culture,* ed. Russell Ferguson et al. (New York: New Museum of Contemporary Art; Cambridge, Mass.: MIT Press, 1990), 408–424.

———. "On Collecting Art and Culture." In Clifford, *The Predicament of Culture,* 215–51.

———. "On Ethnographic Surrealism." In Clifford, *The Predicament of Culture,* 117–151.

———. *The Predicament of Culture: Twentieth-Century Ethnography, Literature, and Art.* Cambridge, Mass.: Harvard University Press, 1988.

Cockcroft, Eva. "Abstract Expressionism, Weapon of the Cold War." *Artforum* 12, no. 10 (June 1974), 39–41.

Cohen, Arthur A. *Herbert Bayer: The Complete Work.* Cambridge, Mass.: MIT Press, 1984.

Collier, Peter, and David Horowitz. *The Rockefellers: An American Dynasty.* New York: Signet, 1977.

Colomina, Beatriz. "Mies Not." Paper to be included in the forthcoming *The Presence of Mies* (Princeton Architectural Press).

———. *Privacy and Publicity: Modern Architecture as Mass Media.* Cambridge, Mass.: MIT Press, 1994.

———, ed. *Sexuality and Space.* New York: Princeton Architectural Press, 1992.

"Common Bond of Man." *Life,* 14 February 1955, 132–143.

Constantine, Mildred. *Sign Language for Buildings and Landscape.* New York: Reinhold, 1961.

Creighton, T. H. "Kiesler's Pursuit of an Idea." *Progressive Architecture* 42 (July 1961), 104–123.

Curtis, William J. R. *Modern Architecture since 1900.* Englewood Cliffs, N.J.: Prentice-Hall, 1982.

D'Amico, Victor. *Experiments in Creative Art Teaching: A Progress Report on the Department of Education 1937–1960.* New York: Museum of Modern Art; Garden City: Doubleday and Company, 1960.

Davidson, Martha. "Epitaph Exhibit of the Bauhaus: Commemoration of a Famous Modern Source of Design." *Art News* 37, no. 11 (10 December 1938), 13, 22.

Davis, Douglas. "Information Press." *Newsweek,* 20 July 1970, 47.

De Hart Mathews, Jane. "Art and Politics in Cold War America." *American Historical Review* 81 (1976), 762–787.

De Mazia, Violette. *The Barnes Foundation: The Display of Its Art Collection.* Merion Station, Pa.: V.O.L.N. Press, 1983.

Degenerate Art: The Fate of the Avant-Garde in Nazi Germany, Stephanie Barron et al. Ex. cat. Los Angeles: Los Angeles County Museum of Art; New York: Harry N. Abrams, 1991.

"Design for Sport." Section in *Sports Illustrated,* 14 May 1962, 42–61. This special section served as the exhibition catalogue for the Museum of Modern Art show.

"A Design Tour de Force Destroys Walls to Turn Illusion into Reality: Arthur Drexler Reconstructs Architectural Substance in a Totally Blacked-out Gallery." *Interiors* 116, no. 10 (May 1957), 135.

Deutschland Ausstellung 1936. Ex. cat., Berlin. Reprinted as insert in *Gebrauchsgraphik/Advertising Art* 13, no. 4 (April 1936).

Doesburg, Theo van. "The Entry of The Netherlands and Other Pavilions." In *Theo van Doesburg: On European Architecture: Complete Essays from Het Bouwbedrijf 1924–1931,* trans. Charlotte I. Loeb and Arthur L. Loeb, 52. Basel: Birkhauser Verlag, 1986. Originally published as "Het Hollandsche paviljoen op de Exposition des Art Decoratifs te Parijs," *Het Bouwbedrijf* 2, no. 6 (June 1925), 221.

Doordan, Dennis P. *Building Modern Italy: Italian Architecture, 1914–1936.* New York: Princeton Architectural Press, 1988.

Dorner, Alexander. *The Way beyond "Art": The Work of Herbert Bayer,* intro. Walter Gropius. Rev. ed. New York: New York University Press, 1958.

Douglas, Frederic H., and René d'Harnoncourt. *Indian Arts of the United States.* Ex. cat. New York: Museum of Modern Art, 1941.

Drexler, Arthur. "House in the Garden." *Interiors* 113, no. 12 (July 1954), 84–85.

———. *Ludwig Mies van der Rohe.* New York: George Braziller, 1960.

Droste, Magdalena. "Lilly Reich: Her Career as an Artist." In *Lilly Reich: Designer and Architect,* by Matilda McQuaid, 47–59. Ex. cat. New York: Museum of Modern Art; dist. New York: Harry N. Abrams, 1995.

Duchamp, Marcel. "The Richard Mutt Case." *The Blind Man* 2 (May 1917), 5.

Duncan, Carol. *Civilizing Rituals: Inside Public Art Museums.* London: Routledge, 1995.

Duncan, Carol, and Alan Wallach. "MoMA: Ordeal and Triumph on 53rd Street." *Studio International* 194, no. 988 (1978), 48–57.

———. "The Museum of Modern Art as Late Capitalist Ritual: An Iconographic Analysis." *Marxist Perspectives* 1, no. 4 (Winter 1978), 28–51.

———. "The Universal Survey Museum." *Art History* 3 (December 1980), 447–469.

"Elvis: Story of a Legend." Originally titled "Elvis Presley." Arts and Entertainment Network, 1993.

Eskildsen, Ute. "Exhibits." In *Avant-garde Photography in Germany, 1919–1939,* 35–46. Ex. cat. San Francisco: Museum of Modern Art, 1980.

"The Esthetic Discipline: A Traditional Japanese House." *Progressive Architecture* 35, no. 12 (December 1954), 108–113.

Etlin, Richard A. *Modernism in Italian Architecture, 1890–1940.* Cambridge, Mass.: MIT Press, 1991.

"The Exhibition: Sixty Photographs." *Museum of Modern Art Bulletin* 7, no. 2 (December–January 1940–1941), 5.

Exposición Internacional de Barcelona. Ex. cat. Barcelona: Seix y Barral, 1929.

Exposition Internationale des Arts Décoratifs et Industriels Modernes: Catalogue Général Officiel. Ex. cat. Paris: Grand Palais, 1925.

F., J. "Parking Space for 8 Automobiles." *Interiors* 111, no. 2 (September 1951), 124–125.

The Face in the Crowd, dir. Kazan, Elia, 1957.

Family of Man. N.d. Dir. unknown, prod. U.S. Information Service. Film of Corcoran Gallery Installation [1956].

Family of Man. 1955. Dir. Robert Squier, prod. Stanton Catlin, Philip Gelb, and Robert Squier. Minneapolis Institute of Arts. Film of Minneapolis Institute of Arts installation.

Family of Man. 1956. Dir. Joseph Scibetta, prod. Robert Northshield. New York, CBS. Film of MoMA installation.

"The Family of Man." *Popular Photography* 36, no. 5 (May 1955), 80–88, 147–49.

" 'The Family of Man.' " *Vogue,* 1 February 1955, 168.

Feest, Christian F. "From North America." In *"Primitivism" in Twentieth Century Art: Affinity of the Tribal and the Modern,* ed. William Rubin, 1:84–97. Ex. cat. New York: Museum of Modern Art, 1984.

Fiedler, Jeannine, ed. *Photography at the Bauhaus.* Cambridge, Mass.: MIT Press, 1990.

Finkelpearl, Thomas, Brian Wallis, et al. *This Is Tomorrow Today: The Independent Group and British Pop Art.* Ex. cat., Clocktower Gallery, New York. Long Island City, N.Y.: Institute for Art and Urban Resources, 1987.

Fioravanti, Gigliola. *Partitio Nazionale Fascista Mostra della Rivoluzione Fascista.* Rome: Archivio Centrale dello Stato, 1990.

Fisher, Alan. "*PM: PM* Photographer Agrees with Moses about Museums . . . After Comparing the Metropolitan with the Museum of Modern Art." *PM,* 5 March 1941, 18–19.

Flacke-Knoch, Monica. *Museumkonzeptionen in der Weimarer Republik: Die Tätigkeit Alexander Dorners im Provinzialmuseum Hannover.* Marburg: Jonas, 1985.

"For Your Information." *Interiors* 114, no. 7 (February 1955), 12.

Frampton, Kenneth. *History of Modern Architecture.* 1980; rev. ed. London: Thames and Hudson, 1985.

Franciscono, Marcel. *Walter Gropius and the Creation of the Bauhaus in Weimar: The Ideals and Artistic Theories of Its Founding Years.* Urbana: University of Illinois Press, 1971.

Fraser, Steven, ed. *The Bell Curve Wars: Race, Intelligence, and the Future of America.* New York: Basic Books, 1995.

Friedan, Betty. *The Feminine Mystique.* 1963. Reprint, New York: Dell, 1983.

Ghirardo, Diane Yvonne. "Italian Architects and Fascist Politics: An Evaluation of the Rationalist's Role in Regime Building." *Journal of the Society of Architectural Historians* 39, no. 2 (May 1980), 109–134.

Giedion, Sigfried. "Live Museum." In *El Lissitzky: Life, Letters, Texts,* by Sophie Lissitzky-Küppers, trans. Helene Aldwinckle and Mary Whittall, 383. 1967; rev. ed. London: Thames and Hudson, 1980. Originally published in *Der Cicerone* 21, no. 4 (1929), 105–106.

Goldwater, Robert. *Primitivism in Modern Art,* enlarged ed. Cambridge, Mass.: Harvard University Press, Belknap Press, 1986. First published as *Primitivism in Modern Painting* (New York: Harper and Brothers, 1938).

Goldwater, Robert, in collaboration with René d'Harnoncourt. *Modern Art in Your Life.* New York: Museum of Modern Art, 1949. (Also published as *Bulletin of the Museum of Modern Art* 17, no. 1 [1949].)

———. *Modern Art in Your Life.* 2nd ed. New York: Museum of Modern Art, 1953.

Good Design. Ex. pamphlet. Chicago: Merchandise Mart; New York: Museum of Modern Art, 1953.

Good Design: A Joint Program to Stimulate the Best Modern Design of Home Furnishings. Ex. pamphlet. Chicago: Merchandise Mart; New York: Museum of Modern Art, 1950.

" 'Good Design' in Chiaroscuro: Paul Rudolph Designs the Mart's Third Exhibition." *Interiors* 111, no. 8 (March 1952), 130.

"Good Design 1952: Paul Rudolph's Installation Gets Raves." *Architectural Record* 111, no. 3 (March 1952), 26.

"Good Design 1953: First Installment of a Photographic Record," foreword by Edgar Kaufman, Jr. *Interiors* 112, no. 7 (February 1953), 85.

Goodman, Cynthia. "The Art of Revolutionary Display Techniques." In *Frederick Kiesler,* ed. Lisa Phillips, 57–83. Ex. cat. New York: Whitney Museum of American Art, in association with W. W. Norton, 1989.

Goodyear, A. Conger. *The Museum of Modern Art: The First Ten Years.* New York: A. Conger Goodyear, 1943.

Graff, Werner. *Es kommt der neue Fotograf!* Berlin: Hermann Reckendorf, 1929.

Gramly, R. M. "Art and Anthropology on a Sliding Scale." In *Art/Artifact: African Art in Anthropology Collections,* 33–40. Ex. cat. Center for African Art. New York: Center for African Art; Munich: Prestel Verlag, 1989.

The Great Utopia: The Russian and Soviet Avant-Garde, 1915–1932, Paul Wood et al. Ex. cat., Solomon R. Guggenheim Museum, New York; State Tret'iakov Gallery, Moscow; State Russian Museum, St. Petersburg; and Schirn Kunsthalle Frankfurt. New York: Solomon R. Guggenheim Museum; dist. New York: Rizzoli International, 1992.

Greenberg, Clement. "Avant-Garde and Kitsch" (1939). In *Art and Culture,* 3–21. Boston: Beacon Press, 1961.

Greenberg, Reesa, Bruce W. Ferguson, and Sandy Nairne, eds. *Thinking about Exhibitions.* London: Routledge, 1996.

Gregotti, Vittorio. *New Directions in Italian Architecture,* trans. Giuseppina Salvadori. New York: Braziller, 1968.

Gruen, John. "New Worlds to Conquer." *New York Magazine,* 6 July 1970, 65.

Gueft, Olga. "3 Judgments Prophetic and Influential, The Merchandise Mart's Exhibition, The AID's Awards, and The Museum of Modern Art's Competition." *Interiors* 109, no. 8 (March 1950), 86.

Guerrilla Art Action Group. *GAAG, the Guerrilla Art Action Group, 1969–1976: A Selection.* New York: Printed Matter, 1978.

Guilbaut, Serge. *How New York Stole the Idea of Modern Art: Abstract Expressionism, Freedom, and the Cold War.* Trans. Arthur Goldhammer. Chicago: University of Chicago Press, 1983.

Gunther, Sonia. *Lilly Reich, 1885–1947.* Stuttgart: Deutsche Verlag-Anstalt, 1988.

Hairon, Charles. *Société des Artistes Décorateurs: Catalogue du 20e Salon.* Ex. cat. Paris: Grand Palais des Champs-Elysées, 1930.

Halberstam, David. *The Fifties*. New York: Villard Books, 1993.

Hambourg, Maria Morris, and Christopher Phillips. *The New Vision: Photography between the World Wars*. Ex. cat. New York: Metropolitan Museum of Art; dist. New York: Harry N. Abrams, 1989.

Hamlin, Talbot F. "Architecture, People, and the Bauhaus." *Pencil Points* 20, no. 1 (1 January 1939), 3–6.

Harnoncourt, René d'. "Foreword: The Museum of the Future." To "Profile: The Museum of Modern Art." *Art in America* 52, no. 1 (February 1964), 25.

———. "Living Arts of the Indians." *Magazine of Art* 34, no. 2 (19 February 1941), 72.

Harper's Bazaar [Fashion photo feature using MoMA Japanese Exhibition House]. October 1954, 136–139.

Hays, K. Michael. *Modernism and the Posthumanist Subject*. Cambridge, Mass.: MIT Press, 1992.

Held, R. L. *Endless Innovation: Frederick Kiesler's Theory and Scenic Design*. 1977. Reprint, Ann Arbor, Mich.: UMI Research Press, 1982.

Hellman, Gregory T. "Profiles: Imperturbable Noble." *New Yorker*, 7 May 1960, 49–112.

Hemken, Kai-Uwe. "Pan-Europe and German Art: El Lissitzky at the 1926 Internationale Kunstausstellung in Dresden." In *El Lissitzky, 1890–1941: Architect, Painter, Photographer, Typographer*, 46–55. Ex. cat. Eindhoven: Municipal Van Abbemuseum, 1990.

Hendrickson, Robert. *The Grand Emporiums: The Illustrated History of America's Great Department Stores*. New York: Stein and Day, 1979.

Herbert, Robert L., Eleanor S. Apter, and Elise K. Kennedy, eds. *The Société Anonyme and the Dreier Bequest at Yale: A Catalogue Raisonné*. New Haven: Yale University Press, 1984.

Herrnstein, Richard J., and Charles Murray. *The Bell Curve: Intelligence and Class Structure in American Life*. New York: Free Press, 1994.

Hight, Eleanor M. "Encounters with Technology: Moholy's Path to the 'New Vision.'" In *Moholy-Nagy: Photography and Film in Weimar Germany*, 39–45. Ex. cat. Wellesley, Mass.: Wellesley College Museum, 1985.

Highwater, Jamake. "Controversy in Native American Art." In *The Arts of the North American Indian: Native Traditions in Evolution*, ed. Edwin L. Wade, 221–242. New York: Hudson Hills Press, 1986.

"Historic ABCs." *Time*, 19 December 1938, 30.

Hitchcock, Henry-Russell, and Philip Johnson. *The International Style: Architecture since 1922*. New York: W. W. Norton, 1932.

Hochman, Elaine S. *Architects of Fortune: Mies van der Rohe and the Third Reich*. New York: Weidenfeld and Nicolson, 1989.

Holst, Niels von. *Creators, Collectors, and Connoisseurs: The Anatomy of Artistic Taste from Antiquity to the Present Day*, intro. Herbert Read. New York: G. P. Putnam's Sons, 1967.

Honey, Sandra, et al., *Mies van der Rohe: European Works*. London: Academy Editions; New York: St. Martin's Press, 1986.

"How Good Is Good Design? Consumers Speak." *Architectural Record* 111, no. 1 (January 1952), 22.

Hunter, Sam. *Art in Business: The Philip Morris Story*. New York: Harry N. Abrams, 1979.

Internationale Ausstellung Barcelona 1929: Deutsche Abteilung. Ex. cat. Berlin: Reichsdruckerei, 1929.

International Theatre Exposition org. Frederick Kiesler and Jan Heap. Ex. cat. Theater Guild, Provincetown Playhouse, Neighborhood Playhouse, Greenwich Village Theatre, and the Little Review. New York: Little Review, 1926.

Jacoby, Russell, and Naomi Glauberman, eds. *The Bell Curve Debate: History, Documents, Opinions*. New York: Times Books, 1995.

Johnson, Philip. "Architecture in the Third Reich." *Hound and Horn* 7 (October–December 1933), 137–139. Reprinted in *Philip Johnson: Writings*, 53.

———. "The Berlin Building Exposition of 1931." *T-Square* 2, no. 1 (January 1932), 17–19, 36–37. Reprinted in *Oppositions* 2 (January 1974), 83–85.

———. "In Berlin: Comment on Building Exposition." *New York Times*, 9 August 1931, sec. 8, p. 5. Reprinted in *Philip Johnson: Writings*, 49.

———. *Mies van der Rohe*. Ex. cat. New York: Museum of Modern Art, 1947.

———. *Philip Johnson: Writings*, foreword Vincent Scully, intro. Peter Eisenman, commentary Robert A. M. Stern. New York: Oxford University Press, 1979.

Jones, Anna Laura. "Exploding Canons: The Anthropology of Museums." *Annual Review of Anthropology* 22 (1993), 201–220.

Joselit, David. "The Postwar Product: The ICA's Department of Design in Industry." In *Dissent: The Issues of Modern Art in Boston,* 94–105. Ex. cat. Boston: Institute of Contemporary Art; dist. Boston: Northeastern University Press, 1985.

"junkerskoje 'gas un wasser.'" *Bauhaus* 3, no. 3 (July–September 1929), 1.

Kantor, Sybil Gordon. "Alfred H. Barr, Jr., and the Establishment of the Culture of Modernism in America." Ph.D. diss., City University of New York, 1993.

Kaplan, Flora E. S. *Museums and the Making of "Ourselves": The Role of Objects in National Identity.* London: Leicester University Press, 1994.

Karp, Ivan, and Steven D. Lavine, eds. *Exhibiting Cultures: The Poetics and Politics of Museum Display.* Washington, D.C.: Smithsonian Institution Press, 1990.

Kaufmann, Edgar, Jr. *Good Design.* Ex. pamphlet. Chicago: Merchandise Mart; New York: Museum of Modern Art, 1950.

Kaufmann, Edgar, Jr. and Finn Juhl. "Good Design '51 as Seen by Its Director and by Its Designer." *Interiors* 110, no. 8 (March 1951), 100.

Keller, Ulrich. "Photographs in Context." *Image* 19, no. 4 (December 1976), 1–12.

Kennedy, John Michael. "Philanthropy and Science in New York City: The American Museum of Natural History, 1868–1968." Ph.D. diss., Yale University, 1968.

Kiesler, Frederick. "L'architecture élémentarisée." *De Stijl* 7, nos. 79–84 (1927), 101–102.

———. "Ausstellungssystem: Leger und Trager." *De Stijl* 6, nos. 10–11 (1925), 137–140.

———. *Contemporary Art Applied to the Store and Its Display.* New York: Brentano's, 1930.

———. "Frederick Kiesler 1923–64." *Zodiac* 19 (1969), 19–26.

———. "Manifest: Vitalbau-Raumstadt-Funktionnelle-Architektur." *De Stijl* 6, nos. 10—11 (1925), 141–147.

———. "On Correalism and Biotechnique: Definition and Test of a New Approach to Building Design." *Architecture Record* 86, no. 3 (September 1939), 60–75.

———. "Second Manifesto of Correalism." *Art International* 9, no. 2 (March 1965), 16–17.

———. "Die Stadt in der Luft." *G* [Gestaltung] 5 (April 1926), n.p.

———, ed. *Internationale Ausstellung neuer Theatertechnik.* Ex. cat. Konzerthaus. Vienna: Wurthle und Sohn, 1924.

Kimmelman, Michael. "Revisiting the Revisionist: The Modern, Its Critics, and the Cold War." In *Studies in Modern Art,* series ed. John Elderfield. Vol. 4, *The Museum of Modern Art at Mid-Century at Home and Abroad,* 38–55. New York: Museum of Modern Art, 1994.

Kramer, Hilton. "Exhibiting the Family of Man." *Commentary,* October 1955, 364.

———. "Month in Review." *Arts* 31, no. 8 (May 1957), 43.

Laidlaw, Christine Wallace. "The Metropolitan Museum of Art and Modern Design, 1917–1929." *Journal of Decorative and Propaganda Arts, 1875–1945,* no. 8 (Spring 1988), 88–103.

Lamoureux, Johanne. "Exhibitionitis: A Contemporary Museum Ailment." In *Theatergarden Bestiarium: The Garden as Theater as Museum,* 114–127. Cambridge, Mass.: MIT Press, 1990.

Lasch, Christopher. "The Cultural Cold War: A Short History of the Congress for Cultural Freedom." In *Towards a New Past: Dissenting Essays in American History,* 322–359. New York: Pantheon Books, 1968.

Lawrence, Sidney. "Clean Machine at the Modern." *Art in America* 72, no. 2 (February 1984), 135.

Leering, Jean. "Lissitzky's Importance Today." In *El Lissitzky,* by Sophie Lissitzky-Küppers et al., 34–46. Ex. cat. Cologne: Galerie Gmurzynska, 1976.

Leider, Philip. "How I Spent My Summer Vacation or Art and Politics in Nevada, Berkeley, San Francisco, and Utah." *Artforum* 9, no. 1 (September 1970), 40–49.

Leja, Michael. *Reframing Abstract Expressionism: Subjectivity and Painting in the 1940s.* New Haven: Yale University Press, 1993.

Licht, Jennifer. *Spaces.* Ex. cat. New York: Museum of Modern Art, 1969.

Life [Picture photo story on Japanese House], 23 August 1953, 71.

Linton, Ralph, and Paul S. Wingert, in collaboration with René d'Harnoncourt. *Arts of the South Seas.* Ex. cat. New York: Museum of Modern Art, 1946.

Lippard, Lucy. *Get the Message? A Decade of Art for Social Change.* New York: E. P. Dutton, 1984.

Lissitzky, El. *El Lissitzky, 1890–1941: Catalogue for an Exhibition of Selected Works from North American Collections, the Sprengel Museum Hanover, and the Staatliche Galerie Moritzburg Halle,* Peter Nesbit. Ex. cat. [Cambridge, Mass.]: Harvard University Art Museums, Busch-Reisinger Museums, 1987.

———. "PROUN SPACE, The Great Berlin Art Exhibition of 1923." In *Russia: An Ar-*

chitecture for World Revolution, trans. Eric Dluhosch, 138–141. Cambridge, Mass.: MIT Press, 1970. Originally published in G [Gestaltung] 1 (July 1923).

Lissitzky-Küppers, Sophie. El Lissitzky: Life, Letters, Texts, intro. Herbert Read, trans. Helene Aldwinckle and Mary Whittall. 1967; rev. ed. London: Thames and Hudson, 1980.

———. "Lissitzky in Cologne." In El Lissitzky, by Sophie Lissitzky-Küppers et al., 11–22. Ex. cat. Cologne: Galerie Gmurzynska, 1976.

Lissitzky-Küppers, Sophie, et al. El Lissitzky. Ex. cat. Cologne: Galerie Gmurzynska, 1976.

Lloyd, Jill. German Expressionism: Primitivism and Modernity. New Haven: Yale University Press, 1991.

Lodder, Christina. "Constructivism and Productivism in the 1920s." In Art into Life: Russian Constructivism, 1914–1932, 213–218. Ex. cat. Seattle: Henry Art Gallery, University of Washington; New York: Rizzoli, 1990.

Lohse, Richard P. Neue Ausstellungsgestaltung, Nouvelles conceptions de l'exposition, New Design in Exhibitions. Zurich: Verlag für Architektur, 1953.

Long, Rose-Carol Washton, ed. and annot. German Expressionism: Documents from the End of the Wilhelmine Empire to the Rise of National Socialism, trans. Nancy Roth. New York: G. K. Hall, 1993.

Lowe, Jeannette. "Useful Objects under Ten Dollars." Art News 34, no. 9 (30 November 1940), 11.

Lowery, Bates. "Statement by Bates Lowery, Director, The Museum of Modern Art." 30 March 1969. MoMA Library, "Art Workers Coalition" file.

Lynes, Russell. Good Old Modern: An Intimate Portrait of the Museum of Modern Art. New York: Atheneum, 1973.

McClellan, Andrew. Inventing the Louvre: Art, Politics, and the Origins of the Modern Museum in Eighteenth-Century Paris. Cambridge: Cambridge University Press, 1994.

McEvilley, Thomas. "Doctor Lawyer Indian Chief: 'Primitivism' in Twentieth Century Art at the Museum of Modern Art." Artforum 23, no. 3 (November 1984), 54–60. Reprinted with responses by William Rubin, Kirk Varnedoe, and McEvilley in Discourses: Conversations in Postmodern Art and Culture, ed. Russell Ferguson et al. (New York: New Museum of Contemporary Art; and Cambridge, Mass.: MIT Press, 1990), 339–376.

"Machine Art." Bulletin of the Museum of Modern Art 1, no. 3 (November 1933), 2.

"Machine Art." Parnassus 6, no. 5 (October 1934), 27.

McQuaid, Matilda. Lilly Reich: Designer and Architect. Ex. cat. New York: Museum of Modern Art; dist. New York: Harry N. Abrams, 1996.

McShine, Kynaston L., ed. Information. Ex. cat. New York: Museum of Modern Art, 1970.

Mademoiselle [Fashion photo feature using MoMA Japanese Exhibition House], September 1954, 138–142.

Manganaro, Marc, ed. Modernist Anthropology: From Fieldwork to Text. Princeton: Princeton University Press, 1990.

Margolin, Victor. "The Transformation of Vision: Art and Ideology in the Graphic Design of Alexander Rodchenko, El Lissitzky, and László Moholy-Nagy, 1917–1933." Vol. 1 Ph.D. diss., Union Graduate School, 1982.

Marquis, Alice Goldfarb. Alfred H. Barr, Jr.: Missionary for the Modern. Chicago: Contemporary Books, 1989.

Mies van der Rohe, Ludwig. "Mies Speaks." Architectural Record, no. 144 (December 1968), 451.

Miller, Barbara Lane. Architecture and Politics in Germany, 1918–1945. Cambridge, Mass.: Harvard University Press, 1968.

Miller, Michael B. The Bon Marché: Bourgeois Culture and the Department Store, 1869–1920. Princeton: Princeton University Press, 1981.

"Modern Art Museum Puts Up Extra Gallery to Show Furniture." Museum News 19, no. 8 (15 October 1941), 2.

Moholy-Nagy, László. Malerei, Photographie, Film. Bauhausbücher no. 8. Munich: Albert Langen Verlag, 1925. Rev. ed. Painting, Photography, Film, trans. Janet Seligmann. Cambridge, Mass.: MIT Press, 1969.

———. Von Material zu Architektur. Bauhausbücher no. 14. Munich: Albert Langen Verlag, 1929. Rev. eds.: The New Vision: From Material to Architecture, trans. Daphne M. Hoffman. New York: Brewer, Warren, and Putnam, 1930. The New Vision: Fundamentals of Design, Painting, Sculpture, and Architecture. New York: W. W. Norton, 1938. The New Vision and Abstract of an Artist. New York: Wittenborn, Schulz, 1946.

Moholy-Nagy, Sibyl. Moholy-Nagy: Experiment in Totality, intro. Walter Gropius. Cambridge, Mass.: MIT Press, 1969.

Morey, Charles Rufus. Medieval Art. New York: W. W. Norton, 1942.

Morgan, Carol. "From Modernist Utopia to Cold War Reality." In *Studies in Modern Art,* series ed. John Elderfield. vol. 5, *The Museum of Modern Art at Mid-Century, Continuity and Change,* 150–173. New York: Museum of Modern Art, 1995.

Mount, Christopher. *Designed for Speed: Three Automobiles by Ferrari.* Ex. pamphlet. New York: Museum of Modern Art, 1993.

Mumford, Lewis. "The Skyline: Bauhaus—Two Restaurants and a Theater." *New Yorker,* 31 December 1938, 38.

———. "The Sky Line: Windows and Garden." *New Yorker* 2 October 1954, 121–129.

Mumford, Lewis, Henry Wright, Raymond M. Hood, George Howe, and Harvey Wiley Corbett. "Symposium: The International Architectural Exhibition." *Shelter* 2, no. 3 (April 1932), 3–9.

Museum of Modern Art, New York. *Airways to Peace: An Exhibition of Geography for the Future,* Monroe Wheeler and Wendell Willkie. *Bulletin of the Museum of Modern Art* 11, no. 1 (August 1943). The bulletin served as the exhibition catalogue.

———. "Airways to Peace," list of preliminary exhibition titles. Records of Registrar Department, "Airways to Peace," MoMA Exhibition #236.

———. "Airways to Peace," outline of exhibition. Records of the Registrar Department, "Airways to Peace," MoMA Exhibition #236.

———. "Airways to Peace," press release 43629–25, n.d. "President Roosevelt Lends His Fifty-inch Globe to 'Airways to Peace' at the Museum of Modern Art." Records of the Registrar Department, "Airways to Peace," MoMA Exhibition #236.

———. "Airways to Peace," wall labels. Records of Registrar Department, "Airways to Peace," MoMA Exhibition #236.

———. "Arts of the South Seas Open at MoMA," press release #46129–5, quoted in Mordechai Omer, "René d'Harnoncourt: The Art of Installation," 2. MoMA Archives: RdH Papers, Box IV: "Arts of the South Seas," MoMA Exhibition #306, labels.

———. *De Stijl 1917–1928. Museum of Modern Art Bulletin* 20, no. 2 (Winter 1952–1953). The bulletin served as the exhibition catalogue.

———. "The Family of Man," press release, n.d. MoMA Archives: CE, *Family of Man,* II.1/57(1) [filing unit 1].

———. "The Family of Man," press release, n.d. MoMA Archives: CE, *Family of Man,* II.1/57(1) [filing unit 2].

———. *Fantastic Art, Dada, Surrealism,* ed. Alfred H. Barr, Jr. Ex. cat. New York: Museum of Modern Art, 1936.

———. "Guide to Activities of the International Program and the International Council of the Museum of Modern Art, New York, 1952–1975." MoMA Archives.

———. "Guide to the Records of the Department of Circulating Exhibitions in the Museum of Modern Art Archives." MoMA Archives.

———. "Information," press release, no. 69, 1 July 1970. MoMA Library, "Art Workers Coalition" file.

———. "Interim Report: House in the Museum Garden," 12 May 1948. Records of the Registrar Department, "Marcel Breuer House in Museum Garden," MoMA Exhibition #405.

———. "Japanese Exhibition House and Garden 1954–1955, Plant Materials." MoMA Library, "Japanese Exhibition House" file, MoMA Exhibition #559.

———. *Machine Art,* by Philip Johnson, foreword by Alfred H. Barr, Jr. Ex. cat. New York: W. W. Norton, 1934.

———. *Modern Architecture: International Exhibition,* by Henry-Russell Hitchcock, Jr., Philip Johnson, and Lewis Mumford, foreword by Alfred H. Barr, Jr. Ex. cat. New York: Museum of Modern Art, 1932. Also published as Henry-Russell Hitchcock, Jr., Philip Johnson, and Lewis Mumford, *Modern Architects,* foreword by Alfred H. Barr, Jr. (New York: W. W. Norton, 1932).

———. *Photography, 1839–1937,* intro. Beaumont Newhall. Ex. cat. New York: Museum of Modern Art, 1937.

———. *Prize Designs for Modern Furniture from the International Competition for Low-Cost Furniture Design,* by Edgar J. Kaufmann, Jr. New York: Museum of Modern Art, 1950.

———. *Road to Victory: A Procession of Photographs of the Nation at War,* Monroe Wheeler and Carl Sandburg. *Bulletin of the Museum of Modern Art* 10, nos. 5–6 (June 1942). The bulletin served as the exhibition catalogue.

———. *Steichen the Photographer,* foreword by René d'Harnoncourt, Carl Sandburg et al. Ex. cat. Garden City, N.Y.: Doubleday, 1961.

———. *Teaching Portfolio Number Three: Modern Art Old and New (A Portfolio Based on the Exhibition "Timeless Aspects of Modern Art" Held at the Museum of Modern Art in New York),* René d'Harnoncourt. New York: Museum of Modern Art, 1950.

———. *Timeless Aspects of Modern Art: The First of a Series of Exhibition Marking the Twentieth Anniversary of the Museum of Modern Art.* Ex. pamphlet. New York: Museum of Modern Art, 1949.

Museum of Primitive Art, New York. *The Museum of Primitive Art: Selected Works from the Collection,* intro. Nelson Rockefeller. Ex. cat. New York: Museum of Primitive Art, 1957.

Nelson, George. "Architects of Europe Today: 7—Van der Rohe, Germany." *Pencil Points* 16, no. 9 (September 1935), 459.

———. *Display.* New York: Interiors Library, 1953.

Nemiroff, Diana. "Modernism, Nationalism, and Beyond: A Critical History of Exhibitions of First Nations Art." In *Thinking about Exhibitions,* ed. Reesa Greenberg, Bruce W. Ferguson, and Sandy Naire, 411–436. London: Routledge, 1996.

Nerdinger, Winfried, ed. *The Walter Gropius Archive: An Illustrated Catalogue of the Drawings, Prints, and Photographs in the Walter Gropius Archive at the Busch-Reisinger Museum, Harvard University.* 4 vols. New York: Garland; Cambridge, Mass.: Harvard University Art Museum, 1990–1991.

Neuhart, John, Marilyn Neuhart, and Ray Eames. *Eames Design: The Work of the Office of Charles and Ray Eames.* New York: Harry N. Abrams, 1989.

Newark Museum Association. *A Survey: Fifty Years of the Newark Museum.* Newark, N.J.: Newark Museum Association, 1959.

"New Display Techniques for 'Art of This Century' Designed by Frederick J. Kiesler." *Architectural Forum* 78, no. 2 (February 1943), 50.

Newhall, Beaumont. "Alfred H. Barr, Jr.: He Set the Pace and Shaped the Style." *Art News* 78, no. 8 (October 1979), 134–135.

Newman, Amy. "The Visionary." In *Defining Modern Art: Selected Writings of Alfred H. Barr, Jr.,* ed. Irving Sandler and Amy Newman, 49–51. New York: Harry N. Abrams, 1986.

"New York's 'Machine Art' Exhibit Would Have Pleased Old Plato." *Art Digest* 8, no. 12 (15 March 1934), 10.

"The New York Version." *Interiors* 112, no. 4 (November 1952), 130.

Nine Days to Picasso, prod. and dir. Warren Forma, text and narr. René d'Harnoncourt. Museum of Modern Art, 1968.

Noyes, Eliot F. *Organic Design.* Ex. cat. New York: Museum of Modern Art, 1941.

Omer, Mordechai. "The Art of Installation: Biographical Notes." Unpublished manuscript, MoMA Archives: RdH Papers, box I.

———. "The Art of Installation: Part II, Selected Exhibitions." Unpublished manuscript, MoMA Archives: RdH Papers, box I.

———. Wall labels from memorial exhibition "René d'Harnoncourt: The Exhibitions of Primitive Art," The Museum of Primitive Art, 1970. Archives of the Department of the Arts of Africa, Oceania, and the Americas. The Metropolitan Museum of Art, New York.

"Organic Design." *Art Digest* 16, no. 1 (15 October 1941), 9.

"Organic Design Show Opens in New York." *Retailing: Home Furnishings* 13, no. 38 (29 September 1941), 44.

Palazzo Grassi, Venice. *Futurismi: Futurism and Futurisms,* org. Pontus K. G. Hulten, trans. Karen W. B. Asterisco et al. Ex. cat. New York: Abbeville Press, 1986.

Parallel of Life and Art, org. and des. Nigel Henderson, Eduardo Paolozzi, Alison Smithson, and Peter Smithson. Ex. cat. London: Institute of Contemporary Arts, 1953.

Parr, Albert. "Science, Arts, and Anthropology." In *The Reopening of the Mexican and Central American Hall,* 14–16. Pamphlet. New York: American Museum of Natural History, 1944.

Paudrat, Jean-Louis. "From Africa." In *"Primitivism" in Twentieth Century Art: Affinity of the Tribal and the Modern,* ed. William Rubin, 1:124–175. Ex. cat. New York: Museum of Modern Art, 1984.

"Pegasus to Planes." *Newsweek,* 12 July 1945, 76.

Peltier, Philippe. "From Africa." In *"Primitivism" in Twentieth Century Art: Affinity of the Tribal and the Modern,* ed. William Rubin, 1:99–115. Ex. cat. New York: Museum of Modern Art, 1984.

Penrose, Roland. *The Sculpture of Picasso: A Selection from Sixty Years,* foreword by Monroe Wheeler, chron. Alicia Legg. Ex. cat. New York: Museum of Modern Art, 1967.

Pepis, Betty. "Japanese House in New York." *New York Times Magazine,* 20 June 1954, 138–139.

Peterhans, Walter. "On the Present State of Photography." In *Photography in the Modern Era: European Documents and Critical Writings, 1913–1940,* ed. Christopher Phillips, 170–174. New York: Metropolitan Museum of Art and Aperture, 1989. Originally published as "Zum gegenwartigen Stand der Fotographie," *ReD* 3, no. 5 (1930), 138–140.

Philip Morris Companies, Inc. *Philip Morris and the Arts.* Pamphlet. n.p.: Philip Morris Companies, 1986.

Philip Morris Europe. *When Attitudes Become Form: Works-Concepts-Processes-Situations-Information; Wenn Attituden Form Werden: Werke-Konzepte-Prozesse-*

Situationen-Information; Quand les Attitudes Deviennent Forme: Oeuvres-Concepts-Processus-Situations-Information: Quando Attitudini Diventano Forma: Opere-Concetti-Processi-Situazioni-Informazione, Harald Szeemann. Ex. cat. Kunsthalle, Berne. [London, 1969].

Phillips, Christopher. "In the Family Way." *Afterimage* 11, no. 10 (May 1984), 10–13.

———. "The Judgment Seat of Photography." *October* 22 (Fall 1982), 27–63. Reprinted in *The Contest of Meaning: Critical Histories of Photography,* ed. Richard Bolton (Cambridge, Mass.: MIT Press, 1989), 15–47.

———. *Steichen at War.* New York: Harry N. Abrams, 1981.

———. "Steichen's 'Road to Victory.'" *Exposure* 18, no. 2 (1981), 38–48.

Phillips, Christopher, ed. *Photography in the Modern Era: European Documents and Critical Writings, 1913–1940.* New York: Metropolitan Museum and Aperture, 1989.

Phillips, Lisa. *Frederick Kiesler.* Ex. cat. New York: Whitney Museum of American Art, in association with W. W. Norton, 1989.

Phillips, Sarah, et al. *Commerce and Culture: From Pre-Industrial Art to Post-Industrial Value.* London: Design Museum and Fourth Estate, 1989.

Platt, Susan Noyes. "Modernism, Formalism, and Politics: The 'Cubism and Abstract Art' Exhibition of 1936 at the Museum of Modern Art." *Art Journal* 47, no. 4 (Winter 1988), 284–295.

Polin, Giacomo. "La Triennale di Milano 1923–1947: Allestimento, astrazione, contestualizzazione." *10 Rassegna (Allestmenti/Exhibit Design)* 4 (June 1982), 34–47.

Pollock, Griselda. *Vision and Difference: Femininity, Feminism, and the Histories of Art.* London: Routledge, 1988.

Pommer, Richard. "Mies van der Rohe and the Political Ideology of the Modern Movement in Architecture." In *Mies van der Rohe: Critical Essays,* ed. Franz Schulze, 96–145. New York: Museum of Modern Art, 1989.

Poster, Mark. *Critical Theory of the Family.* New York: Seabury Press, 1978.

Progressive Education Association. *The Visual Arts in General Education: A Report of the Committee on the Function of Art in General Education.* New York: D. Appleton-Century Company, 1940.

Pulos, Arthur J. *The American Design Adventure, 1940–1975.* Cambridge, Mass.: MIT Press, 1988.

Ratcliff, Carter. "New York Letter." *Art International* 14, no. 7 (September 1970), 95.

Reynolds, Ann. "Reproducing Nature: The Museum of Natural History as Nonsite." *October* 45 (Summer 1988), 109–127.

———. "Resemblance and Desire." *Center: A Journal for Architecture in America* 9 (1995), 90–107.

———. "Visual Stories." In *Visual Display: Culture beyond Appearances,* ed. Lynne Cooke and Peter Wollen, 83–109, 318–324. Seattle: Bay Press, 1995.

Richter, Hans. *Filmgegner von Heute—Filmfreunde von Morgen.* Berlin: Hermann Reckendorf Verlag, 1929.

Riedel, Hans. "Veranwortung des schaffenden." *Bauhaus* 3, no. 3 (July–September 1929), 2–7.

Riegl, Alois. *Late Roman Art Industry,* trans., foreword and annot. Rolf Winkes. Rome: Giorgio Bretschneider Editore, 1985.

———. *The Problems of Style: Foundations for a History of Ornament,* intro. David Castriota, pref. Henri Zerner, trans. Evelyn Kain. Princeton: Princeton University Press, 1992.

Riley, Terence. *The International Style: Exhibition 15 and the Museum of Modern Art,* ed. and des. Stephen Perrella, foreword by Philip Johnson, pref. Bernard Tschumi. Ex. cat., Arthur Ross Architectural Gallery, Columbia University, New York. Columbia Books of Architecture 3. New York: Rizzoli/CBA, 1992.

Riley, Terence, and Edward Eigen. "Between the Museum and the Marketplace: Selling Good Design." In *Studies in Modern Art,* series ed. John Elderfield. Vol. 4, *The Museum of Modern Art at Mid-Century at Home and Abroad,* 150–179. New York: Museum of Modern Art, 1994.

"'Road to Victory.'" *Art Digest* 16, no. 17 (1 June 1942), 5.

"'Road to Victory.'" *Newsweek,* 1 June 1942, 64.

Robinson, O. Preston, J. George Robinson, and Milton P. Mathews. *Store Organization and Operation.* 3rd ed. Englewood Cliffs, N.J.: Prentice-Hall, 1957.

Roeder, George. *The Censored War: American Visual Experience during World War Two.* New Haven: Yale University Press, 1993.

Roh, Franz, and Jan Tschichold, eds. *Foto-Auge.* Stuttgart: Akademischer Verlag Dr. Fritz Wedekind, 1929.

Roob, Rona. "Alfred H. Barr, Jr.: A Chronicle of the Years 1902–1929." *Our Campaign,* special issue of *New Criterion* (1987), 1–19.

Roosevelt, Eleanor. Foreword to *Indian Arts of the United States,* by Frederic H. Douglas and René d'Harnoncourt, 8. Ex. cat. New York: Museum of Modern Art, 1941.

Ross, Andrew. *No Respect: Intellectuals and Popular Culture.* New York: Routledge, 1989.

Rosskam, Edwin. "Family of Steichen." *Art News* 54, no. 1 (March 1955), 34–37, 64–65.

Roters, Eberhard, Bernhard Schulz, et al. *Stationen der Moderne: Die bedeutenden Kunstausstellungen des 20. Jahrhunderts in Deutschland.* Ex. cat. Berlin: Berlinische Galerie, 1988.

Rubin, William. *Dada, Surrealism, and Their Heritage.* Ex. cat. New York: Museum of Modern Art, 1968.

———, ed. *"Primitivism" in Twentieth Century Art: Affinity of the Tribal and the Modern.* 2 vols. Ex. cat. New York: Museum of Modern Art, 1984.

Rubin, William, Kirk Varnedoe, and Thomas McEvilley. Letters. *Artforum* 23, no. 5 (February 1985), 42–51; 23, no. 8 (May 1985), 63–71. Reprinted in *Discourses: Conversations in Postmodern Art and Culture,* ed. Russell Ferguson et al. (New York: New Museum of Contemporary Art; Cambridge, Mass.: MIT Press, 1990), 339–424.

Rudofsky, Bernard. "Notes on Exhibition Design." *Interiors and Industrial Design* 106, no. 12 (July 1947), 60–77.

Rushing, W. Jackson. "Marketing the Affinity of the Primitive and the Modern: René d'Harnoncourt and 'Indian Art of the United States.'" In *The Early Years of Native American Art History,* ed. Janet Catherine Berlo, 191–236. Seattle: University of Washington Press; Vancouver: University of British Columbia Press, 1992.

———. *Native American Art and the New York Avant-Garde: A History of Cultural Primitivism.* Austin: University of Texas Press, 1995.

Ruskin, John. *The Lamp of Beauty: Writings on Art by John Ruskin,* ed. Joan Collins. Oxford: Phaidon, 1980.

Sachesse, Rolf. "Germany: The Reich." In *A History of Photography: Social and Cultural Perspectives,* ed. Jean-Claude Lemagny and Andre Rouille, trans. Janet Lloyd, 150–157. Cambridge: Cambridge University Press, 1990.

Sandburg, Carl. *Home Front Memo.* New York: Harcourt, Brace, 1943.

Sandeen, Eric J. *Picturing an Exhibition: The Family of Man and 1950s America.* Albuquerque: University of New Mexico Press, 1995.

Sandler, Irving. Introduction to *Defining American Art: Selected Writings of Alfred H. Barr, Jr.,* ed. Irving Sandler and Amy Newman, 7–47. New York: Harry N. Abrams, 1986.

———. *The Triumph of American Painting: A History of Abstract Expressionism.* New York: Harper and Row, 1970.

Schapiro, Meyer. "The Nature of Abstract Art." *Marxist Quarterly* 1 (January–March 1937), 78–97. Reprinted in his *Modern Art, Nineteenth and Twentieth Centuries: Selected Papers* (New York: George Braziller, 1978), 185–211.

Scheyer, Margaret W. "Exhibition as Art Machine: 'Machine Art' at MoMA, 1934." Paper presented at the College Art Association, February 1993.

Schrader, Robert Fay. *The Indian Arts and Crafts Board: An Aspect of New Deal Indian Policy.* Albuquerque: University of New Mexico Press, 1983.

Schulze, Franz. *Mies van der Rohe: A Critical Biography.* Chicago: University of Chicago Press, 1985.

———. *Philip Johnson: Life and Work.* New York: Alfred A. Knopf, 1994.

———, ed. *Mies van der Rohe: Critical Essays.* New York: Museum of Modern Art, 1989.

Schumacher, Thomas L. *Surface and Symbol: Giuseppe Terragni and the Architecture of Italian Rationalism.* New York: Princeton Architectural Press; London: Architecture, Design, and Technology Press; Berlin: Ernst und Sohn Verlag für Architektur und technische Wissenschaflen, 1991.

Schwartz, Jane. "Exhibition of Machine Art Now on View at Modern Museum." *Art News* 32, no. 23 (10 March 1934), 4.

Schwartz, Therese. "The Politicalization of the Avant-Garde," parts 1, 2, and 3. *Art in America* 59, no. 6 (November/December 1970), 96–105; 60, no. 2 (March/April 1972), 70–79; 61, no. 2 (March/April 1973), 67–71.

Sekula, Allan. "The Traffic in Photographs." In *Photography against the Grain: Essays and Photo Works, 1973–1983,* 76–101. Halifax: Press of the Nova Scotia College of Art and Design, 1984. Also published in *Modernism and Modernity: The Vancouver Conference Papers,* ed. Benjamin H. D. Buchloh, Serge Guilbaut and David Solkin (Halifax: Press of the Nova Scotia College of Art and Design, 1983), 121–154.

"Self Appeasement as a Great Danger." *Retailing: Home Furnishings* 13, no. 38 (22 September 1941), 2.

Semenova, Elena. "From My Reminiscences of Lissitzky." In *El Lissitzky,* by Sophie Lissitzky-Küppers et al., 23–24. Ex. cat. Cologne: Galerie Gmurzynska, 1976.

"Seven Moods of Man." *New York Times Magazine,* 23 January 1955, 22.

Shapiro, David. "Mr. Processionary at the Conceptacle." *Art News* 69, no. 5 (September 1970), 58–61.

Smith, Fred. "Challenge of Form." *Sports Illustrated,* 14 May 1962, 47–52.

Stange, Maren. *Symbols of Ideal Life: Social Documentary Photography in America, 1890–1950.* New York: Cambridge University Press, 1989.

Staniszewski, Mary Anne. *Believing Is Seeing: Creating the Culture of Art.* New York: Penguin, 1995.

———. *Dennis Adams: The Architecture of Amnesia.* Ex. cat. New York: Kent Fine Art, 1990.

———. "Designing Modern Art and Culture: A History of Exhibition Installations at the Museum of Modern Art." Ph.D. diss., City University of New York, 1995.

Steichen, Edward. *The Blue Ghost.* New York: Harcourt, Brace, 1947.

———. "The Family of Man." *Picturescope* 3 (July 1955), 7.

———. *The Family of Man,* prol. Carl Sandburg. Ex. cat., Museum of Modern Art, New York. New York: Maco Magazine Corporation, 1955.

———, comp. *The Family of Man,* prol. Carl Sandburg. Ex. cat., Museum of Modern Art, New York. New York: Simon and Schuster in collaboration with the Maco Magazine Corporation, 1955.

———. "The F.S.A. Photographers." *U.S. Camera Annual* (1939), 44.

———. *U.S. Navy War Photographs: Pearl Harbor to Tokyo Harbor.* New York: U.S. Camera, 1946.

Steiner, Ralph. "Road to Victory: Top Notch Photos from Steichen Show." *PM Daily,* magazine sec. 31 May 1942, 26–29.

Stephens, Suzanne. "Looking Back at 'Modern Architecture': The International Style Turns 50." Special section in *Skyline,* February 1982, 24–27.

Stocking, George W., Jr. "Ideas and Institutions in American Anthropology: Thoughts toward a History of the Interwar Years." In *Selected Papers from the American Anthropologist,* ed. George W. Stocking, 1–53. Washington, D.C.: American Anthropological Association, 1976.

———. *Objects and Others: Essays on Museums and Material Culture,* ed. George W. Stocking, Jr. History of Anthropology 3. Madison: University of Wisconsin, 1985.

———. "Philanthropoids and Vanishing Cultures: Rockefeller Funding and the End of the Museum Era in Anglo-American Anthropology." In Stocking, *Objects and Others,* 112–142.

———. *Race, Culture, and Evolution: Essays in the History of Anthropology.* New York: Free Press, 1968.

Stonge, Carmen Luise. "Karl Ernst Osthaus: The Folkwang Museum and the Dissemination of International Modernism." Ph.D. diss., City University of New York, 1993.

Storr, Robert. *Dislocations.* Ex. cat. New York: Museum of Modern Art, 1991.

———. *Dislocations.* Ex. pamphlet. New York: Museum of Modern Art, 1991.

Stryker, Roy. "Road to Victory Photos Captions from Stryker." No. 39237-D. Records of the Registrar Department, *Road to Victory,* MoMA Exhibition #182.

Stryker, Roy, and Nancy Wood. *In This Proud Land: America 1935–1943 as Seen in the FSA Photographs.* Boston: New York Graphic Society, 1973.

Suleiman, Susan R., and Inge Crosman, eds. *The Reader in the Text: Essays on Audience and Interpretation.* Princeton: Princeton University Press, 1980.

Sussman, Elisabeth, ed. *On the Passage of a Few People through a Rather Brief Moment in Time: The Situationist International, 1957–1972.* Ex. cat., Institute of Contemporary Art, Boston. Cambridge, Mass.: MIT Press, 1989.

Sweeney, James Johnson. "The Bauhaus—1919–1928." *New Republic* 11 January 1939, 287.

Szarkowski, John. "The Family of Man." In *Studies in Modern Art,* series ed. John Elderfield. Vol. 4, *The Museum of Modern Art at Mid-Century at Home and Abroad,* 38–54. New York: Museum of Modern Art, 1994.

"Talk of the Town: Machine Art." *New Yorker,* 17 March 1934, 18.

Talley, Manfield Kirby, Jr. "The 1985 Rehang of the Old Masters at the Allen Memorial Art Museum, Oberlin, Ohio." *International Journal of Museum Management and Curatorship* 6, no. 3 (September 1987), 229–252.

Troy, Nancy J. *The De Stijl Environment.* Cambridge, Mass.: MIT Press, 1983.

Tschichold, Jan. "Display That Has DYNAMIC FORCE: Exhibition Rooms Designed by El Lissitzky." *Commercial Art* (London) 10, no. 55 (January 1931), 22.

UNESCO. *The Race Question in Modern Science: Race and Science*. 1951; rev. ed. New York: Columbia University Press, 1961.

U.S. Navy. *Power in the Pacific,* comp. Edward Steichen. New York: U.S. Camera Publishing, 1945.

———. *Power in the Pacific*. Ex. cat., Museum of Modern Art, New York. New York: William E. Rudge's Sons, 1945.

"Useful Objects under Ten Dollars." *The Museum of Modern Art [Bulletin]* 6, no. 7 (7 December 1939–7 January 1940), 3.

Vaillant, George C. *Indian Arts in North America*. New York: Harper and Brothers, 1939.

———. *Masterpieces of Primitive Sculpture: By Their Arts You Shall Know Them.* Ex. cat. Guide Leaflet Series of the American Museum of Natural History 99. New York: American Museum of Natural History, 1939.

Varnedoe, Kirk. "On the Claim and Critics of the 'Primitivism' Show." *Art in America* 73, no. 5 (May 1985), 11–21.

"Visual Road to Victory." *Art News* 4, no. 9 (August–September 1942), 26–29.

Vogue [Fashion photo feature using MoMA's Japanese Exhibition House], 1 September 1954, 179–183.

Wade, Edwin L. "The Ethnic Art Market in the American Southwest, 1880–1980." In *Objects and Others: Essays on Museums and Material Culture,* ed. George W. Stocking, Jr., 167–191. History of Anthropology 3. Madison: University of Wisconsin Press, 1985.

———. "The History of the Southwest Indian Ethnic Art Market." Ph.D. diss., University of Washington, 1976.

———. "Straddling the Cultural Fence: The Conflict for Ethnic Artists within Pueblo Societies." In Wade, *Arts of the North American Indian,* 243–254.

———, ed. *The Arts of the North American Indian: Native Traditions in Evolution,* coordinating ed. Carol Haralson. New York: Hudson Hills Press, 1986.

Wigley, Mark. *White Walls, Designer Dresses: The Fashioning of Modern Architecture.* Cambridge, Mass.: MIT Press, 1995.

Willett, John. *Art and Politics in the Weimar Period: The New Sobriety, 1917–1933.* New York: Pantheon Books, 1978.

Willkie, Wendell L. *One World.* New York: Simon and Schuster, 1943.

Wingler, Hans M. *The Bauhaus: Weimar, Dessau, Berlin, Chicago,* ed. Joseph Stein, trans. Wolfgang and Basil Gilbert. 1962; rev. ed. Cambridge, Mass.: MIT Press, 1986.

Winkes, Rolf. Foreword to *Late Roman Art Industry,* by Alois Riegl, trans. Rolf Winkes, xii–xxiv. Rome: Giorgio Bretschneider Editore, 1985.

Winkler, Jürgen. *Der Architeckt Hannes Meyer: Anschauungen und Werk.* Berlin: Veb Verlag für Bauwesen, 1989.

Women Artists in Revolution. *A Documentary Herstory of Women Artists in Revolution.* New York: Women Artists in Revolution, 1971.

Wright, Frank Lloyd. "Of Thee I Sing." *Shelter* 2, no. 3 (April 1932), 10–12.

Yust, Walter, ed. *1947 Britannica Book of the Year: A Record of the March of Events of 1946.* Chicago: Encyclopaedia Britannica, 1947.

———, ed. *1948 Britannica Book of the Year: A Record of the March of Events of 1947.* Chicago: Encyclopaedia Britannica, 1948.

———, ed. *Britannica Book of the Year 1953: A Record of the March of Events of 1952.* Chicago: Encyclopaedia Britannica, 1954.

———, ed. *Britannica Book of the Year 1954: A Record of the March of Events of 1953.* Chicago: Encyclopaedia Britannica, 1954.

———, ed. *Britannica Book of the Year 1955: A Record of the March of Events of 1954.* Chicago: Encyclopaedia Britannica, 1955.

———, ed. *Britannica Book of the Year 1956: A Record of the March of Events of 1955.* Chicago: Encyclopaedia Britannica, 1956.

Zeller, Terry. "The Historical and Philosophical Foundations of Art Museum Education in America." In *Museum Education: History, Theory, and Practice,* 10–89. Reston, Va.: National Art Education Association, 1989.

Reproduction Credits

Figure 4.10: Corcoran Gallery of Art, photograph courtesy The Museum of Modern Art.

Figures 4.18, 4.22: Ezra Stoller © Esto, courtesy The Museum of Modern Art.

Figure 4.24: Wayne F. Miller, © Magnum Photos, Inc.

Figures 5.1, 5.2, 5.3: Courtesy Jon Hendricks.

Figure 5.7: © VG Bild-Kunst/Hans Haacke.

Figures 5.8, 5.9: Courtesy Barbara Gladstone Gallery.

Figures 6.4, 6.5: Dennis Adams. Photograph: Peter Bellamy.

Figure 6.6: Courtesy Louise Lawler and Metro Pictures Gallery.

Figures 6.7, 6.8, 6.9: Courtesy Christian Hubert.

Figure 6.10: Courtesy Mary Boone Gallery.

Figure 6.11: Courtesy Jack Tilton Gallery.

Figure 6.12: Adrian Piper.

Index

Exhibitions at major museums discussed in the text are listed by title under the museum's name; all other exhibitions are listed directly by title.

Acconci, Vito, 276, 277 (figs. 5.8, 5.9)
Activism, 263–268, 280
Adams, Ansel, 101, 106–107 (figs. 2.37, 2.38), 244
Adams, Dennis, 296–298 (and figs. 6.4, 6.5)
Advertising, 4, 27, 45, 74, 87, 133, 134, 136, 151, 171, 172 (fig.3.21), 173, 219, 220, 222, 257, 285
Affinity, 111, 112–113 (and figs. 2.52, 2.53), 115–117, 124, 128 (and fig. 2.57), 129
African art displays, 320 (n. 68). See also Ethnographic art and artifacts; Museum of Primitive Art
Ain, Gregory, 194
Akron Art Institute, Useful Objects for the Home, 167
Albers, Josef, 152
Albini, Franco, 57
Alsop, Joseph W., Jr., 157
American, use of term in text, 57, 316 (n. 102)
American dream, 70, 251, 263, 293. See also Autonomy; Universalism
American Museum of Natural History (New York), 98, 99, 125, 319 (n. 38), 321–322 (n. 90)
 Ancient and "Primitive" Art from the Museum's Collections, 98, 100–101 (figs. 2.31, 2.32)
 Hall of Mexican and Central American Archaeology, 99, 126–127 (figs. 2.54, 2.55)
American National Exhibition, 256, 334–335 (n. 70), 336 (n. 107)

Amnesia
 cultural, 124, 298, 307
 regarding installation design, xxi–xxiii, xxviii, 3, 124
Andre, Carl, 269
Anthropology, 98, 99, 124, 125, 304, 324 (nn. 124, 126)
Archipenko, Alexander, 136
Armajani, Siah, 276
Armory Show, 4, 7 (fig. 1.5), 62, 63 (fig. 2.3)
Aronovici, Carol, 196, 197–198 (figs. 3.44, 3.45)
Arp, Jean, 134, 136
Art & Language, 269
Art & Project, 270
Art/artifact, 320 (n. 68)
Art History of the Viennese Folk Plays and Music, 4
Artists' strike, 268, 280
Artist-worker, 269
Art market. See Market, art
Art of This Century, 8, 10–13 (figs. 1.7–1.11), 22, 24, 69 (and fig. 2.8)
Art Workers Coalition, 263–268, 271
Asher, Michael, 282
Audiences. See Museums, audiences
Autonomy
 aestheticized installations, 61, 66, 68, 70
 art, xxi, 61, 66, 70, 73, 78, 281, 285, 293, 294 (fig. 6.2), 310 (n. 3)
 cultural, 27
 viewer, 66, 70, 231, 293, 294 (fig. 6.2), 295, 310 (n. 3)

Baader, Johannes, 23 (fig.. 1.21)
Bakst, Leon, 4
Barcelona Pavilion, 36, 37, 41. See also International Exposition Barcelona
Barnes, Albert C., Foundation, 317 (n. 3)
Barr, Alfred H., Jr., xxii, 16, 21, 61–68 (and figs. 2.1, 2.4, 2.6), 70–79 (and figs. 2.9, 2.11–2.13), 81, 82–83 (figs. 2.18–2.20), 84, 94, 110, 125, 128 (and fig. 2.56), 136, 139, 143, 144, 145, 152, 153, 160, 167, 196, 209, 222, 256, 294 (fig. 6.2), 318–319 (n. 18), 321–322 (n. 90), 326 (n. 19), 327 (n. 55)
Barr, Margaret Scolari, 62, 64, 66
Barry, Robert, 270
Barthes, Roland, 209, 222, 259
Battcock, Gregory, 264

Bauhaus, 21, 25–36 (and figs. 1.23–1.32), 44, 48, 74, 77 (fig. 2.14), 78, 84, 143, 153, 310 (n. 3). See also Museum of Modern Art, exhibitions, Bauhaus 1919–1928
Bayer, Herbert, 3, 24, 25, 27, 28–35 (figs. 1.24–1.32), 37, 44, 48, 66, 75, 78 (fig. 2.14), 136, 143–151 (and figs. 3.2–3.9), 158, 159, 167, 173 (fig. 3.22), 174, 176, 210–223 (and figs. 4.1–4.8), 227–235 (and figs. 4.11–4.16), 241, 257, 258, 290 (fig. 6.1), 292
 field of vision, 25, 27, 28 (fig. 1.24), 33 (fig. 1.30), 44, 144, 152, 220, 231
Becher, Bernhard and Hilla, 276
Bell, Larry, 282
Berlin Building Exposition, 153
Berlinische Galerie, 302
Bienal de São Paulo, 268
Bill, Max, 57
Bitsoy, Dinay Chili, 94
Black Mountain College, 159
Bloomingdale's, 167, 171, 172 (fig. 3.21)
Boas, Franz, 124
Boccioni, Umberto, 81
Bocher, Mel, 276, 286
Bonet, Antonio, 134
Bourgeois, Louise, 304, 307
Bowman Brothers, 194
Braden, John W., 224
Brancusi, Constantin, 176
Braque, Georges, 81, 199
Brennan, Daniel, 189
Breuer, Marcel, 25, 75, 78, 134, 167, 194, 199, 200 (fig. 3.46), 293
Broegger, Stig, 281
Brooklyn Museum, 313 (n. 41), 317 (n. 2), 323 (n. 119)
Brouwn, Stanley, 280
Buffalo Museum of Natural Science, 99
Building Workers Unions Exhibition, 25, 32 (fig. 1.29), 34–35 (figs. 1.31–1.32), 37, 221
Burchard, Otto, 23 (fig. 1.21)
Burden, Chris, 304
Buren, Daniel, 218
Bürger, Peter, 310 (n. 3)
Burroughs, William, 278
Bush, George, 298

Cage, John, 278

Calder, Alexander, 67 (fig. 2.6), 134, 294 (fig. 6.2)

Calle, Sophie, 304

Campbell, Joseph, 94

Capitalism, 70, 174, 318 (n. 25)

Carson Pirie Scott, 178

Cassandre, A. M., 134

Cézanne, Paul, 84. See also Museum of Modern Art, exhibitions, Cézanne, Gauguin, Seurat, Van Gogh

Children, xxviii, 79, 81, 223, 234 (and fig. 4.16), 238, 241, 247 (fig. 4.24), 249 (and fig. 4.26), 250, 265. See Museum of Modern Art, exhibitions, children's holiday carnivals and Children's Holiday Circus of Modern Art

Civil rights movement, 251, 254, 336 (n. 109)

Cleaver, Kathleen, 278

Clifford, James, 324 (n. 122)

Coca-Cola, 257, 285

Cold war, 209, 222, 223, 235, 250, 255, 256, 332 (n. 32)

Cole, Thomas, 136

Collier, John, 319–320 (n. 50)

Colomina, Beatriz, 311 (n. 8), 312 (n. 22)

Columbia University, 194, 327 (n. 50)

Commercial displays, 84, 94. See also Commercial showrooms; Department stores; Stores

Commercial showrooms, 291. See also Department stores; Stores

Communism, 151, 336 (n. 112)

Conceptual Art, 269, 276, 280–282, 285, 286

Constantine, Mildred, 192–194 (and figs. 3.41, 3.42)

Constructivism, 8, 14, 21, 74, 312 (n. 18)

Cooper, Dan, 134

Cootswytewa, Victor, 88, 90 (fig. 2.25)

Copyright, 264, 268

Corcoran Gallery of Art (Washington), Power in the Pacific, 226 (fig. 4.10). See also Museum of Modern Art, exhibitions, Power in the Pacific

Corporate culture, 259. See also corporations

Corporations, 224, 281, 285, 295. See also Museum of Modern Art, corporate donations for exhibitions; Museum of Modern Art, corporate membership; Museum of Modern Art, corporate sponsors

Cortissoz, Royal, 151, 152

Cultural producer, 269, 298

Dada, 22, 23 (and fig. 1.21), 24, 87, 136, 139

Dalí, Salvador, 134, 136, 139 (fig. 2.68)

D'Amico, Victor, 79, 80 (figs. 2.16, 2.17), 291

Dana, John Cotton, 327 (n. 55)

Darboven, Hanne, 269, 282

Darwin, Charles, 322 (n. 90)

Davis, Frederick, 84

Delvaux, Paul, 136

De Maria, Walter, 270

Democracy, 70, 160, 162, 221, 280, 319 (n. 38), 338 (n. 139)

Democratic capitalist state, 70. See also American dream; Democracy

Department stores, xxiii, 134, 135 (fig. 2.63), 136, 139, 143, 159, 160, 162, 167, 170–176 (and figs. 3.20, 3.23–3.24), 178, 182, 183, 201, 317 (n. 2), 327 (n. 55), 328 (n. 58). See also Stores

history, 329 (n. 87)

De Renzi, Mario, 50, 51 (fig. 1.44)

Desert Storm. See Gulf War

De Stijl, 8, 13, 14, 74, 75, 78, 189, 301 (n. 3)

Detroit Institute of Arts, For Modern Living, 165

Deutscher Werkbund, 21, 37, 44, 45, 76–78, 165, 167, 176, 220, 327 (n. 55). See also Exposition de la Société des Artistes Décorateurs

Dewey, John, 158, 270, 313 (n. 31), 317 (n. 3), 318 (n. 38)

D'Harnoncourt, René, 61–70, 84–99 (and figs. 2.21–2.24, 2.27–2.29), 101, 110–118 (and figs. 2.44–2.47), 120 (figs. 2.50, 2.51), 124, 125, 128 (and fig. 2.57), 129–137 (and figs. 2.58–2.66), 139 (and fig. 2.68), 188, 202 (fig. 3.47), 210, 224, 238, 291, 292, 322 (n. 103)

vista technique, 88, 111, 112 (and fig. 2.43), 113 (and fig. 2.44), 116, 124, 139, 174, 176, 238 (see also Installation methods, vista)

Dietrich, Marlene, 94

Divorce, 254–255, 337 (n. 116)

Documenta, 268, 342 (n. 16)

Doesburg, Theo van, 14, 16, 17, 134

Dohrn, Bernardine, 278

Domínguez, Oscar, 136

Donahue, Elinor, 258 (fig. 4.29)

Dondero, George, 256

Dorner, Alexander, 16, 18 (fig. 1.14), 19 (fig. 1.16), 20, 21, 25, 64, 69, 70, 73, 69, 313 (n. 31)

atmosphere rooms, 16, 20 (and fig. 1.18), 69, 90, 117

Dougherty, Frazier, 265

Douglas, Frederic H., 87

Dreier, Katherine, 313 (n. 41), 317 (n. 2)

Drexler, Arthur, 117, 121 (fig. 2.49), 190, 191 (fig. 3.39), 199, 201, 265

Duchamp, Marcel, 13 (fig. 1.10), 22, 24 (and fig. 1.22), 136, 159, 201

Duncan, Carol, 312 (n. 29), 318 (n. 25), 333 (n. 39)

Dwelling, The, 38, 42 (figs. 1.36, 1.37), 302

Dwelling in Our Time, The, 41, 302

Eames, Charles, 134, 167, 176–184 (and figs. 3.28–3.32), 188, 199

Eames, Ray, 176–184 (and figs. 3.28–3.32), 199

Earhart, Amelia, 158, 270

Education. See Museums, education; Installation methods, didactic exhibitions/installations

Eisenhower, Dwight D., 256

Eisenstein, Sergei, 45, 281

Electronic art, xxiii

Entartete Kunst, 25

Ernst, Max, 24, 134, 136

Esprit Nouveau Pavilion, 75

Essentialism, 8, 125, 129, 158, 236, 255, 293

Ethnographic art and artifacts, xxii, 16, 65 (fig. 2.5), 73, 81, 82 (fig. 2.18), 87, 98–101, 116–118, 124–128 (and figs. 2.54, 2.55), 291, 320 (n. 68). See also American Museum of Natural History; Metropolitan Museum of Art, Mexican Arts; Museum of Modern Art, exhibitions, Arts of the South Seas, Indian Art of the United States, and "Primitivism" in Twentieth Century Art; Museum of Primitive Art

"primitive art" and Museum of Primitive Art, 323 (n. 111)

Ethnographic surrealism, 324 (n. 122)

Evans, Walker, 196, 197 (fig. 3.44), 198 (fig. 3.45)

Everyday life, xxii, 73, 133, 134, 136, 139, 162, 165, 167, 171, 188, 192, 194, 201, 236, 280, 295, 301 (n. 3)

Evolution, 74, 124, 125, 321–322 (n. 90), 324 (n. 124)

Exhibition of New Theater Technique, 4, 5–6 (figs. 1.2–1.4), 13
Exhibition of the Antique Italian Goldsmiths Shop, 57
Exhibition of the Fascist Revolution, 2 (fig. 1.1), 50–56 (and figs. 1.44–1.48), 221
Exposition de la Société des Artistes Décorateurs (1930), 25, 26 (fig. 1.23), 29–31 (figs. 1.25–1.28), 75, 78 (fig. 2.24), 145
Exposition Internationale des Arts Décoratifs et Industriels Modernes (1925), 13 (and figs. 1.11, 1.12), 14, 15, 75
Exter, Alexandra, 4

Fascism, German. *See* National Socialism
Fascism, Italian, 50, 51, 57, 81, 221. *See also Exhibition of the Fascist Revolution*
Fashion, 40, 94–95 (fig. 2.29), 201. *See also* Museum of Modern Art, exhibitions, *Are Clothes Modern?; Women's Fashion*
Father Knows Best, 258 (fig. 4.29), 338 (n. 139)
Feininger, Lux, 151
Feininger, Lyonel, 27, 144
Film, 3, 4, 21, 45, 47 (fig. 1.41), 73, 74, 87, 222, 223, 238, 240, 255, 268, 270, 280, 281, 282, 304, 333 (n. 41), 334–335 (n. 70), 337 (n. 118), 339 (n. 17)
Film und Foto, 45–47 (and figs. 1.40, 1.41), 57, 281
First International Dada Fair, 23 (fig. 1.21), 342 (n. 16)
First Papers of Surrealism, 24 (and fig. 1.22)
Flavin, Dan, 282
Folkwang Museum (Essen), 64, 65 (fig. 2.5), 98
Fontana, Lucio, 57
Formalism, 75, 110, 117, 136, 259. *See also* Modernism
Friedan, Betty, 255
Froom, Charles, xx (fig. I.1), 72 (fig. 2.10), 117, 122 (fig. 2.52), 123 (fig. 2.53), 270, 272 (fig. 5.5)
Fuseli, Johann, 136
Futurism, 51

Galassi, Peter, 110 (and fig. 2.41), 259, 338 (n. 142)
Gas and Water Exhibition, 27, 36 (fig. 1.33)
Gauguin, Paul. *See* Museum of Modern Art, exhibitions, *Cézanne, Gauguin, Seurat, Van Gogh*

Genauer, Emily, 151
Gender, 282
 feminine and modern interiors/installations, xxiii, xxvi (figs. I.4, I.5), xxviii, 311 (n. 8)
 masculine and modern interiors/installations, xxiv, xxviii
 women, xxviii, 37, 238, 241, 251, 255–264, 331 (n. 8)
Genius, 70, 278
German Building Exposition, 41
German Exhibition, The, 221
German People/German Work, 41, 43 (figs. 1.38, 1.39), 43, 57
Giacometti, Alberto, 136, 268
Giacometti, Annette, 168
Giedion, Sigfried, 44
Gilliam, Sam, 286
Giorno, John, 178
Girard, Alexander, 165, 176, 188 (and fig. 3.38), 189
Goebbels, Joseph, 44
Goering, Hermann, 44
Golden Gate International Exposition, 85. *See also* Museum of Modern Art, exhibitions, *Indian Art of the United States*
Gold Medals Room. See Italian Aeronautics Exhibition
Goldwater, Robert, 111, 112, 113 (fig. 2.47), 118 (fig. 2.47), 124, 132 (fig. 2.60), 133, 134 (fig. 2.62), 136, 322 (n. 103)
Goncharova, Natalie, 4
González, Julio, 177
Goodyear, A. Conger, 61, 72, 73, 171, 292
Grand Central Station (New York), 219
Grand Palais (Paris), 14, 25
Graves, Nancy, 286
Gray, Billy, 258 (fig. 4.29)
Gray, Lauren, 258 (and fig. 4.29)
Greenberg, Clement, 276
Gropius, Walter, 22, 25, 26 (fig. 1.23), 27, 30–32 (figs. 1.26–1.29), 34–35 (figs. 1.31, 1.32), 43 (fig. 1.38), 44, 57, 75, 136, 143 (and fig. 3.1), 144, 151, 167, 194, 326 (n. 19). *See also* Museum of Modern Art, exhibitions, *Bauhaus 1919–1928*
Grosz, George, 23 (fig. 1.21)
Group Fronter, 278, 279 (fig. 5.10), 282
Gruen, John, 285

Guerrilla Art Action Group, 265, 266–267 (figs. 5.1–5.3), 271, 339 (n. 10)
Guggenheim, Peggy, 8, 13 (fig. 1.10)
Gulf War, 298
Gunn, Michael, 121

Haacke, Hans, 264, 270, 271, 275 (fig. 5.7), 276, 278, 281, 282
Haas, Robert, 194
Hadid, Zaha, 302
Hammons, David, 304, 305 (fig. 6.11), 307
Hankins, Evelyn, 311 (n. 8)
Hanover. *See* Landesmuseum
Hardoy, Ferrari, 134
Hare, David, 24
Hartwig, Josif, 75
Hausmann, Raoul, 23 (fig. 1.21)
Haven, Kathleen, 109
Heartfield, John, 23 (fig. 1.21)
Heizer, Michael, 281
Hendricks, Jon, 265, 266–267 (figs. 5.1–5.3), 339 (n. 110). *See also* Guerrilla Art Action Group
Henshell, Justin, 117, 120 (fig. 2.49)
Herman Miller Showrooms, 182, 183 (fig. 3.32)
Herrnstein, Richard J., 324 (n. 126)
Herzfelde, Wieland and Margaret, 23 (fig. 1.21)
Heyward, Susan, 94
Hirsche, Herbert, 43
Hirschmann, I. A., 171
Historical materialism, 68
History of Theater 1890–1900, The, 4
Hitchcock, Henry-Russell, 194
Hitler, Adolf, 25, 39, 44, 143, 151. *See also* National Socialism
Höch, Hannah, 23 (fig. 1.21)
Hoffman, Abbie, 278
Hood, Raymond, 194
Hubert, Christian, 300–301 (figs. 6.7–6.9), 302
Huebler, Douglas, 281
Humanism, 129, 200, 251
 American (U.S.), 263
 anthropological, 324 (n. 122)
 classic, 200, 259
 progressive, 200, 209, 255
 Renaissance, 129
 universal, 124, 125, 209, 255, 293 (*see also* Universalism)
Human rights, 87, 324 (n. 126)

Hussein, Saddam, 298
Hutton, Bobby, 263, 278

Idealist aesthetics, 8, 25, 127, 153, 158, 159, 229, 292, 295. *See also* Modernism
Ideology, xxi, xxii, xxiii, 209, 281, 285, 293
Imperial Exposition of the German Textile and Garment Industry, 43
Independent Group, 194
Indian Arts and Crafts Board, 85, 87, 98, 319 (n. 46)
Installation art, xxii, 3, 41, 50, 269–286, 296, 298, 308
Installation design
 as art/medium, xxi, xxii, 37, 153, 158, 250, 259
 professionalization of field, 323 (n. 119)
 as representation, xxii, 25, 61, 66, 209, 281, 311 (n. 5)
Installation methods
 ahistorical, 84, 125, 128, 131 (*see also* Idealist aesthetics)
 atmosphere rooms, 97, 101, 111, 115, 117 (*see also* Dorner, Alexander)
 chronological, 62, 66
 conceptual art and reconfiguration of practices, 269, 270, 271, 276, 281, 285, 286
 decorative, 61
 didactic exhibitions/installations, 65 (fig. 2.4), 78, 79–80 (figs. 2.15–2.17), 99, 101, 104 (fig. 2.36), 111, 112 (fig. 2.42), 115, 117, 125, 128 (and figs. 2.56–2.57), 158, 159, 167, 168 (fig. 3.19), 171, 192, 193, 196, 197 (fig. 3.44), 198 (fig. 3.45), 227–235 (and figs. 4.13, 4.16), 276, 278, 280, 281, 305
 domestic, xxviii, 25, 42 (fig. 1.36), 196–197, 298, 307, 311 (n. 8), 317 (n. 2) (*see also Exposition de la Société des Artistes Décorateurs;* Museum of Modern Art, exhibitions, *House in the Garden, Japanese House in Garden, Organic Design in Home Furnishings,* and *Useful Objects*)
 eye level, 4, 62, 66, 85, 174, 194, 244, 282
 field of vision, 66, 111, 144, 150 (fig. 3.9) (*see also* Bayer, Herbert)
 salon style, 8, 16, 174, 304

skying, 62, 64, 66, 70, 71 (fig. 2.9), 72, 73, 110, 174, 291, 304, 312 (n. 28), 317 (nn. 2, 3)
 standard modernist, xxiii, 16, 61, 62, 66, 73, 81, 110, 298
 stylistic, 62, 64, 66, 81, 167
 symmetrical, 16, 61, 62
 traditional (nineteenth and early twentieth centuries), 8, 16, 63
 vista, 136, 139, 174, 176, 238 (*see also* D'Harnoncourt, René)
Installations, aspects of
 color, 14, 20, 21, 37, 41 (and fig. 1.35), 47, 51, 52 (fig. 1.46), 88, 90, 97, 101, 103–104 (figs. 2.34, 2.35), 112, 115, 117, 125, 129, 131, 134, 144, 151, 153, 154 (fig. 3.10), 155 (fig. 3.11), 157 (and fig. 3.13), 160, 162, 165, 167, 171, 174, 176, 177, 182, 188, 189, 190, 194, 196, 220, 230, 238, 241, 244, 247 (fig. 4.24), 249, 250, 270, 282, 292, 294, 296, 302, 307, 311 (n. 8), 317 (nn. 2, 3)
 labels, 62, 64, 66, 78, 84, 90, 99, 111, 115, 117, 125, 129, 144, 151, 159, 167, 194, 278, 302, 303 (fig. 6.10)
 lighting, 3, 11 (fig. 1.8), 21, 45, 47, 48, 51, 62, 112, 116, 125, 128, 134, 139, 153, 158, 162, 174, 176, 184, 188, 189, 190, 199, 230, 238, 241, 244, 250, 282, 317 (n. 2)
 sound, 3, 11 (fig. 1.8), 22, 51, 53 (fig. 1.46), 201, 278, 282
 video, 278, 304, 307
Institute of Contemporary Art (Boston), 166
Institute of Contemporary Arts (London), 194
Institute of Design (Chicago), 44
Institutionalization, 281, 320 (n. 68)
 of modern art, xxiii, 57
 of universal humanism, 125 (*see also* Universalism, universal humanism)
International Art Exhibition (Dresden), 16, 21
International avant-gardes, xxii, 3, 4, 13, 14, 21, 22, 27, 36, 44, 45, 57, 62, 68, 74, 75, 78, 98, 160, 167, 174, 189, 201, 215, 219, 257, 281, 302, 324 (n. 122)
 defined, 310 (n. 3)
International Exhibition of Modern Art. See Armory Show

International Exhibition of New Theater Technique, 4, 5 (fig. 1.2), 6 (fig. 1.4)
International Exposition Barcelona, 36, 37, 153. *See also* Barcelona Pavilion
International Exposition of City Planning and Housing, 57
International Exposition of Surrealism, 24, 47
International Fur Trade Exhibition, 50
International Hygiene Exhibition, 50
International Press Exhibition. See Pressa
International Theater Exhibition, 4, 5 (fig. 1.2), 6 (figs. 1.3, 1.4), 13
Italian Aeronautics Exhibition, 56 (fig. 1.49), 57

Janis, Sidney, 78, 79 (fig. 2.15)
Jewell, Edward Alden, 145, 157, 162, 210
Jews, on Bauhaus faculty, 151, 326 (n. 19)
Johnson, Philip, 21, 36, 41, 43, 64, 66, 152–160 (and figs. 3.10–3.13), 165, 166 (and fig. 3.17), 190, 192 (and fig. 3.40), 193 (and figs. 3.41, 3.42), 194, 195 (fig. 3.43), 196, 197 (fig. 3.44), 199, 292, 327 (n. 55)
Johnson, Poppy, 266–267 (figs. 5.1–5.3), 339 (n. 10)
Jones, Julie, 119 (fig. 2.48)
Juhl, Finn, 182, 184, 185 (figs. 3.33, 3.34)
Junkers and Company exhibit, 27, 36 (fig. 1.33)
Jurusu, 212

Kabakov, Ilya, 304
Kabotie, Fred, xxvi (fig. I.4), 90 (and fig. 2.25)
Kandinsky, Wassily, 176, 257
Kaufmann, Edgar J., Jr., 160, 173, 176, 179 (fig. 3.28), 189, 328 (n. 58)
Kaufmann's Department Store, 170 (fig. 3.20), 328 (n. 58)
Kazan, Elia, 337 (n. 118)
Kelly, Richard, 184
Kiesler, Frederick, 3–14 (and figs. 1.2–1.4, 1.6–1.11), 21, 22 (and fig. 1.21), 24, 37, 45, 48, 57, 69 (and fig. 2.8), 70, 75, 78, 79 (fig. 2.15), 145, 313 (n. 41). *See also* Whitney Museum of American Art, *Frederick Kiesler*
 correalism, 8, 69
 L and T system, 4, 6 (figs. 1.3, 1.4), 8, 13, 14, 21, 45, 57, 69, 300 (fig. 6.7)
Kismaric, Susan, 302, 323 (n. 98)

Klee, Paul, 22, 136, 199
Klumb, Henry, 88 (fig. 2.24)
Knoll Associates, 182
Kobodaishi, 244
Komoyousie, Herbert, 88, 90 (fig. 2.25)
Korean War, 250
Kosuth, Joseph, 265, 275 (fig. 5.6), 278
Kozlov, Christine, 280
Kramer, Hilton, 255, 286
Kress (store), 162
Kruger, Barbara, 302, 303 (fig. 6.10), 322 (n. 98)
Kurchan, Juan, 134
Kusama, Yayoi, 265

Land Art, 302
Landesmuseum (Hanover), 16–20 (and figs. 1.14–1.18)
Lange, Dorothea, 212
Latham, John, 276
Lawler, Louise, 298, 299 (fig. 6.6), 341 (n. 11)
Le Corbusier, 75, 78, 136, 194
Lee, Russell, 215
Léger, Fernand, 4, 134, 136, 199
Leider, Philip, 263
Lenin (Vladimir Ilyich Ulyanov), 221
Leonardo da Vinci, 231
Lescaze, William, 194
Libera, Adalberto, 50, 51 (and fig. 1.44), 53 (fig. 1.46)
Liberal democratic capitalist state, 70. *See also* Democracy; Humanism
Licht, Jennifer, 282
Life magazine. *See* Picture magazines
Linton, Paul, 110, 128 (fig. 2.57)
Lippard, Lucy, 269
Lissitzky, El, 3, 4, 16, 17 (fig. 1.13), 20, 21, 25, 27, 37, 45–51 (and figs. 1.41–1.43), 57, 68 (and fig. 2.7), 70, 136, 213, 221
Live in Your Head: When Attitudes Become Form, 269, 285
Loloma, Charles, 88, 90 (fig. 2.25)
Louvre (Paris), 70
Lowery, Bates, 264, 265
Lustig, Alvin, 136

Macy's, 165, 175, 182, 196, 199
Magritte, René, 136
Mailer, Norman, 136
Malevich, Kazimir, 62, 257

Man Ray, 136
Marconi, Guglielmo, 2 (fig. 1.1), 51, 52 (fig. 1.45)
Market, art, 269
 free market, 293
 home furnishings, 173
 Native American artifacts, 87
 photography, 210, 332 (n. 7)
Marxism, 50
Masses, 48 (and fig. 1.42), 56, 215, 219, 221, 222
 term historicized, 332 (n. 32)
Mass media, 2 (fig. 1.1), 3, 4, 22, 45, 46, 48, 49 (fig. 1.43), 50, 101, 105, 221, 222, 250, 257, 258
 term historicized, 332 (n. 32)
Masson, André, 136
Material Show, 42 (fig. 1.37)
Matisse, Henri, 128
Matta (Roberto Sebastian Matta Echaurren), 24, 136
Matter, Herbert, 102 (fig. 2.33), 178 (fig. 3.27), 322, (n. 92)
McAndrew, John, 152
McBride, Henry, 151, 158
McCarthy, Joseph, 254, 336 (n. 112)
McQuaid, Matilda, 40 (fig. 1.34), 327 (n. 50)
McShine, Kynaston L., 263, 269, 270, 273 (fig. 5.5), 274 (fig. 5.6), 276, 278, 280, 304
Melnikov, Konstantin, 14
Merchandise Mart (Chicago), 173, 176, 180 (fig. 3.29), 184, 186 (fig. 3.36), 188 (fig. 3.38), 189, 285
Metropolitan Museum of Art (New York), 85, 86 (fig. 2.22), 117
 Mexican Arts, 85, 86 (fig. 2.22)
 Michael C. Rockefeller Wing, 119 (fig. 2.48), 121 (fig. 2.51), 165, 323 (n. 119)
Meyer, Hans, 26, 44
Mies van der Rohe, Ludwig, 21, 36–44 (and figs. 1.35–1.39), 53, 153, 159, 165, 166 (fig. 3.7), 189, 194, 199, 302
Miller, Wayne, 219, 236, 237 (fig. 4.17), 244, 247 (fig. 4.24), 251, 254
 family, 247 (fig. 4.24)
Miró, Joan, 24, 134, 136, 188, 298
Moderna Museet (Stockholm), 278
Modernism, xxiii, 61, 68, 271, 276, 285, 291, 298, 307, 310 (n. 3), 317 (n. 13). *See also* Installation methods, standard modernist

Moholy-Nagy, László, 18 (fig. 1.14), 21, 22, 25, 27, 32 (fig. 1.29), 34 (fig. 1.31), 35 (fig. 1.32), 43, 44, 45, 46 (fig. 1.40), 48, 101, 215, 221
Moltke, Willie von, 171
Mondrian, Piet, 14, 79, 134, 188, 257
Moore, Henry, 136
Morey, Charles Rufus, 74
Mount, Christopher, 327 (n. 50)
Multimedia art, xxiii
Mumford, Lewis, 152, 201
Muntadas, 342 (n. 21)
Murray, Charles, 324 (n. 126)
Musée de l'Homme (Paris), 99, 124
Museum of Modern Art (New York)
 African American center, 264
 archive, xxii, xxiii, xxiv (fig. I.2), 259
 corporate donations for exhibitions, 230, 282 (*see also* Bloomingsdale's; Kauffman's Department Store; Macy's; Olivetti)
 corporate membership, 329 (n. 82)
 corporate sponsors (underwriters), 340 (n. 45)
 Department of Architecture, 64, 152, 159, 160, 190, 192, 194, 199, 302
 Department of Education, 79, 318–319 (n. 38)
 Department of Industrial Design, 165, 328 (n. 58)
 Department of Photography, 101, 105, 110, 259, 338 (n. 142)
 exhibitions
 African Negro Sculpture, 98
 African Textiles and Decorative Arts, 340 (n. 45)
 Airways to Peace, 81, 209, 227–235 (and figs. 4.11–4.16), 250, 258, 280, 292, 293
 America Can't Have Housing, 196, 197 (3.44), 198 (fig. 3.45), 199, 280
 American Sources of Modern Art, 98
 Ancient Art of the Andes, 116, 323 (n. 110)
 Are Clothes Modern?, 280
 Art Education in Wartime, 210
 Art in War, 210
 Artist's Choice, 302, 304
 Arts of the South Seas, 110, 111–117 (and figs. 2.44–2.46), 128, 133, 238
 Bauhaus 1919–1928, 143–152 (and figs. 3.2–3.9), 158, 159, 160, 171, 173 (fig. 3.22), 219, 230, 257, 290 (fig. 6.1), 292 (n. 326)

Buildings for Business and Government, 199

Camouflage for Civilian Defense, 210

Cézanne, Gauguin, Seurat, Van Gogh, xxiv (fig. I.2), 60 (fig. 2.1), 61, 62

children's holiday carnivals, 79, 190, 291, 318 (n. 38)

Children's Holiday Circus of Modern Art, xxvii (fig. I.6), 80 (figs. 2.16, 2.17)

Color Prints under $10, 162

Cubism and Abstract Art (1936), 74–76 (and figs. 2.11, 2.13), 78, 81, 110, 128, 167, 280, 291

Cubism and Abstract Art (1942), 78–79

Dada, Surrealism, and Their Heritage, 136, 138 (fig. 2.67), 139 (and fig. 2.68)

Designed for Speed: Three Automobiles by Ferrari, 327 (n. 50)

Design for Sport, 190, 191 (fig. 3.39), 192

Design Show: Christmas 1949, 165

Dislocations, 304–307 (and figs. 6.11, 6.12)

Drawings from the Kroller-Muller National Museum, Otterlo, 340 (n. 45)

Eight Automobiles, 190

Family of Man, 97, 209, 235–259 (and figs. 4.17–4.25, 4.28), 285, 293, 334–335 (n. 70), 338 (n. 141)

Fantastic Art, Dada, Surrealism, 81, 136, 310 (n. 4)

Four Americans in Paris: The Collections of Gertrude Stein and Her Family, 340 (n. 45)

Frank Lloyd Wright: Architect, 327 (n. 5)

Good Design exhibitions, 173–190 (and figs. 3.27–3.31, 3.33–3.38), 201, 241, 271, 285, 291, 293

Hemisphere Poster Competition, 224

House in the Garden (Breuer), 199, 200 (fig. 3.46), 293

Indian Art of the United States, xxvi (fig. I.4), 85–97 (and figs. 2.23–2.30), 110, 111, 116, 124, 224, 292, 320 (n. 68)

Information, 263, 268–282 (and figs. 5.4–5.10), 304

International Competition for Low-Cost Furniture Design, 171, 173, 224

Italian Masters, 66, 70

Japanese House in the Garden, 194, 199, 201, 202 (fig. 3.47), 203 (fig. 3.48), 331 (n. 135)

Lilly Reich: Designer and Architect, 37, 38, 40 (fig. 1.34), 302, 327 (n. 50)

Machine Art, xxv (fig. I.3), 64, 152–160 (and figs. 3.10–3.13), 165, 190, 196, 270, 271, 285, 292

Machine Art: Objects 1900 and Today, 328 (n. 57)

Machine at the End of the Mechanical Age, 263

Mies van der Rohe Retrospective, 165, 166 (fig. 3.17)

Modern Architecture: International Exhibition, 16, 194, 195 (fig. 3.43), 196, 327 (n. 50)

Modern Art in Your Life, 132–139 (and figs. 2.60–2.68), 188

100 Useful Objects of Fine Design for under $100, 165

Organic Design in Home Furnishings, 167–172 (and figs. 3.18–3.21)

The Photo Essay, 109

Photography 1839–1937, 100–104 (and figs. 2.33–2.35)

Picasso: 40 Years of His Art, 78

Picturing Greatness, 302, 303 (fig. 3.10)

Power in the Pacific, 81, 97, 109, 224–227 (and figs. 4.9, 4.10), 238, 258

"Primitivism" in Twentieth Century Art: Affinity of the Tribal and the Modern, 117, 122 (fig. 2.52), 123 (fig. 2.53), 124

Projects Rooms, 286, 296–299 (and figs. 6.4, 6.5), 302, 341 (n. 11) (*see also* Adams, Dennis; Lawler, Louise)

Road to Victory, 81, 97, 209–224 (and figs. 4.1–4.8), 225–236, 238, 249, 250, 258, 291, 292, 296, 298 (*see also* Adams, Dennis)

Sculpture of Picasso, 129, 130 (fig. 2.58), 131 (and fig. 2.59), 292

Signs in the Street, 192–194 (and figs. 3.40–3.42)

Sixty Photographs: A Survey of Camera Esthetic, 101, 106 (fig. 2.37), 107 (fig. 2.38)

Spaces, 281–286 (and figs. 5.11, 5.12)

Taxi Project, 190

Ten Automobiles, 190

Timeless Aspects of Modern Art, 81, 84, 85 (fig. 2.21), 128, 129, 131, 133

Toward the "New" Museum of Modern Art, 70, 71 (fig. 2.9)

United Hemisphere Poster Competition, 210

United States Army Illustrators of Fort Custer, Michigan, 210, 231, 298

Useful Household Objects of American Design, xxvi (fig. I.5), 162, 163 (fig. 3.15)

Useful Household Objects under $5, 160, 161 (fig. 3.14)

Useful Objects in Wartime, 165

Useful Objects of American Design under $10.00, 162, 164 (fig. 3.16), 295 (and fig. 6.3)

Useful Objects series, 143, 160, 162, 165, 167, 173, 174, 190, 194, 293

Vincent Van Gogh, 62, 65 (fig. 2.4), 70

Visual Analysis of the Paintings by Picasso, 78, 79 (fig. 2.15)

Wartime Housing, 210

laboratory period, xxii, 70, 81, 104, 133, 139, 152, 159, 174, 190, 194, 201, 231, 236, 257, 258, 259, 270, 276, 280

library, 73

Museum Design Store, 201, 331 (n. 9)

permanent collection, 72, 73, 292

Philip L. Goodwin Galleries, 201, 204 (fig. 3.49)

Young Peoples's Gallery, 79

Museum of Primitive Art (New York), 116, 117, 118 (fig. 2.47). *See also* Metropolitan Museum of Art, Michael C. Rockefeller Wing

Art of Lake Sentani, 117

Art of the Asmat: The Michael C. Rockefeller Collection, 117, 120 (figs. 2.49, 2.50)

Selected Works from the Collection, 118

Museum of the American Indian (New York), 99, 321 (n. 88)

Museum of the Rhode Island School of Design (Providence), 25

Museums

audiences, 78, 271, 341 (n. 11) (*see also* Humanism; Viewer, creation of)

development of modern, 16, 21, 70, 293, 311 (n. 5), 312–313 (nn. 28, 29)

education, 78–80 (and figs. 2.15–2.17), 280, 281, 312 (n. 38) (*see also* Installation methods, didactic exhibitions/ installations)

visit to, as cultural ritual, xxiii, 293, 318 (n. 25), 333 (n. 39)

Music and Theater Festival of Vienna, 4, 13
Mussolini, Benito, 50, 51, 56, 57
Myth, 70, 158, 209, 222, 255, 278, 281

National Gallery of Art (Washington), 323 (n. 119)
National Socialism, 39, 44, 81, 125, 221
Native American Arts and Crafts revival, 85, 87, 319
 (n. 46)
Native American cultures, 85, 87, 88, 90, 94, 97,
 111, 319–320 (nn. 46, 50). *See also*
 Museum of Modern Art, exhibitions, *In-
 dian Art of the United States*
 Crow, 94, 95 (fig. 2.29)
 Haida, 87
 Hopi, 88, 90, 97
 Navaho, 90, 93 (fig. 2.28), 94, 96 (fig. 2.30), 97
 Seminole, 94, 95 (fig. 2.29)
Natural history museums, 84, 90, 98, 99, 100,
 101, 124. *See also* American Museum
 of Natural History
Nauman, Bruce, 304, 307
Naumov, Aleksandr, 46
Nazism. *See* National Socialism
Nelson, George, 134, 173
Neuner, Jerome, 117, 122 (fig. 2.52), 123 (fig.
 2.53), 194
Newark Museum, 37, 165
 Applied Arts, 165
 Decorative Arts Today, 327 (n. 55)
 Deutscher Werkbund exhibition, 165, 327 (n.
 55)
 Inexpensive Articles of Good Design, 165, 327
 (n. 55)
New Bauhaus, 44
New Deal, 87, 171, 319–320 (n. 50)
Newhall, Beaumont, 62, 99–107 (and figs. 2.33–
 2.35, 2.37, 2.38), 139
Newhall, Nancy, 104, 139
New Vision photography, 44, 45, 101, 104
New York City Housing Authority, 196
Niegeman, Johan, 36 (and fig. 1.33)
Nixon, Richard, 270, 271
Nizzoli, Marcello, 56 (fig. 1.49), 57
Noguchi, Isamu, 134
Nomura, Kichisaburo, 212
Nonferrous Metals, 39, 43 (fig. 1.38), 57
Norman, Dorothy, 236, 237 (fig. 4.17)
Noyes, Eliot, 165, 167, 168 (fig. 3.18), 169 (fig.
 3.19), 171

Oelze, Richard, 136
Oiticica, Helio, 278
Olivetti, 272 (fig. 5.4), 281, 282
*On the Passage of a Few People through a Rather
 Brief Moment in Time: The Situationist In-
 ternational,* 302
Op and Pop. See Philip Morris
Op Losse Schroeven: Situaties en Crypostructuren,
 269
Oppenheimer, J. Robert, 254, 336 (n. 113)
Orozco, José Clemente, 84
Oud, J. J. P., 194
Ovid (Publius Ovidius Naso), 249
Ozenfant, Amédée, 134

Paalen, Wolfgang, 136
Palanti, Giancarlo, 57
Paley, William, 265
Parallel of Life and Art, 194
Parks, Rosa, 336 (n. 109)
Parr, Albert, 125
Parsons, Talcott, 254
Patriarchy, 236, 254, 257, 258
Payne, G. Lyman, 196, 197 (fig. 3.44)
Pechter, Paul, 280
Pepis, Betty, 189
Persico, Edoardo, 56 (fig. 1.49), 57
Peterhans, Walter, 44
Petlin, Irving, 265
Philip Morris, *Op and Pop,* 285
Philip Morris Europe, 285, 340 (n. 46)
Phillips, Christopher, 222, 332 (n. 7)
Phillips, Lisa, 300 (fig. 6.7), 302
Picabia, Francis, 4, 136
Picard, Fred A., 94, 95 (fig. 2.29)
Picasso, Pablo, 78, 79, 81, 84, 129–131, 136. *See
 also* Museum of Modern Art, exhibitions,
 Sculpture of Picasso
Picture magazines, 4, 105, 109 (fig. 2.40), 110,
 215, 219, 223, 224, 225, 227
 Life, 201, 215, 223, 244, 254
Piper, Adrian, 269, 278, 304, 306 (fig. 6.12), 307
Piranesi, Giovanni Battista, 84
Piscator, Erwin, 22
Plate-Glass Hall, 38, 42 (fig. 1.36)
Plato, 152, 153
Pop art, 269. *See also* Philip Morris
Popular culture, 73, 81, 144, 145, 201, 209, 219,
 250, 257, 258, 269, 332 (n. 32)

Postmodernism, 302
Power of display, 13, 14, 97, 201, 258, 286, 304
Power of memory, xxi, xxiii, 224, 291, 307
Pragmatism, American, 313 (n. 31)
Prampolini, Enrico, 4
Presley, Elvis, 255
Pressa, 45–49 (and figs. 1.42, 1.43), 51, 221
Primitive art. *See* Ethnographic art and artifacts
Prospect '69, 269
Publicity, xxvi (figs. I.4, I.5), xxvii (fig. I.6), xxviii, 71,
 94, 144, 158, 173, 174, 176, 231,
 238, 256, 264, 270, 271, 312 (n. 22)
Public Works Administration. *See* United States
 government
Pulsa, 282, 283 (fig. 5.11)

Race, 124, 125, 244, 304, 307, 324 (nn. 124,
 126)
Racism, 124, 125, 251, 263, 324 (nn. 124, 126)
Radio, 4, 51, 189, 222, 270, 338 (n. 129)
Rapan, Henri and Jacques, 25, 31 (fig. 1.28)
Ratner, Joseph, 313 (n. 31)
Ratton, Charles, Gallery, 81
Redon, Odilon, 136
Reich, Lilly, 36–44 (and figs. 1.35–1.37, 1.39),
 136, 153, 159, 165. *See also* Museum
 of Modern Art, exhibitions, *Lilly Reich:
 Designer and Architect*
Reynolds, Ann, 318–319 (n. 38), 320 (n. 69)
Richards, Charles R., 158
Richter, Hans, 4, 45
Riegl, Alois, 16, 69, 313 (n. 31), 318 (nn. 30, 38)
Rietveld, Gerrit, 75, 78, 189
Riley, Terence, 204 (fig. 3.49), 327 (n. 50)
Rivera, Diego, 84
Roche, Mary, 143
Rockefeller, John D., 202 (fig. 3.47)
Rockefeller, Michael C. *See* Metropolitan Museum of
 Art, Michael C. Rockefeller Wing; Mu-
 seum of Primitive Art, *Art of the Asmat:
 The Michael C. Rockefeller Collection*
Rockefeller, Nelson, 116, 209, 224, 265, 270,
 271, 322 (n. 103), 323 (n. 111)
Rockefeller family, 265, 267 (fig. 5.3), 271
Rockefeller Foundation, 75, 98, 99
Rodchenko, Aleksandr, 14, 15 (fig. 1.12), 136
Roeder, George, 223
Rogers, Meyric, 176
Rohm and Haas Company, 193

Roman, Giovanni, 57

Roosevelt, Eleanor, xxvi (fig. I.4), 87, 90 (fig. 2.25)

Roosevelt, Franklin Delano, 210, 219, 230, 231

Roosevelt, Theodore, 307

Ross, Andrew, 332 (n. 32)

Roters, Eberhard, 342 (n. 16)

Rubin, William, 117, 122–123 (figs. 2.52–2.54), 124, 136–139 (and figs. 2.67, 2.68)

Rudolph, Paul, 184–188 (and figs. 3.35–3.37), 236–250 (and figs. 4.18, 4.20–4.26), 252 (fig. 4.27), 253 (fig. 4.28), 258, 338 (n. 141)

Ruscha, Ed, 269

Ruskin, John, 312 (n. 28)

Russell, Bertrand, 250

Saarinen, Eero, 167
 Eero Saarinen and Associates, 199

Sachs Quality Stores, 171, 173

Sagebiel, Ernst, 44

Salon of Honor, Triennale (1936), 57

Salon-style installations. See Installation methods, salon style

Sandburg, Carl, 210, 215, 234, 235, 236, 238, 241

Sano, Tansai, 202 (fig. 3.48), 331 (n. 139)

Schapiro, Meyer, 81

Schawinsky, Xanti, 27, 36 (fig. 1.33)

Schlemmer, Oskar, 4, 22, 75

Schmalhausen, Otto, 12 (fig. 1.21)

Schmidt, Joost, 27, 36 (fig. 1.33), 41

School of Design (Chicago), 44

Schulz, Bernhard, 342 (n. 16)

Schwitters, Kurt, 136

Seale, Bobby, 278

Sekula, Allan, 254

Seligmann, Kurt, 136

Sellman, Michael, 342 (n. 16)

Semenova, Elena, 46

Semiology, 310 (n. 6)

Senkin, Sergei, 46, 48 (fig. 1.42), 215

Seurat, Georges. See Museum of Modern Art, exhibitions, Cézanne, Gauguin, Seurat, van Gogh

Sexism, 263

Shaver, Dorothy, 178

Silvana, 266–267 (figs. 5.1–5.3), 339 (n. 10). See also Guerrilla Art Action Group

Site specificity, xxiii, 3, 269, 282, 285, 304

Situationist International, 310 (n. 3). See also On the Passage of a Few People through a Rather Brief Moment in Time: The Situationist International

Skidmore, Owings, and Merril, 199

Smith, George Kidder, 224–226 (and figs. 4.9, 4.10)

Smithson, Robert, 281

Société Anonyme, 313 (n. 41), 317 (n. 2)

Sonnier, Keith, 286

Sonoma News Company, 84

Sottsass, Ettore, 272 (fig. 5.4), 281

Sound. See Installations, aspects of

Soviet totalitarianism, 50, 81

Speer, Alfred, 41

Speyer, James A., 189

Stalin, Joseph, 50

Stamerra, Joanne, 339 (n. 10). See also Guerrilla Art Action Group

Stange, Maren, 222

Stationen der Moderne: Die bedeutenden Kunstausstellungen des 20. Jahrhunderts in Deutschland, 342 (n. 16)

Steichen, Edward, 45, 97, 105, 209–219 (and figs. 4.1, 4.3–4.8), 222, 224, 235–259 (and figs. 4.17, 4.18, 4.21–4.28), 293, 296, 338 (n. 141)

Stella, Frank, 268, 280

Stone, Edward, 199

Stonorov, Oskar, 171

Stores, 84, 160, 162, 165, 167, 171, 182, 183 (fig. 3.32), 327 (n. 55), 331 (n. 140). See also Commercial showrooms; Department stores

Storr, Robert, 304, 307

Stryker, Roy, 219

Subjectivity, modern, 70. See also Autonomy; Humanism; Universalism; Viewer, creation of

Sullivan, Louis, 21

Suprematism, 8

Surrealism, 11 (fig. 1.8), 22 (and fig. 1.20), 24, 81. See also Art of This Century; First Papers of Surrealism

Swan, Natalie, 145

Sweeney, James Johnson, 151

Swiss Section, Triennale (1936), 57

Szarkowski, John, 80, 108–109 (figs. 2.39–2.40), 110, 259, 338 (n. 142)

Tamayo, Ruffino, 84

Tanguy, Yves, 24, 134, 136

Taste, 70, 271

Technology, 3, 14, 50, 99, 101, 105, 235, 258, 293
 technological innovation, 3, 22, 37, 46, 48 (fig. 1.43), 57, 101

Telecopiers, 282

Telephones, 189, 270, 278

Television, 176, 189, 190, 244, 254, 258 (and fig. 4.29), 270
 telemuseum, 313 (n. 41), 338 (n. 139)

Telex machines, 282

Terragni, Giuseppe, 3, 51, 54 (fig. 1.47), 55 (fig. 1.48), 56, 215, 221

Theater, 4, 13, 21, 72, 74, 280

This Is Tomorrow, 194

Thompson, J. Walter, 219

Thygesen, Erik, 278

Till, Emmett, 336 (n. 109)

Toche, Jean, 266–267 (figs. 5.1–5.3), 339 (n. 10). See also Guerrilla Art Action Group

Toche, Virginia, 339 (n. 10). See also Guerrilla Art Action Group

Triennale (1936), 57
 Salon of Honor, 57
 Swiss Section, 57

Triennale (1951), 57

Trocadéro (Paris), 99, 124, 321 (n. 82)

Truman, Harry S., 254

Tsai, 264

Tschichold, Jan, 48, 50

Turquoise, Charley, 94

United Nations, 124, 173, 235, 248 (fig. 4.25), 249, 250, 324 (n. 126), 333 (n. 141)

UNESCO, 125, 324 (n. 126)

United States government, 212, 223, 224, 235, 256, 257, 258
 Army, 219, 230, 231
 Atomic Energy Commission, 251, 252 (fig. 4.27), 336 (n. 113)
 Central Intelligence Agency, 224, 256
 Coast Guard, 224
 Congress, 256
 Coordinator of Inter-American Affairs, 224

Department of the Interior, 85, 90
Farm Securities Administration, 215, 219, 220
Marines, 224, 225
National Guard, 224, 225
Navy, 219, 224, 225
Office of Indian Affairs, 319 (n. 50)
Public Works Administration, 198 (fig. 3.45)
Treasury Department, 338 (n. 139)
United States Information Agency, 255, 256
War Production Board, 223
Works Progress Administration, 88 (and fig. 2.23), 91 (fig. 2.26)
Universalism, 81, 84, 99, 124, 129, 215, 236, 238, 244
 universal aesthetics, 70, 116, 125, 158, 257, 324 (n. 124)
 universal audiences, 257
 universal humanism, 124, 125, 129, 209, 235, 255
 universal language, 257
 universal laws of nature, 129
 universal markets, 257
 universalist installation technique, 128

Vaillant, George, 98
Van Gogh, Vincent, 61, 62 (and fig. 2.1), 70
Varnedoe, Kirk, xx (fig. I.1), 72 (fig. 2.10), 117, 122 (fig. 2.52), 123 (fig. 2.53), 124
Vassilakis, Takis, 23
Velvet and Silk Cafe, 37, 41 (fig. 1.35)
Venice Biennale, 256, 268
Video, 278, 286, 304, 307
Vietnam War, 105, 268, 304
Viewer, creation of, xxiii, xxviii, 14, 20, 27, 37, 45, 68, 70, 78, 111, 116, 129, 144, 176, 177 (fig. 3.25), 220, 231, 233 (fig. 4.15), 234, 244, 292, 294 (fig. 6.2). *See also* Autonomy; Humanism
Viewer interactivity, xxiii, 8, 13 (fig. 1.11), 14, 20, 21, 22, 68, 69, 101, 104 (fig. 2.36), 116, 144, 152, 158, 159, 201, 220, 230, 241, 270, 278, 282, 313 (n. 41)
Visitor polls, 158, 270, 271. *See also* Haacke, Hans

Walker Art Center (Minneapolis), 165, 167
 Everyday Art Gallery, 165
Wallace, Fred, 87
Wallace, John, 87
Wallach, Alan, 318 (n. 25), 333 (n. 39)

Walther, Franz Erhard, 284 (and fig. 5.12)
Warhol, Andy, 278
Weingraber, Thomas, 300 (fig. 6.7)
Welfare Council (New York City), 194
Weston, Edward, 45
Wheeler, Monroe, 199, 220, 227, 228 (fig. 4.11)
Whitechapel Gallery. *See This Is Tomorrow*
Whitelaw Reid Mansion. *See First Papers of Surrealism*
Whitney, John Hay, 73, 210, 224, 256
Whitney Museum of American Art (New York), *Frederick Kiesler,* 300–301 (figs. 6.7–6.9), 302
Whitney Studio Club, 81
Wide Wide World, 258
Wigley, Mark, 311 (n. 8)
Wild, Hanns-Rudolf von, 342 (n. 16)
Wilkie, Wendell L., 227, 235, 257
 One World, 235, 257
Wingert, Paul S., 110, 128 (fig. 2.57)
Women's Fashion, 38, 41 (fig. 1.35)
Wood, Nancy, 219
Woodner-Silverman, I., 96, 97–98 (figs. 3.44, 3.45)
Woolf Brothers Department Store, 175 (fig. 3.24)
Woolworth's, 162. *See also* Department stores; Stores
Works Progress Administration. *See* United States government
World War I, 44, 219
World War II, 57, 124, 160, 189, 209, 223, 235, 251, 263, 296, 304. *See also* Adams, Dennis; Museum of Modern Art, exhibitions, *Road to Victory*
Wright, Frank Lloyd, 194, 327 (n. 5), 328 (n. 58)
Wyatt, Jane, 258 (fig. 4.29)

Xerox Corporation, 282

Yale University, 125, 192
Yoshida, Shigeru, 201, 202 (fig. 3.47), 203 (fig. 3.48), 331 (n. 135)
Yoshimura, Junzo, 194, 199, 202 (fig. 3.47), 203 (fig. 3.48)
Young, Robert, 258 (fig. 4.29)

Zelnio, Andie, 300–301 (figs. 6.7–6.9)
0.10 The Last Futurist Exhibition of Paintings, 62, 63 (fig. 2.2)
Zwart, Piet, 45